Norman Rockwell

3 3 2 M A G A Z I N E C O V E R S

Norman

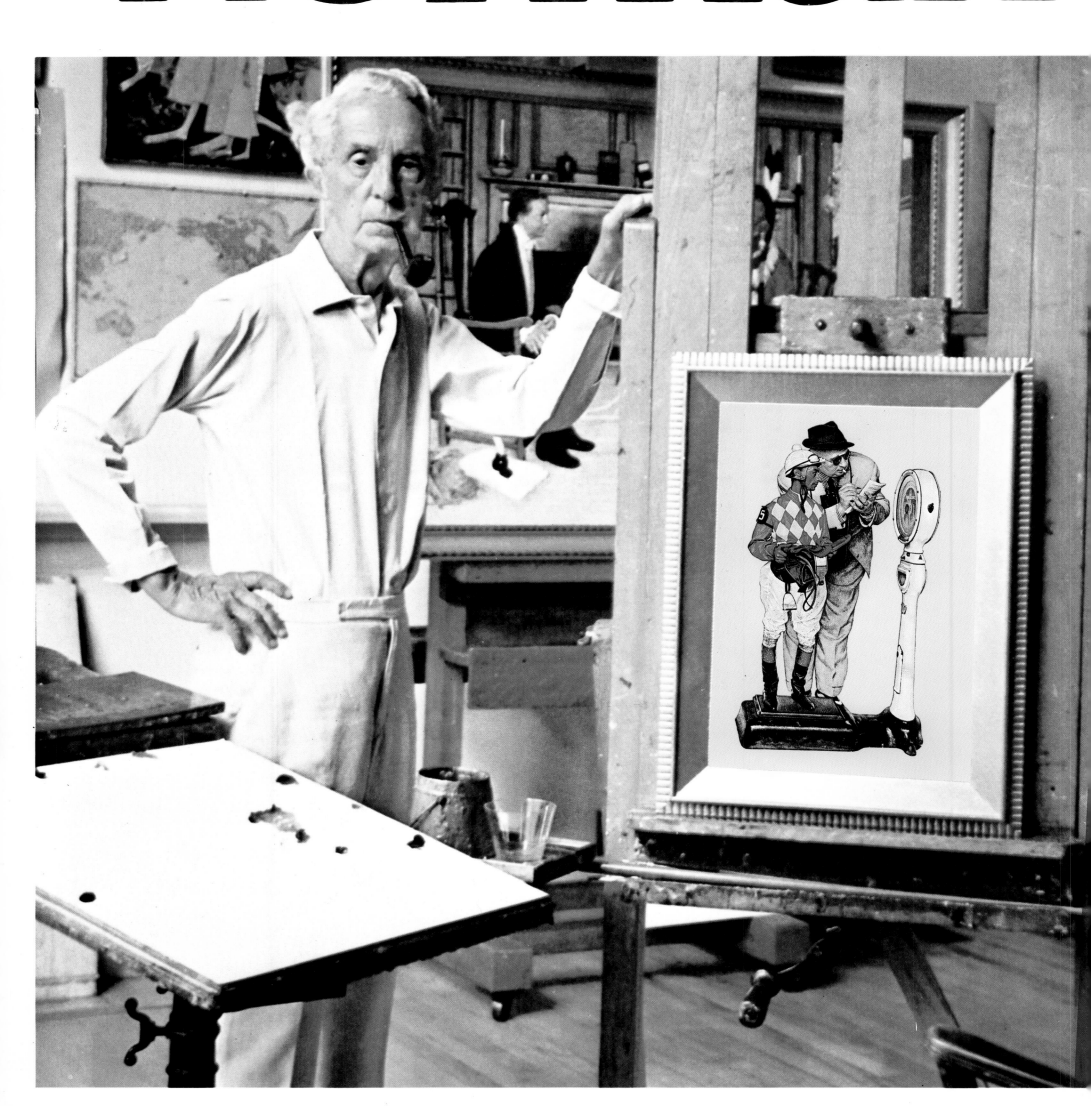

Rockwell

332 MAGAZINE COVERS

by

CHRISTOPHER FINCH

ABBEVILLE PRESS / RANDOM HOUSE
PUBLISHERS · NEW YORK

THIS BOOK WAS DESIGNED AND PRODUCED BY ABBEVILLE PRESS

The publishers gratefully acknowledge the kind cooperation of
CURTIS PUBLISHING COMPANY in the preparation of this book.

Library of Congress Cataloging in Publication Data

Rockwell, Norman, 1894–1978.
 332 magazine covers.

 1. Rockwell, Norman, 1894–1978. 2. Magazine
covers—United States. I. Finch, Christopher. II. Title.

NC975.5.R62A4 1979 759.13 79-11064
ISBN 0-394-50657-X

CONTENTS

Norman Rockwell

3 3 2 MAGAZINE COVERS

Norman Rockwell Portrayed Americans as Americans Chose to See Themselves

NORMAN ROCKWELL began his career as an illustrator in 1910, the year that Mark Twain died. He sold his first cover paintings when there were still horse-drawn cabs on the streets of many American cities, and he began his association with *The Saturday Evening Post* in 1916, the year in which Woodrow Wilson was elected to a second term in the White House and the year in which Chaplin's movie *The Floorwalker* broke box-office records across the country. Young women were enjoying the comparative freedom of ankle-length skirts, and their beaux were serenading them with such immortal ditties as "The Sunshine of Your Smile" and "Yackie Hacki Wicki Wackie Woo." In literature this was the age of Booth Tarkington, Edith Wharton, and O. Henry. Ernest Hemingway, still in his teens, was a cub reporter for the *Kansas City Star,* and F. Scott Fitzgerald—soon to become a frequent contributor to the *Post*—was still at Princeton. The New York Armory Show of 1913 had introduced the American public to recent trends in European painting, but traditional values still reigned supreme in the American art world. Only a handful of artists aspired to anything more novel than the mild postimpressionism of painters like John Sloan and Maurice Prendergast. The movies were becoming a potent force in popular entertainment, but few people took them seriously or thought they might one day take their place alongside established art forms.

It was a world in transition, but the transition had not yet accelerated to the giddy speed it would achieve in the twenties. People could be thrilled by the exploits of pioneer aviators without being conscious of the impact that flying machines would have on modern warfare. It was possible to enjoy the conveniences provided by such relatively new inventions as the telephone, the phonograph, the vacuum cleaner, and the automobile without being too troubled by the notion that technology might some day soon threaten the established order of things.

The illustrator and cover artist working in the mid-teens of the twentieth century was generally asked to embody established values. The latest model Hupmobile Runabout might well be the subject of a given picture—an advertisement, perhaps—

but the people who were shown admiring or driving in the newfangled vehicle were presumed to espouse the same values as their parents and their grandparents. The set of the jaw, the glint in the eye had not changed much since the middle of the nineteenth century. The women wore their hair a little differently, perhaps, and men were doing without beards, but these were superficial differences. The fact is that the minds of the people who edited and bought magazines like *Colliers, Country Gentleman, Literary Digest,* and *The Saturday Evening Post* had been formed, to a large extent, in the Victorian era.

Norman Rockwell himself, born on the Upper West Side of Manhattan, had a classic late-Victorian upbringing. He spent his childhood in a solidly middle-class, God-fearing household in which it was the custom for his father to read the works of Dickens out loud to the entire family. Thus Rockwell had little difficulty in adapting to the conventions that were current in the field of magazine illustration at the outset of his career. Although a New Yorker, he was especially drawn to rural subject matter (he is on record as saying that he felt more at home in the country). This reinforced his affection for traditional idioms, since it focused his attention on the most conservative elements of the population, those who were least susceptible to change of any kind.

In short, Rockwell began his career right in the mainstream of the illustrators of his day, sharing the assumptions and concerns of his contemporaries and of the editors who employed him. His work is remarkable because he sustained through half a century the values that he espoused in those early days when the world was changing more drastically than anyone could have imagined possible. It would be easy enough, of course, to find fault with his refusal to break with those values, but that would be unjust. Rockwell simply continued to believe in what he had always believed in, and in his own way, he did, in fact, change and grow throughout his career. He learned how to embrace the modern age without abandoning his own principles. But he was also forced to modify and enrich his approach to the art of illustration in order to reconcile those principles to a world that was evolving so fast it seemed, at times, on the verge of flying apart.

His earliest paintings are conventional, almost to the point of banality, because the values they embody could be taken so much for granted. As he was forced to deal with a changing environment, however, he was obliged to become more inventive and original. A situation that could be presented in the simplest of terms in 1916, for example, might still be valid a quarter of a century later, but only if it were made more specific. Stereotypes had to be replaced by carefully individualized characters. More and more detail had to be introduced to make a situation more particular. As time

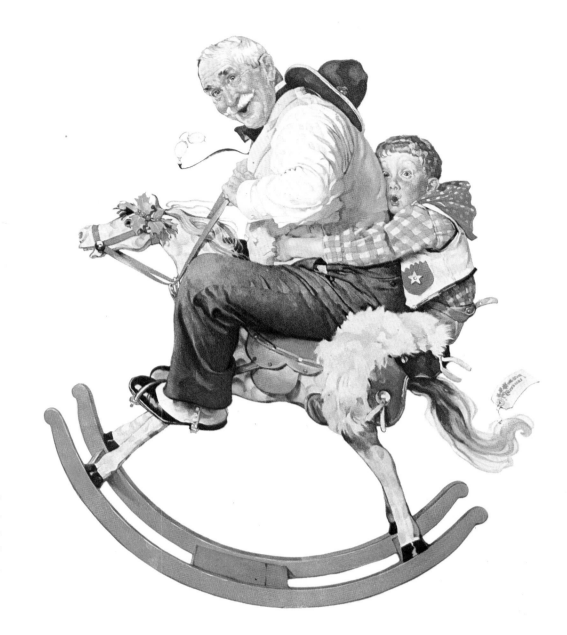

MERRY CHRISTMAS
Post Cover • December 16, 1933

In the late twenties and early thirties, most of Rockwell's Christmas covers were period pieces. In 1933 he turned to a contemporary but very traditional theme. Grandfather is making good use of his grandson's new rocking horse. He has even purloined the boy's cowboy hat. This is a typical exploration of one of Rockwell's favorite themes.

passed, Rockwell was called upon to draw on all his resources as an illustrator in order to pull his audience—which was always changing—along with him. As circumstances became, theoretically at least, more hostile to his kind of traditional image-making, he rose to the challenge. His work became richer and more resonant, reaching a peak in the forties and fifties when most of the men who had been his rivals at the outset of his career were already long forgotten. His most remarkable quality was his ability to grow and adapt—to remain flexible—without ever modifying the basic tenets of his art.

What seems to have enabled him to do this was a belief in the fundamental decency of the great majority of his fellow human beings. This belief was the most deep-seated of all his values, and it enabled him to perceive a continuity in behavior patterns undisturbed by shifts in social mores. The twentieth century has offered plenty of evidence of man's ability to shed his humanity, and Rockwell was certainly aware of this, yet he clung to his belief in decency. It was an article of faith, and it gave his work its particular flavor of innocence.

Over the past hundred years or so, artists and critics have been ambiguous in their attitudes towards innocence. The "naive" vision of such painters as Henri Rousseau has been much prized, yet more schooled artists have often been led astray when they

attempted to embrace such a vision (indeed it would be difficult for such a vision to survive schooling). Picasso, the most protean of all twentieth-century artists—greatly admired by Rockwell, it should be noted—was able to run the full gamut: from a childlike delight in transforming bicycle parts into the likeness of a bull's head to the nightmare vision of Guernica—but Picasso was, in every way, an exception to the rules.

Rockwell's art has nothing, of course, to do with the innovations of modern painting. He was essentially a popular artist—an entertainer—and he was always fully aware that his work was intended to be seen in reproduction. The originals—generally painted on a relatively large scale—are, however, beautiful objects in their own right. He was looking to the general public rather than to a small, highly informed audience, and it was this perhaps that enabled him to sustain the innocence of his vision. Dealing with mass communication rather than the higher reaches of aesthetic decision-making, he has no place in the developing pattern of art history. It is futile even to compare him with American realists like Edward Hopper, whose subject matter occasionally had something in common with Rockwell's. Hopper was always concerned primarily with plastic values, as is the case with any "pure" painter. Rockwell, on the other hand, had to think first and foremost about conveying information about his subject, as must be the case with any illustrator. An illustrator may, of course, have many of the same skills as the "pure" painter, but he deploys them in a different way. Essentially he borrows from existing idioms of easel painting—whether traditional, as in Norman Rockwell's case, or more experimental, as was the case with his notable contemporary Rockwell Kent—and uses them as a means of conveying information. Interestingly, it is known that Norman Rockwell himself, during the twenties, was drawn to modern idioms—the result of a sojourn in Paris—but rejected them in favor of older conventions. The reason for this, we may suppose, was his recognition of the fact that his gift was not painterly at all (remarkable as his painterly skills were). It was, rather, his ability as a pictorial storyteller.

Most of Rockwell's finest covers are, in effect, anecdotes. With occasional exceptions, he can give us only one scene—an isolated episode—but, in his mature work especially, he knows how to pack that scene with so much significant detail that the events that precede it, and follow from it, are, so to speak, latent in the single image. A great short story writer, like Guy de Maupassant, can conjure up a whole life within the span of a dozen pages. Rockwell, at his best, was capable of doing the same kind of thing with a single picture. Because of this he deserves to be thought of as something more than *just* an illustrator. An illustrator, by definition, is someone who

takes another person's story (or advertising copy) and adds a visual dimension. Rockwell, in his cover art, went far beyond this. He was not only the illustrator, but also the author of the story. In his work, image and anecdote were inseparable; each sprang naturally from the other.

It is perhaps easier to find parallels for Rockwell in the world of literature than in the world of painting. His world is full of echoes of Dickens and Twain, and he has much in common with O. Henry. It seems to me, though, that the writer Rockwell most resembles—despite enormous differences in cultural background—is P. G. Wodehouse, another perennial contributor to *The Saturday Evening Post* and Rockwell's senior by eleven years.

Wodehouse was, of course, as quintessentially English as Rockwell was American. It's worth noting, though, that Wodehouse—a longtime United States resident—always kept his vast American readership in mind, peppering his stories with Americanisms that were far from current in his native country at the time. H. L. Mencken credited him with introducing many Anglicisms into the American vocabulary. But while this was undoubtedly the case, he was far more successful in causing his English readers to adopt American slang. What the two have in common, along with being gentle humorists and master storytellers, is a basic innocence of concept allied with tremendous technical skill. Wodehouse succeeded in placing his protagonists in a kind of Arcadian never-never land, a fabulous environment that bore a recognizable resemblance to the real world but was somehow different, drained of malice. His cast of characters—Jeeves, Bertie, Psmith, Lord Emsworth and the Mulliner clan, along with assorted debutantes (both bird-brained and spunky), regulars of the bar–parlour at the Anglers' Rest, and the various Hooray Henrys who keep the leather chairs in the Drones Club polished with the backsides of their Saville Row suits—were drawn from the conventional repertory of English upper-class and upper-middle-class types (always, of course, provided with a supporting cast of dour domestics, canny rustics, and impoverished clerics). It is the way he handled them, however, that is significant. Evelyn Waugh, for example, drew on many of the same prototypes for his own acid brand of satire, treating them—in his early novels—as grotesque puppets. Wodehouse, for his part, transformed them into bumbling nymphs and fauns cakewalking their way through a sylvan landscape in which temporary pecuniary embarrassments, dotty aunts, imagined rivals, and stolen pigs take on cosmic significance. In Wodehouse's world, a loss of timing on the golf links is as near as anyone comes to having an existential experience. It is a world innocent of original sin, and hence of real guilt. In the hands of a lesser technician, it would be merely

ludicrous, but Wodehouse was such a superb wordsmith—his narrative and dialogue always strike just the right note—that we are able to accept every absurd turn of events as being part of the natural order of things.

Rockwell's skill with a paintbrush was a match for Wodehouse's deftness with a turn of phrase. Rockwell drew on American stock characters, just as Wodehouse drew on the British repertory, and—again like Wodehouse—placed them in a world free of malice. It's true that Rockwell found it harder to ignore happenings in the real world—as is clear in his wartime covers—but always he saw things in terms of the small crises of everyday life. Rockwell's protagonists come from backgrounds very different from those that produced Wodehouse's characters, but they have the same basic innocence. We might say that both men were genuinely incapable of perceiving evil, or at least of permitting it to intrude into their work. They represented worlds that may never have existed (though most of us wish they could have), and they made them believable.

Both, in short, created utopias— utopias that are all the more agreeable for being so modest, so unpretentious. Of the two, Wodehouse's was the more self-contained. Since most of his stories were set in a world the great majority of his readers were unfamiliar with—the world of English country houses and titled cadgers—he could, so to speak, draw his own boundaries. To be sure, he occasionally sent his protagonists to Manhattan or Hollywood, but even there they wandered blithely through funhouse settings peopled with improbably sentimental gangsters and movie moguls of unsullied stupidity. Rockwell, on the other hand, created a more open-ended utopia, since, nominally at least, it was based on the world that his audience lived in. This was reinforced by the fact that he worked in an industry where it was an established practice for cover artists to submit ideas to publishers for approval before proceeding with the finished work. Magazine publishers, needless to say, were not unconscious of circulation figures and hence tended to reinforce the cover artist's desire to remain in tune with his audience.

Rockwell never seems to have had much trouble sustaining such a rapport. His utopia and that of his audience were, to all intents and purposes, the same thing. He portrayed Americans as they chose to see themselves. It is easier to recognize this in his earlier covers—those painted prior to the late thirties, say—because, with few exceptions, they make no pretense at being anything but stylized representations of situations, amusing or touching, that play some more or less clever variation on an archetypal theme—the vagaries of young love, the compensation of old age, and so forth. We've met the characters who people these situations in the stories of Mark

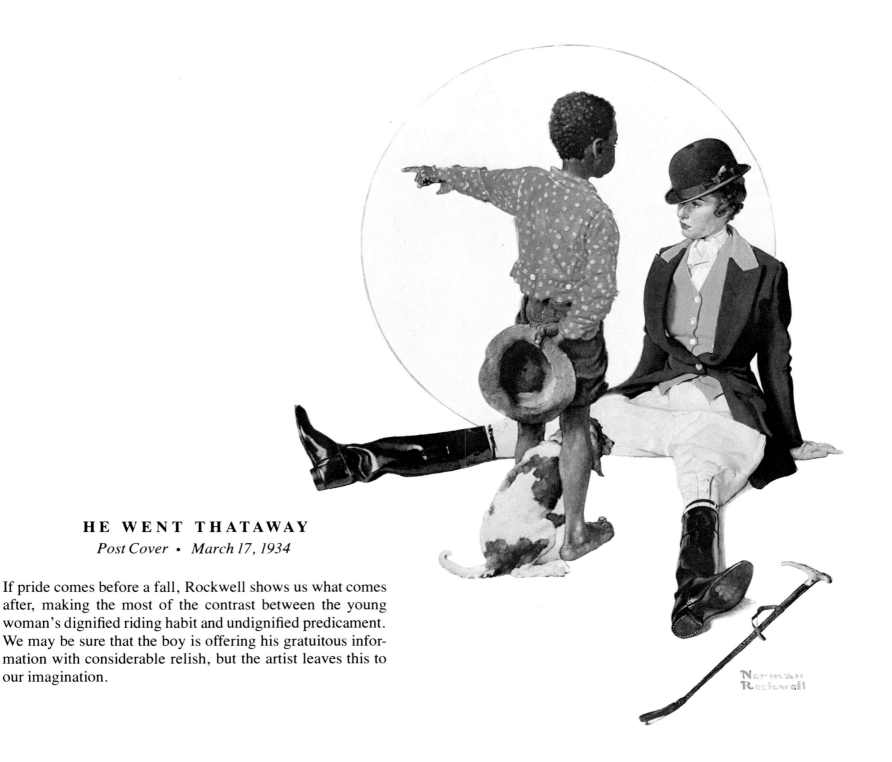

HE WENT THATAWAY
Post Cover • March 17, 1934

If pride comes before a fall, Rockwell shows us what comes after, making the most of the contrast between the young woman's dignified riding habit and undignified predicament. We may be sure that the boy is offering his gratuitous information with considerable relish, but the artist leaves this to our imagination.

Twain and a thousand lesser writers (many of them published by *The Saturday Evening Post*). Rockwell brought to these stereotypes a crispness of vision and, within the limits set by the conventions he adhered to, a subtlety of characterization.

Generally, in the first two decades of his career, the protagonists of his little dramas are portrayed with the minimum of props necessary to tell the story, silhouetted against a white background, the latter designed to accommodate and exploit the expansive magazine logos in style at the time. (More than was the case in his later career, Rockwell was obliged to be a designer as well as an illustrator. The two-dimensional blend of image and logo was at least as important as the treatment of the subject matter. It was this combination that made the individual cover stand out on the newsstand and sold magazines.) The figures in these earlier paintings are familiar icons, isolated from the context of the everyday world. As time passed, however, Rockwell became increasingly skillful at suggesting a broader context through the imaginative use of props.

As early as 1930 a documentary note crept into Rockwell's covers once in a while. (See, for example, p 221 where he brings a gentle irony to the subject of a he-man

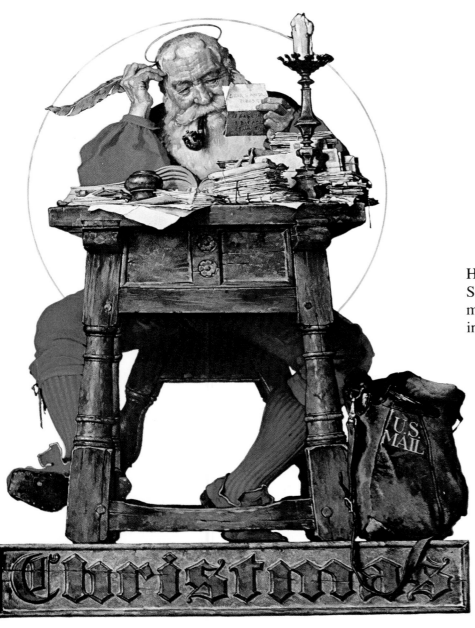

CHRISTMAS

Post Cover • December 21, 1935

Here Rockwell gives us another traditional Christmas image: Santa Claus reading his mail. He manages to bring the subject matter into the present, however, by the simple device of including a U.S. Mail pouch.

movie star, Gary Cooper, being made up for his role in a western.) By the late thirties this note was evident more and more often. When the *Post* changed its logo in 1942, Rockwell was ready to take advantage of this by coming up with a new approach to cover art: his protagonists were placed in detailed settings that themselves helped tell the story or gave us information about the subjects' lifestyles. Increasingly his work took on a documentary appearance. These were real people, the reader could tell himself, in a real setting—and often enough this was literally true.

Rockwell had always drawn from life, and from 1937 on, he made extensive use of photography as an aid to capturing naturalistic poses. These were frequently real people—his family, friends, neighbors—and often the settings, too, were places that were familiar to him—houses, streets, and landscapes that were part of his everyday world.

Early examples of Rockwell's mature technique (which might be described as "fictional" documentary, or synthetic documentary) are to be found in the Willie Gillis covers (pp 312, 313, 315, 317, 318, 319, 329, 334, 342 & 358), a series that Rockwell painted between October 1941 and October 1946. Rockwell was concerned in those covers with portraying the plight of "an ordinary inoffensive little guy

thrown into the chaos of war.'' At the time he was looking for a suitable model for his Gillis, Rockwell was attending a square dance in Vermont; there he spotted a young man named Robert Buck who he thought would be exactly right. Even better, from a practical point of view, Buck was supposedly unfit for military duty; he would thus be available to pose for as many covers as Rockwell might care to paint around that particular character. After Rockwell had painted five Gillis covers, however, Buck succeeded in passing his physical and was inducted into the service, leaving Rockwell with the predicament of having invented a popular character—one who was making his quiet contribution to morale on the home front—but no model to paint him from. Rockwell hit on the solution of devising scenes in which the photographic likeness of Buck/Gillis could be used to stand in for the flesh and blood character (see, for example, p 329). After the war, when Buck came back home, Rockwell used him as a live model once more, winding the series up with a portrayal of Willie's return to civilian life.

The impression of this sequence of covers was that of a documentary portrait of one young man's progress from the period immediately before Pearl Harbor to the period after V-J Day. In fact, of course, Willie Gillis was entirely a figment of Norman Rockwell's imagination—a symbolic protagonist designed to serve a specific purpose at a specific time. If there is anything atypical of Rockwell's career in this, it is only the notion of using a single character over an extended period of time—a device that enabled Willie to come to seem like someone that everyone had known. The way in which a kind of synthetic ''reality'' was created—through the agency of the illustrator's imagination—from models, photographs and sketches was, however, entirely characteristic of the kind of approach Rockwell would utilize throughout the latter part of his career.

Generally, then, each of Rockwell's protagonists is called upon just once, to grace a single cover. We encounter each one like a figure chanced upon in a snapshot that has been selected almost at random from some family album. Yet, in the later work, all the images seem somehow connected. They belong to the same world. The young couple portrayed in ''Marriage License'' (p 422) might well move into one of the houses we see in the background of ''Commuters'' (p 359). It is easy to imagine that the counterman we are shown in ''After the Prom'' (p 430) has his hair cut on the premises presented in ''Shuffleton's Barber Shop'' (p 387). As we study Rockwell's covers—especially since the late thirties—we begin to feel that every image interlocks with half a dozen others. In a sense they are all part of one massive work. Each takes on a greater significance because of those that have preceded it and those that will follow it.

19

As has been remarked, Rockwell enriched his work by making his vision more explicit as time went by, but time itself enriched it by bringing the sum of his previous achievements to bear on each new painting. We should not judge Rockwell by any individual work, nor even by a selection of his finest pictures, but rather by the cumulative effect of his total output. It is this that makes Rockwell so outstanding a figure in the pantheon of American popular culture.

Elsewhere I have remarked that it seems, at first glance, almost absurd to talk of Norman Rockwell as having a distinctive style—his stock in trade is quasi-photographic realism, and his technique derives from a variety of conventional academic sources—yet a Rockwell painting is immediately recognizable as a Rockwell painting. Clearly he does have a style that is unlike any other. It is not easy to define, however, because it does not depend upon any broad mannerisms. It is, rather, made up of small but significant deviations from the photographic and academic norms.

One thing that we will discover if we study Rockwell's work carefully is that the best of his early works are, in general, more "painterly" than most of his later canvases, though these later canvases tended to make more successful covers. When I speak of certain early works as being "painterly," I mean that they are conceived and executed more as conventional easel paintings, whereas the later works often have the look of tinted drawings (even though they are executed in oil paint on canvas). This difference should not be taken as a hard and fast rule, but it does represent a significant tendency, as a few examples will show.

If we turn to the 1921 cover "No Swimming" (p 107), we find that it has been painted in an almost impressionistic way. There is no question here of an outline having been drawn then filled in with color. On the contrary, the image is built up from areas of boldly applied pigment—a well-loaded brush is evident—overlapping and overlaying each other to build up planes that create the illusion of solidity and depth. (Note in particular the way in which the anatomy of the boy in the foreground has been evoked.) Many of the edges of forms have been deliberately blurred in this picture, partly to help produce a sense of speed, but largely as a natural consequence of this approach to image-making. Even Rockwell's highly stylized signature is loosely painted. Turning to the 1930 cover "Gary Cooper" (p 221), we find a composition that is less impressionistic but equally painterly. Again it is built up from carefully placed and orchestrated patches of pigment that add up to the kind of plastic presentation of an image that would win the approval of the most academic of easel painters.

Later examples of Rockwell's cover art often show a very different approach. The

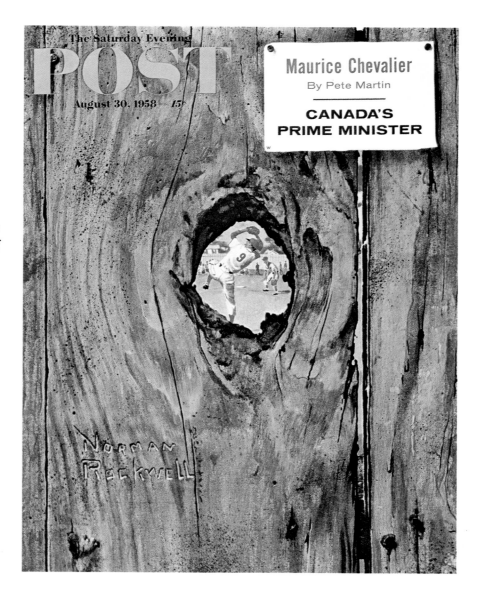

PEEPHOLE

Post Cover • August 30, 1958

It is presumably every small boy's dream to find a hole in the ballpark fence—a peephole that commands a good view of the playing field. Here Rockwell brings that dream to life.

1946 cover painting "New York Central Diner" (p 369) is a clear instance of the dominance of drawing over painting. The dining car itself has been evoked with little more than a few lines, many of them established with the help of a ruler, and everywhere—even in the figures—the outline is dominant. Within these outlines the minimum of modelling is used to produce an illusion of depth and solidity. Again the signature is symbolic of the overall approach: Rockwell has left in the guidelines that ordinarily he would have painted out. If we look at a sixties cover like "The Window Washer" (p 37), we see how clearly the finished painting is prefigured in the preliminary drawing. In many such instances, in fact, the work that appeared on the cover of the *Post* was little more than a drawing transferred onto canvas and heightened with color.

Often, in his later work, Rockwell uses a rather artificial kind of texture to give the illusion of painterliness to what is, in fact, a tinted drawing. In particular, he is fond of a very deliberate kind of impasto (physical buildup of pigment), often applying it in what seems at first glance like a wholly inappropriate way, as for example in his treatment of the mirror in "Triple Self Portrait" (p 442). An extreme example of the application of this technique occurs in the 1946 cover "Commuters" (p 359). This is a

composition governed almost entirely by carefully drawn outlines, but practically the entire area of the canvas has been further enlivened through the use of thickly textured underpainting—roofs, platforms, hillside are all given variations of texture—and clearly this was no accident. Rockwell used this device because he knew that it reproduced well.

As the years passed, Rockwell learned to use any trick of the trade that would lend itself to reproduction and hence contribute to the impact of the cover itself. Correspondingly, he became less and less concerned with what was correct from a strictly academic point of view. He realized, in short, that he was not going to be judged as a conventional easel painter. Again and again he would tell people, ''I am not an artist. I am an illustrator.''

Rockwell's facility was such that he was equally at home whether he was emphasizing the painterly aspects of his skills or demonstrating his virtuosity as a draftsman. It seems to me, in fact, that his finest work generally came about when he achieved some kind of balance between two approaches, as happened from time to time throughout his career, especially in the forties and fifties. To see this, we might look at four of his most successful canvases: ''Shuffleton's Barber Shop'' (p 387), ''Solitaire'' (p 388), ''Breaking Home Ties'' (p 421), and ''The Marriage License'' (p 422).

In ''Shuffleton's Barber Shop'' everything is clearly defined in terms of outlines—we sense the drawing beneath the paint surface—yet there are wonderful painterly touches, such as the atmospheric suggestion of the reflections in the window at the rear of the shop. It is almost as if Rockwell has tried to capture the spirit of the chamber music that is being played in the back room, as if he were searching for an exact blend of line and timbre, of melody and harmony.

In the case of ''Solitaire,'' too, we sense that a careful pencil study has been transferred to the canvas. But here Rockwell seems to have been carried away—delightfully so—by the textures and colors of the seedy hotel room. The carpet and the wallpaper have been conjured up with a splendid fluidity of brushwork. The gaudy necktie draped in the foreground is like a miniature abstract painting in itself.

''Breaking Home Ties'' is perhaps the most painterly of all Rockwell's mature covers—it may just be the finest painting he ever did—but even here the draftsmanship is far more in evidence than in, for example, an early masterpiece like ''No Swimming.'' ''The Marriage License,'' painted just a few months after ''Breaking Home Ties,'' does not display quite the same involvement with paint for its own sake, but still it is much more than just another tinted drawing. One suspects that Rockwell probably took this composition further than he had anticipated when he first painted it.

Norman Rockwell at work in his studio in Stockbridge, Massachusetts.

The idea is rather conventional, but evidently it triggered something in Rockwell's imagination, and he brought more passion than usual to the painting, passion that is evident in the sheer richness of the pigment.

Rockwell was a master of many techniques, then, and he used whatever means was necessary to get across his point. Certain things, however, are constant in his work from the very beginning. There was, for example, something immediately recognizable about the way he assembled the "props" for his paintings. He was never afraid of making the most obvious choices, nor was he afraid of organizing them in the most obvious way. Turning to "Breaking Home Ties" once more, it is full of deliberate

(continued on page 38)

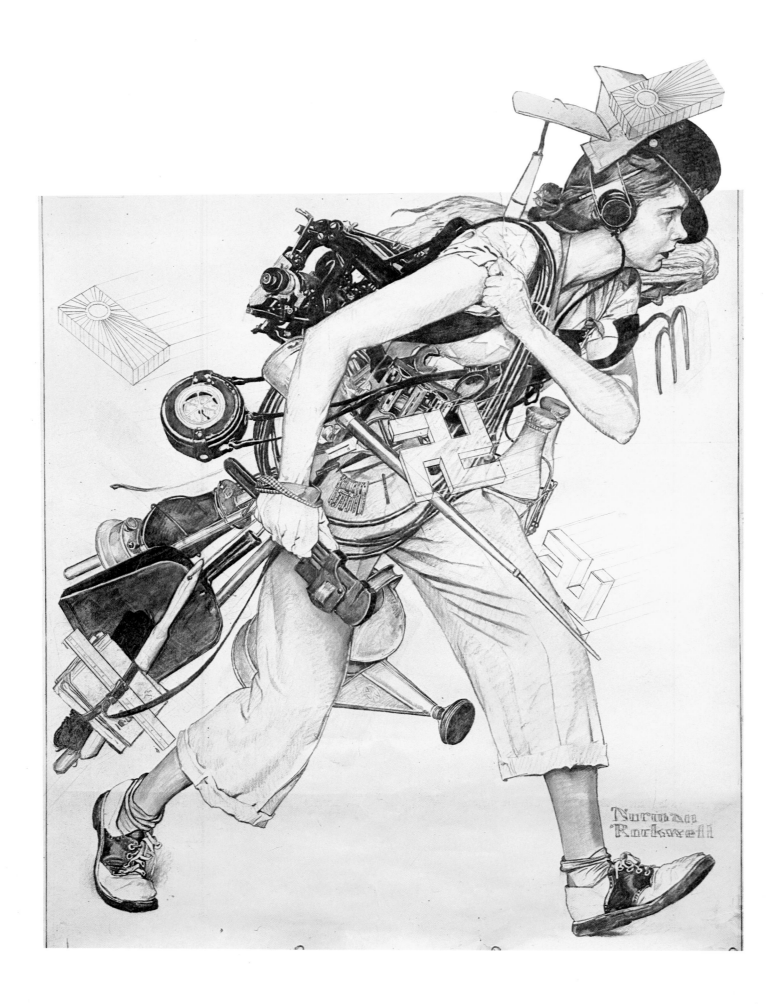

Here Rockwell gives us a World War II housewife ready to do battle against the Axis powers with the weapons available to those who fought on the home front. The detailed pencil sketch shows us how carefully Rockwell planned his covers on paper before committing anything to canvas. The only substantial difference between the sketch and the finished painting is the elimination, in the latter, of the metal swastikas and Imperial Japanese brickbats that the young woman is dodging in the pencil study.

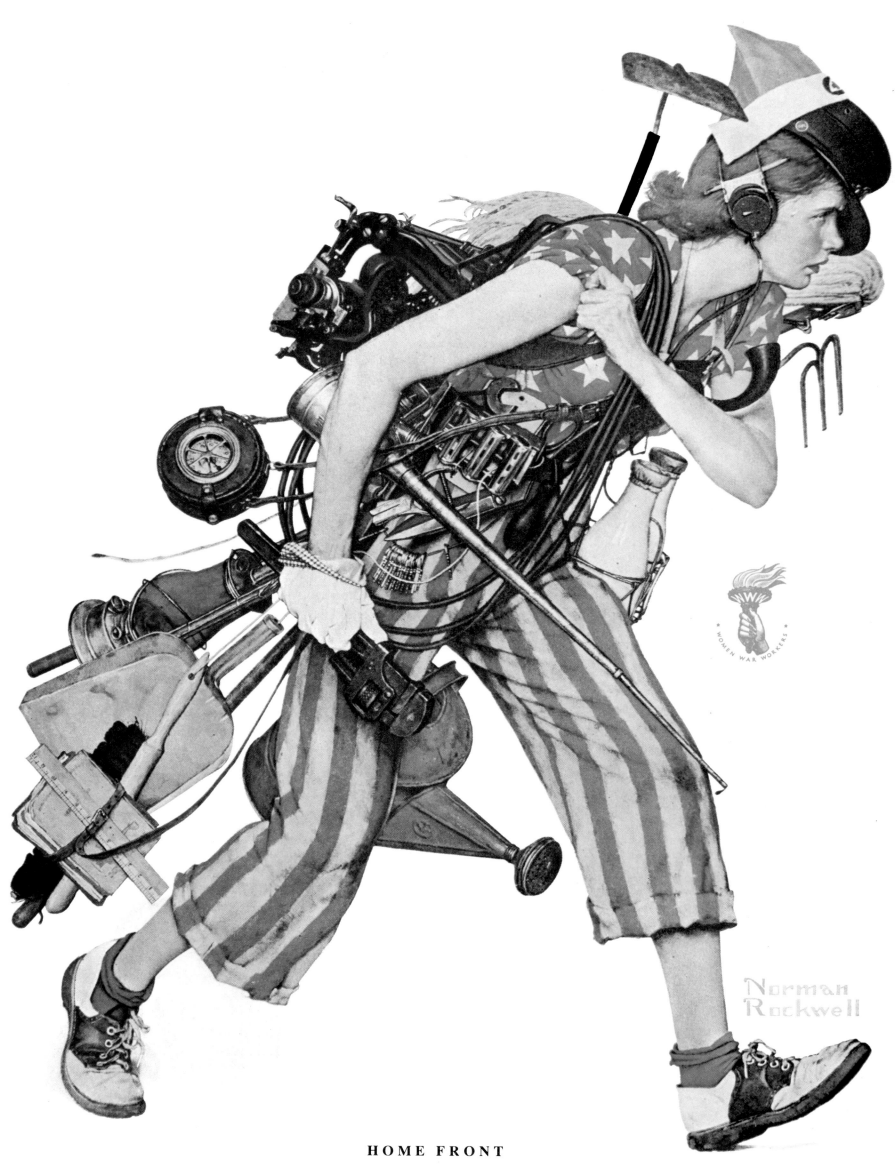

HOME FRONT

Post Cover • September 4, 1943

The color sketch for this delightful New Year's cover, cele-brating the first New Year of peace after World War II, gives us another glimpse of the way in which Rockwell conceived his cover paintings. The sketch itself is a beautiful piece of work, evoking the atmosphere and working out the color scheme that Rockwell delineated fully in the finished work.

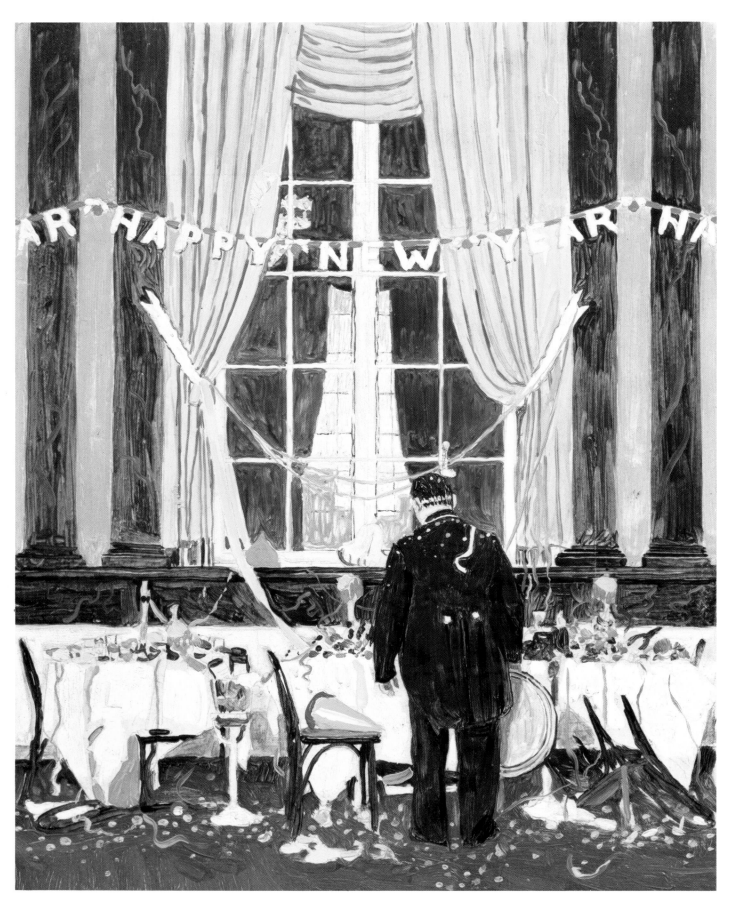

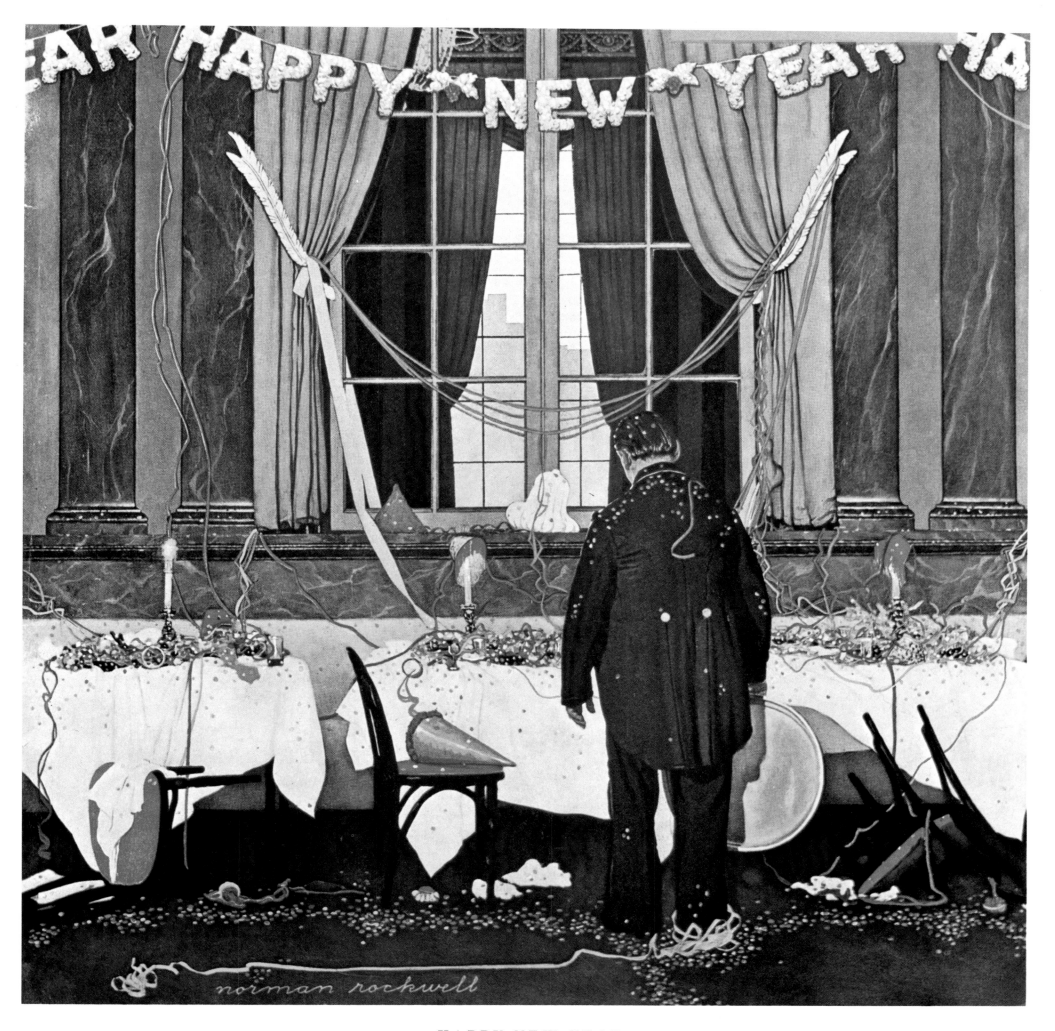

HAPPY NEW YEAR
Post Cover • December 29, 1945

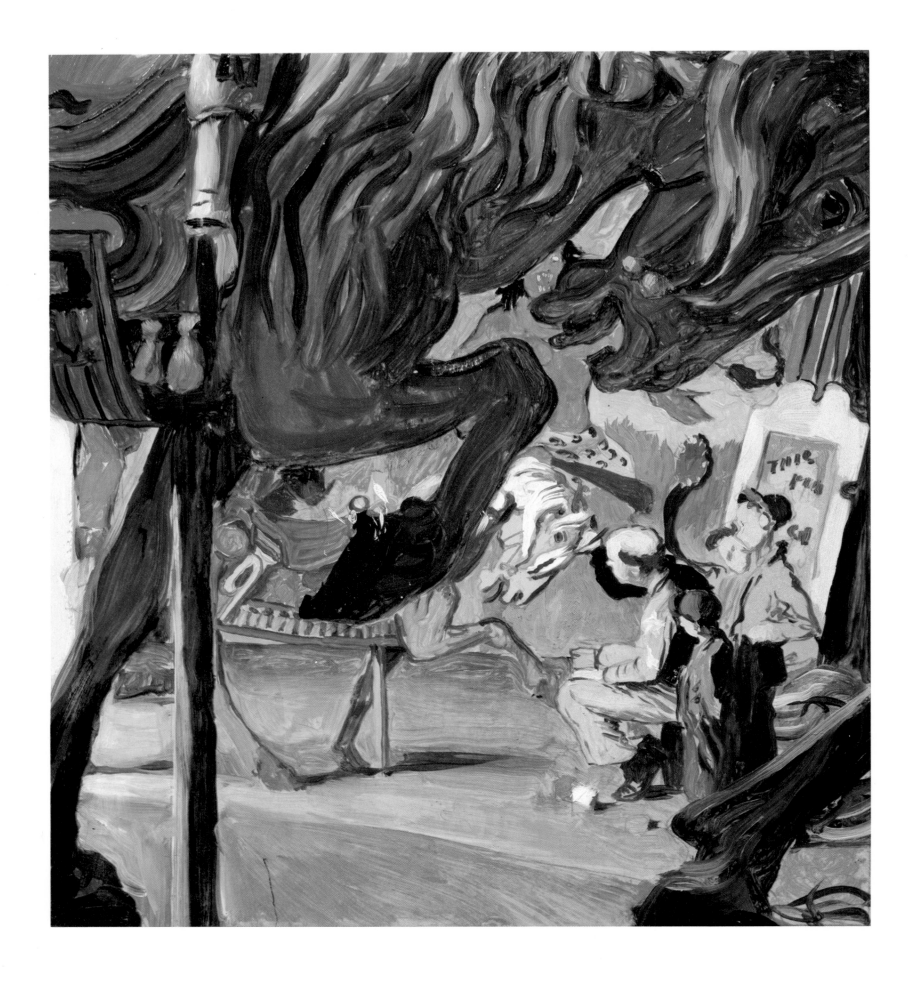

This is another of Rockwell's treatments of an artist, or perhaps we should say a craftsman, at work. In this instance an early color study has survived, and it gives us a chance to see again how Rockwell himself worked, planning everything carefully in advance. These color sketches show us, incidentally, that Rockwell could be a very fine painter in a far more informal mode than was required of him when working for reproduction.

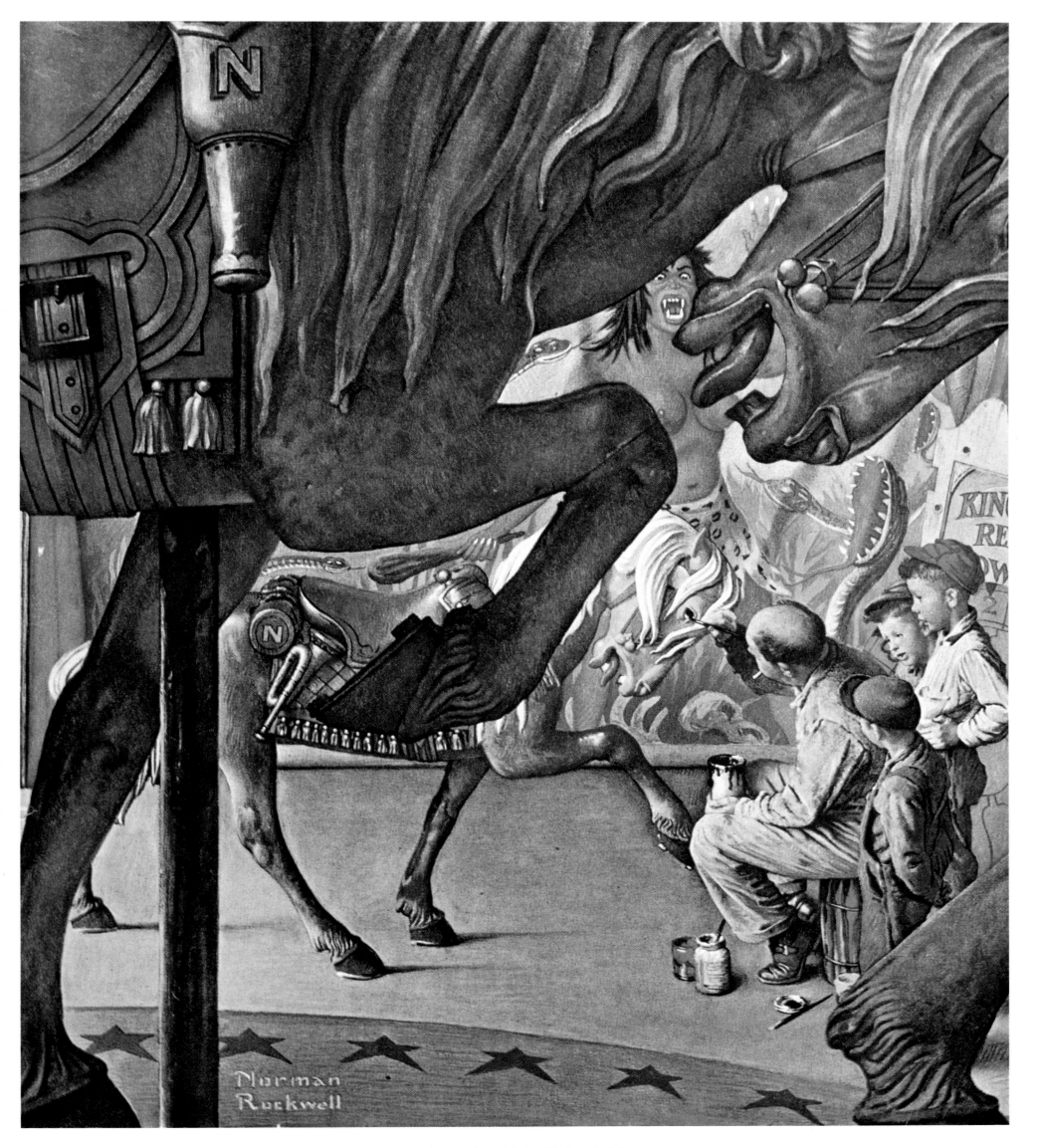

CAROUSEL HORSES

Post Cover • May 3, 1947

29

This famous cover is one that was worked out very precisely in pencil sketch form before it was committed to canvas. Variations between the finished work and the study are almost imperceptible. The final painting is, in fact, a sort of tinted drawing on canvas, and it shows us just how important Rockwell's skills as a draftsman were to his work.

THE GOSSIPS
Post Cover • March 6, 1948

31

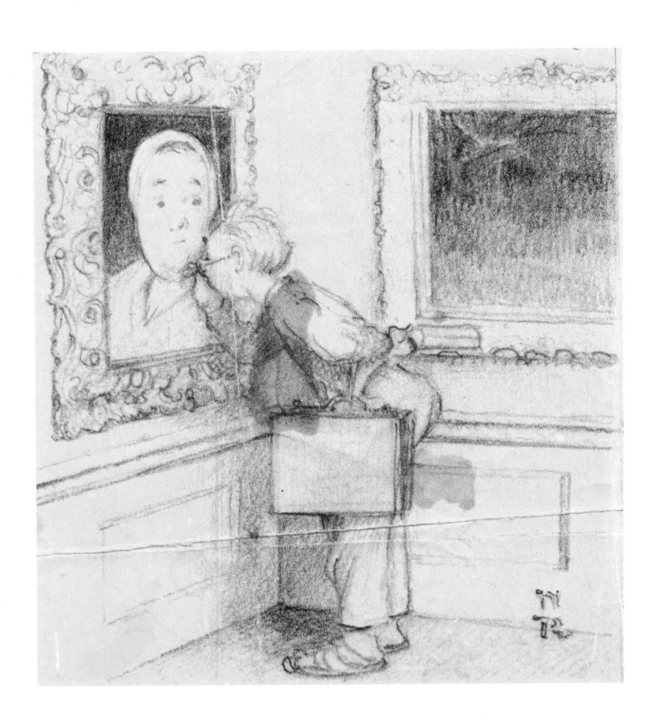

THE ART STUDENT

The many sketches made for this cover, both in color and in black and white, show us how, on occasion, a concept might undergo a number of changes before Rockwell finally hit on the exact formula that he was looking for. Even after the art student's pose has been finalized, the painting he is studying undergoes many alterations, as does the canvas hanging on the adjacent wall.

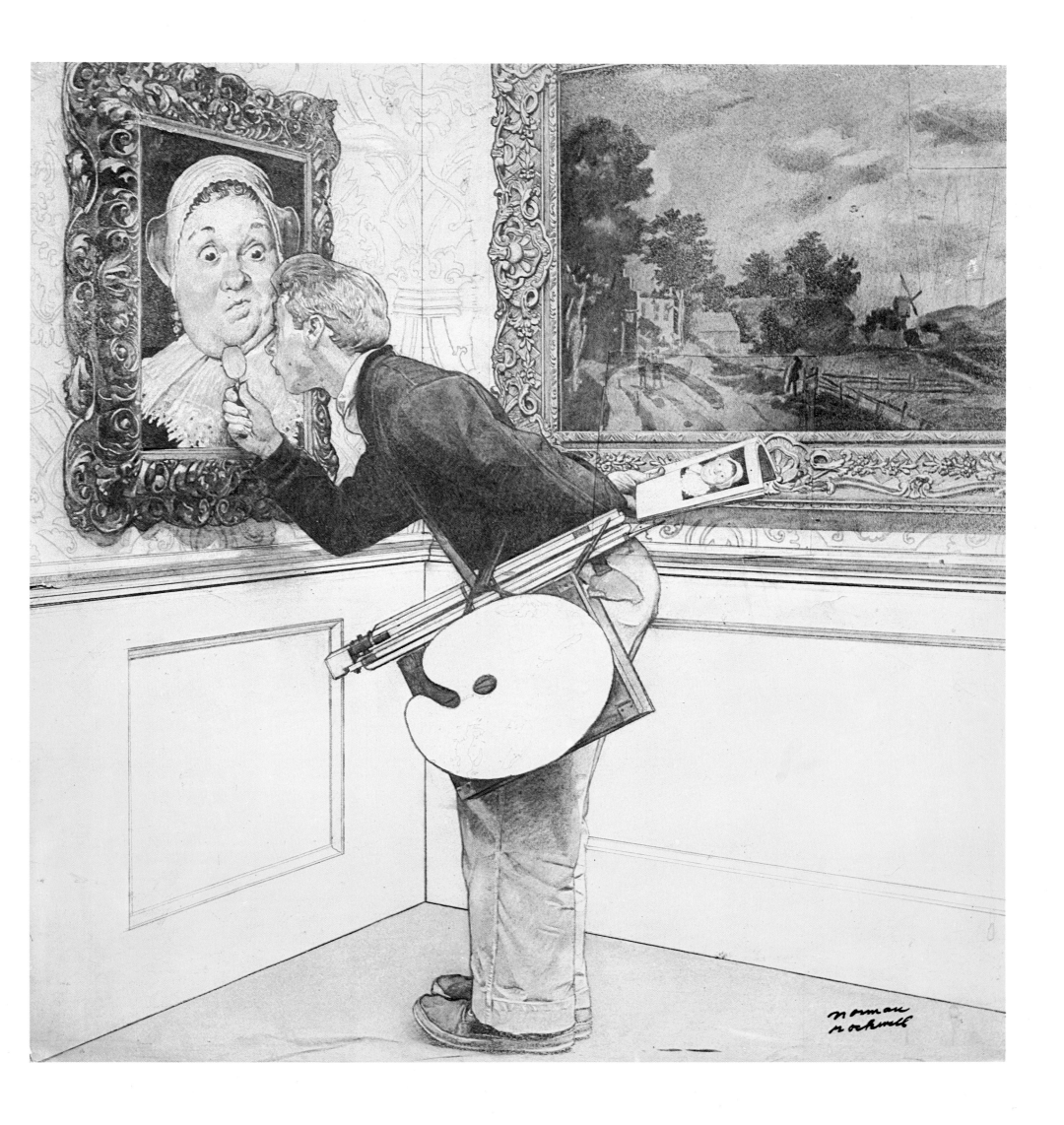

In this instance, even so basic a decision as the attitude of the Flemish lady in the painting was not decided until several possibilities had been tried and discarded.

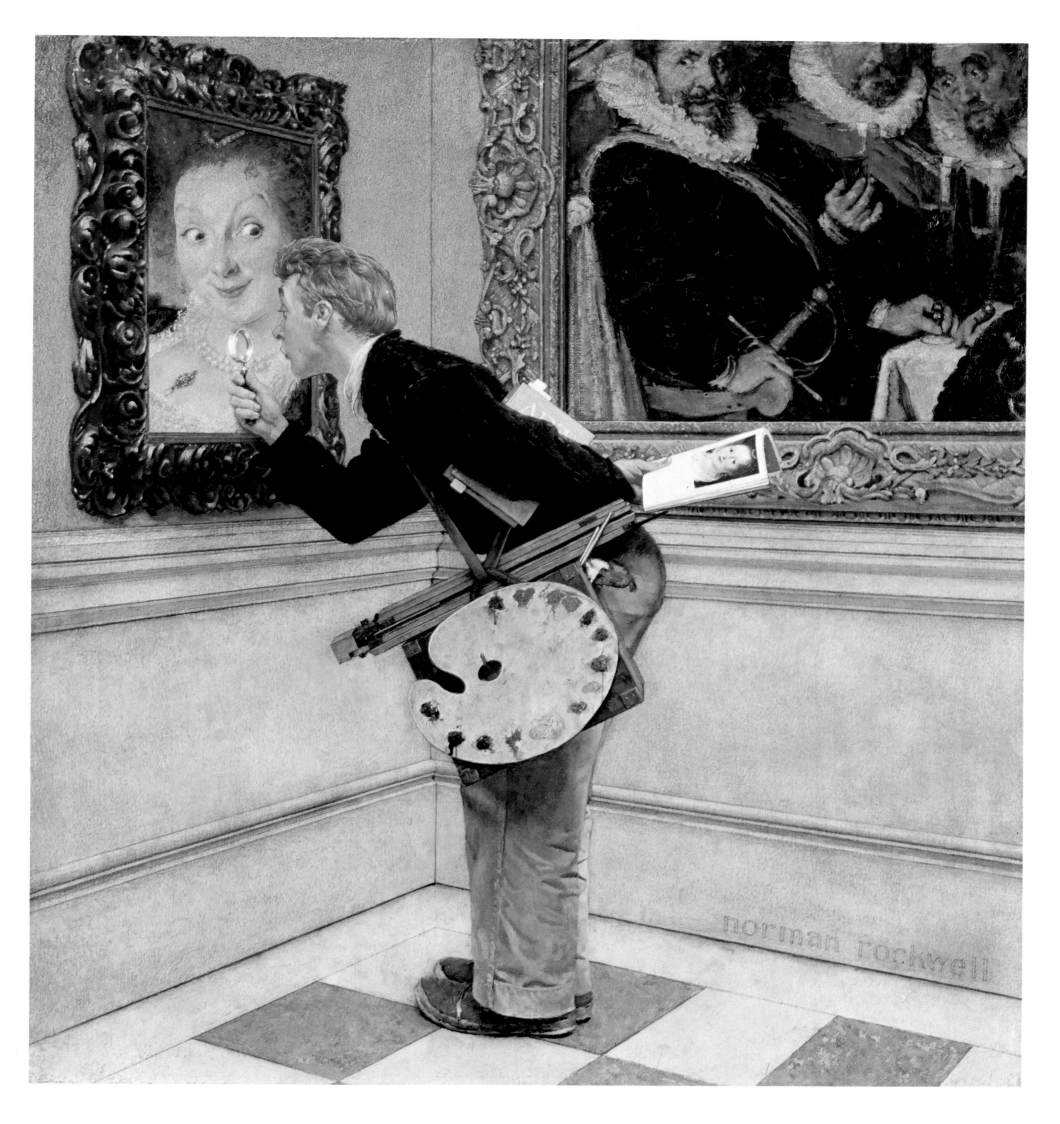

THE ART STUDENT
Post Cover • April 16, 1955

The beautiful wash drawing that Rockwell did in preparation for this cover is another example of the precise studies that he made before confronting his canvas. Comparing the two images, we notice that while they coincide in most details, down to the folds in the secretary's skirt, certain things have been changed. The secretary is given a different hairstyle in the finished work, and the window washer's safety ropes have been tightened. It seems, too—judging from the sketch—that Rockwell had originally intended to show more of the New York skyline.

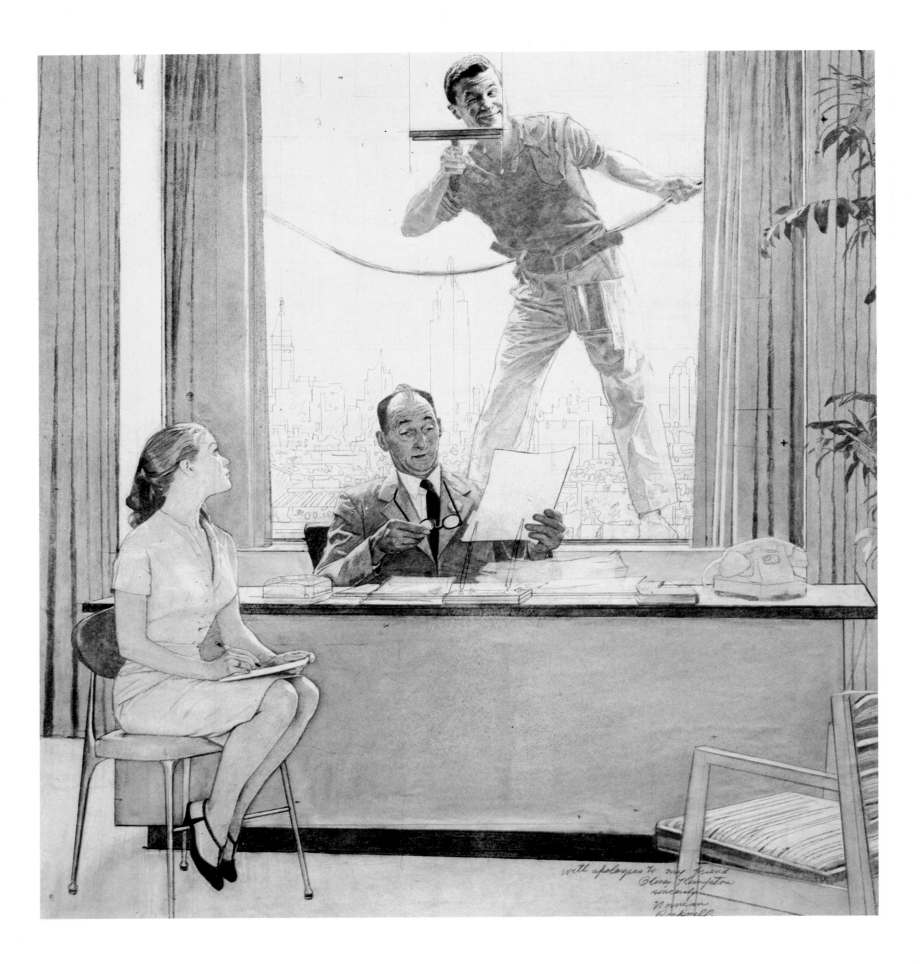

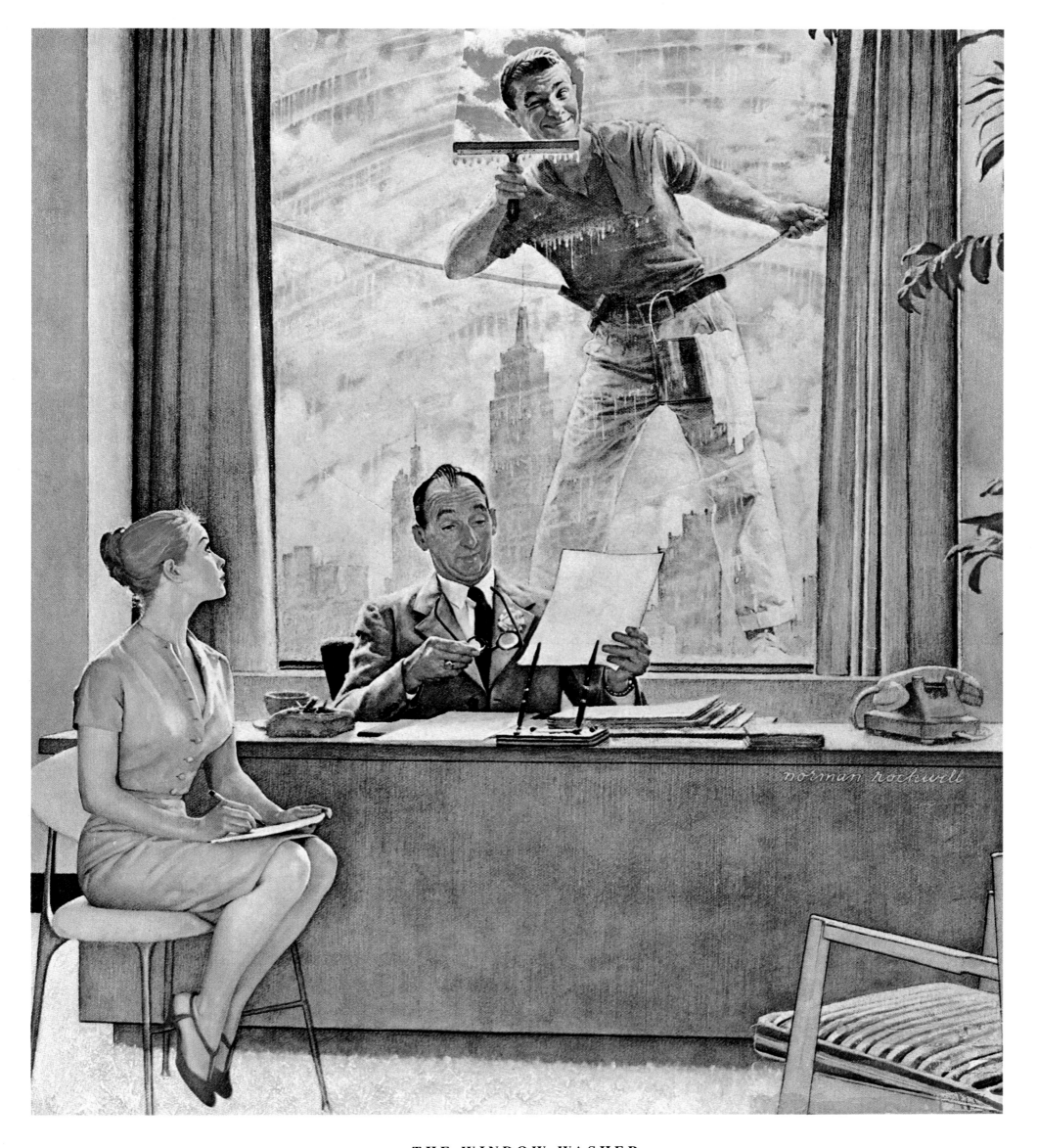

THE WINDOW WASHER

Post Cover • September 17, 1960

37

(continued from page 23)

contrasts that are anything but subtle. To take just a single instance, notice the way the father's worn shoes have been pointedly contrasted with the son's shiny new ones. The word to describe this is—inescapably—"obvious." There is something obvious, too, about the little still life to the left of the picture, made up of the signalman's flag and lamp set down so conveniently on the black trunk. Almost every decision that has been made in this wonderful composition is, essentially, obvious. One suspects that nobody but Rockwell could have gotten away with this. Most artists affect us by surprising us. Rockwell affects us by giving us exactly what we expect. (This is not as easy as it sounds since probably we are unaware of just what it is we do expect until we are presented with it.) To bring the obvious to life is one of the most difficult things that an artist can attempt. Within the field of illustration, Rockwell was the great master of the obvious.

What makes a Rockwell a Rockwell—more even than in the use of "props"—is the way in which he presents faces and hands. "No Swimming" may be impressionistic, but the face and visible hand of the boy in the foreground have been painted with an intensity and an attention to detail that is not found elsewhere on the canvas, except in the face of the dog. You can take almost any Rockwell cover from any period and you will find that more care has been spent on the faces and hands than on anything else. These features give the composition its focal centers. In fact, one reason why many of the costume paintings fail is that, in those instances, Rockwell has sacrificed the emphasis on faces and hands to his interest in rendering fabrics and period folderols.

Occasionally Rockwell indulged in caricature, but more usually, when dealing with the face, he gave us a kind of heightened naturalism that verged on caricature without quite crossing the line. He was particularly good at dealing with such things as family relationships as they are expressed in shared features. He had the knack of concentrating on those little physical similarities that we are all aware of but cannot always define precisely. If we look again at the father and son in "Breaking Home Ties," we can see exactly what Rockwell was capable of when faced with such similarities. The hands, too, in that painting are worth careful study. They are as expressive of family bonds as anything that Rockwell has found in the two faces.

Always, then, it is the little human touches that make Rockwell's paintings memorable. Without them, his brilliance as a storyteller could never have had quite the same ring of authenticity.

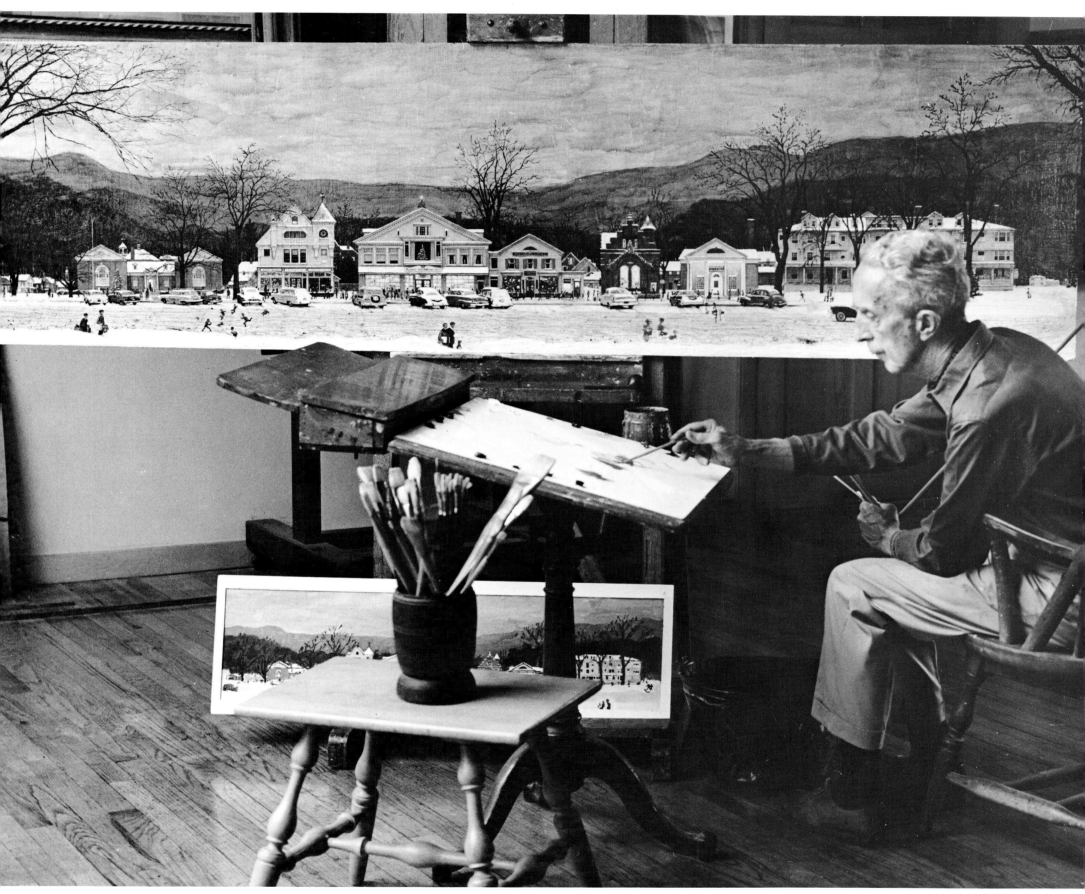

Norman Rockwell working on his 1967 painting *Christmas at Stockbridge*.

From the Very Beginning Norman Rockwell Had an Uncanny Knack of Knowing What the Public Wanted

NORMAN ROCKWELL WAS BORN in New York City, at 103rd Street and Amsterdam Avenue, on February 3, 1894. There were artistic antecedents in the family. Rockwell's mother was the daughter of Thomas Hill, an English painter who had emigrated to the United States after the Civil War and had supported himself by painting animals of various sorts—prize-winning Herefords or pet bulldogs—on commission. Rockwell would later recall that his grandfather's work was notable for its attention to detail. Rockwell's father, as we noted, was a businessman—he managed the New York office of a textile company—but, in the fashion of the day, he liked to copy illustrations from popular magazines, and he had a passion for reading the works of Charles Dickens aloud. The young Norman sang in the choir of St. Luke's Church, near his home, and at the Cathedral of St. John the Divine. Of slight build, and hampered in his physical activities by eyeglasses and corrective shoes, he turned naturally to drawing and painting as a way of establishing an identity among his peers. Not overly fond of city life, he was delighted when his parents moved from Manhattan to Mamaroneck, in Westchester County.

Rockwell was then nine years old. By the time he was in his early teens, he knew he wanted to be an artist and, at the age of fourteen, he began taking lessons at the Chase School of Fine and Applied Art. He was attending high school at the same time, but before he had completed his sophomore year, he quit to become a full-time student at the National Academy School. In 1910 he transferred to the Art Students League, on 57th Street in Manhattan, then at the height of its fame. During most of this period, Rockwell commuted to the city from his parents' suburban home; then, in 1912, they returned to Manhattan. By that time, Rockwell was already earning his living as an illustrator. His first commission, which had come when he was sixteen, was for four Christmas cards. At the age of nineteen he became art director for *Boy's Life*, and in that same year—1913—he produced one hundred illustrations for *The Boy Scout's Hike Book* (thus inaugurating an association with the Boy Scout movement that was to last all his life). By the time he joined his parents in another move—this time to New Rochelle—Rockwell was on the verge of becoming a topflight illustrator, and the following year—1916—he made his first sale to *The Saturday Evening Post*.

It is with the *Post*, of course, that we most closely identify Rockwell's name, and it was for the *Post* that he painted most of his magazine covers. He did produce, however—mostly early in his career—numerous covers for other magazines, such as *Country Gentleman, Ladies' Home Journal, Life,* and *Literary Digest*, and we begin this color section by taking a look at a representative selection of these early covers. The different idioms Rockwell used when working for different publications make it clear how skillful he was in tailoring his approach to the needs of a given market. None of these paintings for other clients would have looked quite right on a *Post* cover.

It is the extraordinary sequence of covers painted for the *Post*, however, that must be our main concern. Prompted by a friend, Clyde Forsythe, Rockwell had gone to the *Post*—the most successful magazine of the day—with two paintings and a sketch. The editors bought both paintings on the spot, commissioned him to develop the sketch into a finished work, and asked him to submit ideas for three more covers. Rockwell was astounded. At the age of twenty-two he suddenly found himself the professional equal of the greatest illustrators of the day.

Things were happening very fast in Norman Rockwell's life. Soon after becoming a regular contributor to the *Post*, he married Irene O'Connor. He hardly had time to become used to married life when war broke out and he found himself in the navy (having gone on a special diet to gain enough weight to be accepted into the service). Rockwell was assigned to the Navy Yard in Charleston, South Carolina, with the rank of third-class varnisher and painter. His budding reputation as an illustrator soon won him a degree of celebrity among his service mates. His talent was employed for the navy magazine *Afloat and Ashore*, but he still found plenty of time to fulfill commissions for his civilian clients. Close to a dozen publications carried his work during the war years, and he also managed to paint advertisements for Perfection oil heaters, Fisk tires, Overland automobiles, Jell-O, and Orange Crush.

The demand for his work was extraordinary. From the very beginning, Norman Rockwell had an uncanny knack of knowing what the public wanted, and of being in tune with his clients' needs. It would be decades before his style reached its full maturity, but some essential quality—the seed from which the Rockwell idiom would grow—was already present.

SATURDAY EVENING POST COVERS
May 20, 1916–June 28, 1919

Preceded by covers for COUNTRY GENTLEMAN, LITERARY DIGEST,
and LADIES' HOME JOURNAL, 1919–1928

CHRISTMAS
Country Gentleman Cover • *Dec. 18, 1920*

PAGE 49

OVER the years Norman Rockwell painted so many Christmas covers that it is only appropriate to start with one of these. Most of the covers Rockwell painted for *Country Gentleman* were humorous—usually picturing the misadventures of a city-bred ninny called Reginald—but in this instance Rockwell forgoes laughter for a straightforward statement of the seasonal theme.

LOST BATTALION
Literary Digest Cover • *March 1, 1919*

PAGE 50

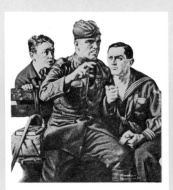

UNLIKE most of the covers Rockwell painted for *The Saturday Evening Post* and *Country Gentleman*, his covers for *Literary Digest* were never overtly humorous. Here he gives us a study of a wounded veteran recounting one of his more bloodcurdling war experiences for the benefit of an attentive audience. As is so often the case in Rockwell's work, the hands express as much as the face.

PLANNING THE HOME
Literary Digest Cover • *May 8, 1920*

PAGE 51

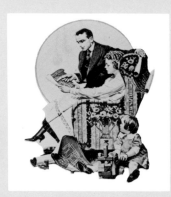

THIS is typical of the kind of cover Rockwell contributed to the *Literary Digest* over a period of several years. He usually sought his subject matter in quiet domestic moments, and for this magazine the presentation was always direct and simple. Looking at this cover today, it is probably the detail—the young woman's dress, the fabric in the chair—that is most interesting.

FIRST OF THE MONTH
Literary Digest Cover • *February 26, 1921*

PAGE 52

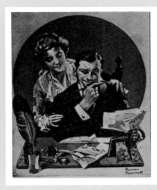

EVERY good illustrator, and every good art editor, knows the audience at which any given publication is targeted. It is likely that when he painted this cover, Rockwell could be reasonably sure that many *Literary Digest* readers would find it easy to identify with this couple. There is nothing exceptional about it, but he demonstrates the ability to focus on the everyday, the familiar, which later provides the basis of his finest work.

GONE FISHING
Literary Digest Cover • *July 30, 1921*

PAGE 53

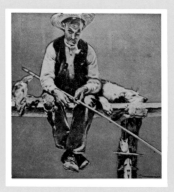

THIS is a good early example of Rockwell's ability as a colorist. Many of the magazines he worked for, including the *Post* when he first became a contributor, did not run their covers on presses that permitted a full chromatic range. Thus most of the early Rockwell cover paintings make only limited use of color. Here, however, the artist makes the most of a vivid blue background—something that was not yet available to him at the *Post*—to evoke the mood of a sultry summer day.

GRANDPA AND CHILDREN
Literary Digest Cover • *December 24, 1921*

PAGE 54

IF the previous cover was drenched in sunlight, this one is bathed in firelight. We tend to think of Rockwell as a master of detail—which he undoubtedly was—but here he shows himself to be a master of mood, and capable of considerable economy.

THE OLD COUPLE
Literary Digest Cover • April 15, 1922
PAGE 55

EVEN as a young man, Rockwell was capable of sympathetic studies of older people, as is evident from this painting. Often he chose to bring age and youth together (p 62), but here he gives us a straightforward study of an elderly couple, and his tenderness towards his subjects matches their tenderness towards one another. The era of their youth is evoked with the aid of the gold frame he has painted around them, and of the sketched-in background that recalls elements from late-Victorian decorative idioms.

MENDING THE FLAG
Literary Digest Cover • May 27, 1922
PAGE 56

LIKE some other paintings done for the cover of *Literary Digest*, this one might have been done as an illustration for a story rather than as a composition specifically devised to appear on a cover. It does not display the layout skills that Rockwell was beginning to utilize in his work for the *Post*, and, in this regard, it's worth noting that this painting postdates his first real masterpiece, "No Swimming" (p 107), by several months. From this we may deduce that the *Post's* editorial staff was giving him more room to experiment and stretch his wings.

SETTLING AN ARGUMENT
Literary Digest Cover • June 24, 1922
PAGE 57

IT is *Literary Digest* itself that has provided these two old men—amateur *philosophes* walking in the footsteps of Flaubert's *Bouvard et Pécuchet*—with their bone of contention. Rockwell has given this painting a fake Old Master look, something he would never have done had this been intended for the *Post* (though it's easy enough to imagine him painting a variant on this theme for the *Post*).

A HOPELESS CASE
Literary Digest Cover • January 13, 1923
PAGE 58

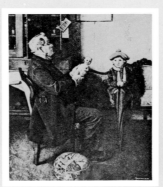

IN this case, Rockwell did indeed paint a variation on this theme for the *Post* (p 209), although he waited six years to do so. If we compare the two works, we will find that the *Post* version is, as might be expected, more skillfully constructed; but this one still holds up because it has a distinctly realistic look to it. The little girl, with her oversized umbrella, is especially well observed and is, perhaps, more convincing than her successor in the *Post* painting.

TOP OF THE WORLD
Ladies' Home Journal Cover • April, 1928
PAGE 59

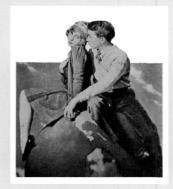

THIS *Ladies' Home Journal* cover in some ways resembles one which Rockwell painted for the *Post* several years later (p 268). This earlier example is the more successful of the two despite the fact that, with the couple literally seated on a globe, it has an allegorical slant of the sort that often led Rockwell astray. This cover succeeds, and has great charm, because these young people are so crisply observed. The subject matter is sentimental, but the treatment of the figures is almost matter of fact, which prevents the picture from becoming too sugary.

SALUTATION
Post Cover • May 20, 1916
PAGE 60

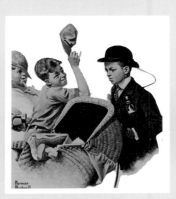

ALMOST inevitably, Rockwell's first cover for *The Saturday Evening Post* centered on the world of small boys. Forty-one of the first fifty covers he painted for the *Post* featured children, and most of these children were boys. One suspects that the young man taking his baby sibling for an airing would prefer to be on his way to the sandlot. This cover is typical of the kind of thing other *Post* artists were supplying, yet it has Rockwell's personal touch. One can understand why the editors greeted the young artist's work with such enthusiasm.

CIRCUS STRONGMAN
Post Cover • June 3, 1916
PAGE 61

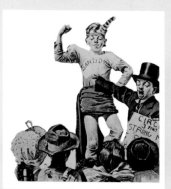

As children today like to dress as Superman and Wonderwoman, so in 1916 they chose to imitate the superheroes of their period, such as Eugene Sandow, the famous German physical culturist. The scene is neatly observed. The artist gives us the viewpoint of an adult standing behind the group of children who make up the audience of this pretended strongman.

GRAMPS AT THE PLATE
Post Cover • August 5, 1916
PAGE 62

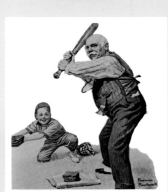

One of Rockwell's recurring themes was the continuity of experience between age and youth. In his early work especially, his boys seem to have more in common with their grandfathers than with their fathers. In this instance we may conjecture that father, unseen, is the pitcher, but we cannot be sure, and what is more important is that gramps is shown to be capable of reliving the innocent pleasures of childhood.

REDHEAD LOVES HATTY
Post Cover • September 16, 1916
PAGE 63

The barefoot boy in this painting, his slingshot protruding from his hip pocket, belongs to an America that has long vanished. His is still the world of Huck Finn and Tom Sawyer. He probably belonged to an endangered species even when this picture was painted, but Rockwell would return to this stereotype again over the next twenty years.

PICTURE PALACE
Post Cover • October 14, 1916
PAGE 64

The programs held by members of this family party tell us that the person bringing smiles and gasps of delight to their faces is the great Charlie Chaplin, who was, in 1916, riding the crest of his first great wave of success. Illuminated by light reflected from the movie screen, these faces tell us that Chaplin's little tramp transcends age barriers with his inspired clowning.

Interestingly, Rockwell uses a device popularized by film-makers, making his point by showing the reaction of the spectators rather than by showing the event that inspires the reaction.

PLAYING SANTA
Post Cover • December 9, 1916
PAGE 65

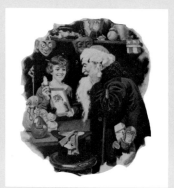

In this, the first of many Christmas covers he was to paint for the *Post*, Rockwell portrays an elderly man trying on a false beard preparatory to playing Santa Claus. This is the first of Rockwell's *Post* covers not to feature a child, or children; but the toys, the occasion —everything about the painting— conspires to evoke the child's world.

SHALL WE DANCE?
Post Cover • January 13, 1917
PAGE 66

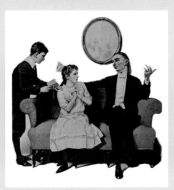

The charming young lady in this composition is clearly enthralled by the urbane demeanor and world-weary chit-chat of the college man—for that is what he seems to be—in the evening clothes. She has, however, promised this dance to a rather more callow admirer who is about to claim his rights and seems unlikely to defer them. This cover is significant in that it offers a first hint of the more subtle kind of wit that will appear in Rockwell's later work.

READY TO SERVE
Post Cover • May 12, 1917
PAGE 67

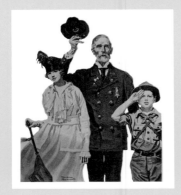

THIS simple patriotic cover was published just a month after the United States entry into World War I. Given publishing deadlines, even under these special circumstances, it must have been painted and delivered virtually overnight. The subject matter speaks for itself. Rockwell makes it visually effective by adopting an almost symmetrical pyramidic design.

RECRUITING OFFICER
Post Cover • June 16, 1917
PAGE 68

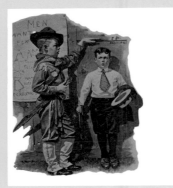

IN this, a more typical Rockwell approach to the problem of painting a patriotic cover, we are shown children imitating their elders. What makes the painting work is the seriousness with which the protagonists take the situation created in their imagination.

KNOWLEDGE IS POWER
Post Cover • October 27, 1917
PAGE 69

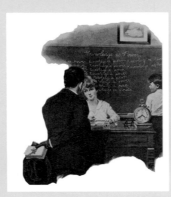

THIS is an early example of a Rockwell cover in which a whole story is conjured up with a single image.

PARDON ME!
Post Cover • January 26, 1918
PAGE 70

THERE is nothing novel about this painting, but it is a good example of Rockwell's early style. The theme is stated succinctly, the design is solid, and the draftsmanship assured.

OFF-DUTY CLOWN
Post Cover • May 18, 1918
PAGE 71

ROCKWELL delighted in catching the subjects of his paintings off guard, and here one of his barefoot boys discovers a clown half in character and half out.

THE HAIRCUT
Post Cover • August 10, 1918
PAGE 72

THE child in this picture is delighted to be in the barber's chair. The mother, on the other hand, is experiencing a gamut of emotions that will not permit her to share her offspring's pleasure. There is no doubt, of course, whom we are expected to identify with. Rockwell has carefully set up this composition so that we see this incident in the barber's mirror, and so our own viewpoint is that of the child.

RED CROSS VOLUNTEER
Post Cover • September 21, 1918
PAGE 73

THE first of three consecutive patriotic covers, this shows a young Red Cross volunteer asking for a contribution from an old gentleman who seems more than willing to oblige. About the only significant Rockwell touch is the dog at the girl's feet. Dogs in Rockwell's world—and they make many appearances there—tend to enter into a symbiotic relationship with their masters or mistresses, and so they can be used to underline or reinforce the statement the artist is trying to make. In this example, the dog even has its own uniform, just to make the point quite clear.

REMINISCING
Post Cover • *January 18, 1919*
PAGE 74

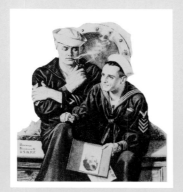

IN this rather conventional work—we feel it could have been painted by almost anyone—a sailor far from home recalls for his buddy the sweetheart he left behind. This was painted during Rockwell's stint in the navy (note the artist's signature), and perhaps it is best understood as a tribute to his comrades in arms.

HERO'S WELCOME
Post Cover • *February 22, 1919*
PAGE 75

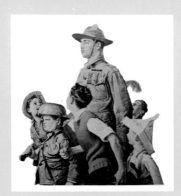

THE youngsters who gather around this returning hero permit Rockwell to introduce a few characteristically informal touches, but essentially this is a painting that owes more to the national mood of the day than to the artist's personal vision.

COURTING AT MIDNIGHT
Post Cover • *March 22, 1919*
PAGE 76

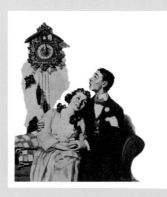

THIS early gem is a harbinger of things to come. Rockwell has captured the exact moment that will give us the maximum information about the two sweethearts. The painting has a crispness that we have not seen before, and, everything considered, this must be taken as something of a landmark in Rockwell's career.

PARTY GAMES
Post Cover • *April 26, 1919*
PAGE 77

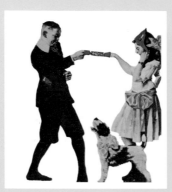

IN contrast to the previous composition, this is a relatively undistinguished cover, and one feels that Rockwell turned it out almost automatically. The boy, in particular, seems far too much of a stereotype.

VALEDICTORIAN
Post Cover • *June 14, 1919*
PAGE 78

THE class valedictorian who forgets his speech on graduation day has become such a cliché—Hollywood producers were especially fond of it (see, for example, Freddie Bartholomew in *Listen Darling*)—that it is impossible to know how familiar the average *Post* reader would have been with the joke in 1919. It's even possible that Rockwell invented it, but, from our point of view, we will have to admit that the valedictorian's knickerbockers have become more amusing than his predicament.

LEAPFROG
Post Cover • *June 28, 1919*
PAGE 79

WHAT makes this cover effective is the fact that the leapfrogger, and his dog too, seem to be leaping clean off the page. Rockwell had not attempted anything quite like this before, but he pulls it off neatly. As time goes by, in this early phase of his career, we find him using more and more tricks of the trade like this one—sometimes to dress up a rather banal image, sometimes to make an original statement.

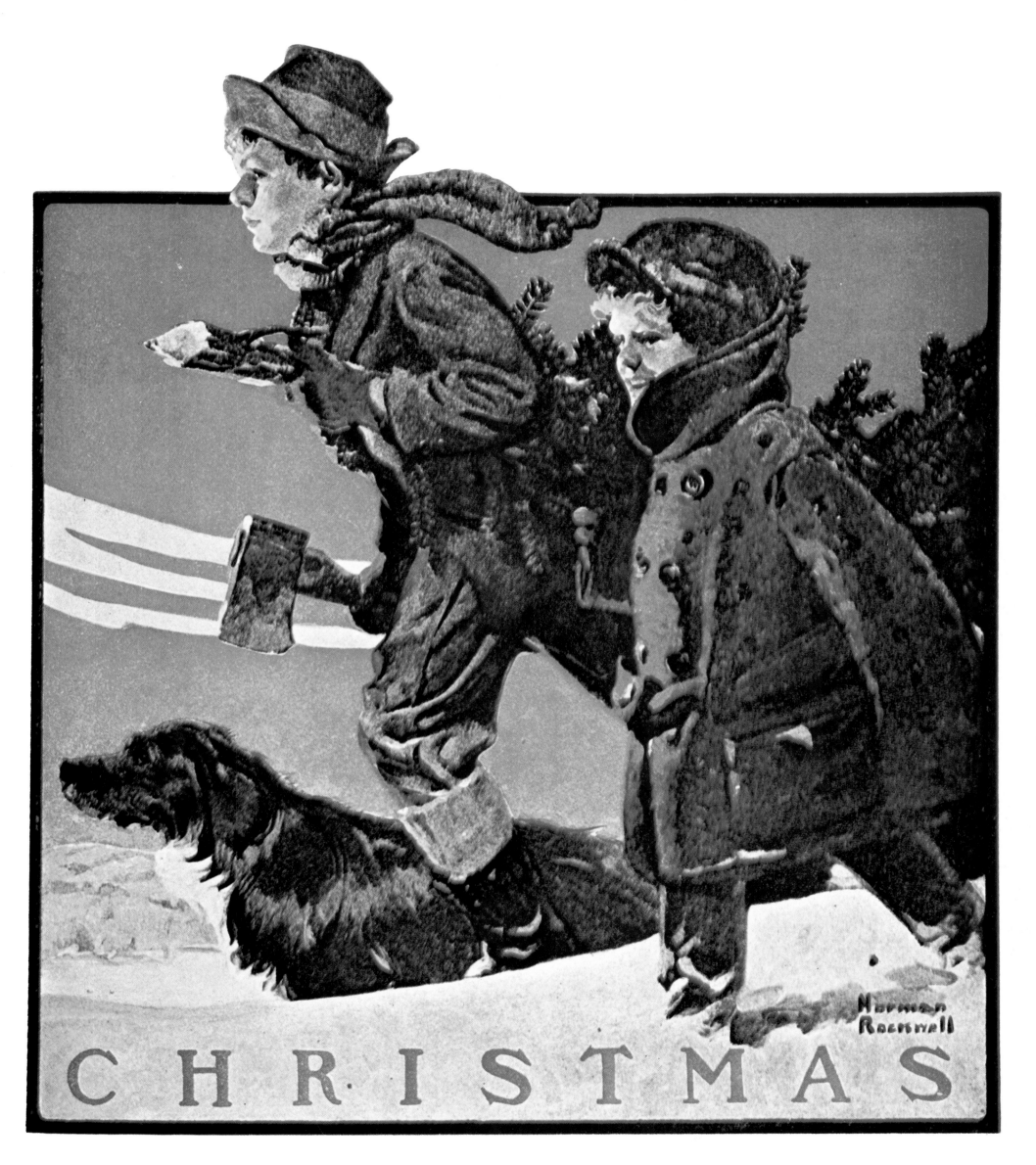

CHRISTMAS

Country Gentleman Cover • Dec. 18, 1920

49

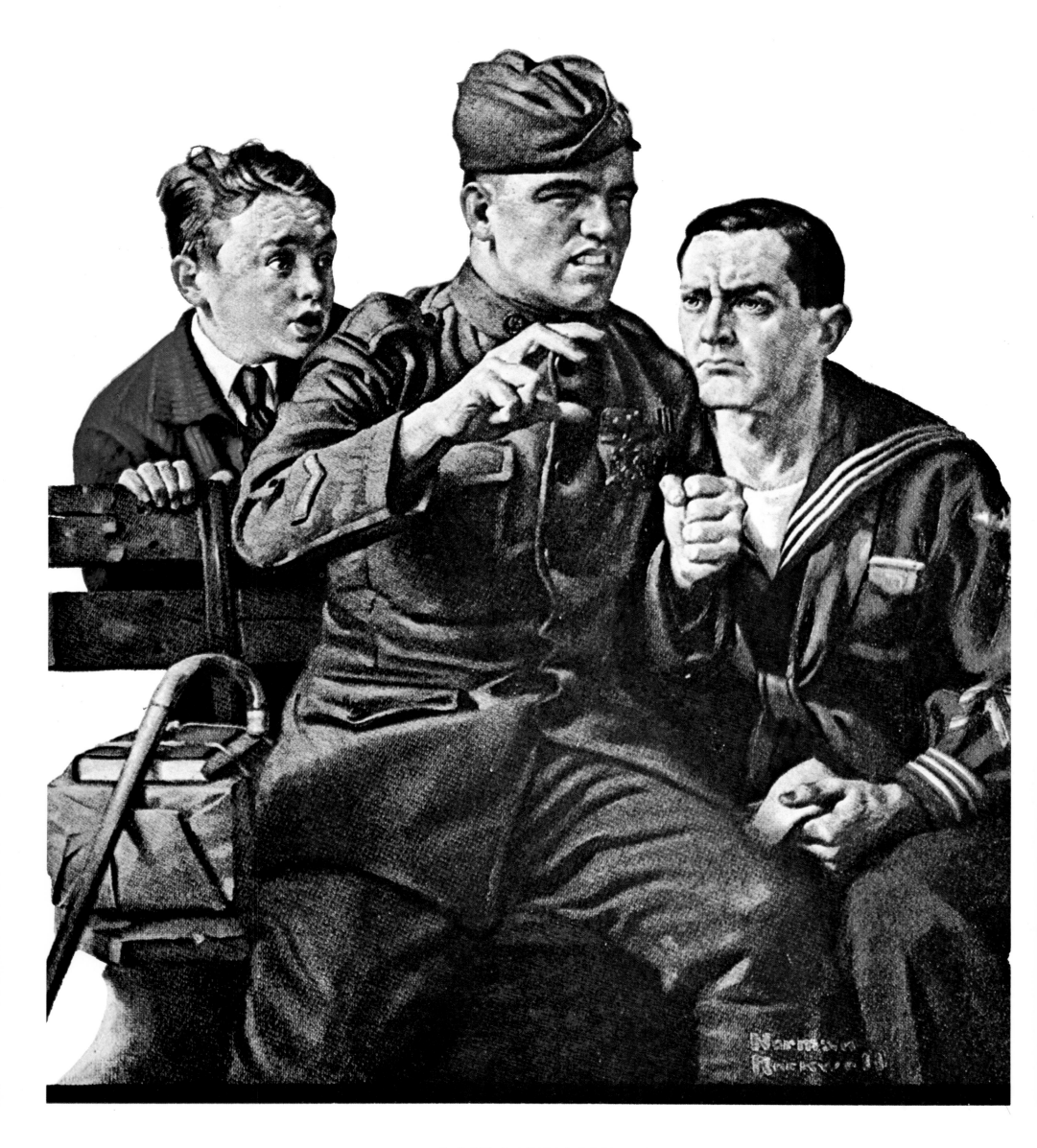

LOST BATTALION

Literary Digest Cover • March 1, 1919

50

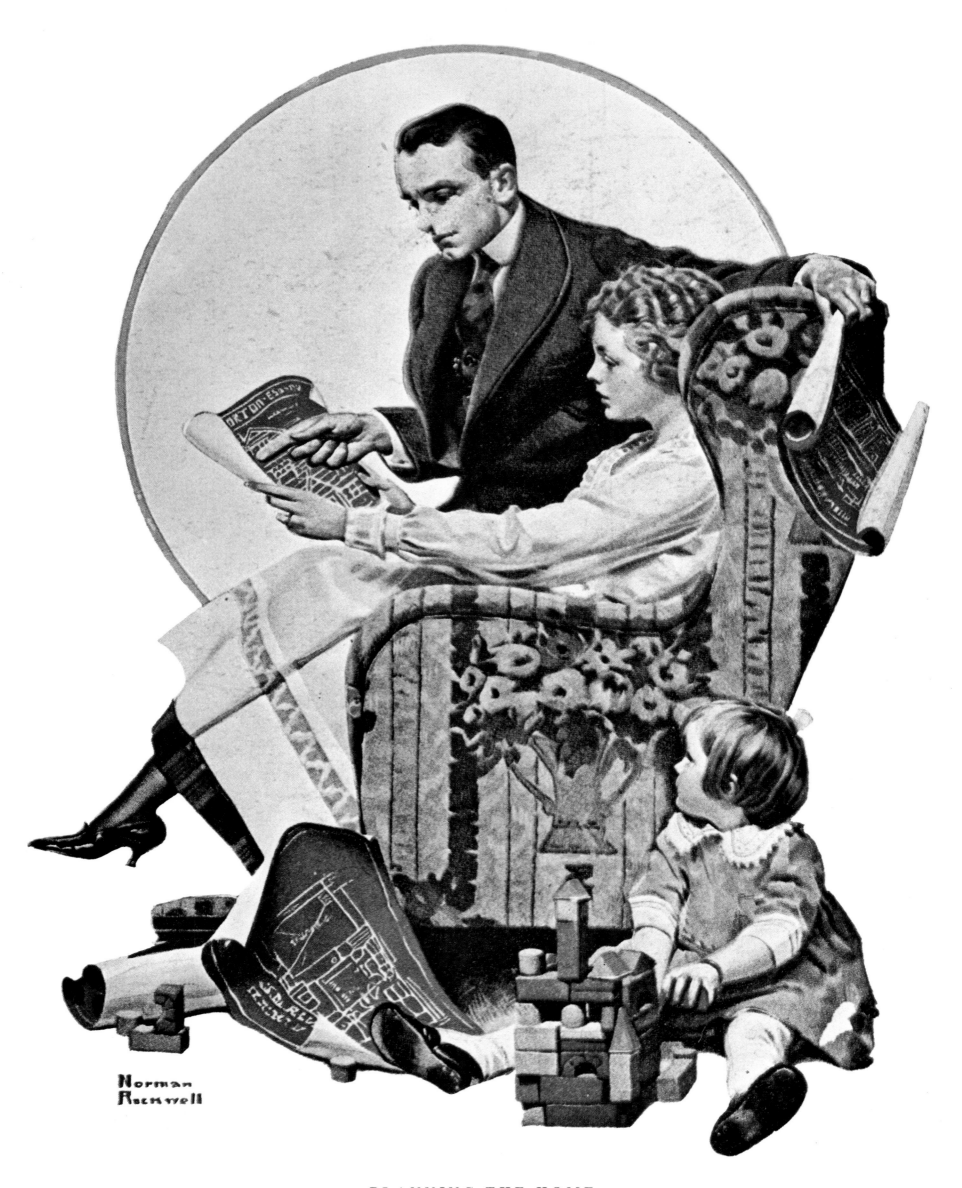

PLANNING THE HOME

Literary Digest Cover • May 8, 1920

51

FIRST OF THE MONTH

Literary Digest Cover • February 26, 1921

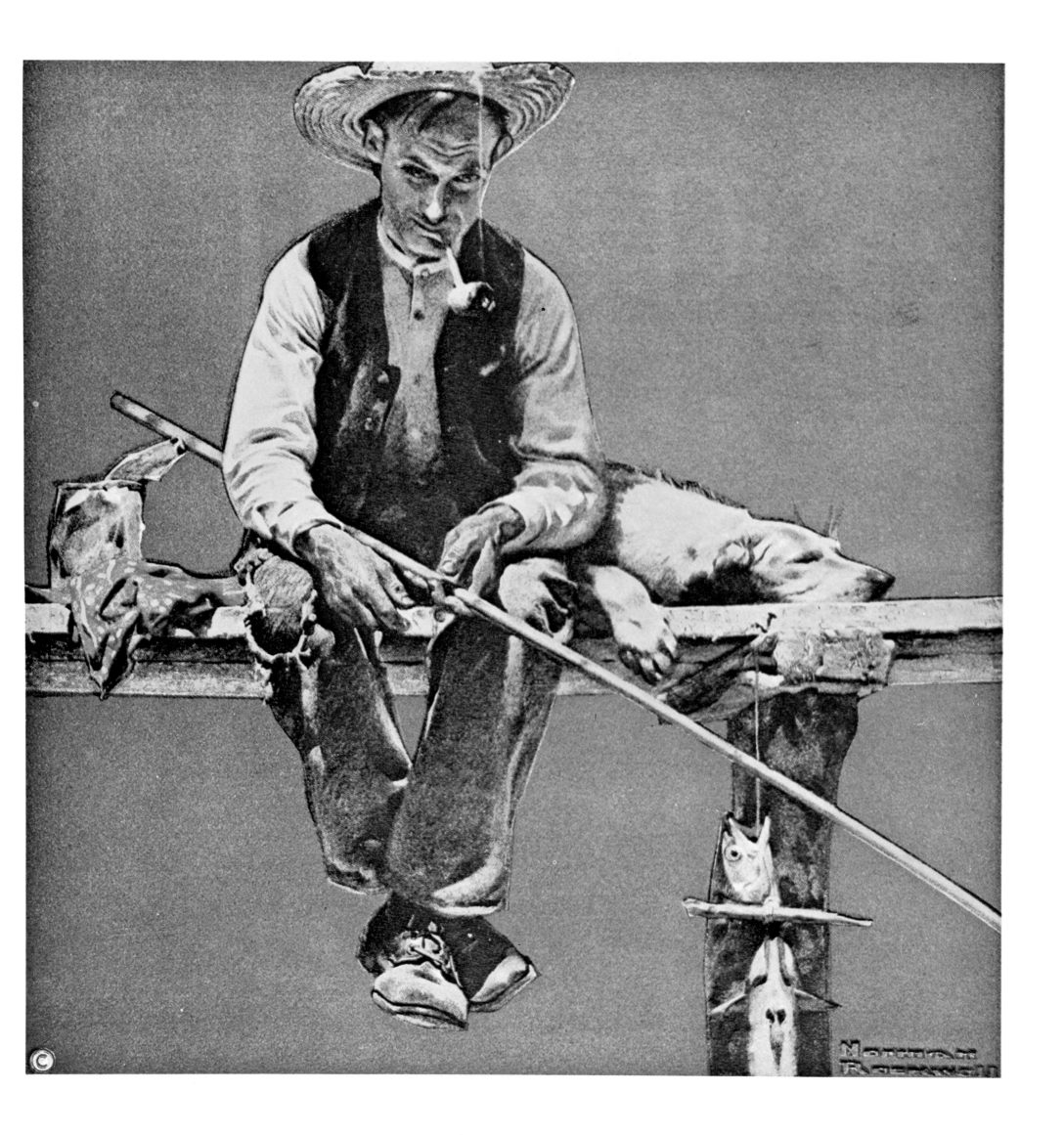

GONE FISHING

Literary Digest Cover • July 30, 1921

53

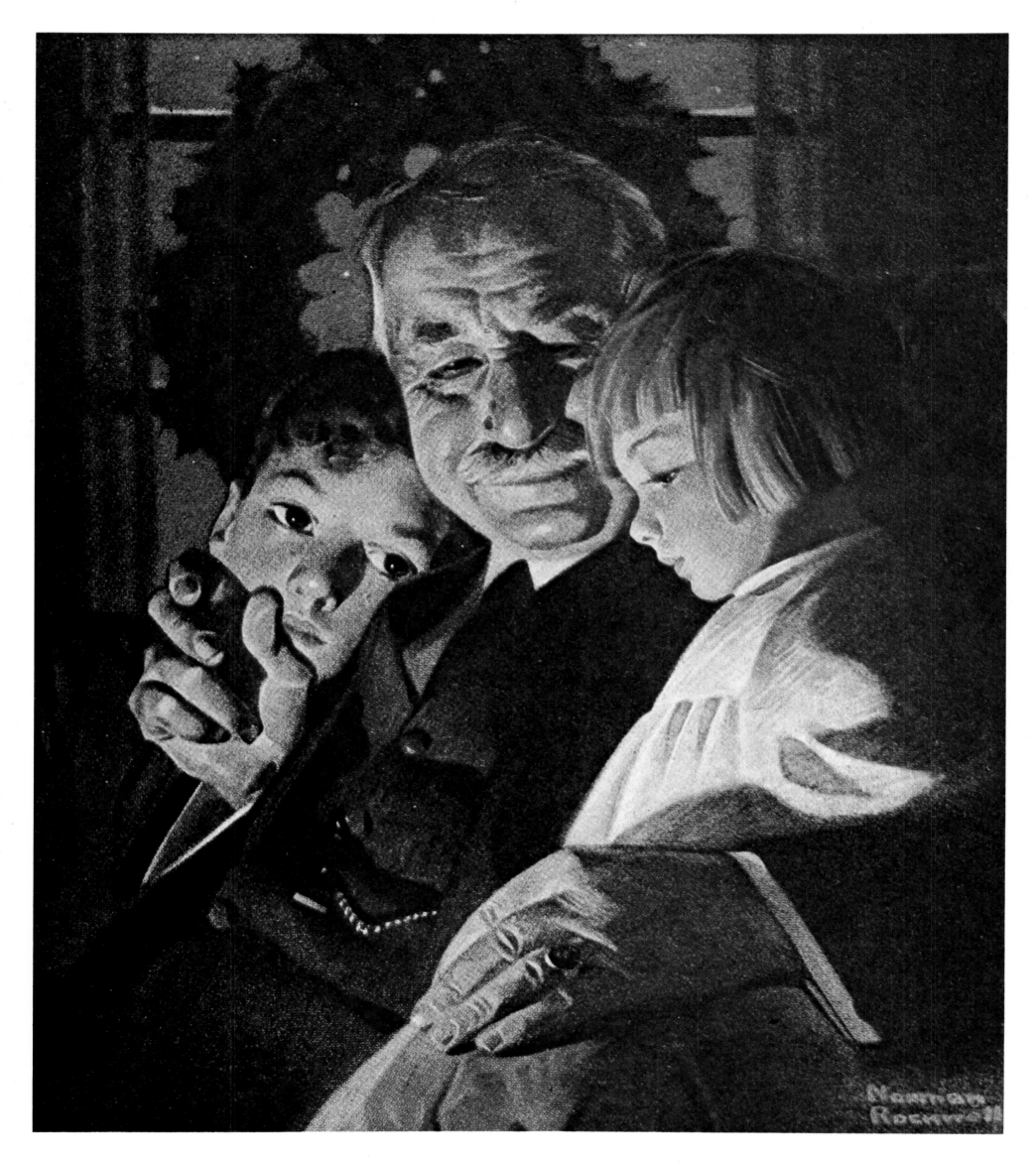

GRANDPA AND CHILDREN
Literary Digest Cover • December 24, 1921

THE OLD COUPLE

Literary Digest Cover • April 15, 1922

MENDING THE FLAG

Literary Digest Cover • May 27, 1922

SETTLING AN ARGUMENT

Literary Digest Cover • June 24, 1922

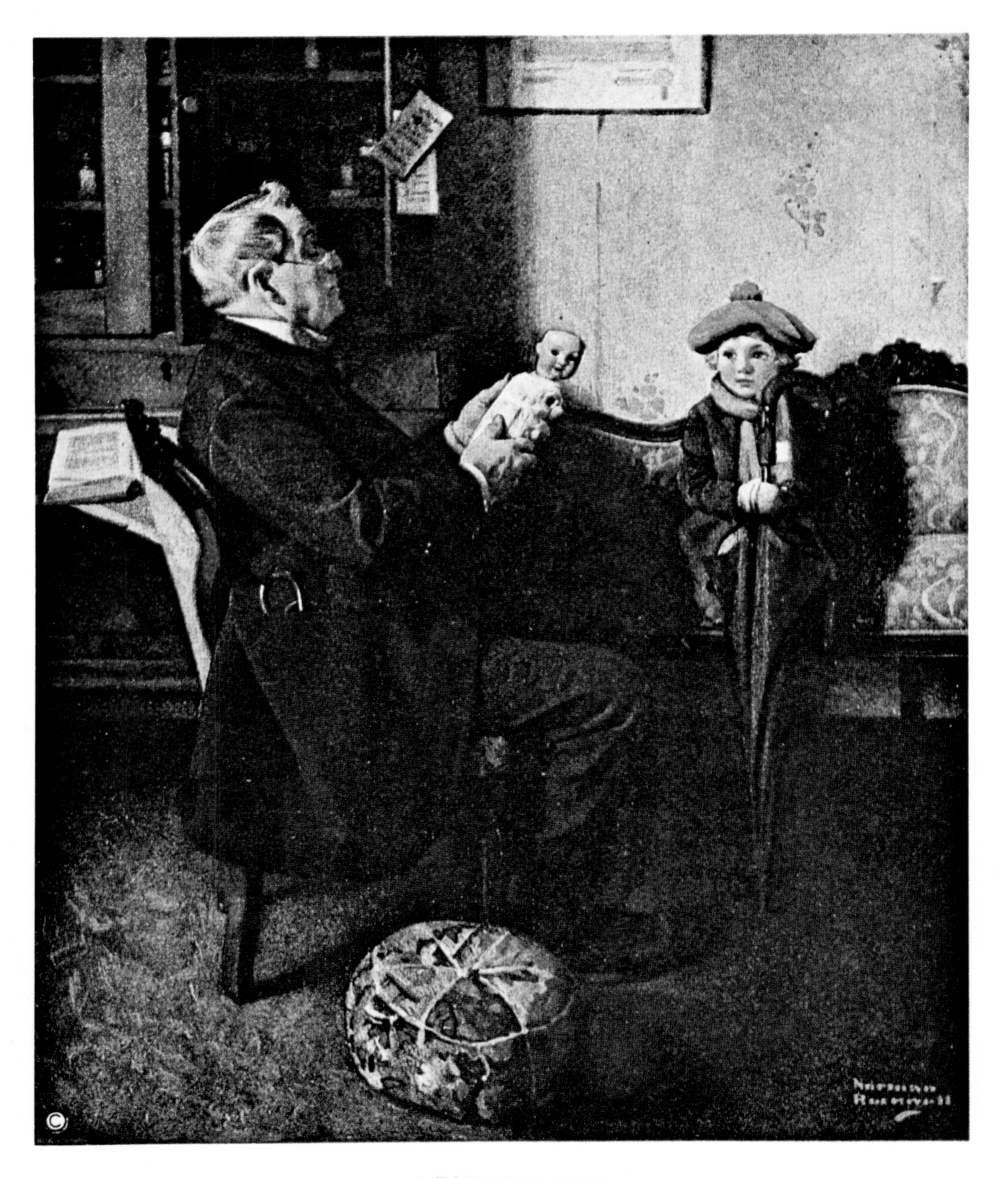

A HOPELESS CASE

Literary Digest Cover • January 13, 1923

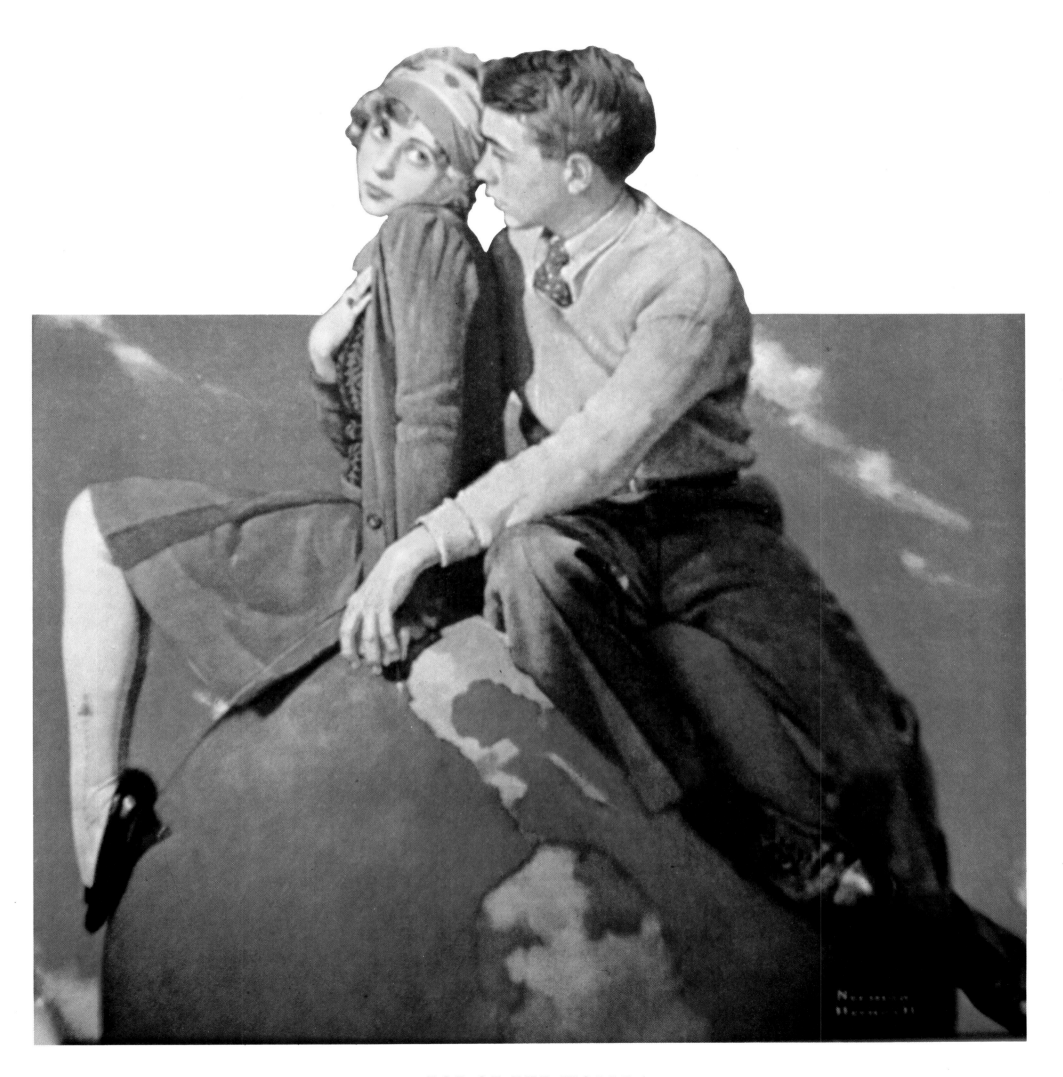

TOP OF THE WORLD

Ladies Home Journal Cover • April, 1928

SALUTATION

Post Cover • May 20, 1916

60

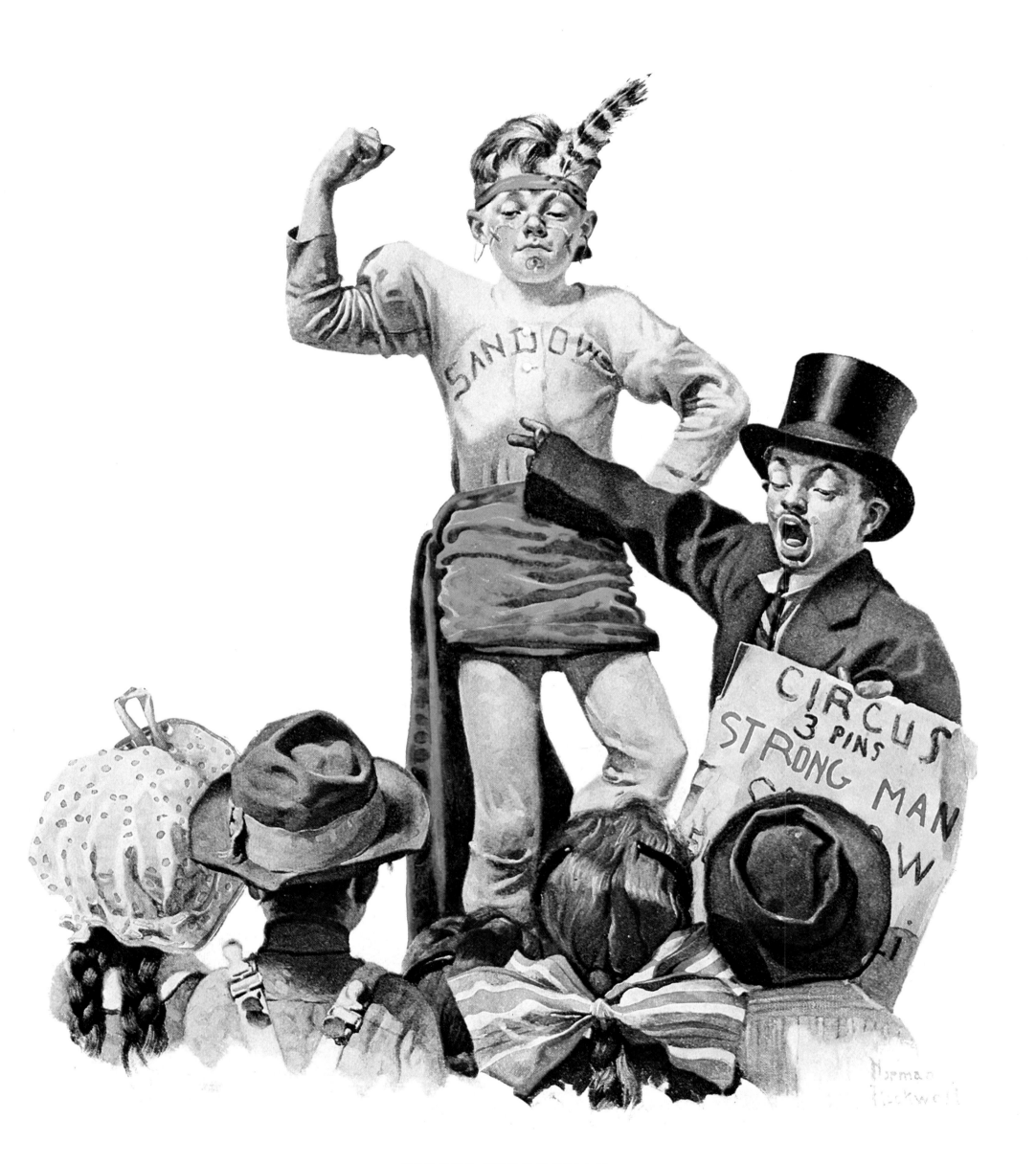

CIRCUS STRONGMAN

Post Cover • June 3, 1916

61

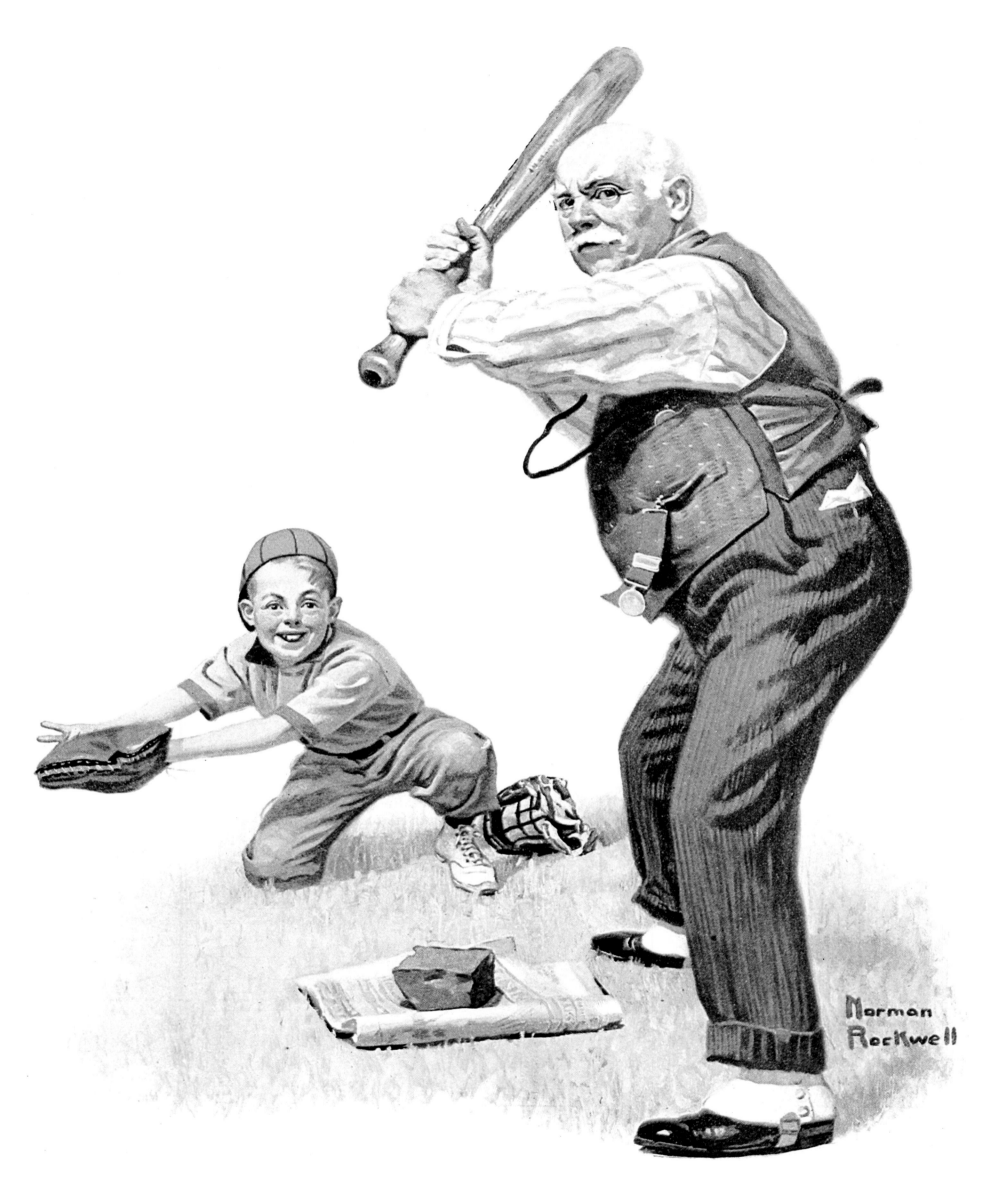

GRAMPS AT THE PLATE

Post Cover • August 5, 1916

62

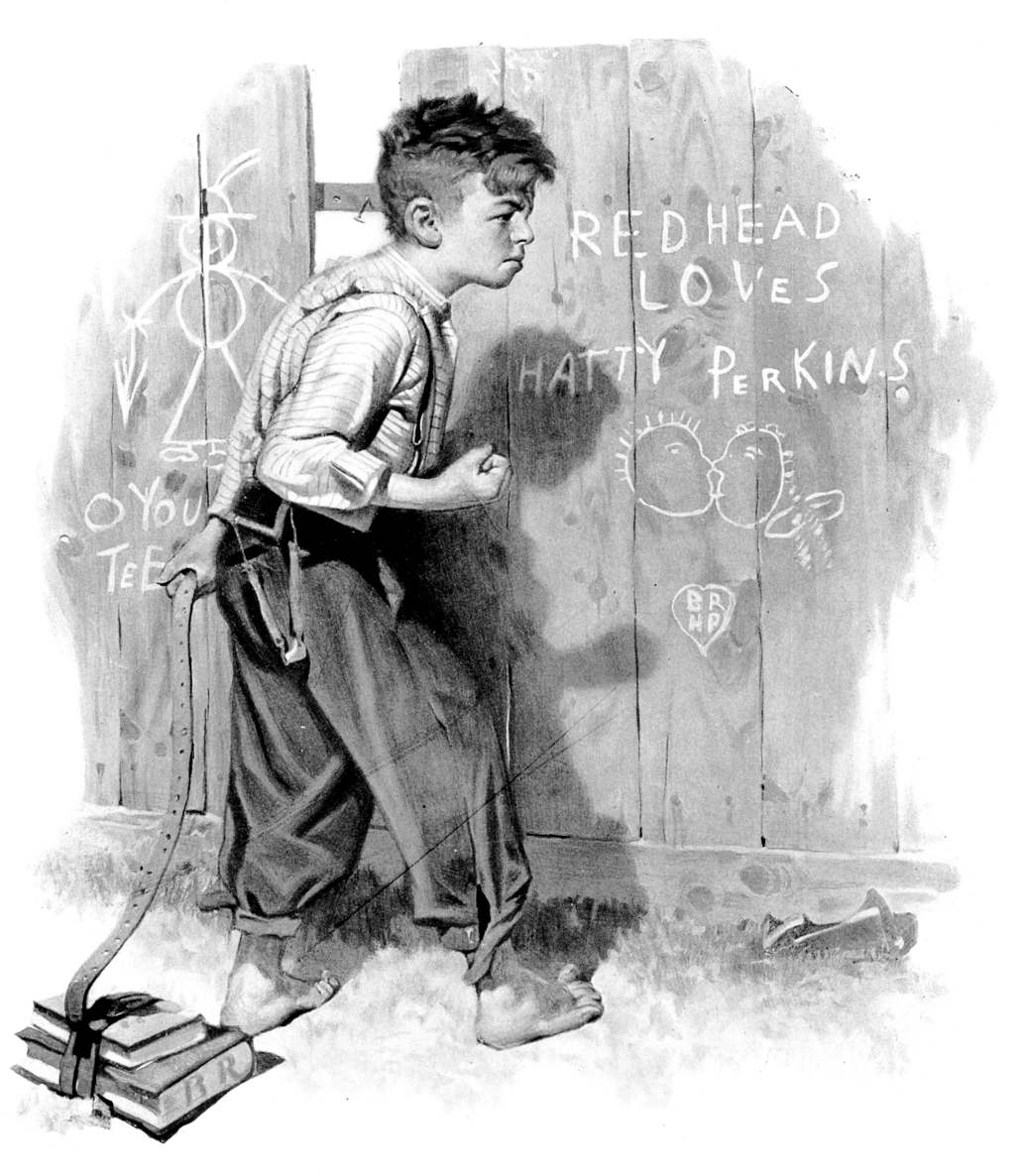

REDHEAD LOVES HATTY

Post Cover • *September 16, 1916*

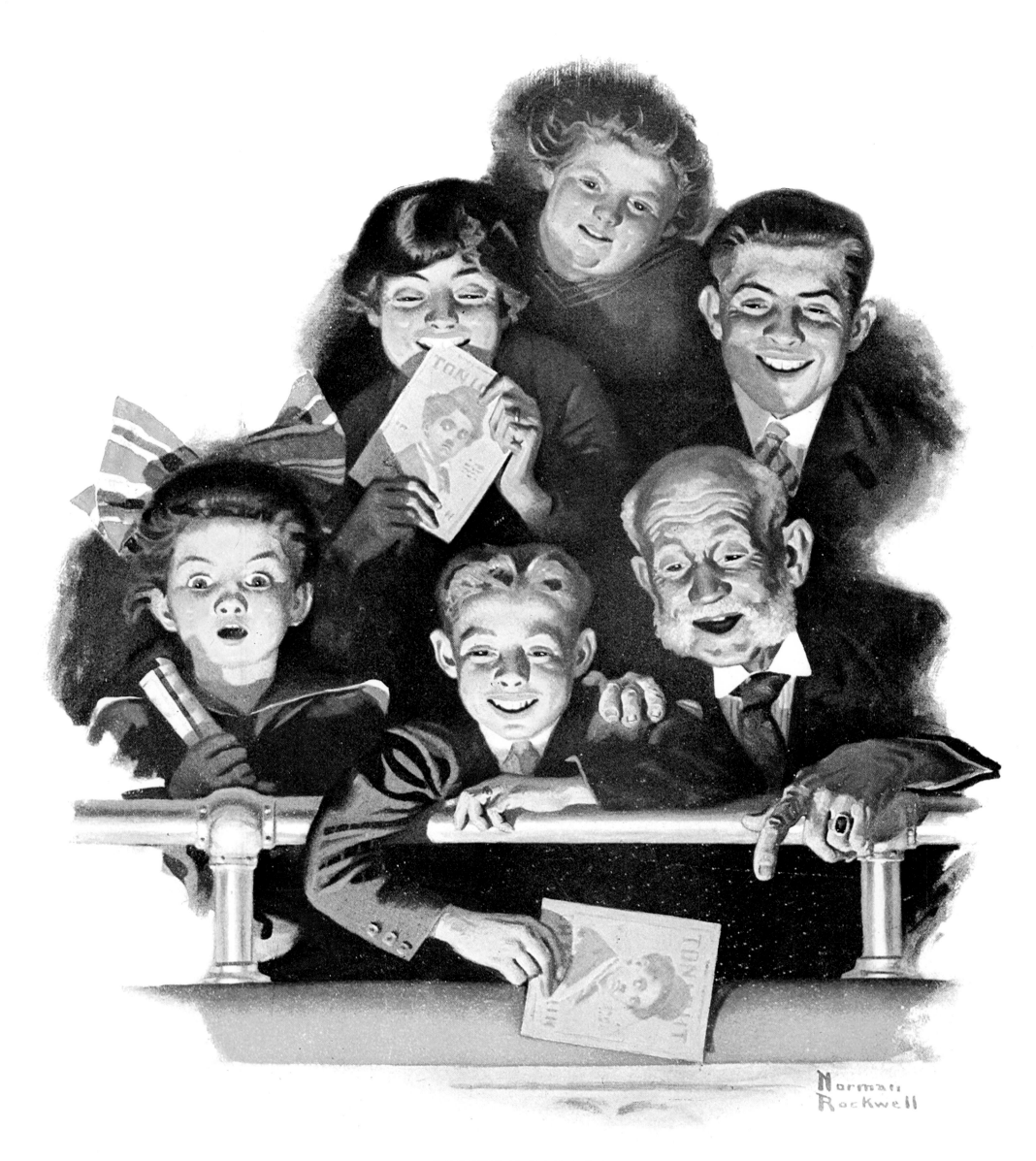

PICTURE PALACE

Post Cover • October 14, 1916

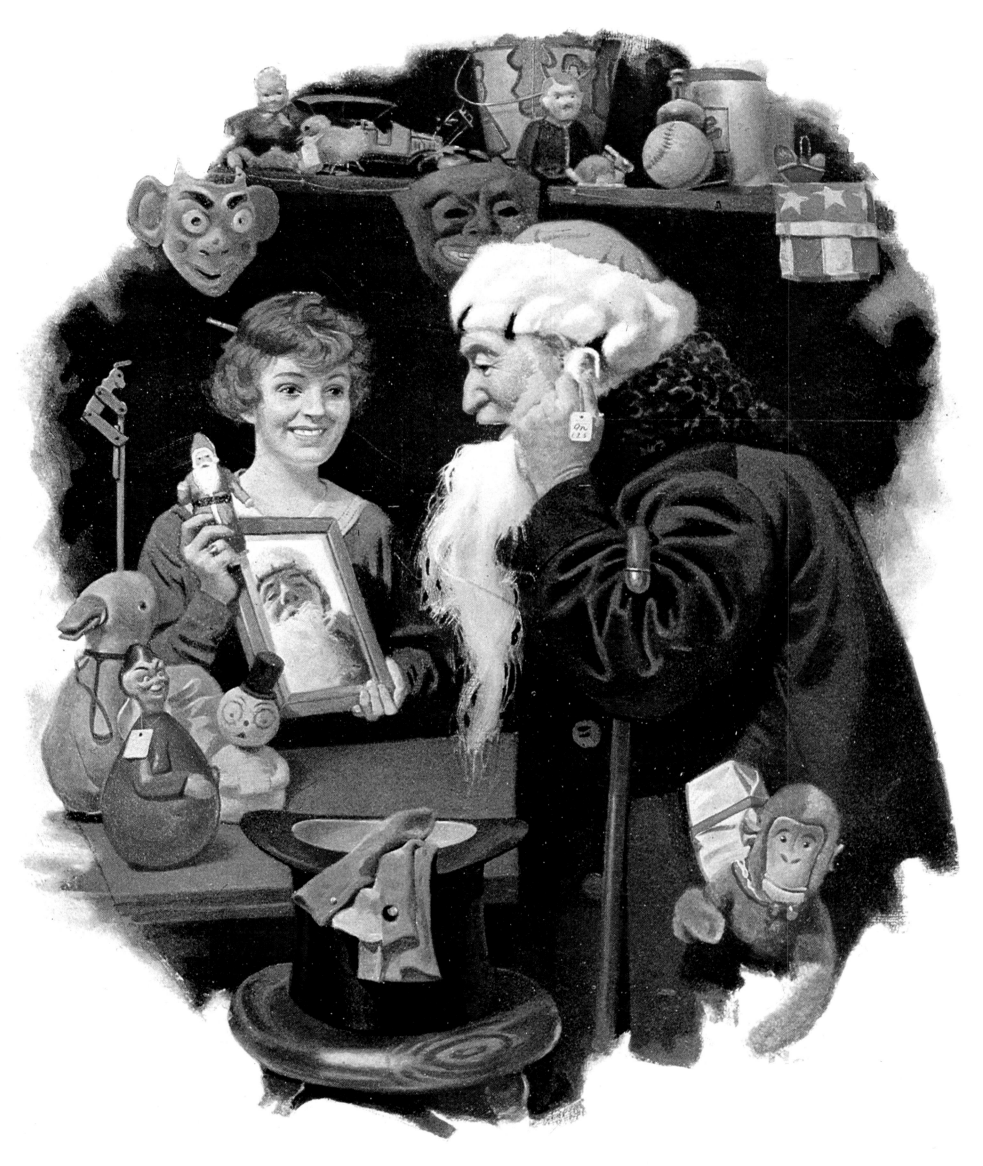

PLAYING SANTA

Post Cover • December 9, 1916

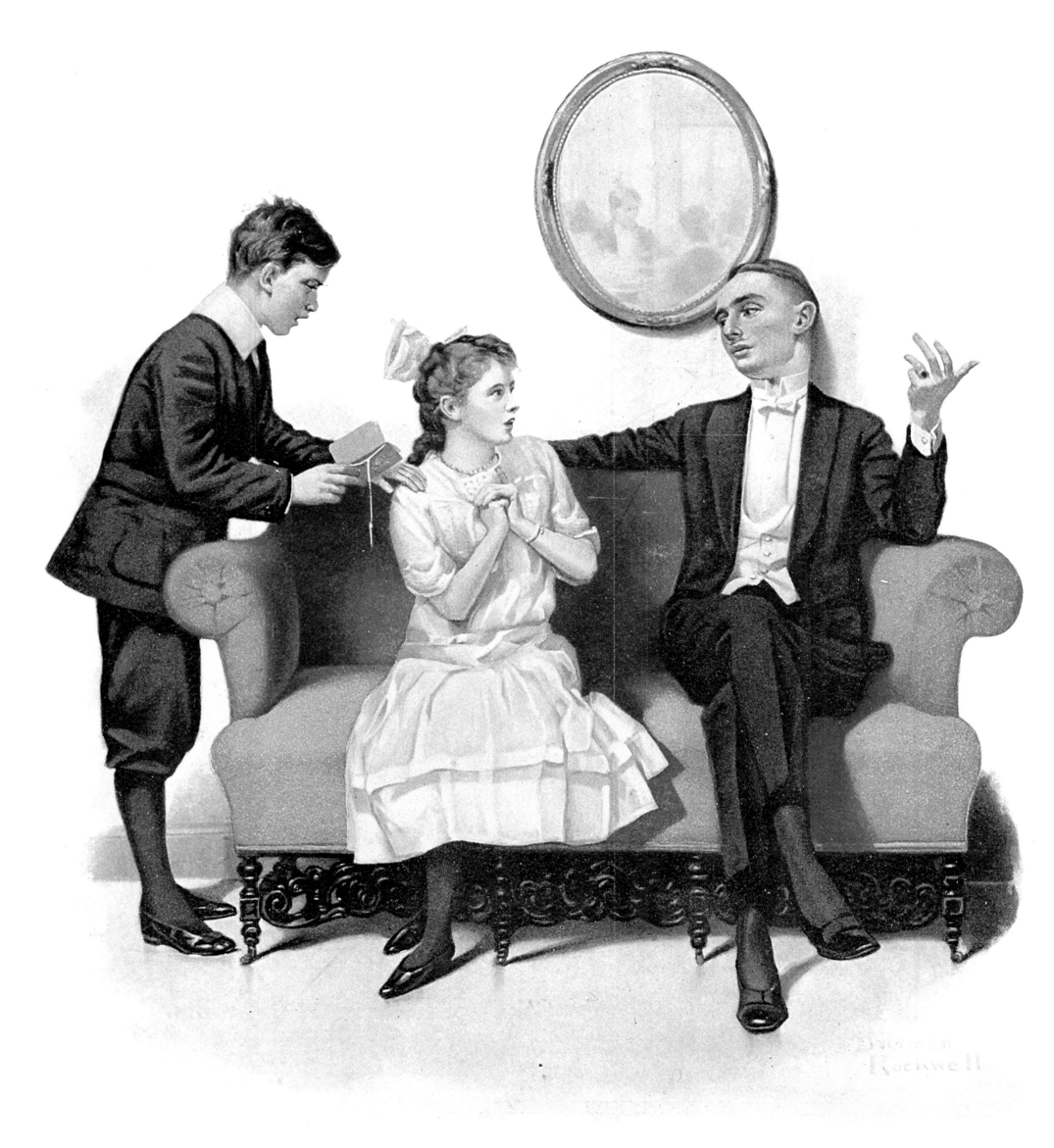

SHALL WE DANCE?
Post Cover • January 13, 1917

READY TO SERVE

Post Cover • May 12, 1917

RECRUITING OFFICER

Post Cover • June 16, 1917

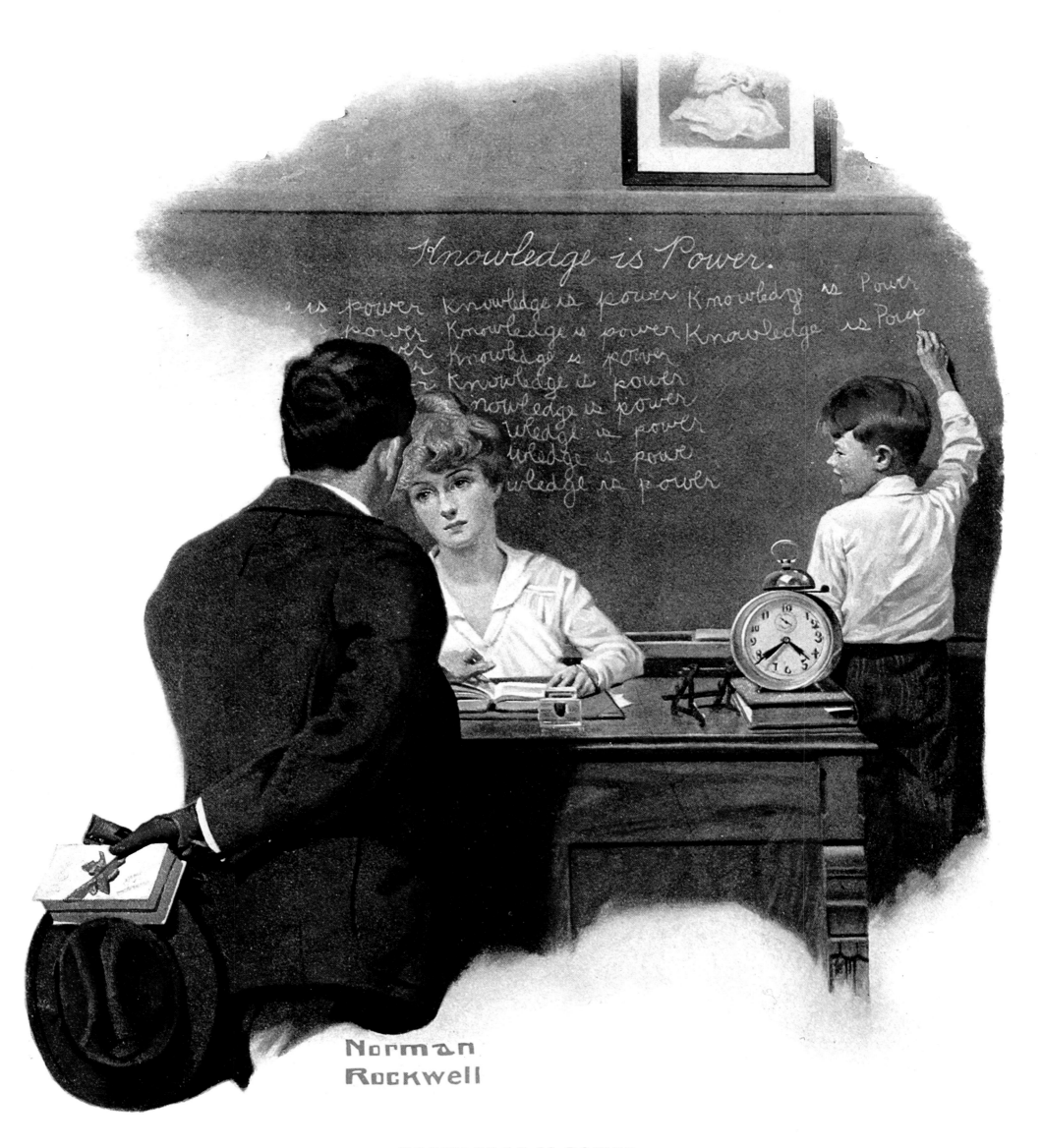

KNOWLEDGE IS POWER

Post Cover • October 27, 1917

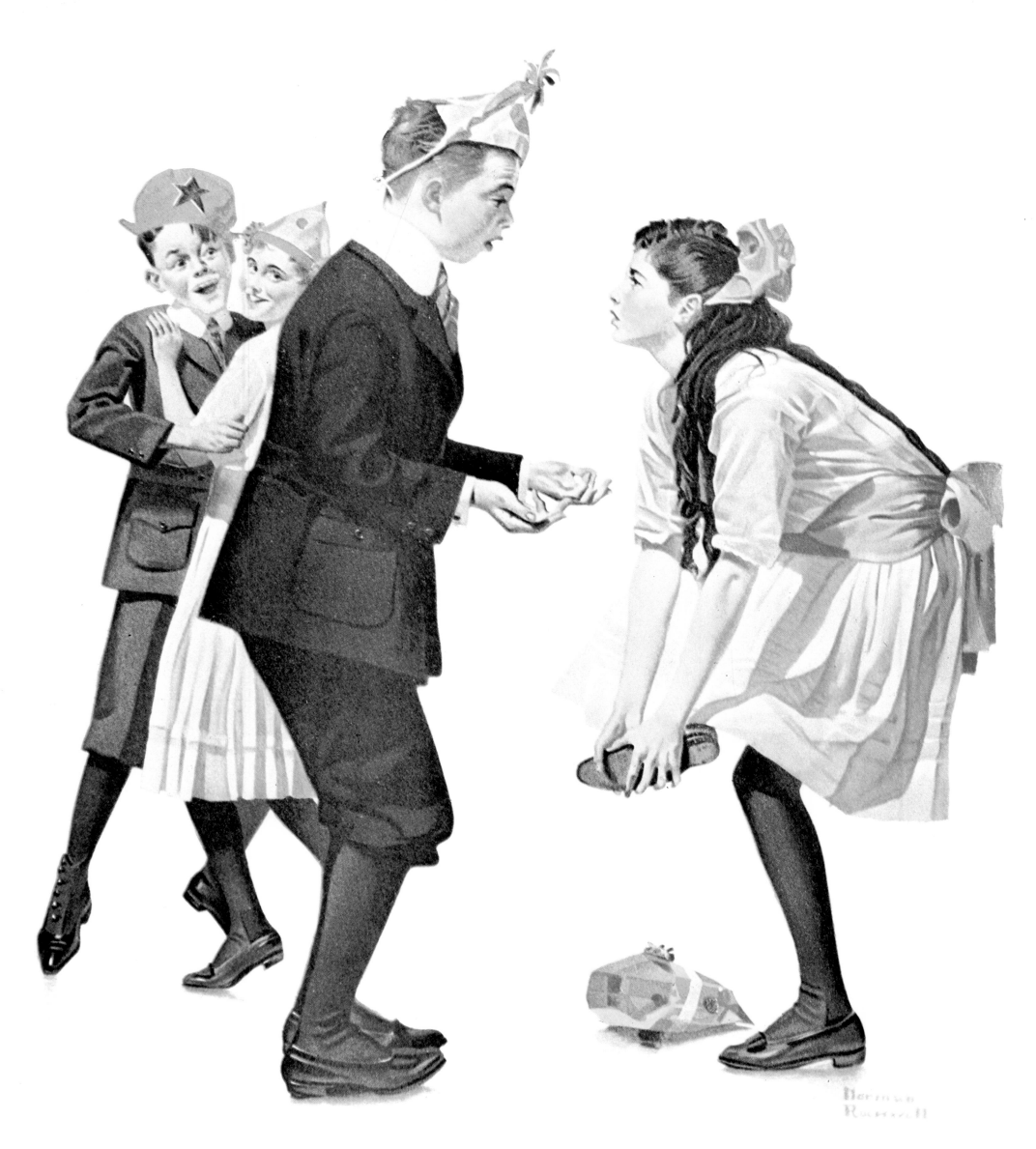

PARDON ME!

Post Cover • January 26, 1918

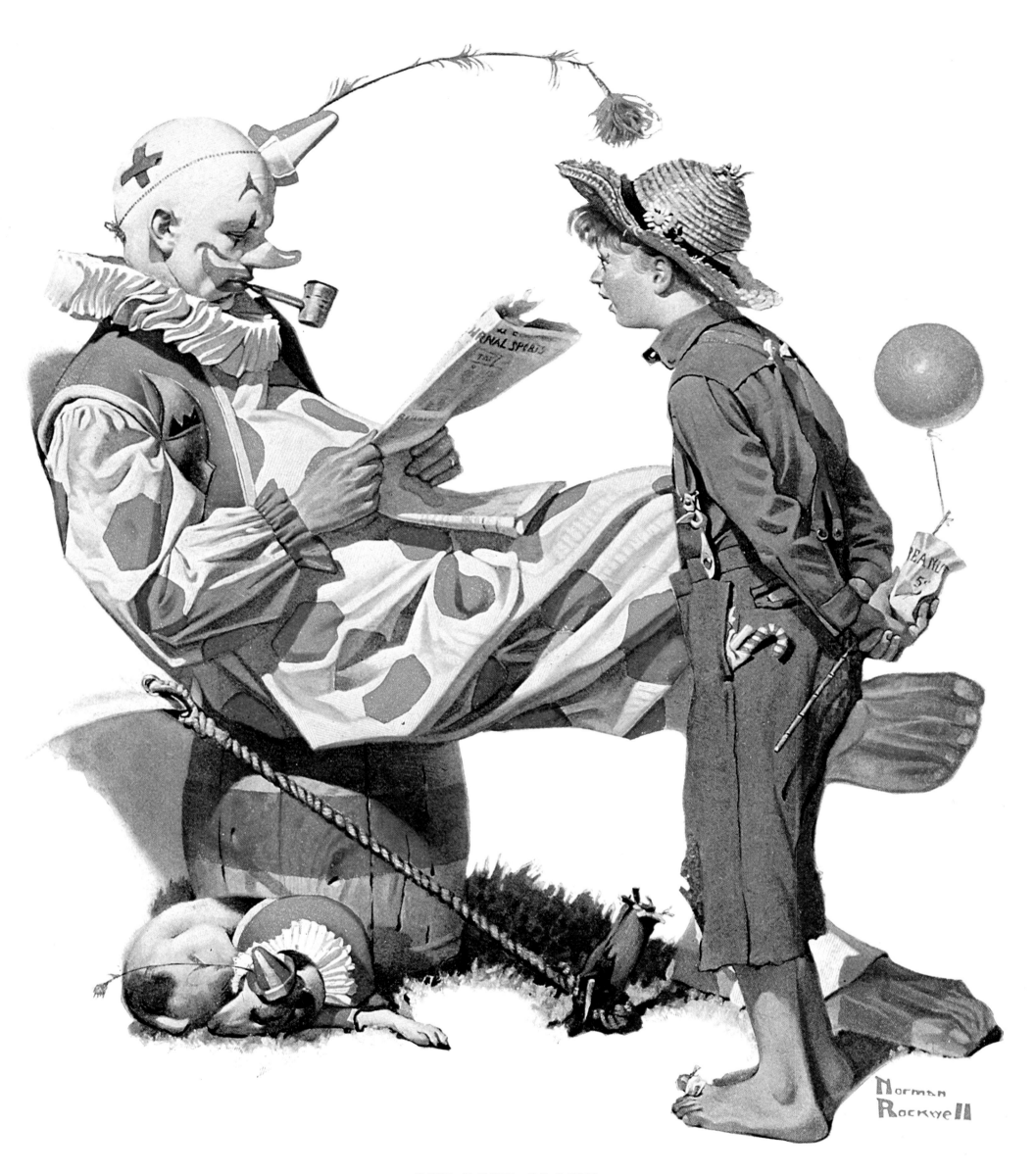

OFF-DUTY CLOWN

Post Cover • May 18, 1918

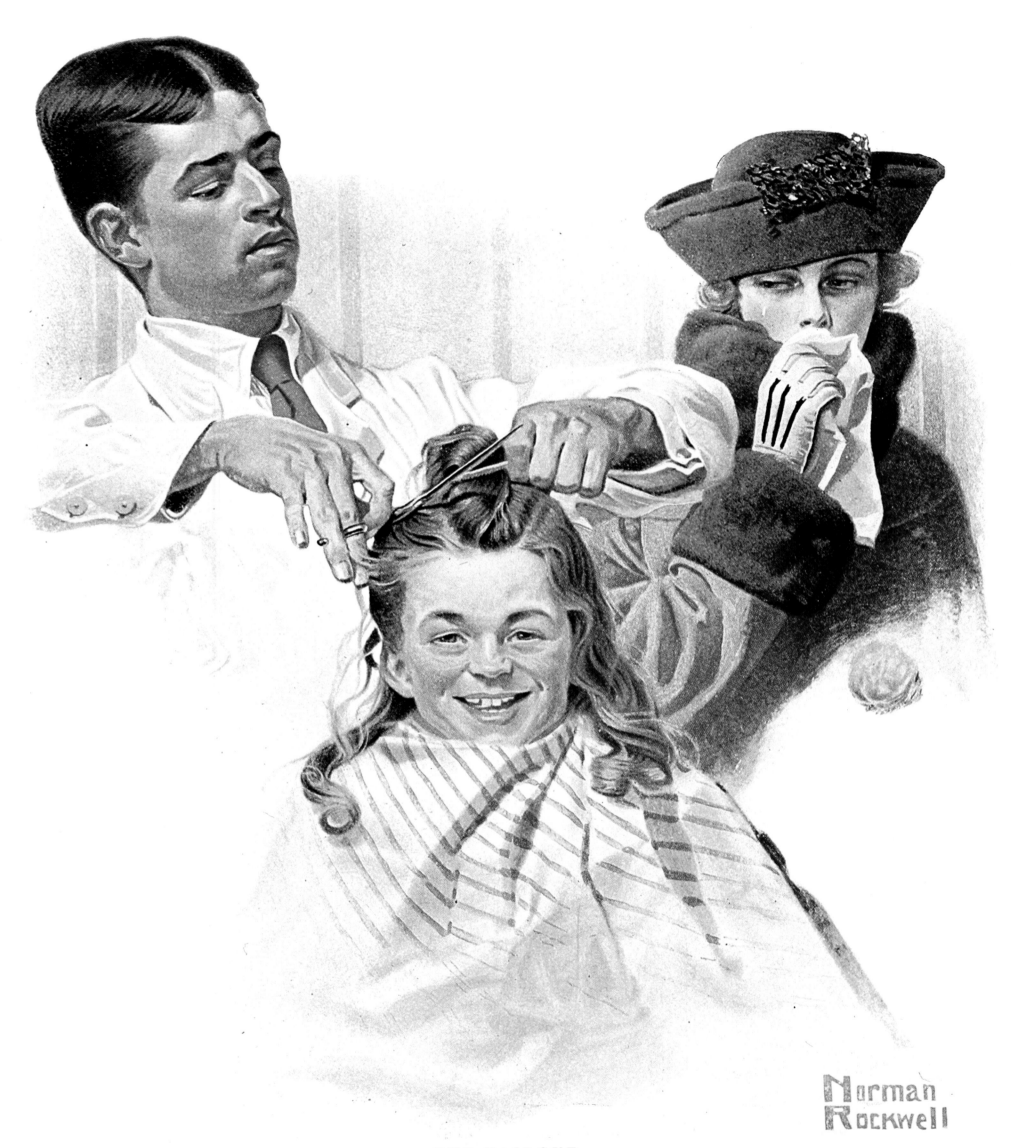

THE HAIRCUT

Post Cover • August 10, 1918

72

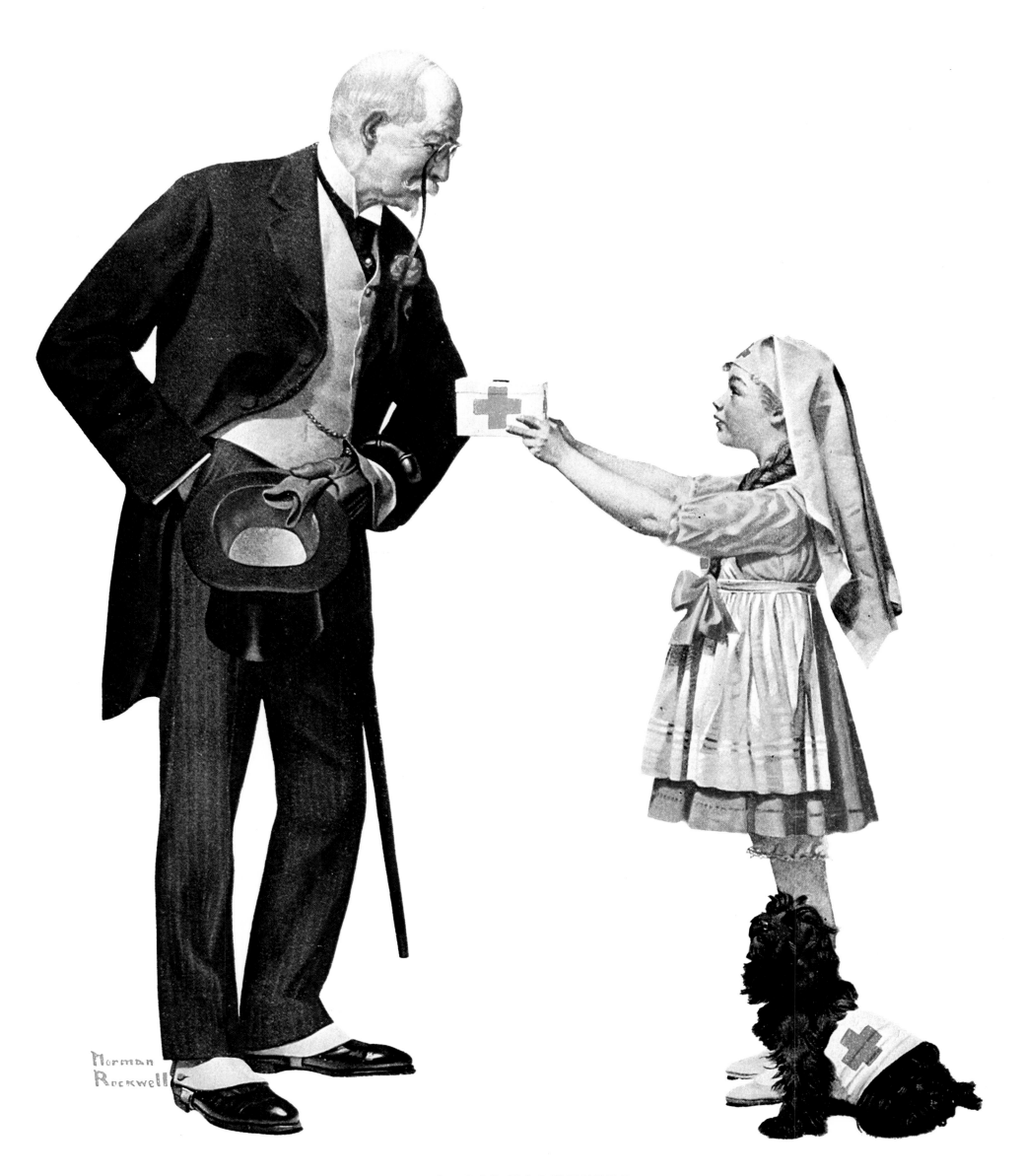

RED CROSS VOLUNTEER

Post Cover • September 21, 1918

73

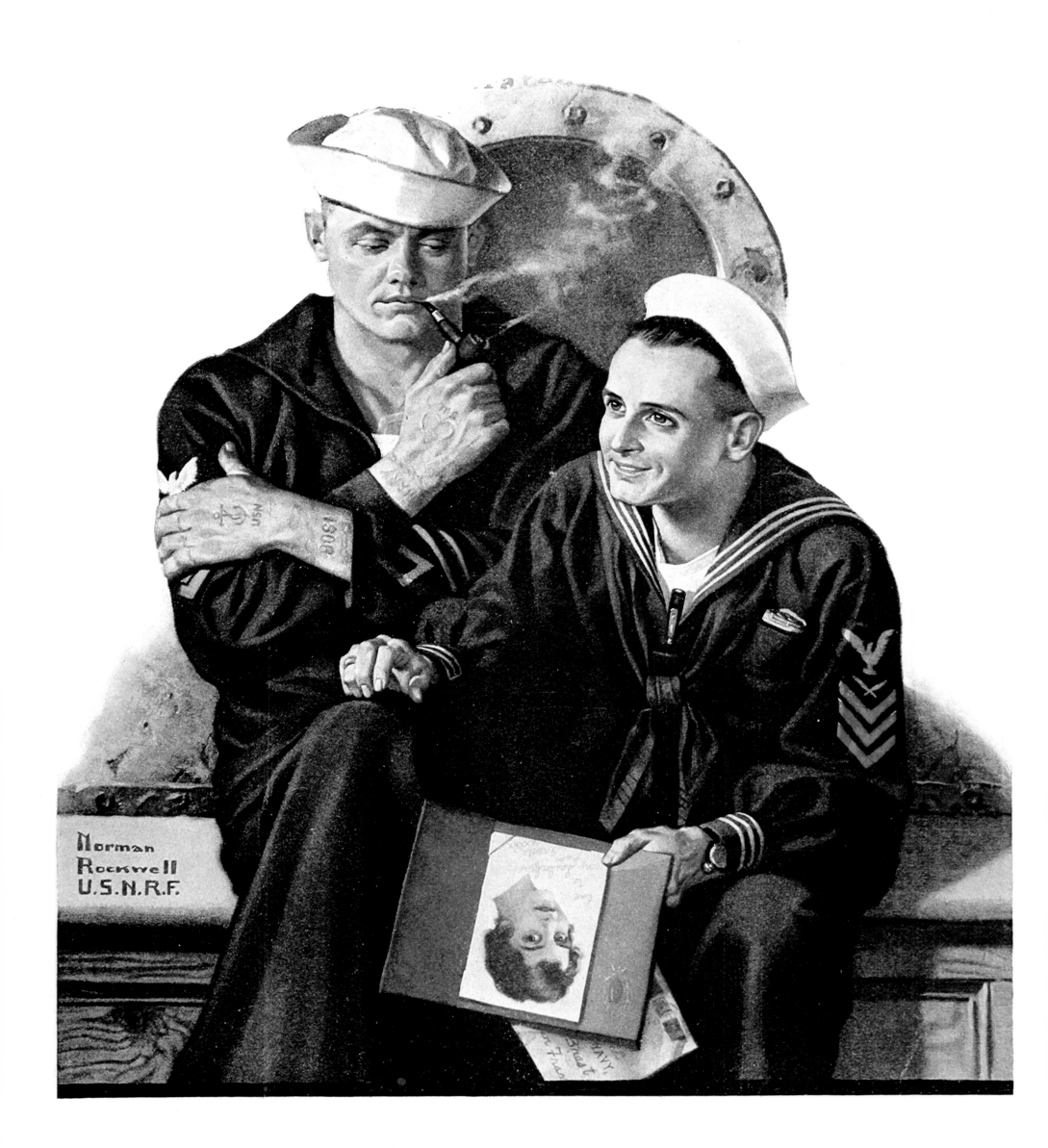

REMINISCING

Post Cover • January 18, 1919

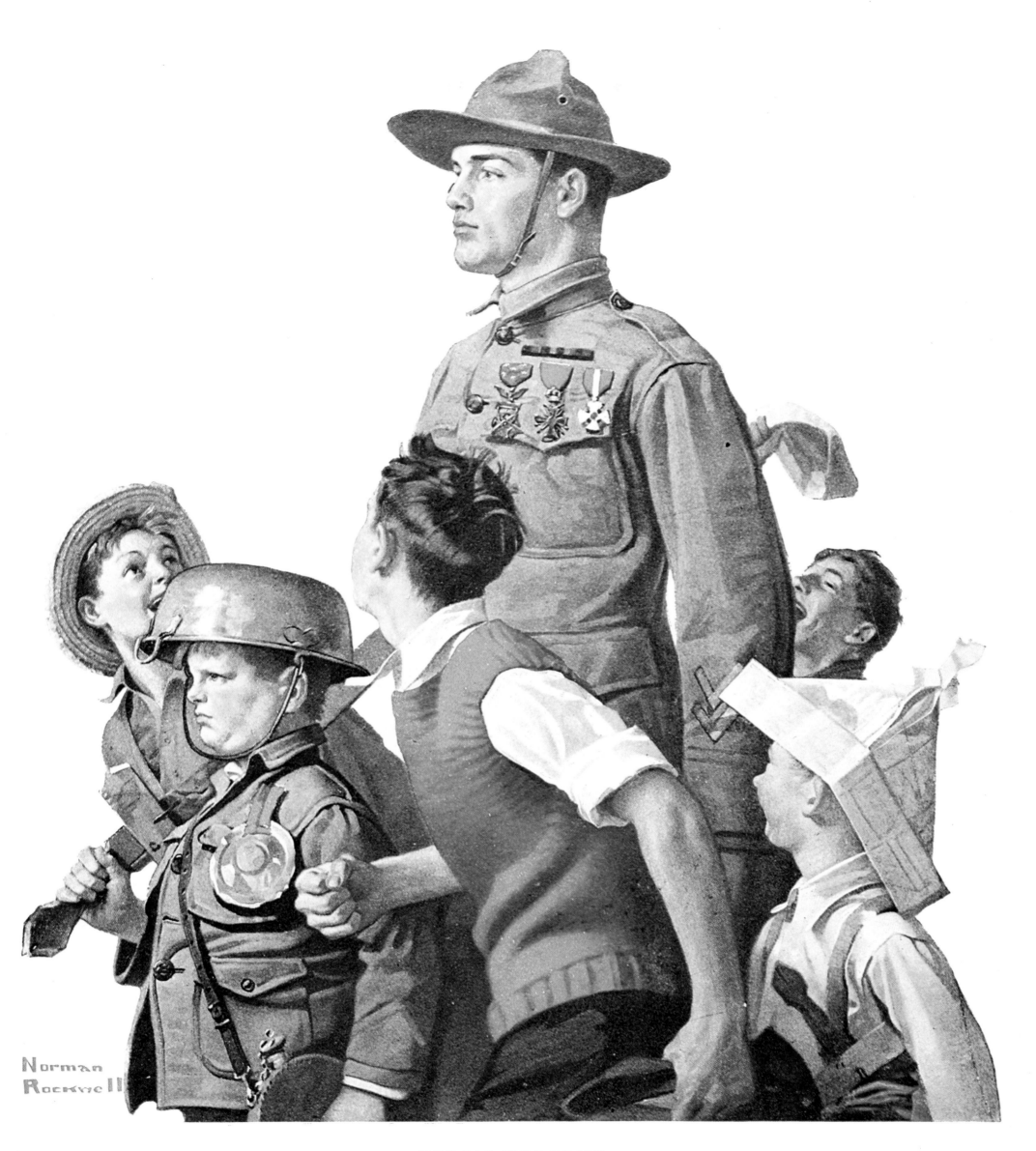

HERO'S WELCOME

Post Cover • February 22, 1919

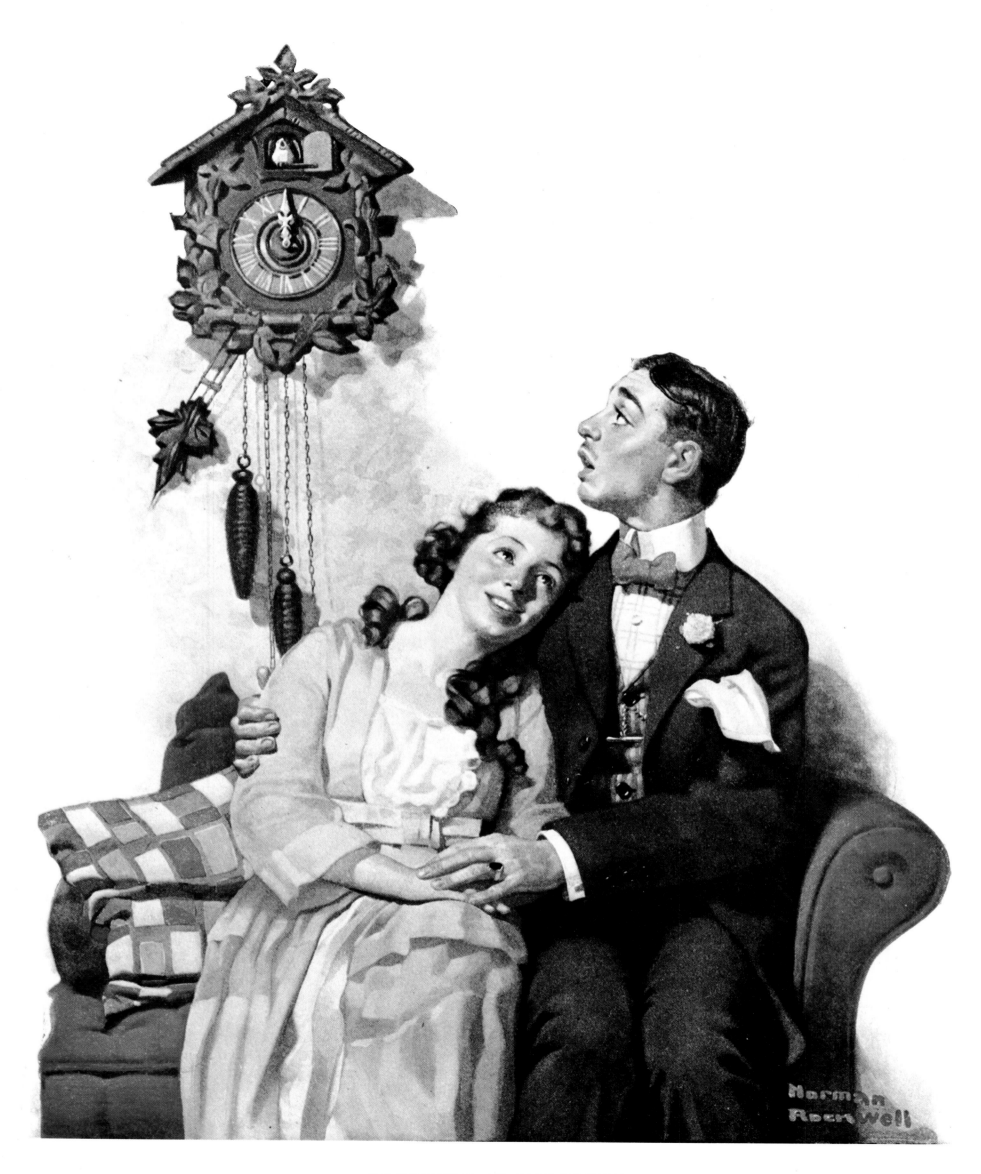

COURTING AT MIDNIGHT

Post Cover • March 22, 1919

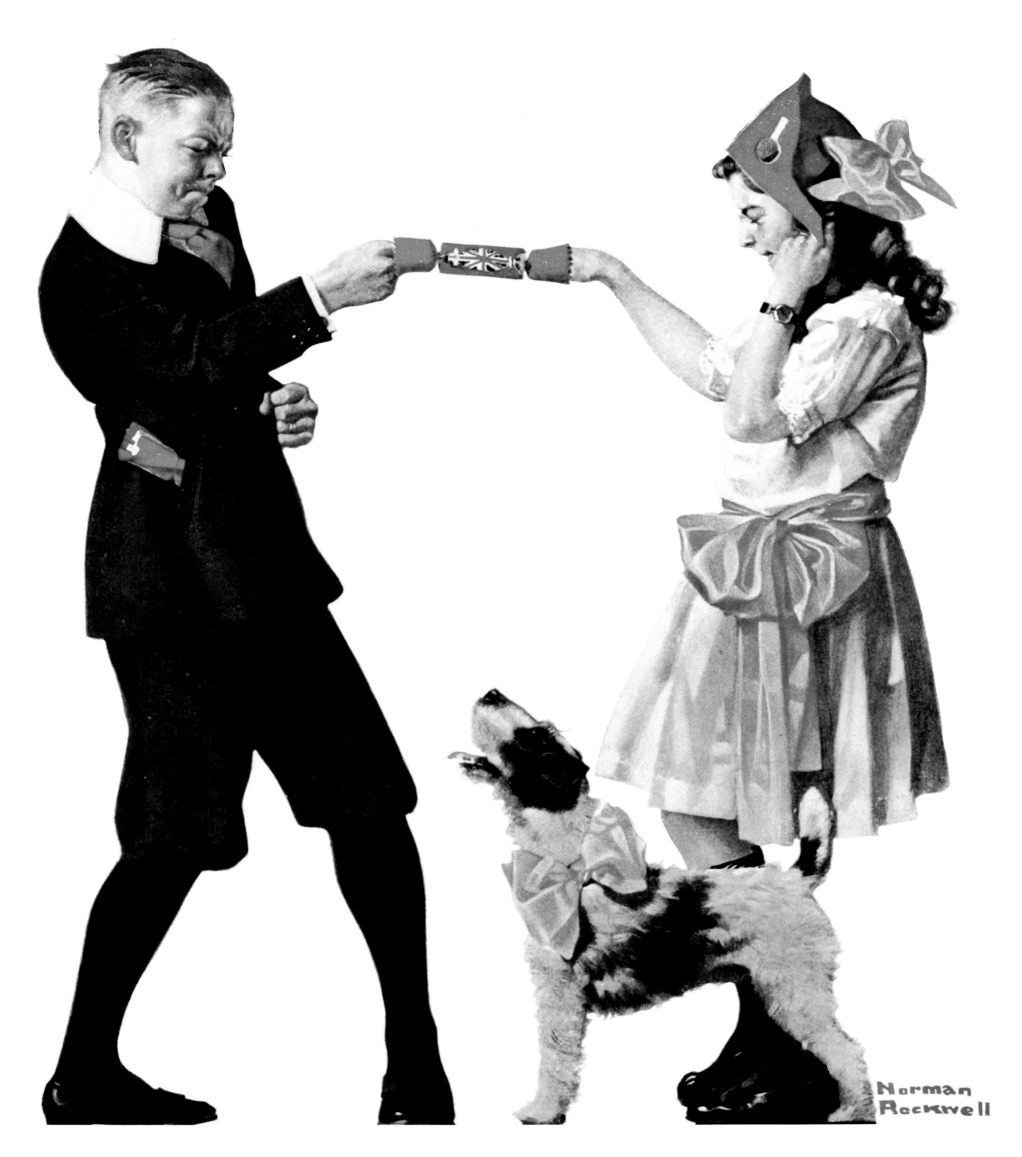

PARTY GAMES

Post Cover • April 26, 1919

VALEDICTORIAN

Post Cover • *June 14, 1919*

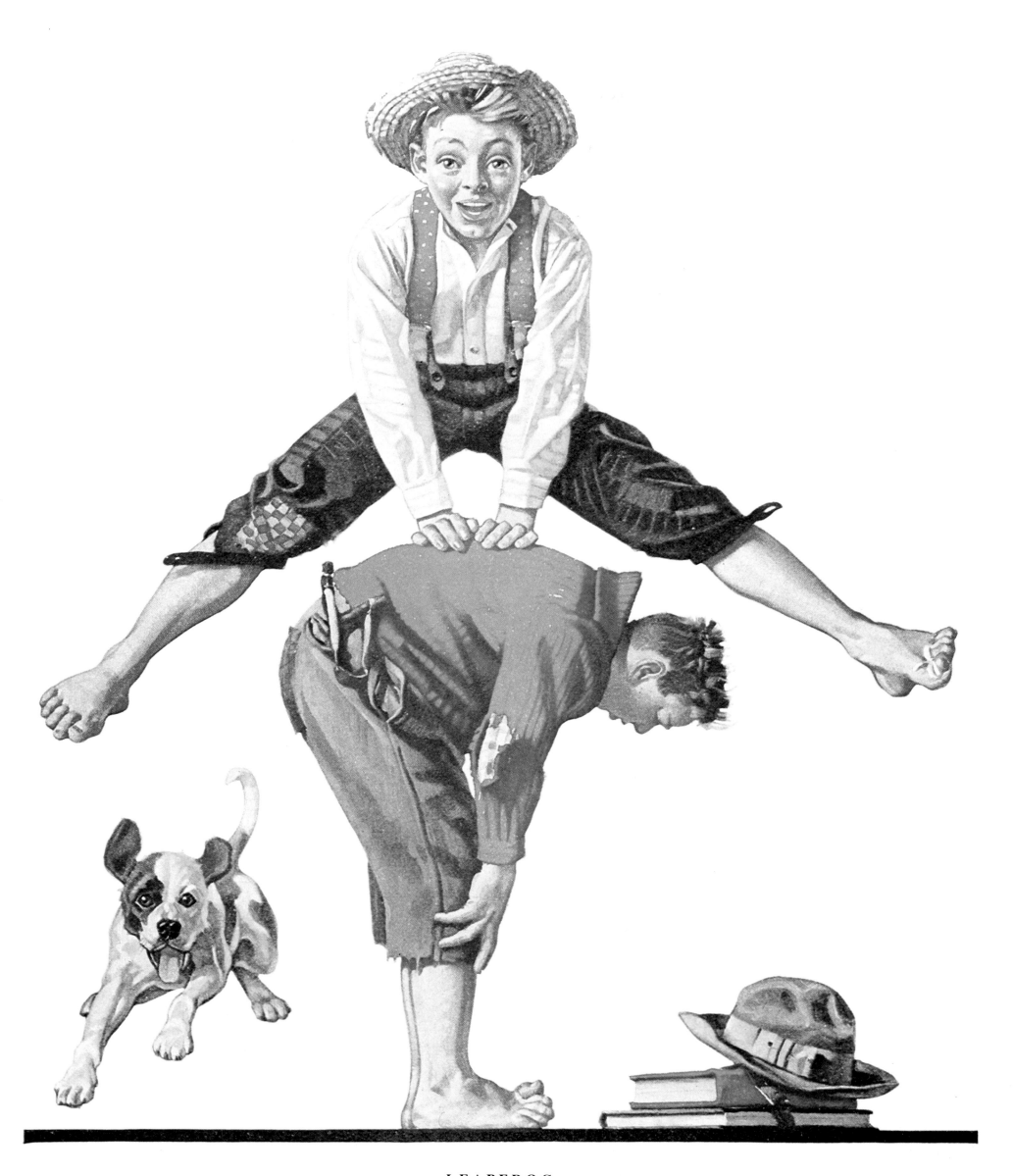

LEAPFROG

Post Cover • June 28, 1919

Although Still Under Thirty
Rockwell Was Rapidly Becoming the *Post's* Premier Cover Artist

AS THE TEENS CAME TO AN END and the twenties began, Rockwell found himself back in New Rochelle, working harder than ever and enjoying his position as the peer of the other well-known illustrators—Clare Briggs, Charles Dana Gibson, Coles Phillips, J. C. and F. X. Leyendecker—who had made the community something of an art colony. The postwar world did not arrive without its crises and upheavals. A terrible influenza epidemic killed thousands, there were anarchist scares, and the Volstead Act made it illegal to sell alcohol beverages (a fact that resulted in the overnight growth of a new underground—or underworld—industry). America was changing rapidly. The war had emancipated women to an unprecedented extent—showing them capable of replacing men in many jobs—and now they won the right to vote. Younger women exercised their new-found freedom in ways that seemed frivolous but were symptomatic of the spirit of a new era: they shortened their skirts and bobbed their hair, and brazenly smoked in public, to the disbelief and horror of their elders. In Europe, President Wilson spearheaded the drive to found the League of Nations, then returned home to find that Congress would have nothing to do with his dream. In the 1920 presidential election, the people chose the GOP's compromise candidate—Warren Gamaliel Harding—and for a dozen years the White House would have a Republican occupant. Inflation was rampant abroad—in Germany a loaf of bread could cost as much as a million marks—but the United States was headed for a period of economic boom. Americans began to put every spare dollar into the stock market, which seemed to rise like the mercury on a hot summer day.

No decade has become more stereotyped than the twenties. This, according to our folklore—recorded in books and movies—was the age of the flapper and the Black Bottom, of speakeasies, gangsters and the Lost Generation. Very little of this is apparent in Norman Rockwell's covers of the period. While other artists recorded each shift of taste, however transitory, Rockwell celebrated those citizens who resisted change, or were indifferent to it. Certainly he would take note, from time to time, of some novelty—radio, for example, or the ouija board craze (pp 97 & 116)—but he always did so in such a way as to suggest that it did not alter the eternal verities.

Interestingly, Rockwell seems to have been leading, at that time, a life which fits in perfectly with our stereotyped image of the Roaring Twenties. In his autobiography he tells us that he acquired a fashionable bootlegger and partied almost as hard as he

worked. His world was not too far removed from the world we discover in a book like *The Great Gatsby*. He was a young celebrity and he took advantage of the perks that came along with the status he acquired. He travelled to Europe, to North Africa, and to South America. He was even invited to judge the Miss America beauty contest.

It is the work that counts, however, and here we find Rockwell building on the foundations he had laid at the beginning of his career, but adding new skills, evolving new twists, always growing. During the period between August 9, 1919 and September 9, 1922, he did paint a few indifferent covers—even a couple that were not very good—but he also painted at least a dozen that are better than almost anything he had sold prior to this time, and two (pp 107 & 114) that have to be reckoned among his early masterpieces.

In several instances we find Rockwell making much more effective use of layout, the two-dimensional aspect of designing a cover. In his earlier work he had generally provided what amounted to a conventional illustration in which foreground and, especially, background had been largely eliminated. This was an approach favored by many *Post* artists, and it worked well enough on a cover that was largely white and dominated by the powerful lettering of the magazine's logo. In the early twenties, Rockwell began to be far more imaginative in the way he presented his subjects. The elimination of background made for a very shallow depth of field, so that the image could be considered almost as a flat silhouette. Rockwell began to learn the art of structuring this "silhouette" so that it would read most effectively against the white background and the logo, almost as if he was dealing with abstract forms rather than with figurative elements. Sometimes this was just a matter of placing the image strikingly (p 114), and sometimes it involved using a framing device such as a circle or a square. When a circle was used (p 103), it was generally employed to pull the composition together and to focus attention on some aspect of the image by forming a secondary silhouetting device within the primary silhouette. When a square was employed it usually functioned in such a way as to define the outer limits of the image, though parts of the image were often permitted to burst from its confines, a trick which helped the artist to get a feeling of energy into the composition. Most Rockwell covers of this period were conceived as tableaux, and sometimes the tableau has more impact if it is boxed in, just as some objects seem more impressive in a glass display case.

It was during the twenties that Rockwell perfected his use of such devices, which he continued to use for two decades until there was a radical change in his approach (and even then he never lost his skill at silhouetting images and composing them effectively on the page). At this same time, we find him introducing a more varied cast of characters into his cover paintings, and scrutinizing them more carefully while placing them in more original situations. Although still under thirty, he was rapidly becoming the *Post's* premier cover artist.

SATURDAY EVENING POST COVERS
August 9, 1919–September 9, 1922

STOLEN CLOTHES
Post Cover • August 9, 1919
PAGE 89

THIS is a typical "seasonal" cover of the period. Summer means swimming and Rockwell takes a situation that anyone can imagine himself in and presents it in a perfectly straightforward fashion. This painting breaks no new ground, serving rather as another link in a long tradition of *Post* covers.

ASLEEP ON THE JOB
Post Cover • September 6, 1919
PAGE 90

LIKE the previous cover, this one is completely unremarkable. It takes another stock situation and presents it with the minimum of fuss. It is typical of the kind of bread-and-butter subject and treatment that Rockwell would fall back upon for the next decade and a half, whenever more original ideas failed to present themselves.

IMPORTANT BUSINESS
Post Cover • September 20, 1919
PAGE 91

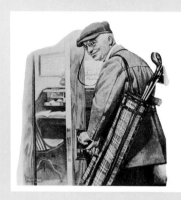

WE may suppose that this cover was suggested by the one that preceded it. Again the theme is the triumph of leisure over labor and this time the subject is treated in a more interesting way. The businessman about to lock up his office, golf clubs slung over shoulder, is presented as if we had caught him in the act. He confronts us with a smile that blends sheepishness and self-satisfaction, with the latter apparently about to triumph.

STILT WALKER
Post Cover • October 4, 1919
PAGE 92

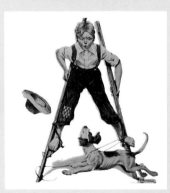

THIS cover works in much the same way as the earlier "Leapfrog" (p 79). It depends upon the illusion that the accident which is about to happen will cause the boy to actually fall off the page. Rockwell was taking advantage of a device that had been a favorite of mural painters since the High Renaissance (and which has roots going back to Pompeii), adapting it to the needs of the cover.

GRAMPS ENCOUNTERS GRAMPS!
Post Cover • December 20, 1919
PAGE 93

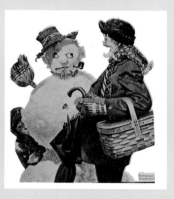

THE situation here is ordinary enough but Rockwell brings it to life with one small touch. The snowman's eyes have been placed so as to give him the same expression of apprehension that is visible on the small boy's face. Because of this, the snowman—an inanimate object—becomes the animate center of the picture.

LOVE LETTERS
Post Cover • January 17, 1920
PAGE 94

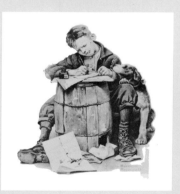

THIS cover and the one that follows it are further examples of Rockwell's bread-and-butter style. The boy writing clumsy love letters, watched by the faithful mutt who no longer has first claim on his affections, represents a blatant appeal to sentiment that, in his more creative moments, the artist could afford to shun.

SKATERS

Post Cover • *February 7, 1920*

PAGE 95

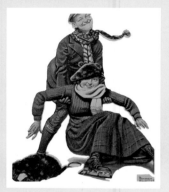

THIS must be reckoned as one of Rockwell's weakest *Post* covers. The situation is banal and the artist brings nothing original to his treatment of it. In his best work, even at this early period, Rockwell gave us individuals, characters who were so particularized that we can believe in them. Here he gives us types.

DEPARTING SERVANT

Post Cover • *March 27, 1920*

PAGE 96

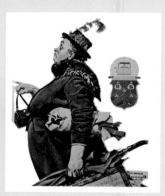

STARTING with this study, Rockwell entered a very fruitful period, painting a dozen *Post* covers in a fifteen-month span, several of them numbering among his finest to date.

This cook, leaving in a huff—with her pride intact, and her demeanor unsullied—is quite new in Rockwell's world. One would like to believe that he must have witnessed just such an exit at first hand, for certainly this painting bears the authority of an event observed, which a touch of caricature does nothing to diminish.

THE OUIJA BOARD

Post Cover • *May 1, 1920*

PAGE 97

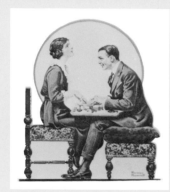

THE Ouija board craze arrived with the twenties and Rockwell lost no time in utilizing it for his own purposes. It is clear that this young couple is looking for the answers to some very specific questions. These may not be the questions that they care to express in words, but the Ouija board gives them an excuse to establish a degree of physical contact that is itself sufficiently articulate.

TRAVELLING COMPANIONS

Post Cover • *May 15, 1920*

PAGE 98

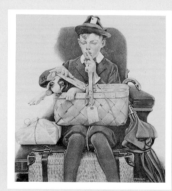

ESSENTIALLY this is another bread and butter cover, but it has a good deal of charm because of the thought and care the artist has put into its execution. Every detail—the boy's expression, the giant umbrella—is just right. We can imagine having a conversation with this young traveller. We can even guess, from his evident preparedness and the neatly wrapped parcel at his side, at what kind of mother he has.

A DOG'S DAY

Post Cover • *June 19, 1920*

PAGE 99

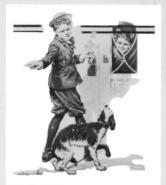

AS has been mentioned, the dogs in Rockwell's paintings tend to enter into a symbiotic relationship with their owners. In this instance, however—a more successful variant on the theme broached in "Love Letters" (p 94)—these ties have been broken and the unfortunate pet finds himself banished. Tail between legs, the dog epitomizes pathos, a pathos that is heightened when we notice the stake that drags behind the poor creature at the end of a rope.

THE OPEN ROAD

Post Cover • *July 31, 1920*

PAGE 100

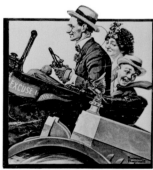

THE subject of this cover needs little commentary. An ancient bone shaker has, to the delight of its occupants, overtaken a spanking new roadster. Clearly the artist knows that most of the *Post*'s readers will have no difficulty identifying with the driver of the jalopy and his passengers.

What is most striking about this particular painting is the composition. It utilizes the page more fully than any of Rockwell's *Post* covers had up to this point.

CAVE OF THE WINDS
Post Cover • August 28, 1920
PAGE 101

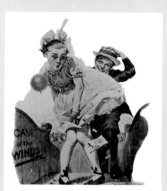

Aᴺᴼᵀᴴᴱᴿ delightful cover. We might be at Coney Island, at Atlantic City, or on Venice Pier in California. This was the golden age of the amusement park and Rockwell gives us a glimpse of a typical scene. Everything is carefully orchestrated to make an effective image: the way the girl clutches at her skirt, the way her feet are planted, the expression on her face, even the way the man-made breeze plucks at her balloon.

The clothes worn by the girl and her young man make this a period piece, but the snapshot approach once more hints at the mature Rockwell who will emerge twenty years later.

THE DEBATE
Post Cover • October 9, 1920
PAGE 102

Rᴼᶜᴷᵂᴱᴸᴸ's Election Eve covers were to become something of a tradition for *Post* readers. This is the first of them and the theme he returned to again and again—husband and wife on opposite sides of the political fence—is stated with the utmost simplicity, but with considerable force.

HALLOWE'EN
Post Cover • October 23, 1920
PAGE 103

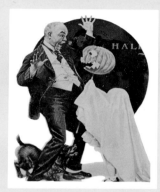

Iɴ this striking cover, the dark circle behind the figures gives focus to the composition, adding to its atmosphere, and helping to bring the scene to life.

SANTA
Post Cover • December 4, 1920
PAGE 104

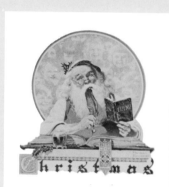

Tʜɪs traditional scene suggests that even Santa Claus has to watch his expenses. As in the previous cover, good use is made of a circular framing device as a way of pulling the composition together.

ON THE HIGH SEAS
Post Cover • January 29, 1921
PAGE 105

Iɴ this instance, the circle is reshaped into an oval and enlarged, giving interest to a relatively ordinary painting.

A NIGHT ON THE TOWN
Post Cover • March 12, 1921
PAGE 106

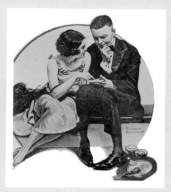

Aɢᴀɪɴ Rockwell employs the circle, permitting the image to break through its confines so that he achieves a strong three-dimensional effect—note the skillful foreshortening—without losing any of the impact of the two-dimensional layout on the page.

NO SWIMMING
Post Cover • June 4, 1921
PAGE 107

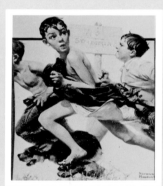

Tʜɪs is the most famous of Rockwell's early covers, and deservedly so since he takes a traditional theme and treats it in an original and innovative way. The fleeing boys are evoked with splendid economy. The grasp of anatomy is sure and the play of sunlight is handled with considerable virtuosity. Although he presents the child's world as an idyllic one, for the most part his boys are no better behaved than they ought to be. Such matters aside, the way he has managed to suggest the speed of the protagonists' hasty retreat is almost cinematic. Rockwell's figure painting techniques may be completely traditional, but the compositional method he employs here owes nothing to the old masters. The way the figures are cut off at the black box adds enormously to the sense of urgency.

WATCH THE BIRDIE
Post Cover • *July 9, 1921*
PAGE 108

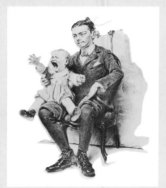

THE gadget used to hold the young man's head steady tells us we are in a portrait photographer's studio. The expression on the youth's face, not to mention the violent protests of his baby brother, tells us that this is not an enjoyable experience for anyone. We cannot see the photographer, but it's easy to imagine that if we could, his own features would reflect a degree of frustration. This is a good example of the kind of slice of life subject that Rockwell would make his own.

DISTORTING MIRROR
Post Cover • *August 13, 1921*
PAGE 109

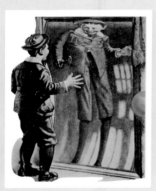

FOR this cover, Rockwell returned to the amusement park for subject matter. This example, though, is far less inspired than "Cave of the Winds" (p 101), painted a year earlier, and must be categorized as one of Rockwell's less interesting covers of the period.

SNEEZING SPY
Post Cover • *October 1, 1921*
PAGE 110

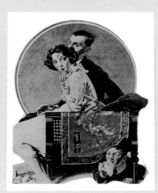

THIS painting of a courting couple surprised by the young woman's kid brother is worthy of study for its documentary detail. The young woman's clothing and the Chinese fabric draped over an arm of the sofa tell us a good deal about the taste and fashions of the period. Unusually for Rockwell, the composition has an almost Art Deco look to it. Rarely did the artist come so close to what we now think of as the spirit of the twenties. The situation is pure Rockwell, but these two bright young things look as if they would not be completely at loss in the company of John Held's flappers.

MERRIE CHRISTMAS
Post Cover • *Dec. 3, 1921*
PAGE 111

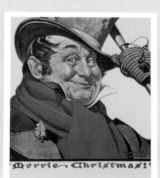

THIS is the first of Rockwell's Dickensian Christmas covers (and we remember how the artist's father loved to read Dickens out loud to his family). Given the difference of cultures, and of centuries, Rockwell is about as Dickensian as any illustrator could be. He may have lacked the novelist's great sweep of imagination, and his ability to deal with the social issues of the day, but Rockwell had the same eye for comic incident and quirks of character that we find in *Pickwick Papers*.

THE SPHINX
Post Cover • *January 14, 1922*
PAGE 112

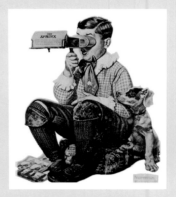

THIS plump boy, wondering at the magic of stereoscopic vision, seems curiously old-fashioned, even given the early date of this cover. It is not clear, in fact, if this is a contemporary subject—a kid who has found an old stereoscope in the attic—or whether it was intended as a period piece.

SORTING MAIL
Post Cover • *February 18, 1922*
PAGE 113

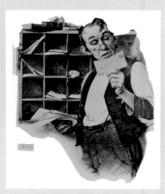

THIS painting belongs so much to the mainstream of *Post* covers that it could easily have decorated the magazine twenty years earlier. The notion of the local mail clerk knowing everybody's business, because of his access to everyone's mail, is as old as the postal service itself. Rockwell's version of the theme is in no way novel, but he makes the clerk a believable character. We can see that he conceives of prying into other people's affairs as a de facto requisite of his office.

THREADING A NEEDLE

Post Cover • April 8, 1922

PAGE 114

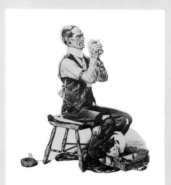

WITHOUT a doubt this is one of Rockwell's finest covers of the twenties. A single, seemingly insignificant act is used to sum up the character of an individual. A stoical bachelor—or perhaps he is a widower—bent on keeping up appearances, threads a needle prior to darning his socks. The deceptively simple image conveys many things. The situation itself conjures up a history of deprivation, and the cat speaks to us of loneliness endured, while the man's stiff collar and straight back tell us that he has not been broken by his hard life.

At first glance this is a comical picture, but it also contains an element of genuine tragedy. We sense what this person has been through, and what he must still face.

BE A MAN!

Post Cover • April 29, 1922

PAGE 115

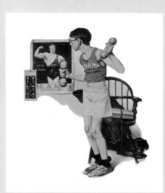

As a child Norman Rockwell was slight, and he must have found it easy to identify with this would-be body builder. Although this is a relatively slight work, it is interesting in that it has a definitely modern feel to it. Just as "Sorting Mail,"

(p 113), might have been painted twenty years earlier, so this cover might have been painted twenty years later.

THE WONDERS OF RADIO

Post Cover • May 20, 1922

PAGE 116

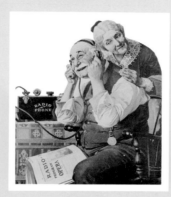

RADIO was still very much a novelty in 1922, a mysterious world of tall antennae, ear-phones and crystal detectors. Rockwell emphasizes this by showing the new wonder as it is experienced by an elderly couple. In their lifetime they have seen many marvels—the telephone, the phonograph, the horseless carriage, the flying machine—and now they can hear opera (interrupted by static, it's true) in the comfort of their own home, as it is being performed on the stage at the Met.

BOY GAZING OUT OF A WINDOW

Post Cover • June 10, 1922

PAGE 117

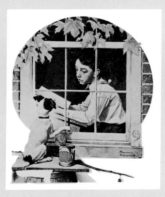

A BOY is busy with his studies. Outside the window a fishing pole is ready, and the boy's dog waits impatiently. The summer vacation is about to begin, but these last days of schoolwork seem the longest. It is an old story and Rockwell tells it with the utmost simplicity.

SETTING ONE'S SIGHTS

Post Cover • August 19, 1922

PAGE 118

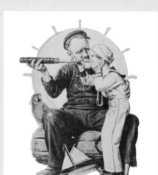

THIS must count among Rockwell's least convincing covers. It takes a considerable stretch of the imagination to suppose that this old salt, who has lost a leg somewhere in his peregrinations about the globe, would bear so patiently with the pampered child in his oh-so-fresh sailor suit. This weak painting marks Rockwell's entry into a fallow period.

THE RIVALS

Post Cover • September 9, 1922

PAGE 119

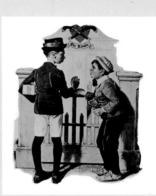

THIS cover makes us yearn for the urchins of "No Swimming" (p 107), though, curiously, the same model seems to have posed for the plump lad at the right of each composition. For the sake of the unseen object of their affections, one wishes ill fortune to both these rivals.

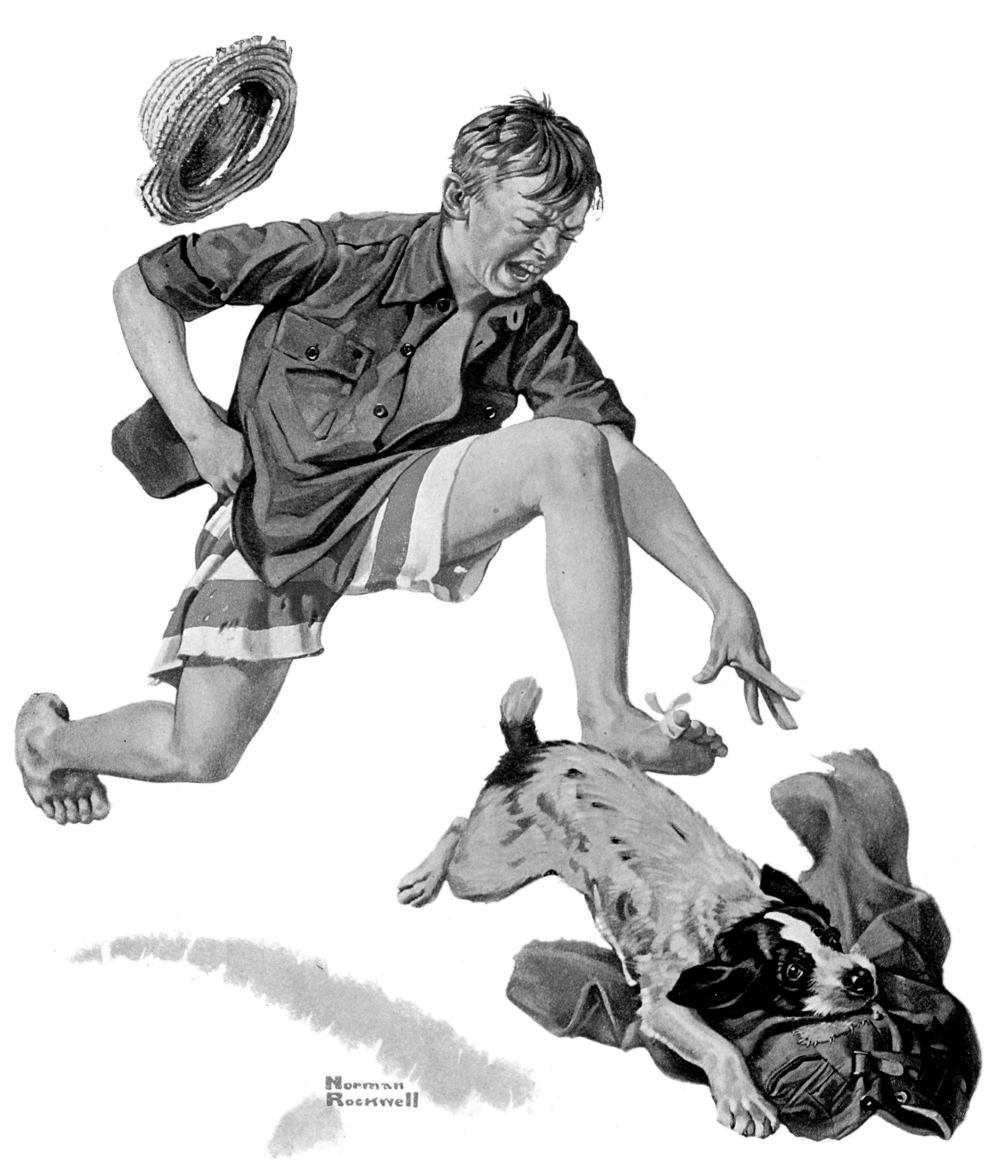

STOLEN CLOTHES

Post Cover • August 9, 1919

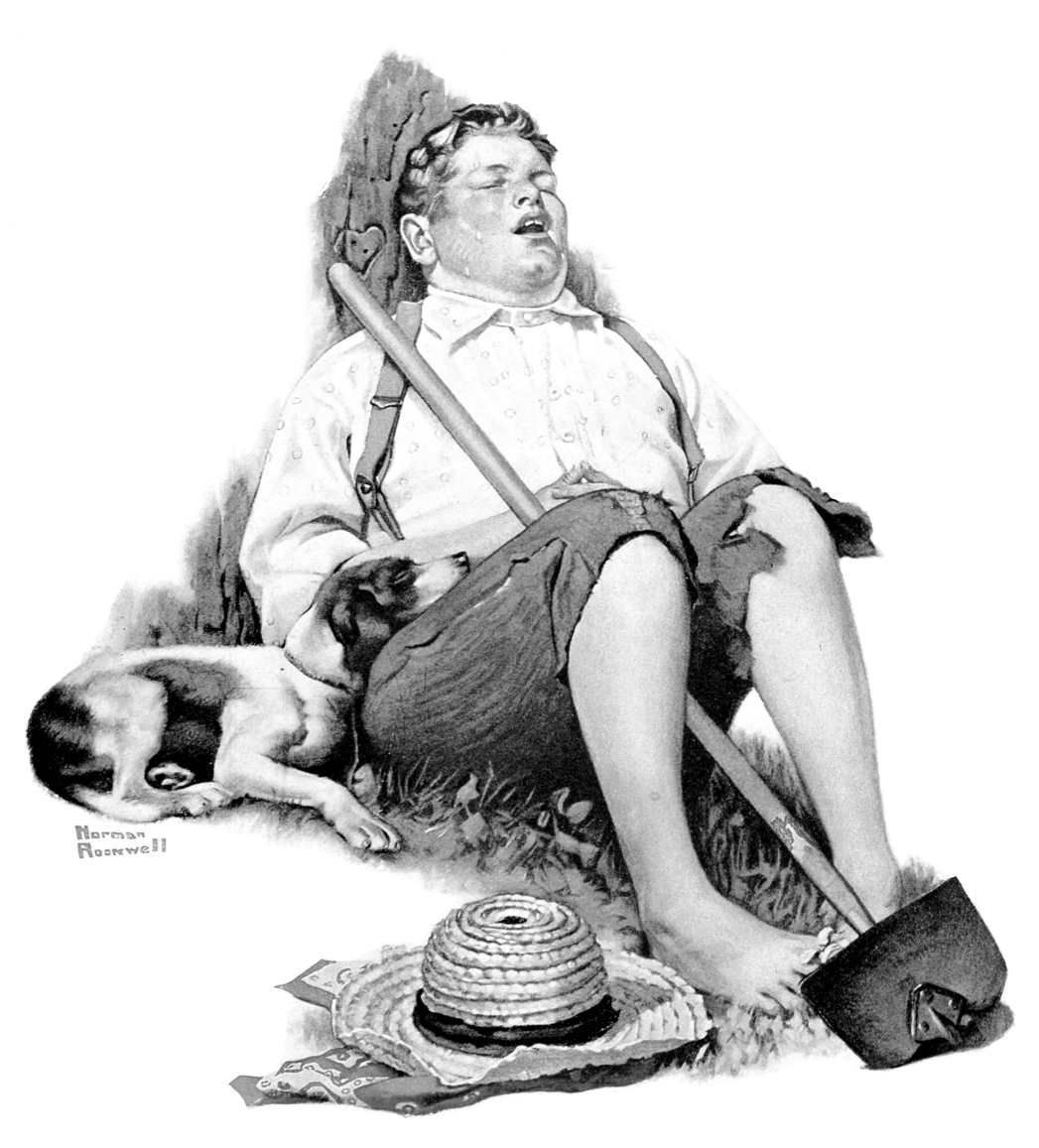

ASLEEP ON THE JOB

Post Cover • *September 6, 1919*

90

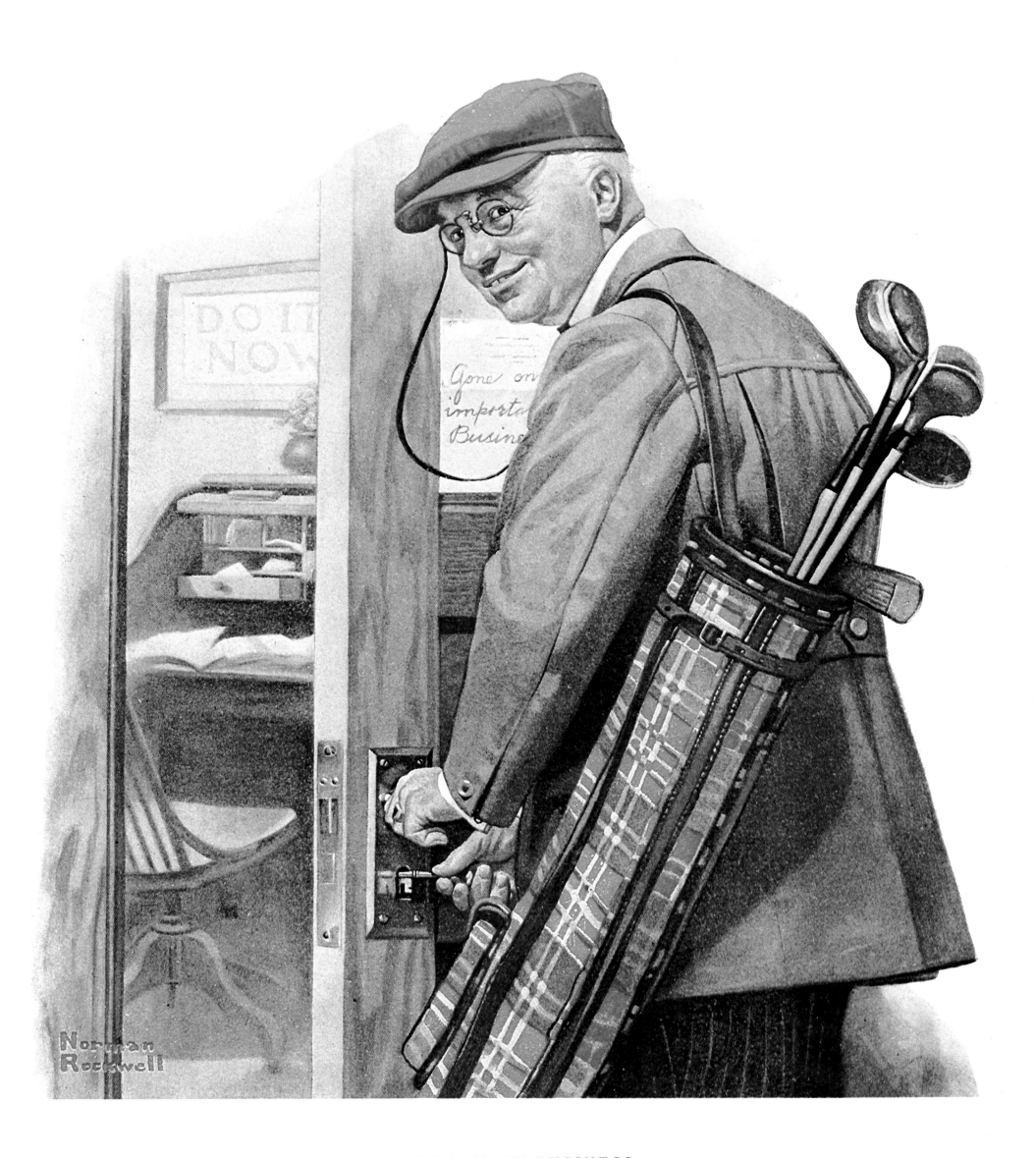

IMPORTANT BUSINESS

Post Cover • September 20, 1919

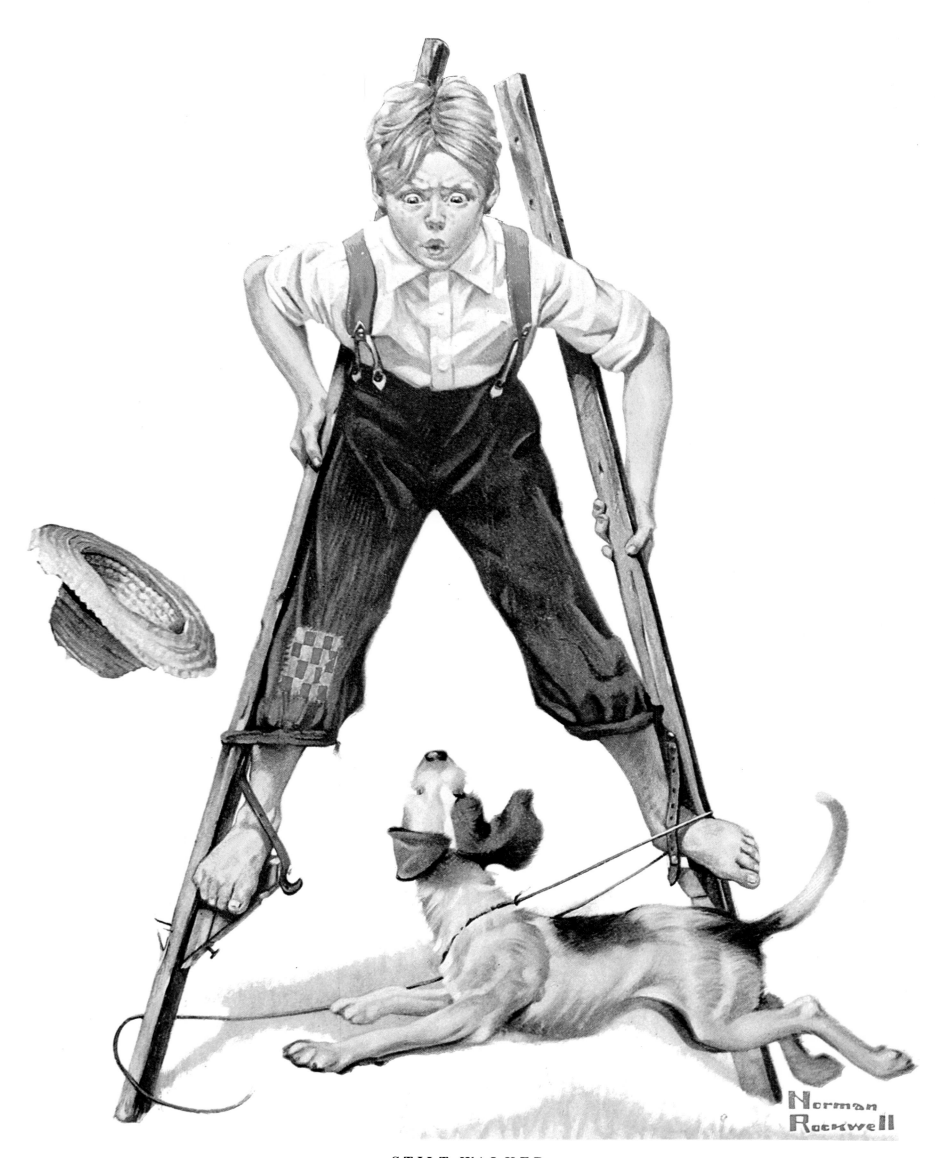

STILT WALKER
Post Cover • October 4, 1919

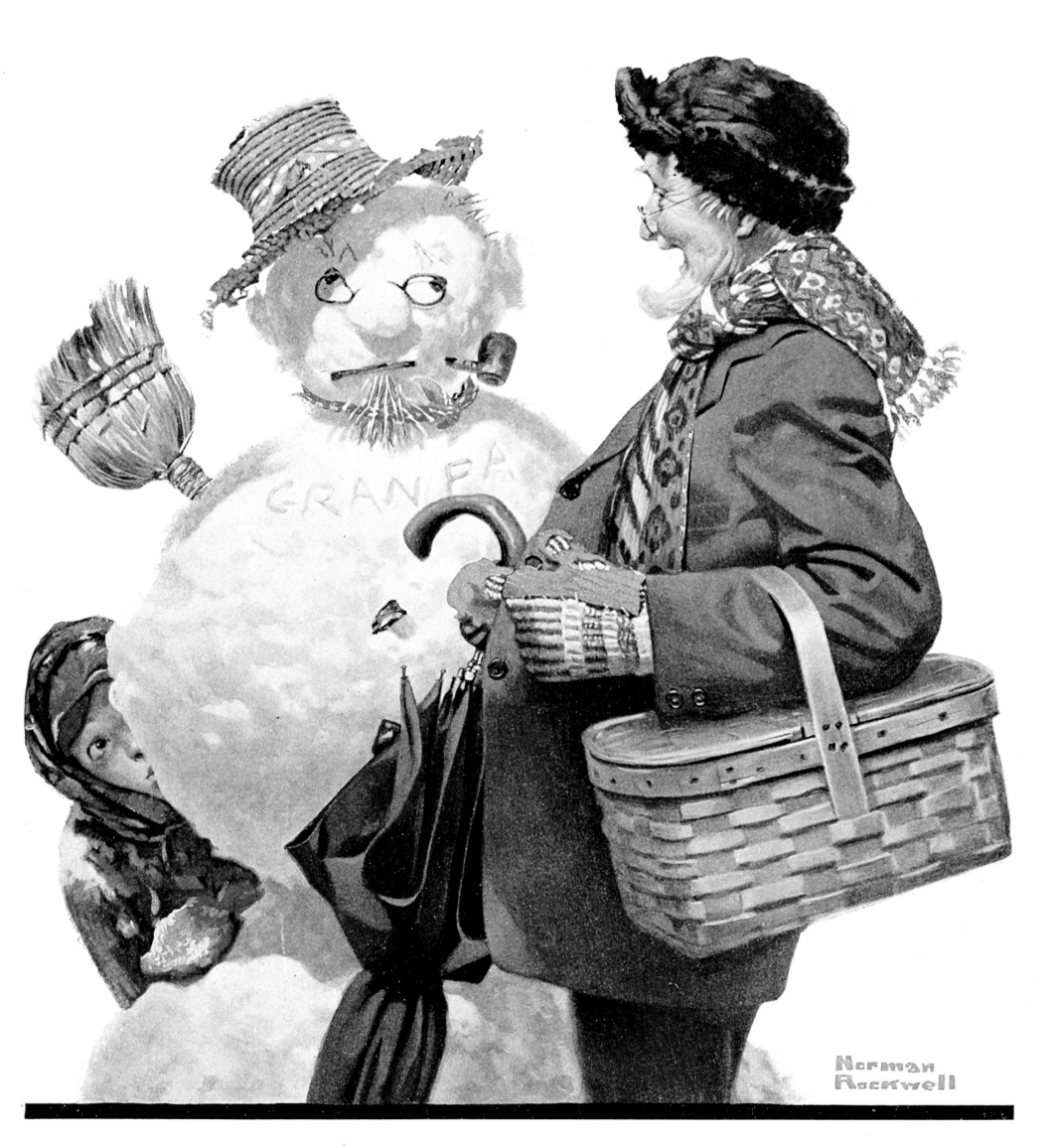

GRAMPS ENCOUNTERS GRAMPS!

Post Cover • December 20, 1919

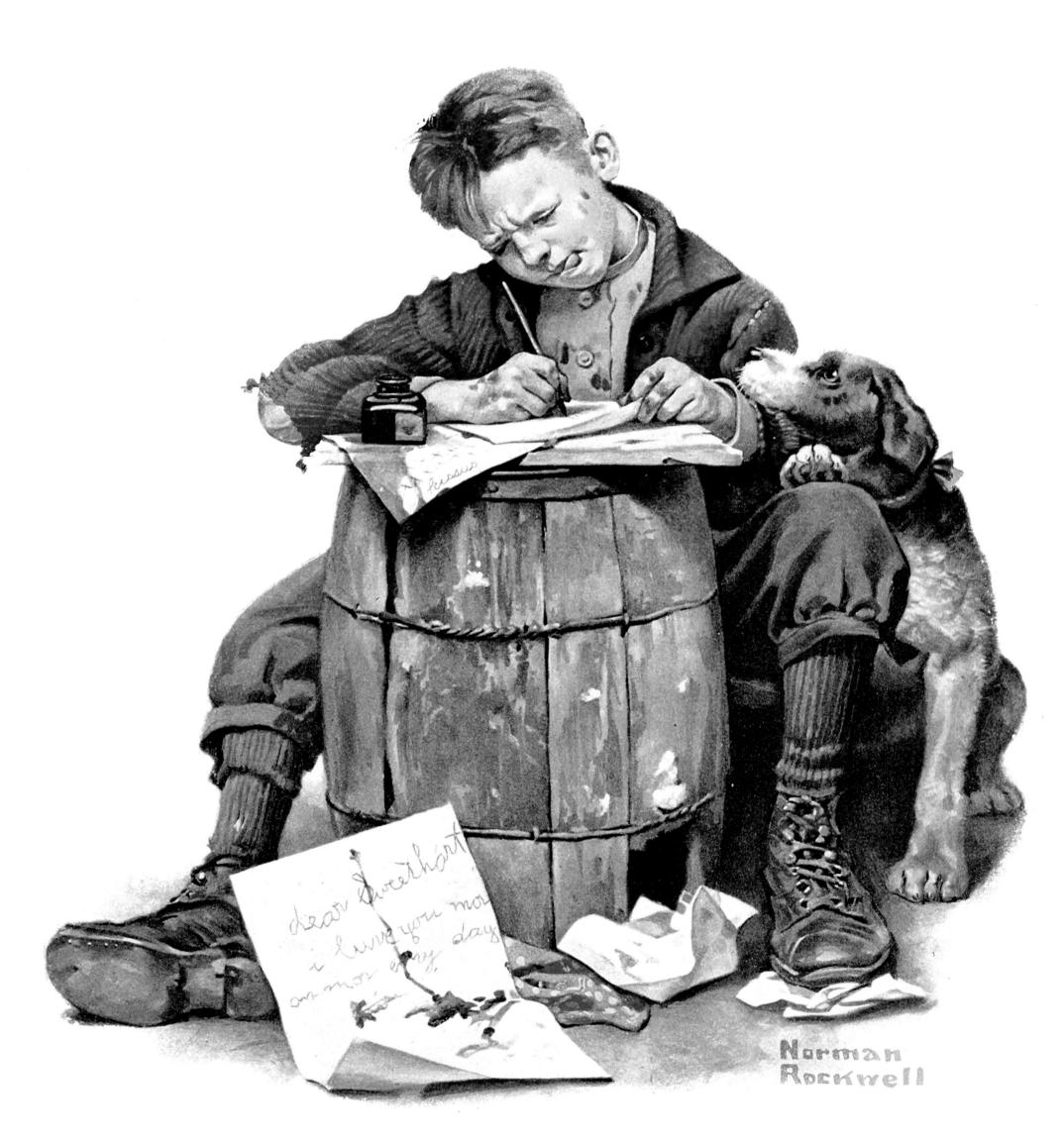

LOVE LETTERS

Post Cover • January 17, 1920

94

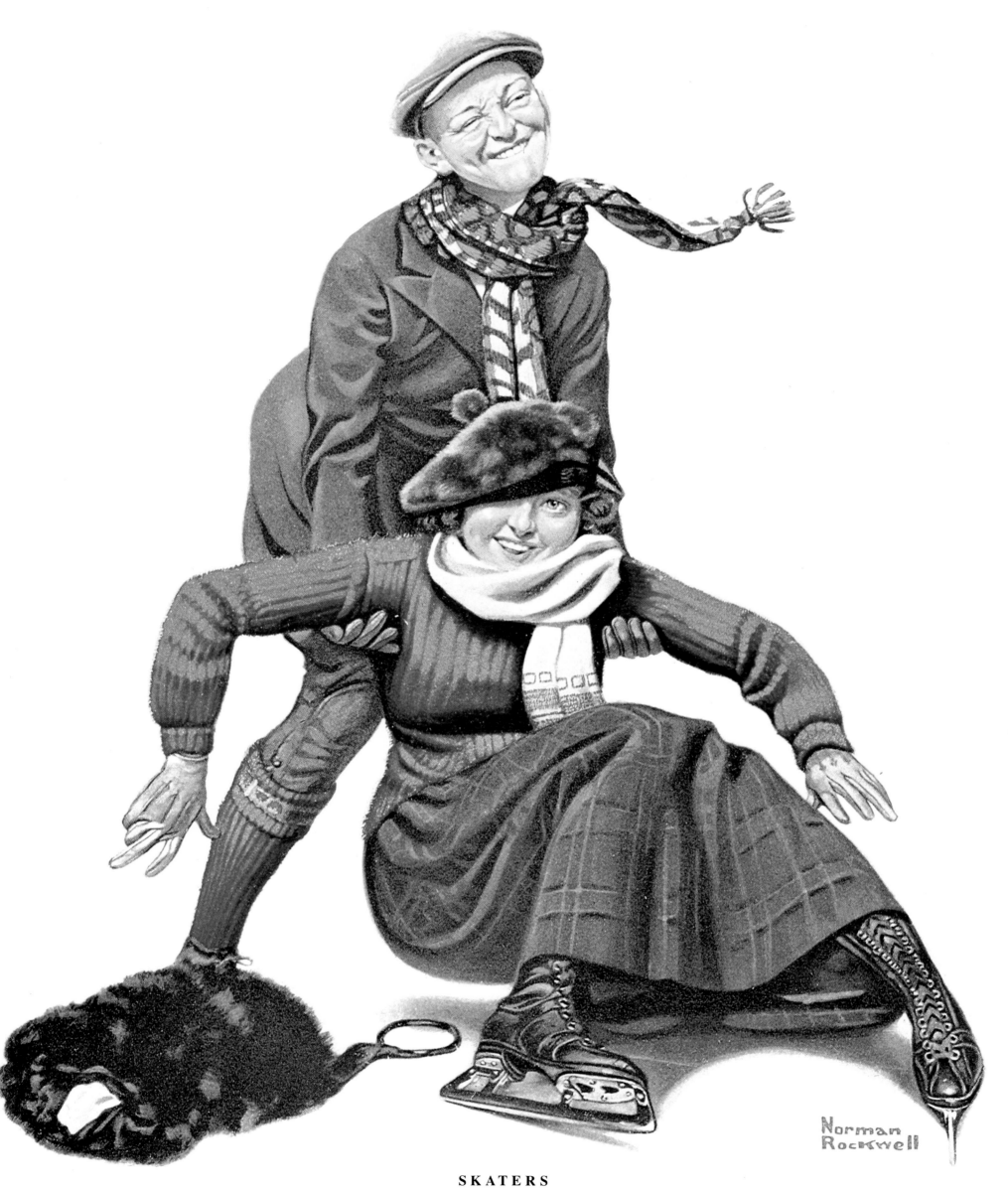

S K A T E R S
Post Cover • February 7, 1920
95

DEPARTING SERVANT

Post Cover • March 27, 1920

96

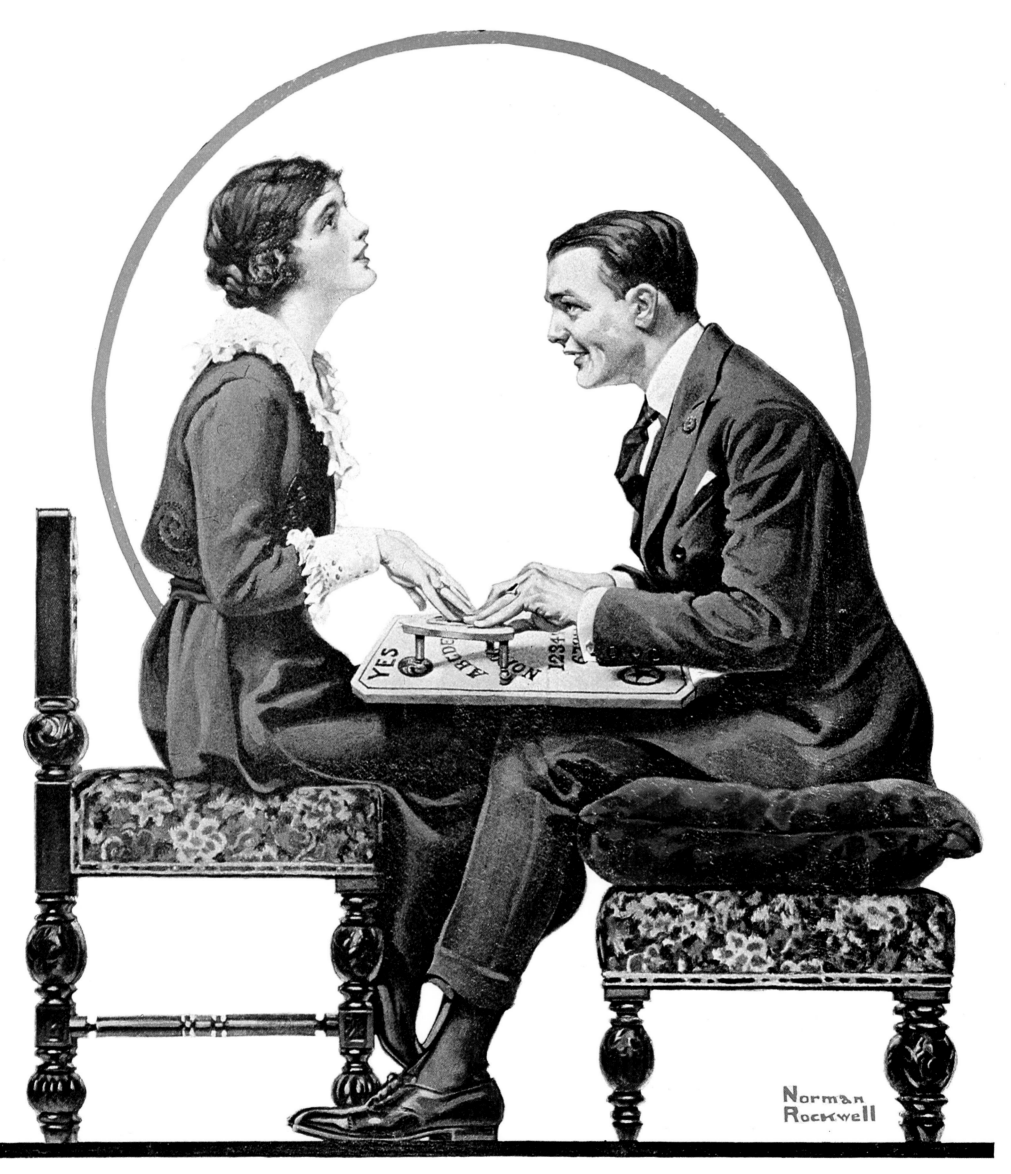

THE OUIJA BOARD

Post Cover • May 1, 1920

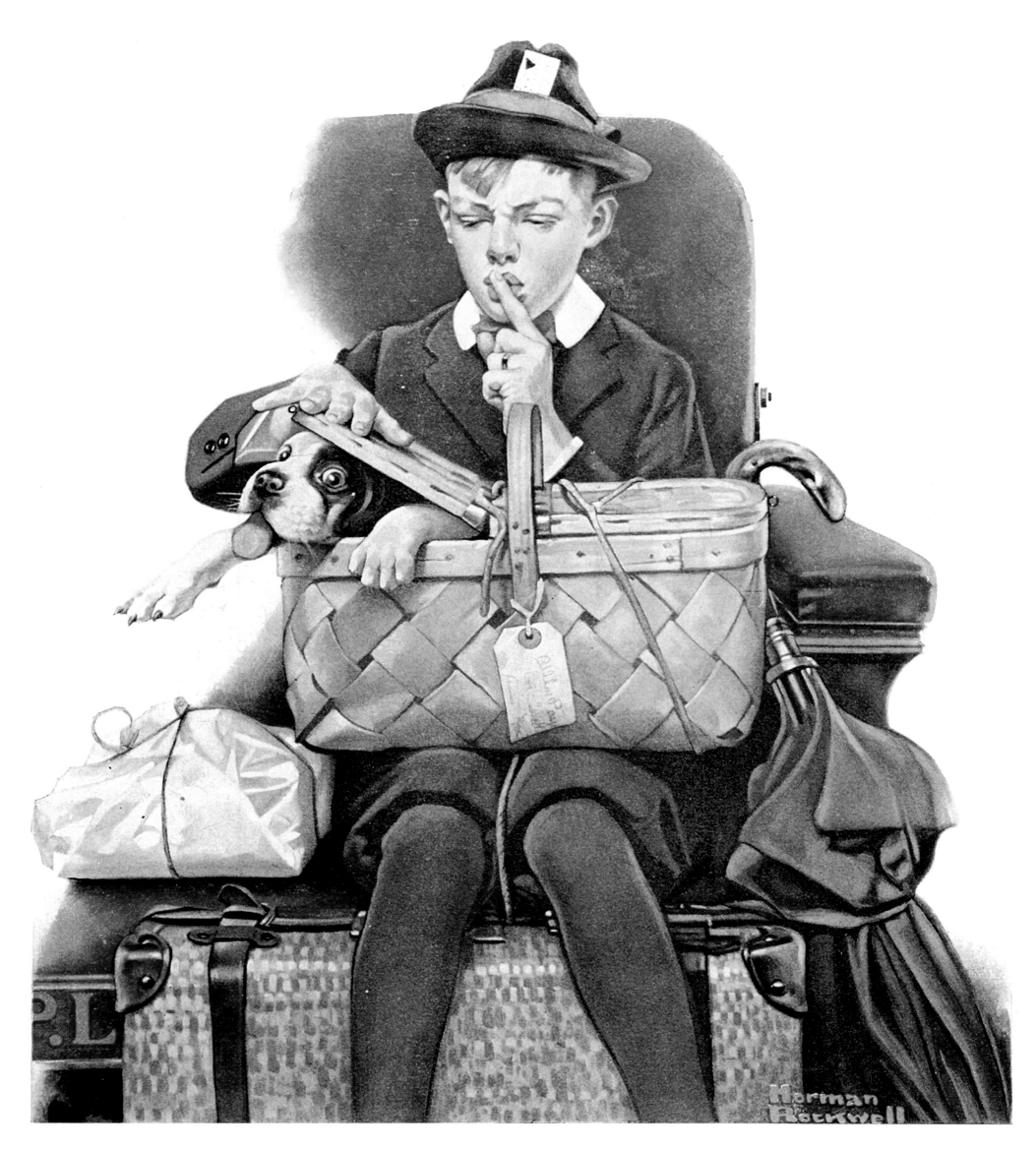

TRAVELLING COMPANIONS

Post Cover • May 15, 1920

A DOG'S DAY

Post Cover • June 19, 1920

THE OPEN ROAD

Post Cover • July 31, 1920

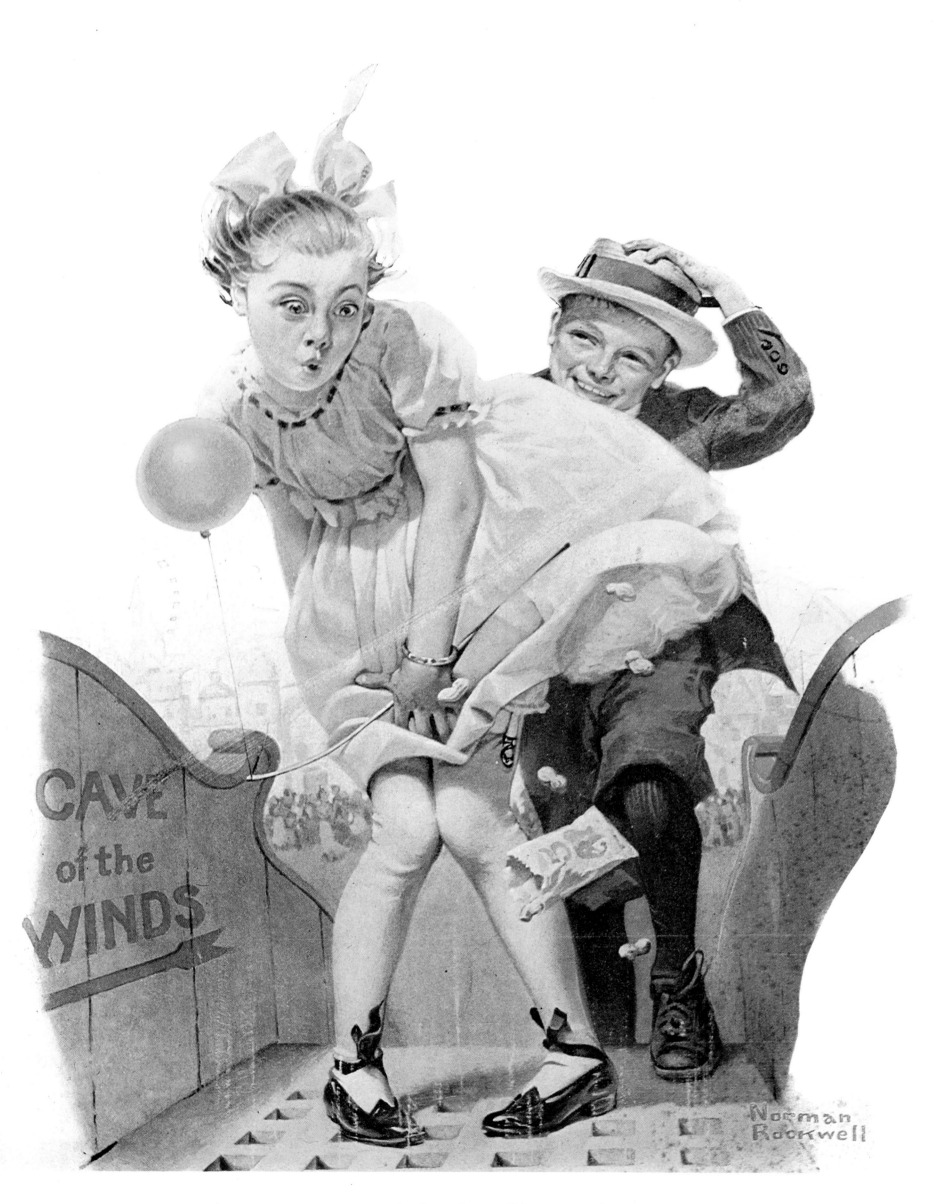

CAVE OF THE WINDS

Post Cover • August 28, 1920

101

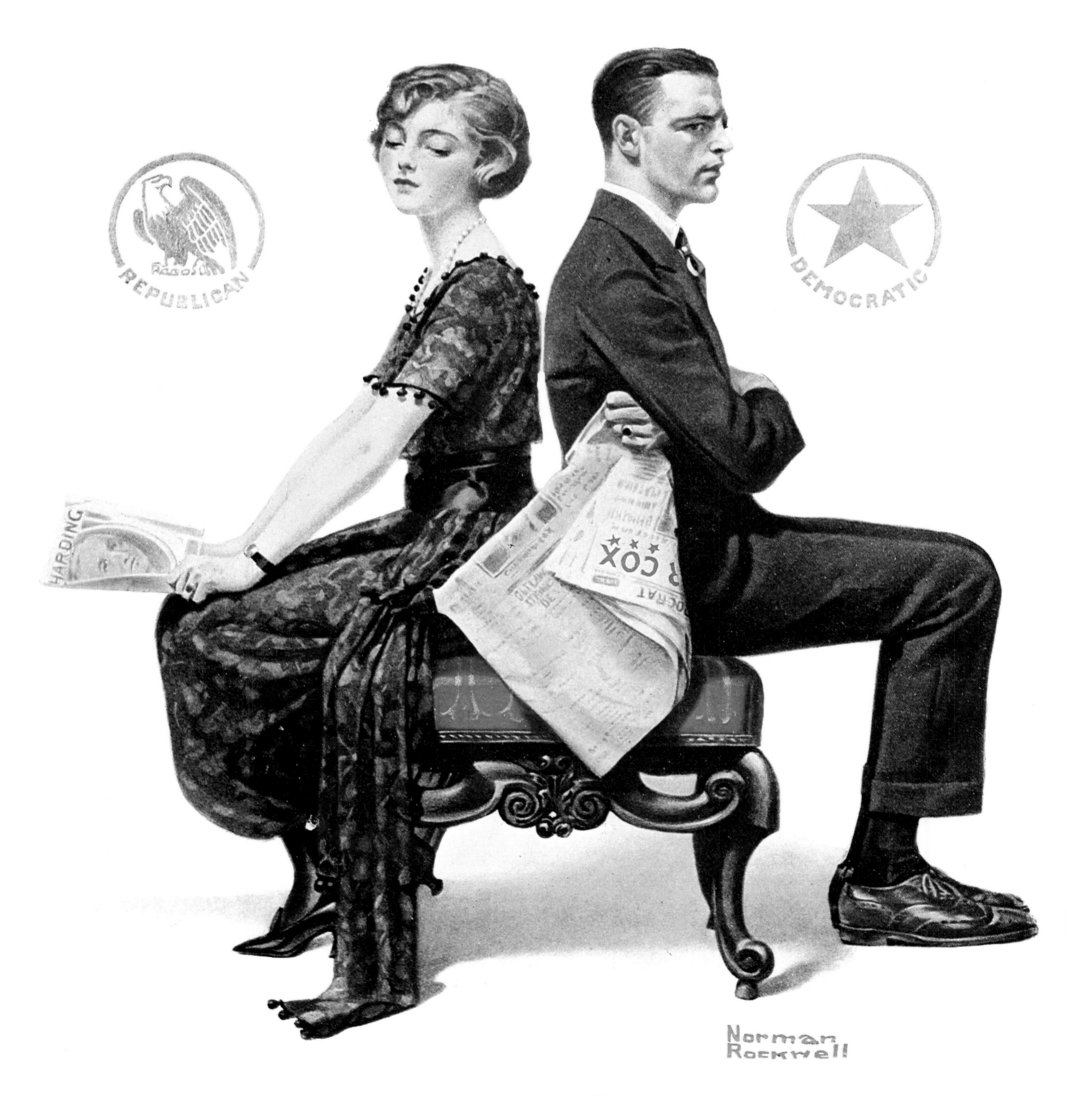

THE DEBATE

Post Cover • October 9, 1920

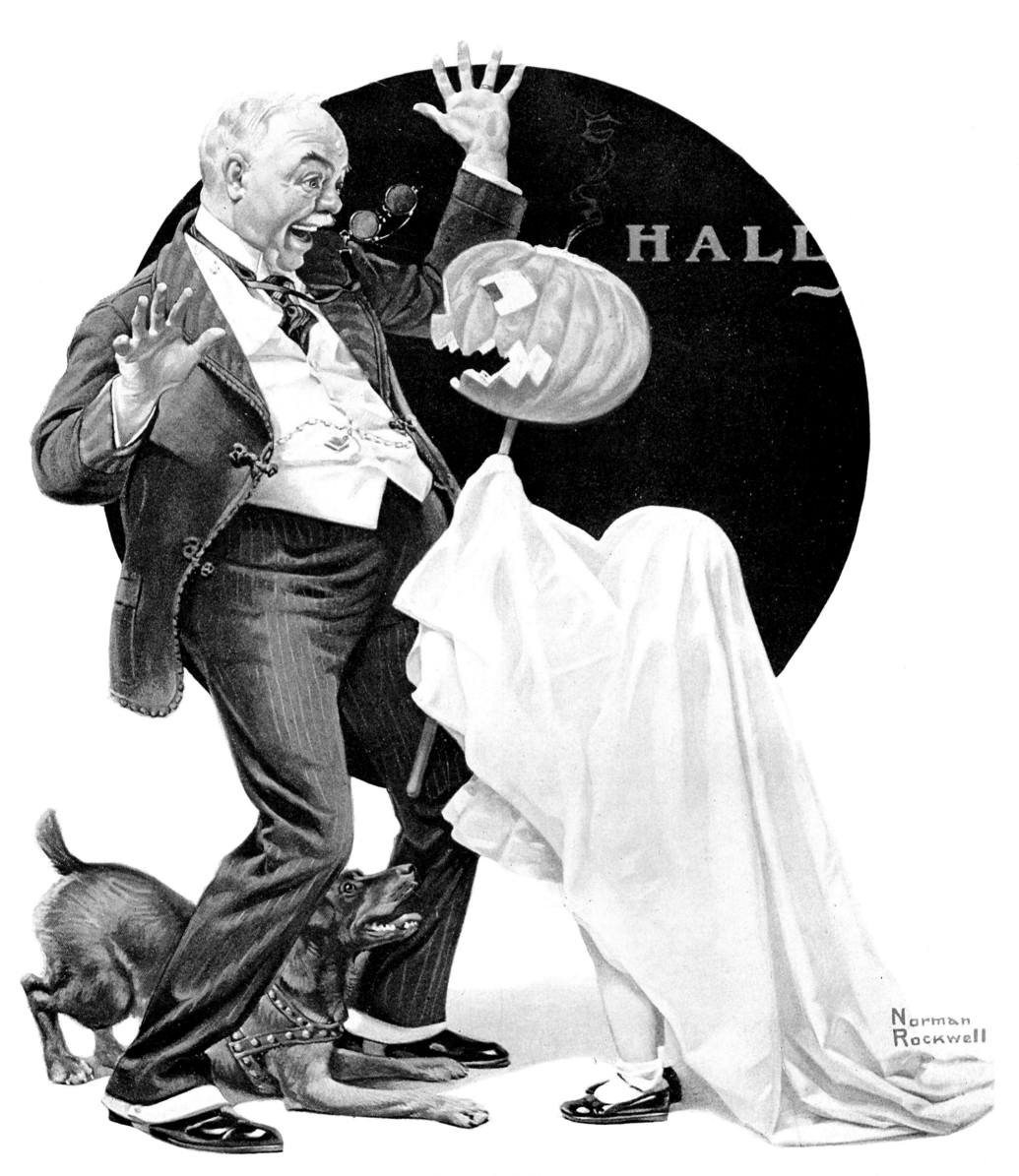

HALLOWE'EN

Post Cover • *October 23, 1920*

103

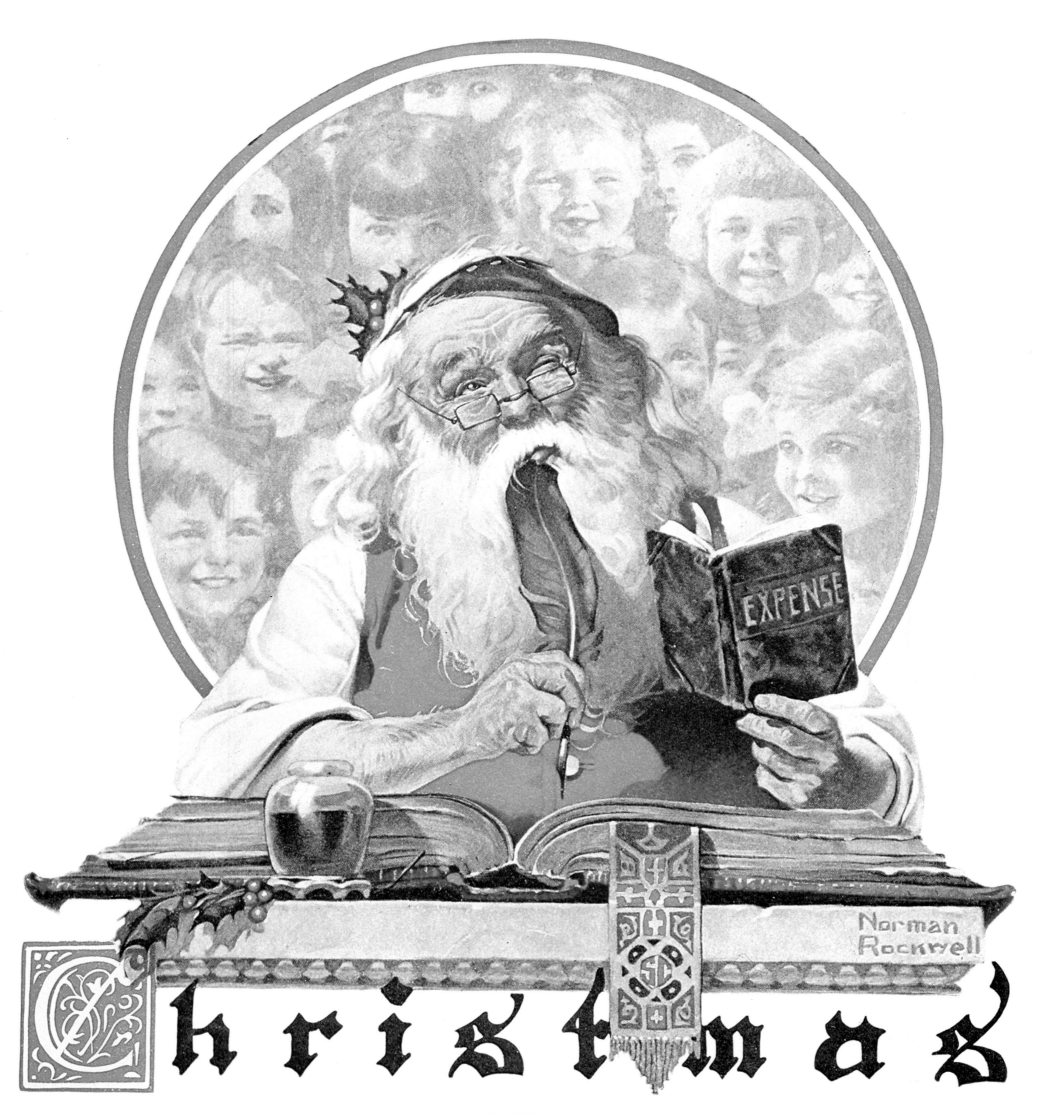

SANTA

Post Cover • December 4, 1920

ON THE HIGH SEAS

Post Cover • January 29, 1921

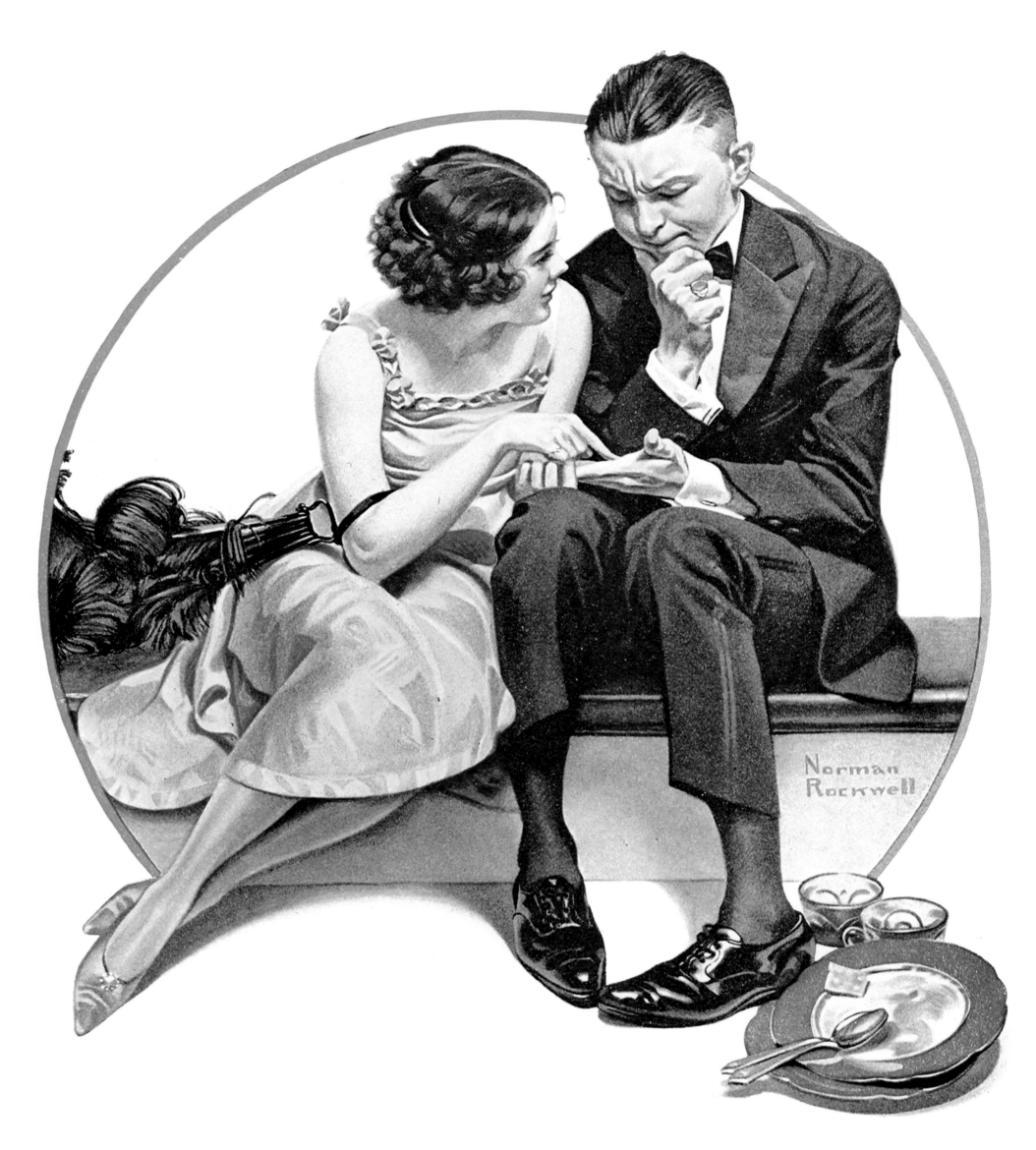

A NIGHT ON THE TOWN

Post Cover • March 12, 1921

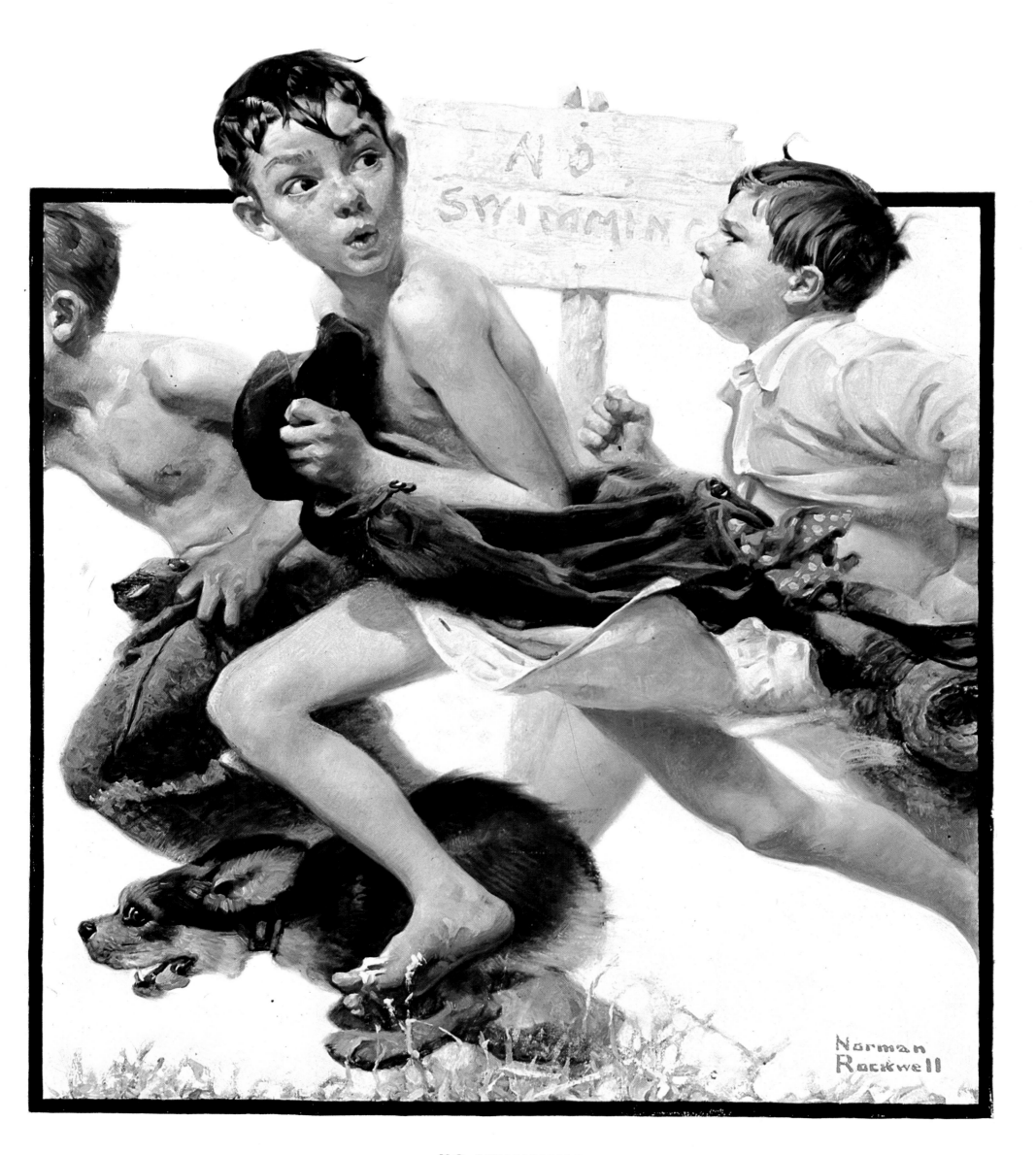

NO SWIMMING

Post Cover • *June 4, 1921*

WATCH THE BIRDIE

Post Cover • July 9, 1921

108

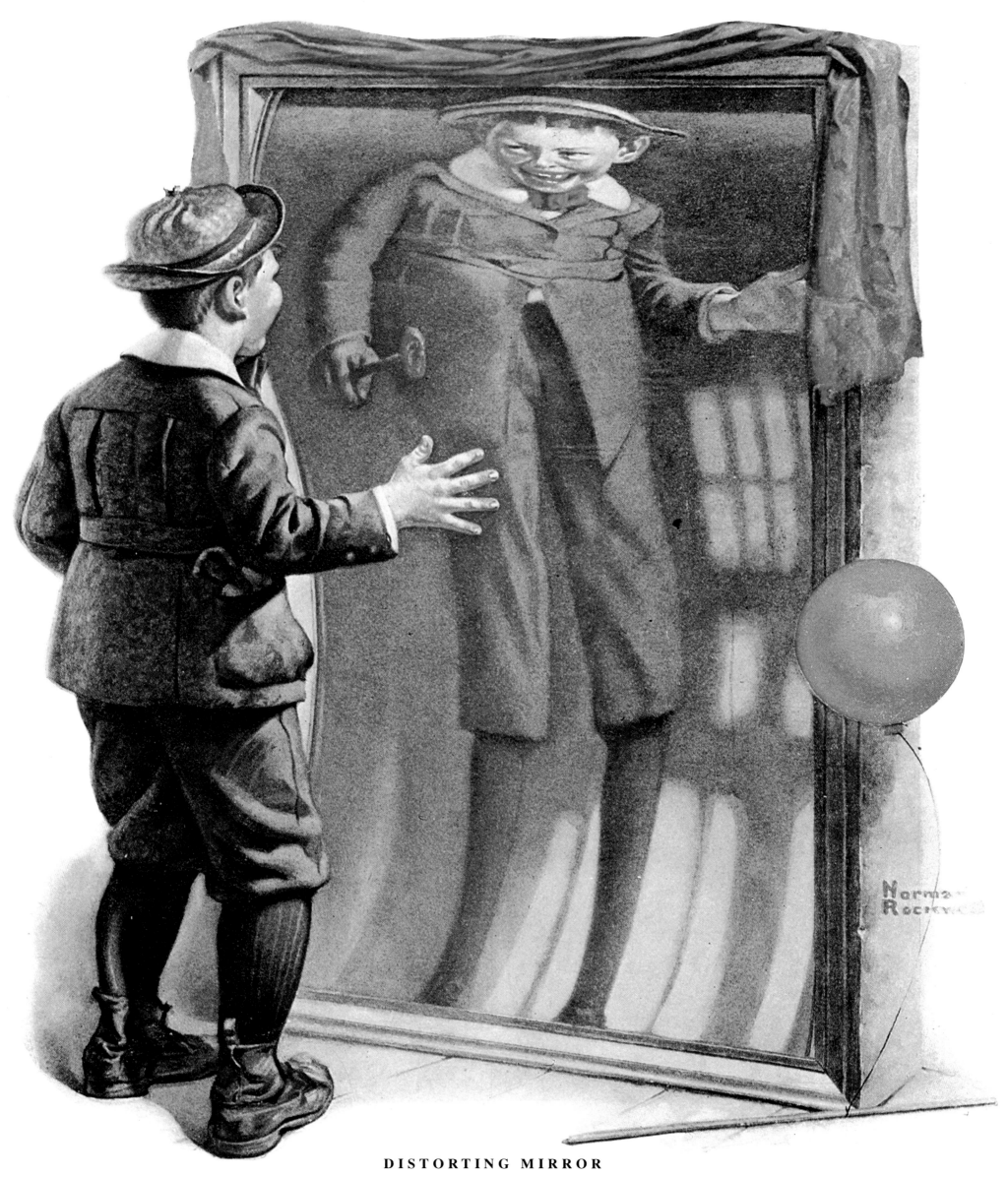

DISTORTING MIRROR

Post Cover • August 13, 1921

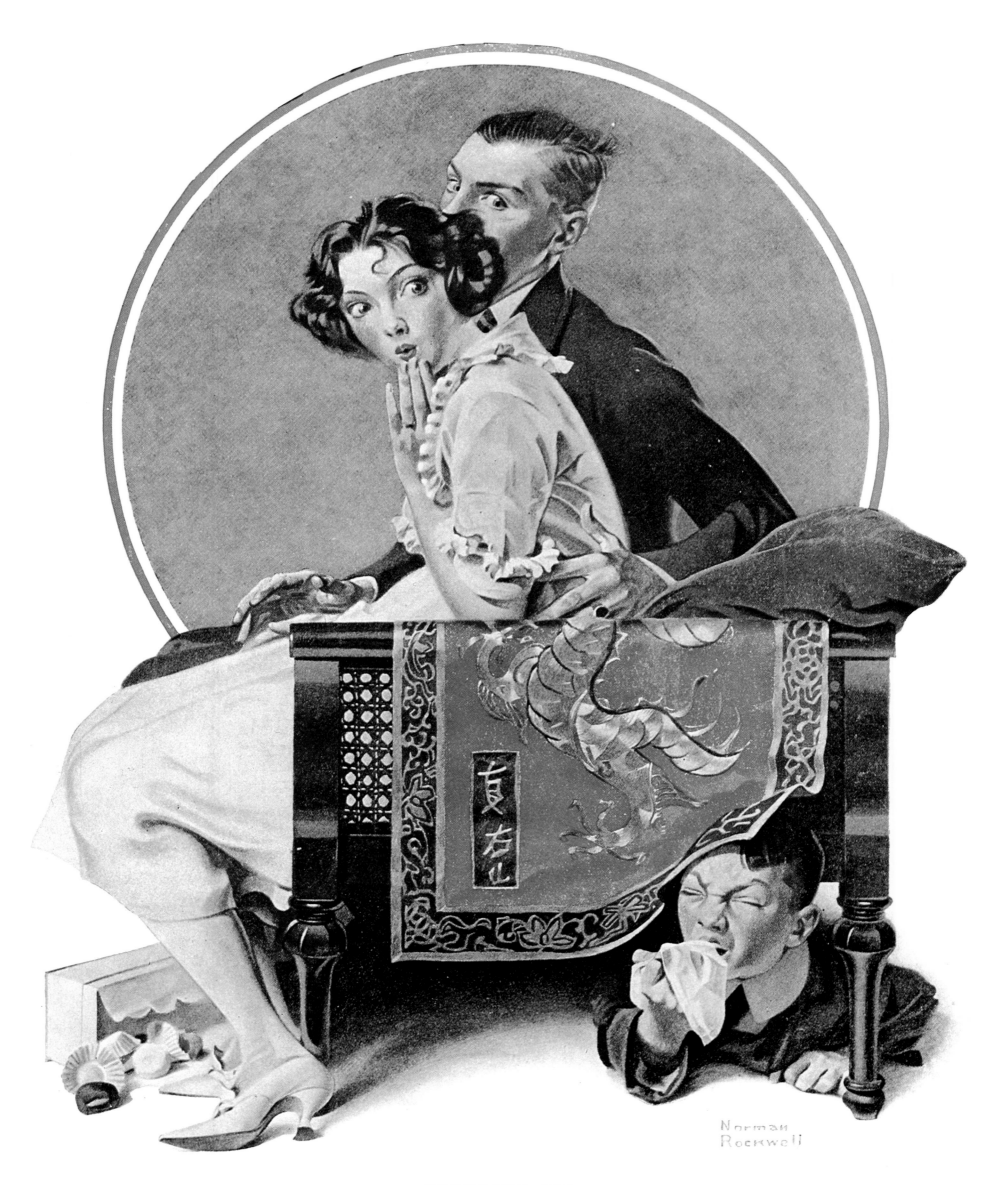

SNEEZING SPY

Post Cover • October 1, 1921

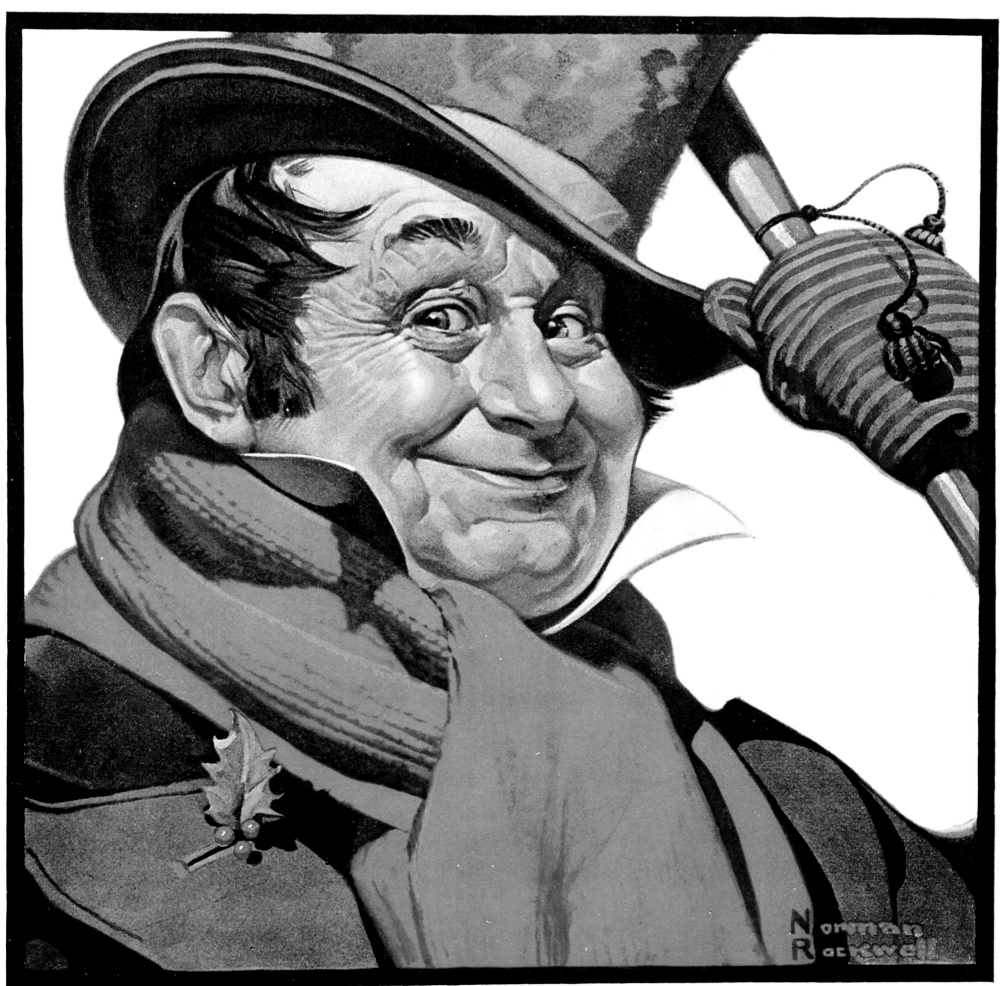

"Merrie Christmas!"

MERRIE CHRISTMAS

Post Cover • Dec. 3, 1921

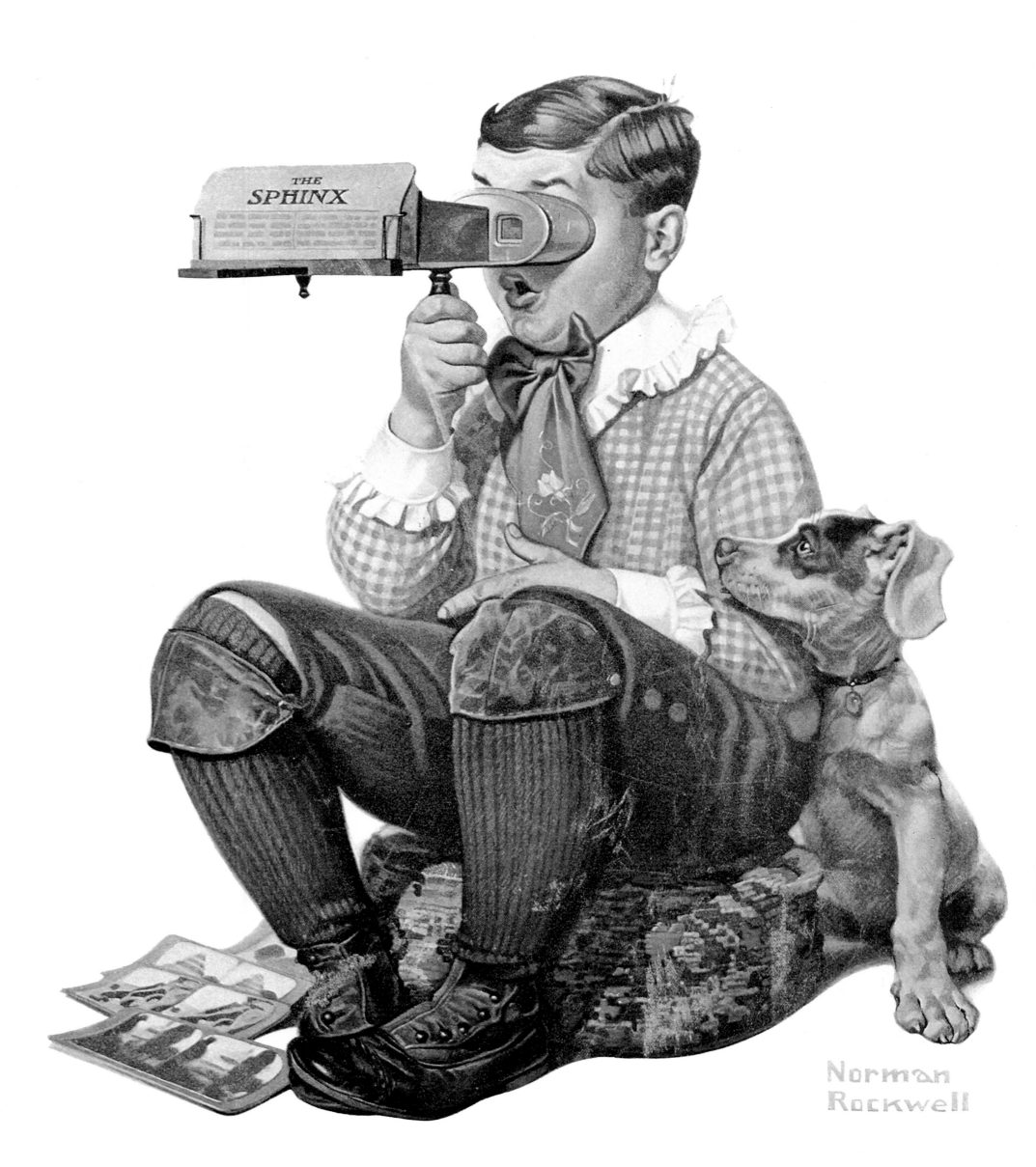

THE SPHINX

Post Cover • January 14, 1922

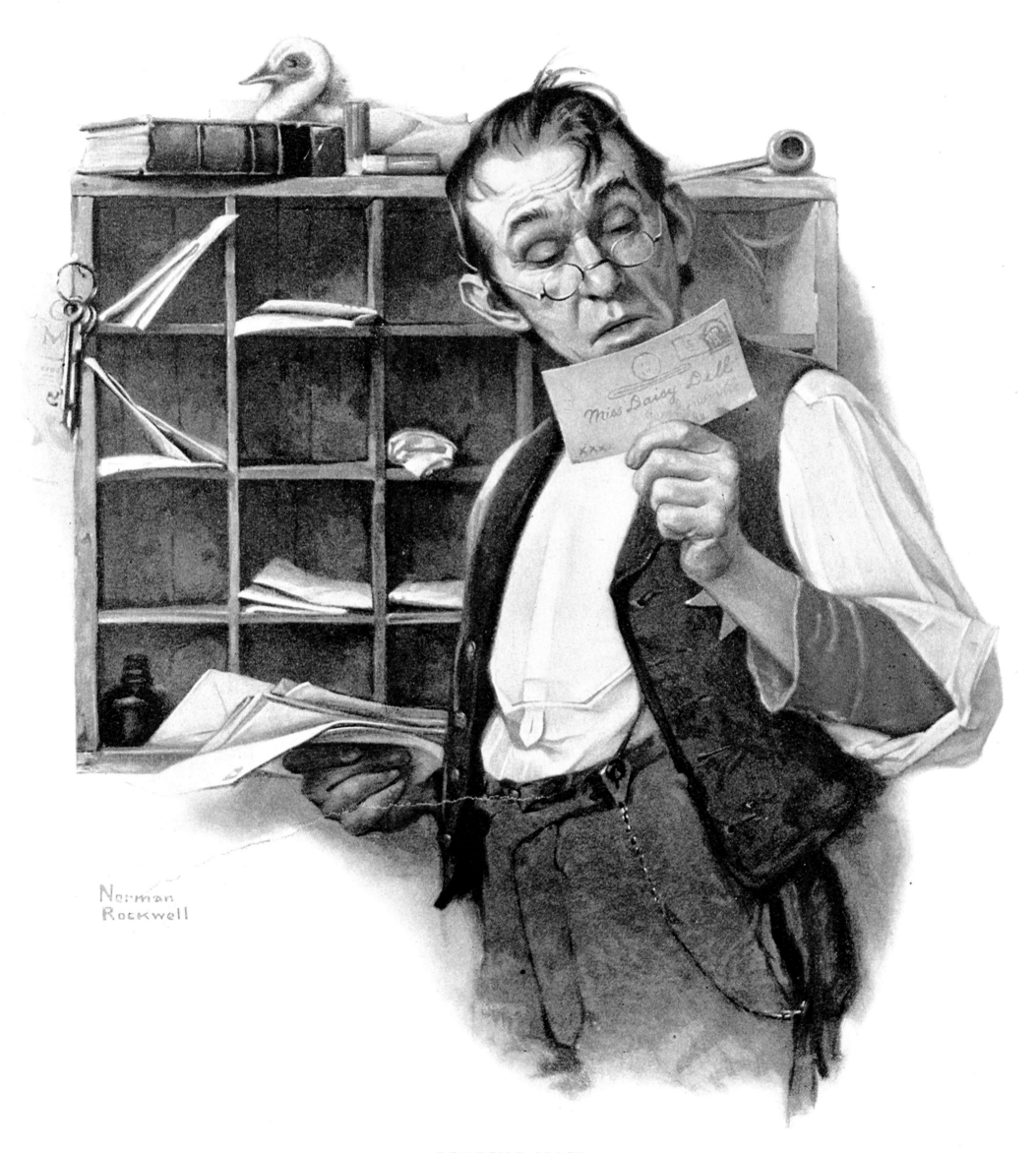

SORTING MAIL

Post Cover • February 18, 1922

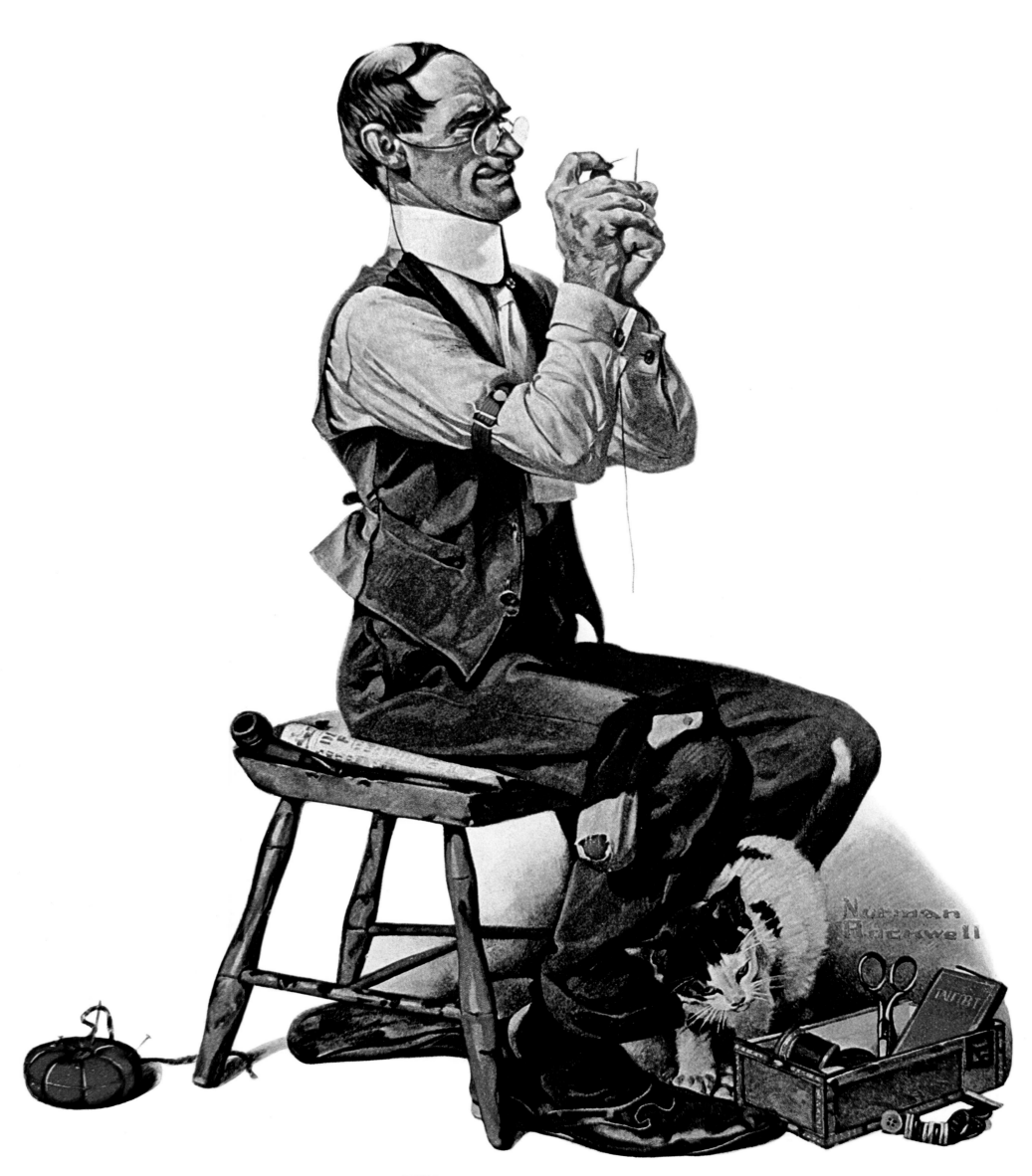

THREADING A NEEDLE
Post Cover • April 8, 1922

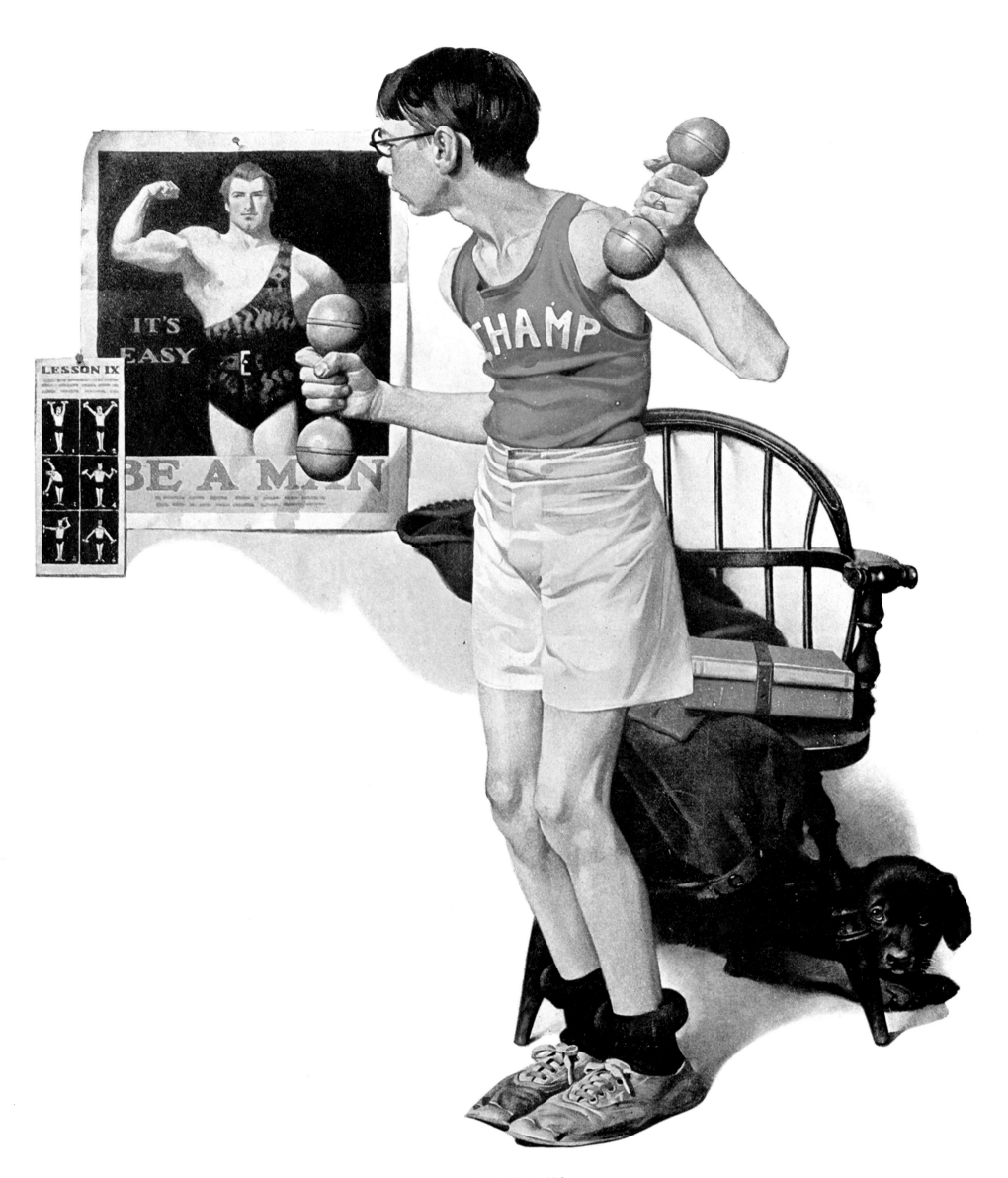

BE A MAN!

Post Cover • April 29, 1922

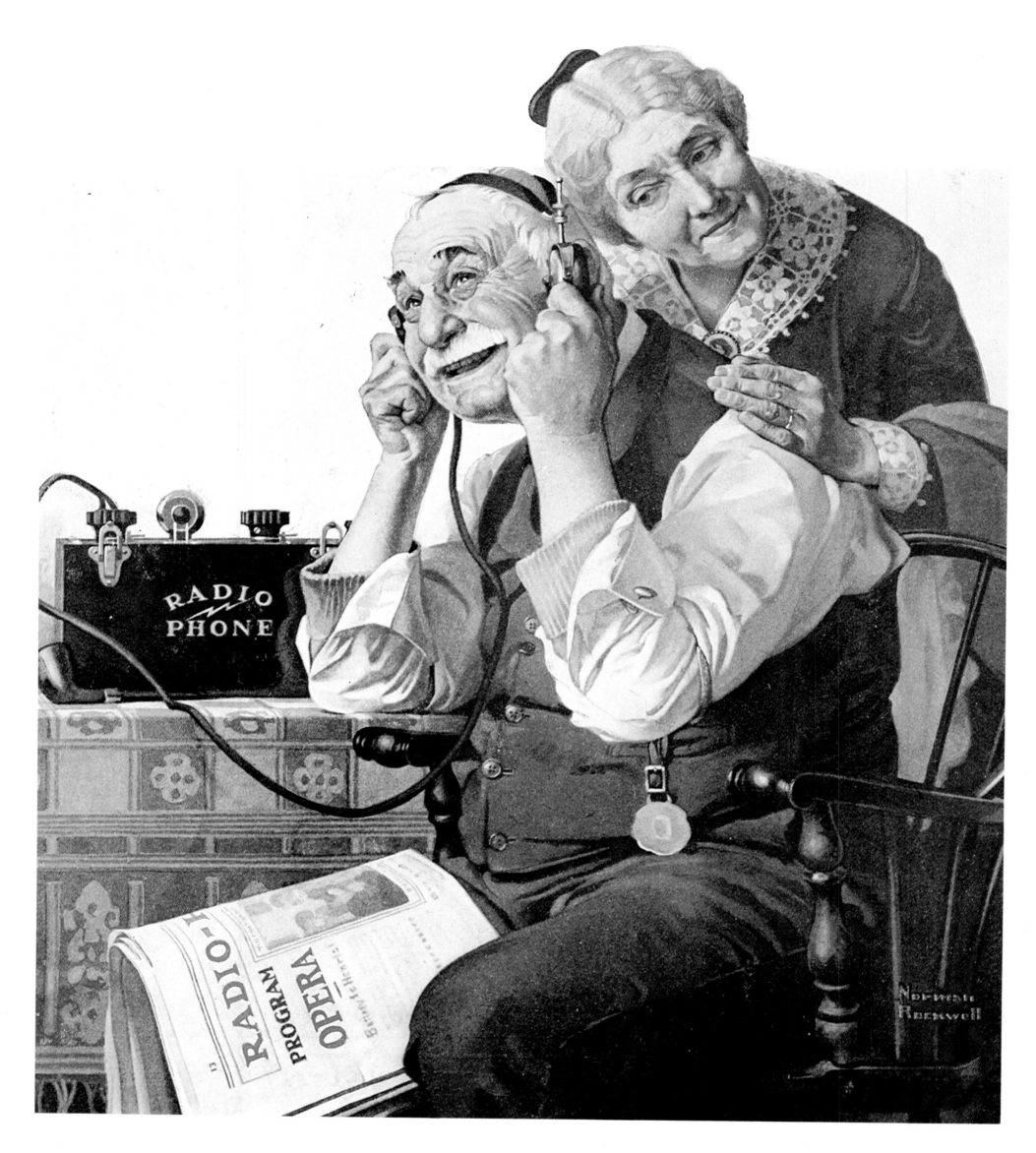

THE WONDERS OF RADIO
Post Cover • May 20, 1922

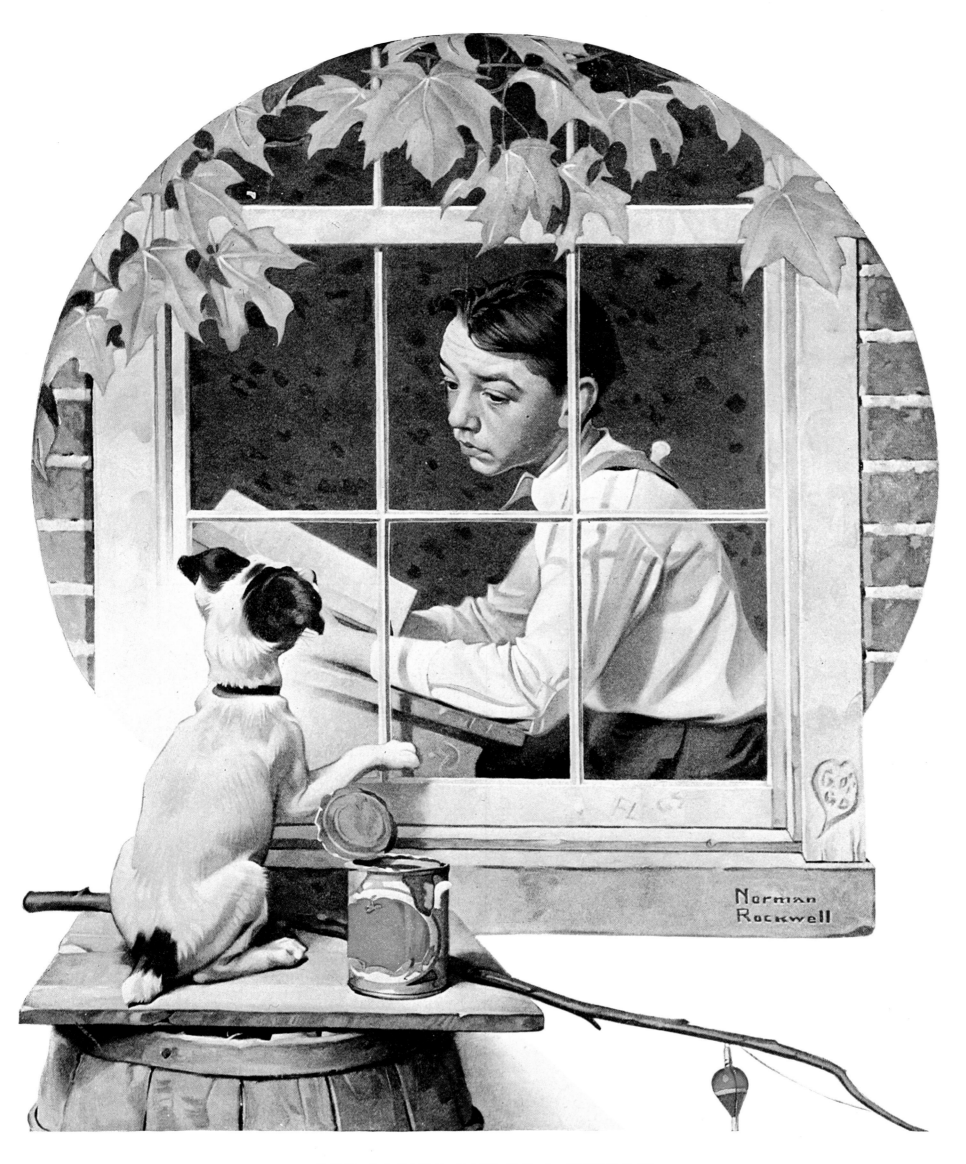

BOY GAZING OUT OF A WINDOW
Post Cover • June 10, 1922

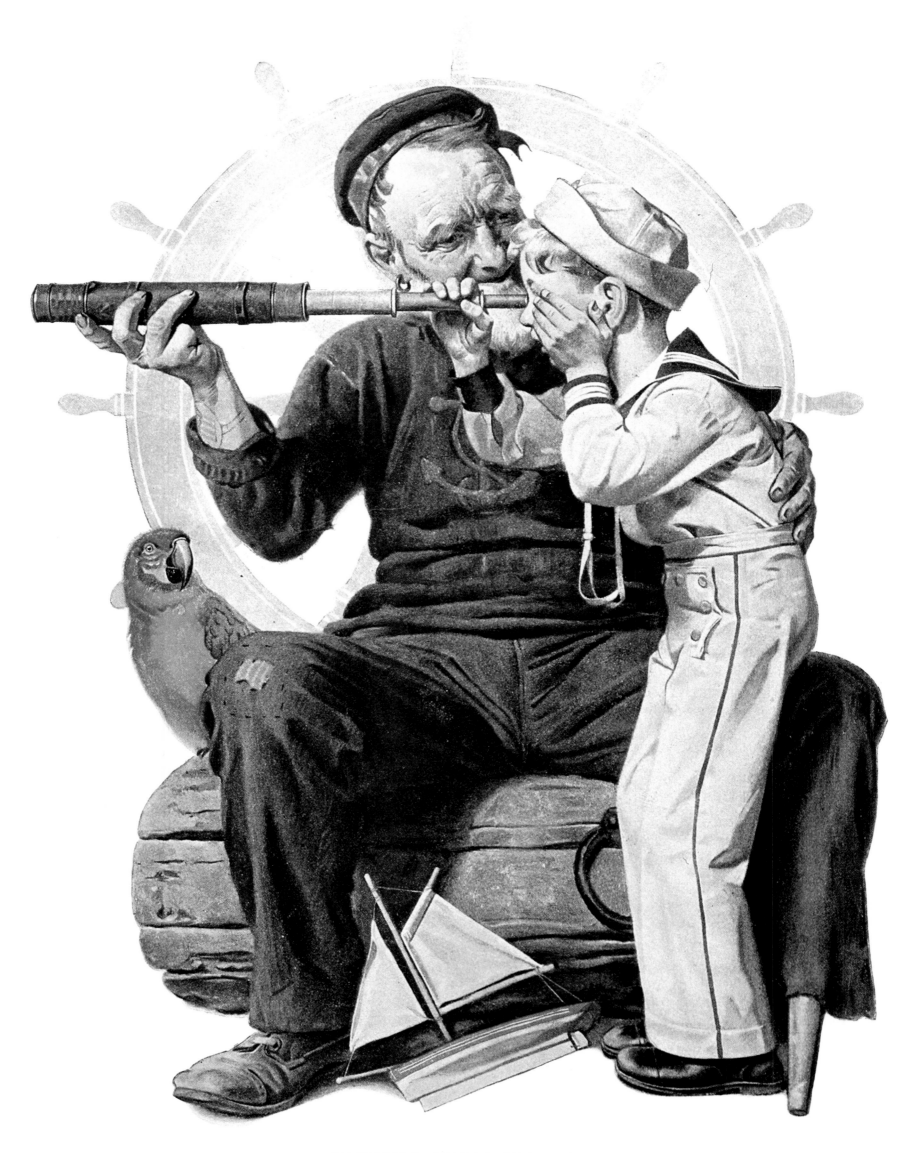

SETTING ONE'S SIGHTS
Post Cover • August 19, 1922

118

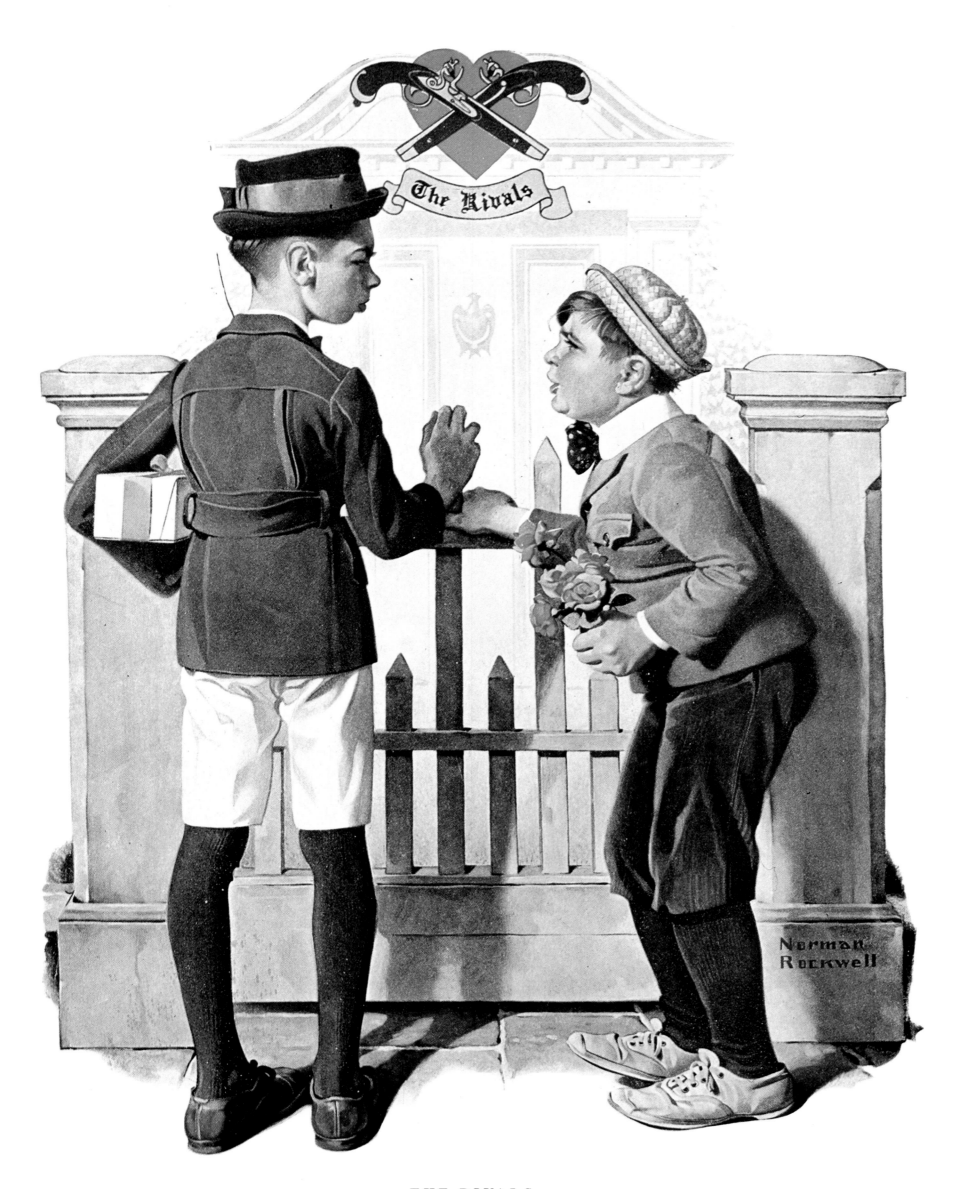

THE RIVALS

Post Cover • September 9, 1922

Things Were Changing Too Fast and Rockwell Gave People Nostalgic Glimpses of the World They Had Left Behind

THE YEARS FROM 1922 to 1925 can be looked on as a period of consolidation for Norman Rockwell, while in the nation at large there was a frenetic search for novelty. Despite a huge, and still mounting, national debt—a consequence of World War I—the United States seemed to be riding the crest of an unprecedented wave of prosperity. True, there was a good deal of labor unrest—bitter strikes in the anthracite mining region of Pennsylvania, for example—but this itself was, in large part, a product of the general prosperity. The labor unions wanted a fair share of the pie. The wealth of the nation had, after all, almost doubled in the decade between 1912 and 1922, and the stock market continued on its steady upward climb.

President Harding died suddenly in the summer of 1923, without having to face the consequences of the Teapot Dome scandal, and was succeeded by Calvin Coolidge, legendarily dour and hardly equipped to become a symbol of dynamic leadership. This did not really matter, however, because the country seemed to be running itself. Those who shared in its wealth craved excitement and newness for its own sake, and they found these commodities in speakeasies, dance marathons, heavy petting, still shorter skirts, Pierce-Arrow Runabouts, and a hundred fads and fashions, from mah-jongg and crossword puzzles to Oxford bags and flagpole sitting. Hollywood scandals, the feats of aviators, the deadly doings of bootleggers, and the progress of sensational trials—such as the prosecution of Leopold and Loeb—these were the standard fare of the daily tabloids, which thrived in the twenties. The yellow press, as it was by then known, could turn what would formerly have been an event of limited local interest into a national affair. The entire country followed the efforts to rescue Floyd Collins, trapped in an underground passage near Mammoth Cave. The young man died, and his family's grief was paraded for the benefit of the great American public—an early example of the sensationalism that has become all too familiar. Genuine news events, such as the Ku Klux Klan's phenomenal show of strength on the streets of Washington D.C. in 1925, were frightening enough for the reader who found the time to read the more serious papers, or who could resist turning at once to the financial pages where the news was always good.

On the surface, then, it was an age of cloche hats and concealed hip flasks, of Mayor

Jimmy Walker and Pola Negri; but Rockwell continued to cater to the other America, to what today we would call the silent majority, the people who were relatively untouched by the cycle of novelties. If many Americans seemed determined to celebrate the bizarre for its own sake, Rockwell preferred to pay tribute to an older, and perhaps obsolescent, tradition of sanity and common sense. For the most part, his protagonists stood for the very values from which the flappers were trying to liberate themselves.

In short, Rockwell appears to have done nothing to modify his basic approach to the art of the magazine cover (though, as we shall see, he did have a moment of hesitation). As the years passed, of course, he did become more and more accomplished, especially with regard to his mastery of design and layout, but it is interesting to note that in the following group of *Post* covers there are only a couple that even so much as pay significant attention to the changing fashions of the era, whereas close to a dozen deliberately evoke the past.

It is possible to predicate from this—given Rockwell's intuitive sense of what his public wanted—that he was reflecting something that was widespread in the nation at that time, a groundswell of feeling against the surface ballyhoo of the twenties. Things were changing too fast for many people, and Rockwell gave them nostalgic glimpses of the world they had left behind.

It is interesting to note in this regard that during the course of a trip to Paris in 1923, Rockwell became strongly attracted to modern art (and to the end of his life he remained a fervent admirer of Picasso and other twentieth-century masters). As a consequence of this, he submitted several "modernistic" cover ideas to the editors of the *Post*, who seem to have recoiled in horror. Rockwell was persuaded to return to the kind of approach he understood so well. Since these "modernistic" works have not survived, we don't know if Rockwell had any real talent in that direction, though it's interesting to speculate on how his career might have developed if the *Post's* editors had encouraged his experiments. We can tell from the work he did for other clients that he was very flexible in his stylistic approach, and he may indeed have been quite successful with a more contemporary kind of idiom. It seems likely, though—and no paradox is intended—that he would have become less of an original since his uniqueness has always depended, to a large extent, on the anachronistic stance he has taken. It is often the people who are slightly out of step with their times, whether a little ahead or a little behind, who give us the insights that remain the most memorable.

SATURDAY EVENING POST COVERS
November 4, 1922–December 5, 1925

CINDERELLA
Post Cover • November 4, 1922
PAGE 129

A movie star is the Prince Charming of this fairy tale, and the girl with the broom strikes a pose that she might have borrowed from Mary Pickford at her most maudlin. Rockwell, especially on the strength of his earlier work, might well be nicknamed the Master of the Inturned Toes, but here the gesture seems pat and mechanical rather than expressive. It is difficult to escape the conclusion, in fact, that this modern Cinderella is something of a glass slipper's nightmare.

SANTA'S HELPERS
Post Cover • December 2, 1922
PAGE 130

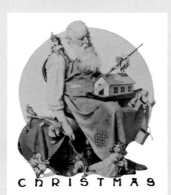

All artists experience doldrums and here Rockwell presents us with his fourth weak cover in a row. It's easy enough to accept the premise that Santa's preparations for the Christmas season leave him exhausted, but one fears for his safety when he shuts his eyes on helpers like these.

A MEETING OF MINDS
Post Cover • February 3, 1923
PAGE 131

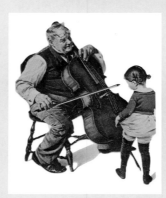

Again we have the theme of youth and age, and this time, plausibly enough, music is what provides a link between the two. This is hardly one of Rockwell's most original covers, but compared with the four that preceded it, it marks a definite return to form. The situation and characters are believable, and the composition is strong, if conventional.

BEDSIDE MANNER
Post Cover • March 10, 1923
PAGE 132

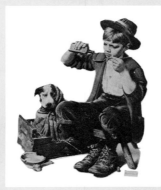

This painting of a boy caring for his sick dog is richly observed and convincingly executed. We are presented, once more, with a real boy (as opposed to a stereotype), one we feel it would be possible to know. His concern and concentration are fully apparent. This might be described as a "typical" Norman Rockwell cover, and a good one at that.

THE VIRTUOSO
Post Cover • April 28, 1923
PAGE 133

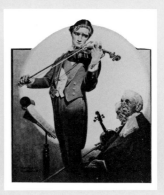

Here we have a rather less typical example of Rockwell's art, but an interesting work nonetheless. The old musicians listening to the young virtuoso evoke a whole world of dedication to art; and the fact that their dedication has probably never enabled them to even approach the natural brilliance of this soloist lends poignance to the theme.

CLOWN
Post Cover • May 26, 1923
PAGE 134

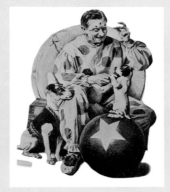

As this clown, without his comic hat and only partially made up, encourages the eager puppy to display its newly acquired prowess, we see the very human face beneath the mask of pantomime. In contrast with "Off-Duty Clown" (p 71), no juvenile observer is employed to drive the point home; and this is an altogether more mature and successful statement of the theme.

VACATIONS

Post Cover • June 23, 1923

PAGE 135

Sснооl is out and this singular fact provides one of Rockwell's barefoot urchins with the occasion for a celebratory cartwheel. This is not a particularly distinguished painting, but it undoubtedly made an effective cover since we are not accustomed to seeing small rustics grinning at us upside down from newsstands.

FARMER AND BIRDS

Post Cover • August 18, 1923

PAGE 136

Rockwell loved clear-cut contrasts, and here he sets off the obvious strength of the farmer—muscles bulging in his arms—against the fragility of the bird he holds so gently in his powerful hands. Here Rockwell is showing us, in a posterish way, the natural bond between a man tied to the land by decades of hard work and a creature whose role in life is to soar above the countryside where the farmer toils.

THE CRUISE

Post Cover • September 8, 1923

PAGE 137

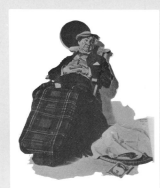

This elderly citizen is attempting to enjoy the fruits of his labors, taking his leisure in the form of an ocean cruise. Unfortunately, the motion of the ship seems to have had a disturbing effect on his stomach. Rockwell—who himself crossed the Atlantic by boat twice in 1923—makes an elegant, if somewhat pathetic, tableau of the subject. The recurrent circle device appears, this time reduced in size to form a porthole, which looks as if it has been cut into the page.

THE AGE OF ROMANCE

Post Cover • November 10, 1923

PAGE 138

Like Don Quixote, this boy has lost himself in the literature of chivalry. He imagines himself clad in armor, astride a proud charger, a newly rescued princess clinging to him as he heads back to the keep after a day well spent slaughtering dragons and bringing discomfort to the king's enemies. The boy appears to be a bookish type, but he dreams of becoming a man of action. Rockwell treats him sympathetically. The boy can hardly wait to turn the page to see what happens next.

CHRISTMAS CAROL

Post Cover • December 8, 1923

PAGE 139

For his 1923 Christmas cover, Rockwell again turned to Dickens for inspiration and came up with a strong, if traditional, painting. We might almost be looking at an illustration for one of Dickens's Christmas books.

THE SAMPLER

Post Cover • March 1, 1924

PAGE 140

Dipping into the nineteenth century for the second cover in a row, Rockwell gives us a demure young thing at work with needle and thread. As a secondary image, he shows us the sampler itself. We can easily imagine that he found this in his attic, or in some rural antique store, and that this discovery led him to conjure up the girl busy at her frame.

Rockwell's love of costume is evident in the care that he has lavished on every flounce and frill of the voluminous skirt, and we may be sure that it is historically accurate.

CUPID'S MESSAGE
Post Cover • *April 5, 1924*
PAGE 141

S PRING is here once more and this young man's fancy turns to things other than the opening of the baseball season. We are not shown the object of his daydreams, but we are left in no doubt as to his feelings towards her. The knotted hands and the hat tossed blithely on the grass tell us that he is smitten in a way that leads us to recall H. L. Mencken's observation, "To be in love is merely to be in a state of perpetual anesthesia." (Rockwell was an accomplished interpreter of "body language" decades before the term was invented.) Cupid, it seems, is preaching to the converted.

THE MODEL
Post Cover • *May 3, 1924*
PAGE 142

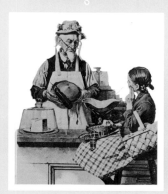

O NE feels for the proprietor of this old-fashioned general store as he models Easter bonnets for a young customer. His morose countenance tells us that, while he has learned to live with the sometimes quirky demands of his patrons, he has not managed to persuade himself that this is entirely in keeping with his notion of dignity. At the same time, one suspects that he has a mild theatrical streak. One can imagine his droll way with a piece of gossip, and surely he

would be devastated if he were not enlisted to play Uncle Sam in the Fourth of July parade.

ADVENTURE
Post Cover • *June 7, 1924*
PAGE 143

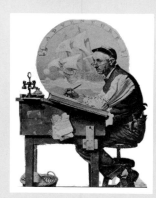

A melancholy interpretation of this painting is that Rockwell is giving us the young bookworm of "The Age of Romance" (p. 138), now grown to manhood and still dreaming of adventure— this time on the high seas—as he labors at his desk. Whether or not this is a correct reading, the clerk's lot is a pitiable one.

HOME
Post Cover • *June 14, 1924*
PAGE 144

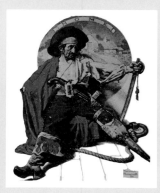

I N this companion piece to the previous cover, we are given a closer look at one figment of the clerk's imagination—a fierce-looking buccaneer, complete with timber leg and well-exercised cutlass— and shown that there are interludes, between those welcome sessions of pillage and bloodletting, when boredom and its constant companion, nostalgia, impinge on the pirate's imagination. As the brigands' boat makes its sluggish way back to Port-au-Prince, weighed down with stolen doubloons, the Jolly Roger barely fluttering in a slack breeze, scurvy

breaking out among the crew, even the most bloodthirsty sea dog may think wistfully on the little thatched cottage we all call home.

SPEED
Post Cover • *July 19, 1924*
PAGE 145

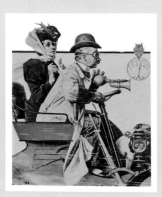

C ELEBRATING the pioneer days of the automobile, Rockwell captures that memorable moment when the brand new roadster—with its shiny coach lamps and external gear shift—is on the verge of attaining the staggering speed of fifteen miles an hour. It is interesting to note that, though Rockwell was still a young man when he painted this cover, he was recording a period that was very much within the span of his own memory.

THE ACCORDIONIST
Post Cover • *August 30, 1924*
PAGE 146

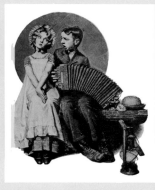

T HE expression on this young woman's face is a trifle ambiguous. Just how accomplished a musician is her admirer? And to what extent does she welcome his attentions? This image is not so much an episode in a story as it is a scene that we have happened upon by chance. We wish this charming couple well, but the outcome of the dalliance is far from certain.

HOMECOMING
Post Cover • September 27, 1924
PAGE 147

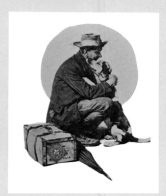

R ETURNING from a trip to the big city, one of Rockwell's rustic stalwarts —his clothing reveals his character and background—is greeted by his dog. The subject matter could hardly be more straightforward, and there is little to say except that the artist treats his protagonists with sympathy and dignity.

HOBO
Post Cover • October 18, 1924
PAGE 148

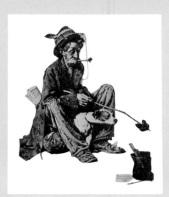

O N the evidence of this cover, Rockwell's view of the traveling man's lifestyle was somewhat romanticized. It was not exactly commonplace, for example, for a hobo to acquire a canine companion, since a dog was something of a liability when you were trying to vault aboard a moving "cannonball" as it rattled out of the freight yards.

One can forgive much, however, for the sake of the man's wonderful face, which in real life belonged to James K. Van Brunt, one of Rockwell's favorite models of the period. Like the professional models described by Henry James in "The Real Thing," Van Brunt could become anything he was asked to be—from hobo to millionaire—simply by changing costume and picking up a new set of props.

CEREMONIAL GARB
Post Cover • November 8, 1924
PAGE 149

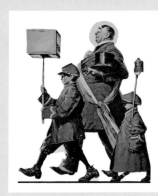

T HE contrast of the boys, in oversized costumes, and the well-fed dignitary with halo and a highly developed sense of importance, is all Rockwell needed to make his comic point.

CHRISTMAS
Post Cover • December 6, 1924
PAGE 150

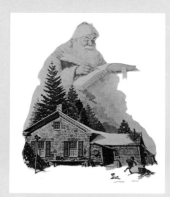

O UT of the snow-laden clouds, Christmas looms over a rural cottage. For the first time Rockwell gives us a panorama instead of one or two figures.

CROSSWORD PUZZLE
Post Cover • January 31, 1925
PAGE 151

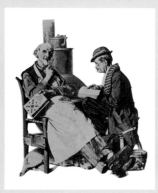

T HE crossword puzzle craze started in 1924 when Simon and Schuster pub-

lished a book of puzzles. They soon penetrated to the most isolated regions.

SELF-PORTRAIT
Post Cover • April 18, 1925
PAGE 152

A young photographer prepares to take his own portrait with an ancient box camera. Lacking a tripod, he has been obliged to improvise a stand, but this makeshift measure does not prevent him from taking the occasion very seriously. He has found an old top coat and silk hat in the attic. He has studied the family's ancestral portraits and knows what is expected of the self-respecting sitter. We wish him good fortune.

SPRING SONG
Post Cover • May 16, 1925
PAGE 153

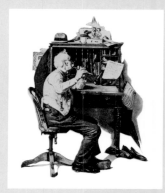

R OCKWELL returned again and again to the theme of music as one of the comforts of old age. Here he evokes an elderly music lover with all the tenderness he can muster. The play of light and shade is imaginatively used. The man's face, for example, is in soft shadow, which has the effect of granting him a degree of privacy.

BEGGING
Post Cover • June 27, 1925
PAGE 154

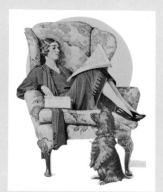

THIS is another straightforward but effective cover. A dog begs for a chocolate from the box into which his mistress dips with a casualness that he evidently finds supremely frustrating. The subject makes the painting, and the artist does not have to resort to any cleverness in presenting it. All that is required of him is an honest portrayal.

CIGAR BUTT
Post Cover • July 11, 1925
PAGE 155

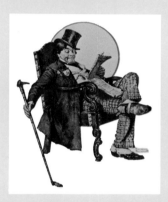

CURIOUSLY, this slightly down-at-heel dandy has adopted a pose very similar to the young woman's shown on the previous cover. Even the newspaper prop is used in much the same way. This raffish gent, however, is only feigning distraction. He is another of Rockwell's Dickensian protagonists—though he would be as at home on a Mississippi riverboat as in a London saloon—and his performance is worthy of W. C. Fields.

ASLEEP ON THE JOB
Post Cover • August 29, 1925
PAGE 156

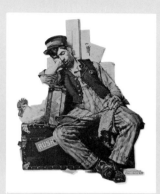

THE "rush" label on the trunk is what gives point to this composition. Not everyone, it seems, has the same priorities, especially in August when the temperature rises. (Even when Rockwell was not painting a specifically "seasonal" cover, he would often try to relate the subject matter to the time of year when the cover was scheduled to appear on the newsstands.)

THE BUGGY RIDE
Post Cover • September 19, 1925
PAGE 157

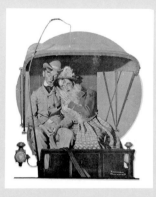

THE disk of sky, shot with stars, seems to enclose these sweethearts in their own world. The horse must know his way home because the young man cannot keep his eyes open. Note the attention Rockwell has lavished on the young man's hands and on the young woman's gloves and skirt.

TACKLED
Post Cover • November 21, 1925
PAGE 158

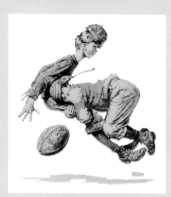

HERE Rockwell gives us a stirring moment from the annals of sandlot football. These players may never be elected to the Hall of Fame, but they know how the game should be played. The ball is jarred loose as the result of a bone-crunching open-field tackle, and we can almost feel the impact. This cover works well because of the artist's vigorous draftsmanship. The determination of the tackler, and the shock on the face of the boy he has stopped in his tracks, are graphically expressed.

MERRIE CHRISTMAS
Post Cover • December 5, 1925
PAGE 159

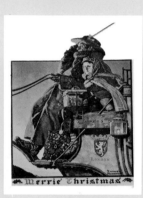

THIS is another Christmas cover that might serve as an illustration for one of Dickens's Christmas books. The coachman and his young companion, wrapped up against the cold, are not, for once, the subject of anecdote, but they serve instead as the symbols of an age in which we feel—perhaps largely because of Dickens's stories—that Christmas had more meaning.

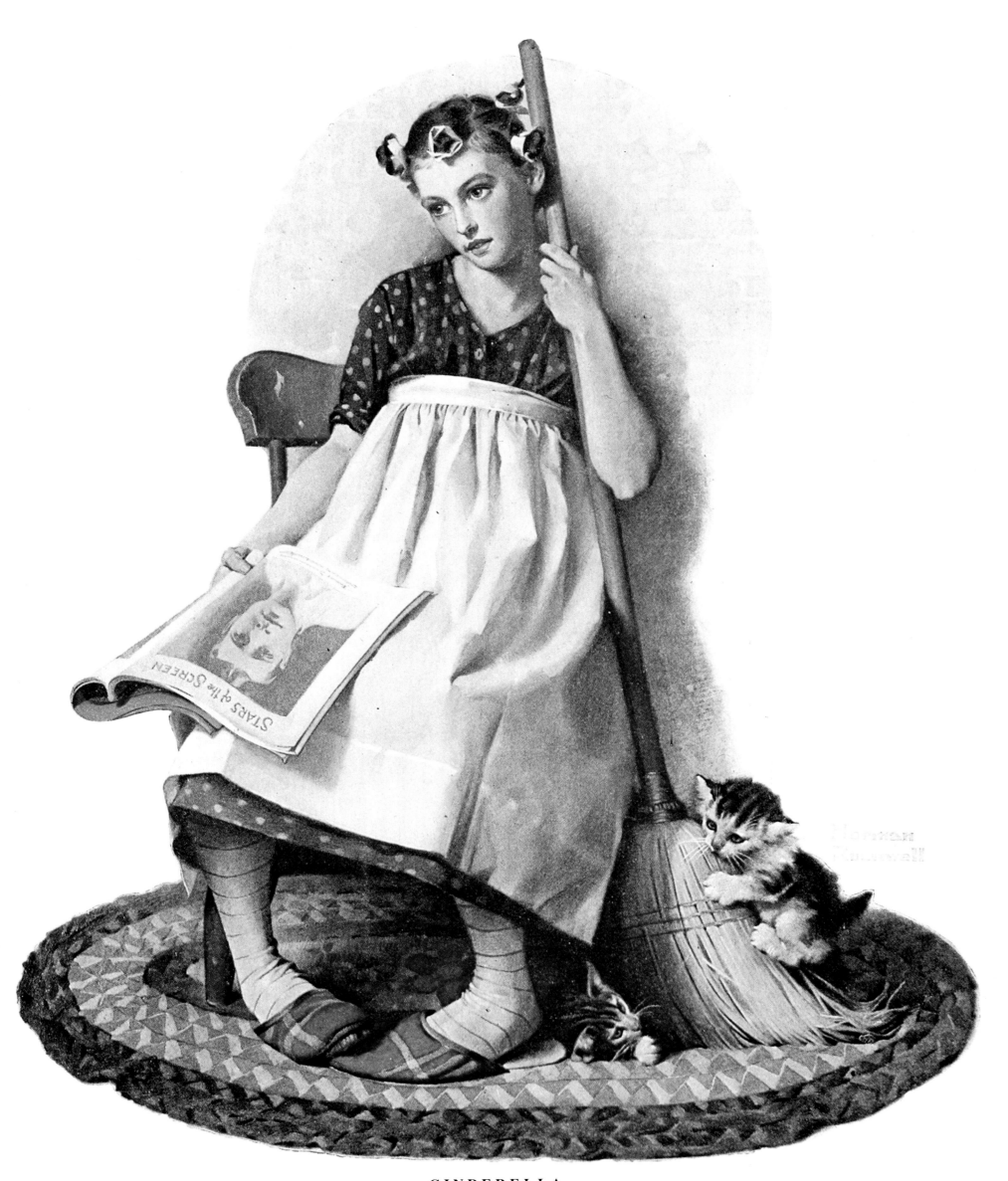

CINDERELLA
Post Cover • November 4, 1922

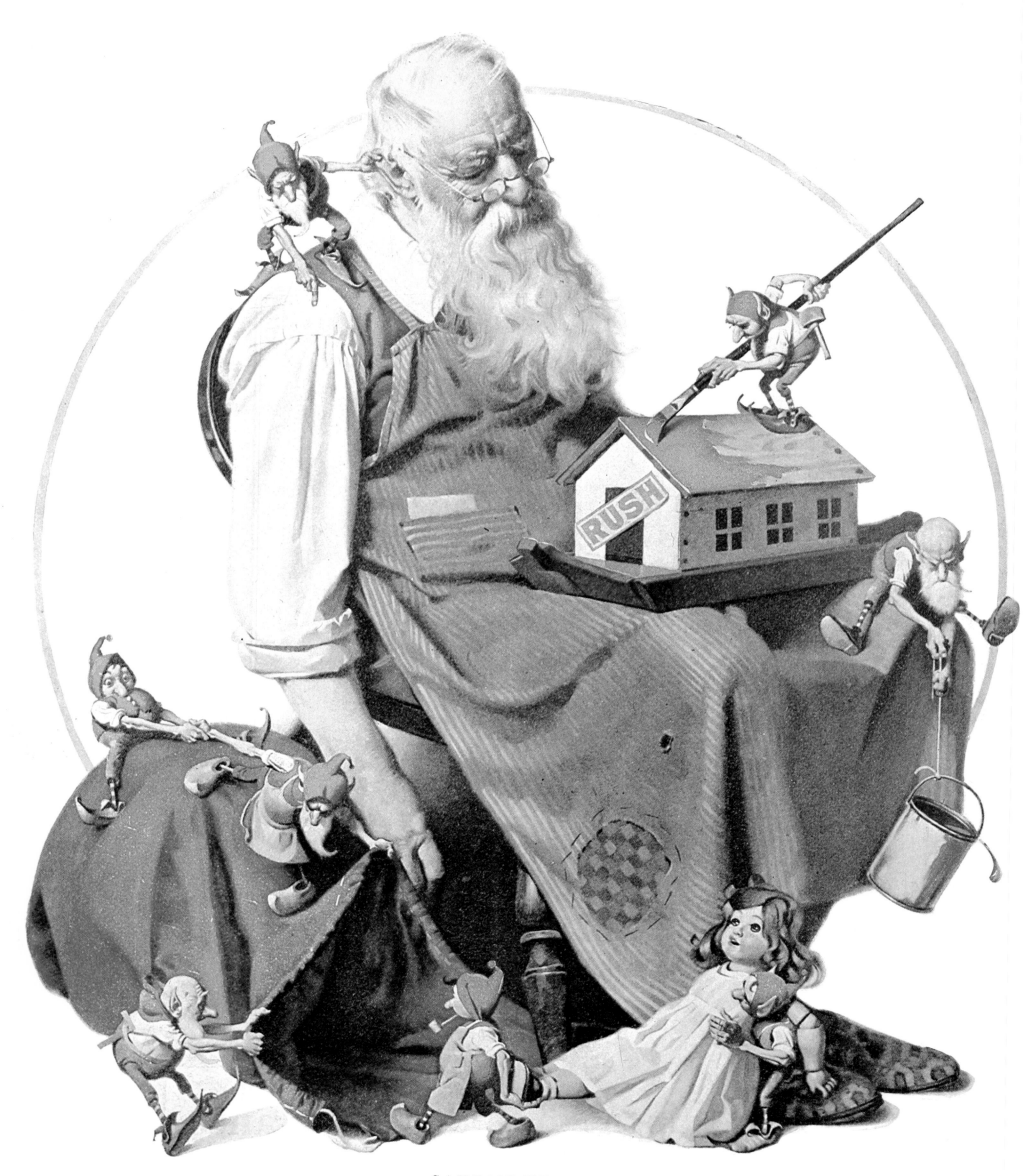

SANTA'S HELPERS
Post Cover • December 2, 1922

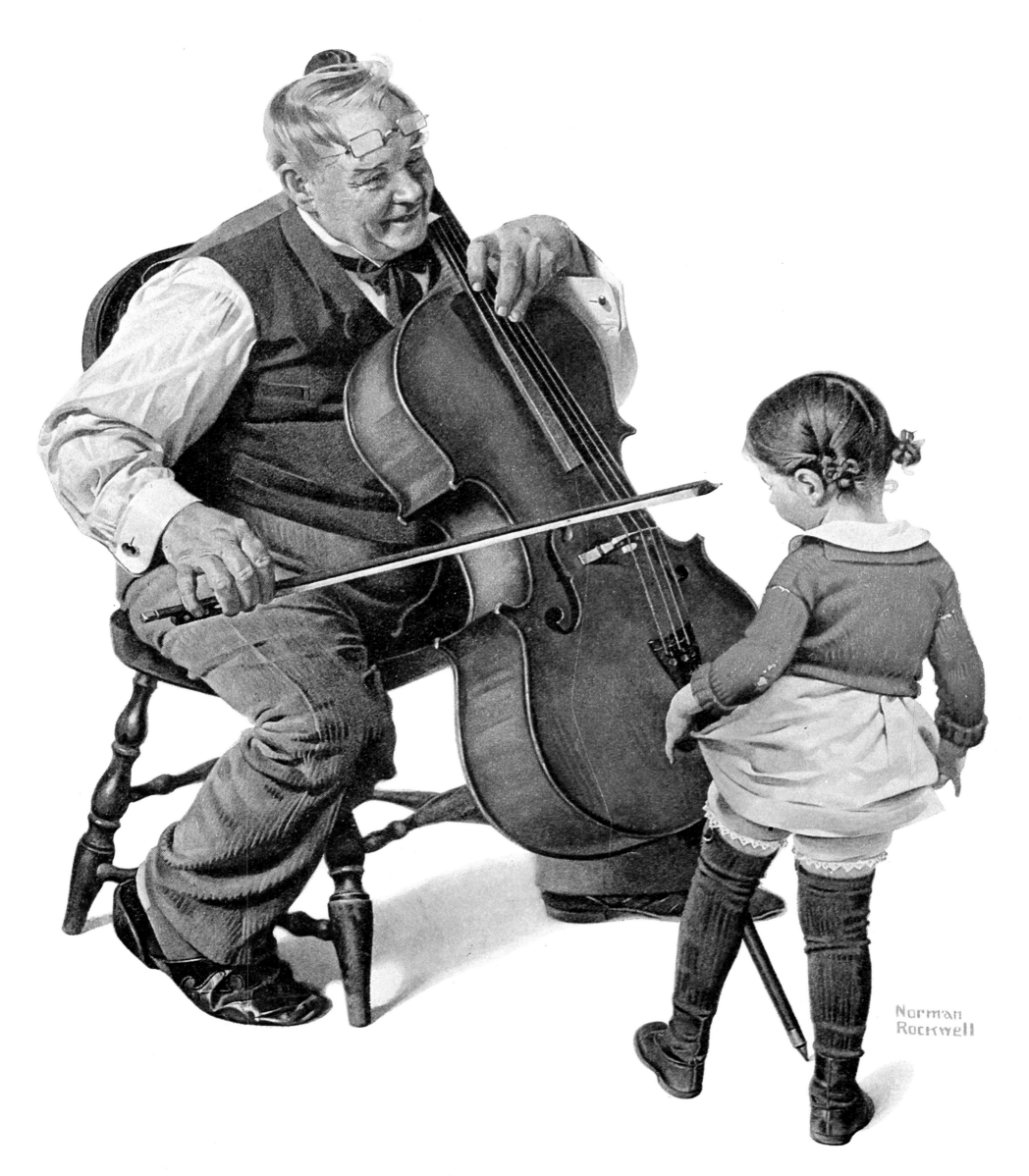

A MEETING OF MINDS

Post Cover • February 3, 1923

131

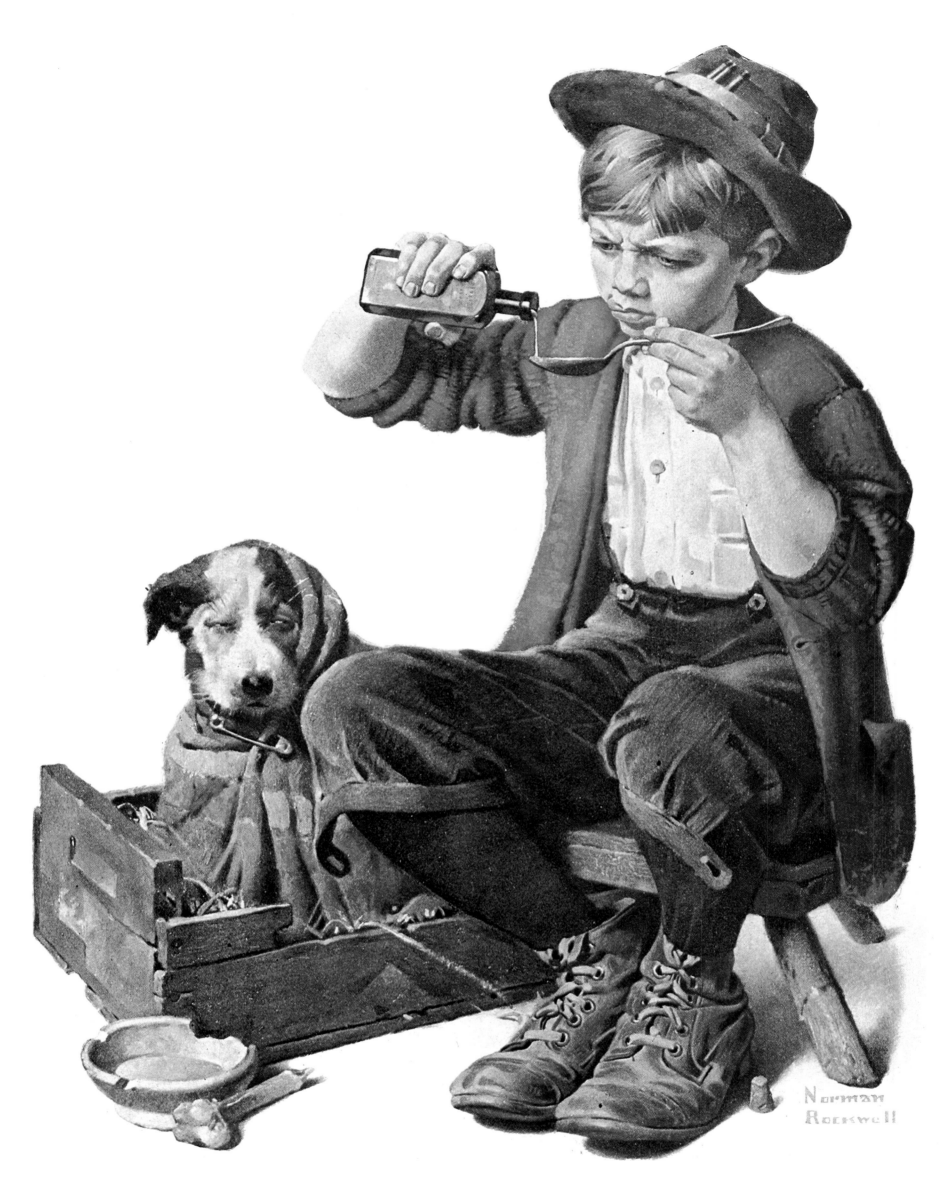

BEDSIDE MANNER
Post Cover • March 10, 1923

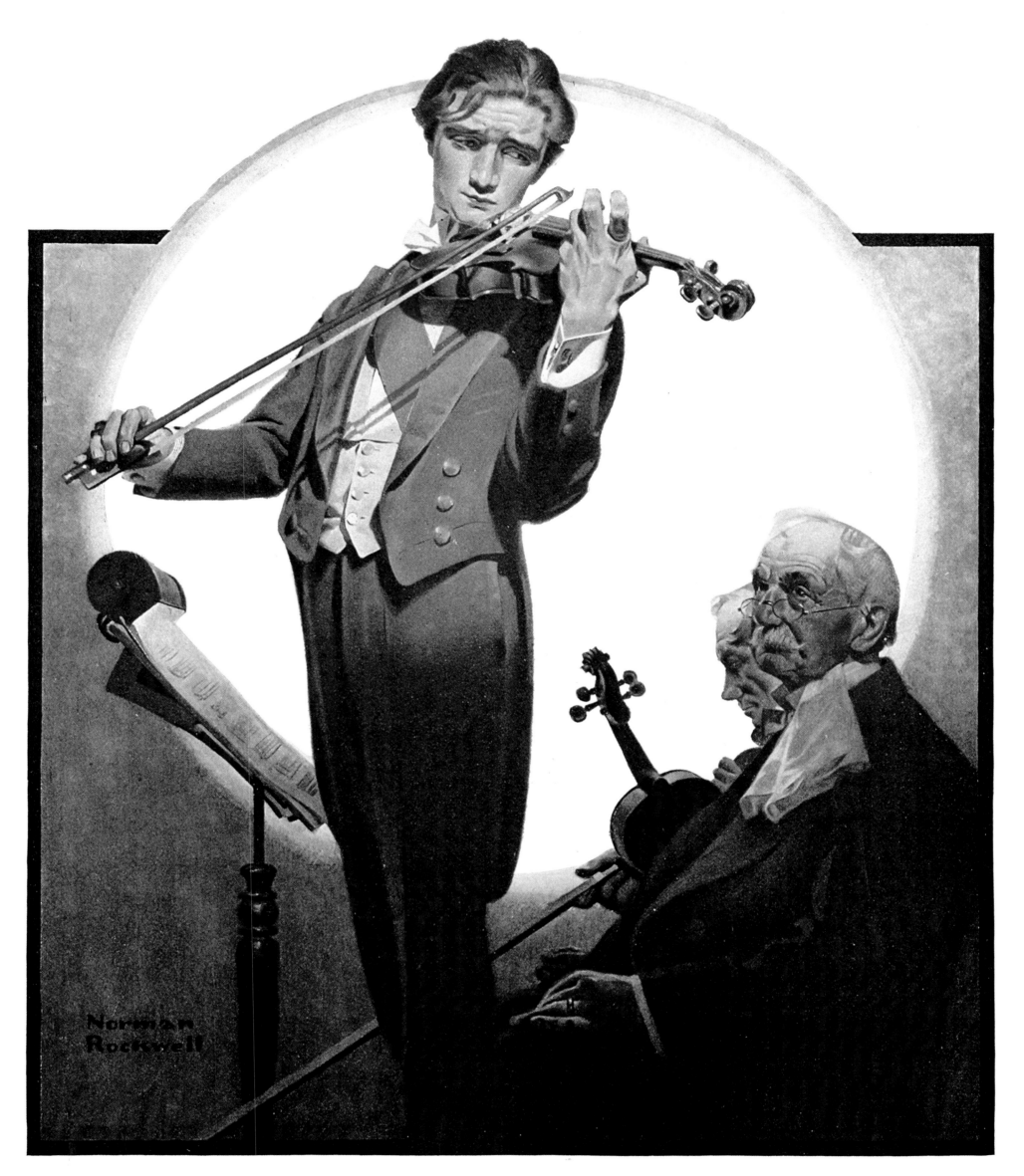

THE VIRTUOSO

Post Cover • April 28, 1923

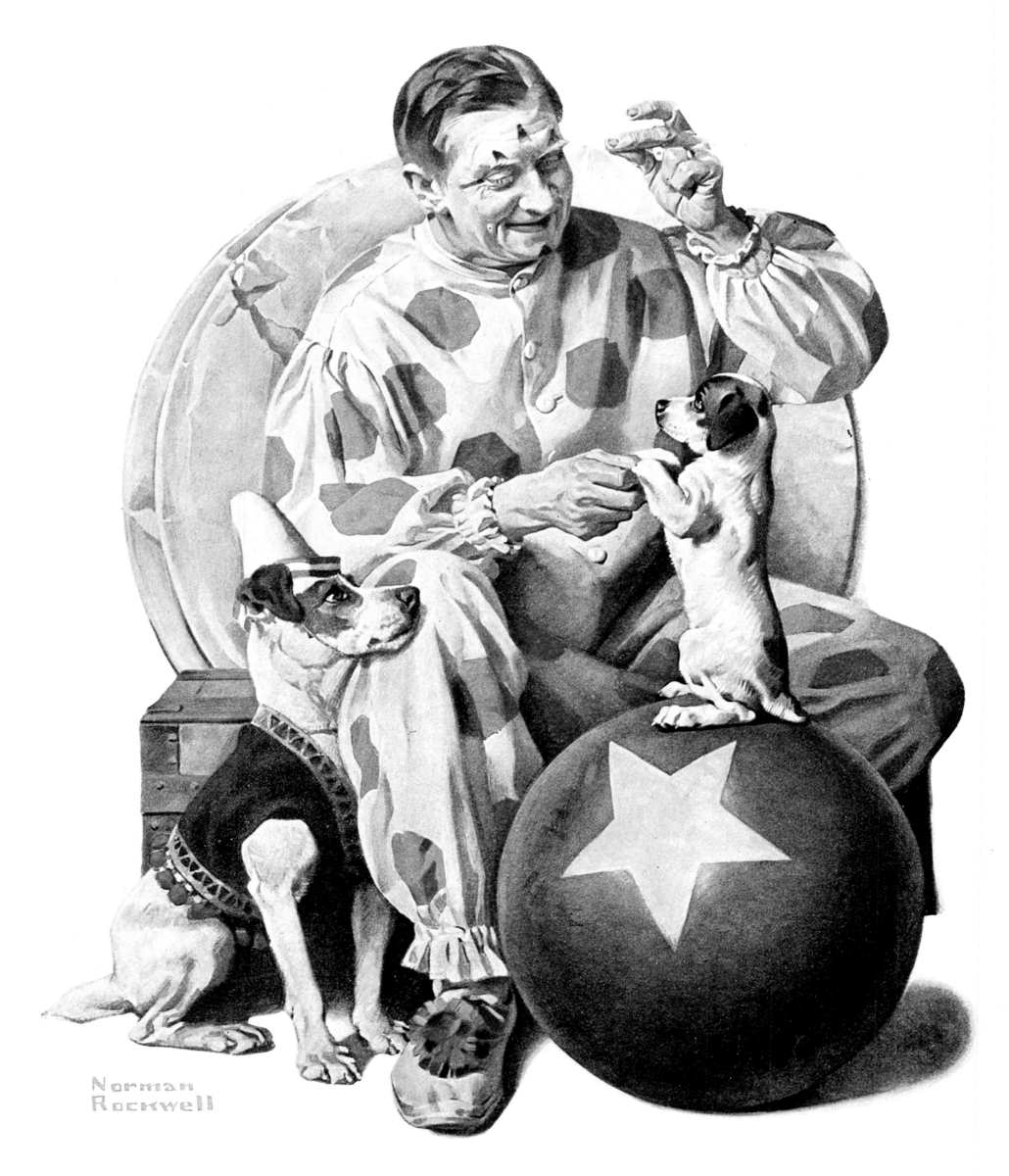

CLOWN
Post Cover • May 26, 1923

VACATION
Post Cover • June 23, 1923

FARMER AND BIRDS

Post Cover • August 18, 1923

THE CRUISE

Post Cover • September 8, 1923

137

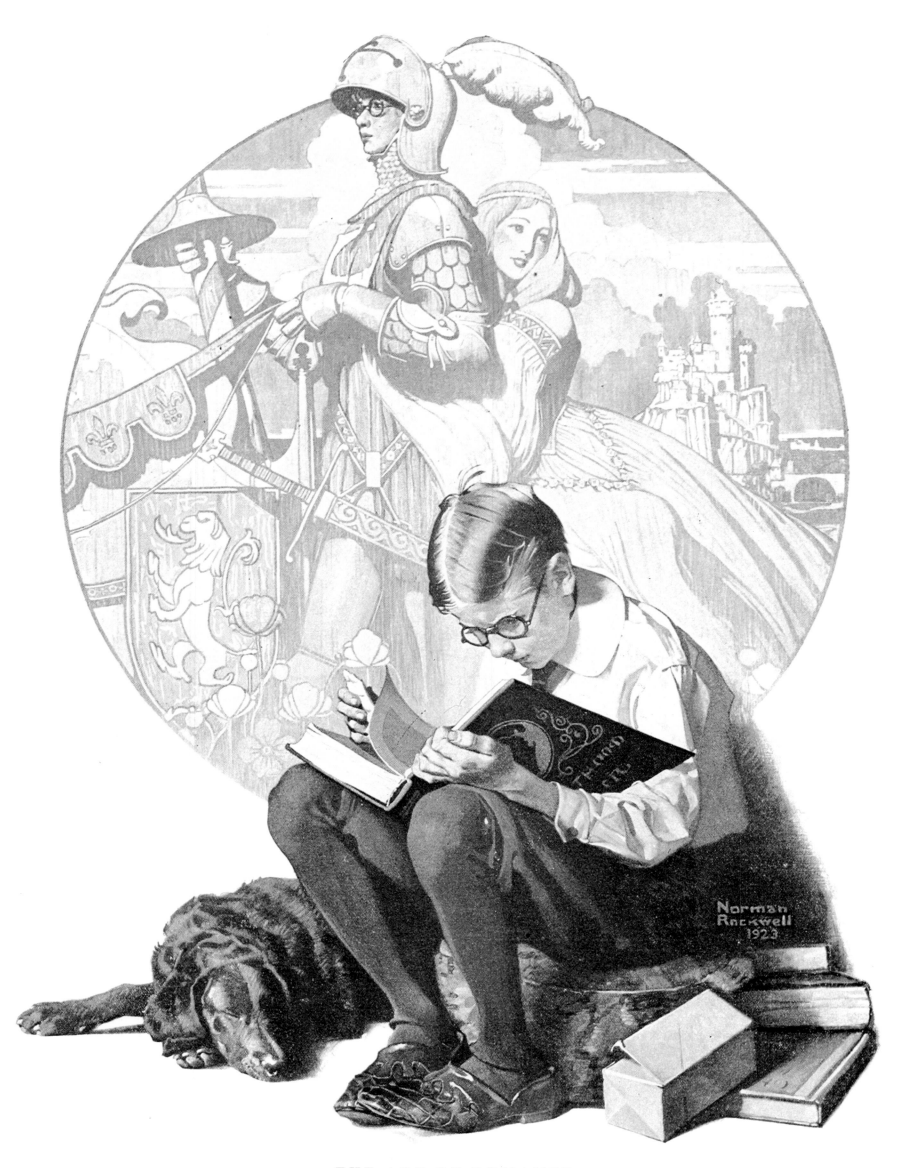

THE AGE OF ROMANCE

Post Cover • November 10, 1923

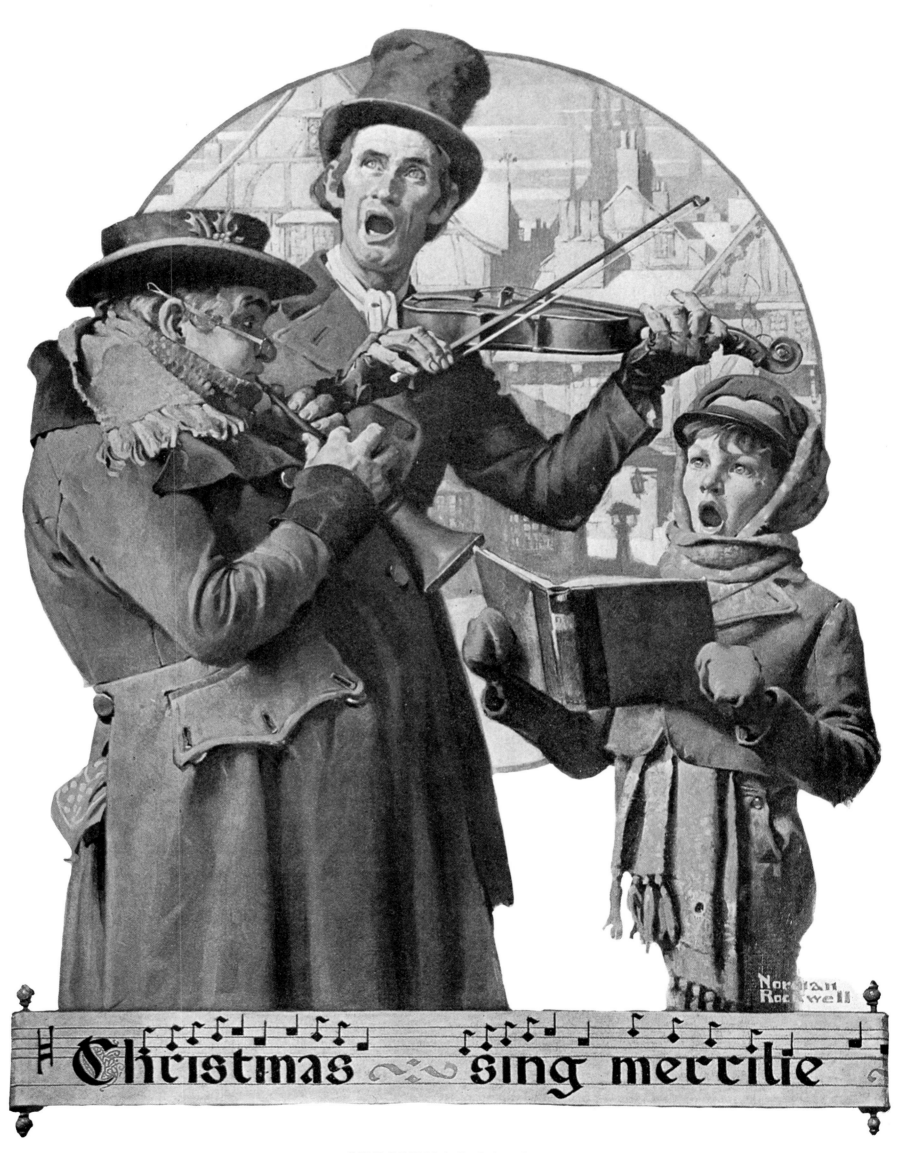

CHRISTMAS CAROL

Post Cover • December 8, 1923

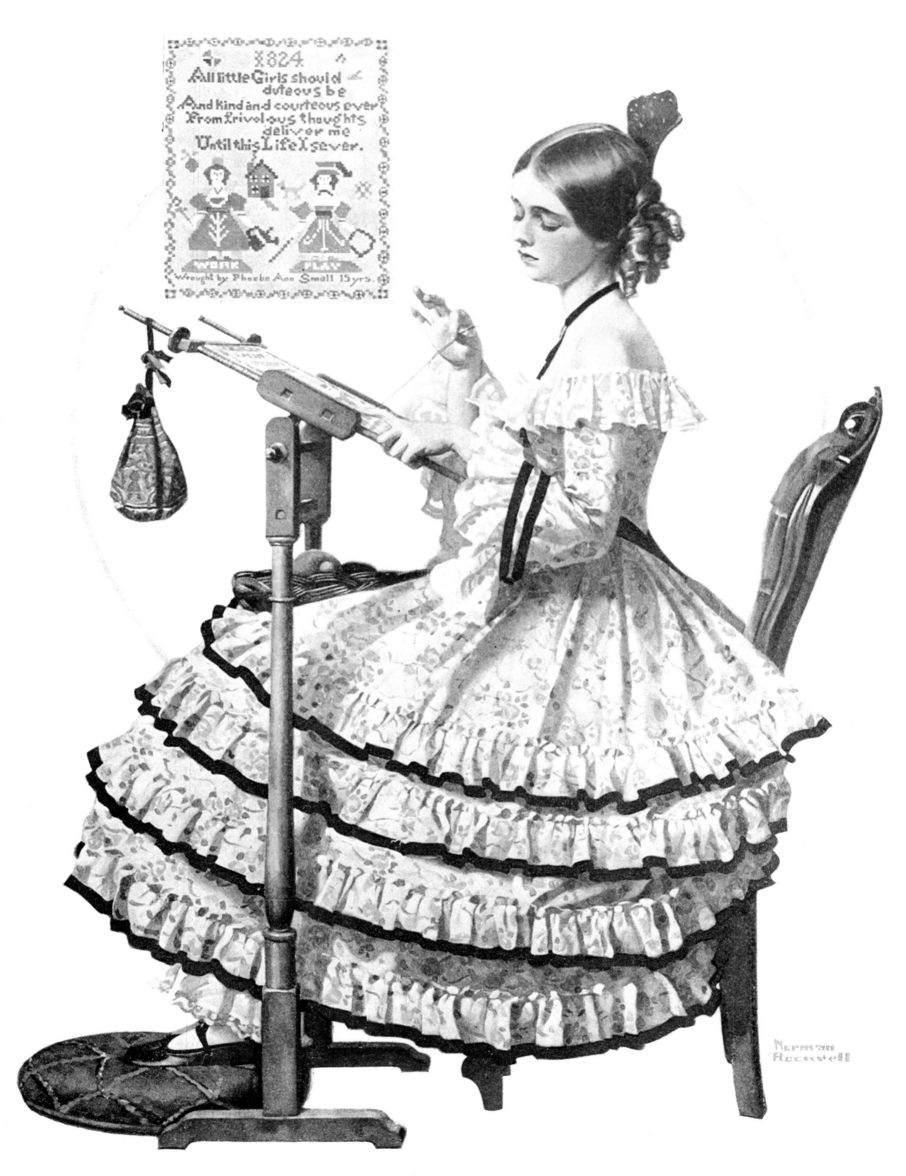

THE SAMPLER

Post Cover • March 1, 1924

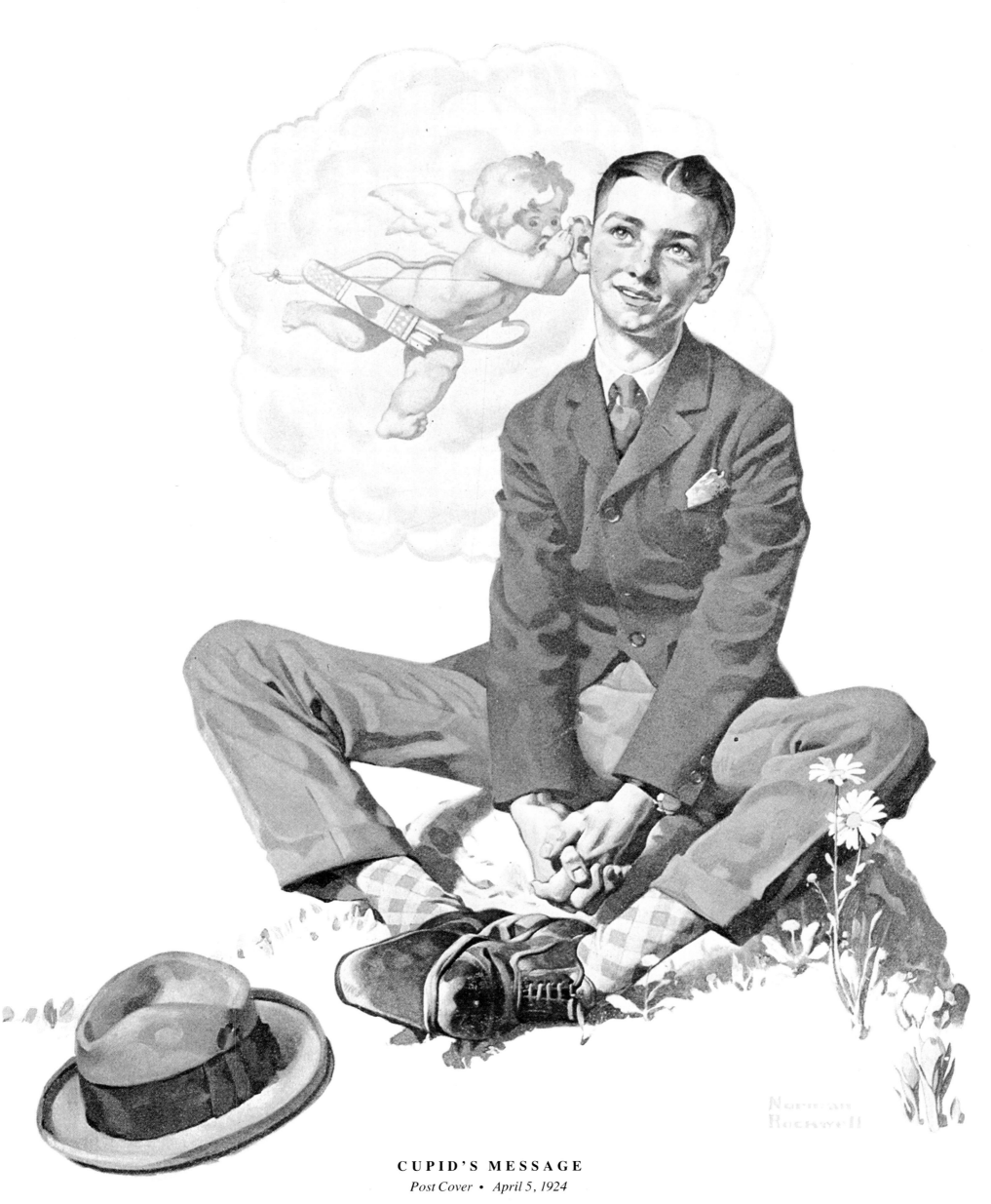

CUPID'S MESSAGE

Post Cover • April 5, 1924

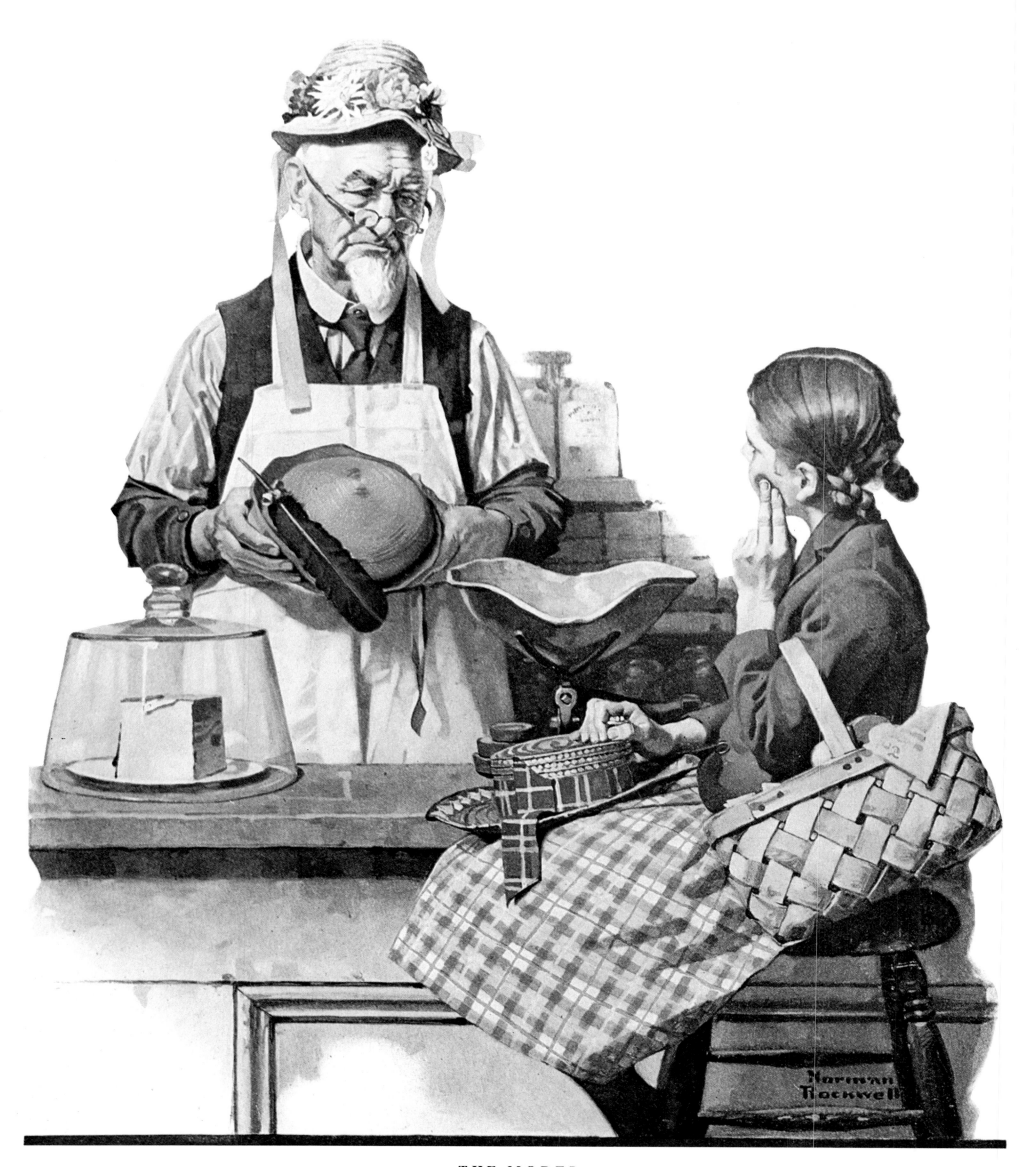

THE MODEL

Post Cover • May 3, 1924

ADVENTURE

Post Cover • June 7, 1924

143

HOME

Post Cover • June 14, 1924

144

SPEED

Post Cover • July 19, 1924

145

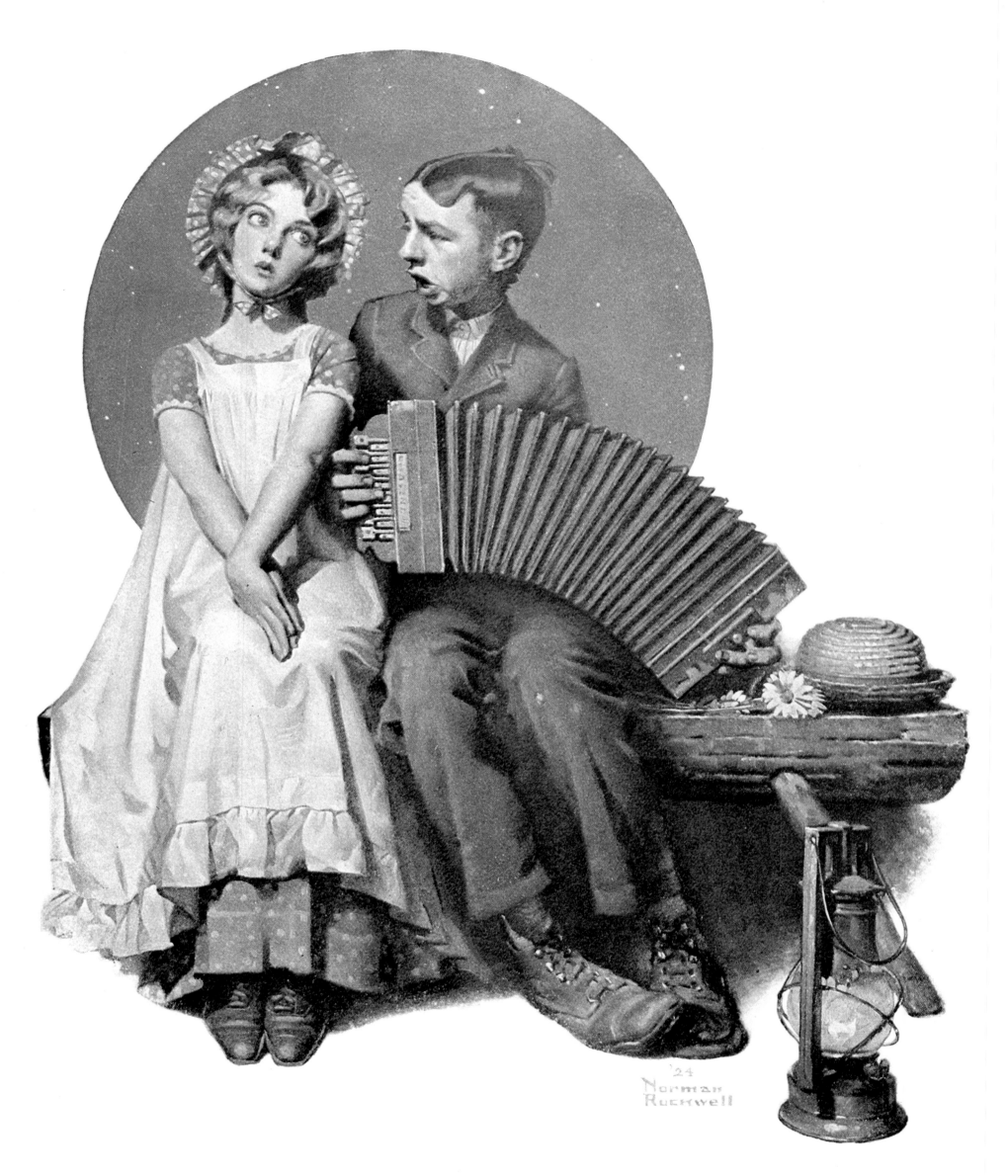

THE ACCORDIONIST

Post Cover • August 30, 1924

146

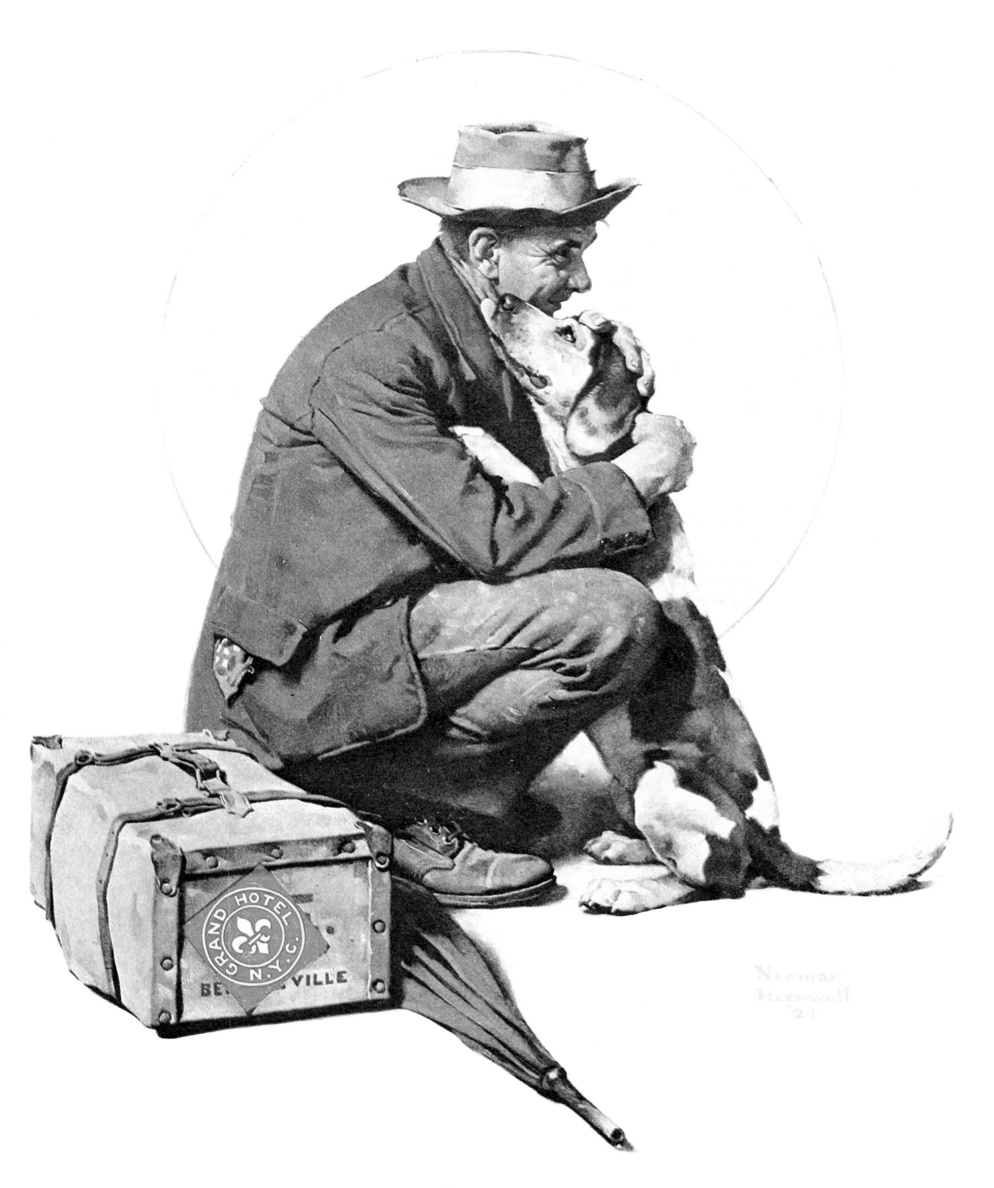

HOMECOMING

Post Cover • September 27, 1924

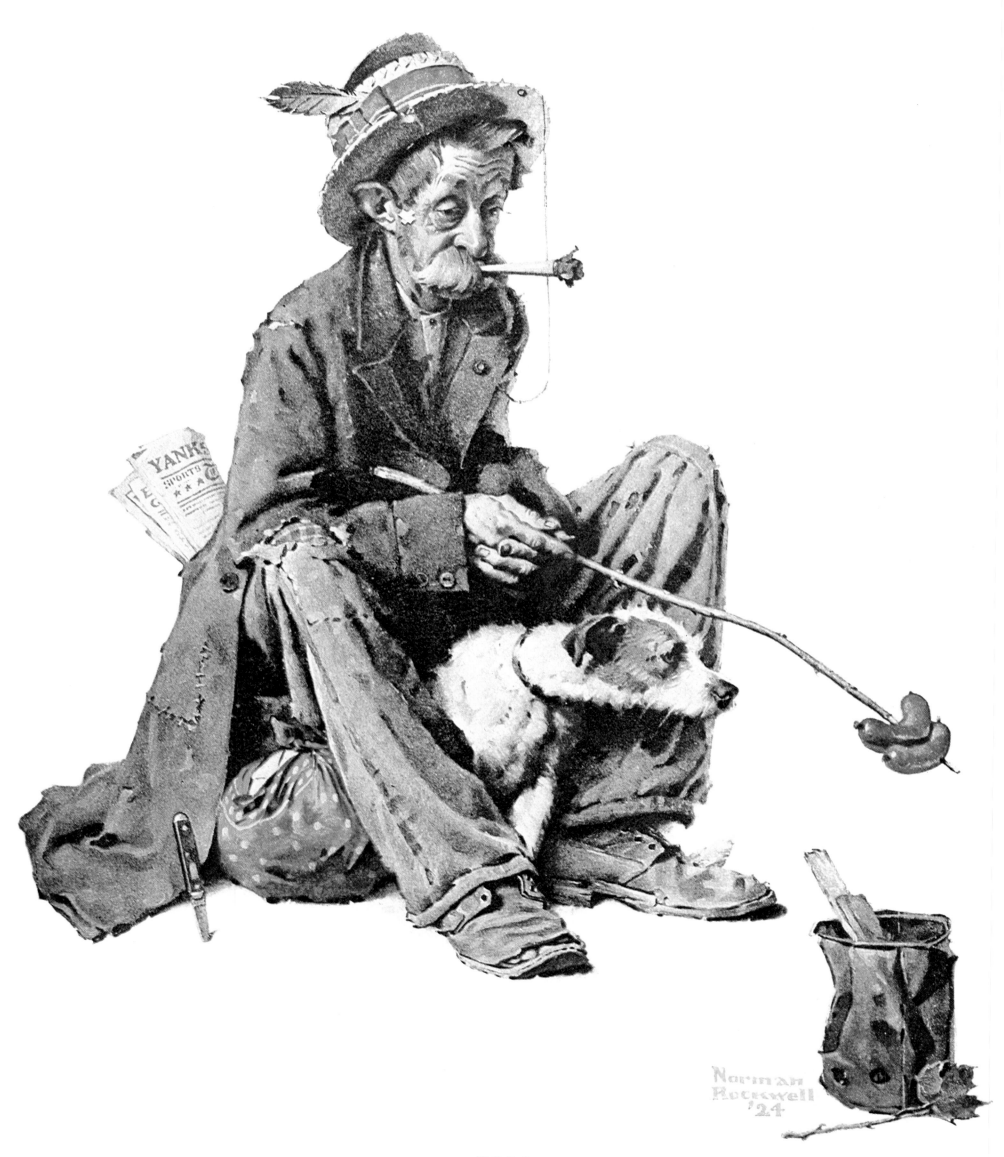

HOBO

Post Cover • October 18, 1924

148

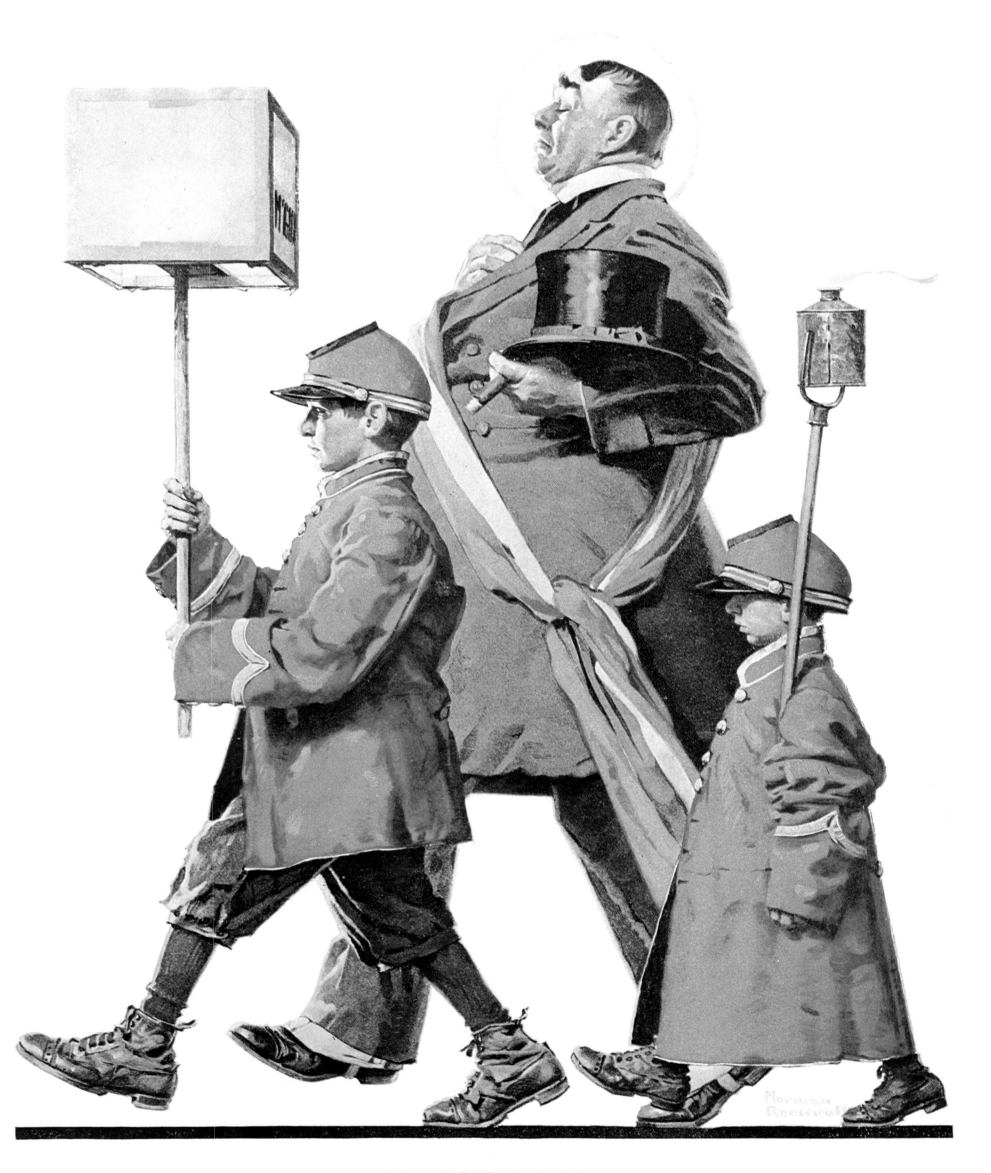

CEREMONIAL GARB

Post Cover • November 8, 1924

149

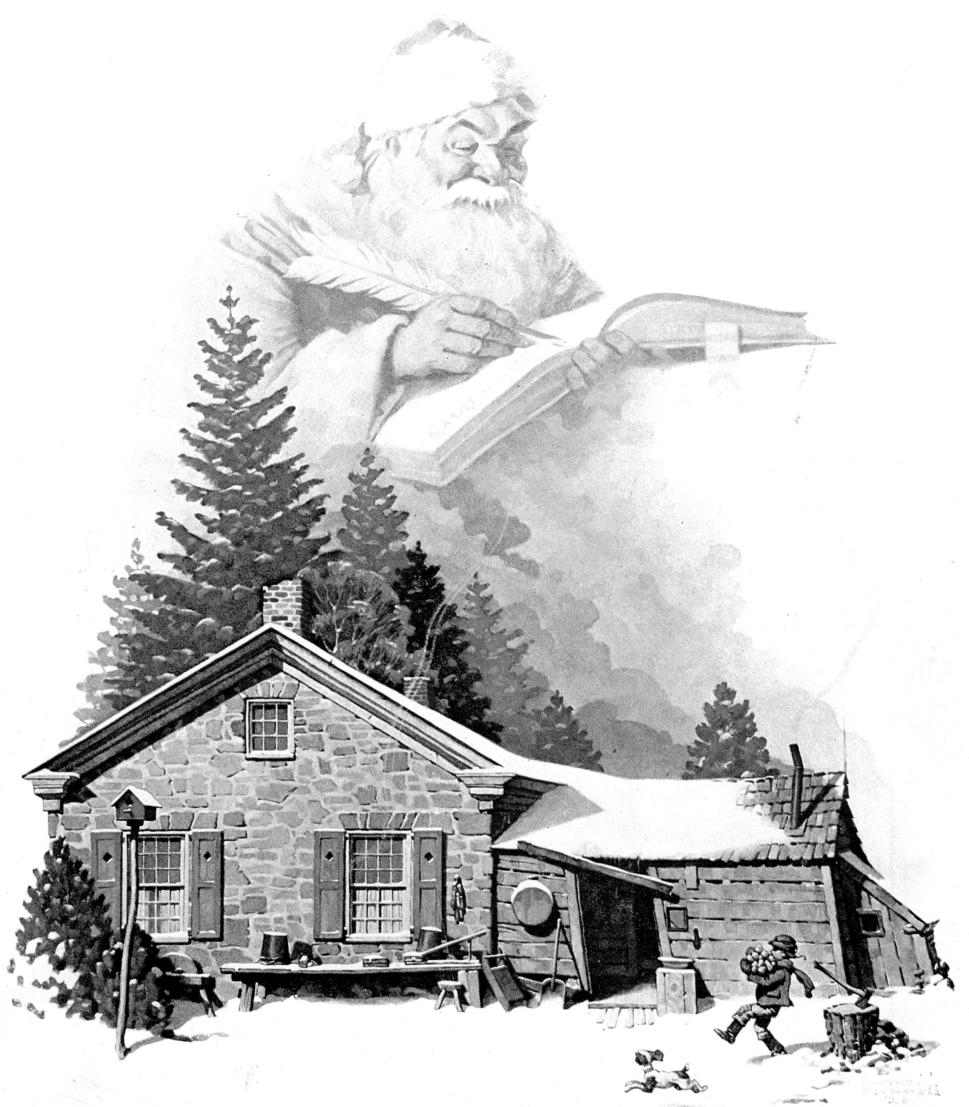

C H R I S T M A S

CHRISTMAS

Post Cover • December 6, 1924

150

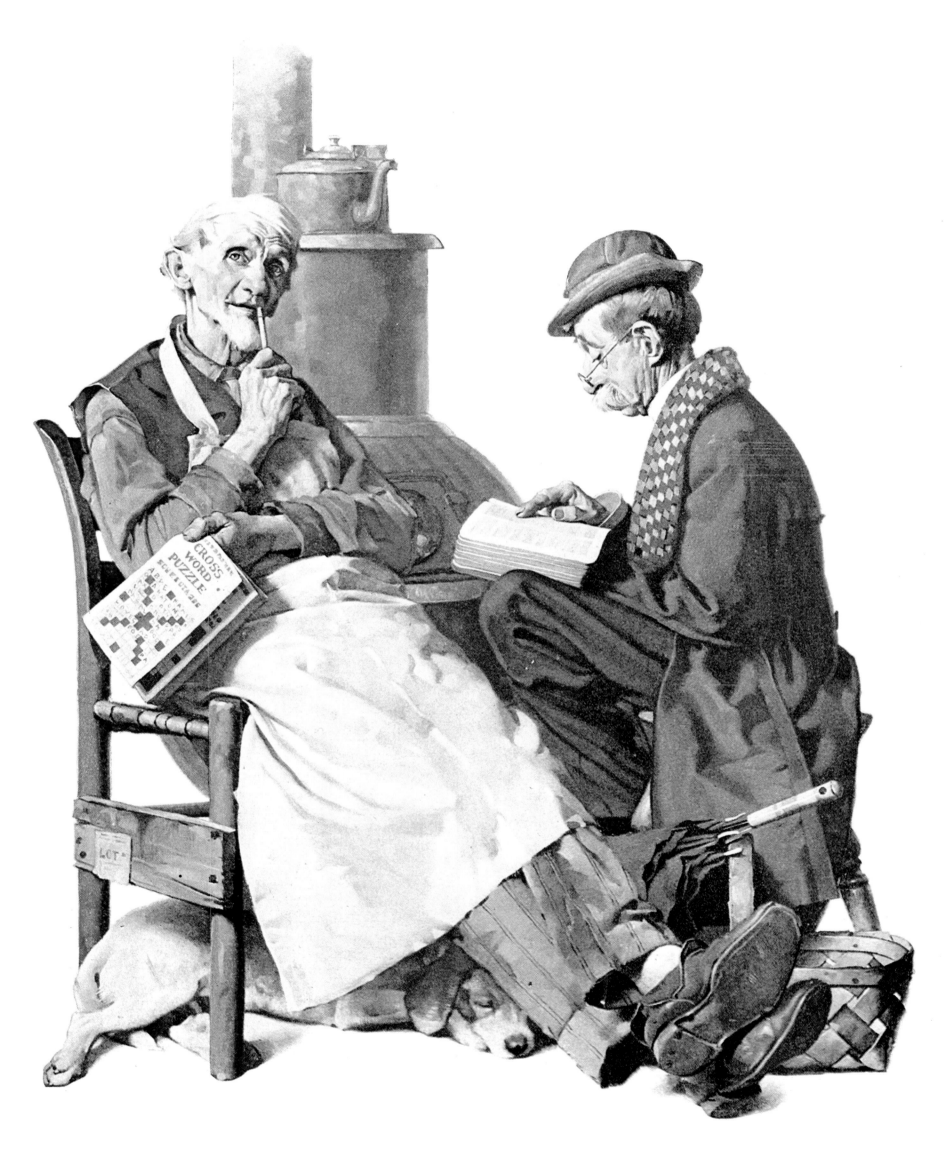

CROSSWORD PUZZLE
Post Cover • January 31, 1925

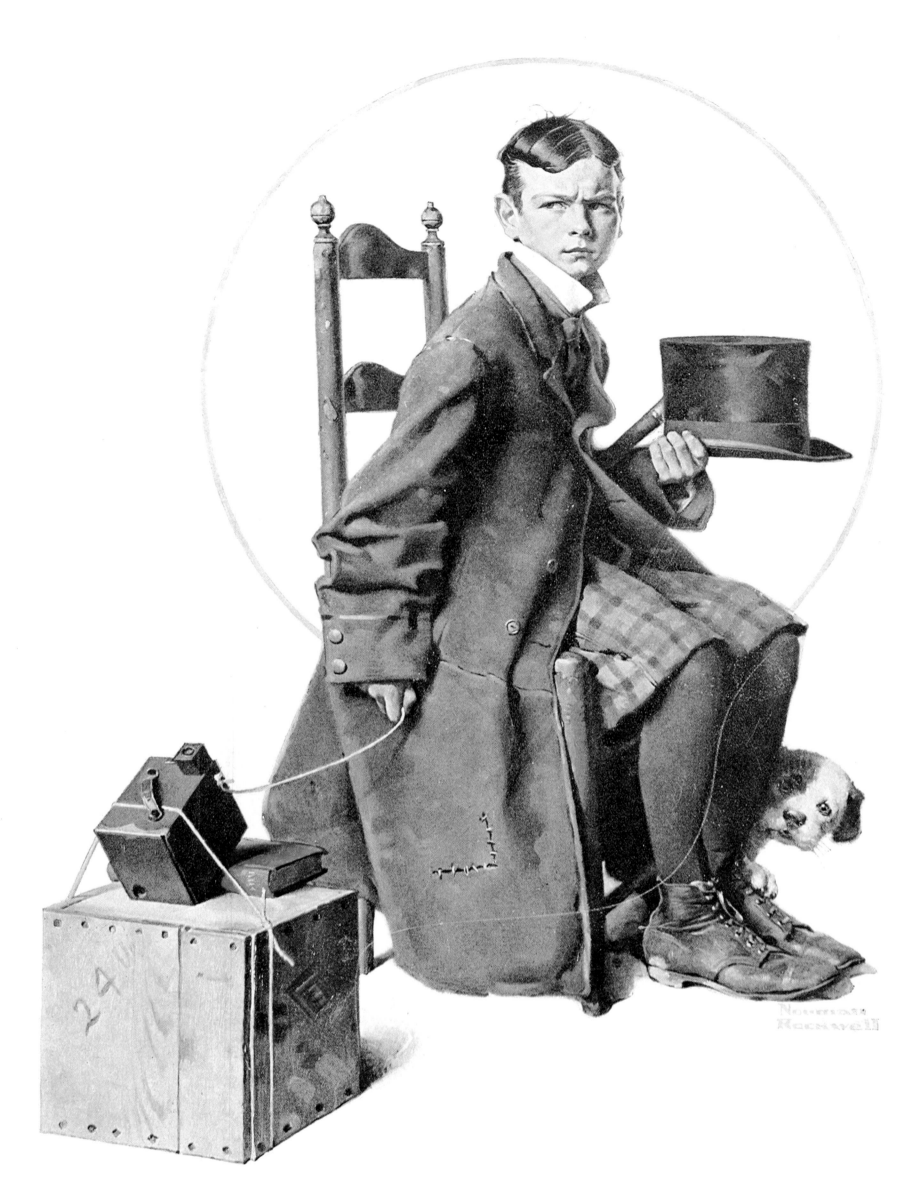

SELF-PORTRAIT
Post Cover • April 18, 1925

152

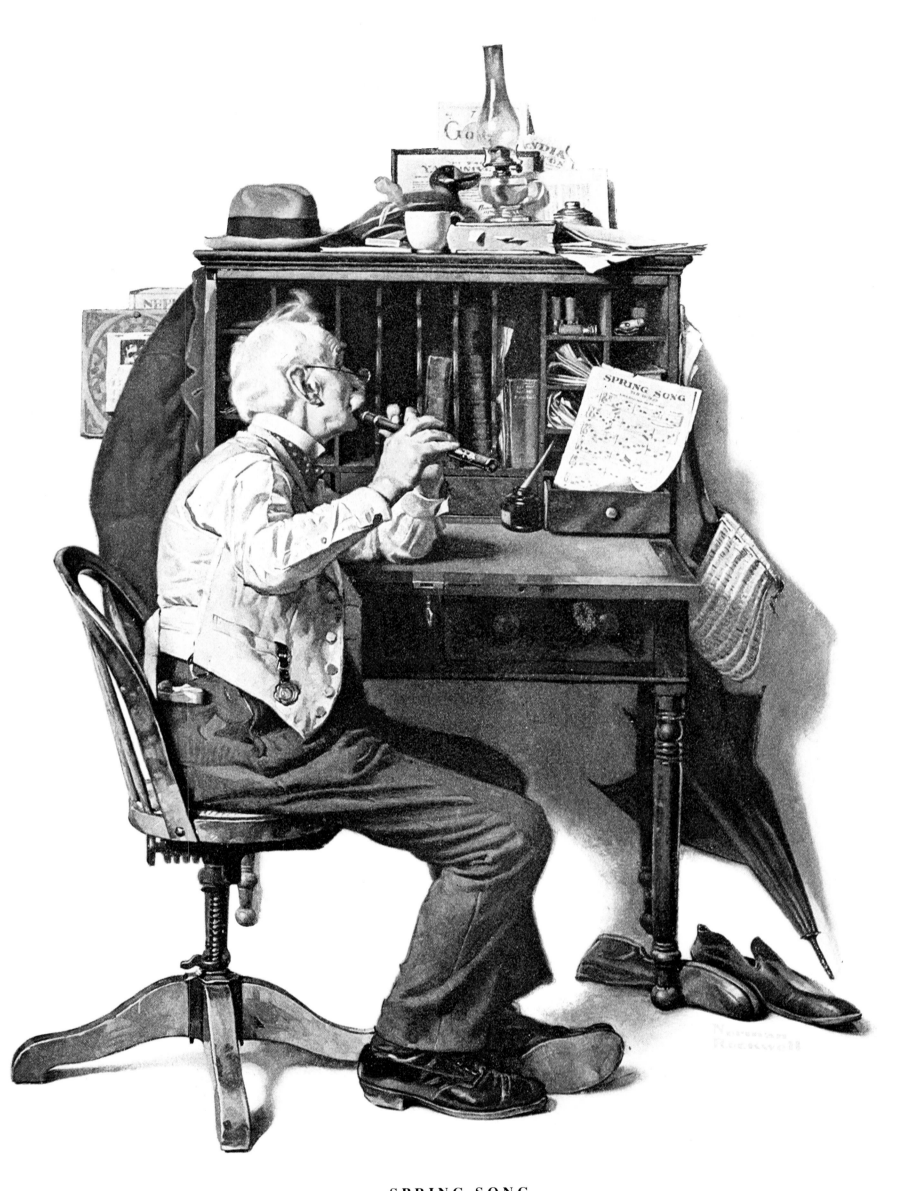

SPRING SONG

Post Cover • May 16, 1925

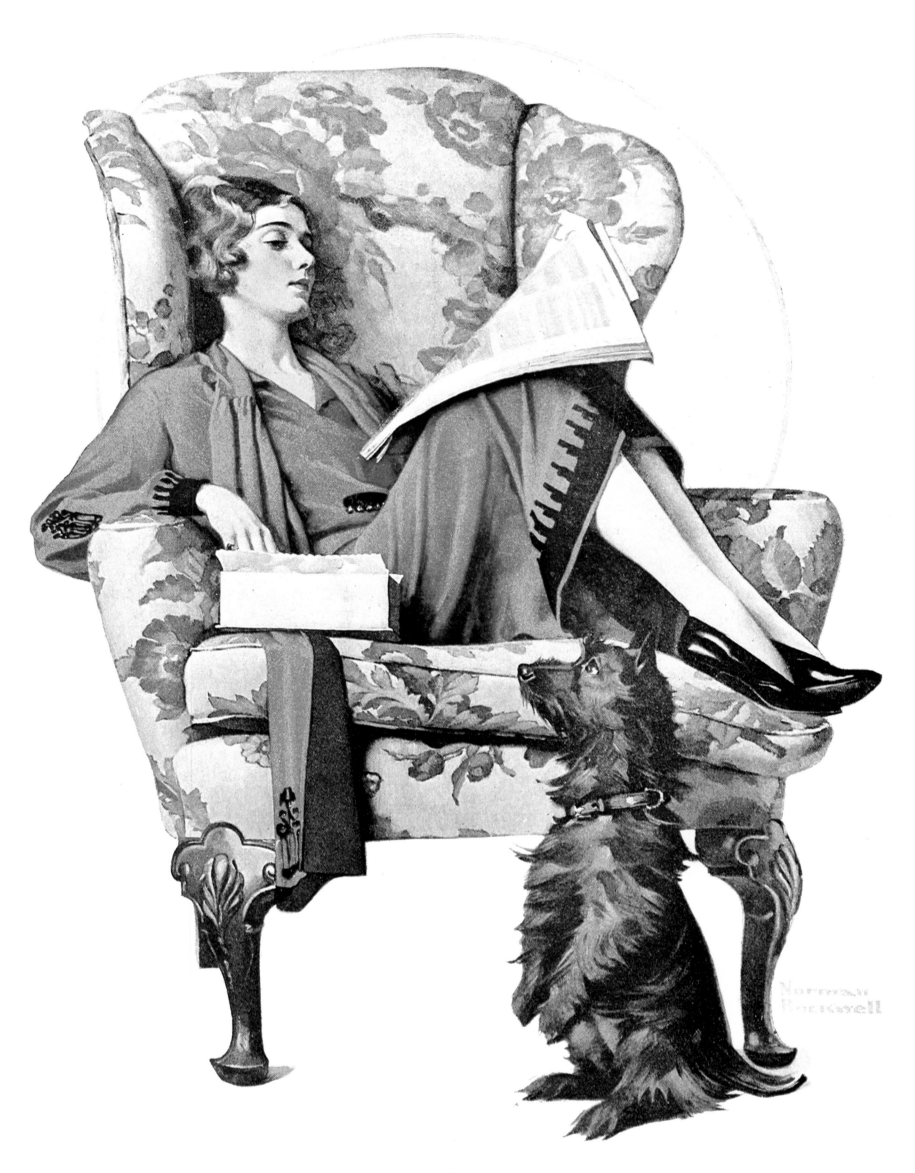

BEGGING

Post Cover • June 27, 1925

154

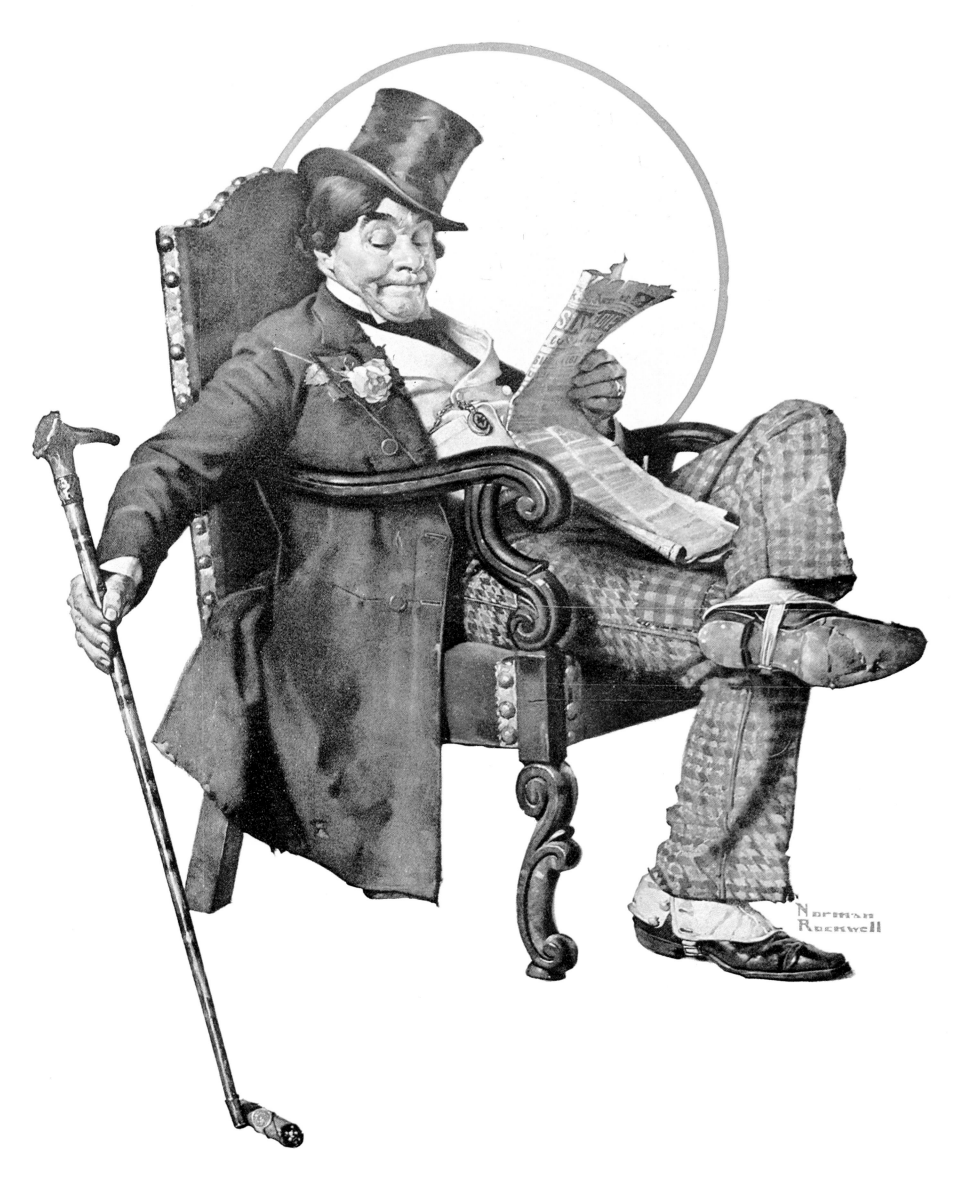

CIGAR BUTT
Post Cover • July 11, 1925

155

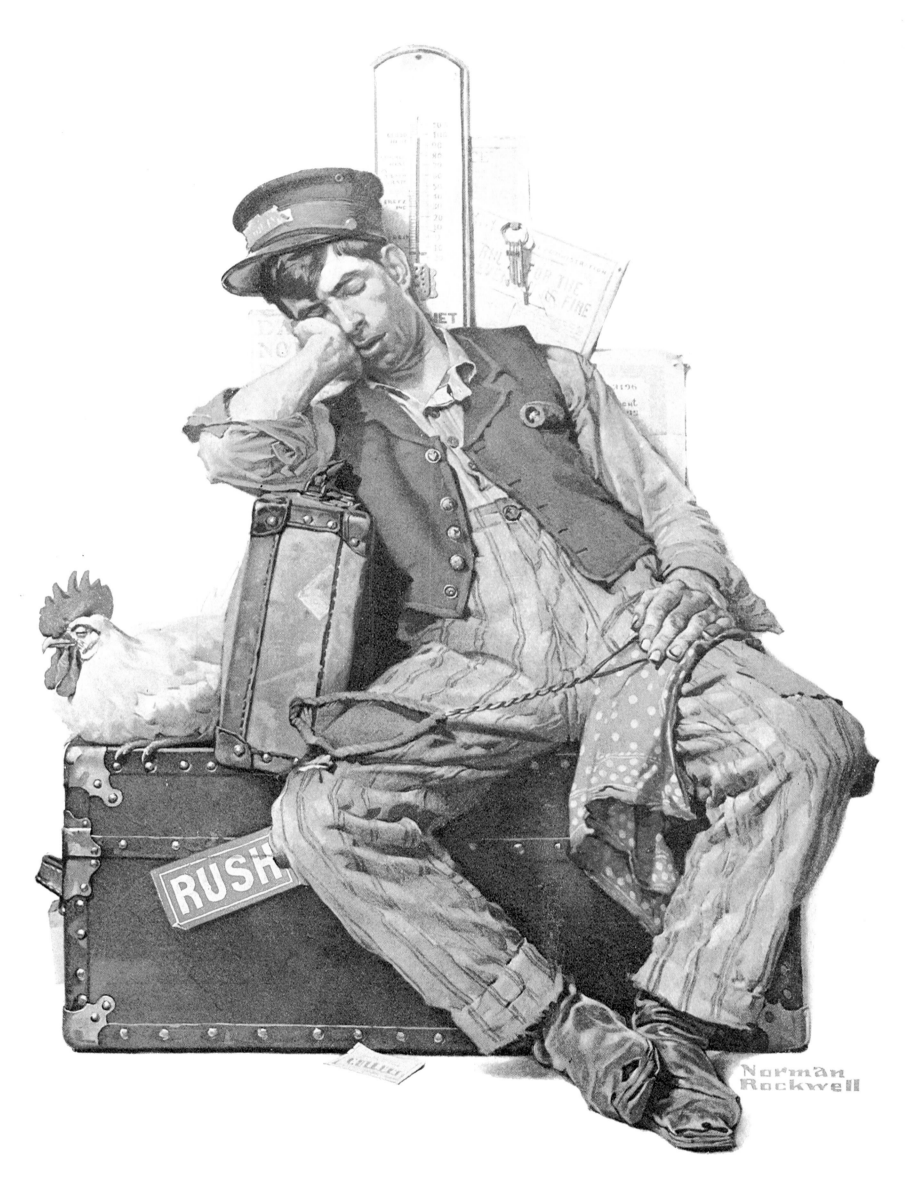

ASLEEP ON THE JOB

Post Cover • August 29, 1925

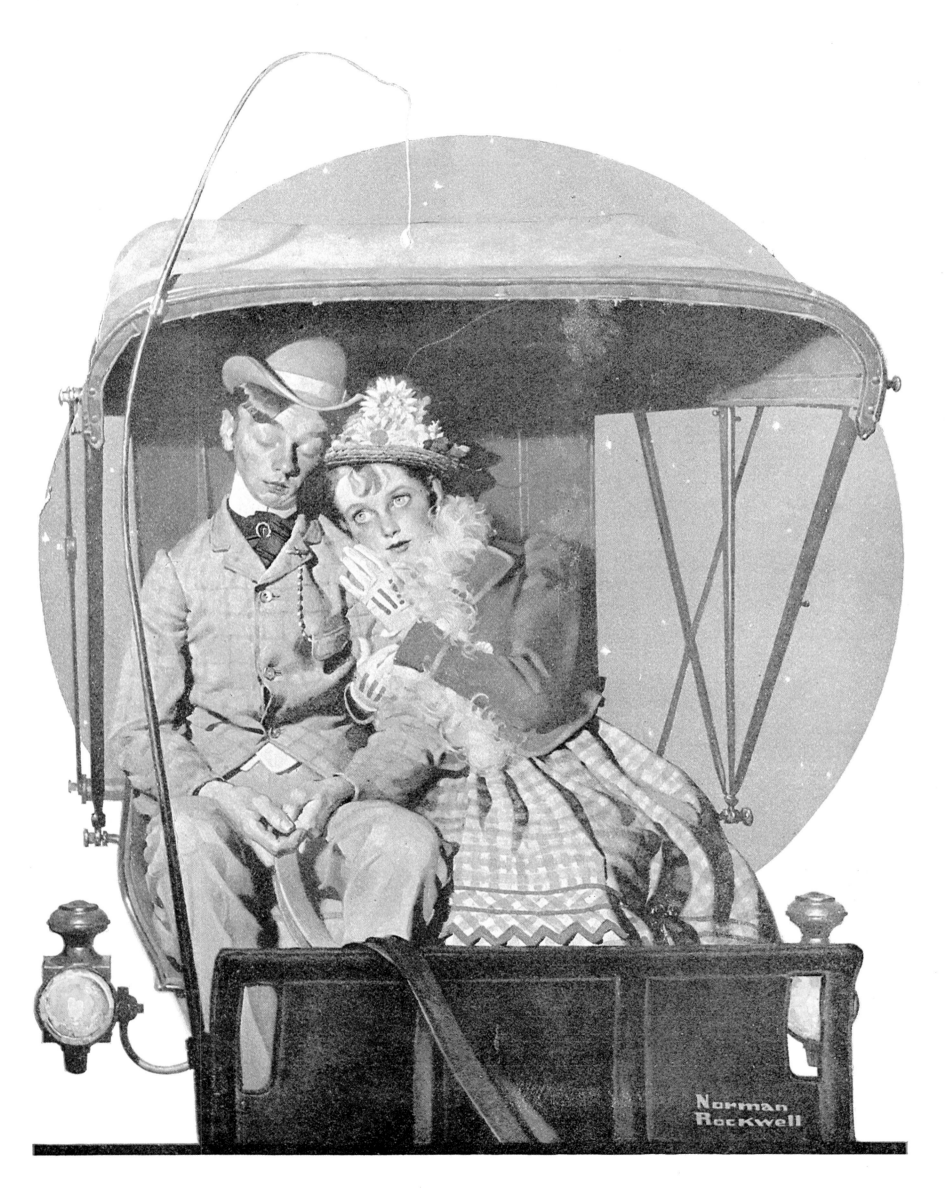

THE BUGGY RIDE

Post Cover • September 19, 1925

157

TACKLED

Post Cover • November 21, 1925

Merrie Christmas

MERRIE CHRISTMAS

Post Cover • December 5, 1925

Again and Again Rockwell Fell Back on Tried and Tested Themes

THE TWENTIES CONTINUED TO BOOM. Between 1926 and the early months of 1929, what has been called the Age of Ballyhoo reached a new pitch of hysteria. "Sell, sell, sell; buy, buy, buy," were the words on everyone's lips. Magazines like the *Post* were packed with slick, glossy advertisements of a kind never seen before, often making their pitch in an oblique way, presenting the products they were designed to sell— from hosiery to refrigerators—more as adjuncts to a certain lifestyle than as merely useful commodities. It was the good life itself they were promoting—the good life, which could hardly be conceived of, it was implied, without a Coke in one hand and a Camel in the other. And people did buy because for the first time in history it became almost respectable to furnish your home and put a car in your garage on the installment plan. "$5 down and $5 a week"—that was the slogan. To be in debt became a badge of honor; it meant you were worthy of a strong line of credit.

This was the heyday of Bessie Smith and Louis Armstrong, of the Harlem cabarets and the domesticated jazz of Paul Whiteman's band. Skirts had become so short that girls began to powder their knees. But, above all, this was a time for heroes. Never before had so many great sports champions crowded the scene, for this was the age of Bobby Jones and Johnny Weissmuller, of Bill Tilden and Helen Wills. Knute Rockne was still at the helm of the Fighting Irish and, in Chicago, Red Grange was making professional football respectable. In 1926 Gertrude Ederle swam the English Channel, beating the best previous time—by man or woman—by a margin of almost two hours. The following year Gene Tunney ended Jack Dempsey's ring career, at Soldiers' Field, despite the controversy over the disputed long count; and this gladiatorial spectacle, followed over radio by more than 40,000,000 Americans, happened less than a month after the greatest sports hero of them all, Babe Ruth, stunned the baseball world by hitting his sixtieth home run of the season. The movies, too, provided their share of heroes, and the scenes that followed Rudolph Valentino's death in 1926 have become folklore. No one could compete, however, with the archetypal hero of the decade, the boyish Charles A. Lindbergh. In the spring of 1927 he coaxed his tiny monoplane, *The Spirit of St. Louis*, up into a Long Island drizzle and piloted it single-handedly across the Atlantic Ocean to Le Bourget field—a feat that was almost beyond belief.

As for Rockwell, his first wife had divorced him, and he spent much of this period at his New York studio, in the Hotel des Artistes, just off Central Park West. It was not, in general, a happy time for him, although this did not affect his productivity. By now he was working almost exclusively for the *Post* and a handful of other longtime clients, such as the Mazda Lamp Company and the *Encyclopaedia Britannica*. On the average, he was painting a *Post* cover every five weeks, and they were a little more varied than in the previous two or three years. Still, this was not one of Rockwell's strongest periods. There are no true masterpieces from these years and relatively few paintings that could be called really first-rate. Again and again he fell back on tried and tested themes. Costume pictures, mostly with eighteenth- and nineteenth-century settings, were still his most important standbys, and references to the social phenomena of the twenties remained rare, although, interestingly, he was often at his best when he did take note of such things, as can be seen from such examples as "The Artist" (p 183).

We sense, in fact, that Rockwell was beginning to need an infusion of new subject matter, or that some stylistic shift was necessary to free his imagination. The time was not yet ripe for such changes, and so he proceeded as best he could, relying on his professional competence to see him through, still managing to produce from time to time a painting that had some real spark to it.

SATURDAY EVENING POST COVERS
January 9, 1926–February 16, 1929

SOAP BOX RACER
Post Cover • January 9, 1926

PAGE 169

In this painting, the world of childhood —usually, in Rockwell's work, a timeless and innocent Arcadia—has been invaded by the demon of speed. It would be fascinating to know whether this eclectic vehicle was painted from life and, if so, whether it was something the artist chanced upon, a found object, or whether he had it built for the occasion of this cover.

SIGN PAINTER
Post Cover • February 6, 1926

PAGE 170

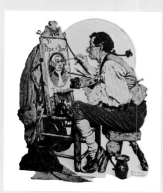

This cover might have been more effective if Rockwell had resisted the temptation to caricature the artist, however gently. The subject matter just does not seem to justify such a treatment. If the sign painter were less of a grotesque, the contrast between Rockwell's enormous skill and the crudeness of the portrait on the signboard would have been more pointed.

PHRENOLOGIST
Post Cover • March 27, 1926

PAGE 171

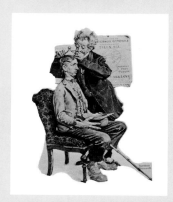

In this instance, gentle caricature works very well since the situation is essentially humorous. If the young man's seriousness was not quite so exaggerated, and if the phrenologist himself was not so much the epitome of the charlatan, this painting would not, in fact, work at all.

SUNSET
Post Cover • April 24, 1926

PAGE 172

Again we have the theme of the puppy abandoned in favor of puppy love. This cover is rather well executed, but in this case Rockwell's treatment seems rather cloying by today's standards. Everything—from the sagging bench to the girl's dainty boots—seems a trifle too studied, too willfully cute. The whole thing is too close in sensibility to those kitsch portraits of small girls, with eyes the size of saucers, that were so popular during the 1950s and 60s.

DECLARATION OF INDEPENDENCE
Post Cover • May 29, 1926

PAGE 173

This cover celebrates the 150th anniversary of the signing of the Declaration of Independence. Appropriately —one might say, inevitably—Rockwell chose to mark the occasion by presenting us with one of the most illustrious of the signatories, Benjamin Franklin, who had founded The Saturday Evening Post almost half a century before he put his name to the Declaration.

THE SCHOLAR
Post Cover • June 26, 1926

PAGE 174

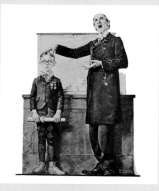

One can easily imagine that this bemedaled grind, offered by his teacher as a paragon, is not much loved by his classmates. Rockwell encourages us to identify with the latter by showing the scene as we might see it from one of the desks, looking up at the priggish scholar and his eulogist.

THE BOOKWORM
Post Cover • August 14, 1926
PAGE 175

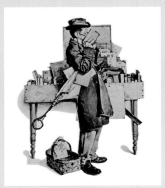

COULD this be the scholar of the previous cover grown old? We can easily imagine how one idea might have grown out of the other. The note on the basket tells us that priorities have changed, now that school days are left behind. But, no matter how pressing his errands, the true addict cannot stay away from books, especially those that have acquired a patina of age.

CONTENTMENT
Post Cover • August 28, 1926
PAGE 176

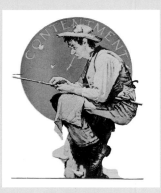

THIS is a straightforward ode to the old-fashioned summer pleasures, although—given the title emblazoned behind him—the fisherman looks a trifle morose. As in the similar *Literary Digest* cover painted five years earlier (p 53), color is used effectively to evoke the mood of a sultry August day.

A TEMPORARY SETBACK
Post Cover • October 2, 1926
PAGE 177

HERE a favorite theme is given a refreshing twist. Love has taken one of its unpredictable turns, and the young man's dog loses no time in re-establishing its credentials.

CHRISTMAS
Post Cover • December 4, 1926
PAGE 178

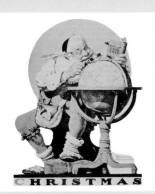

THIS is a fine example of a traditional Christmas cover. Santa, armed with a magnifying glass and his notorious list of "good boys," pores over a globe.

BACK TO SCHOOL
Post Cover • January 8, 1927
PAGE 179

THIS child has the hangdog expression of one of Rockwell's jilted puppies,

and, with its toppled Christmas tree and broken toy, this cover strives a little too hard to make its point.

THE LAW STUDENT
Post Cover • February 19, 1927
PAGE 180

THIS cover belongs to a period when the general public held the legal profession in far greater esteem than it does today. This earnest young student has pinned up the likenesses of his heroes, and clearly we are intended to see him as a link in a great tradition. The painting itself is solid, if unremarkable, displaying none of Rockwell's personal touches.

THE INTERLOPER
Post Cover • March 12, 1927
PAGE 181

THIS tough-looking character, poking his nose into the bookish affairs of the timid gent, is probably harmless enough. He just happens to be one of those people whose physical presence can all too easily become somewhat overbearing. Rockwell is completely at home with this kind of subject matter, and here, as so often, he expresses his theme through a skillful presentation of "body language."

SPRINGTIME
Post Cover • April 16, 1927
PAGE 182

ROCKWELL was seldom at his best with allegorical subjects, and this is a particularly unhappy example of the genre. The concept is banal, to say the least. In contrast with the many very real dogs and puppies that grace his work, the woodland creatures that he shows dancing round this boy are quite charmless, even grotesque. The general effect is that of Beatrix Potter travestied.

THE ARTIST
Post Cover • June 4, 1927
PAGE 183

LIKE the young man's Fair Isle sweater and plus fours, the hand-painted rain slicker was very much a vogue of the twenties, especially among college students. This couple is somewhat younger than college age, but they are clearly determined to stay abreast of fashion. The youth, with his faintly bohemian hat, is clearly a serious craftsman. It is a charming cover with a distinctly documentary feel.

PIONEER
Post Cover • July 23, 1927
PAGE 184

IN May of 1927 Charles Lindbergh piloted his tiny Ryan monoplane across the Atlantic. It was the most significant event in aviation history since the Wright brothers had succeeded in flying the first self-propelled heavier-than-air machine almost a quarter century earlier. This allegory seems less a direct tribute to Lindbergh than an ode to aviators in general, presenting them as a new breed of pioneers and the natural heirs of the men and women who colonized the New World.

DREAMS OF LONG AGO
Post Cover • August 13, 1927
PAGE 185

THIS old cowhand relives his youth on the frontier with the aid of Gramophone records of cowboy songs; or perhaps this is actually a city dude who likes to dress up on weekends and exercise his imagination. This might be described as a "prop" picture, one that may well have been suggested by certain of the props in Rockwell's studio—the old phonograph, the Western clothes. Fortunately, the artist was able to call on just the right model to bring the scene to life.

A NEW HAIRSTYLE
Post Cover • September 24, 1927
PAGE 186

WHILE Rockwell seems to have had a special feeling for Victorian subject matter, he was not always so successful when dealing with other periods. This cover—with its foppish hairdresser and its intent young beauty—seems rather arid. We feel we are looking at models rather than real people. Once again, it seems reasonable to suppose that this picture may have been suggested by props in Rockwell's studio.

TEA TIME
Post Cover • October 22, 1927
PAGE 187

AN elderly couple enjoys tea in front of the fire. This cozy domestic scene is presented entirely for its own sake—there is no anecdotal incident involved—and it is painted in a low-keyed, academic style, which is appropriate enough, given the subject matter.

CHRISTMAS

Post Cover • December 3, 1927

PAGE 188

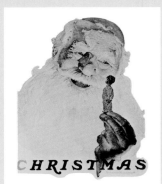

THERE is something vaguely disquieting about this giant Santa Claus balancing a small boy on his finger tips. Clearly, it is intended that Santa be seen as a benevolent figure, but one cannot escape the dreadful thought that he might, at any moment, be tempted to pop the child into his mouth, then wash the snack down with a glass of eggnog.

UNCLE SAM TAKES WINGS

Post Cover • January 21, 1928

PAGE 189

ANOTHER celebration of aviation, this time treated more humorously. Uncle Sam seems very pleased with himself, and Rockwell provides him with a light, airy composition. The painting is relatively slight, but it succeeds in evoking the intended mood.

ADVENTURERS

Post Cover • April 14, 1928

PAGE 190

ROCKWELL'S notion that the thinkers who pored over maps and globes were adventurers—every bit as much as the men of action who sailed their flimsy boats into uncharted oceans—is a sound one. But it's hard to understand why he presented the idea as if it were an inn sign painted by an imitator of Frank Brangwyn. This cover belongs to a moribund school of illustration, one from which Rockwell's better and fresher work helped release us.

SPRING

Post Cover • May 5, 1928

PAGE 191

WHAT we are given here is a curiously militaristic celebration of the arrival of spring, one which seems to have very little charm when we look back on it now. The composition works well enough, but it is difficult to find much to admire in this rather odd cover.

MAN PAINTING FLAGPOLE

Post Cover • May 26, 1928

PAGE 192

A definite return to form is apparent in this painting, one of the best things Rockwell did at this period. Utilizing once again a favorite model, James K. Van Brunt, Rockwell evokes a cheerful painter gilding the eagle at the top of a flagpole. There is nothing especially clever about the concept, but the whole thing is beautifully observed and lovingly executed.

WEDDING MARCH

Post Cover • June 23, 1928

PAGE 193

INSTEAD of giving us the June bride, Rockwell presents us with the organist who is about to lend drama to her progress down the aisle. We can imagine, easily enough, what he sees out of the corner of his eye; and this cover is a good example of how Rockwell could conjure up a whole event by showing us only one almost inconsequential aspect of the proceedings.

THE CRITIC
Post Cover • *July 21, 1928*
PAGE 194

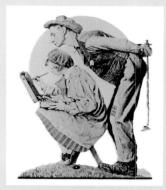

WE can assume that this yokel is very familiar with the scene the girl is painting, and so he feels a proprietary interest in the representation she is laboring over. She, for her part, is so wrapped up in her work that she seems hardly aware of his intrusion. We hope his remarks will not be ignored and will offer constructive criticism.

FLEEING HOBO
Post Cover • *August 18, 1928*
PAGE 195

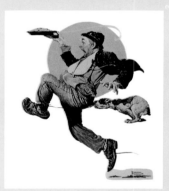

THE notion that hobos were in the habit of stealing pies left to cool on the kitchen window-sill cropped up frequently in the folklore of the twenties. This, then, is a conventional piece of subject matter, but the treatment is certainly vigorous, and Rockwell makes the most of his material. One can see that this must have been a very eye-catching cover during its brief newsstand life.

SERENADE
Post Cover • *September 22, 1928*
PAGE 196

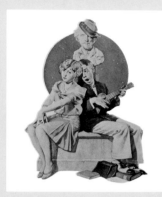

THIS painting is a reworking of the theme that first appeared as a *Post* cover in August, 1924 (p 146). The clothes have been updated, and the musical instrument is now a ukulele—the ubiquitous favorite of amateur crooners in the late twenties—but the rest remains almost the same. The boy wears an expression very close to that worn by his predecessor, and the girl strikes a pose very similar to that of her predecessor, although we see her from a slightly different angle. Her legs are more bent, and her fingers a trifle more tangled, but it's quite clear that Rockwell referred back to his earlier effort before beginning work on this one.

MERRIE CHRISTMAS
Post Cover • *December 8, 1928*
PAGE 197

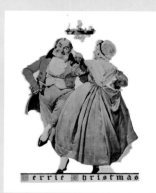

ANOTHER Dickensian Christmas cover, not as strong as some, but still in the spirit of earlier examples. Its weakness lies in the characters who are less particularized than in Rockwell's better work.

GOSSIPS
Post Cover • *January 12, 1929*
PAGE 198

BY making these three old women seem almost like parts of a single organism, Rockwell emphasizes the covert nature of the information they are exchanging. The women themselves, however, are rather stereotyped, and one feels that Rockwell has, in this instance, saved most of his affection for the fabric of the women's clothes.

THE AGE OF CHIVALRY
Post Cover • *February 16, 1929*
PAGE 199

HERE Rockwell gives us the unusual experience of observing the world from within a lighted fireplace. The man sleeping in front of the flames dreams of bygone days. The artist employs chiaroscuro to give a sense of depth to the image; the play of light and shadow is manipulated so that the domestic setting merges seamlessly with the imaginary world of chivalry.

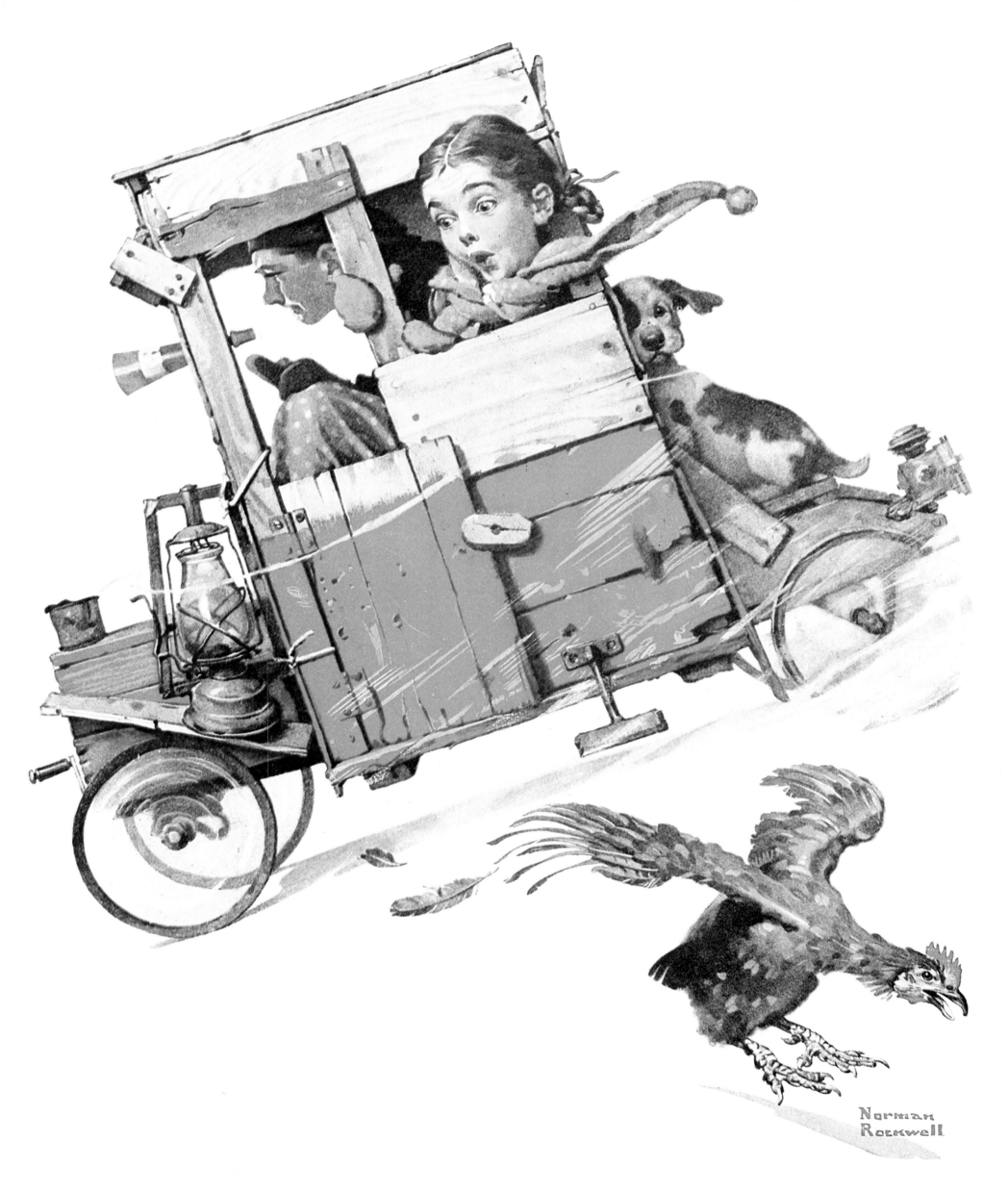

SOAP BOX RACER
Post Cover • January 9, 1926

169

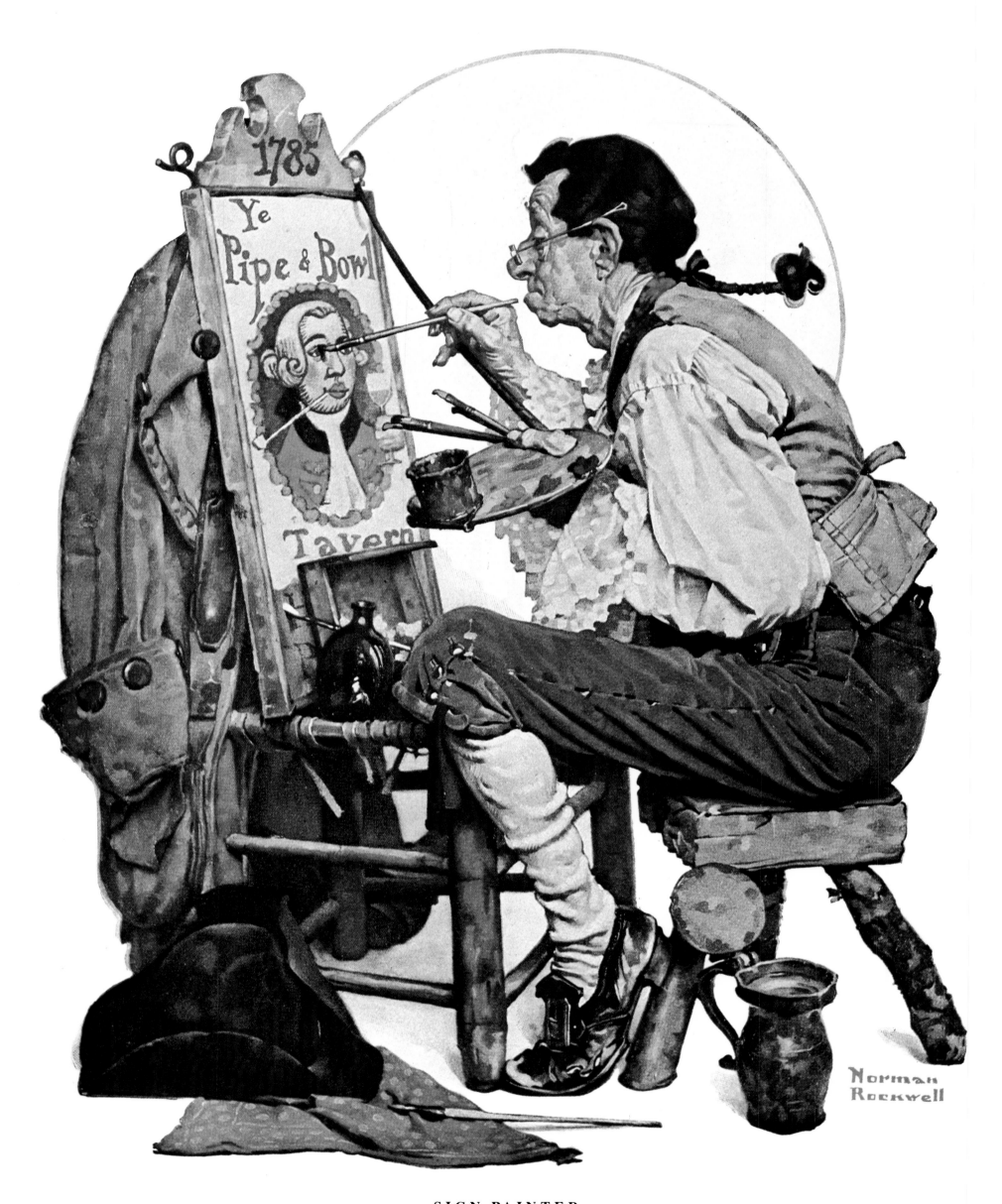

SIGN PAINTER

Post Cover • February 6, 1926

170

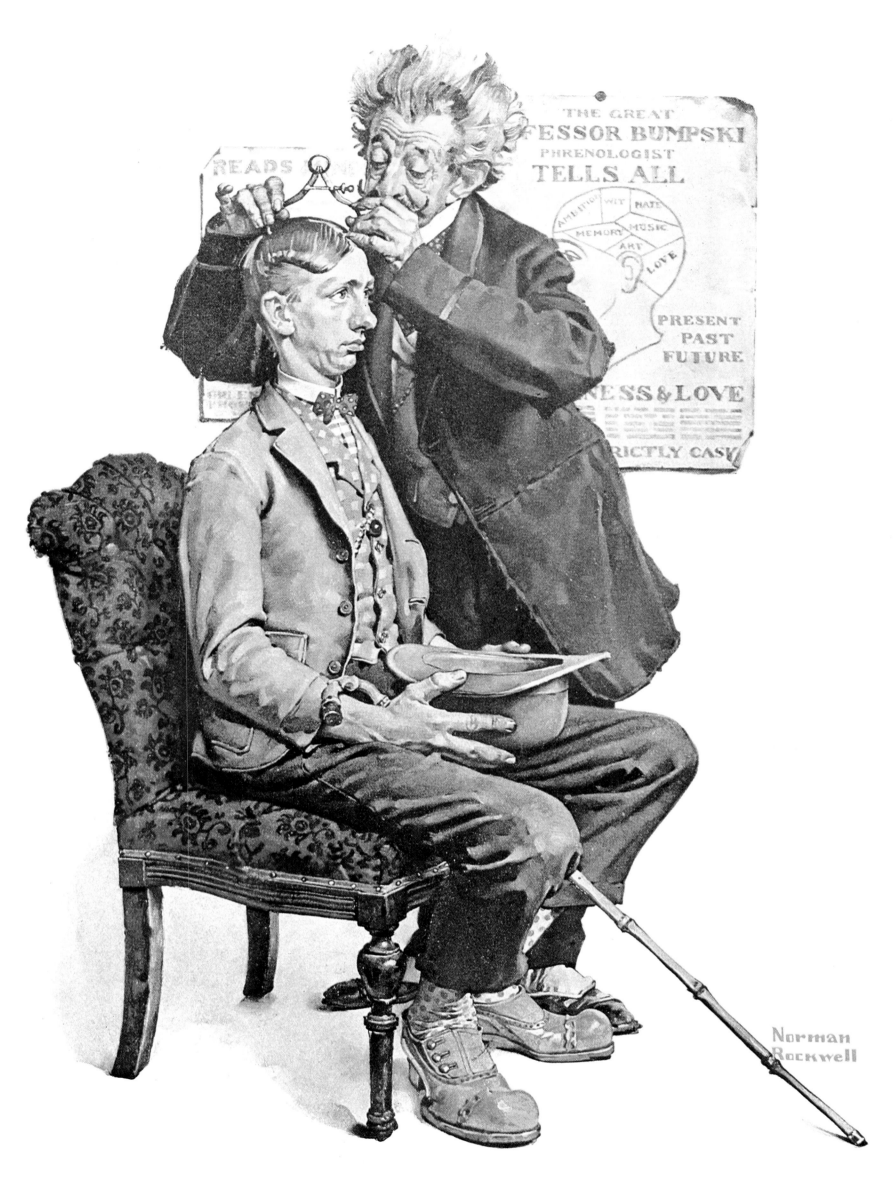

PHRENOLOGIST

Post Cover • March 27, 1926

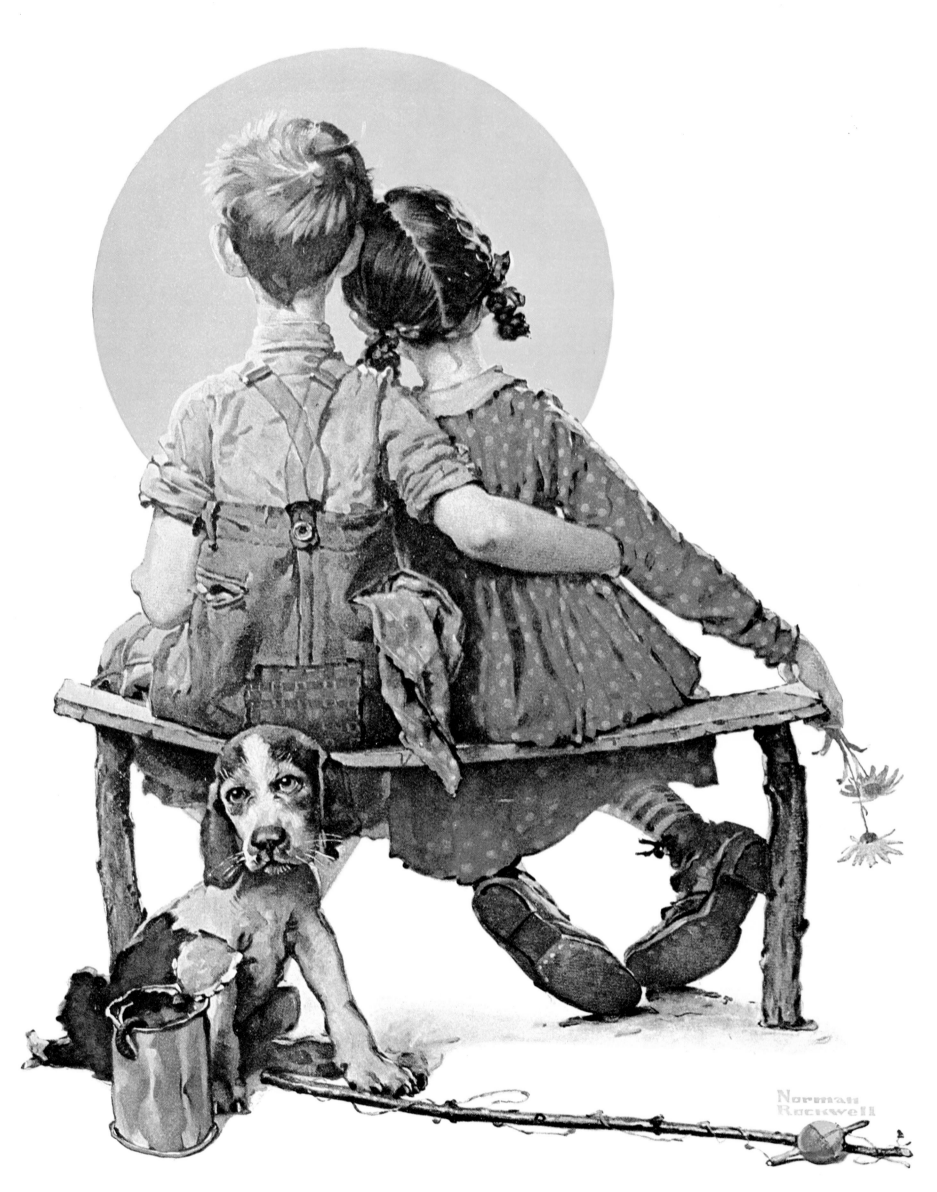

SUNSET

Post Cover • April 24, 1926

172

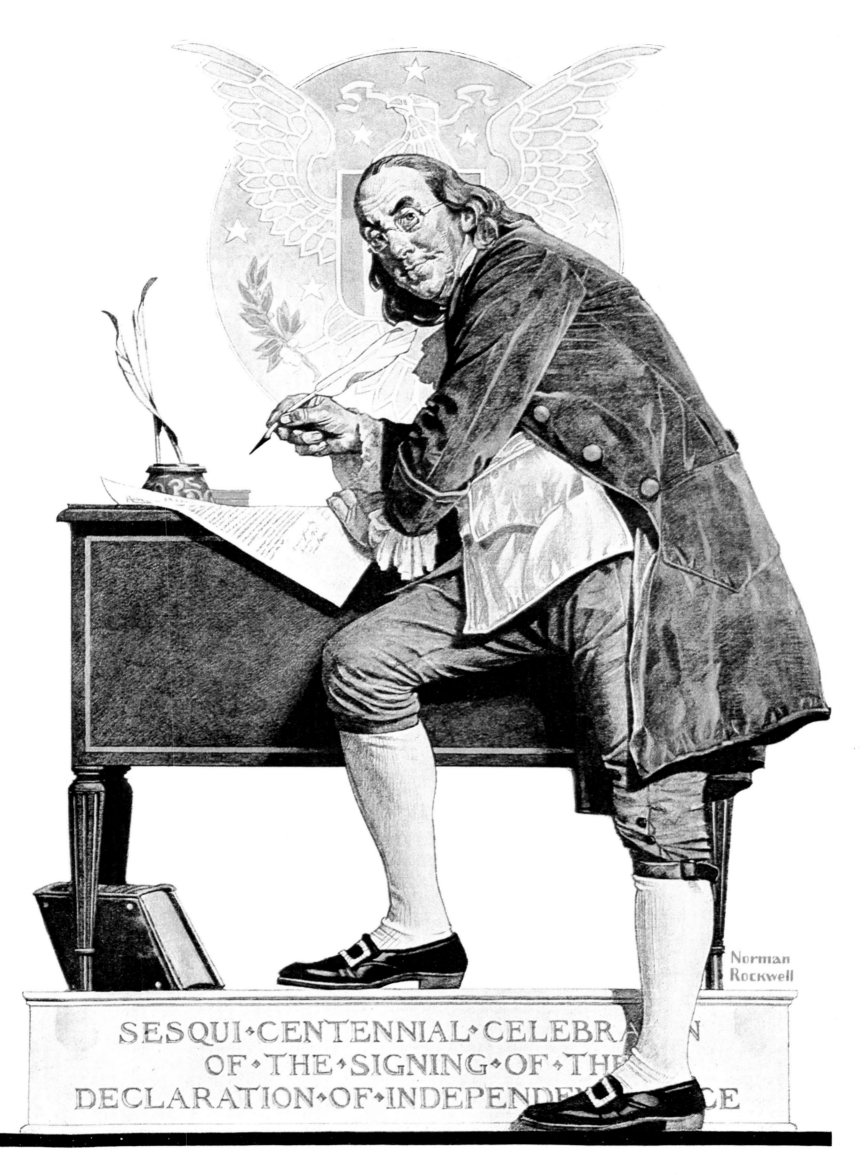

SESQUI·CENTENNIAL·CELEBRATION
OF·THE·SIGNING·OF·THE
DECLARATION·OF·INDEPENDENCE

DECLARATION OF INDEPENDENCE
Post Cover • May 29, 1926

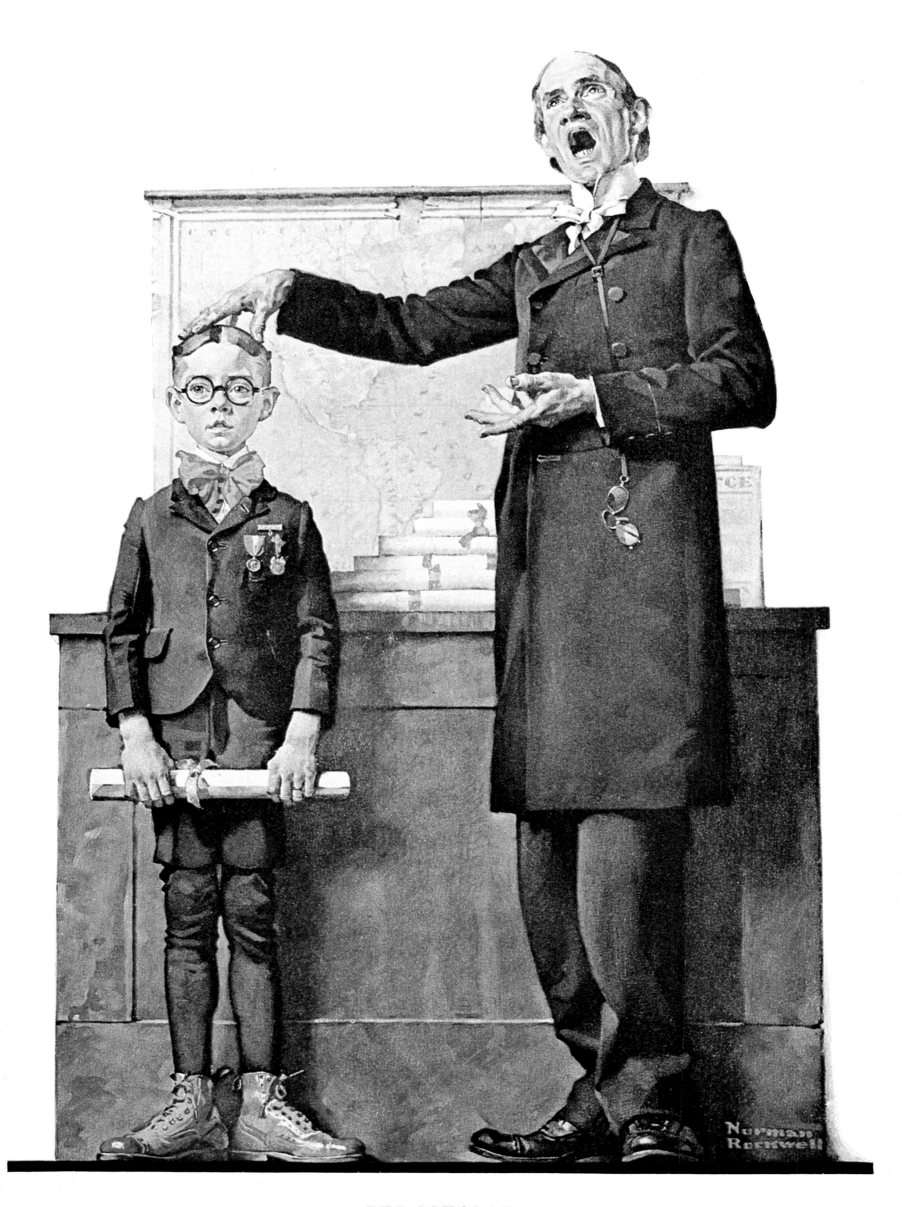

THE SCHOLAR

Post Cover • June 26, 1926

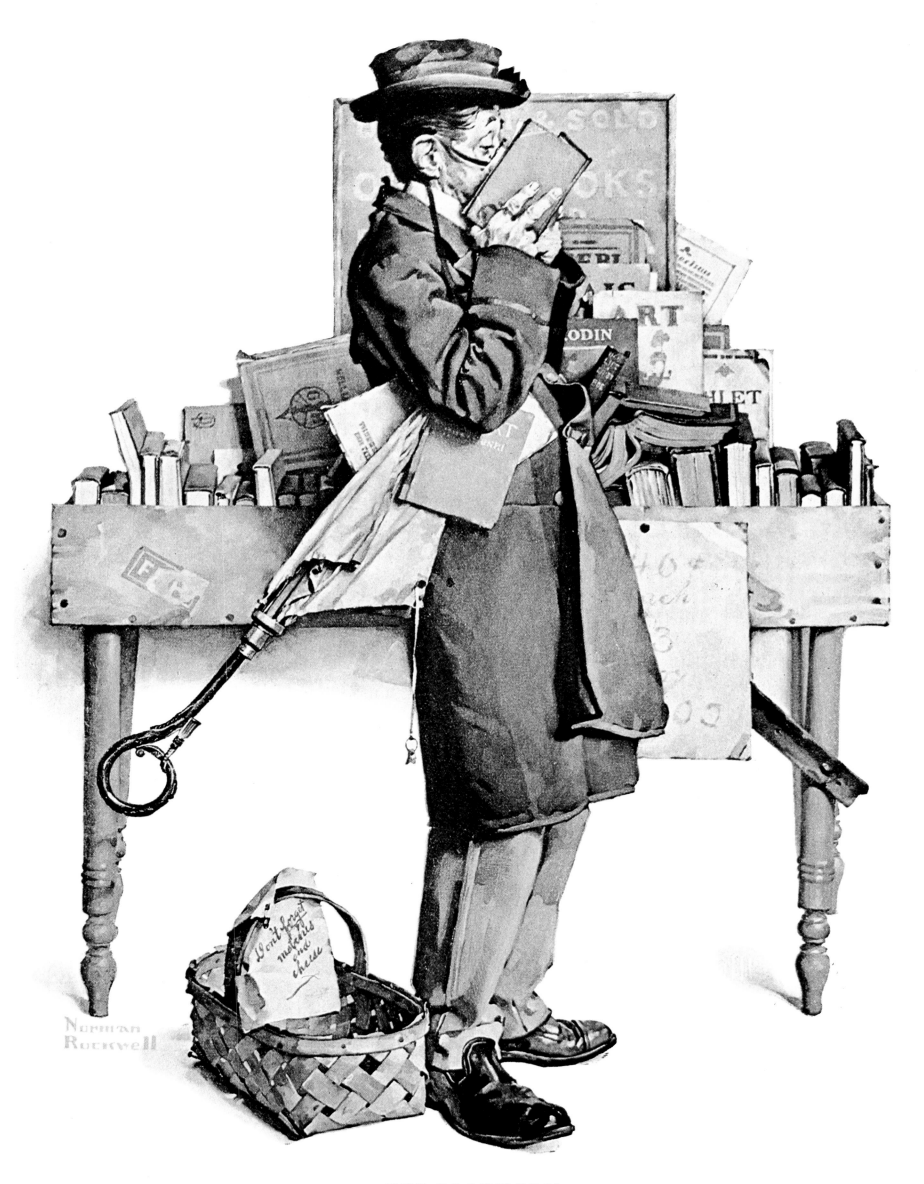

THE BOOKWORM

Post Cover • August 14, 1926

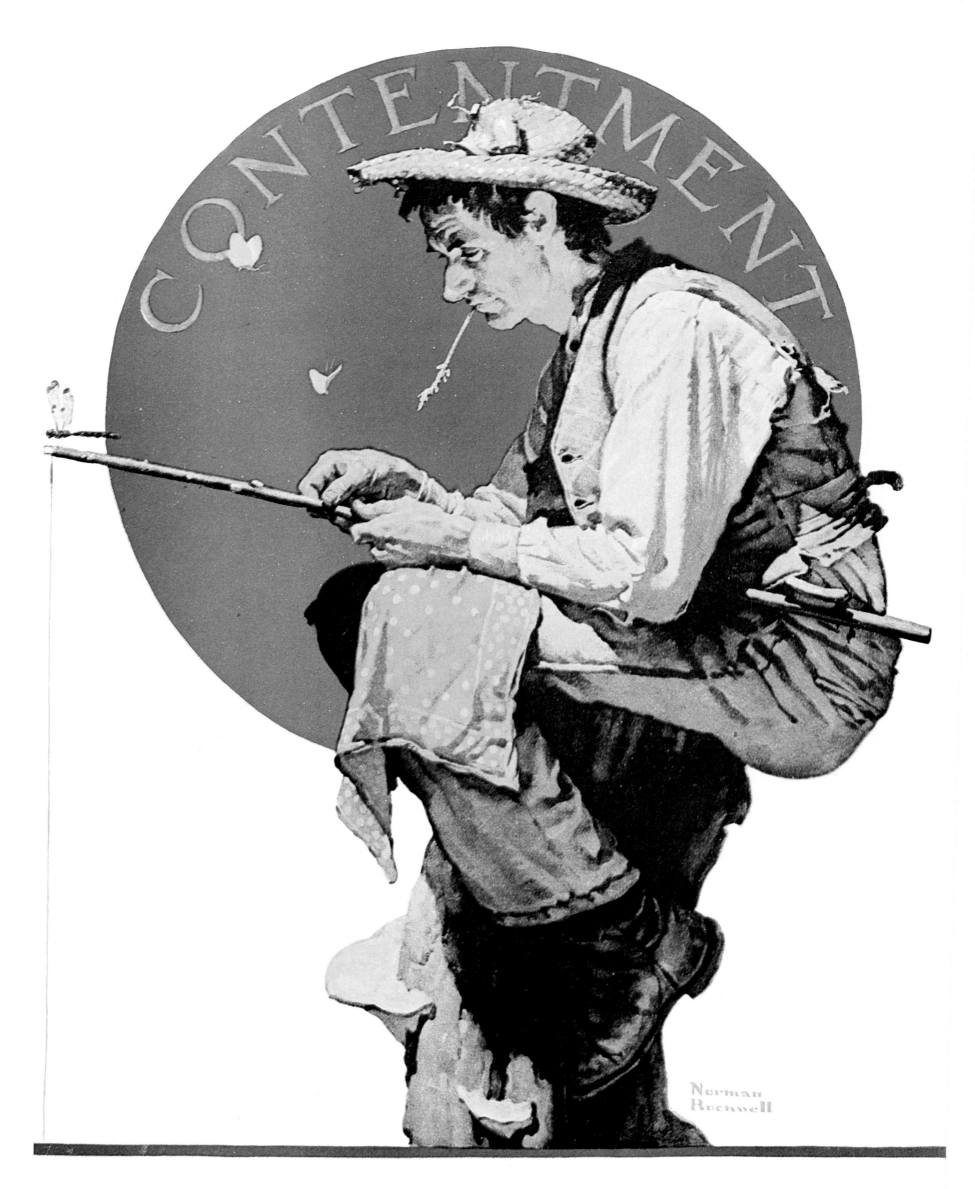

CONTENTMENT

Post Cover • August 28, 1926

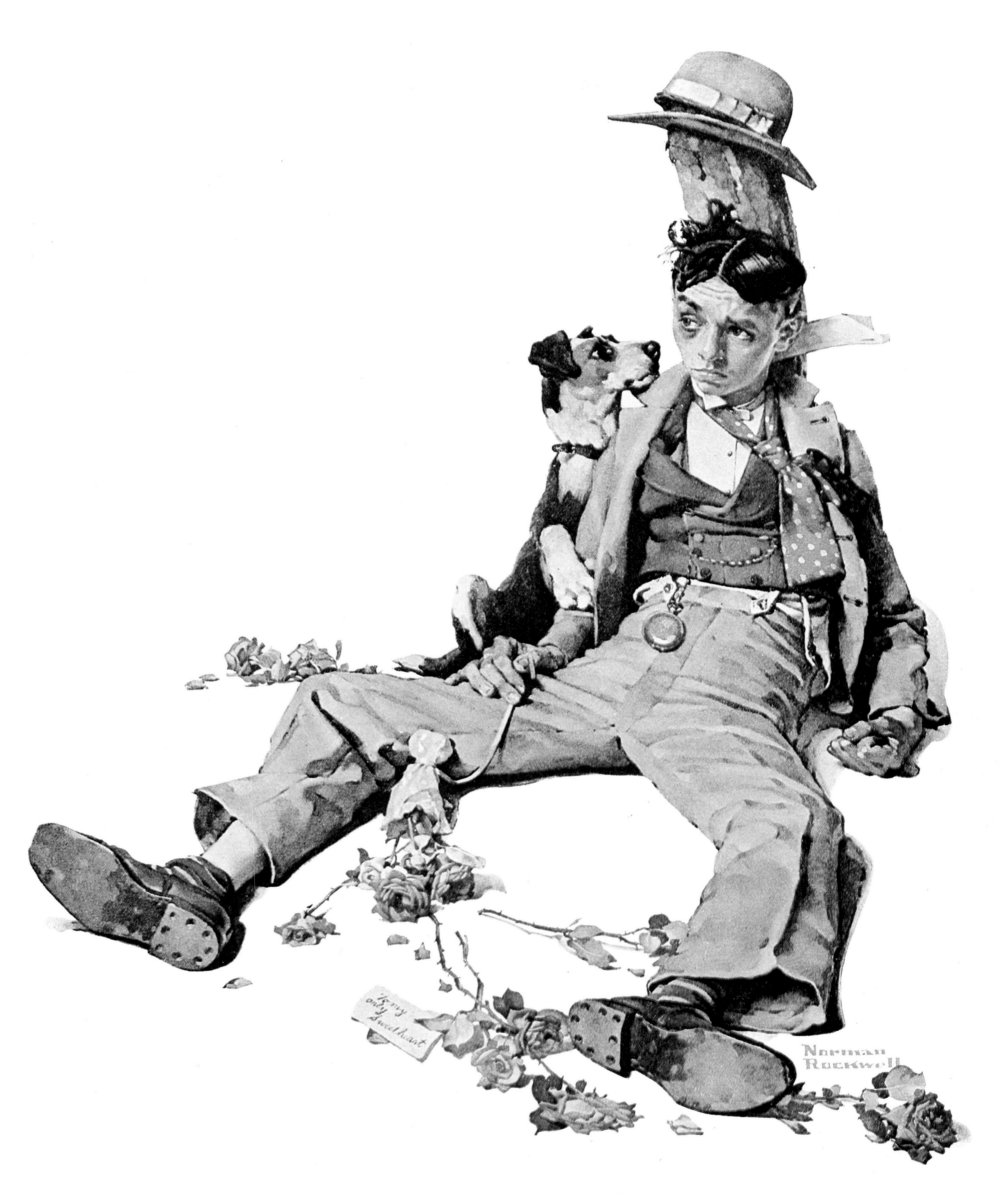

A TEMPORARY SETBACK

Post Cover • October 2, 1926

177

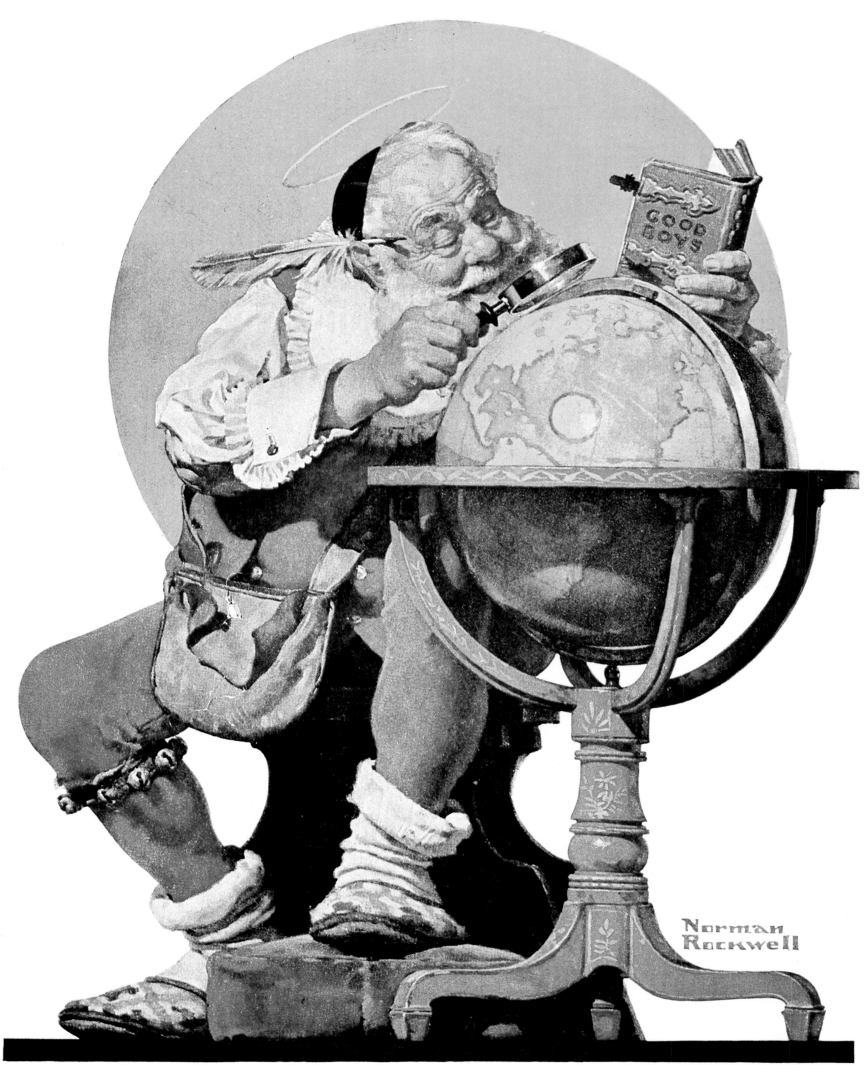

CHRISTMAS

Post Cover • December 4, 1926

178

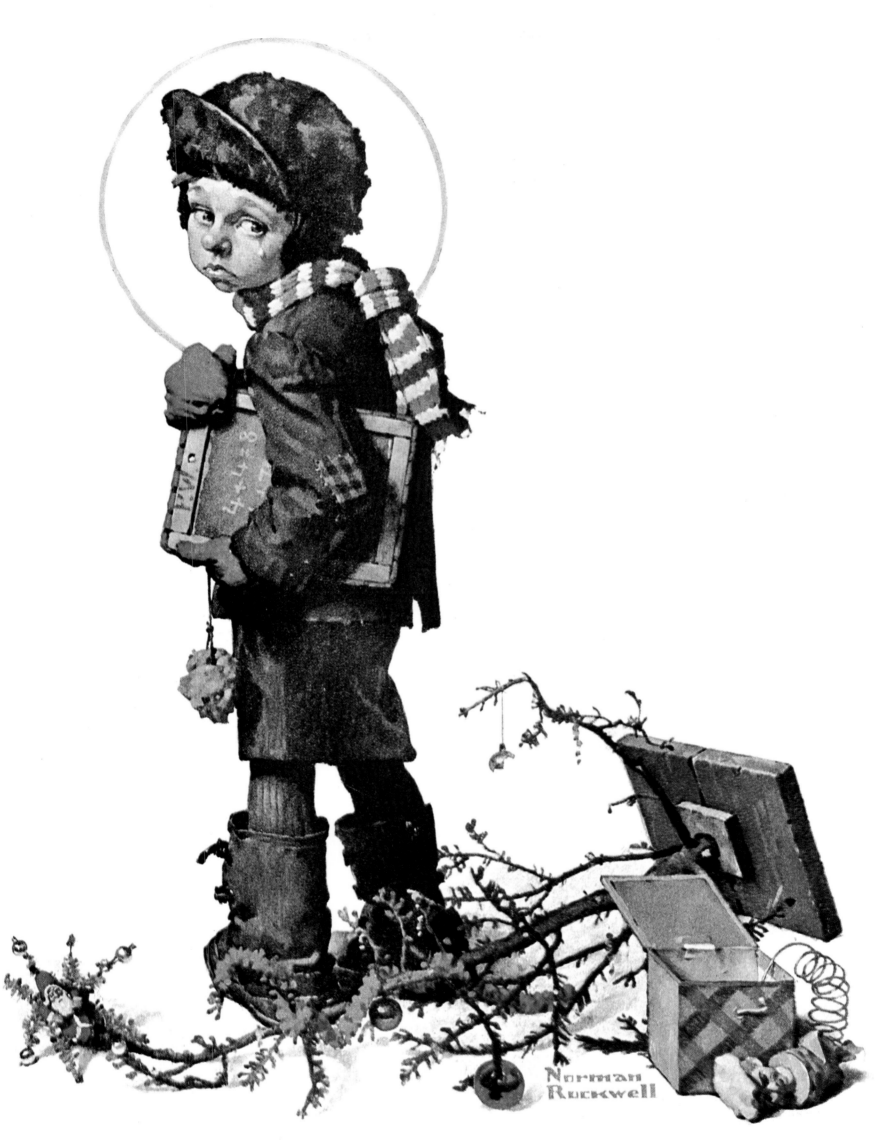

BACK TO SCHOOL
Post Cover • January 8, 1927

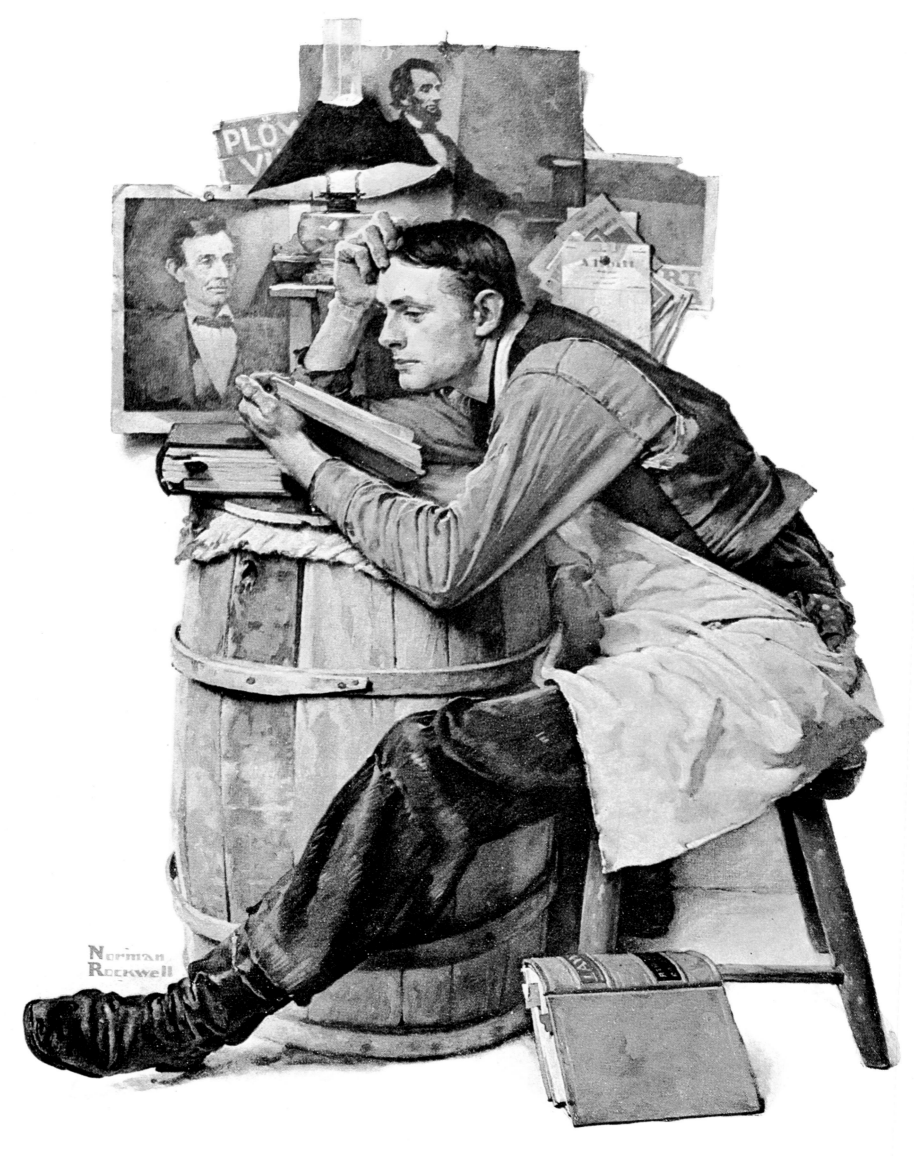

THE LAW STUDENT

Post Cover • February 19, 1927

180

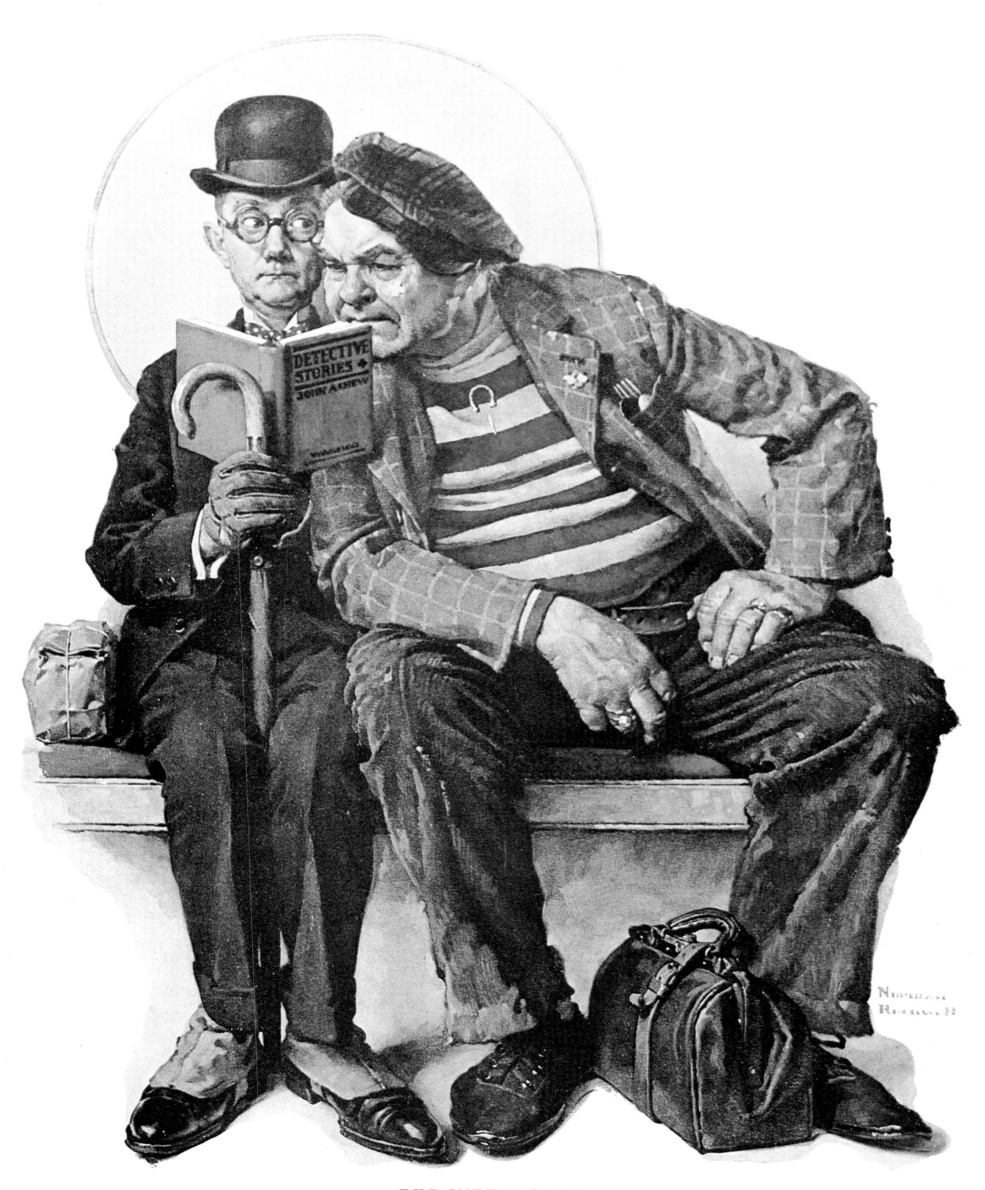

THE INTERLOPER
Post Cover • March 12, 1927

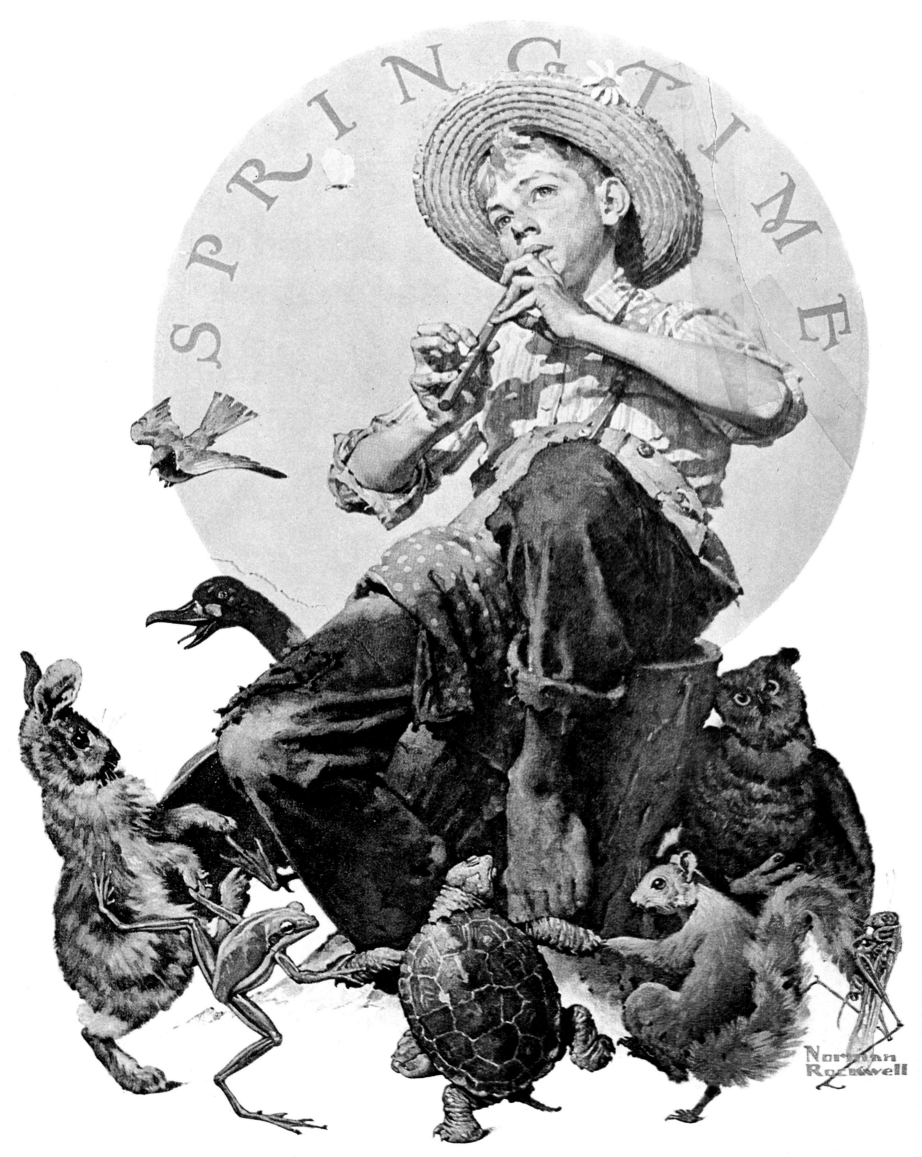

SPRINGTIME

Post Cover • April 16, 1927

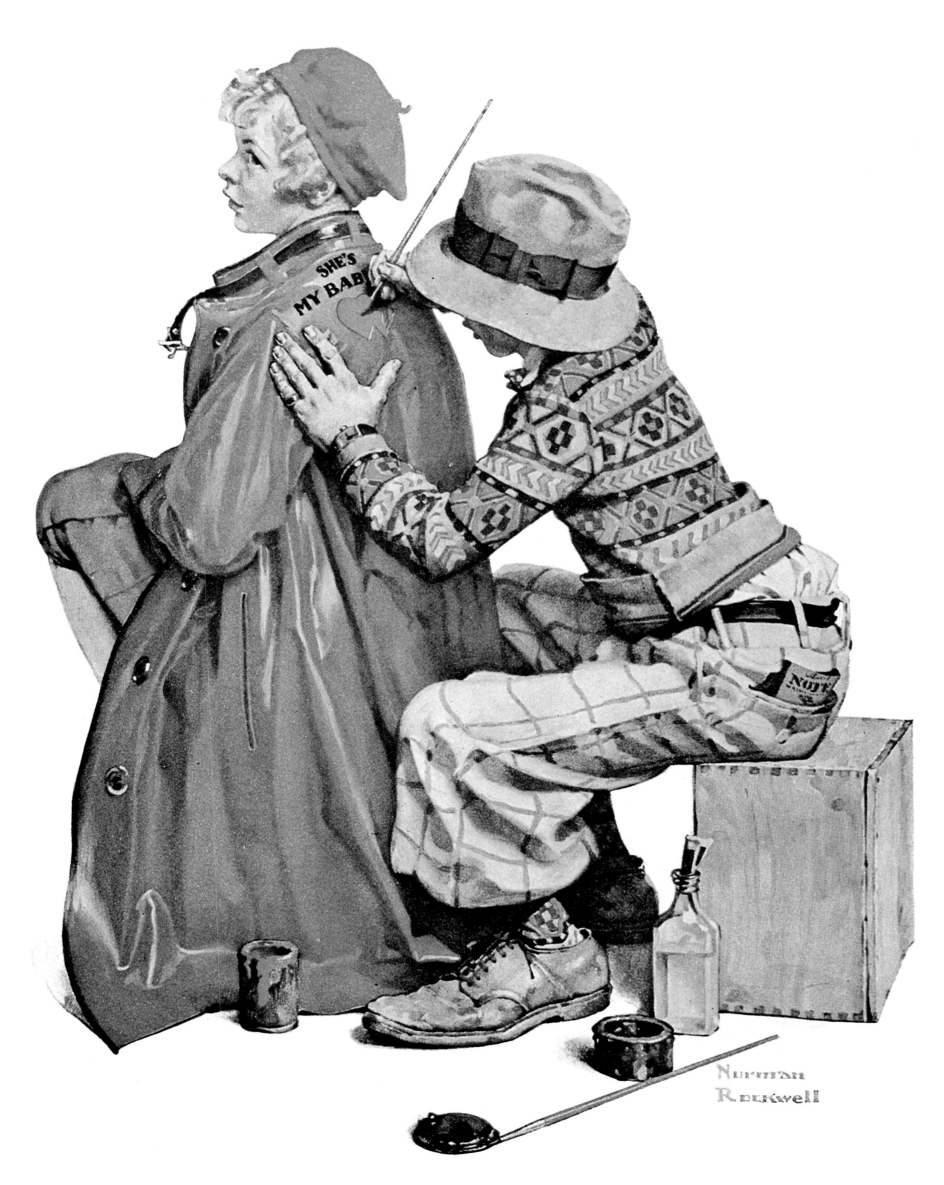

THE ARTIST
Post Cover • June 4, 1927

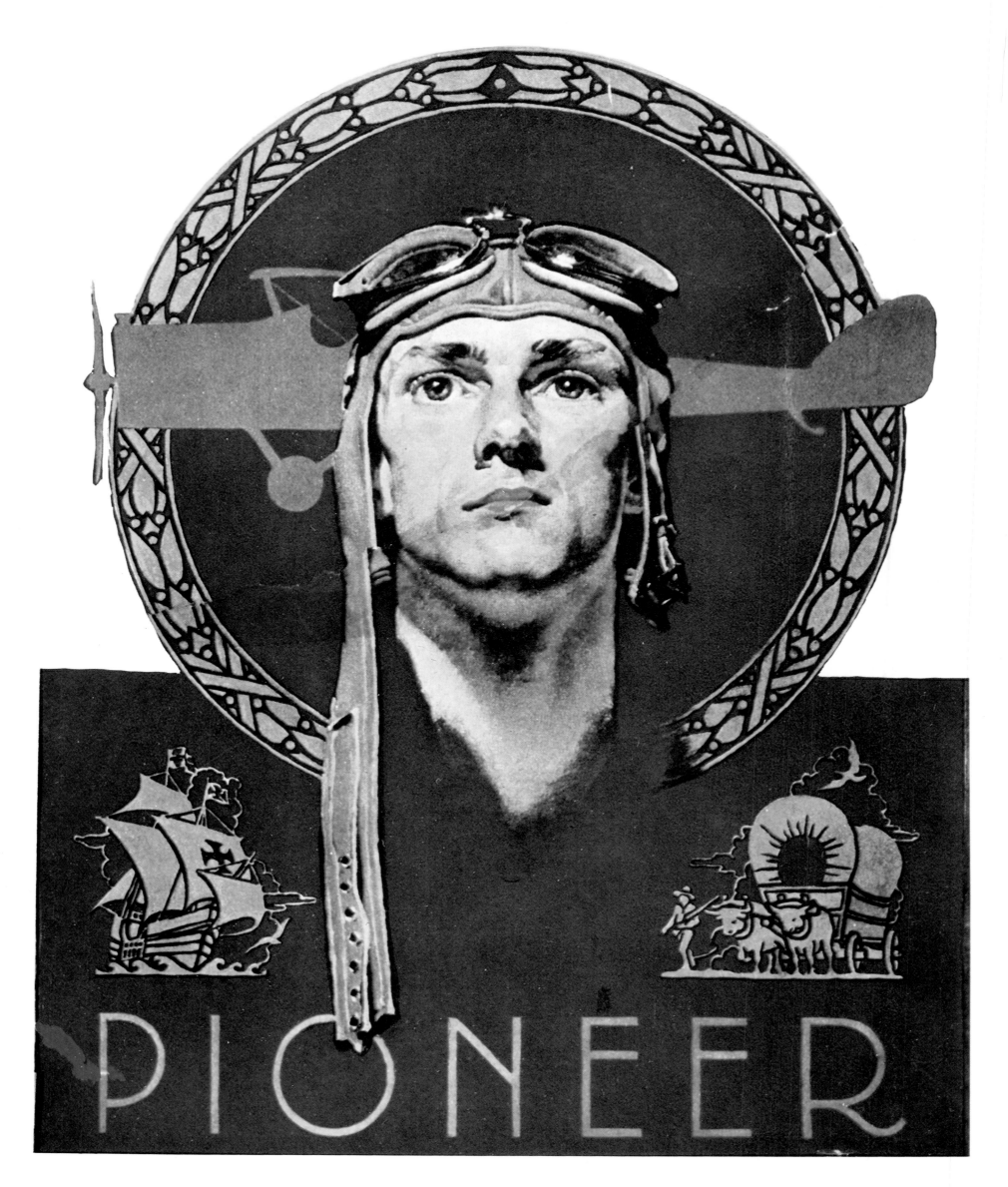

PIONEER

Post Cover • July 23, 1927

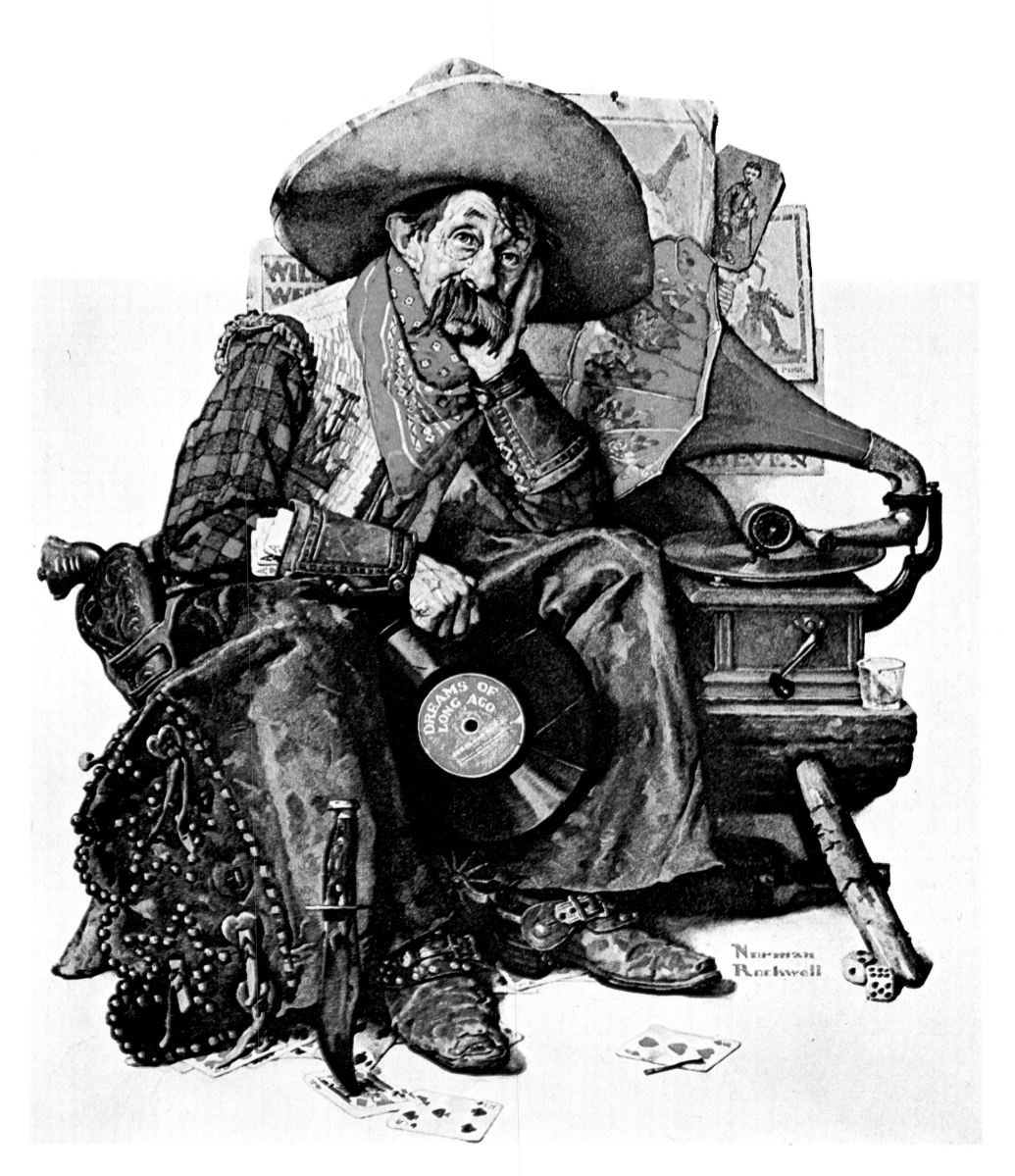

DREAMS OF LONG AGO

Post Cover • August 13, 1927

185

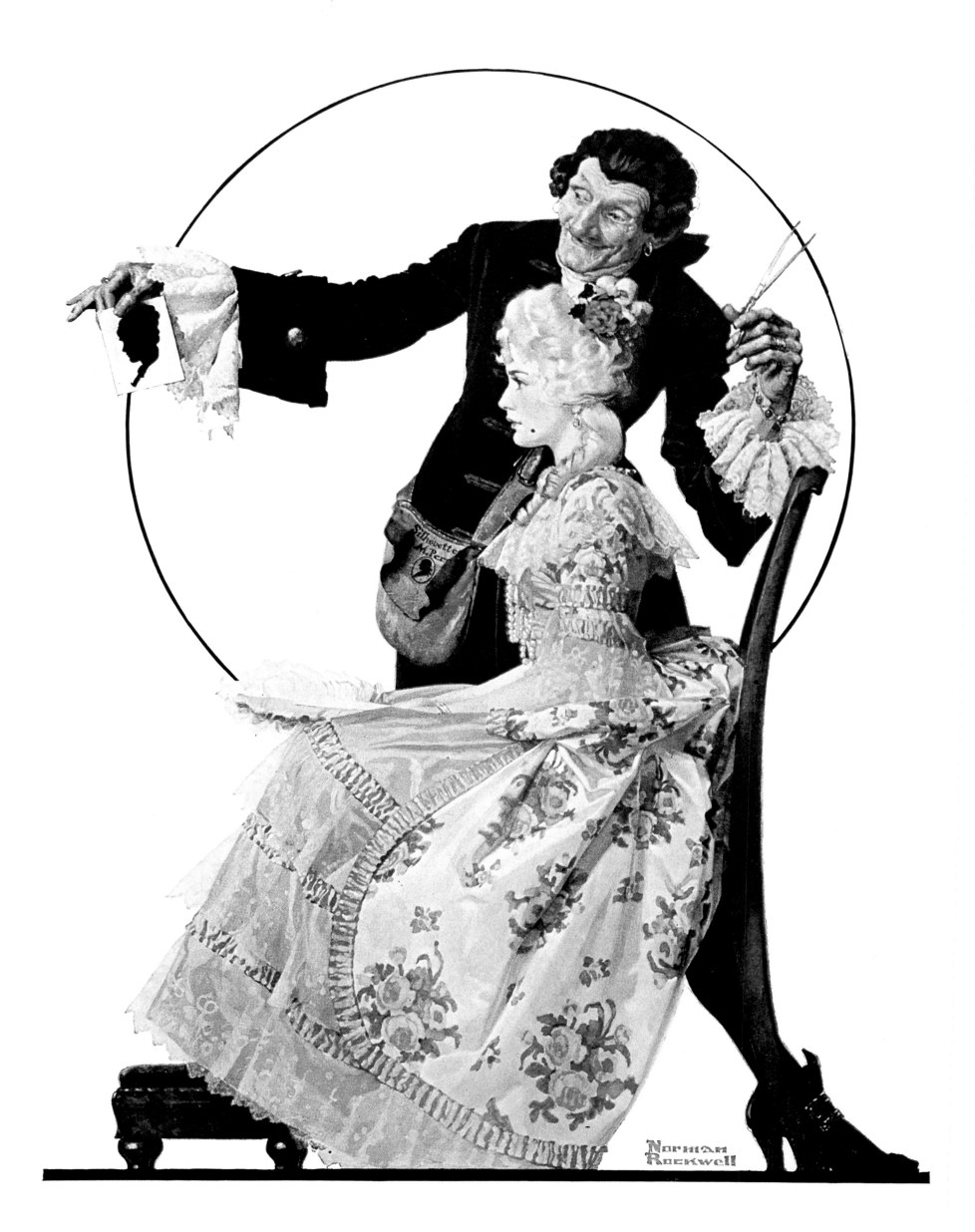

A NEW HAIRSTYLE
Post Cover • September 24, 1927

TEA TIME

Post Cover • October 22, 1927

187

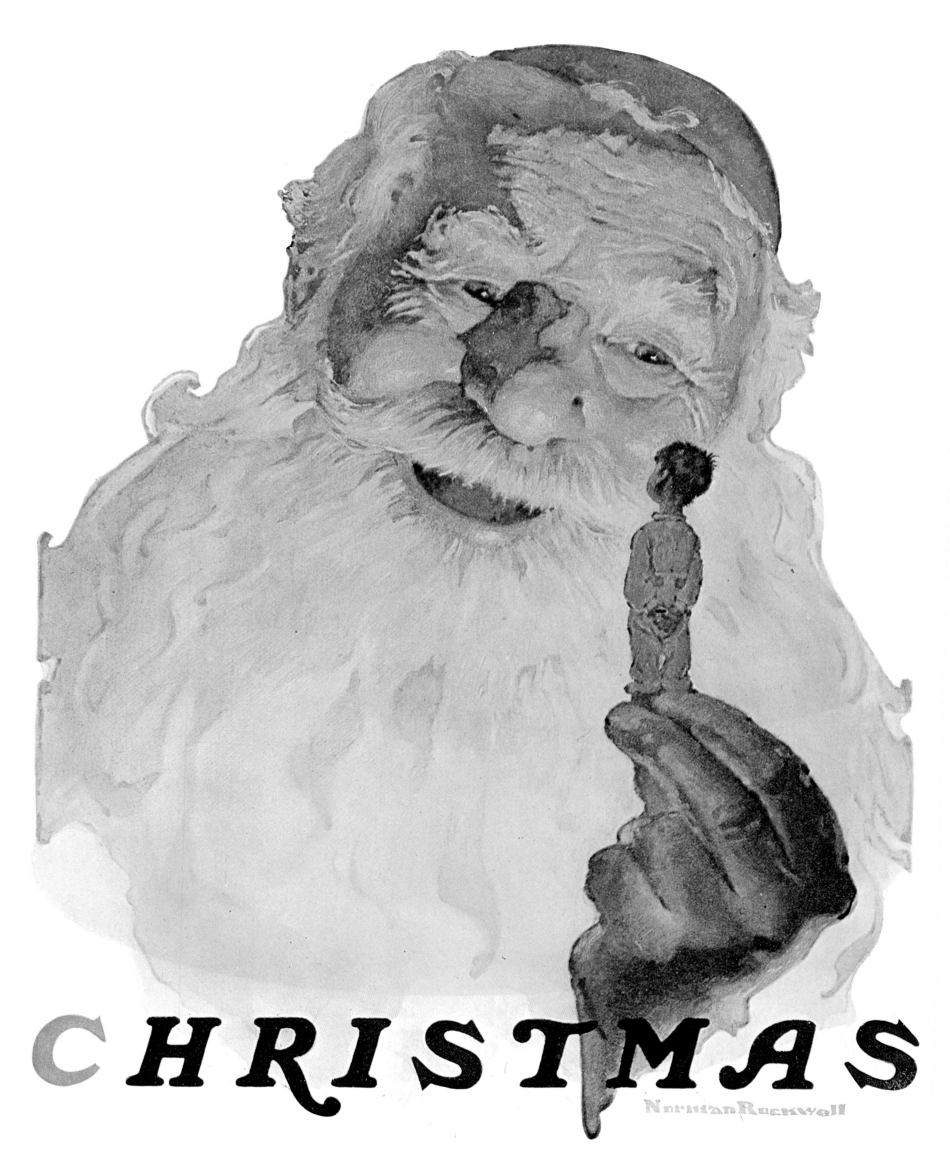

CHRISTMAS

CHRISTMAS
Post Cover • December 3, 1927

188

UNCLE SAM TAKES WINGS
Post Cover • January 21, 1928

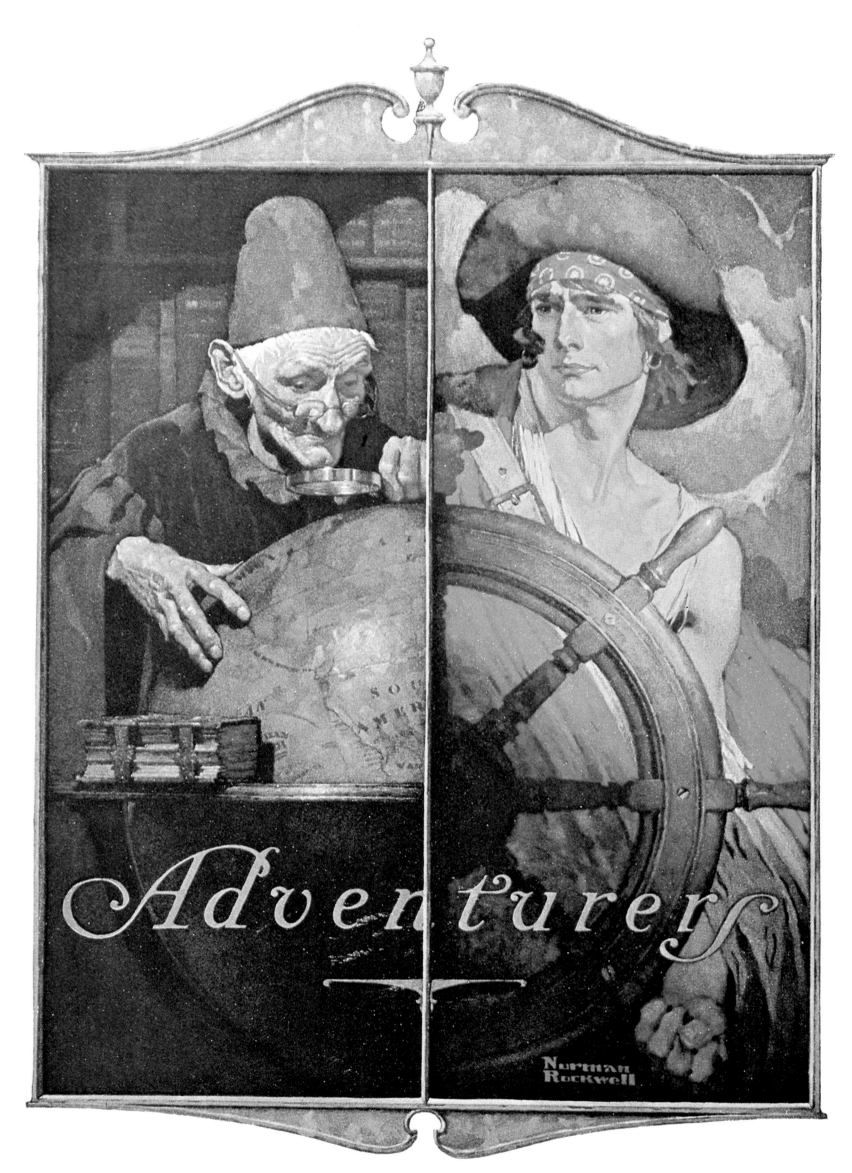

ADVENTURERS
Post Cover • April 14, 1928

SPRING

Post Cover • May 5, 1928

191

**MAN PAINTING
FLAGPOLE**
Post Cover • May 26, 1928

192

WEDDING MARCH

Post Cover • June 23, 1928

193

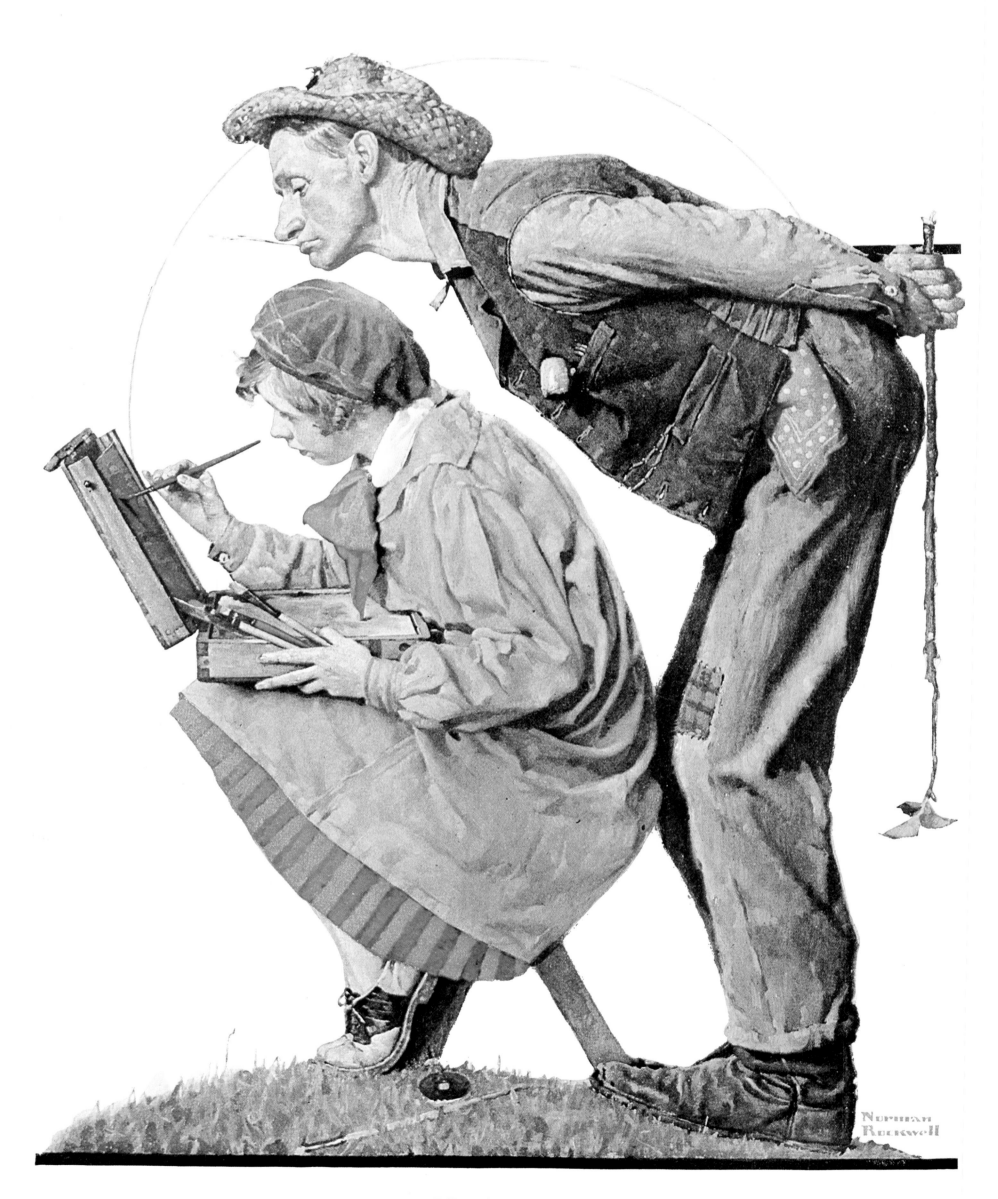

THE CRITIC
Post Cover • July 21, 1928
194

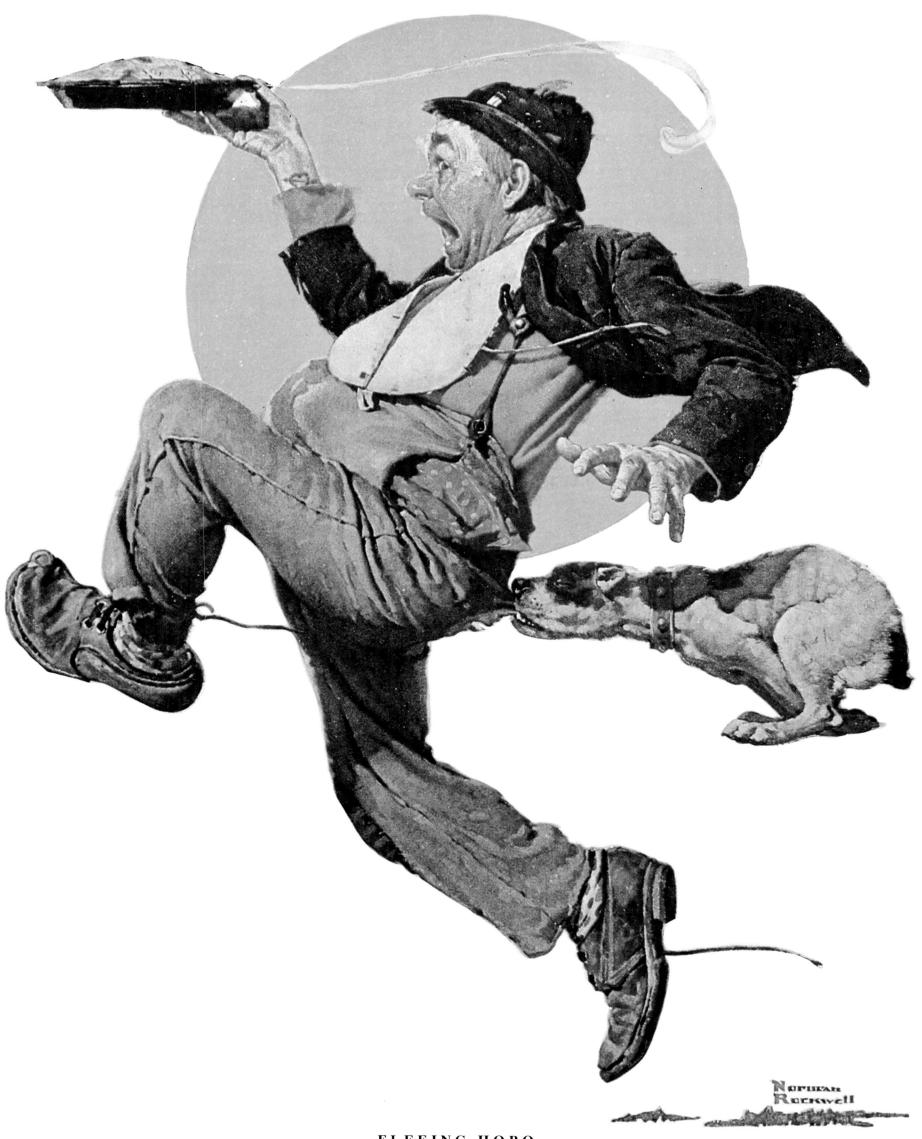

FLEEING HOBO

Post Cover • August 18, 1928

195

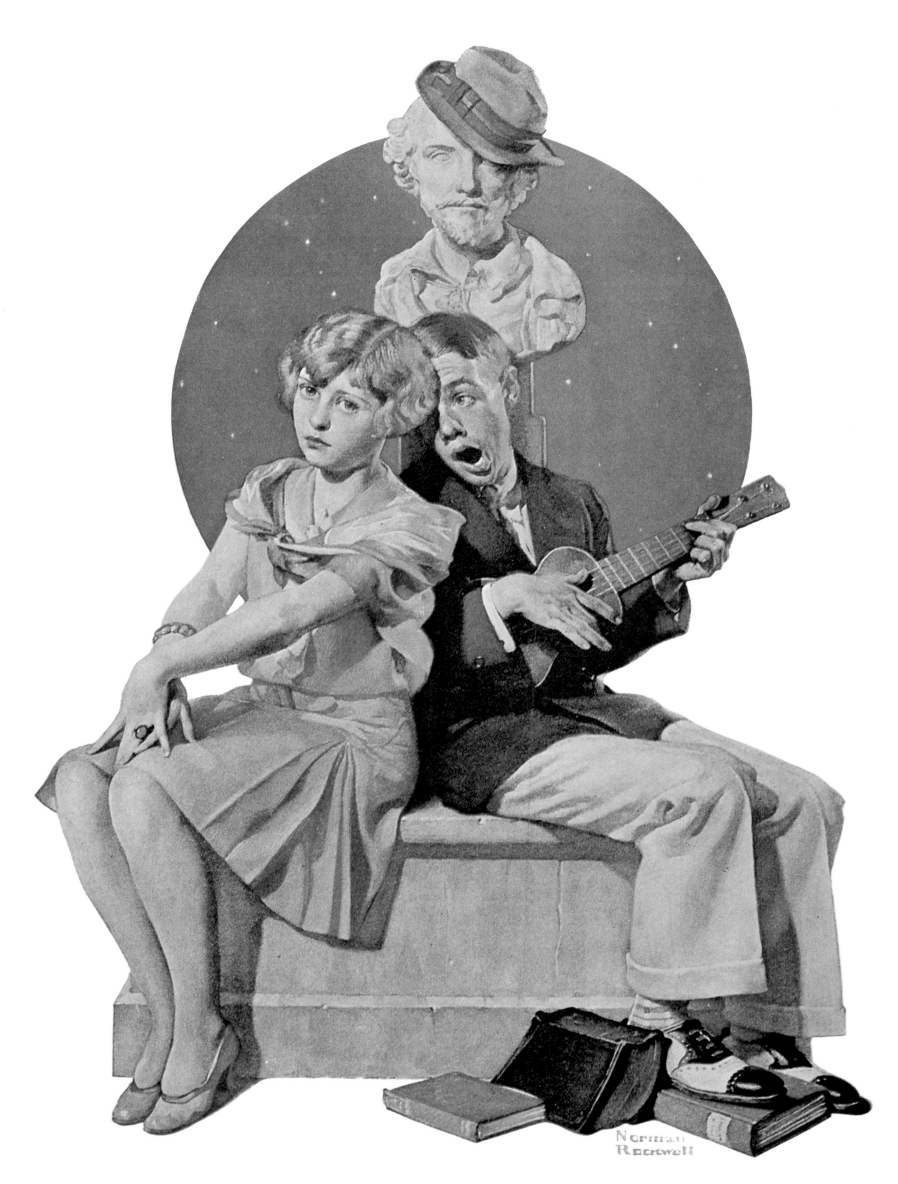

SERENADE

Post Cover • September 22, 1928

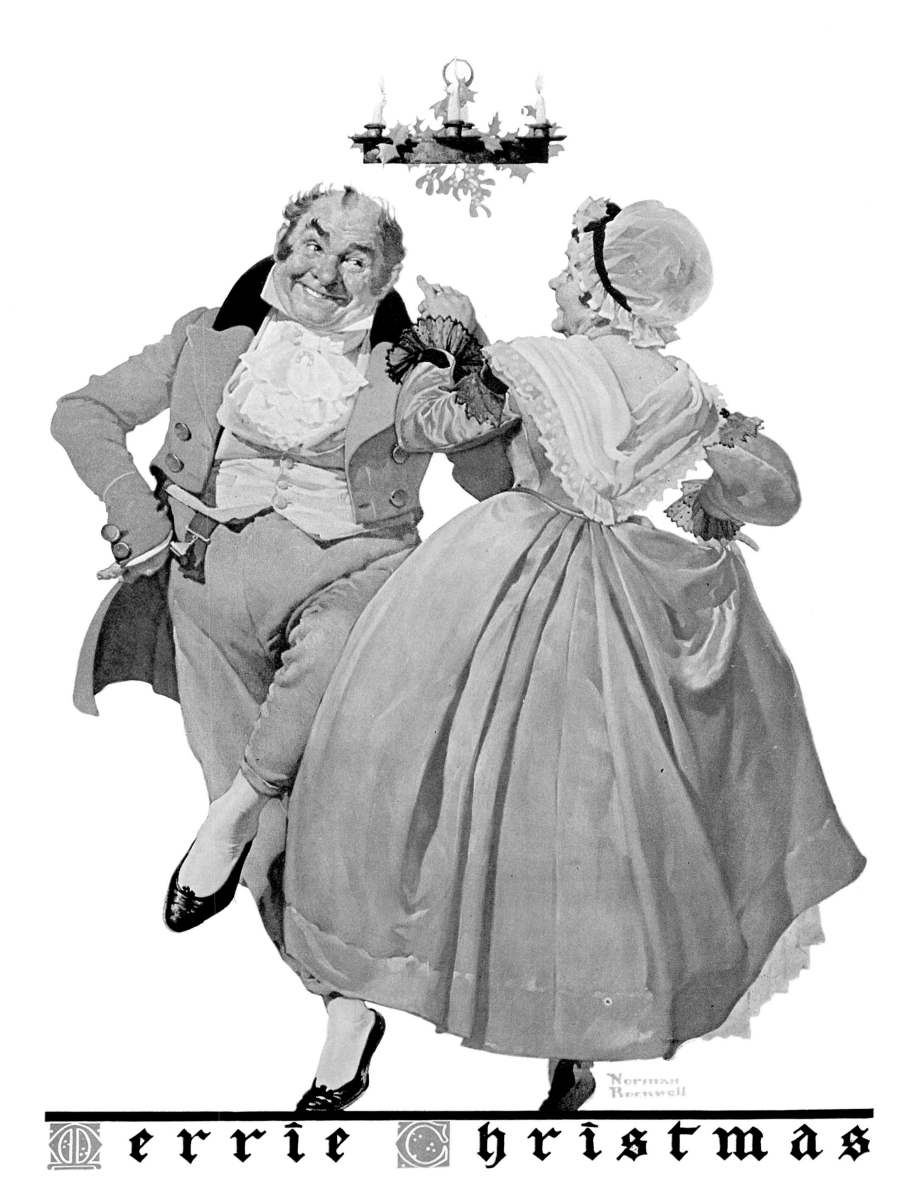

MERRIE CHRISTMAS

Post Cover • December 8, 1928

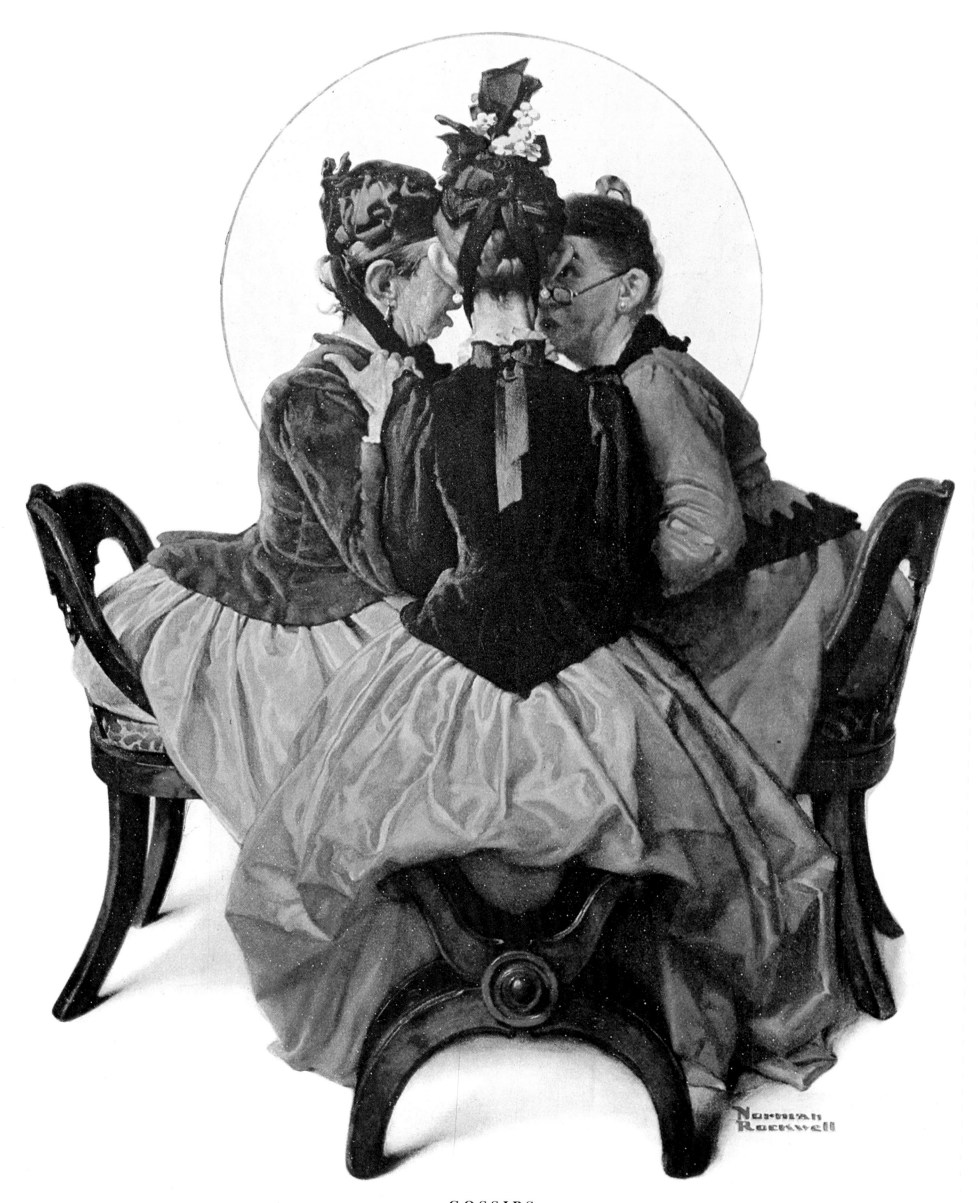

GOSSIPS

Post Cover • January 12, 1929

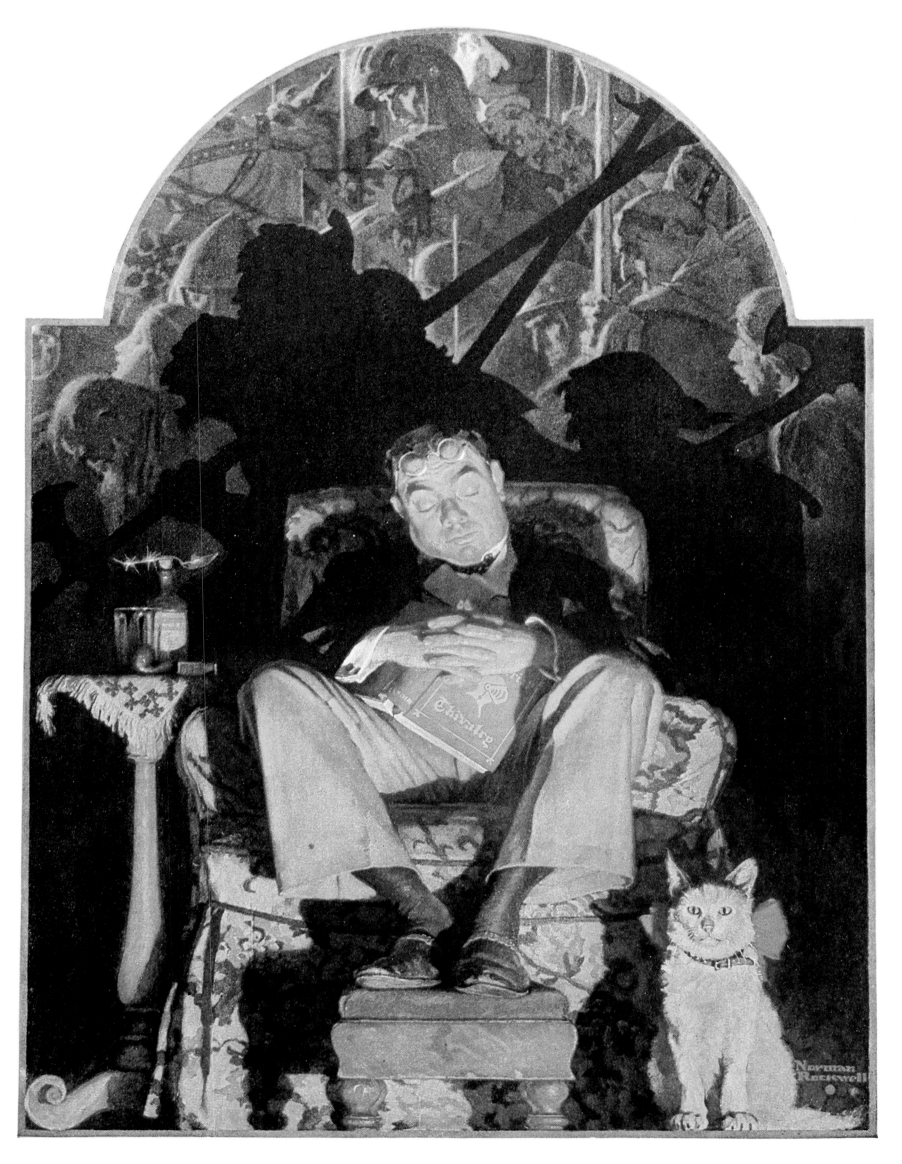

THE AGE OF CHIVALRY

Post Cover • February 16, 1929

Rockwell Was One of the Lucky Few Who Was Not Much Affected by the Depression

———

OCTOBER 29, 1929, BLACK TUESDAY, marks the Wall Street Crash, the day the stock market suffered its most devastating losses. In fact, although there were intermittent hints that it might rally—even on the Wednesday and Thursday following Black Tuesday—the collapse of the market was a painfully drawn-out affair. It began in September as a slow slide, then gathered momentum, and became, in the last week of October and the first half of November, an avalanche of falling prices. The Roaring Twenties, the Jazz Age, the Age of Ballyhoo came to a grinding halt. It was as though a watch spring had been overwound, and now the Great Depression began to coil for its own deadly season.

The years after 1929, when the Hoover administration began to look for a way out of the economic crisis, to the spring and summer of 1933, when the policies of Franklin Delano Roosevelt and his Brain Trust began to purchase a grip on the fiscal and social problems, were a terrible and terrifying interlude. It took a few months for the Depression to bite, but by the middle of 1930 there were many industrial towns where one worker in four was unemployed. Soon apple sellers appeared on street corners; they were unemployed men and women who had been thoughtfully supplied with apples on credit by the International Apple Shippers Association, which happened to be faced with a glut. The hobos who made a vocation of riding the rails were joined first by thousands and then by millions of new riders who found themselves crossing the continent in box cars and gondolas because there was no longer any reason to stay home. With these involuntary migrations came the Hoovervilles, rambling shanty towns built from scrap wood and corrugated steel—anything that came to hand— which sprang up in or near towns all over the country, housing the unemployed. (One Hooverville, in Central Park, a short walk from Rockwell's studio, was sardonically nicknamed Radio City in honor of the highly publicized complex—all of Rockefeller Center was then called Radio City—that was rising between Fifth and Sixth Avenues.) The Bonus Army, which marched on Washington in the summer of 1932 and camped in swampland across the Potomac, was routed by the regulars under the command of General Douglas MacArthur, one of whose subordinates was Major Dwight D. Eisenhower. Throughout the Heartland farmers found themselves driven from their

land by foreclosure; then, on the eve of Roosevelt's inauguration, more and more banks began to fail, and the whole banking system seemed to be on the verge of collapse. The new president had hardly been sworn into office when he declared an extended bank holiday, closing banks across the nation until the panic subsided, and the long uphill grind of the New Deal years could begin.

Some people and a few industries stood outside the general chaos, for a while at least. Those of the well-to-do and comfortably well-off who had not been wiped out in the Crash itself continued to prosper (the Depression actually made many items, especially luxury goods, less expensive). The rest of the nation—that part of it that could afford to live above the subsistence level, anyway—was able to indulge itself in cheap forms of entertainment. The talkies had given Hollywood a tremendous boost and brought on a whole new crop of stars. Radio was bringing shows like *Amos 'n' Andy* into an increasing number of homes, and the yellow press continued to titillate its faithful public with staccato gossip columns and lurid accounts of gangland slayings.

Rockwell was one of the lucky few who was not much affected by the Depression. Magazines still enjoyed vast circulations—they provided another cheap form of entertainment—and Rockwell's work was as much in demand as ever. In 1930 he made an extended trip to Hollywood where he painted one of his finest covers in years (p 221), a study of Gary Cooper being made up for his part in a western. While in Los Angeles, Rockwell met and married Mary Barstow, who remained his wife until her death in 1959.

This marriage ushered in a happier period in his personal life, but he was becoming gradually dissatisfied with his work. There were several strong covers in 1930, but 1931 was a mediocre year for him, and towards the end of the year he decided that he needed to get away for a while, needed time to think and take stock of his career. A decade and a half of deadlines was beginning to sap his imagination, and so he took his wife, and a new baby son, on an extended visit to Paris. During 1932 he contributed only three covers to the *Post*—and the next did not appear until the following April—but happily all three were examples of Rockwell near the peak of his form. As the Depression reached its lowest point, during the lame-duck period between the 1932 election and Roosevelt's inauguration, Rockwell found himself back in the United States and ready to return to his former level of productivity.

SATURDAY EVENING POST COVERS

March 9, 1929–June 17, 1933

DOCTOR AND DOLL
Post Cover • March 9, 1929

PAGE 209

THIS is one of the best known of Rockwell's *Post* covers from this period. It almost falls into the trap of being overly cute—and an earlier version (p 58) was perhaps better—but it is saved by the fact that the doctor is a very believable character. We are persuaded, by Rockwell's skill, that such a man might actually exist and, if he did, would act in just this way if confronted by the forlorn youngster and her broken doll.

SPEED TRAP
Post Cover • April 20, 1929

PAGE 210

SPEED traps, as is evident from this picture, were already one of the hazards of motoring in the twenties. This menacing-looking law officer lies in wait behind a sign that bears a message contradicting his intentions. Rockwell's skill, as both painter and story teller, enables us to intuit from this one vignette the character and ambience of Elmville.

TWINS
Post Cover • May 4, 1929

PAGE 211

HERE Rockwell imagined the plight of the suitor who comes to call on a twin. It is hard to know with whom we should sympathize most, the confused caller, or the unfortunate young women who have clearly found themselves in this position before.

NO SWIMMING
Post Cover • June 15, 1929

PAGE 212

IT is not quite the same "No Swimming" sign that appears in the earlier painting with the same title (p 107), but we can easily imagine that the three boys on that cover are up to their mischief once more. We see their clothes but not their crime. The girl passing by closes her eyes so that she cannot be called upon to bear witness against them. There is also the strong possibility, of course, that the boys are skinny dipping, thus providing another reason for her reaction.

TOURIST
Post Cover • July 13, 1929

PAGE 213

THIS crass sightseer, with his ample paunch and citified clothes, is an inherently comical figure, and the comedy is heightened by the situation we discover him in. It would be hard to imagine anywhere that he would seem more out of place than here, astride an overworked burro on the rim of the Grand Canyon. Rockwell makes his point economically and well.

FISHING
Post Cover • August 3, 1929

PAGE 214

HERE Rockwell returns once more to the subject of youth and age. As so often when he treats this theme, the artist permits the old timer to display his prowess for the benefit of the youngster. This is a pleasant cover, atmospheric and full of summer light.

MAKING FRIENDS
Post Cover • *September 28, 1929*
PAGE 215

ROCKWELL's love of dogs is evident over and over again in his work, and his skill in portraying them is not the least of his gifts. Always he seems to catch just the right pose, and he does not patronize them. Usually they are called on to play a secondary role in the composition, but here they are the focus of the situation.

JAZZ IT UP
Post Cover • *November 2, 1929*
PAGE 216

THIS little violinist seems to be wondering how a saxophone might change his life. Like the tourist on page 213, he is essentially a comical figure—there is a touch of Chaplin about him—and, once more, Rockwell has found the perfect situation in which to bring this out. Ironically this cover appeared on the stands just as the stock market crashed, bringing the so-called Jazz Age to an end.

MERRIE CHRISTMAS
Post Cover • *December 7, 1929*
PAGE 217

THIS Dickensian coachman is notable for his girth and evident good humor. The painting is perhaps most interesting as a costume study, and it is typical of Rockwell to lavish so much attention on the coat, with its many buttons, and the scarf and weathered mail pouch.

STOCK EXCHANGE QUOTATIONS
Post Cover • *January 18, 1930*
PAGE 218

PAINTED a couple of months after the Crash, this cover would have carried a topical message for contemporary readers of the *Post*. The device of having all the figures turned away from us, their faces hidden, has the effect of emphasizing the extent to which they are absorbed in the document they are studying. In reality, the entire nation was watching the progress of the stock market at this time, hoping for a miraculous recovery.

NOTHING UP HIS SLEEVE
Post Cover • *March 22, 1930*
PAGE 219

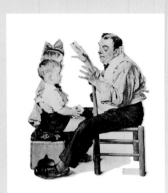

BECAUSE the artist has given us a privileged viewpoint, we can see that this conjurer has tucked a couple of cards into his shirt collar. They are, however, concealed from the two children who watch the man's movements with such wonder. The poses here are very convincing: the small boy's seriousness is just right, and the way the conjurer straddles the chair tells us volumes about his personality.

APRIL SHOWERS
Post Cover • *April 12, 1930*
PAGE 220

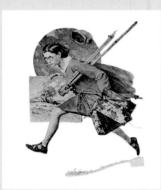

THIS is a conventional enough seasonal cover, but it works well because the young artist, seeking to rescue her masterpiece from the elements, has been nicely observed. Rockwell organizes carefully chosen pieces of information—the hairstyle, the glasses, the sandals—to tell us about the girl's character and aspirations. We feel we know how she would behave in other situations, too: in the classroom, at home, or with friends.

GARY COOPER
Post Cover • May 24, 1930
PAGE 221

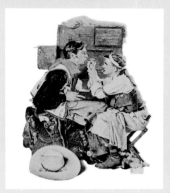

WHILE visiting Hollywood, Rockwell was taken to the set where Gary Cooper and Fay Wray were at work on *The Texan*, and here he observed the comical, yet everyday, scene of the he-man movie star being made up for the camera. His faithful record of this has to be considered one of his best paintings of the period. His study of the makeup artist—so far removed from any stereotype—is every bit as interesting as the portrait of the star.

GONE FISHING
Post Cover • July 19, 1930
PAGE 222

THIS is still another variation on a favorite theme, and a cover that has been lovingly painted. We can almost feel the warmth of the sunlight and hear the buzzing of the mosquitos that have made the flyswatter an essential piece of equipment for this fishing expedition.

BREAKFAST
Post Cover • August 23, 1930
PAGE 223

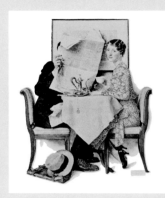

THERE is little to say about the situation portrayed here—it is a staple of cartoonists and comedy writers—but it should be remarked that Rockwell has managed to bring a good deal of sympathy to it. The way the wife's knees, though hidden by the table cloth, seem to be reaching for physical contact with her husband is especially poignant.

HOME FROM VACATION
Post Cover • September 13, 1930
PAGE 224

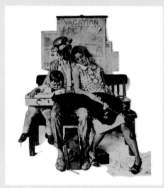

THIS is another strong cover. The two adults in particular are excellent studies. The child seems rather more of a stereotype, and the frog attempting to escape from the cardboard box is, perhaps, an unnecessary touch (Rockwell had very little luck in his attempts to imbue reptiles with personality), but this is still a delightful and skillfully executed painting.

THE YARN SPINNER
Post Cover • November 8, 1930
PAGE 225

THIS is the first of four consecutive "period" covers; over the next year or so, only three of ten covers would deal with contemporary themes. Rockwell may have felt the public did not want to face the present in the wake of the Crash. A young sailor is telling of his adventures on the high seas and in foreign ports. The young woman is fascinated, apparently, but seems uncertain as to how far she dare go in trusting his intentions.

CHRISTMAS
Post Cover • December 6, 1930
PAGE 226

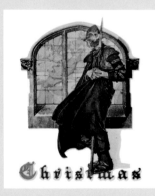

THE period this time appears to be the late Middle Ages. A pikeman, wrapped up against the cold, stands guard outside a window, looking in on the room where Yuletide festivities are under way. This interesting painting stands outside the mainstream of Rockwell's work. The idiom is old-fashioned, but the design is rather strong.

A NEW HAT
Post Cover • January 31, 1931
PAGE 227

As in some other instances, we sense that Rockwell devised this composition for the sheer pleasure of painting the period costume. He has done so beautifully, but the cover still seems somewhat trite. The artist does not succeed in creating a believable sense of the past—the kind of sense that we find for instance, in the best of his Dickensian covers.

FIRE!
Post Cover • March 28, 1931
PAGE 228

Here we are taken back to the days of the volunteer fire brigades, and Rockwell seems much more at home with this action scene than he was with the feminine tranquillity of the previous cover. This may be run-of-the-mill Rockwell, but it does have life and energy.

BUSTS
Post Cover • April 18, 1931
PAGE 229

A contrast is drawn between the idealized features of the classical busts and the non-idealized figure of the individual who was entrusted with them.

CRAMMING
Post Cover • June 13, 1931
PAGE 230

With finals upon them, these college students find themselves making up for lost time. This is not one of Rockwell's stronger covers.

THE MILKMAID
Post Cover • July 25, 1931
PAGE 231

A milkmaid and a musician meet and kiss on a rustic bridge. At first

glance this seems to be a scene from country life during colonial days, but the couple has an improbably manicured look. Perhaps they are French aristocrats—members of Madame de Pompadour's entourage—amusing themselves by impersonating peasants.

CROQUET
Post Cover • September 5, 1931
PAGE 232

The charming young woman in the smart Edwardian dress is the picture of concentration. Her dapper opponent leans in towards her, as if to watch the trajectory of the ball. This composition is nostalgic without being cloying. It is one of the most likable of all Rockwell's costume paintings.

SOUR NOTE
Post Cover • November 7, 1931
PAGE 233

At first this, too, looks like a period cover, but the painting represents not a nineteenth-century military bandsman taking time out from KP, but, rather, a twentieth-century grocer rehearsing for his duties in the local marching band. Judging from the dog's expression, the trumpeter's abilities are strictly those of the amateur.

MERRY CHRISTMAS
Post Cover • December 12, 1931
PAGE 234

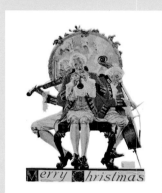

HERE we are back in the age of Mozart, and the members of a bewigged trio are playing what must be—to judge from the cellist's right foot—a sprightly dance tune. This is one of Rockwell's least convincing historical pieces. There is, in particular, something disconcertingly artificial and coy about the way the musicians are perched on a single bench. This was, in fact, the last cover Rockwell painted before he and his wife left for an extended trip to Paris, where the artist hoped to refresh his imagination.

BOULEVARD HAUSSMANN
Post Cover • January 30, 1932
PAGE 235

THIS cover was clearly a direct result of the Rockwells' sojourn in France. An attractive young tourist has sought the assistance of a member of the Parisian constabulary. His immensely Gallic gesture seems to suggest that she is demanding too much of his time—or that there is some serious language problem here—and her grip on his cloak indicates that she has no intention of letting him go until he produces the information she needs. Elegantly dressed, as befits the context,

she is silhouetted against the *agent*'s cloak, which is, in turn, silhouetted against the white page. The result is an especially strong piece of design.

PUPPET MAKER
Post Cover • October 22, 1932
PAGE 236

HERE Rockwell gives himself the opportunity to paint period costume within a contemporary setting. Looking back at some of the costume paintings of the early thirties, we see that Rockwell himself was acting as a kind of puppet master, manipulating figures from the past for the amusement of a modern audience.

MERRIE CHRISTMAS
Post Cover • December 10, 1932
PAGE 237

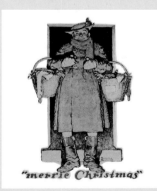

THIS represents a welcome return to Rockwell's Dickensian idiom. The mittens, the boots, and the scarf tell us about the weather the man has just come out of; the glow of the firelight on his face tells us about the warmth of the room he has entered; the loaded baskets tell us of the celebration that will soon commence. The design is powerful and the atmosphere convincing.

SPRINGTIME
Post Cover • April 8, 1933
PAGE 238

HERE we have another of Rockwell's slightly gauche allegories of spring, but at least this one has a certain charm in its execution. The allegory suggests an uneasy alliance between Mark Twain and Ovid, but the painting itself is light and airy, informed by the first balmy breezes of the year.

THE DIARY
Post Cover • June 17, 1933
PAGE 239

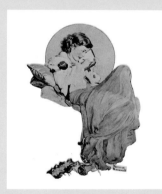

THIS painting marks the entry of something new into Rockwell's art. There is a softness and informality to it that he had never quite achieved before. His touch here is especially delicate—as is only appropriate to the subject matter—and to help fix the atmosphere, he makes full use of a tinted background—itself something of an innovation so far as *Post* covers were concerned.

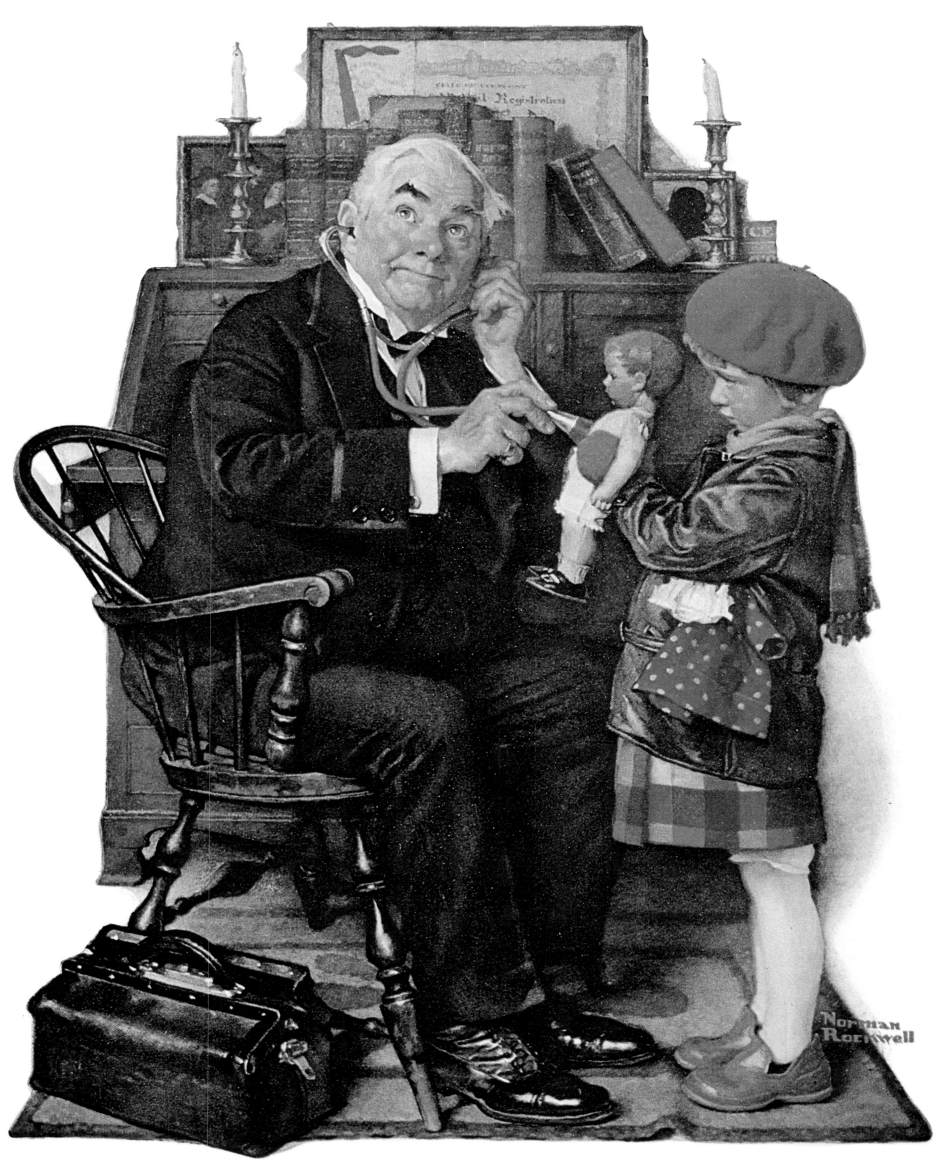

DOCTOR AND DOLL

Post Cover • March 9, 1929

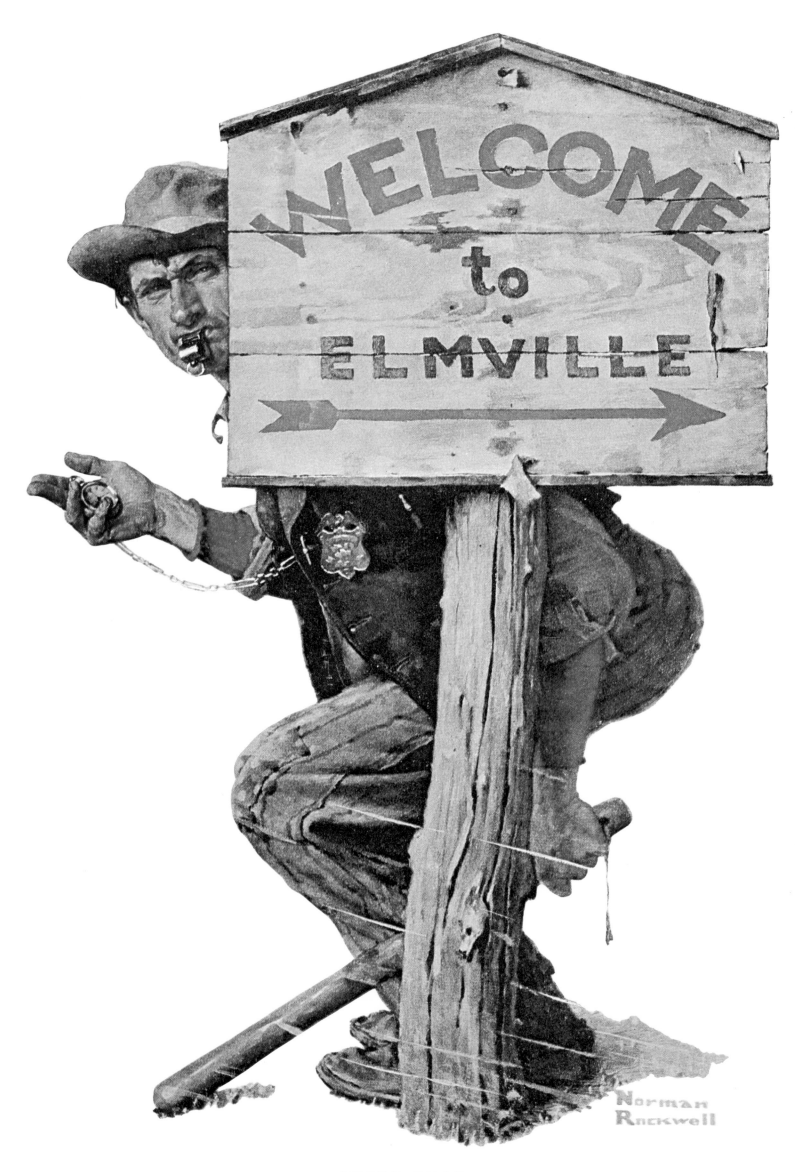

SPEED TRAP

Post Cover • April 20, 1929

210

TWINS

Post Cover • May 4, 1929

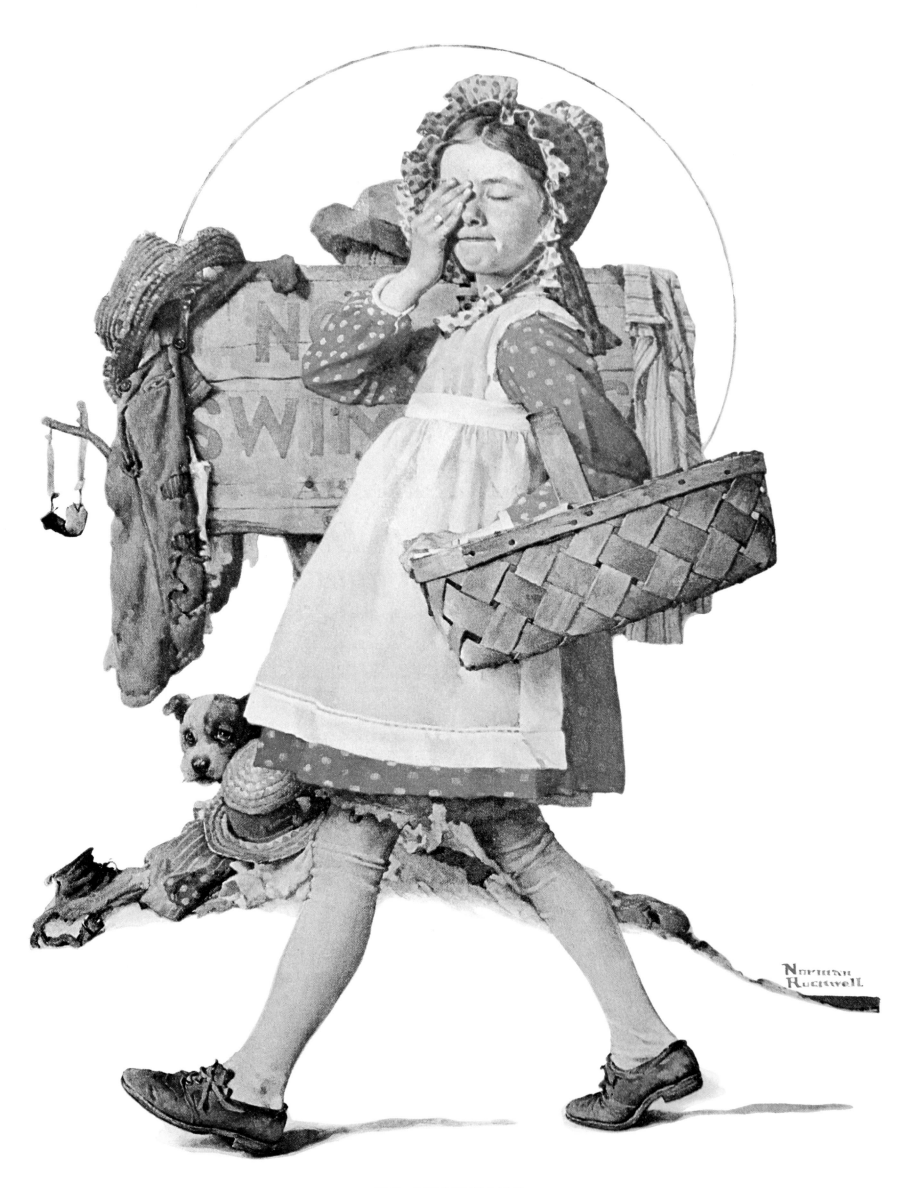

NO SWIMMING

Post Cover • June 15, 1929

TOURIST

Post Cover • July 13, 1929

213

FISHING

Post Cover • August 3, 1929

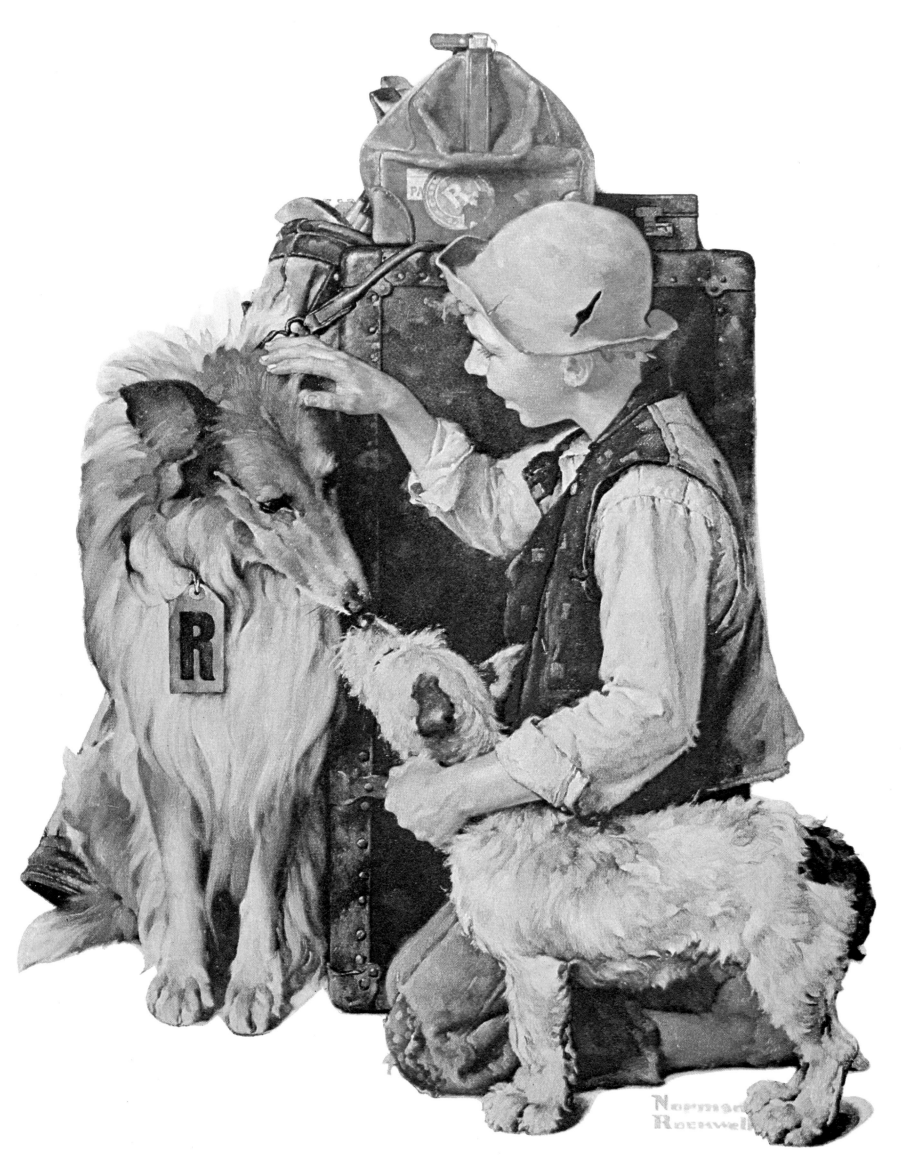

MAKING FRIENDS

Post Cover • *September 28, 1929*

215

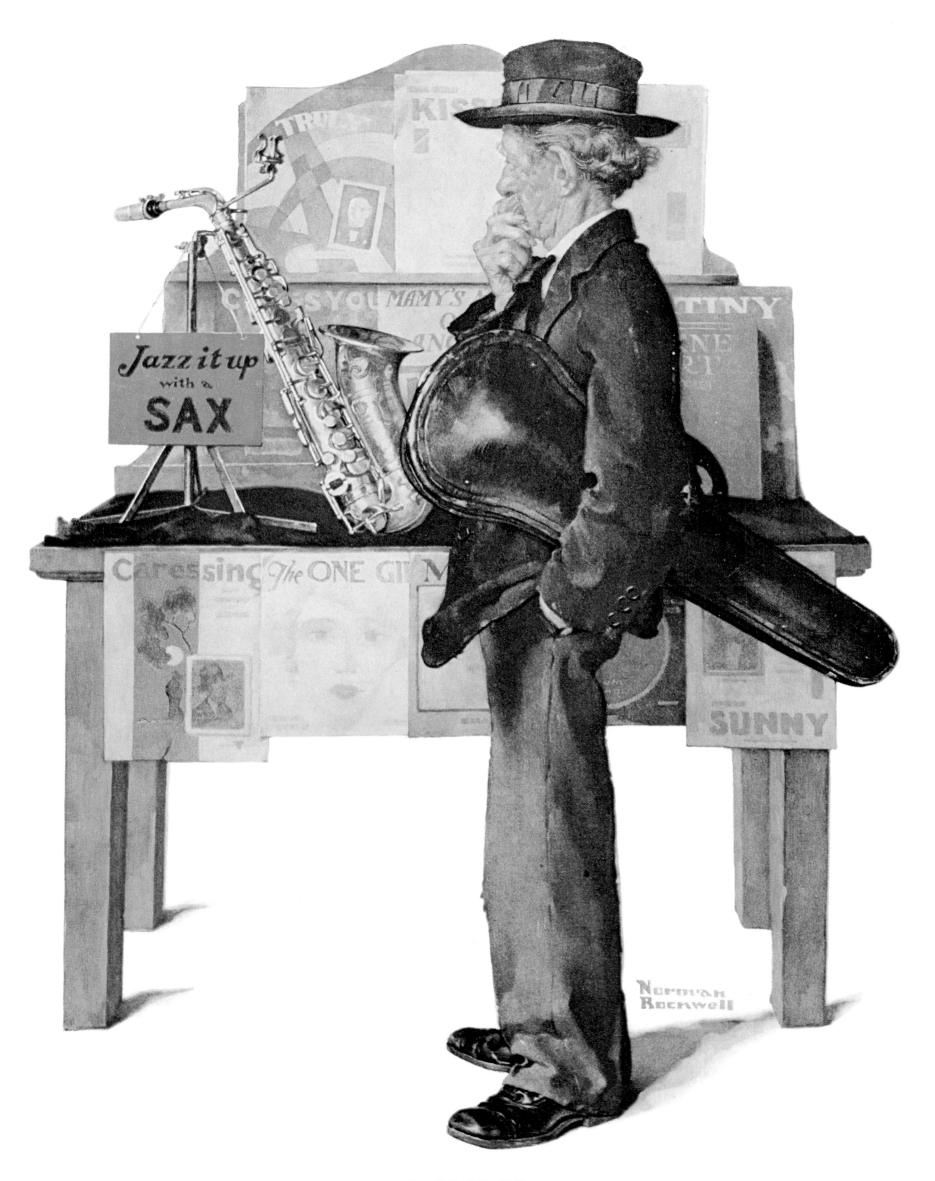

JAZZ IT UP

Post Cover • *November 2, 1929*

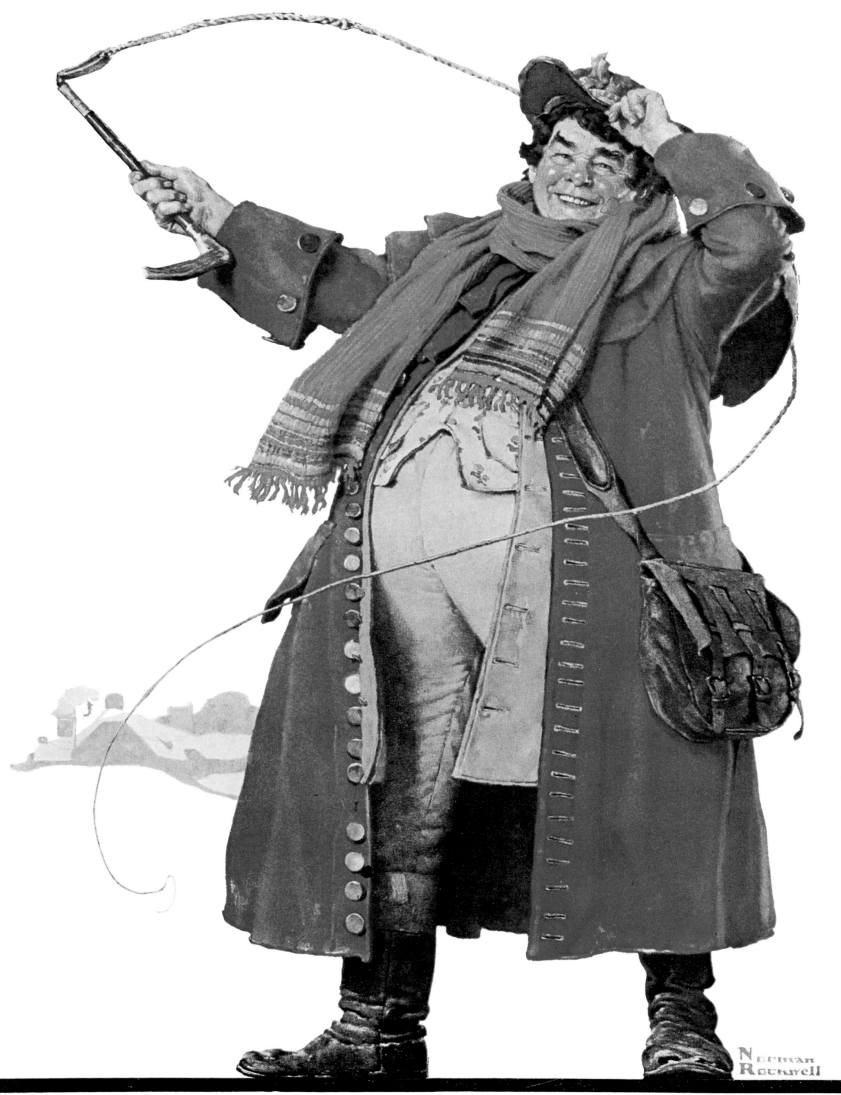

Merrie Christmas

MERRIE CHRISTMAS

Post Cover • December 7, 1929

217

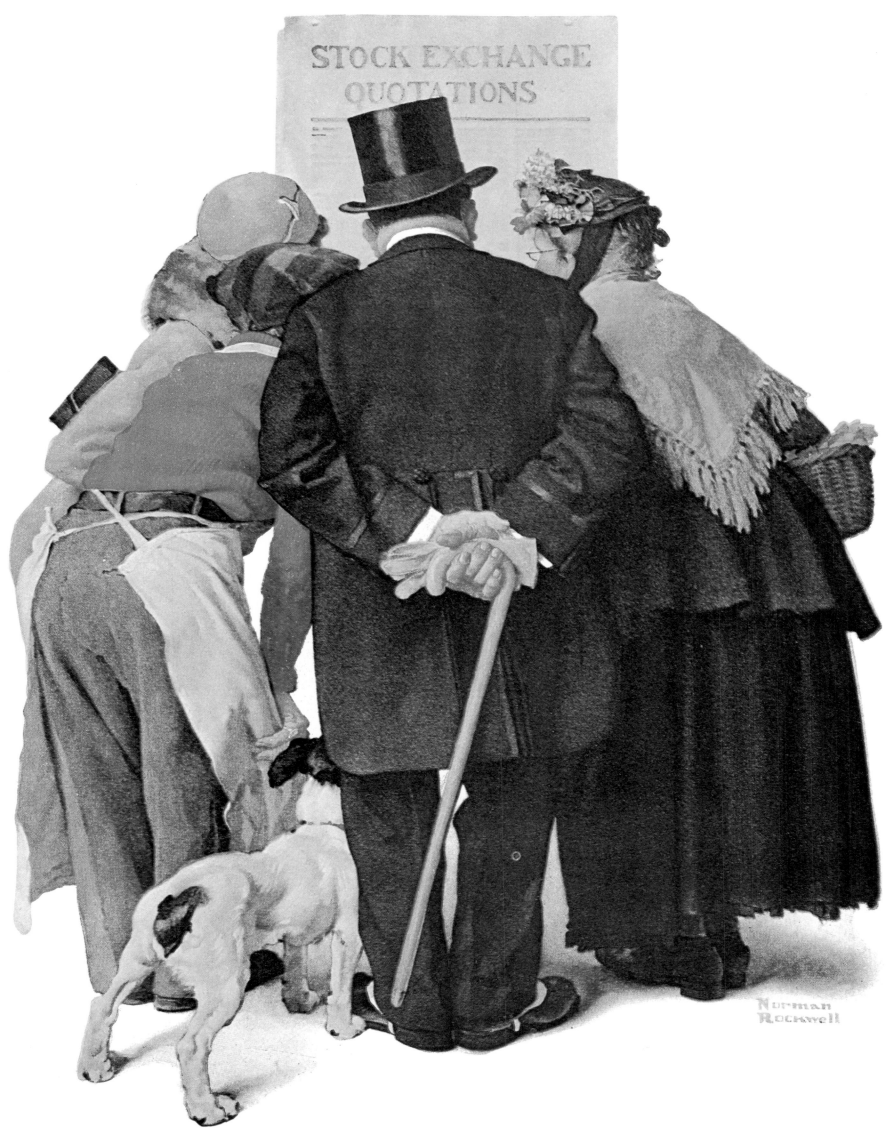

**STOCK EXCHANGE
QUOTATIONS**

Post Cover • January 18, 1930

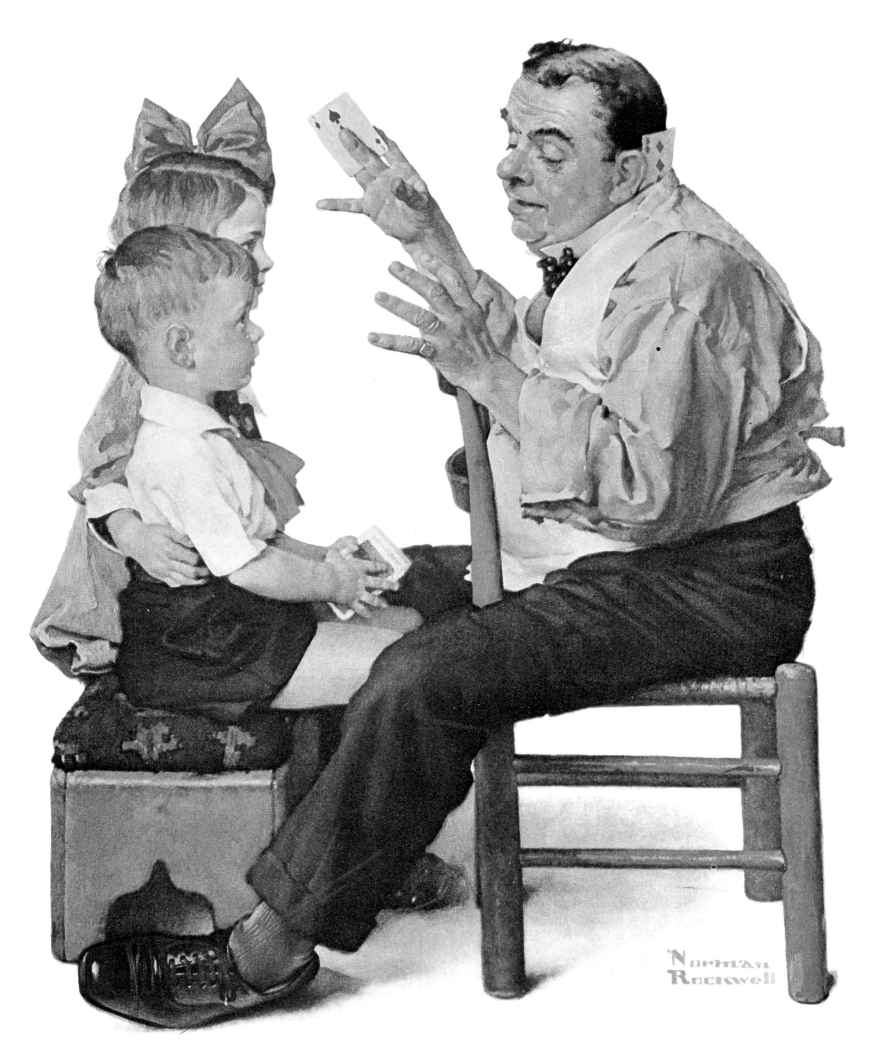

NOTHING UP HIS SLEEVE

Post Cover • March 22, 1930

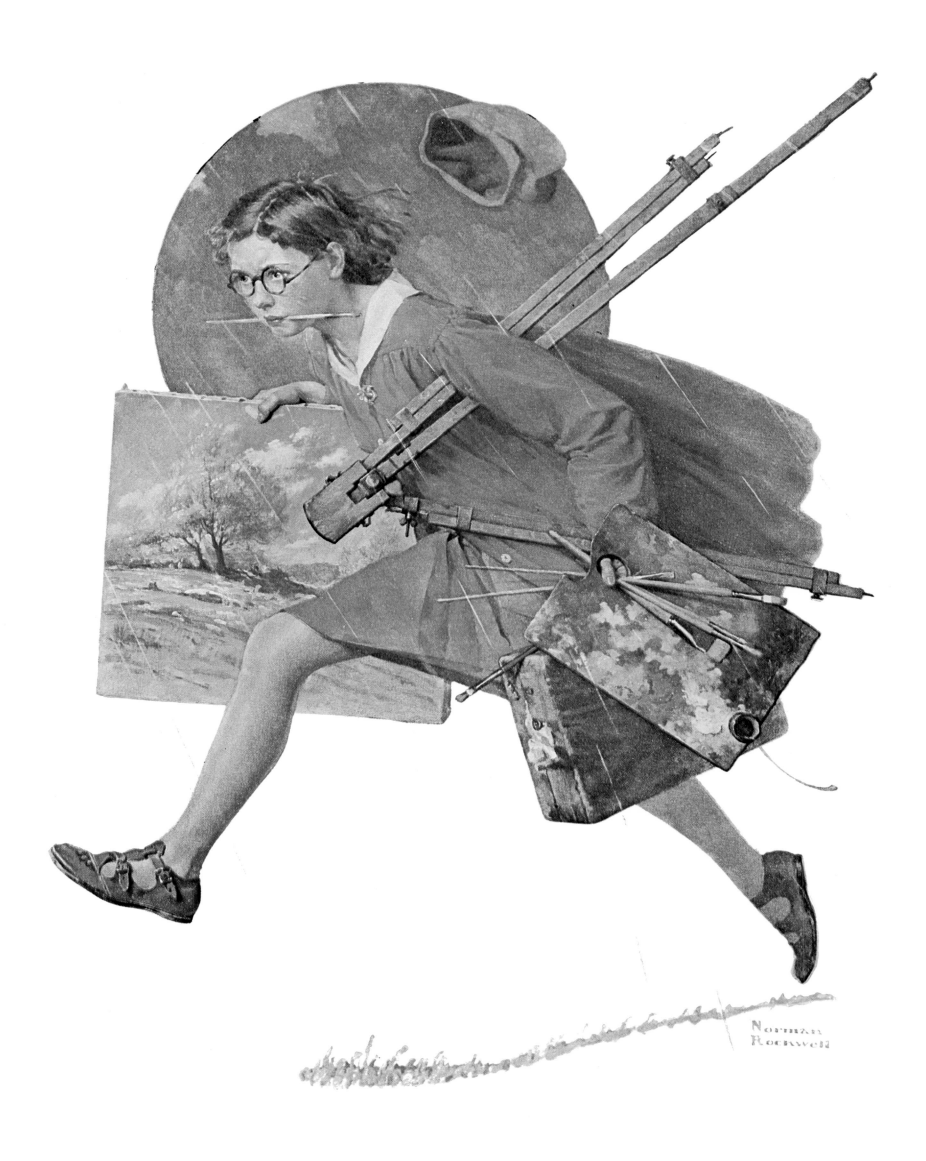

APRIL SHOWERS

Post Cover • April 12, 1930

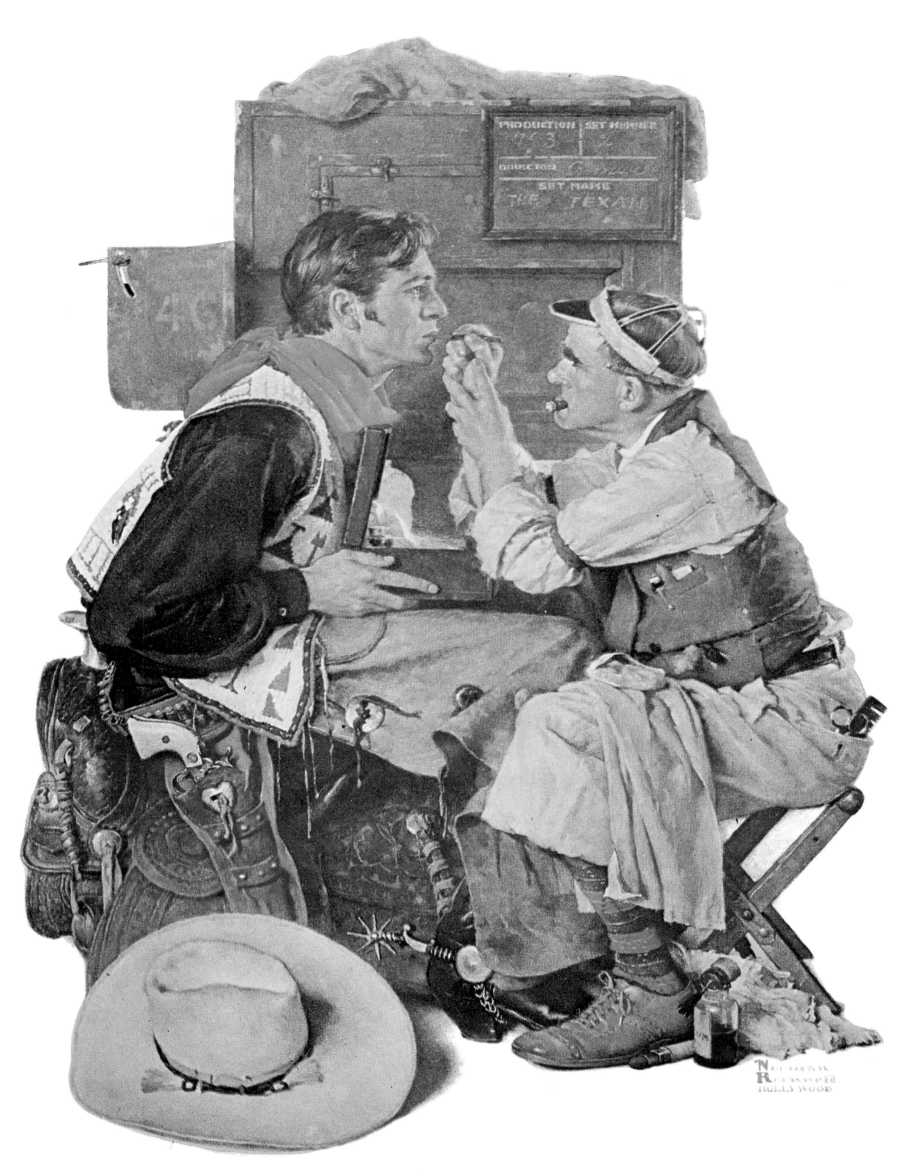

GARY COOPER

Post Cover • May 24, 1930

221

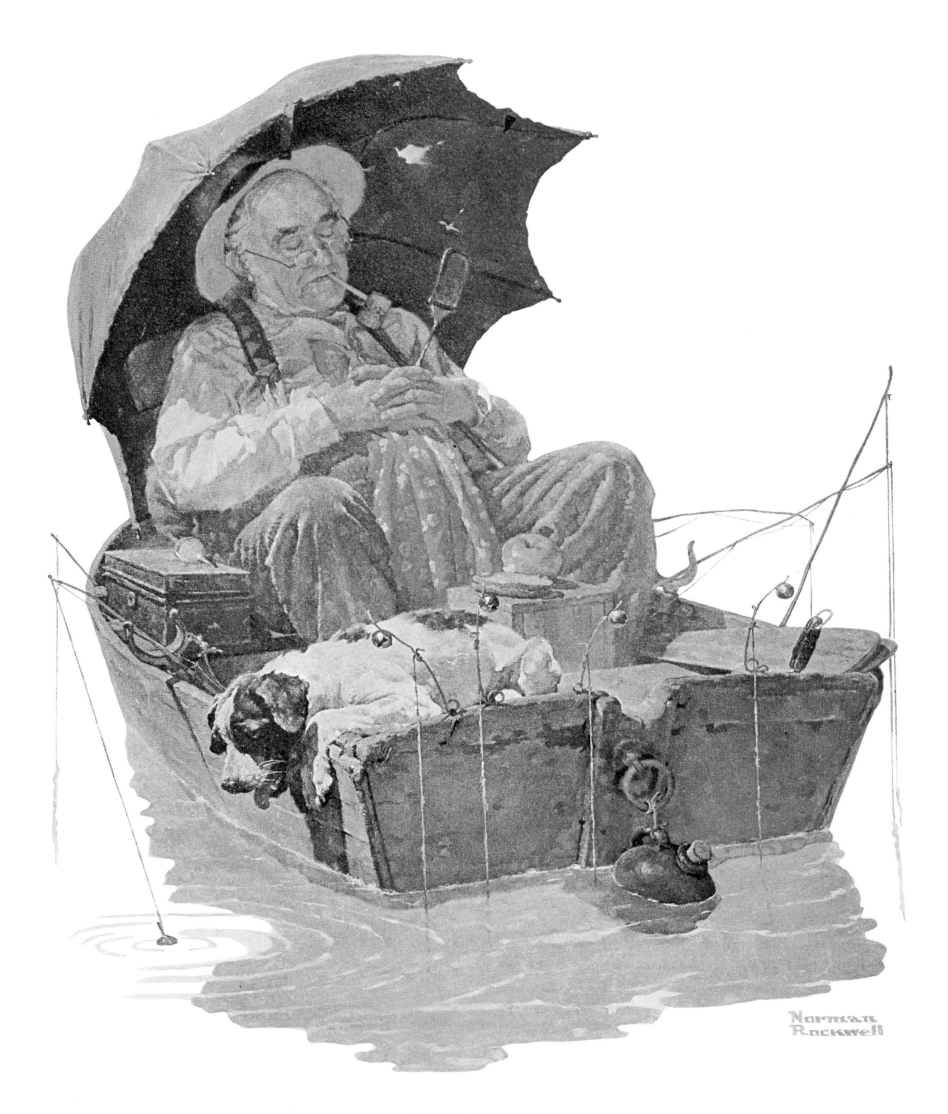

GONE FISHING

Post Cover • July 19, 1930

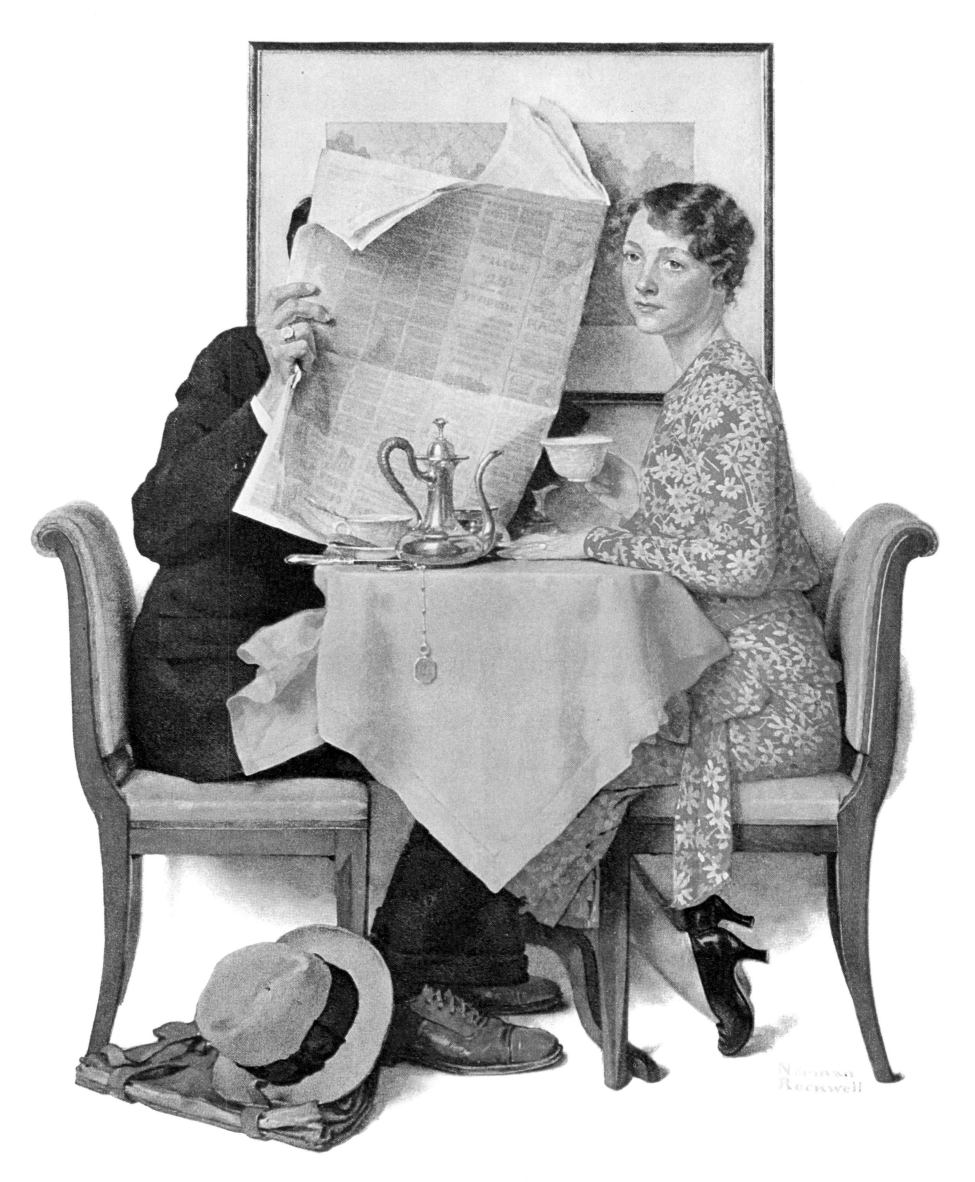

BREAKFAST

Post Cover • August 23, 1930

223

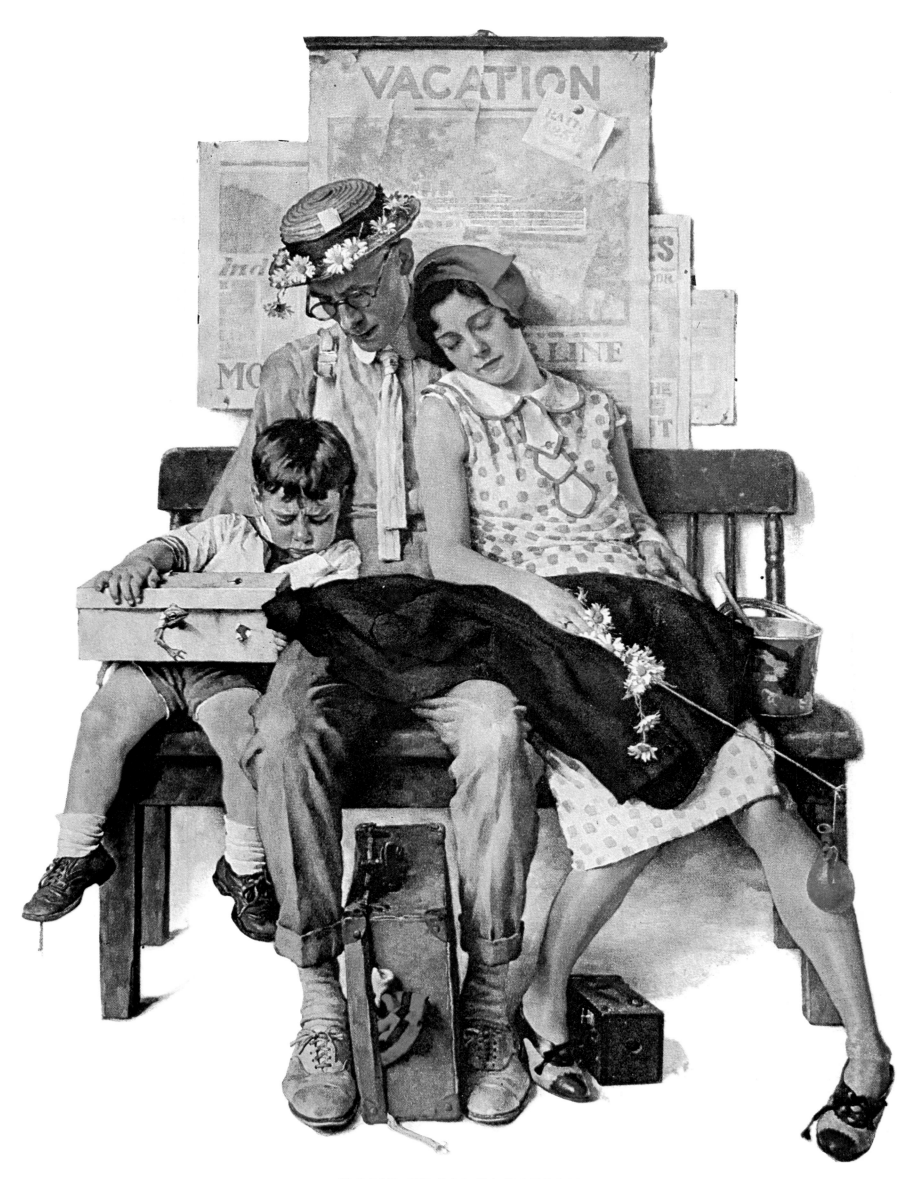

HOME FROM VACATION

Post Cover • September 13, 1930

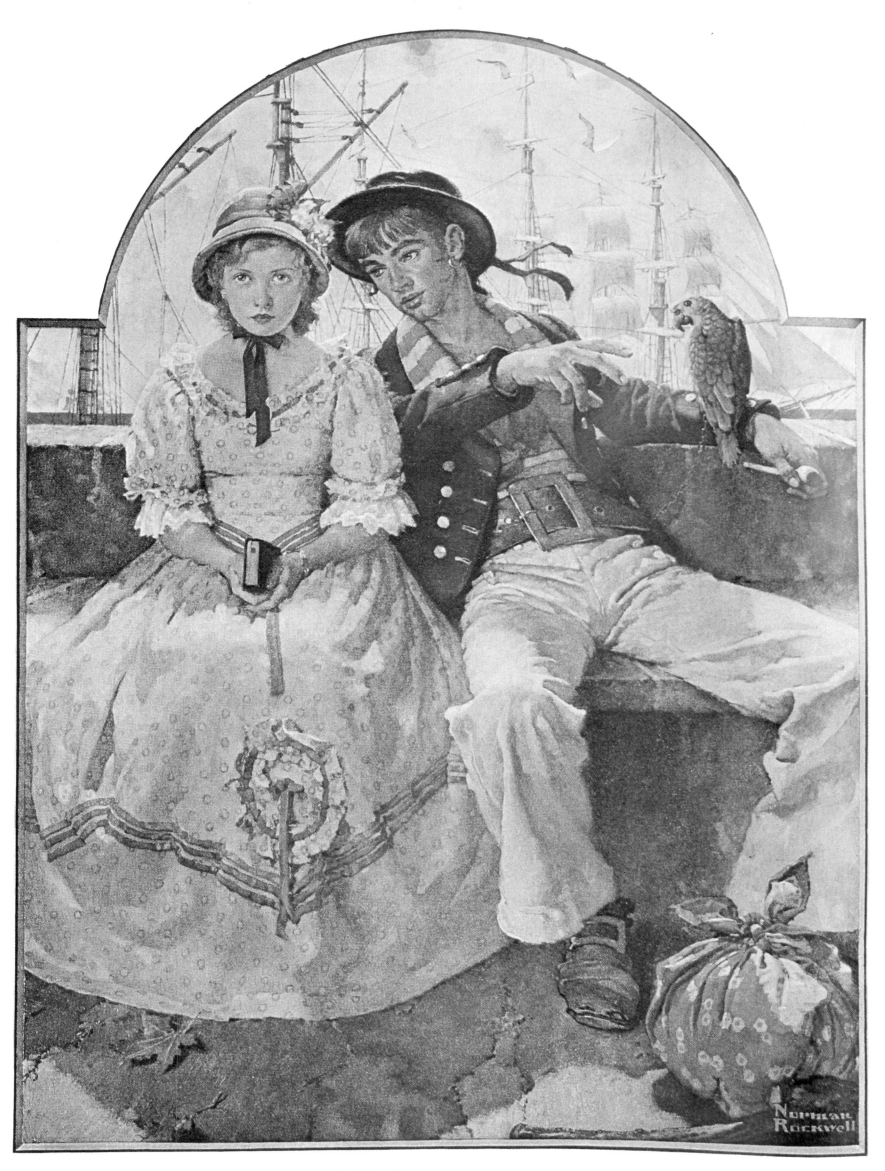

THE YARN SPINNER

Post Cover • *November 8, 1930*

225

Christmas

CHRISTMAS

Post Cover • December 6, 1930

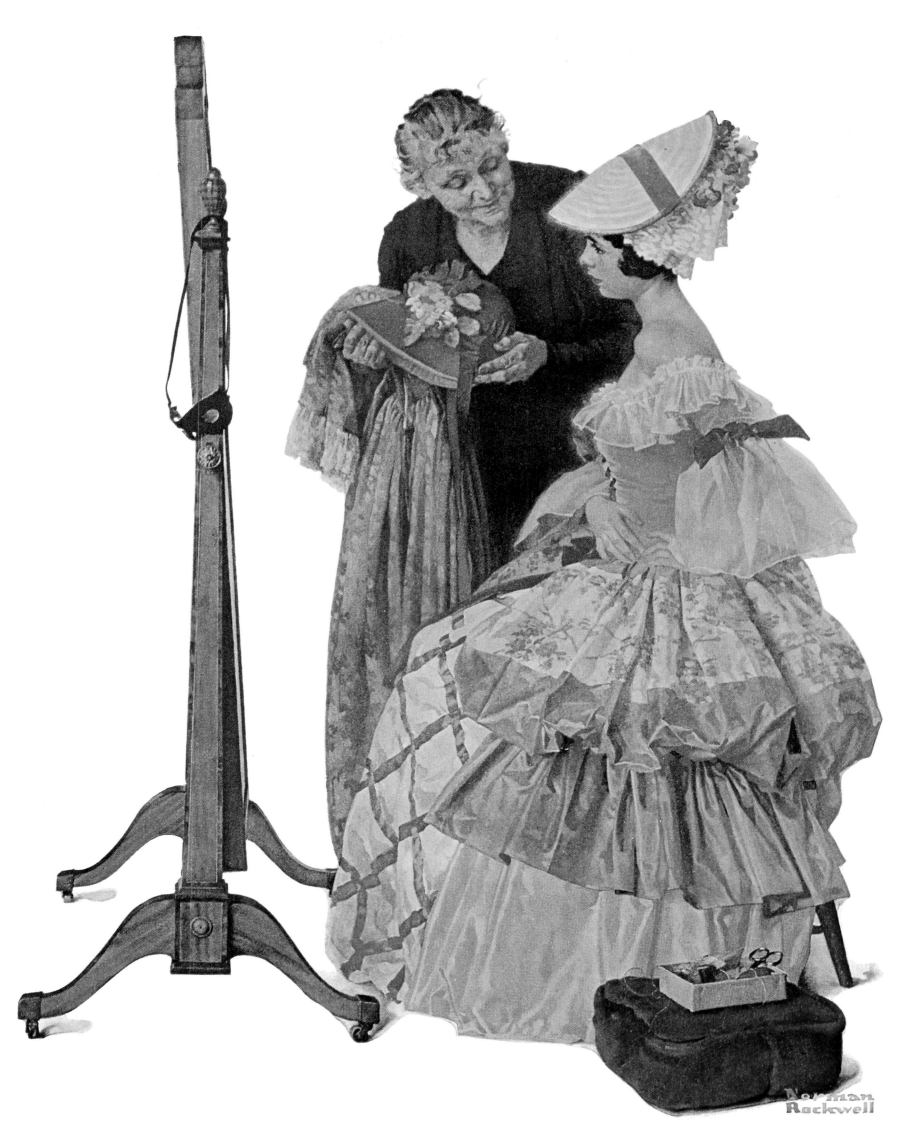

A NEW HAT

Post Cover • January 31, 1931

227

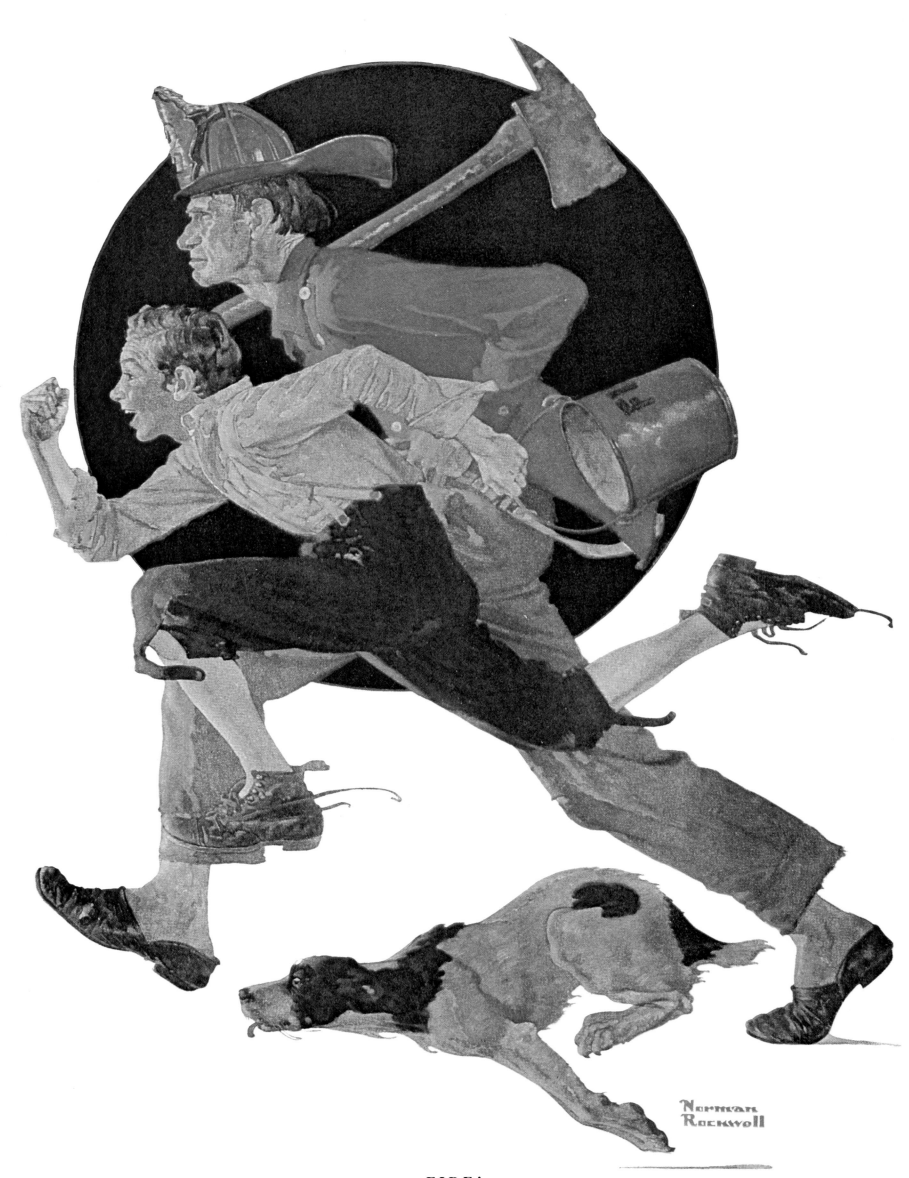

FIRE!
Post Cover • March 28, 1931

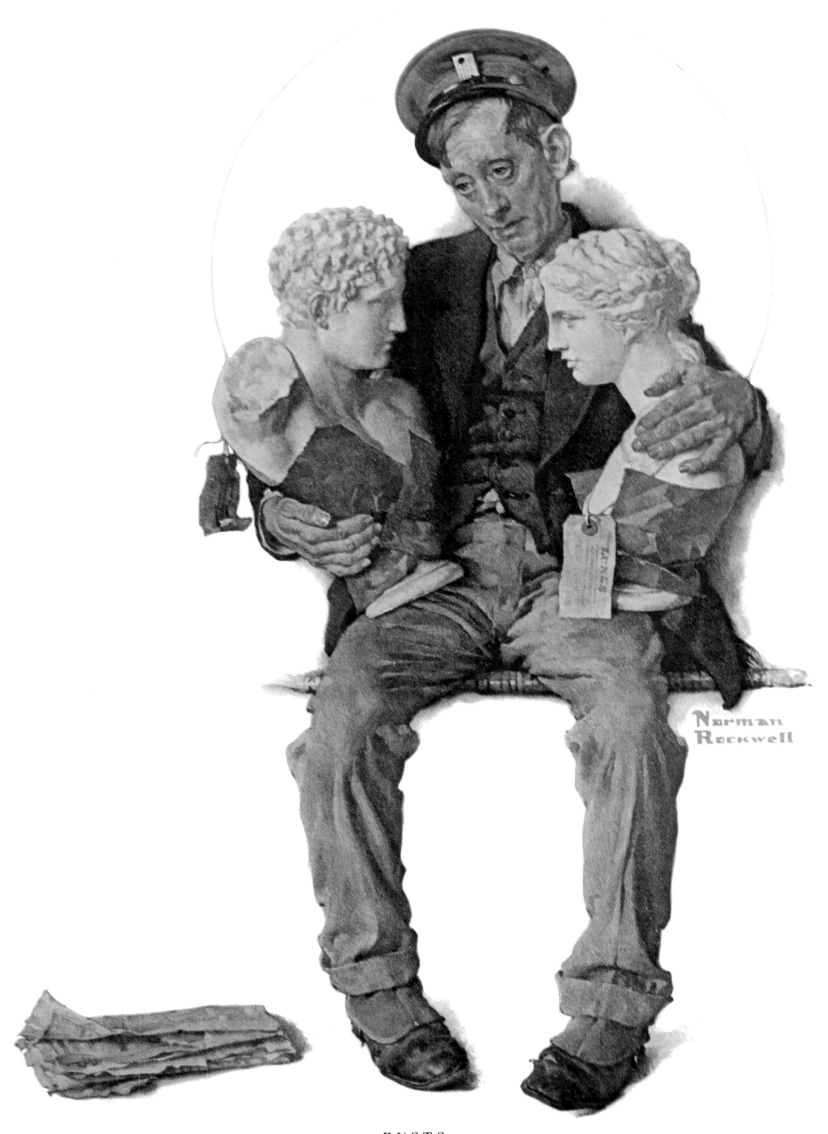

BUSTS

Post Cover • *April 18, 1931*

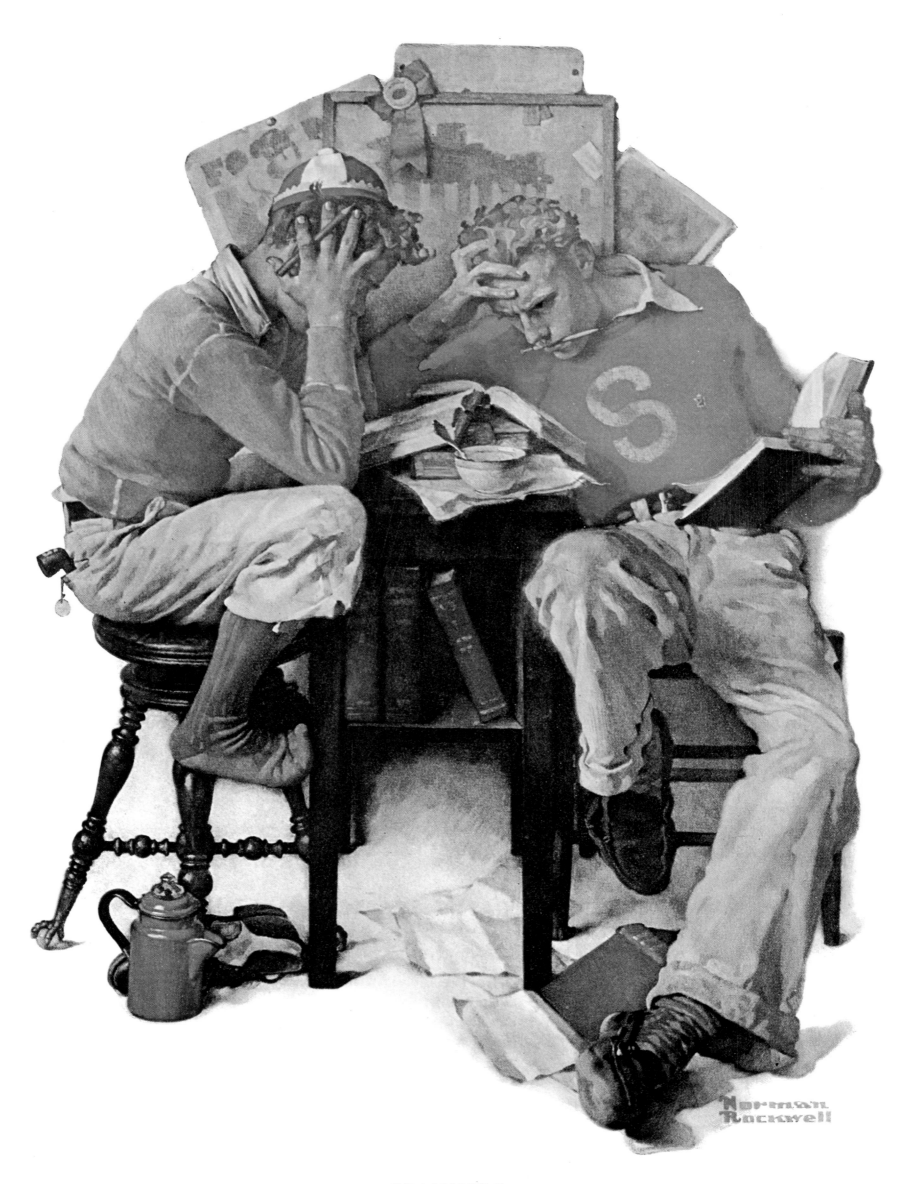

CRAMMING

Post Cover • June 13, 1931

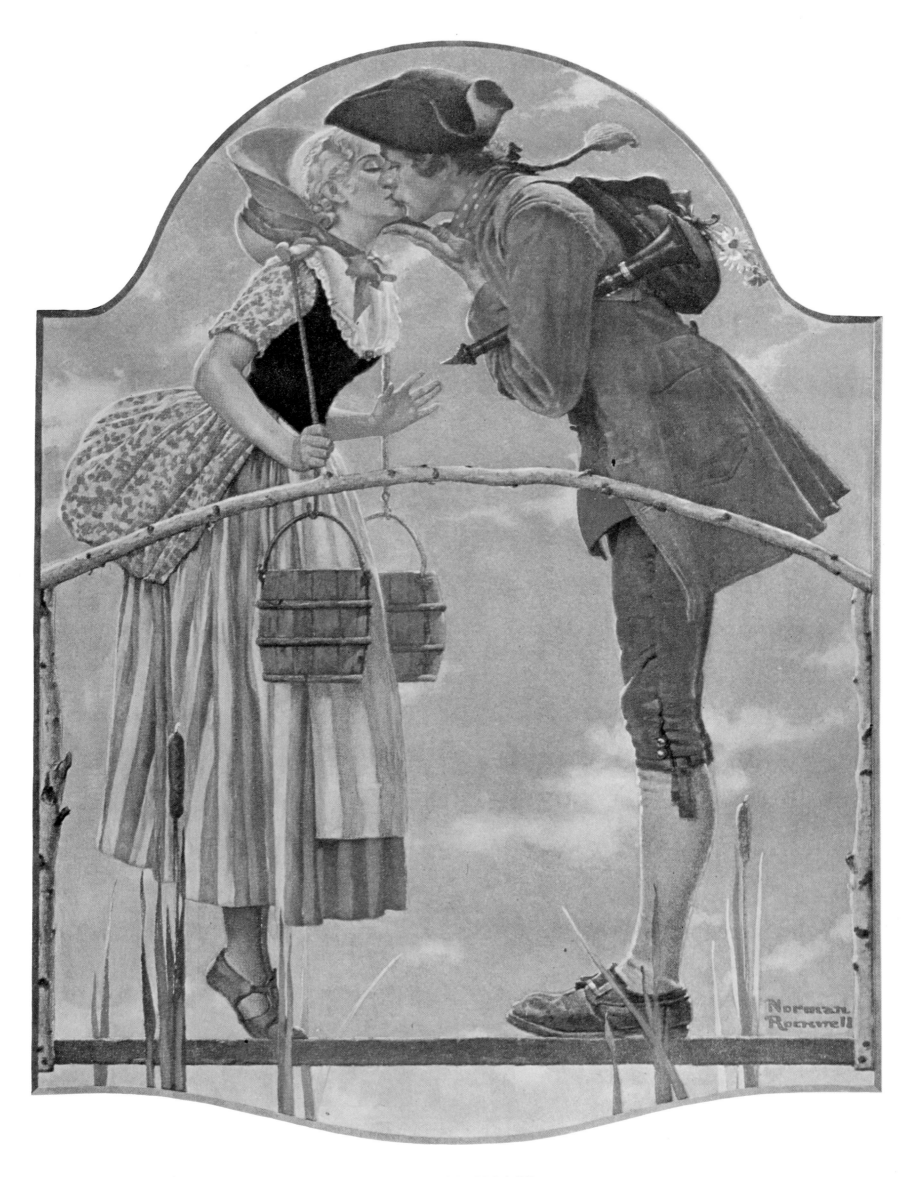

THE MILKMAID

Post Cover • July 25, 1931

231

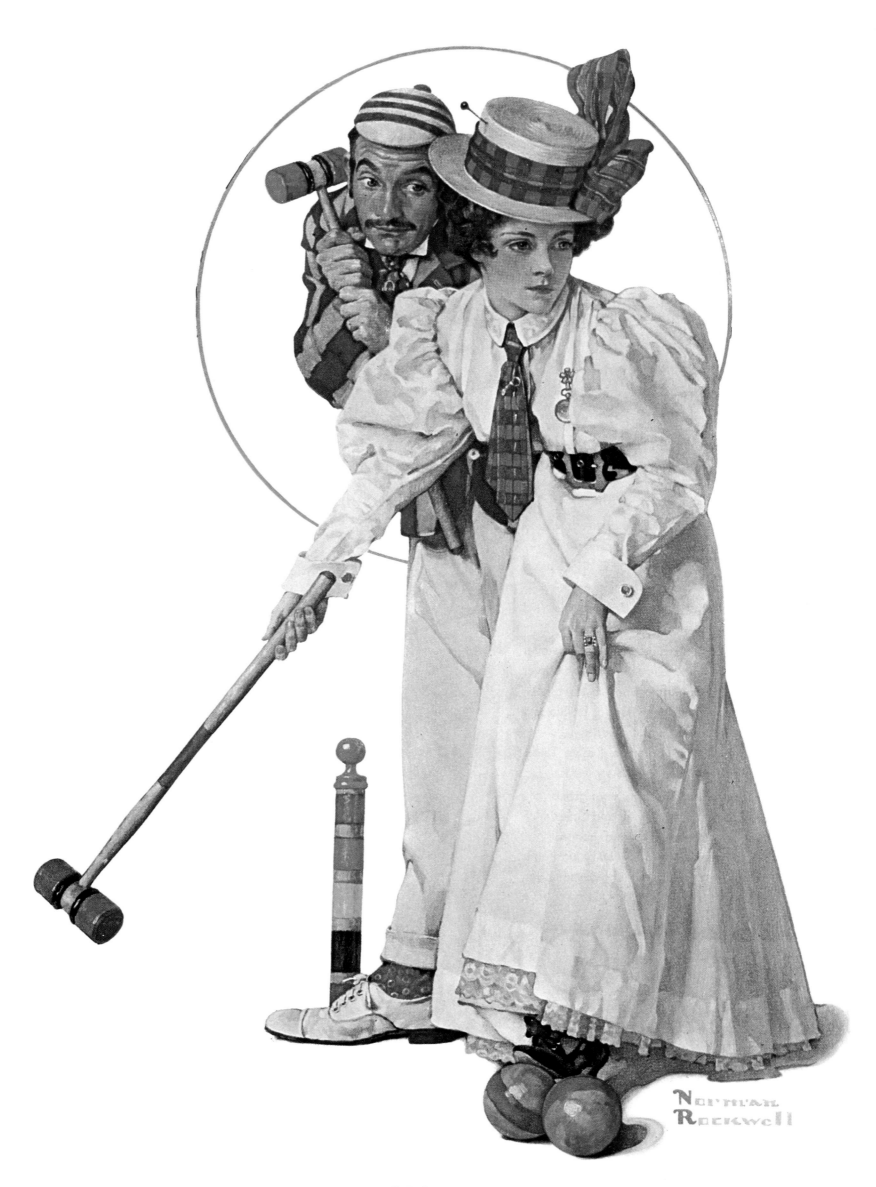

CROQUET

Post Cover • September 5, 1931

232

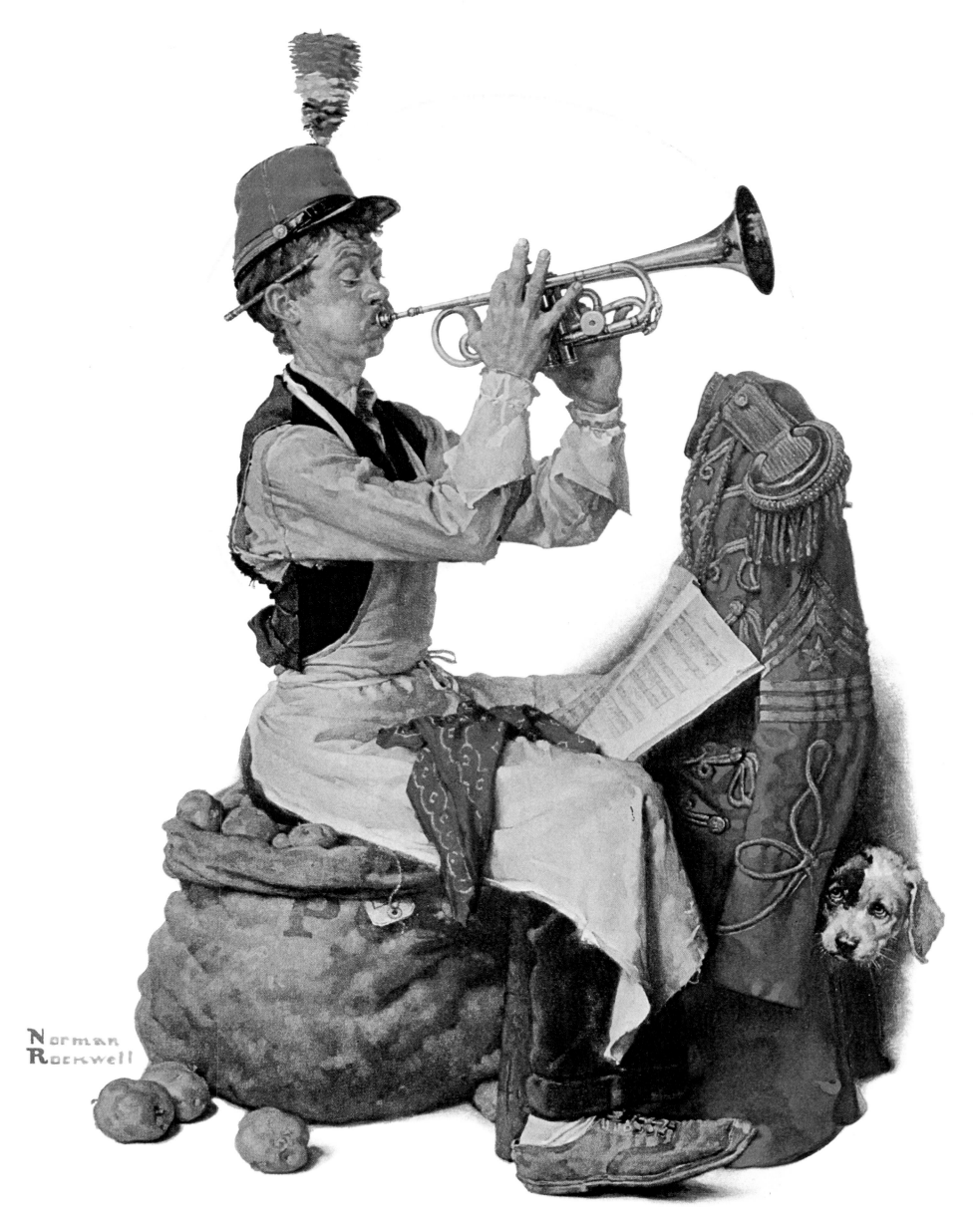

SOUR NOTE

Post Cover • *November 7, 1931*

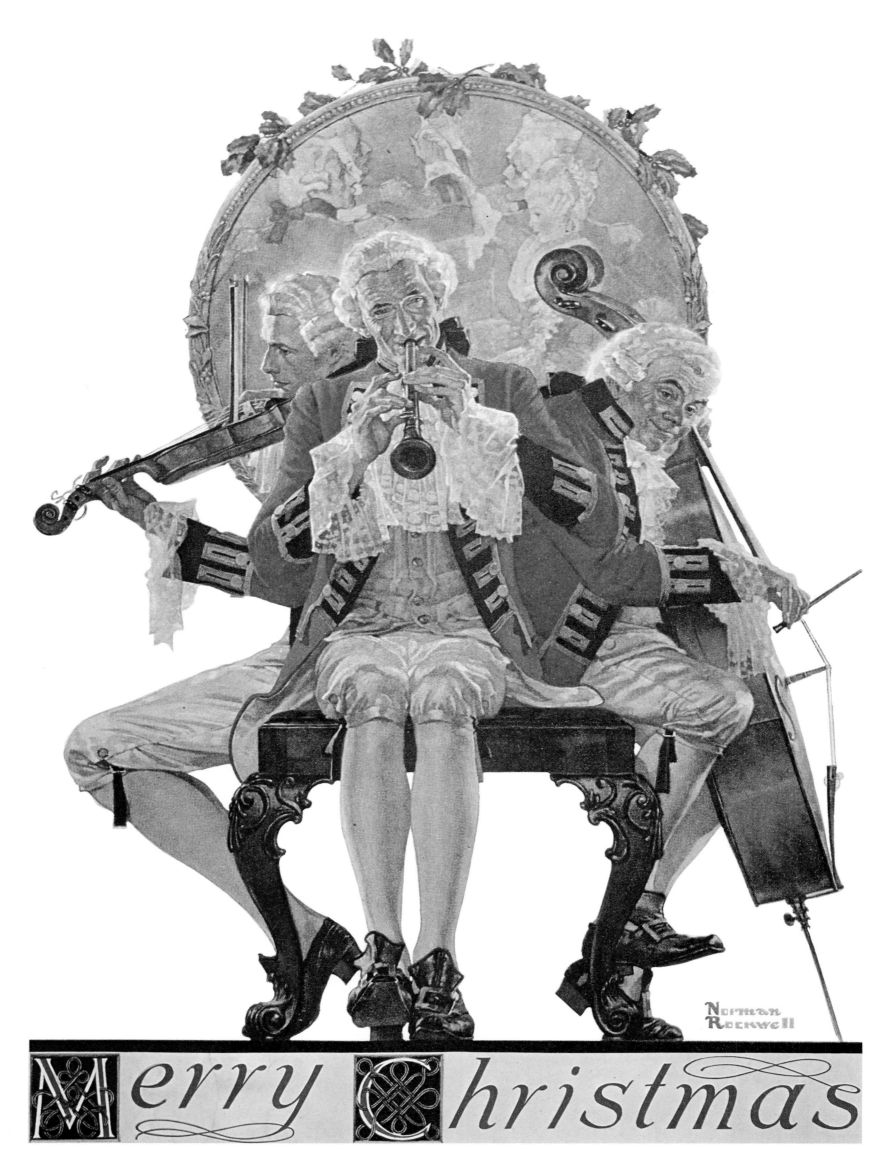

MERRY CHRISTMAS

Post Cover • December 12, 1931

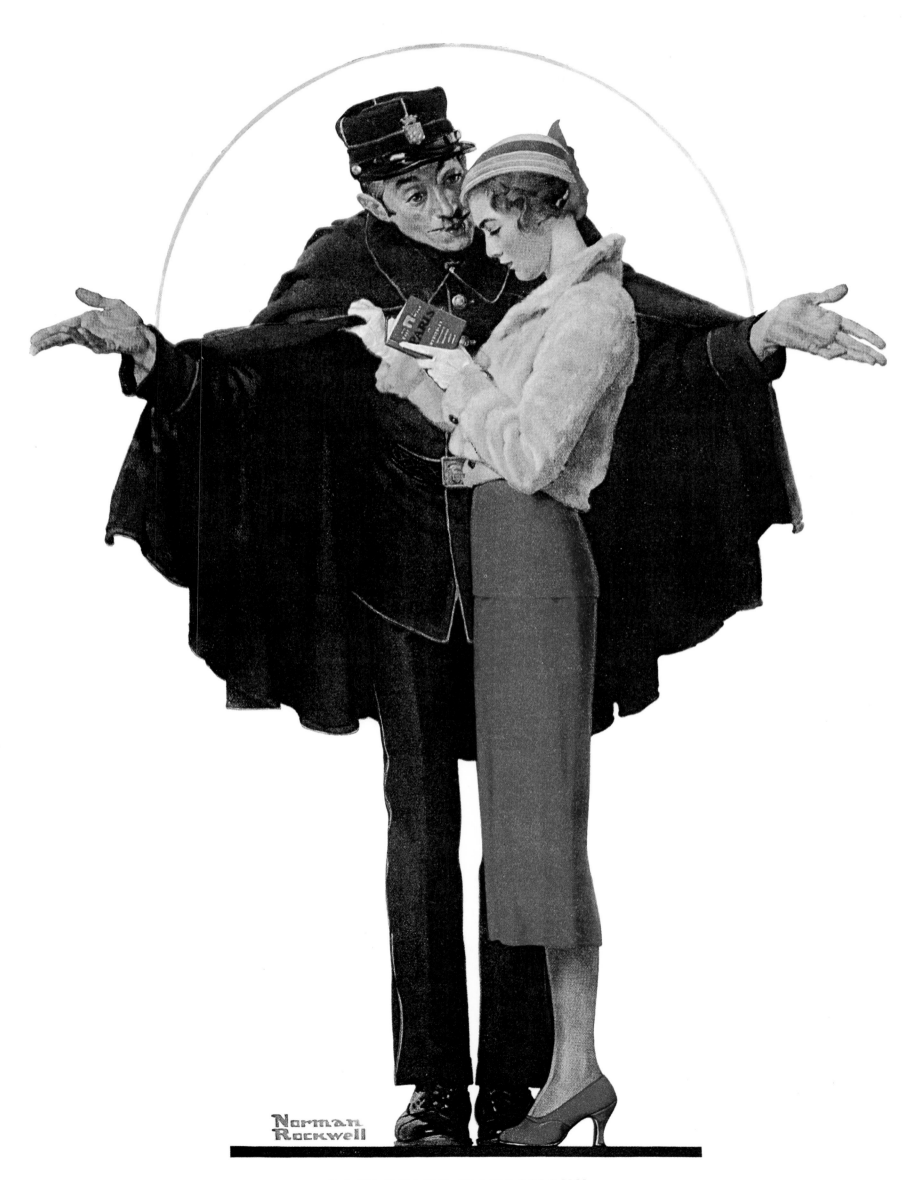

BOULEVARD HAUSSMANN

Post Cover • January 30, 1932

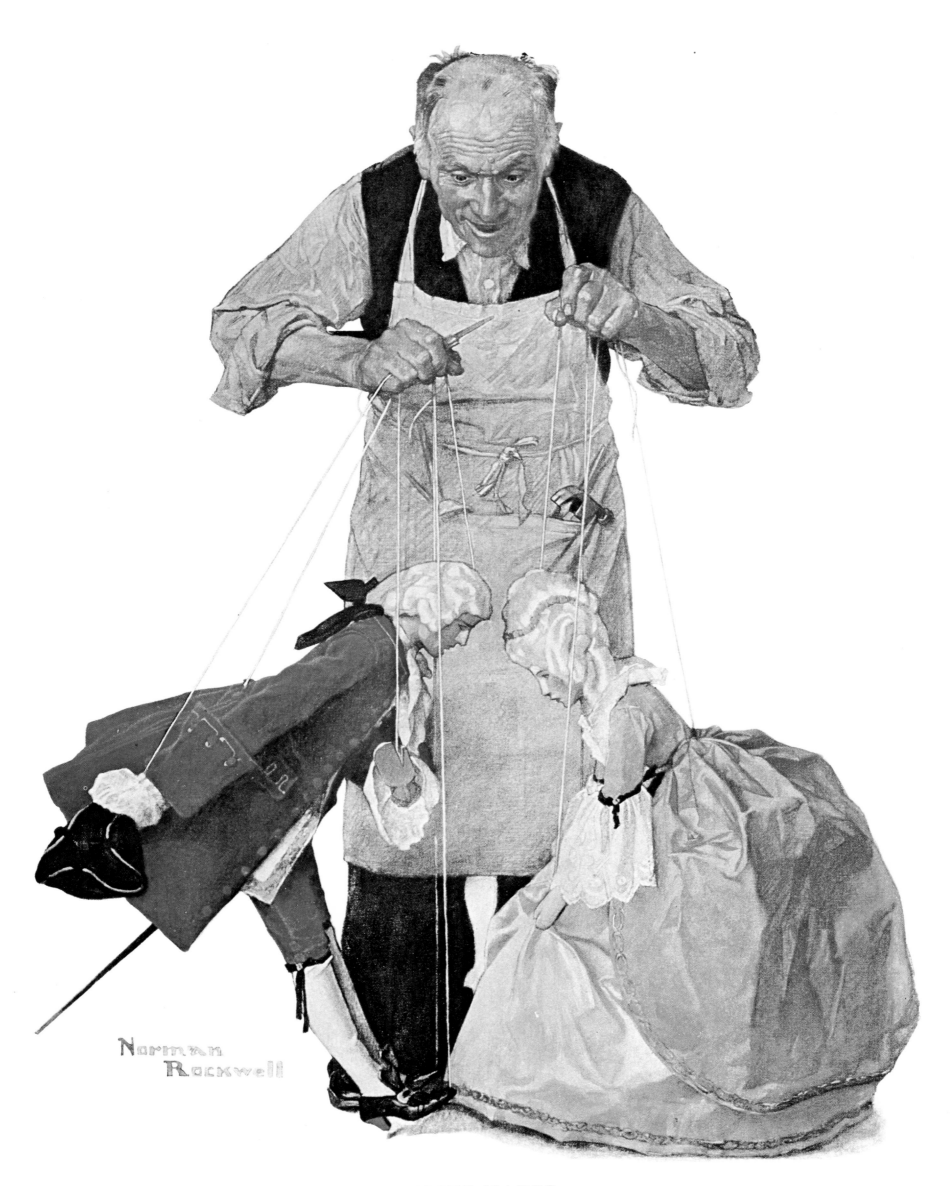

PUPPET MAKER

Post Cover • October 22, 1932

236

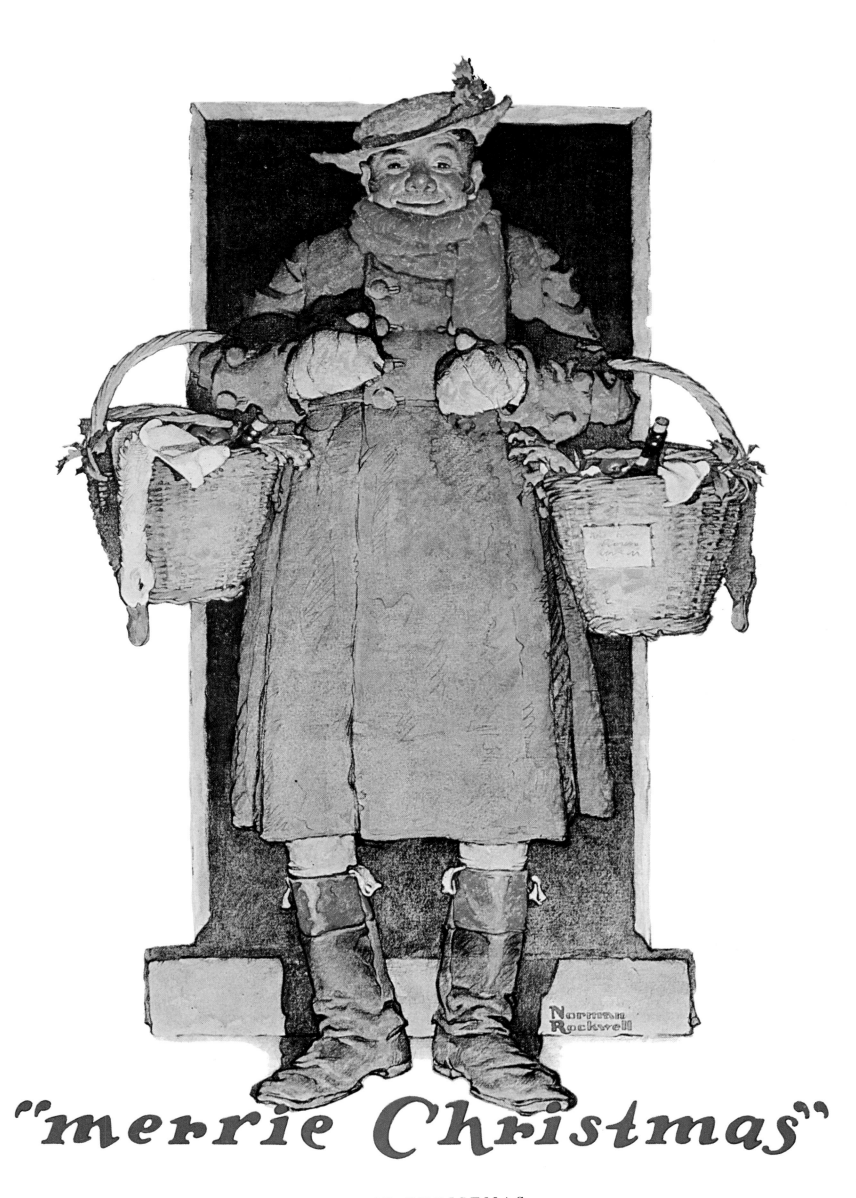

"merrie Christmas"

MERRIE CHRISTMAS

Post Cover • *December 10, 1932*

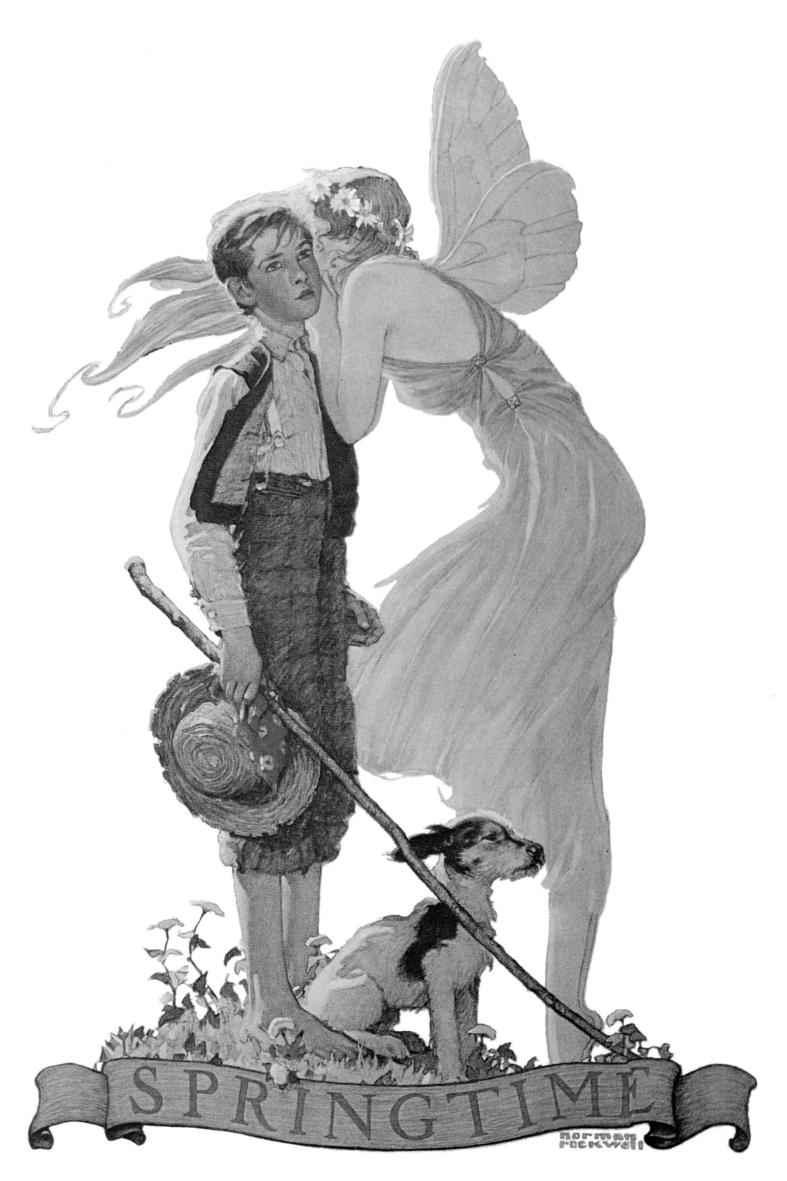

SPRINGTIME

Post Cover • April 8, 1933

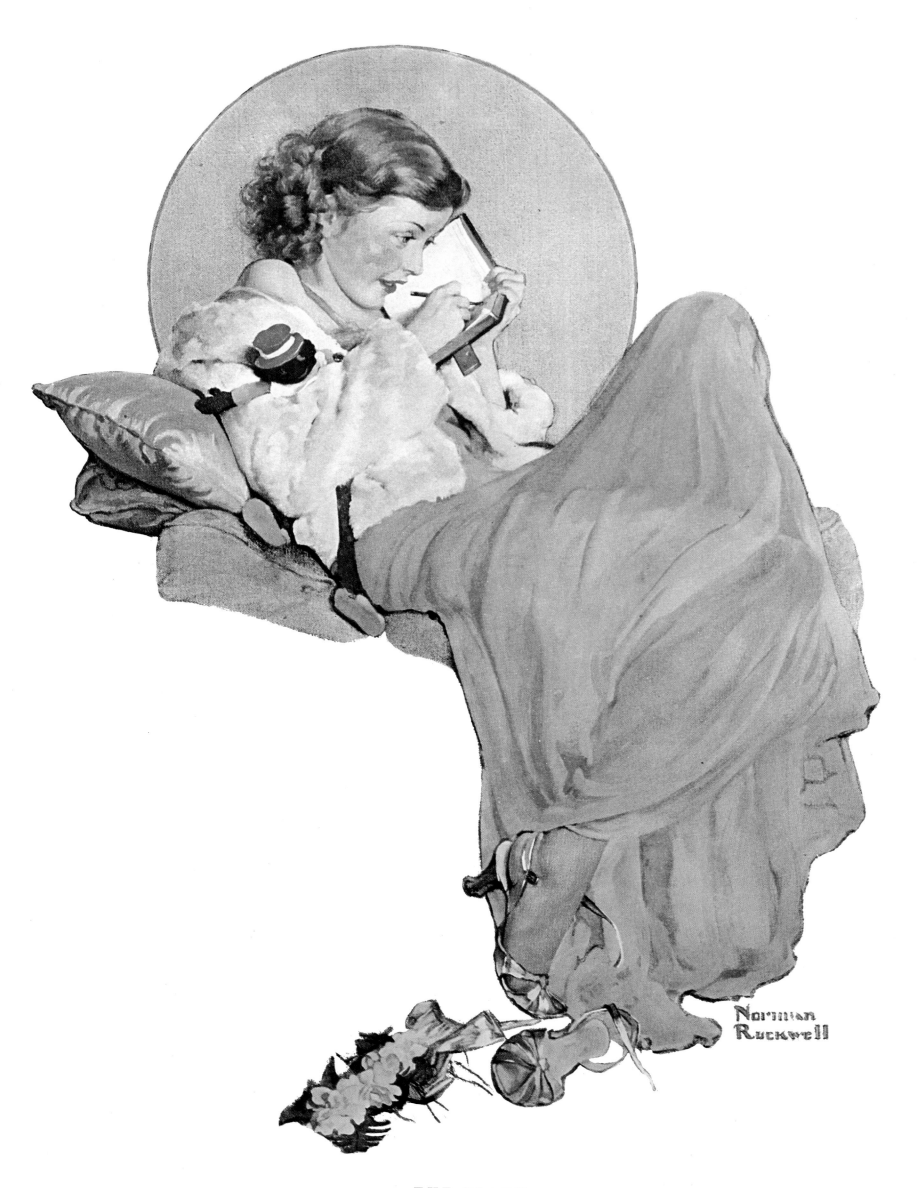

THE DIARY

Post Cover • June 17, 1933

239

Rockwell's Work Was Becoming More Personal

THE ROOSEVELT ADMINISTRATION had hardly managed to get things moving again when nature took a hand in the fate of the nation. In 1933 the first of the great dust storms hit the farm lands of South Dakota. In November of that year, a terrible storm picked up the dust loosened from the northern prairies by a prolonged drought, and it blackened skies from Chicago to Albany. For four years the drought continued, and dust storms devastated whole counties in the Dakotas, Nebraska, Kansas, Oklahoma, and down into Texas, transforming thousands of acres of arable land into a virtual desert. Waves of refugees driven from their wasted farms began to stream westward. Most of them headed for California, lured by its reputation as the land of milk and honey.

The country was beginning to recover, however, despite the terrible pockets of poverty remaining in rural and urban areas alike, where the Depression held on as grimly as ever. Widespread labor unrest led to bitter confrontations with management and law enforcement officers, confrontations that often ended in violence, bloodshed, and even death. The chaos of the early thirties had brought about a mood of uncertainty favorable to demagogues like Huey Long and Father Charles E. Coughlin—men whose words were disturbingly like the rhetoric of the new breed of tyrants across the Atlantic. But Roosevelt managed to keep the nation on track and moving forward.

Surprisingly, given the problems that beset almost everybody in the thirties, the decade has left us a legacy of glamour—whether real or ersatz is a matter of opinion—which has tended to cloud our perception of the very real suffering of the time. Thirties glamour was very different from twenties gaiety. Where the twenties had been brash, the thirties were polished. Where the twenties had offered a heady blend of wisecracks, bravado, and flamboyance for its own sake, the thirties aspired to an almost Parisian sense of chic.

The thirties are Jean Harlow, who slunk across the screen in white satin, knowing that despite the brassiness of the born tramp she could strut her stuff with the best of the old money. The thirties are Mae West taking it for granted that audiences in Farmingdale and Fresno can hear both sides of a double entendre. The thirties are screwball comedies: precisely choreographed collisions of fast-talking reporters, gangsters with pretensions to culture, society matrons, and scatterbrained maidens

from Connecticut suburbs and Bucks County mansions. The thirties are Fred Astaire and Ginger Rogers gliding across polished floors. And, since the decade mercifully had an anarchistic streak, the thirties are Groucho Marx and W. C. Fields leaving havoc in their wake.

Cafe Society was the arena in which Hollywood and the old money—this was the day of the playboy—could meet on common ground. Prohibition was over and the age of slightly naughty fun, as personified by Texas Guinan, gave way to the age of the lounge lizard. In the gossip columns, millions loved to read of the adult version of musical chairs that was played out—according to Louella Parsons and Walter Winchell—in nightspots on both coasts. People who had never seen the inside of a nightclub (or the outside, for that matter) lapped up the latest sly asides about the elegant and outré carryings-on of Brenda Frazier, Alfred G. Vanderbilt, Ali Khan, and the rest of the glittering crowd who populated the Stork Club and El Morocco under the benevolent gaze of Elsa Maxwell. These cafe celebrities became as familiar to many readers as the local beaux and belles who danced the night away at the Rotary Club's Fourth of July Picnic and Social Dance.

Norman Rockwell, although famous, was not much mentioned in the gossip columns. He did not need the kind of attention that is engineered, more often than not, by an energetic press agent. He was in his forties now, happily married, and his first son was followed by two more. His work, although he had still not found his mature style, was becoming looser—in concept, not in execution—and more personal in an as yet indefinable way. There were still paintings that were obvious throwbacks to earlier periods, but many of his covers had a fresh, new look. There was an important development in his working methods. Starting in 1937 Rockwell began to use photographs as a visual aid. Previously, he had always worked from live sitters—and he continued to use them even now—but his best work had often had a "snapshot" quality, and the use of actual photographs may well have enhanced this.

For Rockwell, this period was not one of radical change, but if we pay close attention to the covers he was painting then, we can find many small shifts that taken together tell us much about the direction in which he would soon be moving.

SATURDAY EVENING POST COVERS
August 5, 1933–February 19, 1938

SUMMERTIME
Post Cover • August 5, 1933
PAGE 249

Here Rockwell's flirtation with allegory becomes infused with an unexpected hint of eroticism. The nymph who whispered sweet nothings into the boy's ear earlier in the year (p 238) was chaste and ethereal. These naiads emerging from the reeds have far more of a flesh-and-blood look to them and seem game for any kind of sport the boy may have in mind.

GOING OUT
Post Cover • October 21, 1933
PAGE 250

A four-year-old, ready for bed, watches as her mother—or perhaps it is an older sister—makes final adjustments to her coiffure in preparation for what seems to be an important engagement. Rockwell does not show us the child's face but, rather, leaves us to imagine what her features might reveal. The cards attached to the mirror tell us that this is probably a familiar scene, since the young woman seems to receive many invitations.

CHILD PSYCHOLOGY
Post Cover • November 25, 1933
PAGE 251

This young mother is struggling to make up her mind between the options of enlightened child rearing and traditional discipline. The debris scattered on the floor suggests that the child has behaved in an entirely traditional manner when given access to a hammer and breakable objects. Since the Rockwells had become parents by this time, we might wonder if this cover drew upon personal experience.

THE SPIRIT OF EDUCATION
Post Cover • April 21, 1934
PAGE 252

A touch of stage fright and a sense of creeping absurdity are both reflected in this boy's face. In any situation in which a child is confronted with the adult world's concept of behavior appropriate to childhood, Rockwell is always squarely on the side of the child, and this painting is no exception.

BARGAINING
Post Cover • May 19, 1934
PAGE 253

It seems clear that this rustic antique peddler has met his match. While Rockwell was no Petty or Vargas, he evidently loved to paint attractive young women, and this determined bargain hunter is typical of the type that appears in his paintings again and again. His young women are almost always pert, pretty, slim, neatly dressed and groomed. One can find examples from as early as 1920 and as late as 1960, and here we get the archetypal Rockwell beauty in her mid-thirties incarnation.

VACATION
Post Cover • June 30, 1934
PAGE 254

For this cover Rockwell illustrated the notion "free as a bird" in a completely literal way. This curious concept works remarkably well because of the clever way the artist has placed the image on the page; he has left as much space as possible beneath the boy and his unlikely mount, evoking a real sense of flight.

STARSTRUCK

Post Cover • September 22, 1934

PAGE 255

HERE we have a new variation on the forsaken mutt theme. This time the poor animal has been displaced by a collection of eight-by-ten glossies.

UNDER SAIL

Post Cover • October 20, 1934

PAGE 256

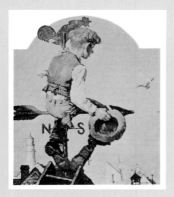

THIS is a delightful painting. Rockwell evokes the feel of the ocean without showing it and makes the most of the roofscape from the boy's vantage point.

GOD BLESS US EVERYONE

Post Cover • December 15, 1934

PAGE 257

HERE Rockwell acknowledges his Dickensian inspiration by illustrat-

ing Tiny Tim's famous invocation. The way Tim is pushed up against the top of the page emphasizes his smallness and frailty.

BILLBOARD PAINTER

Post Cover • February 9, 1935

PAGE 258

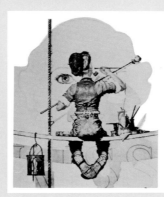

FOR this amusing cover, Rockwell treats the canvas as if it were, in effect, part of an actual billboard, and "suspends" the painter in front of it. This is the kind of visual trick that he would never have attempted in his early career, and it shows him moving toward new concepts and possibilities.

THE PARTYGOERS

Post Cover • March 9, 1935

PAGE 259

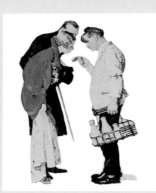

IN the 1935 song "Lullaby of Broadway," the early hours were signified by the observation that "the milkman's on his way." Now that we buy our milk in supermarkets, this imagery belongs to the past, but here Rockwell evokes for us that lost world.

SPRINGTIME

Post Cover • April 27, 1935

PAGE 260

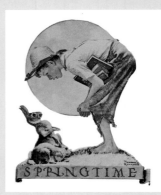

ONCE again an attempt at allegory finds Rockwell a bit off form. Rockwell was at a point in his career when he desperately needed to get away from such tired concepts. New ideas and new concepts were cropping up with increasing frequency, but, as this example shows, he had not yet succeeded in throwing off old habits.

RUMBLE SEAT

Post Cover • July 13, 1935

PAGE 261

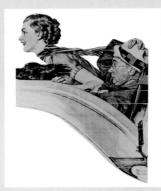

WHILE not as rich in detail as most of Rockwell's best work, all the same this painting makes for a lively cover. The contrast between the two protagonists is neatly executed, and the coachwork of the automobile is deftly employed to pull the composition together.

SCHOOL DAYS
Post Cover • *September 14, 1935*
PAGE 262

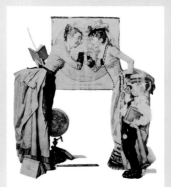

THIS is an amusing cover, but there
seems to be very little reason for the
period setting except to provide an oppor-
tunity for the artist to display his virtuosity
in painting elaborate costumes.

A WALK IN THE COUNTRY
Post Cover • *November 16, 1935*
PAGE 263

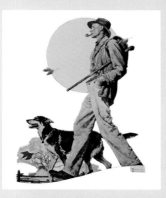

THIS is among the least anecdotal of
Rockwell's *Post* covers. The con-
cept could hardly be any simpler, but the
design is strong and the draftsmanship
sure.

THE GIFT
Post Cover • *January 25, 1936*
PAGE 264

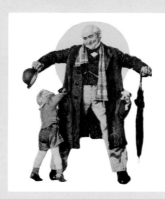

THIS is very much a bread-and-butter
cover, but by 1936 Rockwell had
learned how to present the uninspired with
a degree of panache. He has allowed the
old man to occupy practically the whole
canvas. This gives a concreteness to his
presence that would probably have been
lacking if this same subject had been
painted a dozen years earlier.

MOVIE STAR
Post Cover • *March 7, 1936*
PAGE 265

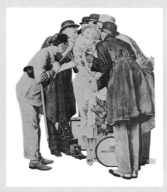

IN the thirties, Americans—and people
all over the world, for that matter—
were obsessed with Hollywood (both its
movies and its personalities), and here
Rockwell captures part of its ritual, the
movie star interview. We can almost hear
this actress answering the questions she
has heard a thousand times before with
well-oiled platitudes provided by some
studio publicist. Yet she is properly glam-
orous and has clearly enchanted the gen-
tlemen of the press.

SPRINGTIME
Post Cover • *April 25, 1936*
PAGE 266

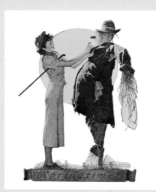

ROCKWELL's best spring cover in years
finds one of his pert young things
—we can picture her striding across
flower-strewn meadows and vaulting
five-barred gates—presenting a bouton-
niere to a scarecrow. The subject is whim-
sical without drifting into feyness. One
can imagine anyone, on a balmy April
day, behaving in just this way, and one can
certainly believe it of someone with such
refined taste in walking canes.

MEDICINE
Post Cover • *May 30, 1936*
PAGE 267

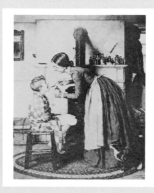

THE figures in this painting are quite
unremarkable, but the composition
is notable for its fully realized back-
ground. We have seen nothing in
Rockwell's *Post* covers to date that quite
matches this study of an environment—in
this case a cozy country kitchen. In illus-
trations for books and stories, however,
Rockwell had often provided detailed set-
tings. But there he was dealing with a
different kind of problem, one that did not
involve catching the eye of the newsstand
browser. This painting presages many as-
pects of Rockwell's later work.

YOUNG LOVE
Post Cover • July 11, 1936
PAGE 268

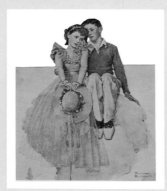

ROCKWELL often caught his young lovers at moments of awkwardness or indecision, or else sought the humor in their situation, but here he resisted all such temptation and gave us a cover that is defined by simplicity and affection.

BARBERSHOP QUARTET
Post Cover • September 26, 1936
PAGE 269

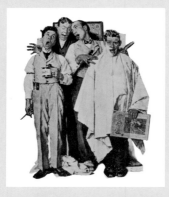

HERE we have unabashed nostalgia, an American institution captured with sympathy and deft brushwork. The four harmonizers are stereotypes, but this time that is just as it should be.

THE NANNY
Post Cover • October 24, 1936
PAGE 270

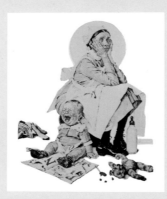

THIS cover is a study in frustration. The young woman's costume marks her as a professional, but all the expertise and training in the world can do nothing to alleviate this situation.

PARK BENCH
Post Cover • November 21, 1936
PAGE 271

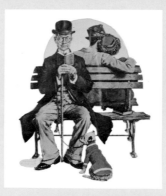

WE cannot tell what whispers he has overheard, but clearly the gentleman with the book is disturbed by what is happening behind him and cannot bring himself to ignore it. This is an example of Rockwell's ''reaction shot'' approach. If this were a scene from a movie, the stars—Claudette Colbert and Fred MacMurray, say—would be the couple with their backs to us. Instead of confronting us directly with their endearments, the director might choose to make his point by giving us the reactions of a comical third party, and that is precisely the cinematic technique that Rockwell has decided upon for this painting.

MISTLETOE
Post Cover • December 19, 1936
PAGE 272

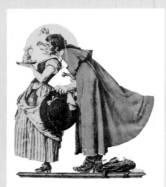

AWARE, apparently, that he will find a pretty young serving girl at the inn, the handsome visitor has thoughtfully brought his own mistletoe with him. The past may never have been quite like this, but the way the figures have been set up in profile—allowing the artist to take advantage of the girl's bustled skirt and the young man's full cloak—make for a strong composition.

THE COLD
Post Cover • January 23, 1937
PAGE 273

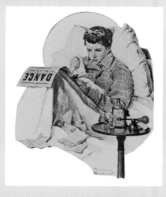

IT was in 1937 that Rockwell began to use photographs as an aid in preparing his compositions, but he continued to paint some subjects from life; this is probably one of them. Rockwell suggests the character of the girl's room by softening the edges of most of the forms. Only the medicine on the table in the foreground is seen in sharp focus.

TICKET AGENT
Post Cover • April 24, 1937
PAGE 274

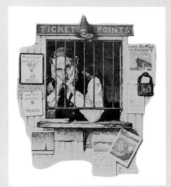

"ARE you bored? Travel!" says one of the posters affixed to this ticket office. The painting is a study in boredom and also, perhaps, a reminder of the Great Depression that still lingered on in 1937. The worst of it might have been over by then, but few people had the money to take advantage of invitations such as "Why not go to Europe?" In any case, Europe had been rendered less attractive to some potential travelers by events like the Spanish Civil War.

DOLORES AND EDDIE
Post Cover • June 12, 1937
PAGE 275

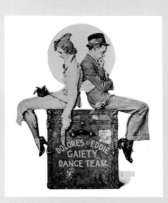

THIS cover is another reflection of the times. Vaudeville had been on its last legs for a decade or more; now it was on its knees, and the plight of this gaiety dance team is typical of what many entertainers faced around 1937.

THE ANTIQUE HUNTER
Post Cover • July 31, 1937
PAGE 276

IT seems likely that this is an early example of a cover made, in part at least, from photographs. It would have been virtually impossible, after all, for a model to pose for any length of time while holding and balancing so many objects.

THE CHASE
Post Cover • October 2, 1937
PAGE 277

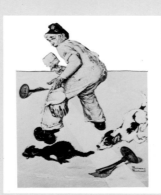

THIS again is a rather "cinematic" cover, and it seems reasonable to suppose once more that photographs were used in its preparation. The way that the workman is being pulled off balance is what makes the entire composition work.

CHRISTMAS
Post Cover • December 25, 1937
PAGE 278

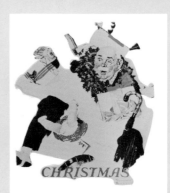

ALTHOUGH Rockwell was increasingly using fresh subject matter, this painting is something of a throwback to earlier years. In contrast to the realism of the previous cover, this one seems rather artificial. The old man is a little too pink-cheeked and stereotyped, and his predicament is a trifle too contrived.

DREAMBOATS
Post Cover • February 19, 1938
PAGE 279

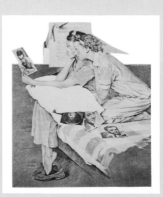

THIS cover is the counterpart of "Starstruck" (p 255), painted almost four years earlier. As in "The Cold" (p 273), Rockwell softens his style somewhat to suggest a feminine environment. This is a quiet study of two wistful young women. The one closer to us is especially well observed.

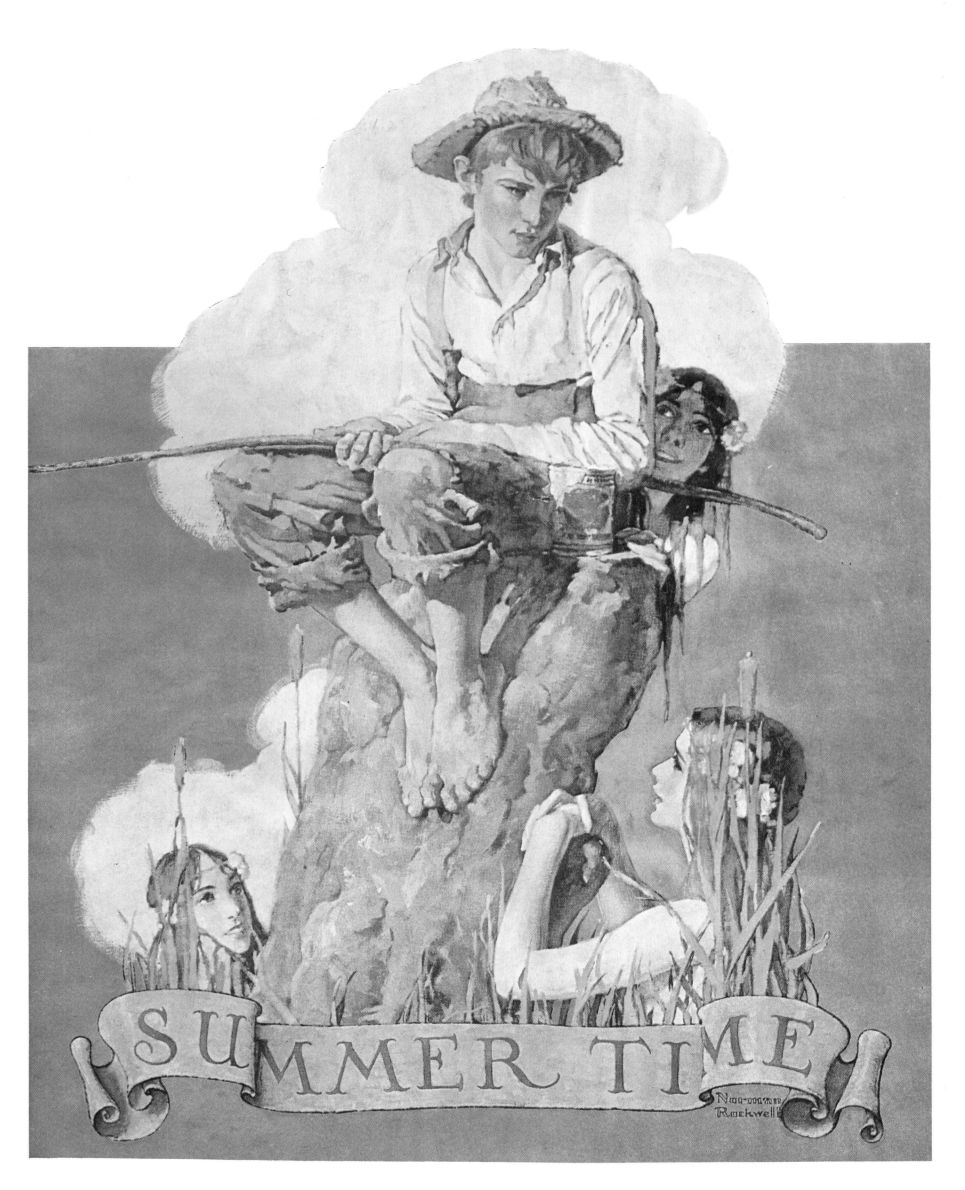

SUMMERTIME

Post Cover • August 5, 1933

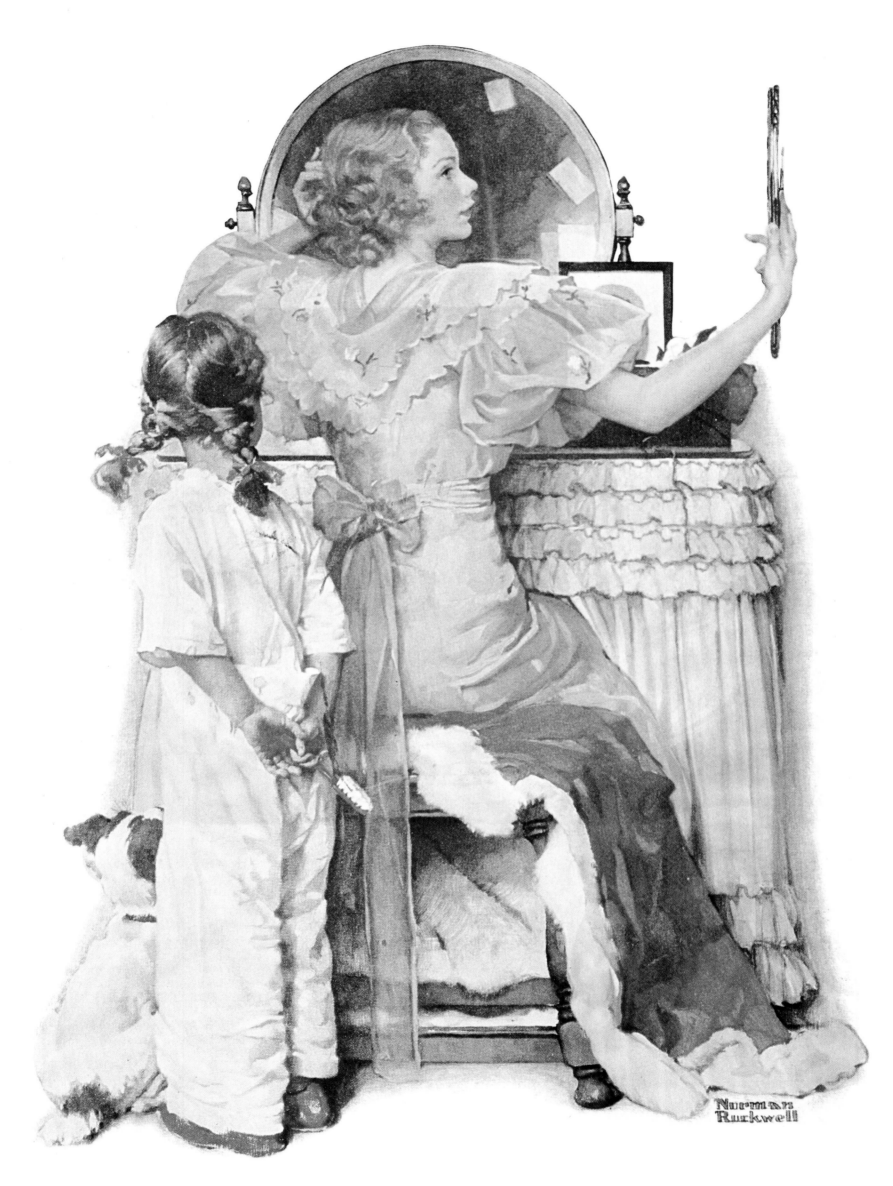

GOING OUT

Post Cover • October 21, 1933

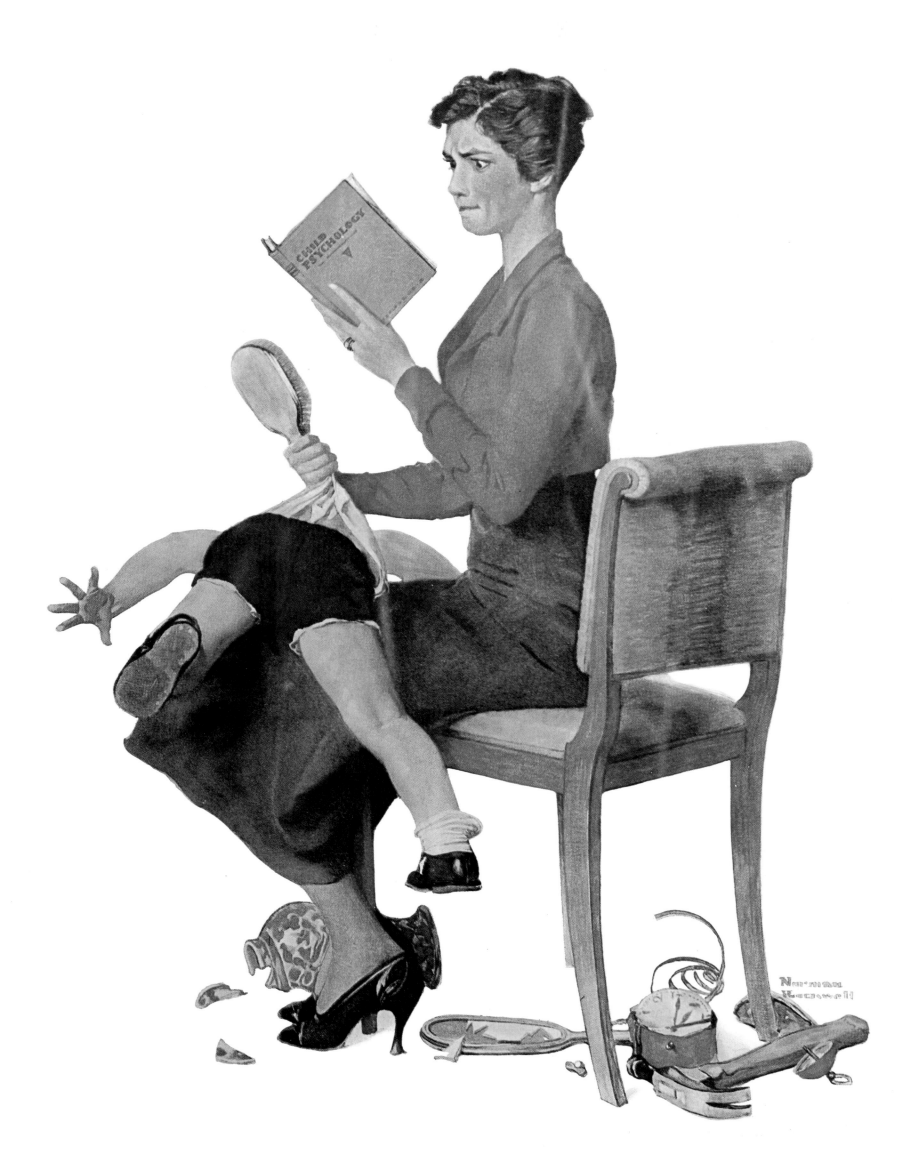

CHILD PSYCHOLOGY

Post Cover • *November 25, 1933*

251

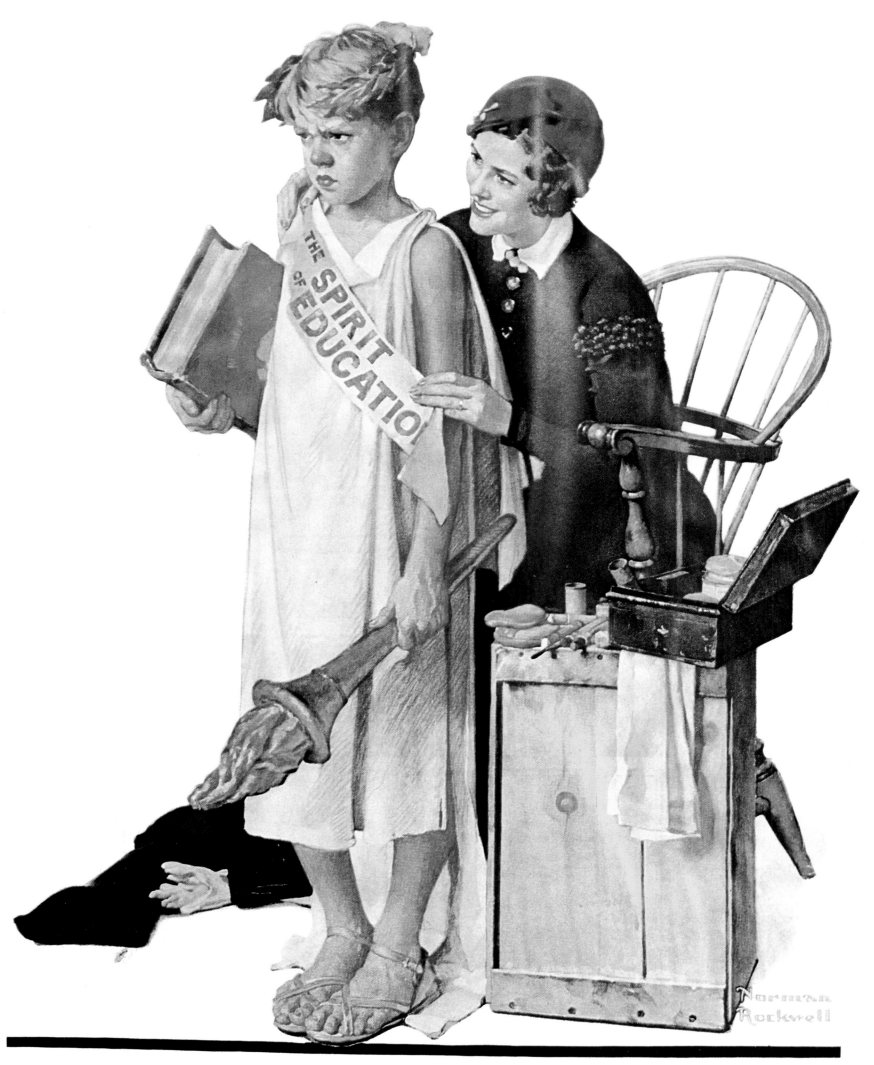

**THE SPIRIT OF
EDUCATION**

Post Cover • April 21, 1934

252

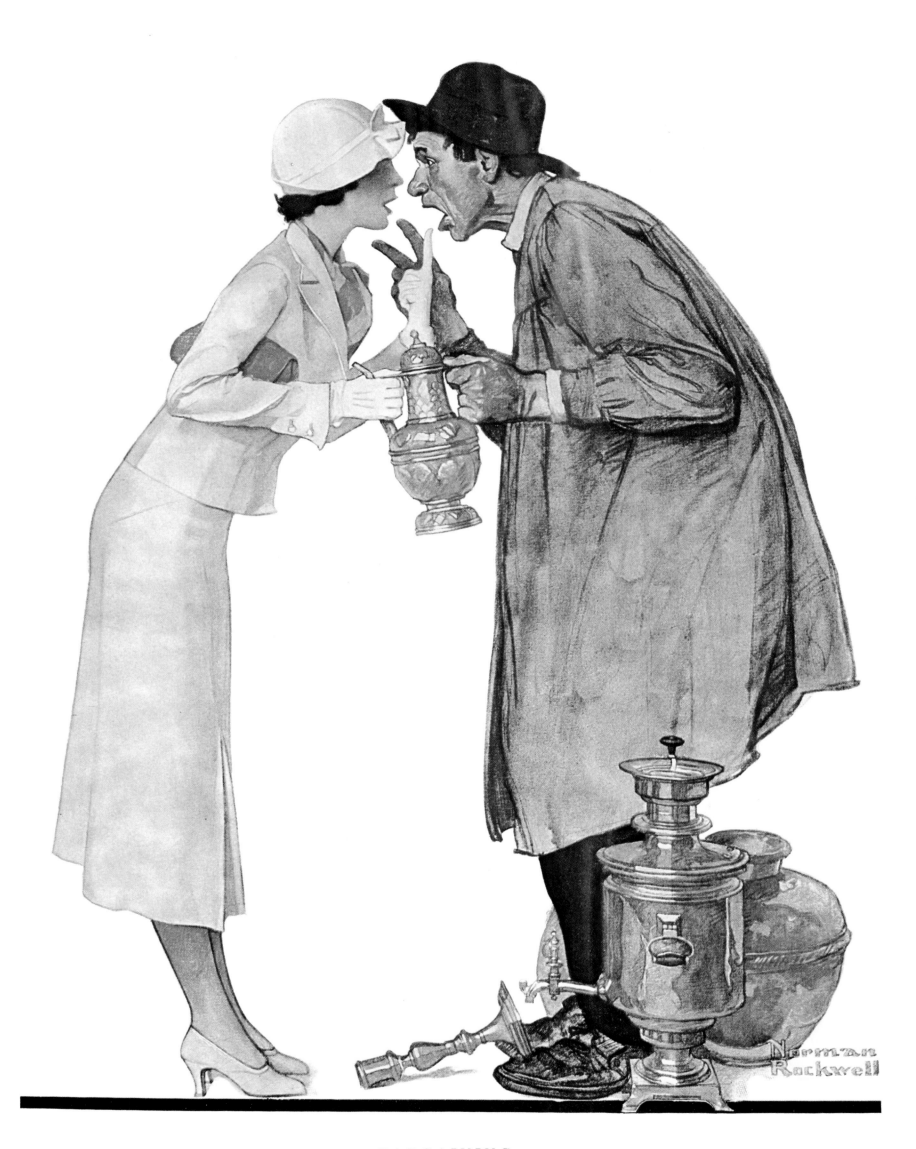

BARGAINING

Post Cover • May 19, 1934

VACATION

Post Cover • June 30, 1934

STARSTRUCK

Post Cover • September 22, 1934

255

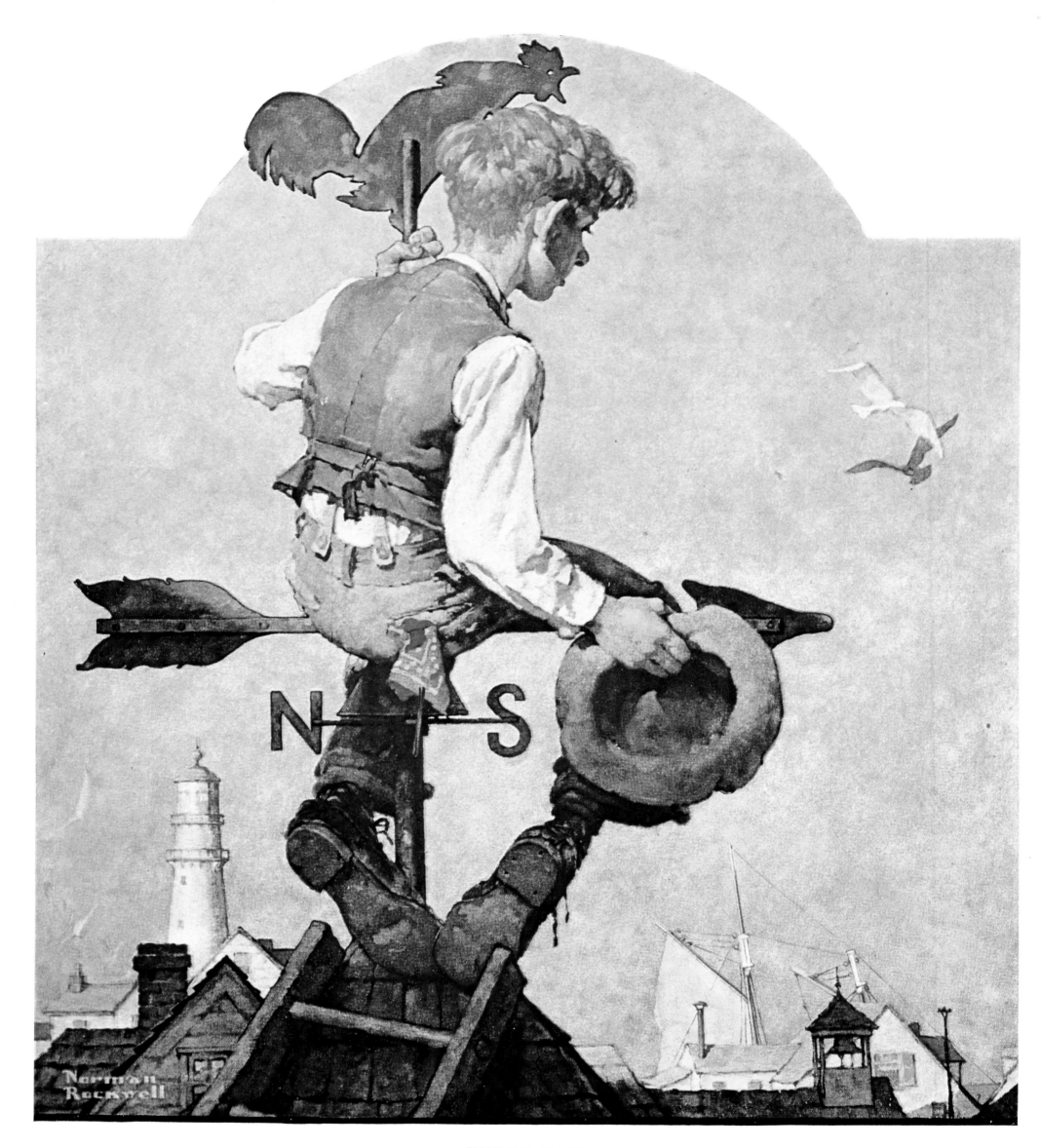

UNDER SAIL

Post Cover • October 20, 1934

256

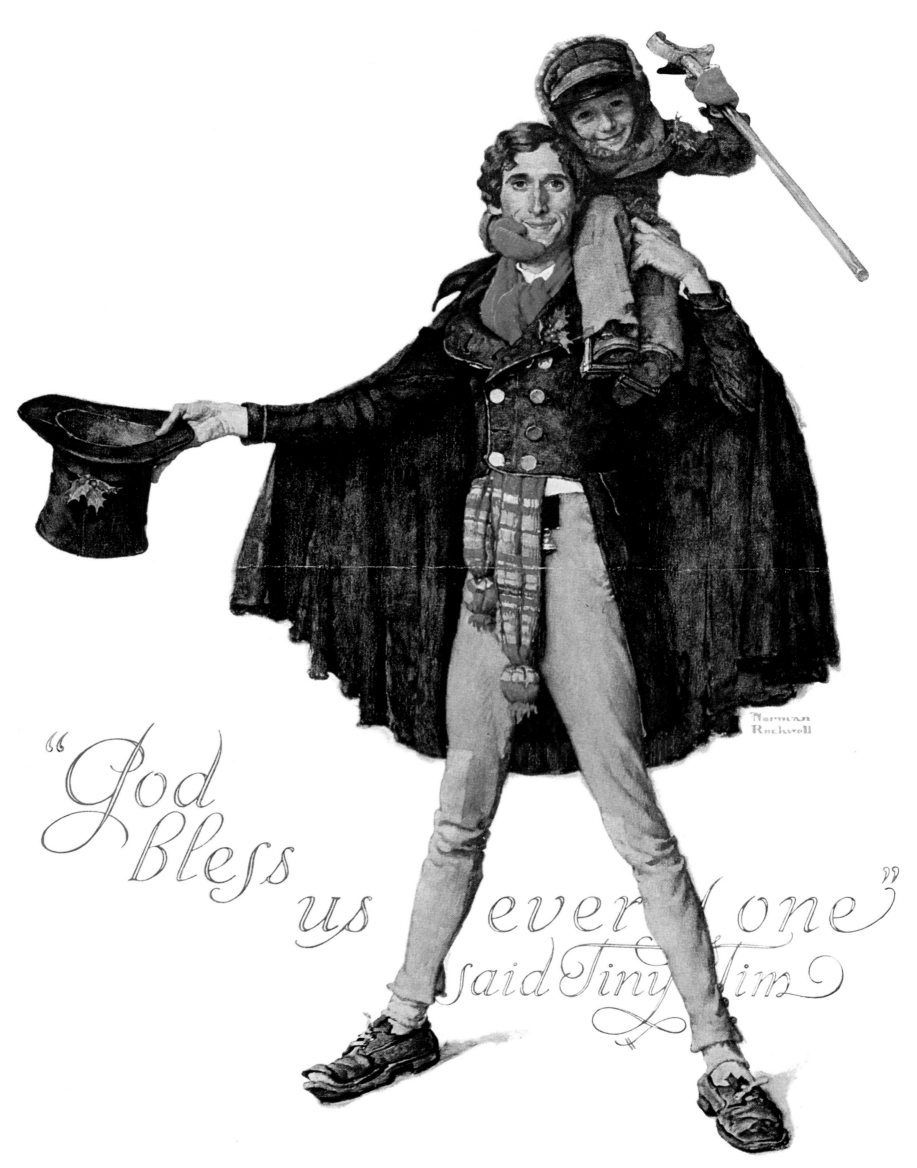

GOD BLESS US EVERYONE

Post Cover • December 15, 1934

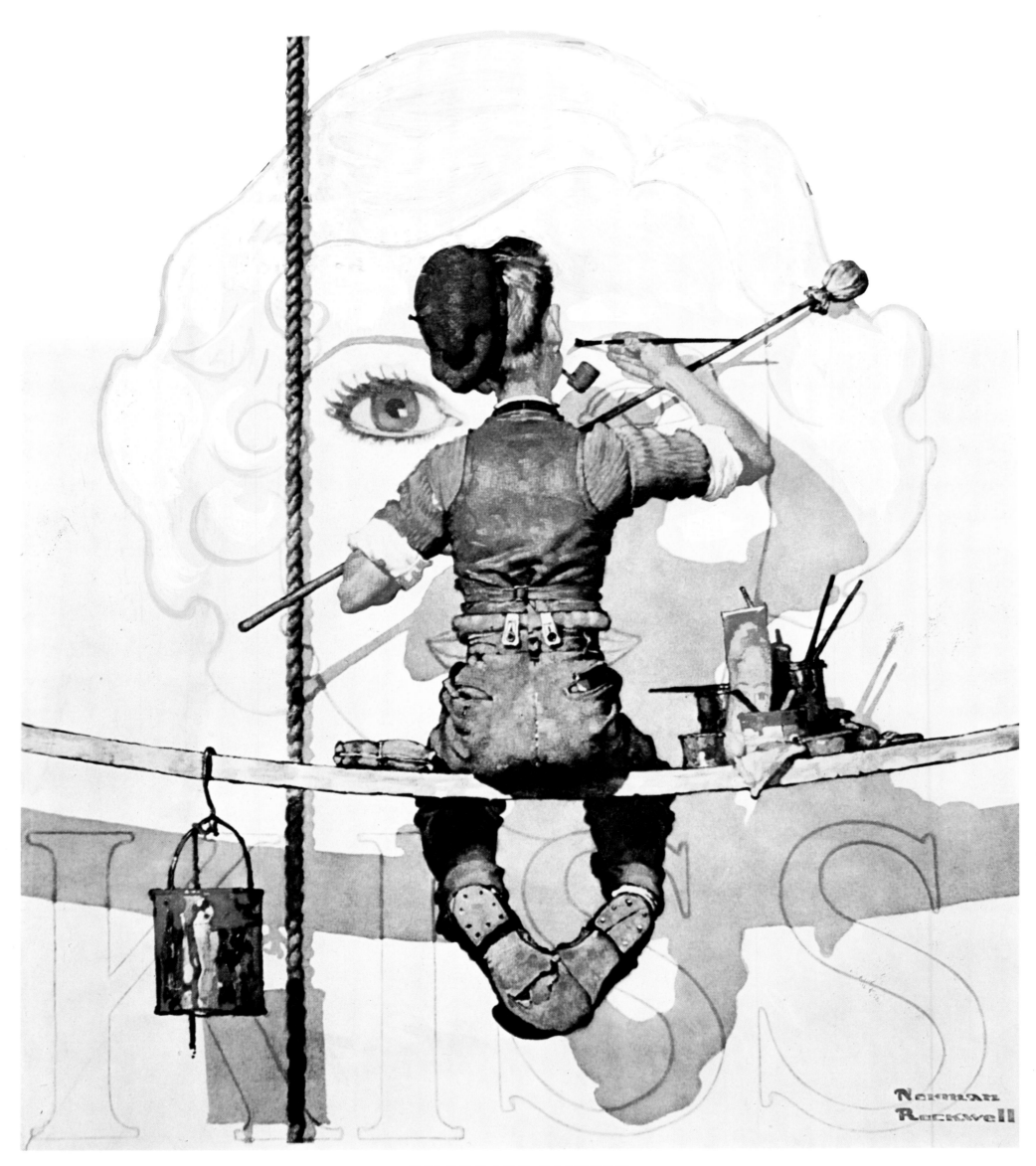

BILLBOARD PAINTER

Post Cover • February 9, 1935

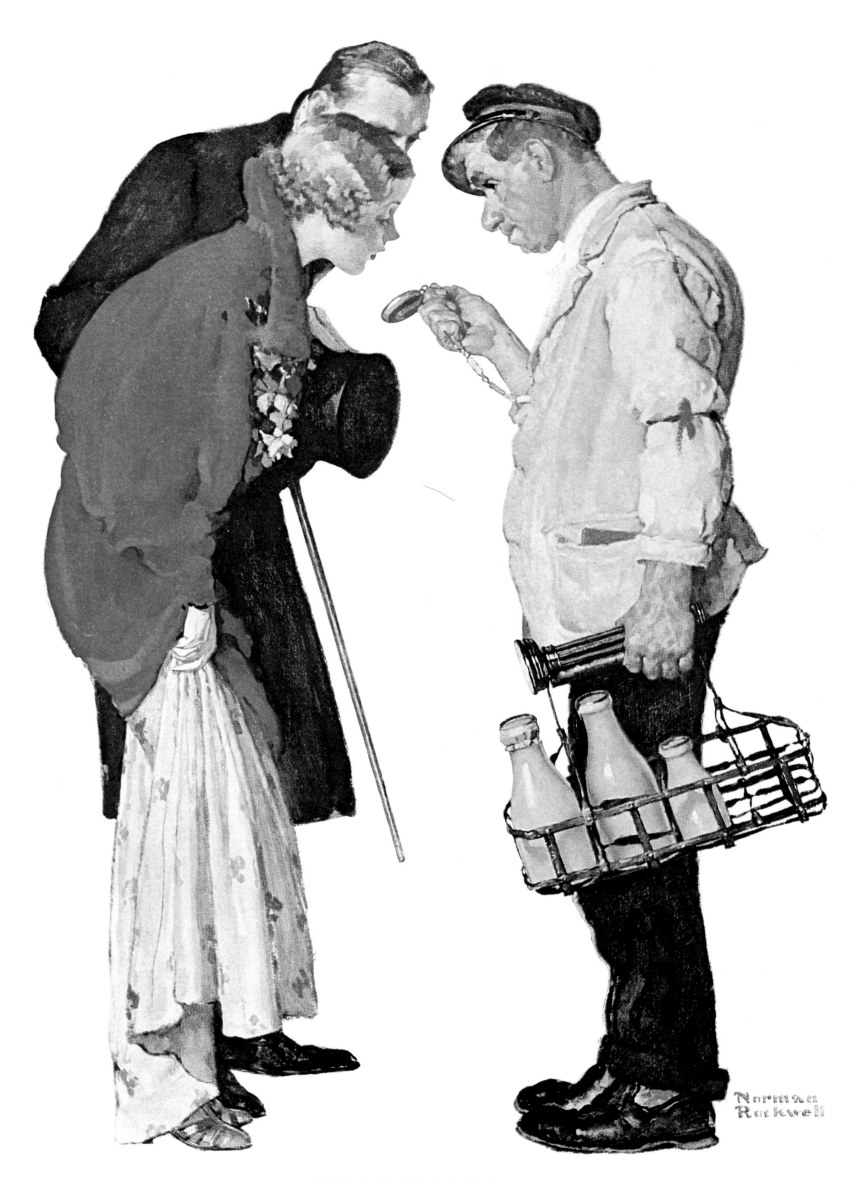

THE PARTYGOERS

Post Cover • March 9, 1935

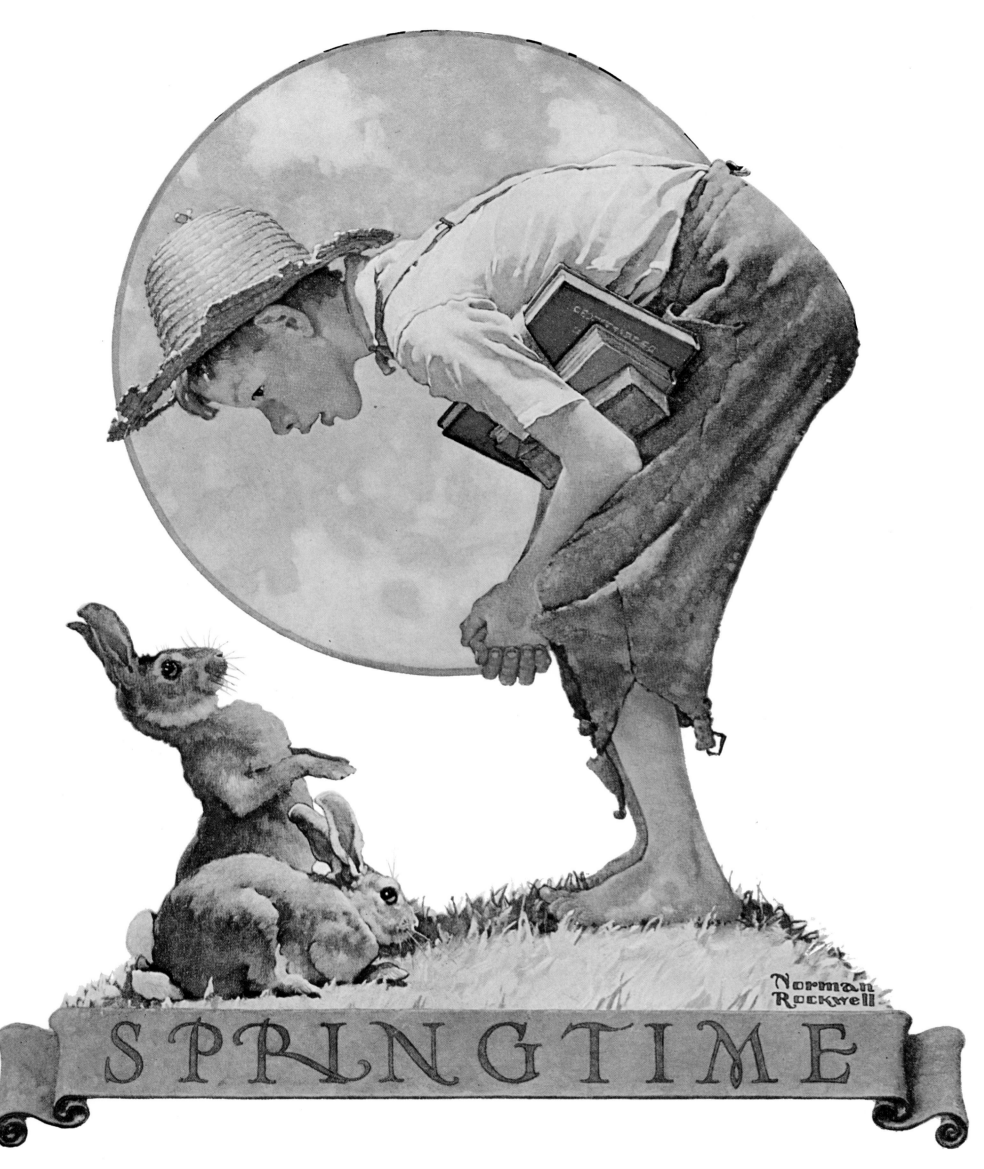

SPRINGTIME

Post Cover • April 27, 1935

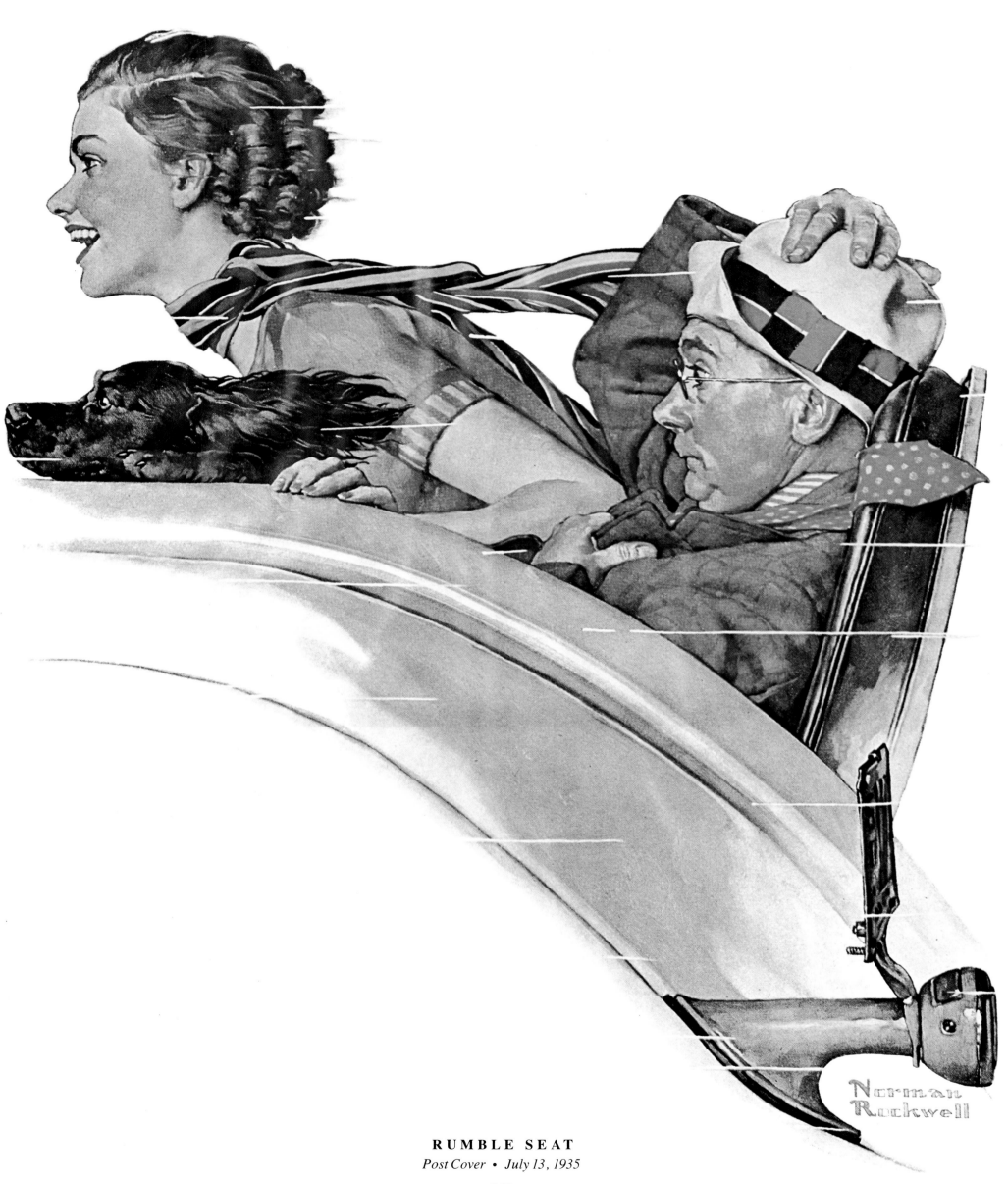

RUMBLE SEAT

Post Cover • July 13, 1935

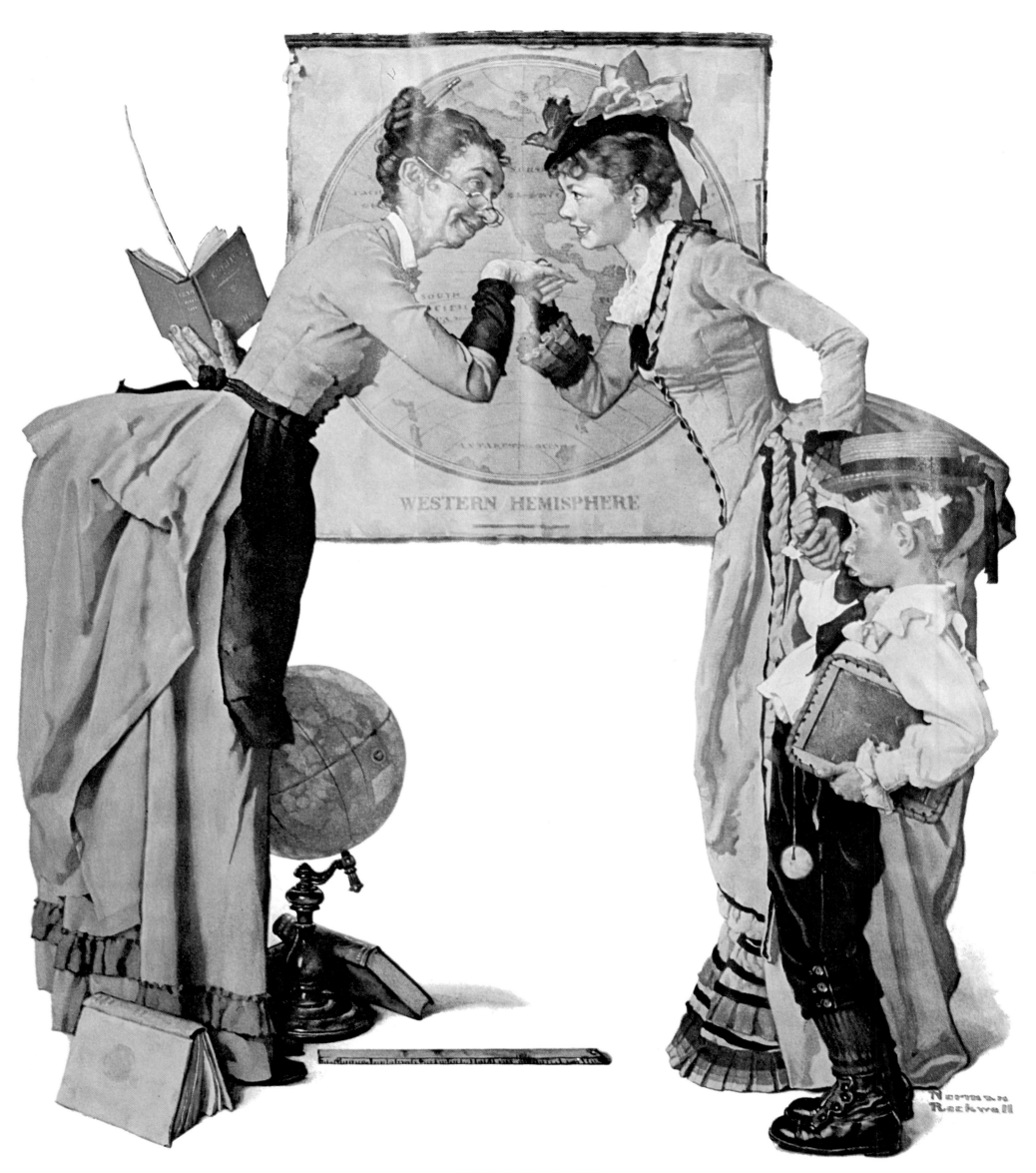

SCHOOL DAYS

Post Cover • September 14, 1935

262

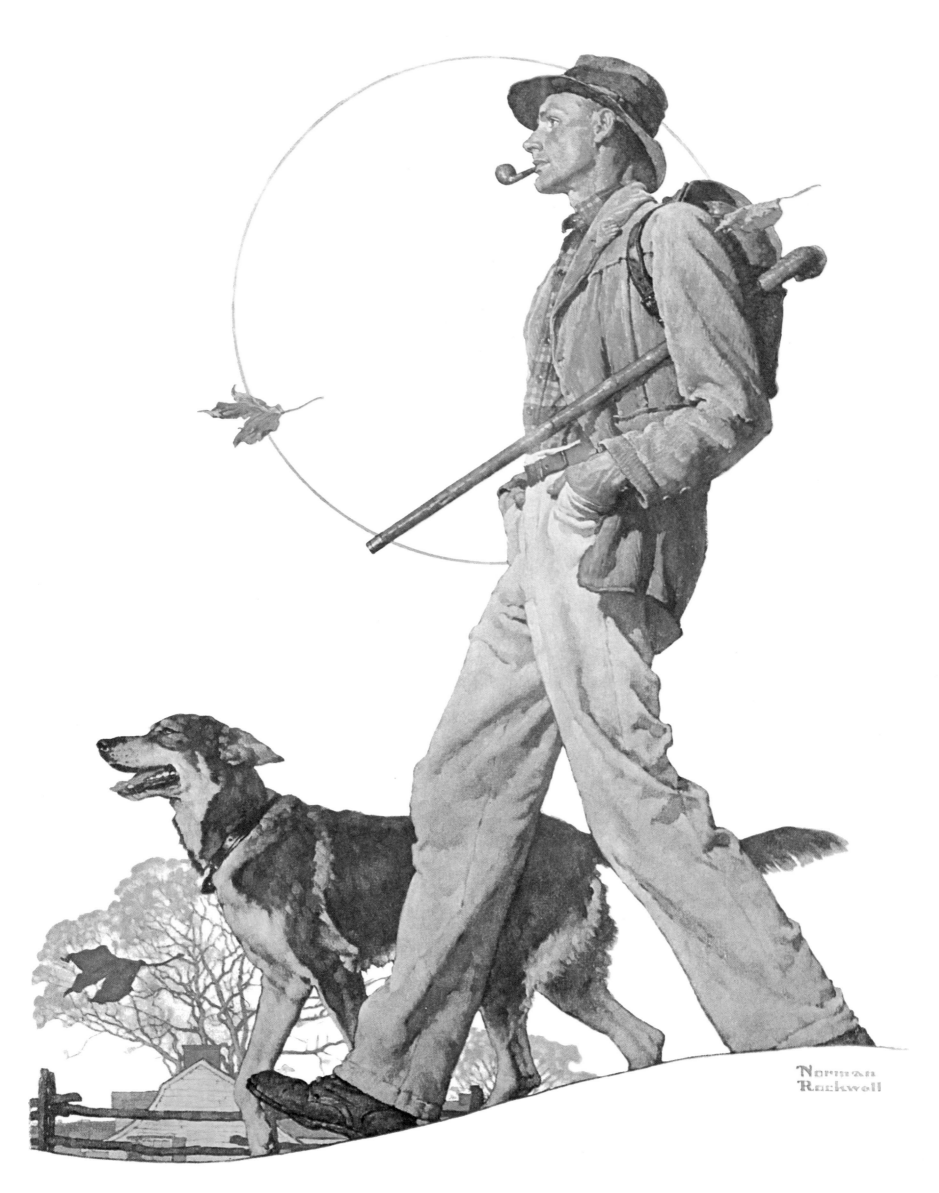

A WALK IN THE COUNTRY

Post Cover • *November 16, 1935*

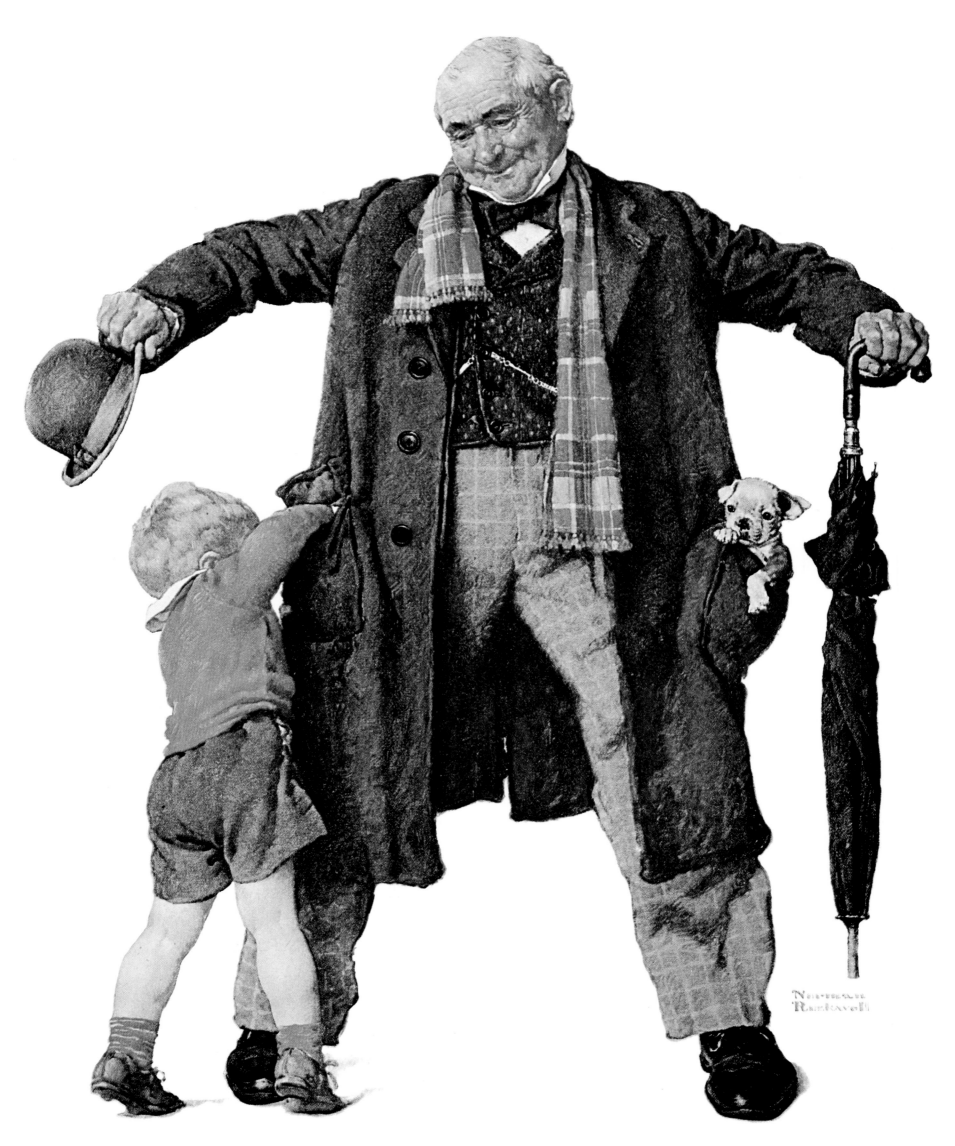

THE GIFT

Post Cover • January 25, 1936

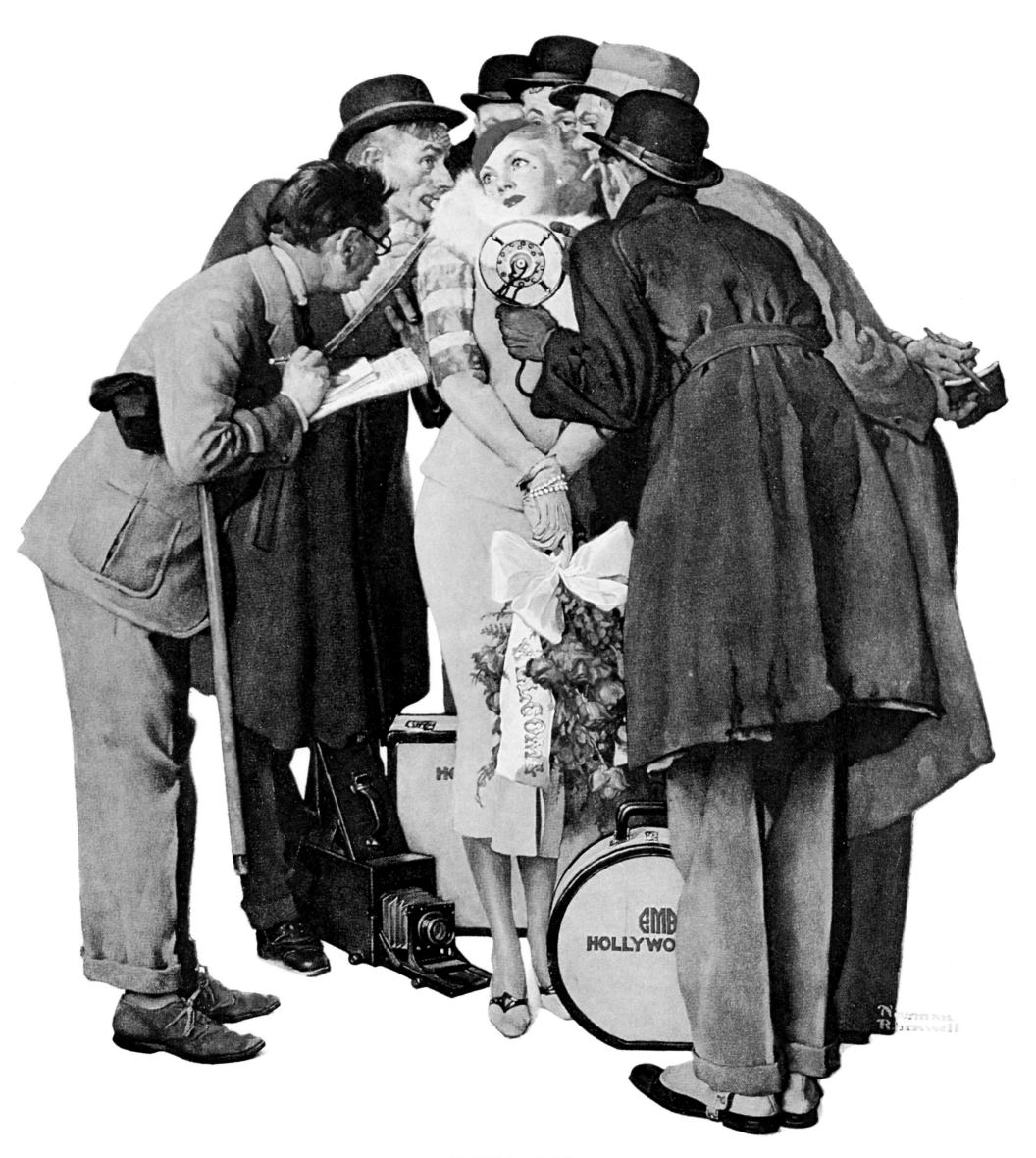

MOVIE STAR

Post Cover • *March 7, 1936*

265

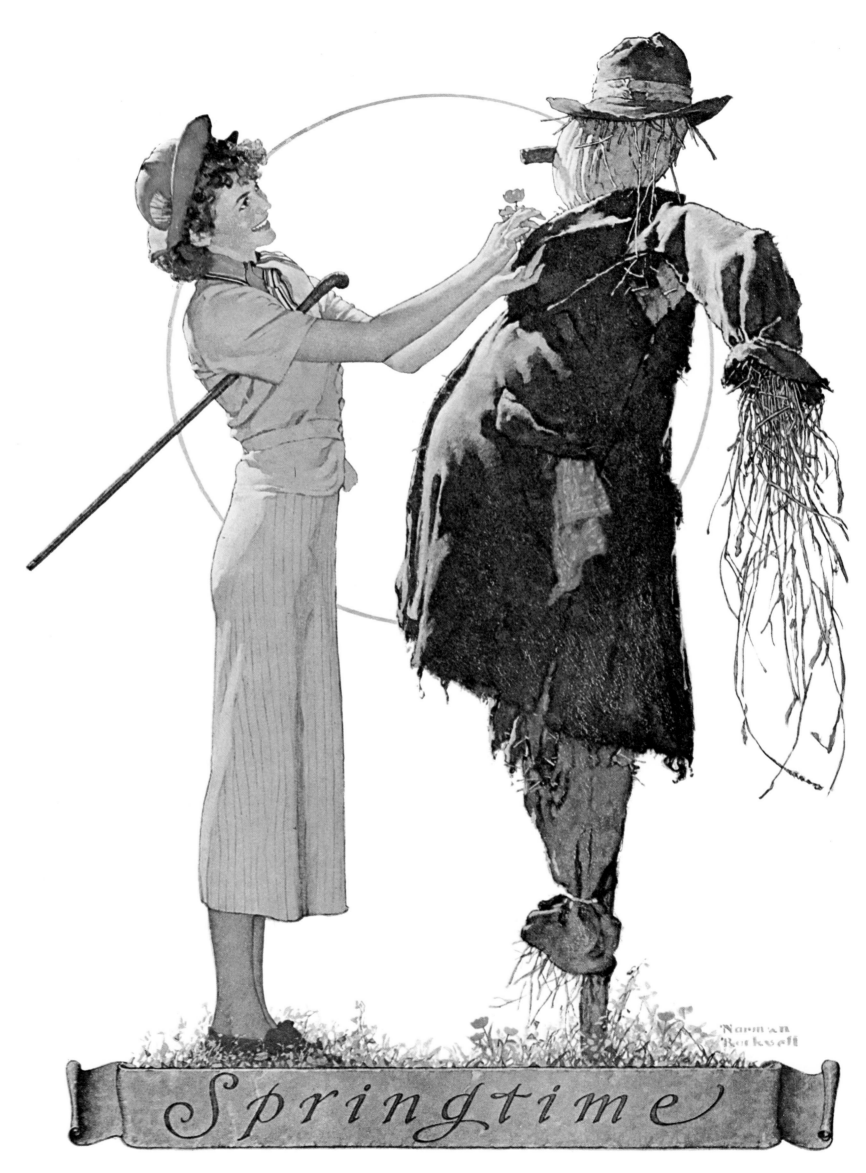

SPRINGTIME

Post Cover • April 25, 1936

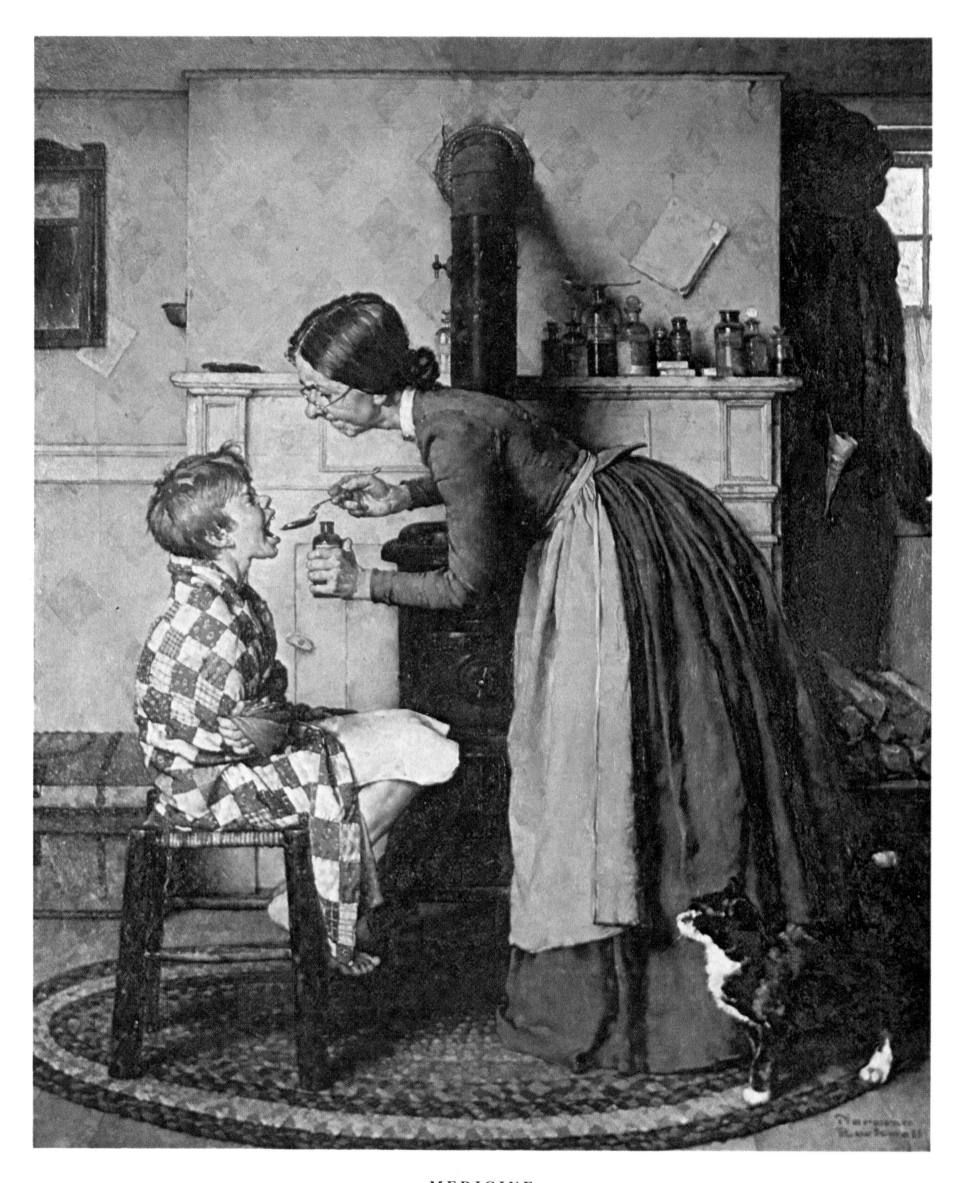

MEDICINE

Post Cover • May 30, 1936

267

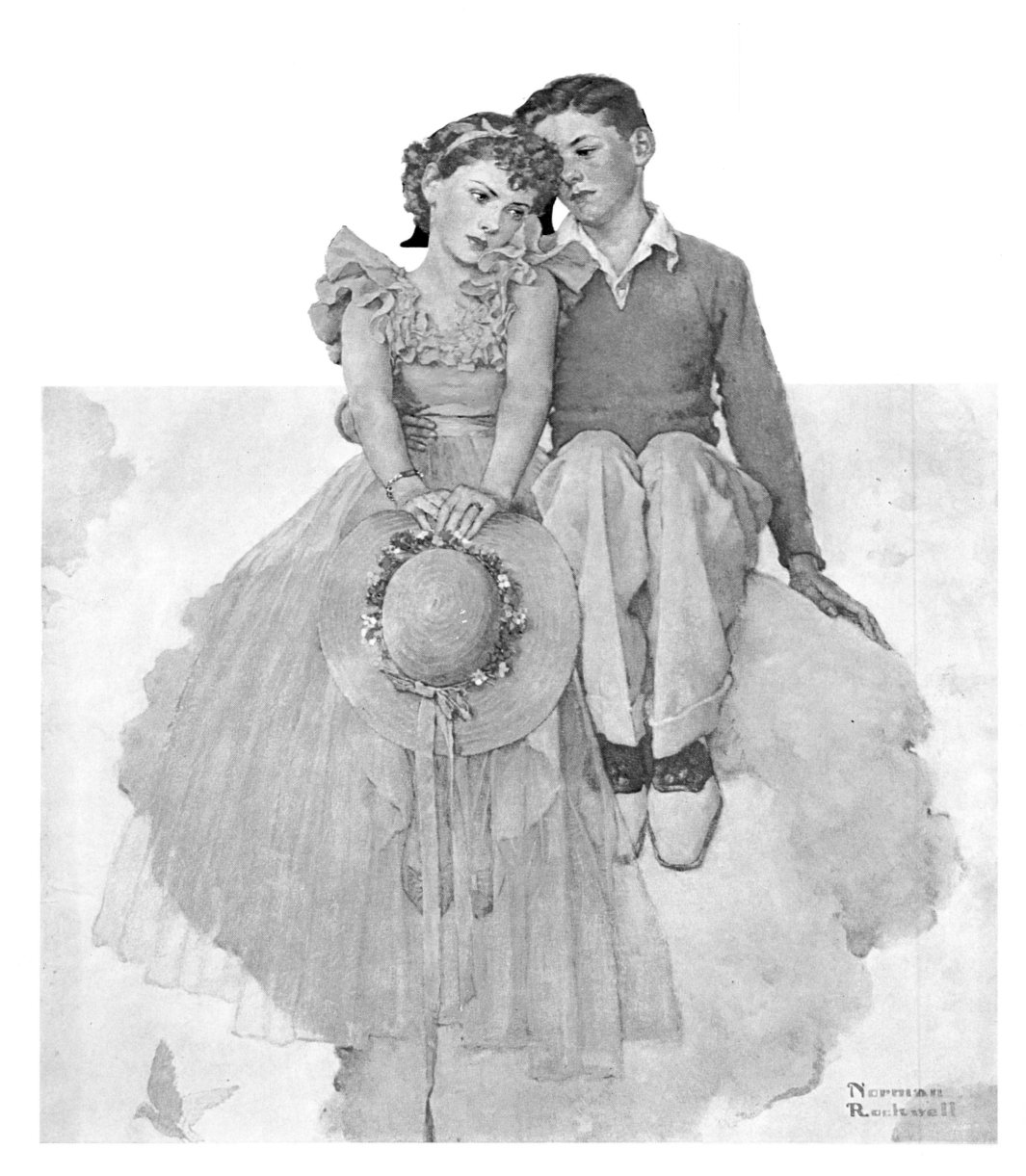

YOUNG LOVE

Post Cover • July 11, 1936

268

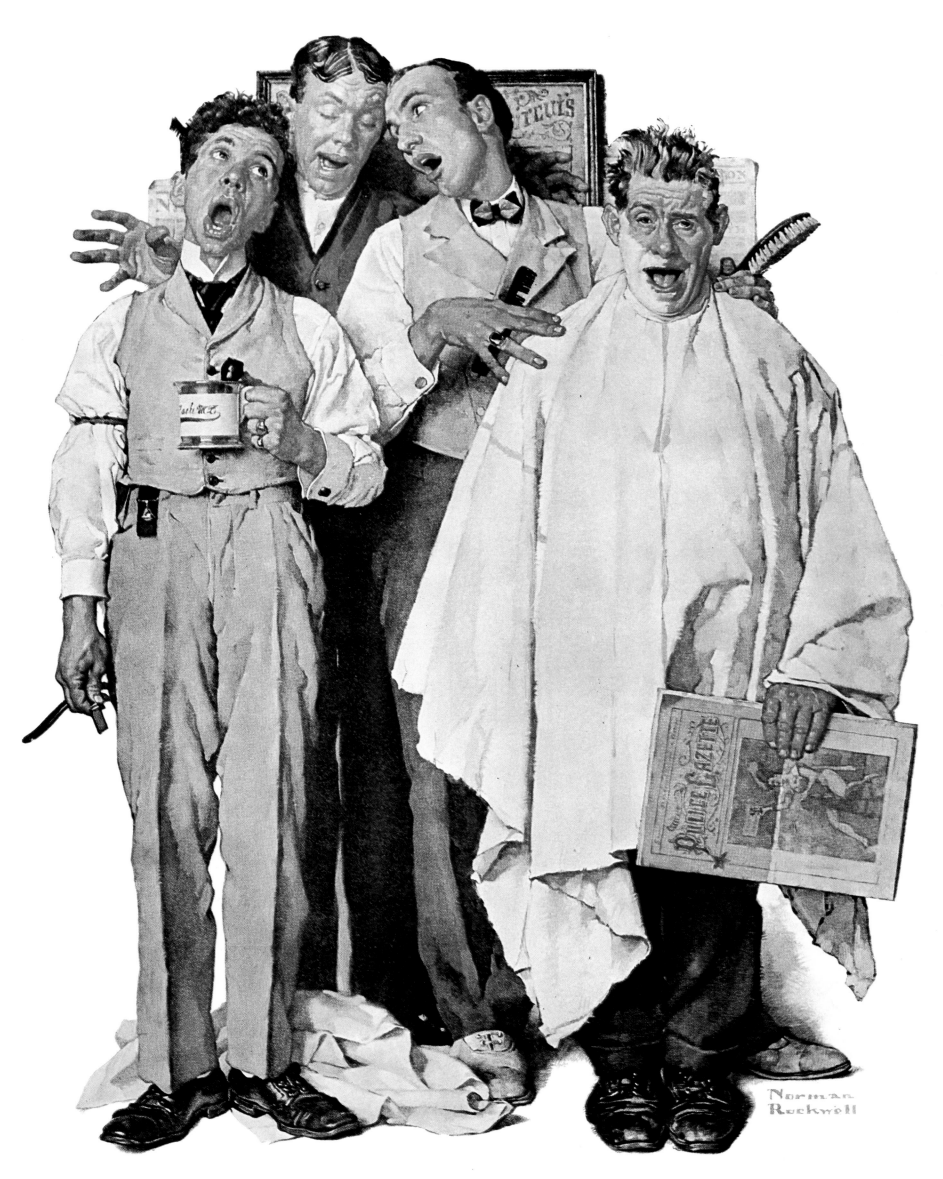

BARBERSHOP QUARTET

Post Cover • September 26, 1936

THE NANNY

Post Cover • October 24, 1936

PARK BENCH

Post Cover • November 21, 1936

271

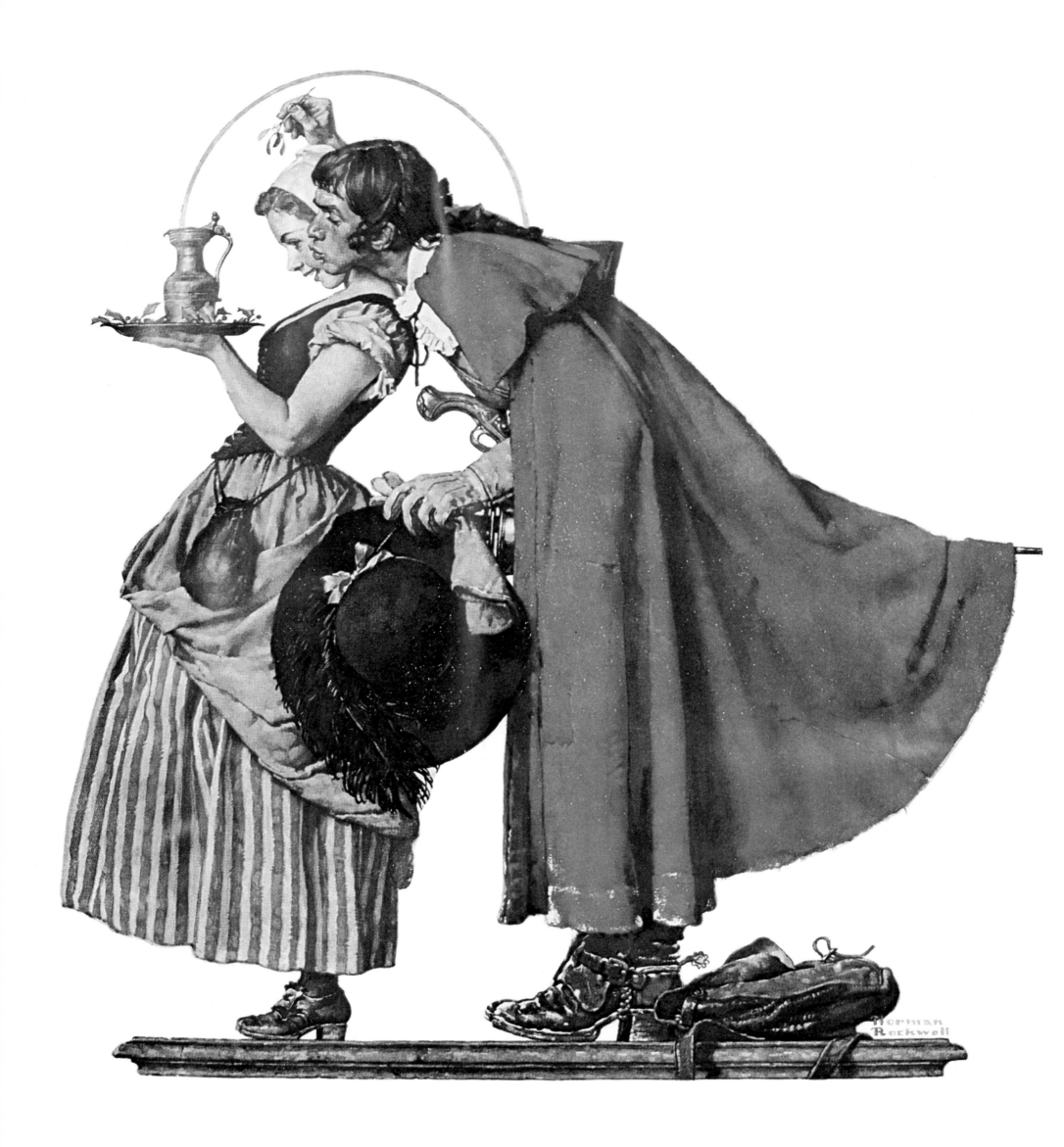

MISTLETOE

Post Cover • December 19, 1936

272

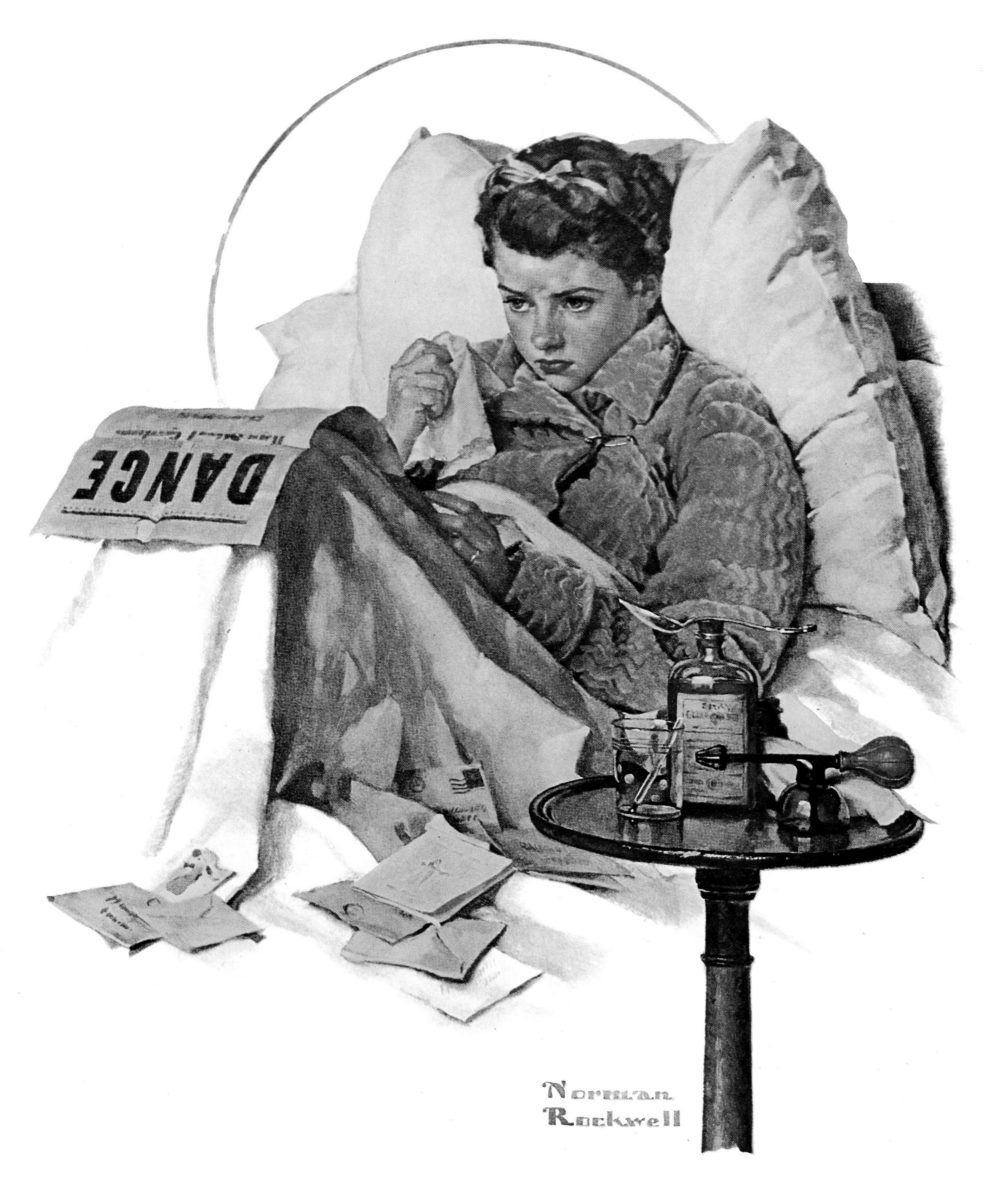

THE COLD

Post Cover • January 23, 1937

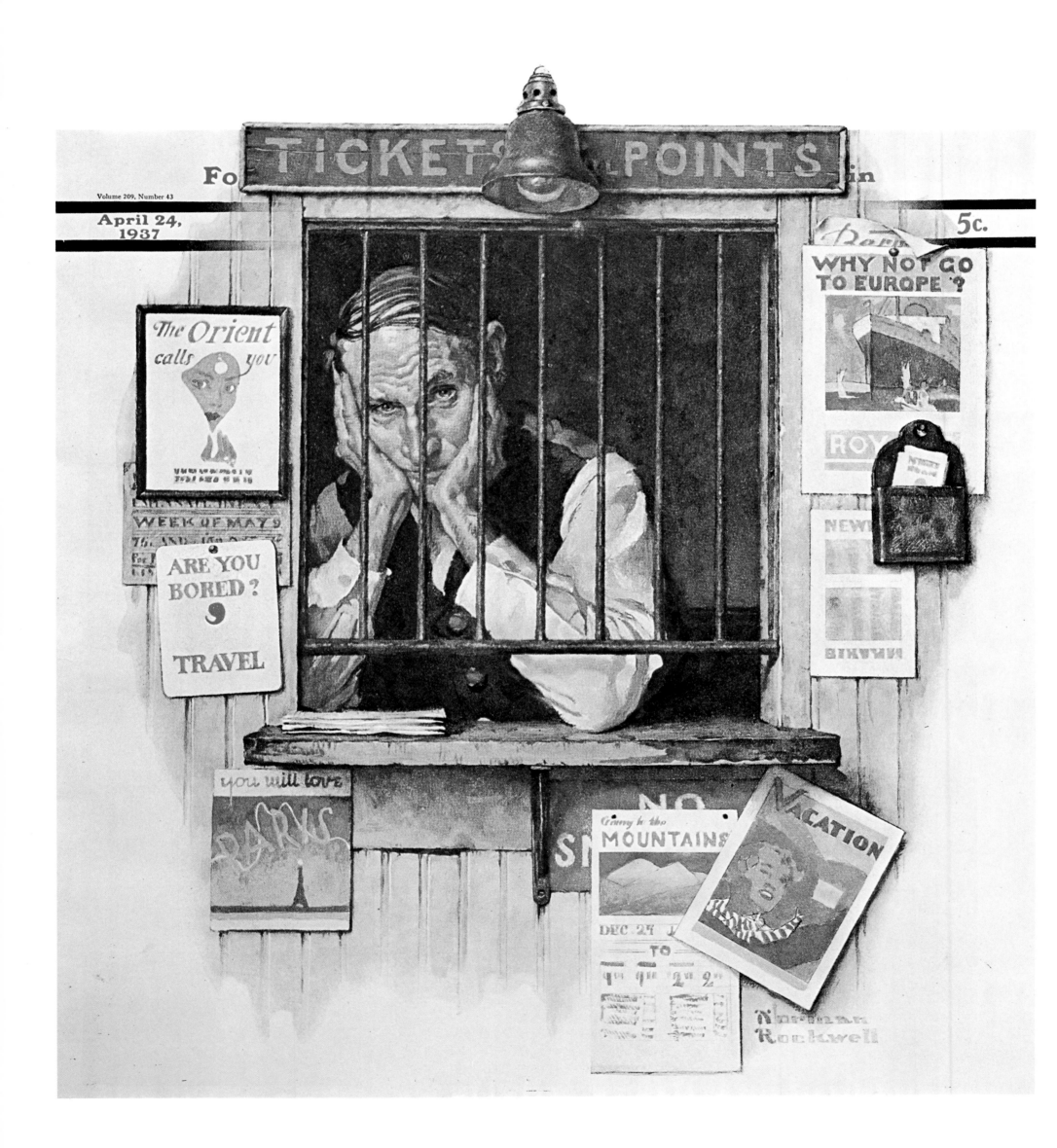

TICKET AGENT

Post Cover • April 24, 1937

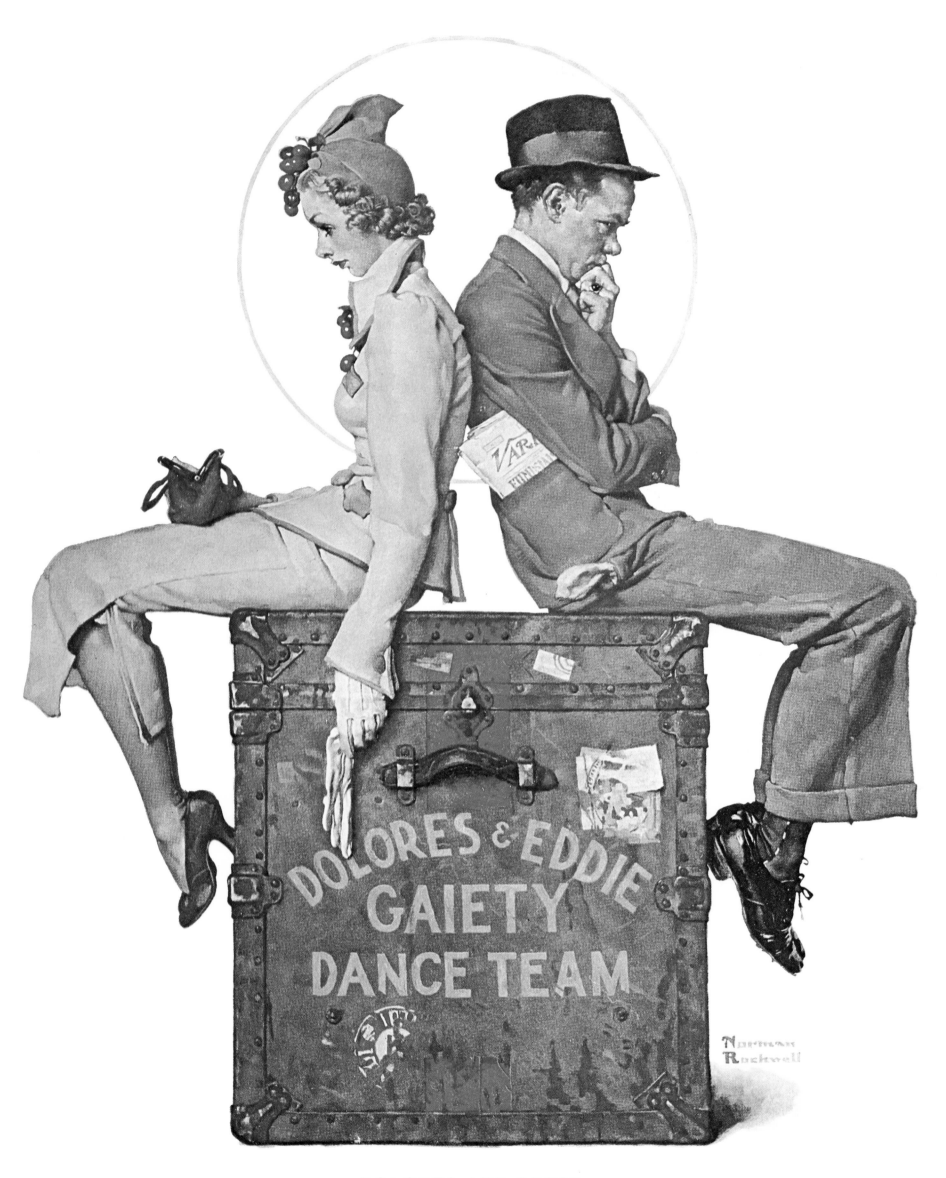

DOLORES AND EDDIE

Post Cover • *June 12, 1937*

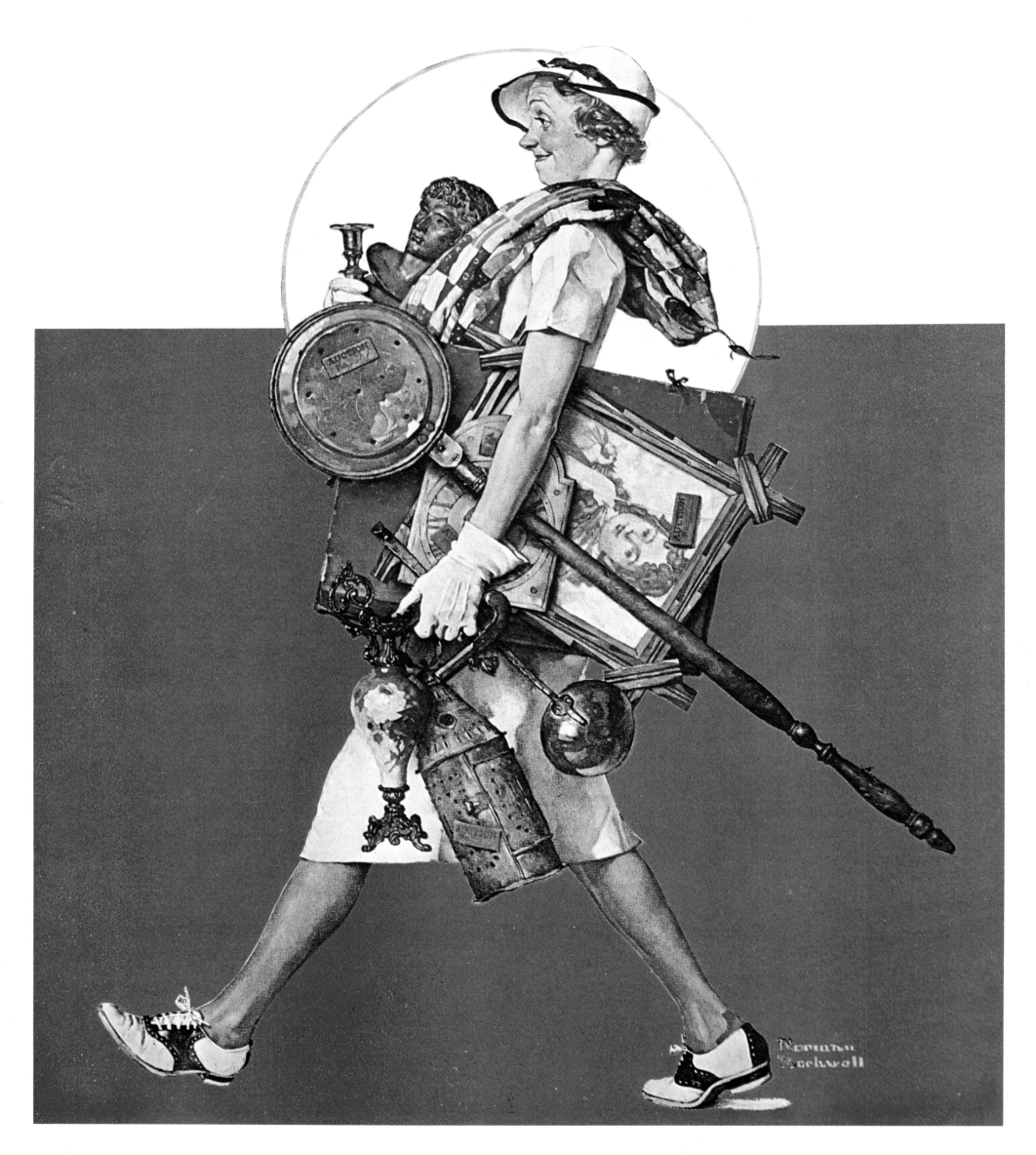

THE ANTIQUE HUNTER

Post Cover • July 31, 1937

THE CHASE

Post Cover • October 2, 1937

CHRISTMAS

Post Cover • *December 25, 1937*

278

DREAMBOATS

Post Cover • February 19, 1938

279

Rockwell Was Now on the Verge of a Major Breakthrough

BY 1939 THE NATION was well on its way to economic recovery. Another age of prosperity, more solidly based this time, seemed almost within grasp. But war clouds were gathering across the Atlantic, and before the year was over, a new World War had begun (although, for a while at least, Americans could refer to it as the European War). The prevailing wisdom was to keep the nation out of the conflict, but the war could not fail to have an impact upon many aspects of American life.

The period offered all kinds of diversions from such serious matters, however. The Swing Era was at its peak. Band leaders like Tommy Dorsey, Artie Shaw, Glenn Miller, Harry James, Count Basie, Jimmie Lunceford, Cab Calloway, and the great Duke Ellington kept the jitterbugs truckin' in the aisles. The big hit of 1939 was "And the Angels Sing," sung by Liltin' Martha Tilton with the Benny Goodman Orchestra, the top band of the day. That same year, Harry James discovered a young man named Frank Sinatra singing at a roadhouse in New Jersey.

In Flushing Meadow, within sight of Manhattan's skyscrapers, a vast exposition—the New York World's Fair—had sprung up. Its symbols were the Trylon, a concrete needle almost as high as the Woolworth Building, and the Perisphere, a globe 200 feet in diameter. Clustered around them were wonders of all kinds. There was a building in the shape of a doughnut and another in the shape of a cash register. There were pavilions representing nations from around the world, glimpses of cities of the future, and a variety of amusements ranging from an aerial joyride to Billy Rose's aquacade.

This was also a vintage year for Hollywood movies—some have suggested that it was the greatest year ever—with releases that included *The Wizard of Oz, Ninotchka, Stagecoach, Dark Victory, Goodbye Mr. Chips, Mr. Smith Goes to Washington,* and the film that everyone had been anxiously awaiting since its production had been announced three years earlier, *Gone With the Wind*.

In 1939 the Rockwell family moved to the tranquillity of Arlington, Vermont. Rockwell was now on the verge of a major breakthrough as an artist. His work began to take on more and more of a documentary feel, and he dealt more consistently with contemporary subject matter. A dozen or more of the covers he painted in 1939, 1940, and 1941 can stand comparison with the very best of his work.

Meanwhile, the nation moved inexorably towards involvement in the World War.

By the time the Japanese had attacked Pearl Harbor, Rockwell had already created an archetypal wartime protagonist, Willie Gillis, the epitome of the man-in-the-street conscripted into the service.

It was at this point in his career that Rockwell's art became a kind of running commentary on the American scene. True, this was a somewhat romanticized version of America—and there were many aspects of life in the United States it did not touch upon—but still it represented a commitment to the present that had not been evident in his earlier work. From this time on we find very few costume paintings and few throwbacks to the old conventions. Rockwell had finally become his own man.

SATURDAY EVENING POST COVERS
April 23, 1938–July 25, 1942

SEE AMERICA FIRST
Post Cover • April 23, 1938
PAGE 289

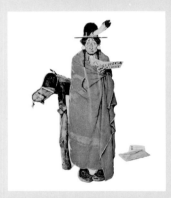

GIVEN changed attitudes towards Native Americans, this portrait of an old Indian seems a trifle patronizing, a little too much of a cliché out of a Hollywood movie. While the irony of his receiving a "See America First" brochure does invite us to sympathize with him, he is portrayed as a comical stereotype, and this diminishes the impact of the painting.

FIRST FLIGHT
Post Cover • June 4, 1938
PAGE 290

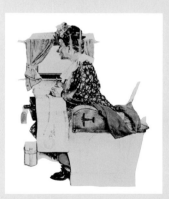

THIS older woman taking her first plane trip is far from stereotyped; we can believe in her completely. She has a map spread out on her knees, and she is alert. Perhaps she is a little nervous, but she is savoring every moment of this new experience. This is a first-rate painting, and although it was designed to conform to the old *Post* cover layout, it has the kind of documentary look that was soon to become Rockwell's hallmark.

BLANK CANVAS
Post Cover • October 8, 1938
PAGE 291

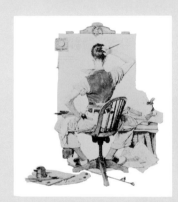

DEADLINES have no respect for inspiration, and here Rockwell takes a predicament that like all commercial illustrators he must have faced dozens of times and turns it into an amusing cover. Sometimes Rockwell uses caricature when it isn't entirely appropriate, but here it works rather well.

LETTERMAN
Post Cover • November 19, 1938
PAGE 292

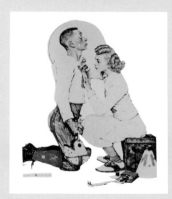

DESPITE the fact that Rockwell has mischievously placed a halo above the head of this gridiron hero, this is a naturalistic painting, and a fine one at that. Typically, instead of showing the heroics of the game itself, Rockwell concentrates on a quiet moment after the action is over. When he captures the poetry of such moments, Rockwell is at his best.

MERRIE CHRISTMAS
Post Cover • December 17, 1938
PAGE 293

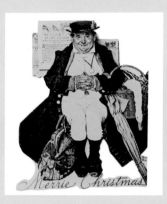

IN this, the last of his Dickensian Christmas covers, Rockwell gives us a jovial, well-fed, Pickwickian kind of a fellow, equipped for the season and awaiting the Muggleton stage coach. This painting winds up a long-running series with appropriate flair.

JESTER
Post Cover • February 11, 1939
PAGE 294

THIS gloomy jester is most notable for the way in which he so completely occupies the page. This painting shows us just how far Rockwell had come from the early days when, faced with the same subject matter, he would have quite simply "floated" the image in the center of the page, leaving it to the *Post*'s elegant logo to carry the weight of the design.

THE DRUGGIST
Post Cover • March 18, 1939
PAGE 295

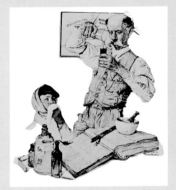

FOR this cover Rockwell does return to the "floating" image, although here it is handled with more skill than he had at his disposal twenty years earlier. Despite the deftness of touch brought by two decades of experience, this is a rather lackluster painting, decidedly old-fashioned in both concept and execution.

SPORT
Post Cover • April 29, 1939
PAGE 296

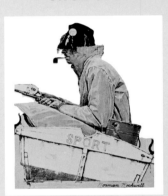

THIS study of a dogged angler is a fine example of the style Rockwell was perfecting in the late thirties. We still have the shallow space demanded by the old *Post* cover layout, but Rockwell uses it in a novel way, calling on background color to evoke mood and permitting the fisherman and his boat to occupy almost the entire cover. The yellow of the man's slicker and the orange of the bait-can contrast vividly with the neutral colors that dominate the rest of the painting.

100 YEARS OF BASEBALL
Post Cover • July 8, 1939
PAGE 297

WHY is the umpire behind the pitcher? Was this the custom in 1839? Has Rockwell placed him there only because he feels that such an arrangement will make a strong composition?

SUMMER STOCK
Post Cover • August 5, 1939
PAGE 298

THIS fine study of an actress making up for a Shakespearian role offers Rockwell an interesting opportunity to indulge his taste for painting period costume.

MARBLES CHAMPION
Post Cover • September 2, 1939
PAGE 299

THIS simple idea is faultlessly carried out. The confidence of execution

marks it as belonging to the beginning of Rockwell's mature period.

SHERIFF AND PRISONER
Post Cover • November 4, 1939
PAGE 300

AGAIN we have an example of the sheer skill Rockwell had acquired in the art of designing a magazine cover. The barred window in the cell door has been placed as if to punch a hole through the *Post*'s logo. This produces the illusion that the prisoner is incarcerated within the magazine itself.

SANTA
Post Cover • December 16, 1939
PAGE 301

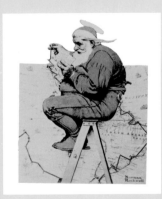

IN this Christmas cover, a variant on a theme first stated in the twenties (page 178), Santa is planning the route he must take to make his annual deliveries. With the aid of his little white book, he is plotting his course through the present-day state of Washington and up into British Columbia. The map he is using is an ancient one, however, so we must presume that Rockwell is giving us a glimpse of Christmas Past.

THE DECORATOR
Post Cover • March 30, 1940
PAGE 302

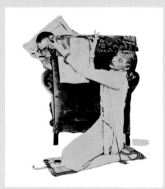

IN this nicely observed domestic scene we get another clear hint of the direction in which Rockwell is moving. There is again a definite documentary look to this painting. Certainly, as has been noted, such an approach is not entirely new to his work, but it is rapidly becoming his favored method. As the decade ends, it is clear that Rockwell is undergoing an important transition.

CENSUS TAKER
Post Cover • April 27, 1940
PAGE 303

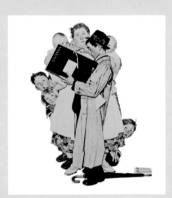

THE joke here is that this harassed woman is having difficulty remembering just how many children she has. Although the gag is hardly a new one, Rockwell manages to bring it to life. The census taker himself is a believable and amusing character, giving the impression of being a schoolboy in Bogart's clothing.

THE FULL TREATMENT
Post Cover • May 18, 1940
PAGE 304

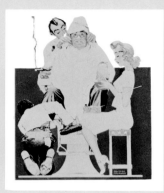

THIS is a delightful cover, particularly striking for the way in which the figures are silhouetted against the brightly colored background. With its frankly nubile manicurist, this picture is a long way from the Rockwell mainstream. It is the kind of image that we might sooner expect to find somewhere in the pages of *Esquire*, around this same period, rather than on the cover of the *Post*.

BEACH SCENE
Post Cover • July 13, 1940
PAGE 305

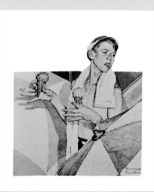

IN this fine painting, the sea of parasols, among which the boy finds himself lost, becomes a lively abstract background. Here, once more, Rockwell proves his ability as an imaginative colorist. Like other Rockwell paintings of this period, "Beach Scene" has a marvellous freshness about it—almost as if the artist were discovering all over again the pleasure of making images.

RETURNING FROM CAMP
Post Cover • August 24, 1940
PAGE 306

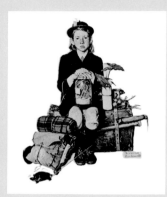

ONE virtue of this fine cover is that it tells us much about what must have happened to this wistful girl in the past few weeks. She herself is believable—indeed, Rockwell seldom painted a more convincing portrait of a child—but the mementos she is taking home with her really bear the weight of the story.

MIAMI BOUND
Post Cover • November 30, 1940
PAGE 307

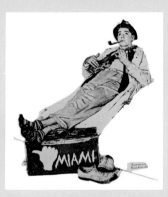

IN contrast to the exactness of the previous cover, this study of a young hitchhiker is rather loose and disappointing. There is something whimsical about the youth that detracts from the impact of the painting.

SANTA ON A TRAIN
Post Cover • December 28, 1940
PAGE 308

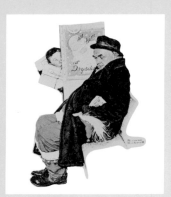

HERE we have a radically new approach to the problem of creating a Christmas cover. Instead of the authentic Saint Nick, we are given an imposter—Santa transformed into an exhausted commuter dozing on a train. The fact that he has been spotted by a small boy—who presumably has just visited him at the department store where he works—makes this cover almost blasphemous. It is interesting to note that the *Post*'s editors decided to use it for the issue that would appear on the stands immediately *after* Christmas.

DOUBLE TAKE
Post Cover • March 1, 1941
PAGE 309

THIS painting is, quite simply, a visual pun, and it works remarkably well. We look twice before we realize that we are seeing the face of a glamorous, mature woman superimposed—by chance—onto the body of a young co-ed. One reason why it does work (and why it must have been doubly effective during its newsstand life) is that Rockwell has handled it in such an off-hand manner, so that we are deceived by the casualness of the composition and caught off guard.

HATCHECK GIRL
Post Cover • May 3, 1941
PAGE 310

ROCKWELL has caught this pretty hatcheck girl at a moment when she would, quite clearly, prefer to be somewhere else. The situation is inherently funny and touching, and all the artist has to do is present it in a direct and honest way, which is precisely what he has done. Another first-rate cover.

THE FLIRTS
Post Cover • July 26, 1941
PAGE 311

THIS is a beautifully conceived and executed cover, despite certain apparent inconsistencies. Note, for example, that the young woman in the convertible has been painted in a far more stylized way than the two truckers. This has the effect of making her seem like a figure of fantasy.

The stop light reflected in the back of the truck's rear view mirror is a nice touch, spelling out the situation. It's amusing to see that Rockwell has reduced his signature to a monogram painted onto the side of the young woman's car.

PACKAGE FROM HOME
Post Cover • October 4, 1941
PAGE 312

THIS is the first of the Willie Gillis covers, and it reminds us that conscription began several weeks before Pearl Harbor. There was a touch of Buster Keaton about Robert Buck, the young man who posed for Gillis, and this shows up quite clearly in this example. We can imagine Keaton—small like Willie—in this same situation.

FURLOUGH
Post Cover • November 29, 1941
PAGE 313

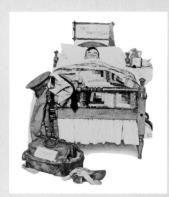

THE second Gillis cover—this one appeared just days before the attack on Pearl Harbor and the United States' entry into the war—shows Willie at home on furlough. It is a simple portrayal of the pleasure of sleeping late in your own bed.

NEWSSTAND IN THE SNOW
Post Cover • December 20, 1941
PAGE 314

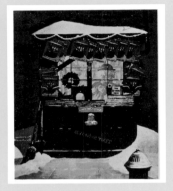

ROCKWELL'S first wartime cover was one of his finest Christmas covers to date. Presumably this was painted before war had been declared, but it captures nonetheless the feeling of security that Americans were trying to cling to that bleak December. The economy with which Rockwell has brought the scene to life is wholly admirable.

USO VOLUNTEERS
Post Cover • February 7, 1942
PAGE 315

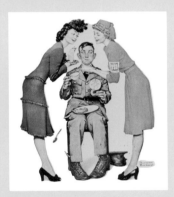

WILLIE Gillis makes his third appearance, this time in the company of a pair of attractive and eager USO volunteers. He seems somewhat overwhelmed. Already we feel we know him well. He has one of those faces that reveal everything at a glance, and this makes him ideal for Rockwell's purposes.

SECRETS
Post Cover • March 21, 1942
PAGE 316

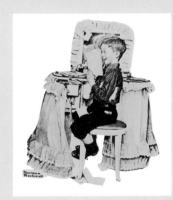

THIS young boy has discovered his sister's diary—not without some premeditation, if we are to judge from the state of her dresser drawer—and it is yielding up secrets that are almost too good to be true. One doubts that he has the ability to restore the room to the state in which he found it, or, for that matter, the self-control to keep his mouth shut. We can, therefore, predict various consequences from this one scene, and this is typical of the way that the mature Rockwell could evoke a whole story with a single image.

HOMETOWN NEWS
Post Cover • April 11, 1942
PAGE 317

HERE Willie Gillis is presented in a situation that would have had guaranteed popular appeal when it first appeared on newsstands. Millions of Americans had brothers, sons, grandsons, sweethearts, or neighbors in uniform at this time. The painting is a nicely executed treatment of a standard wartime theme.

BLACKOUT
Post Cover • June 27, 1942
PAGE 318

A few months in the service seems to have given Willie Gillis a good deal more confidence when it comes to dealing with women. Certainly he has no qualms about finding himself in a blackout with this attractive young thing. Rockwell himself takes advantage of the new *Post* cover layout—a layout that would give him considerable compositional freedom in the future.

WILLIE GILLIS IN CHURCH
Post Cover • July 25, 1942
PAGE 319

HERE we have an uncharacteristically serious cover, but one which must have made a great deal of sense at the time. The mood is quite different from that of most other Willie Gillis covers.

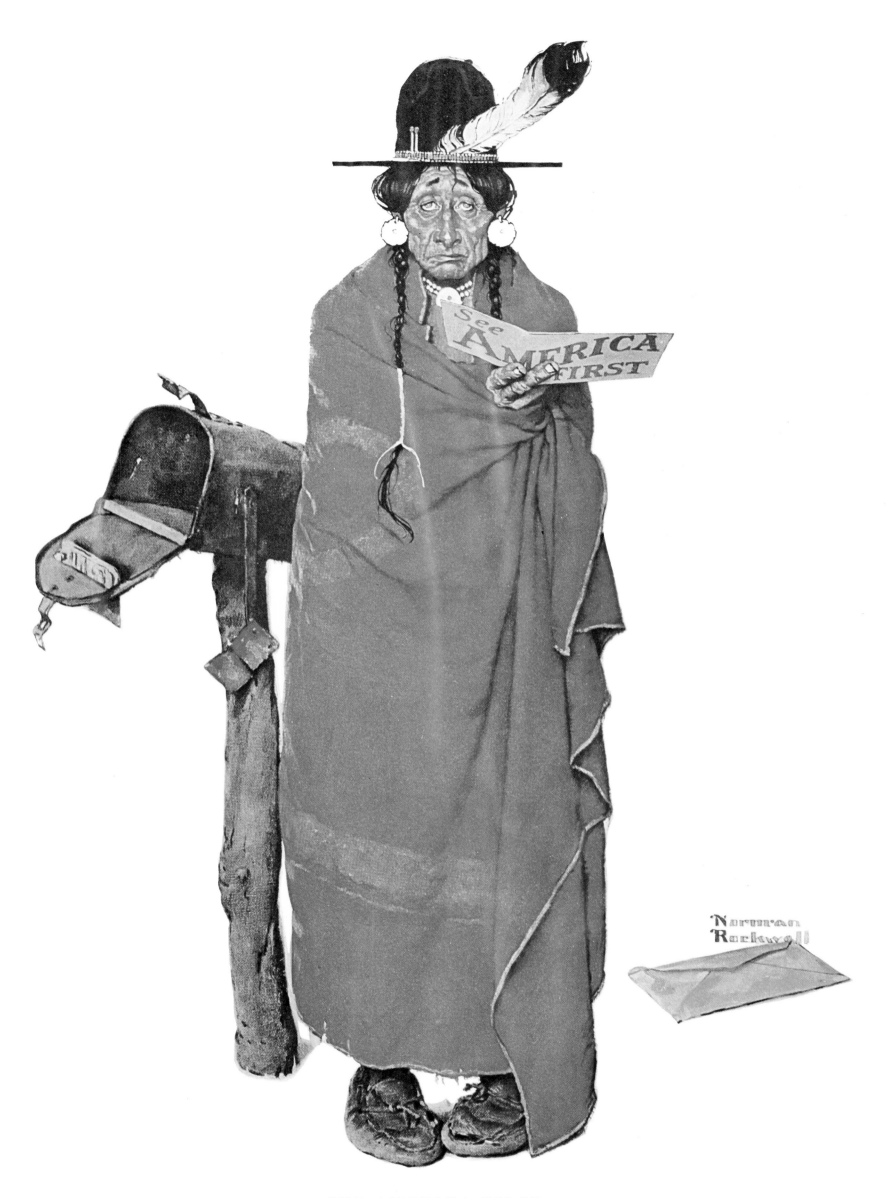

SEE AMERICA FIRST

Post Cover • April 23, 1938

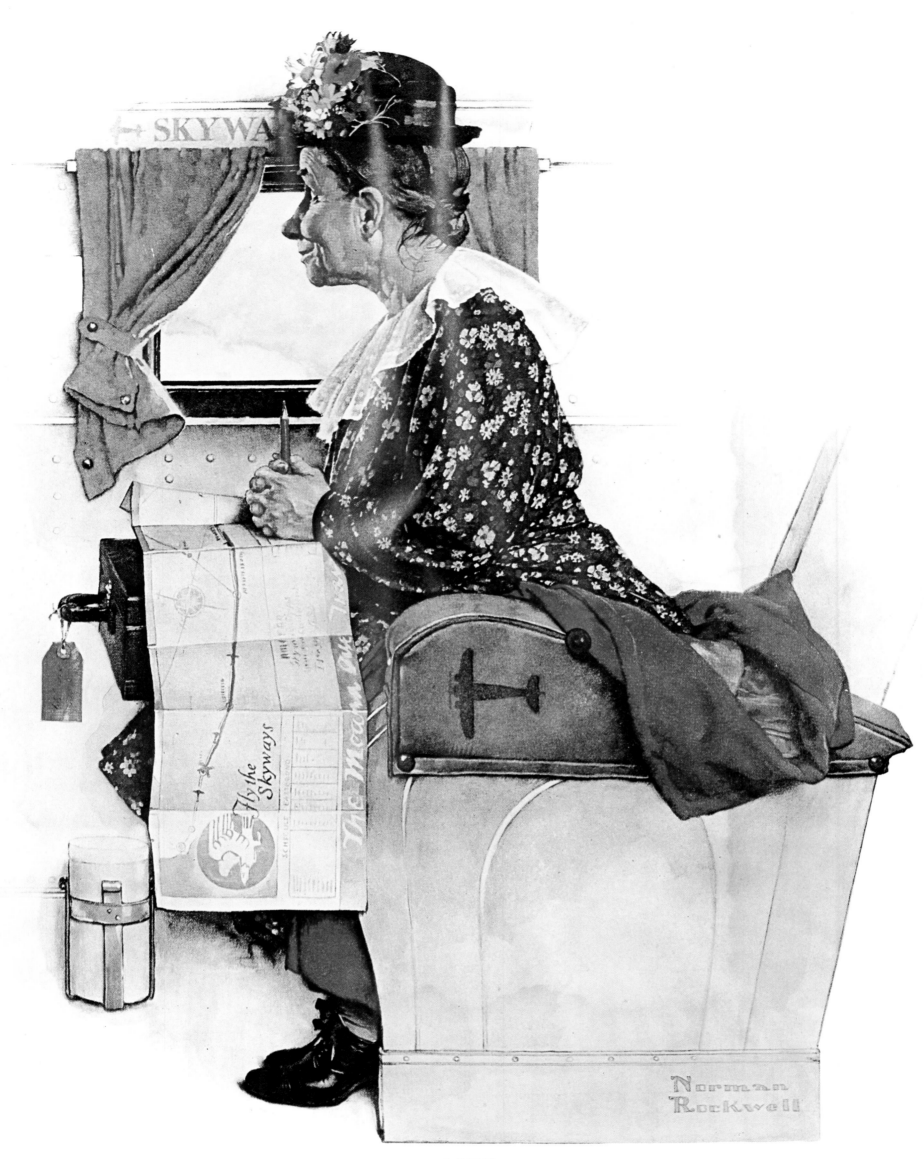

FIRST FLIGHT

Post Cover • June 4, 1938

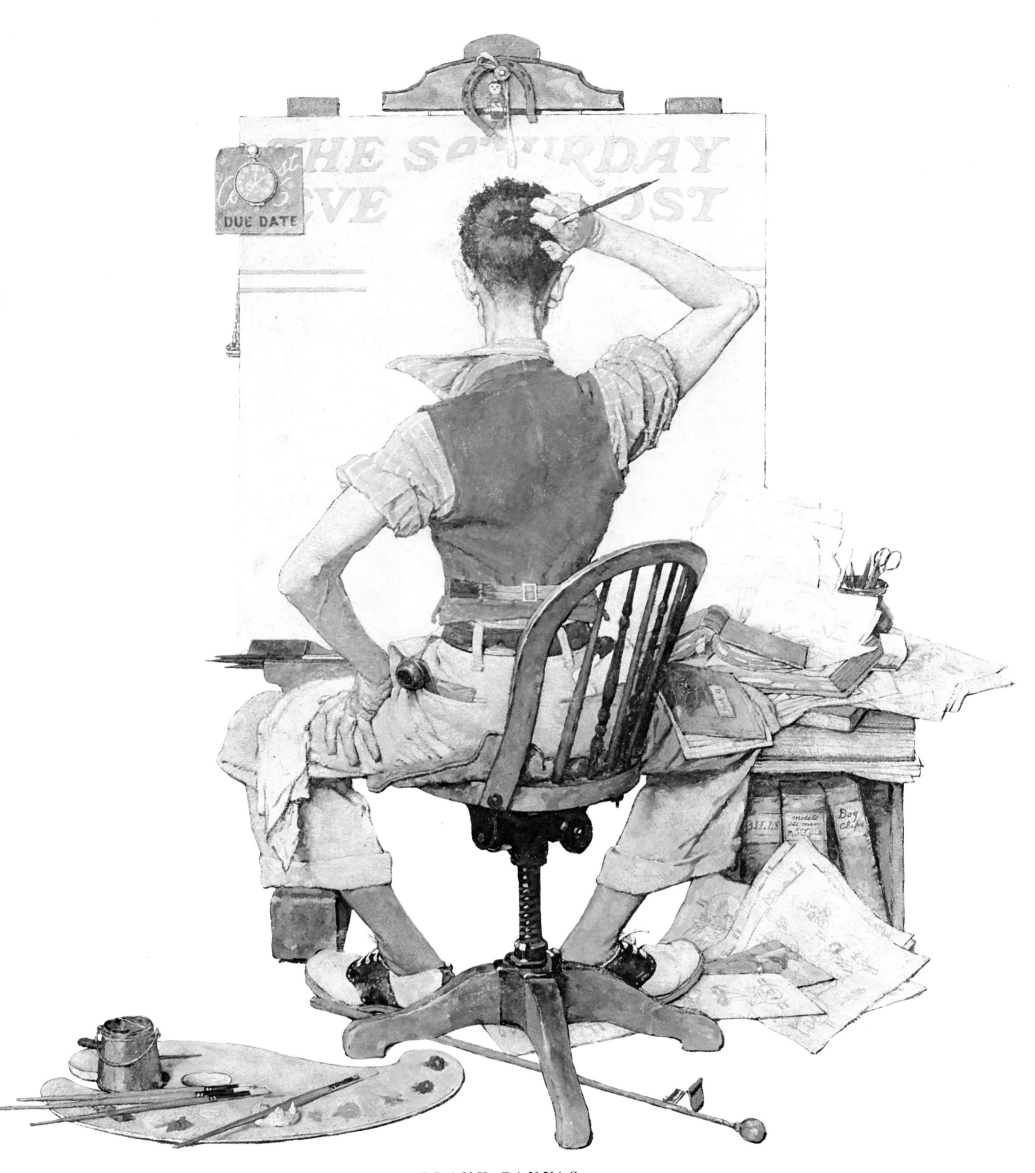

BLANK CANVAS

Post Cover • October 8, 1938

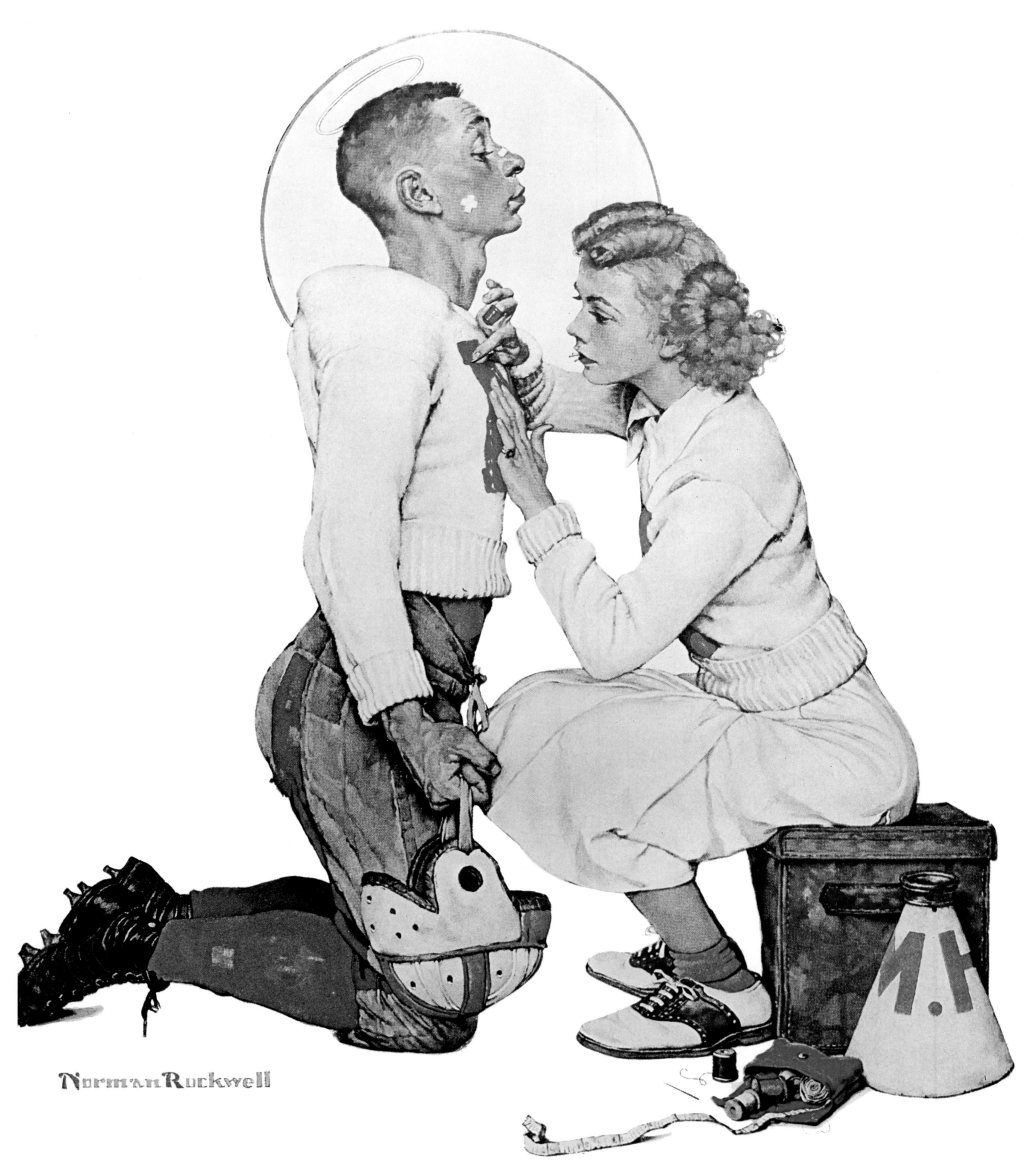

LETTERMAN

Post Cover • November 19, 1938

292

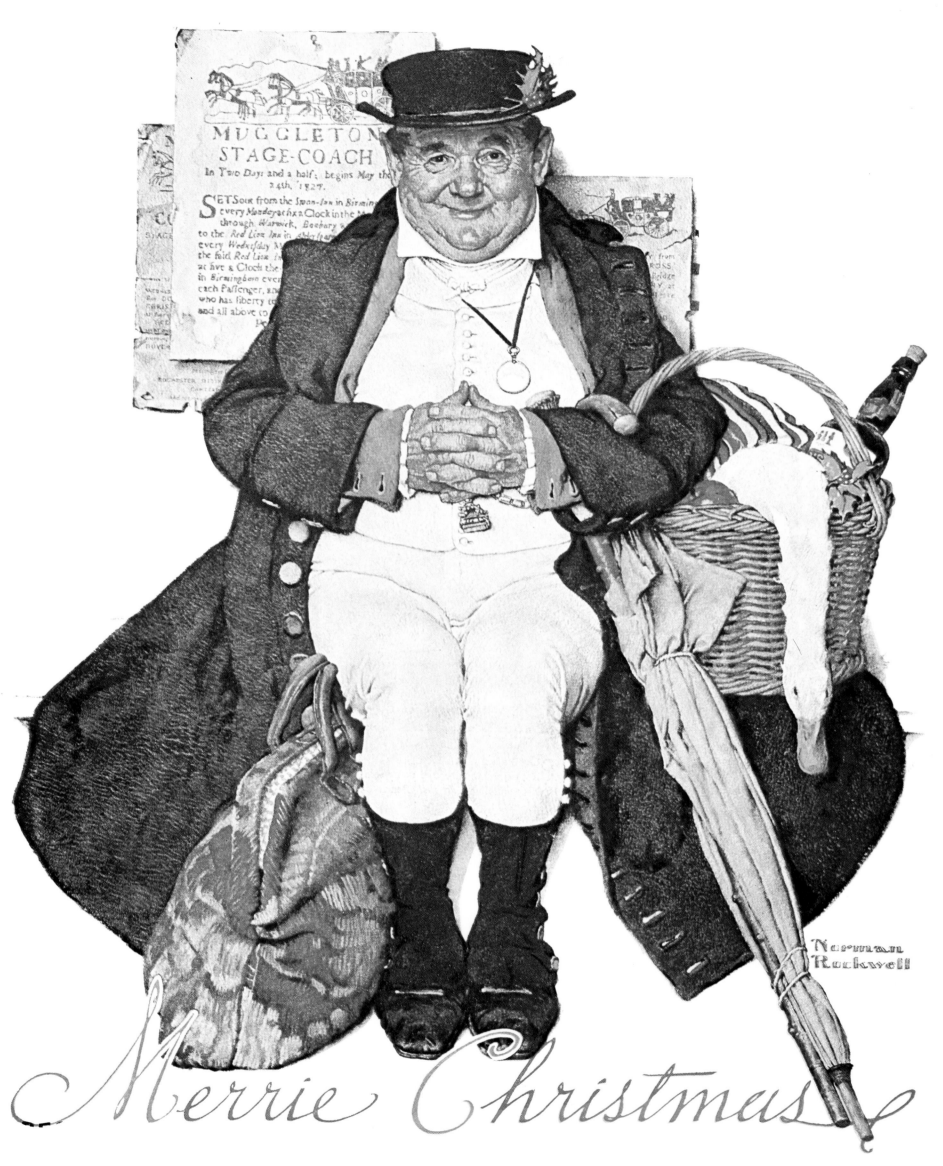

Merrie Christmas

MERRIE CHRISTMAS
Post Cover • December 17, 1938

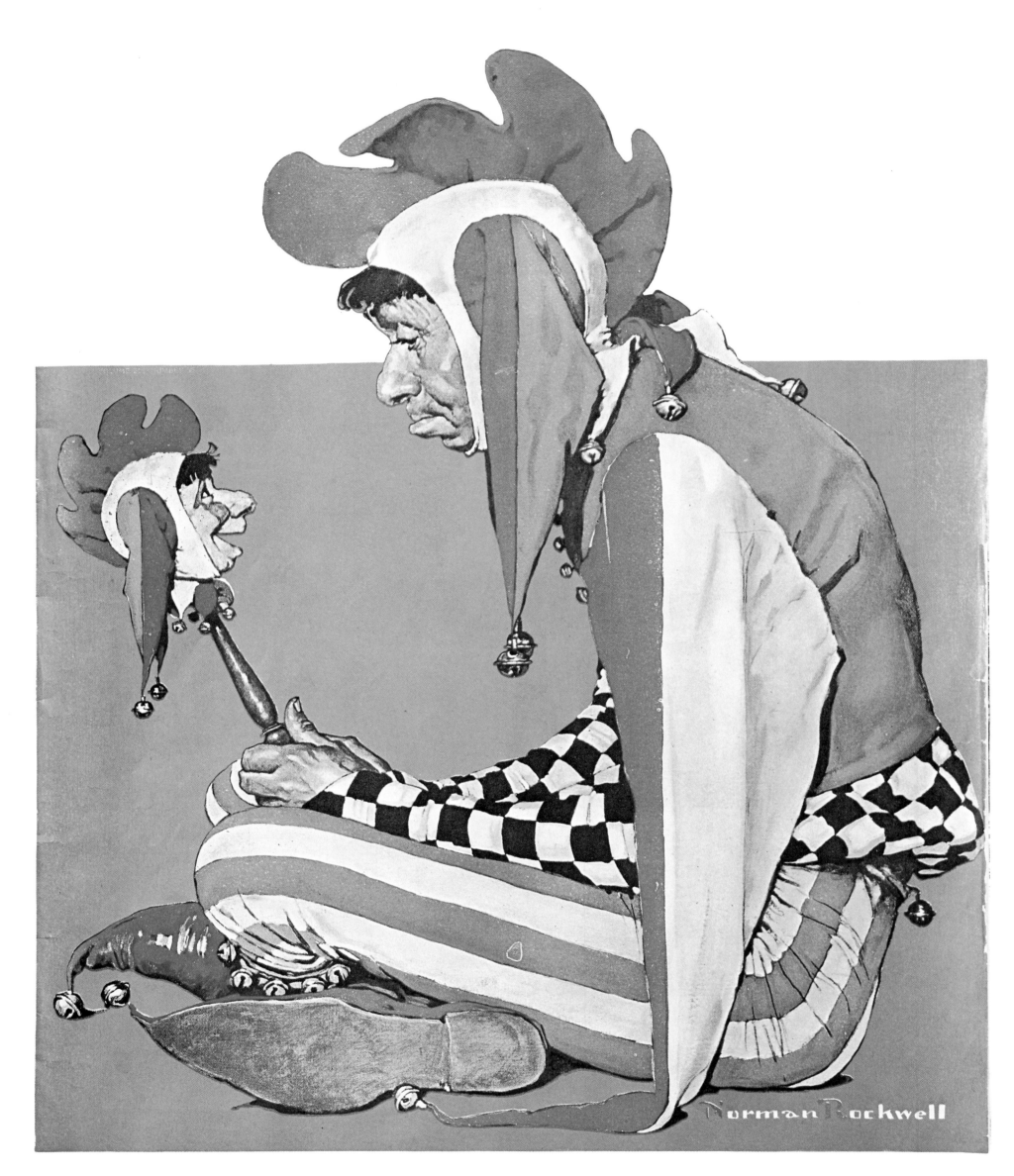

JESTER

Post Cover • February 11, 1939

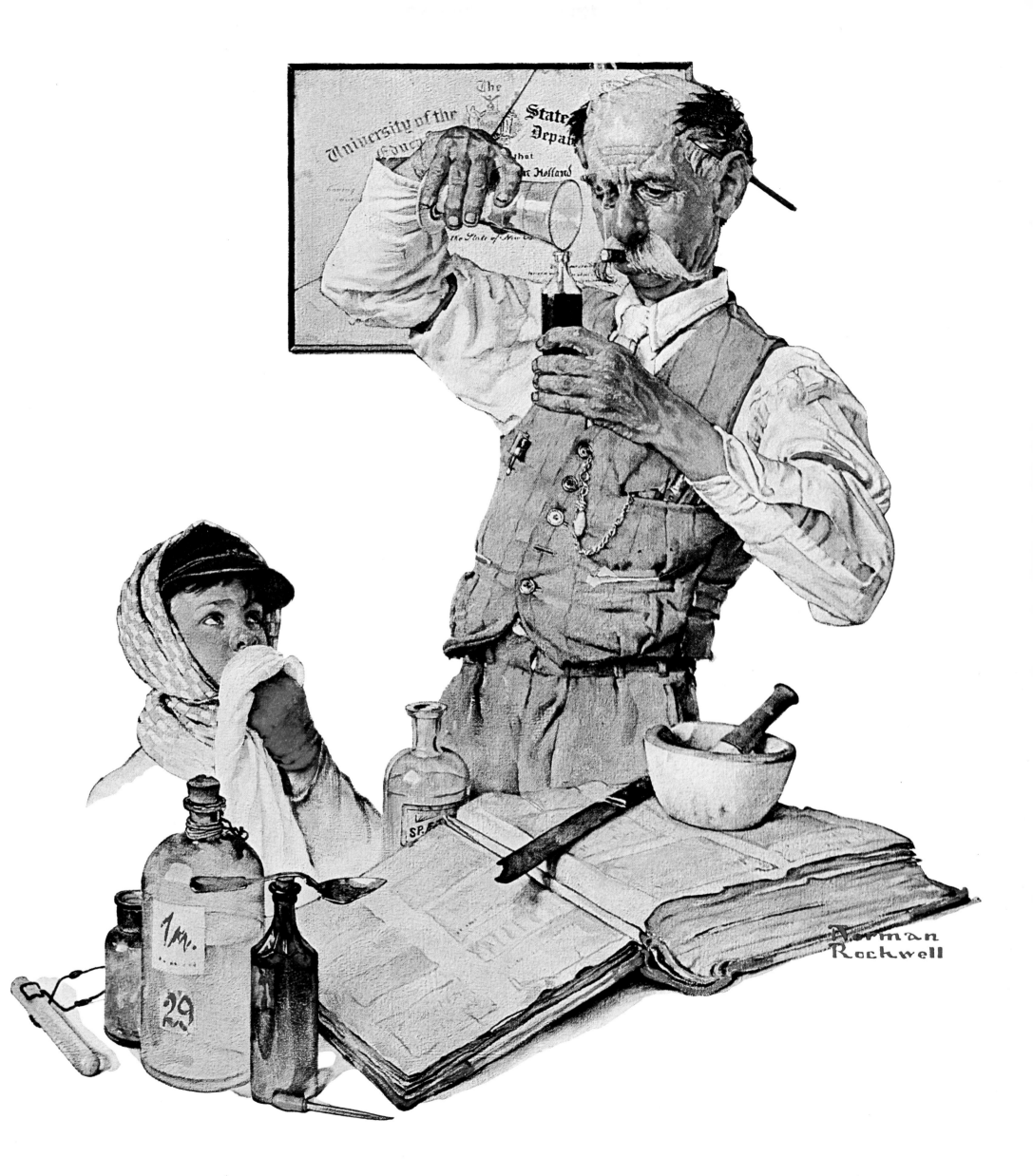

THE DRUGGIST

Post Cover • March 18, 1939

295

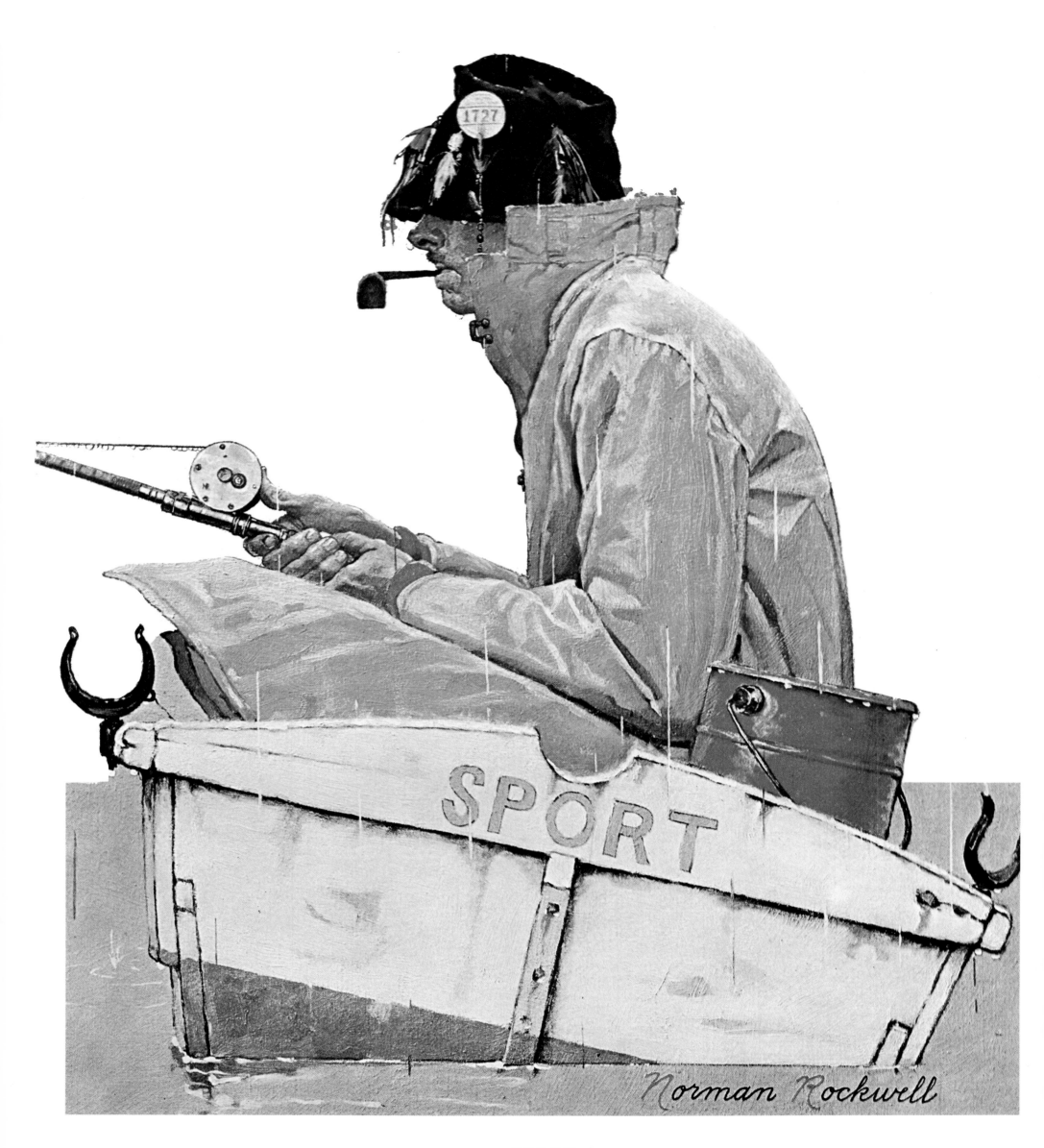

SPORT

Post Cover • April 29, 1939

296

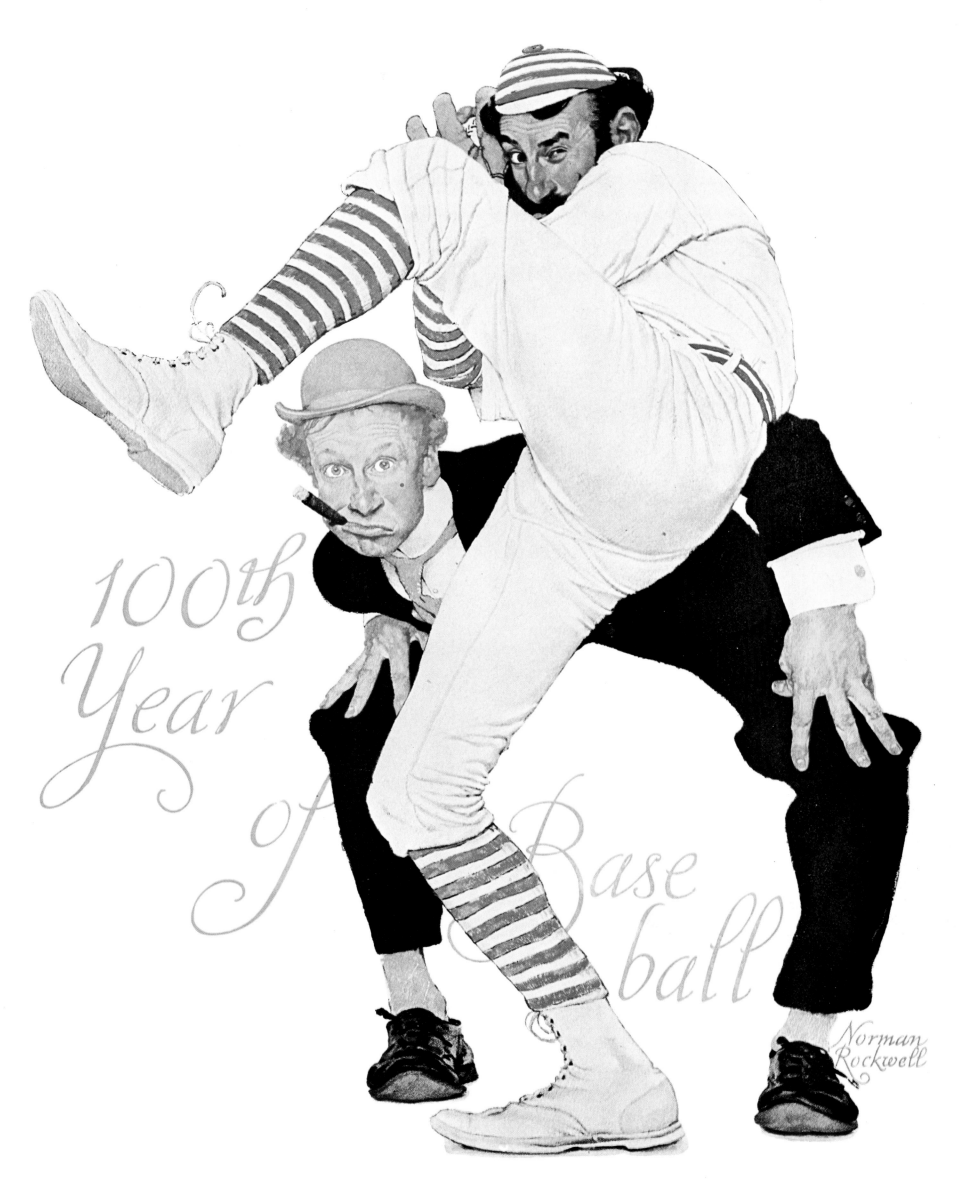

100 YEARS OF BASEBALL
Post Cover • July 8, 1939

297

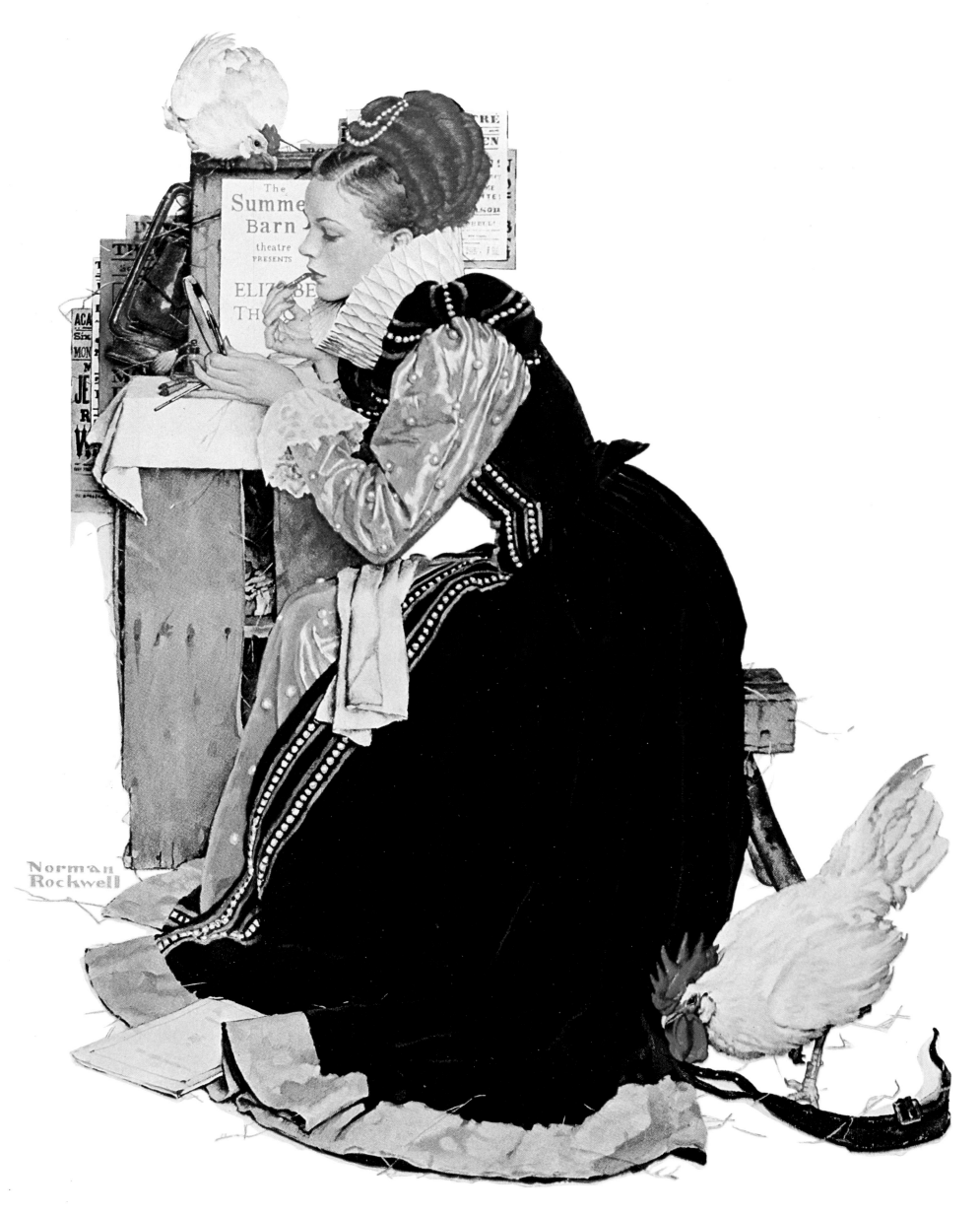

SUMMER STOCK

Post Cover • August 5, 1939

298

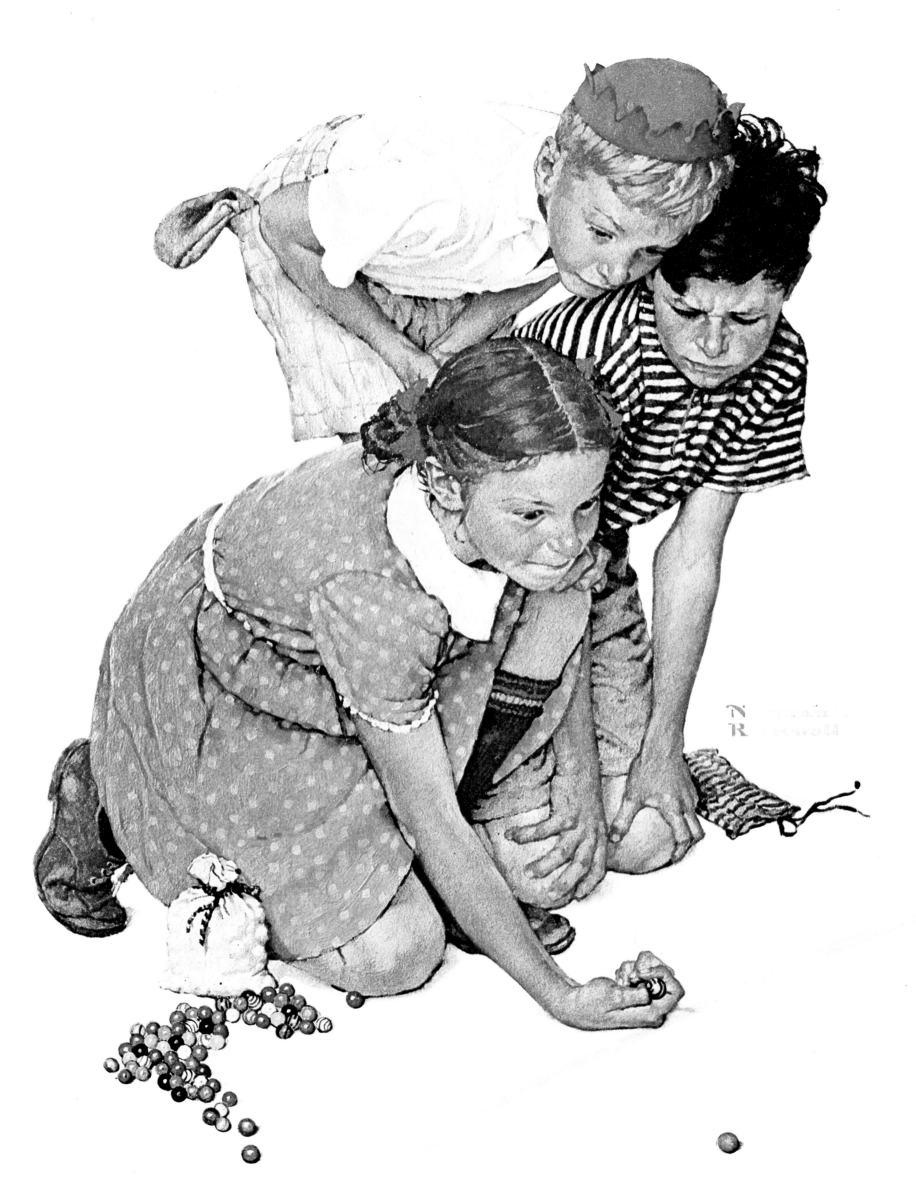

MARBLES CHAMPION

Post Cover • *September 2, 1939*

299

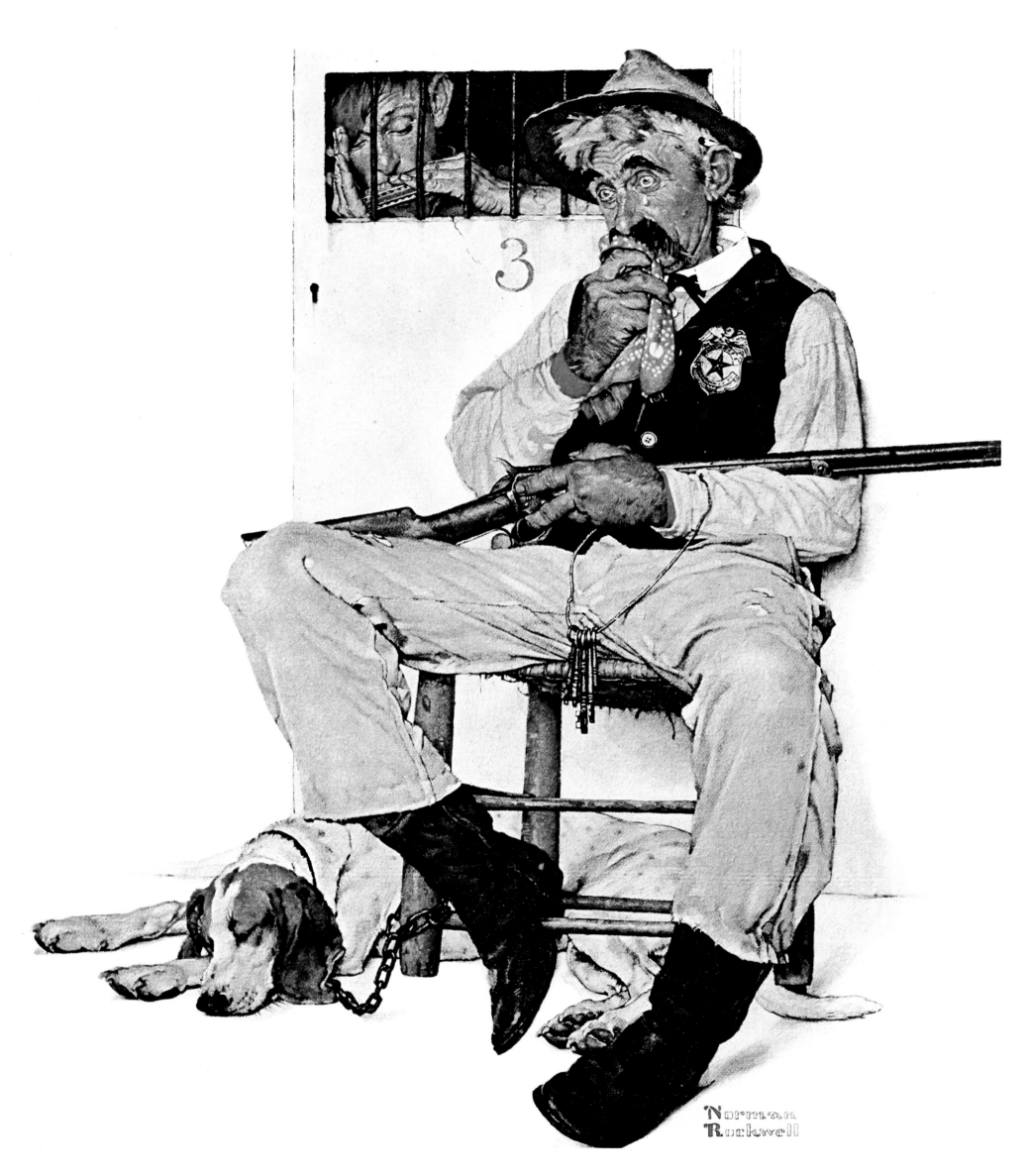

SHERIFF AND PRISONER

Post Cover • November 4, 1939

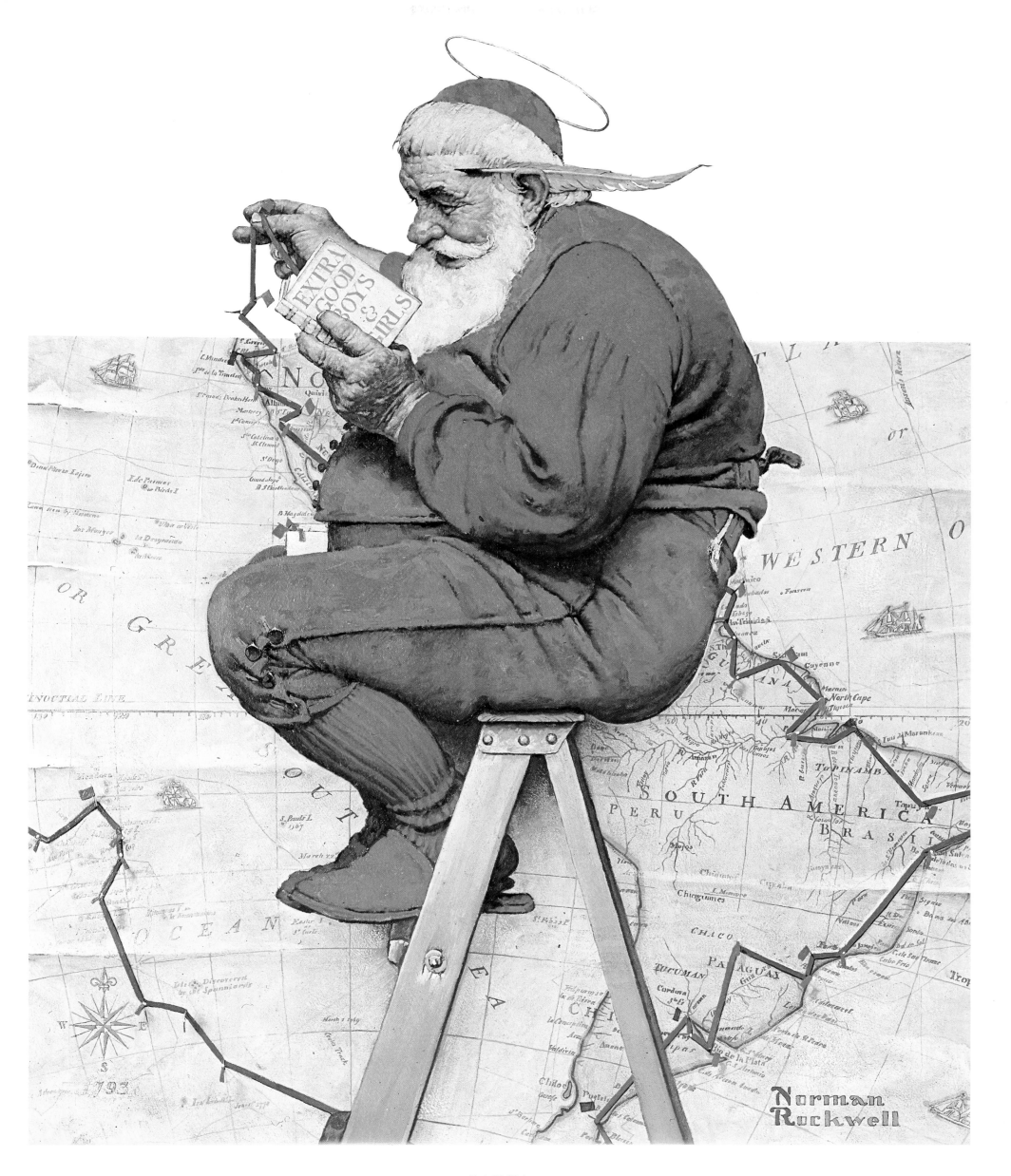

SANTA
Post Cover • December 16, 1939

301

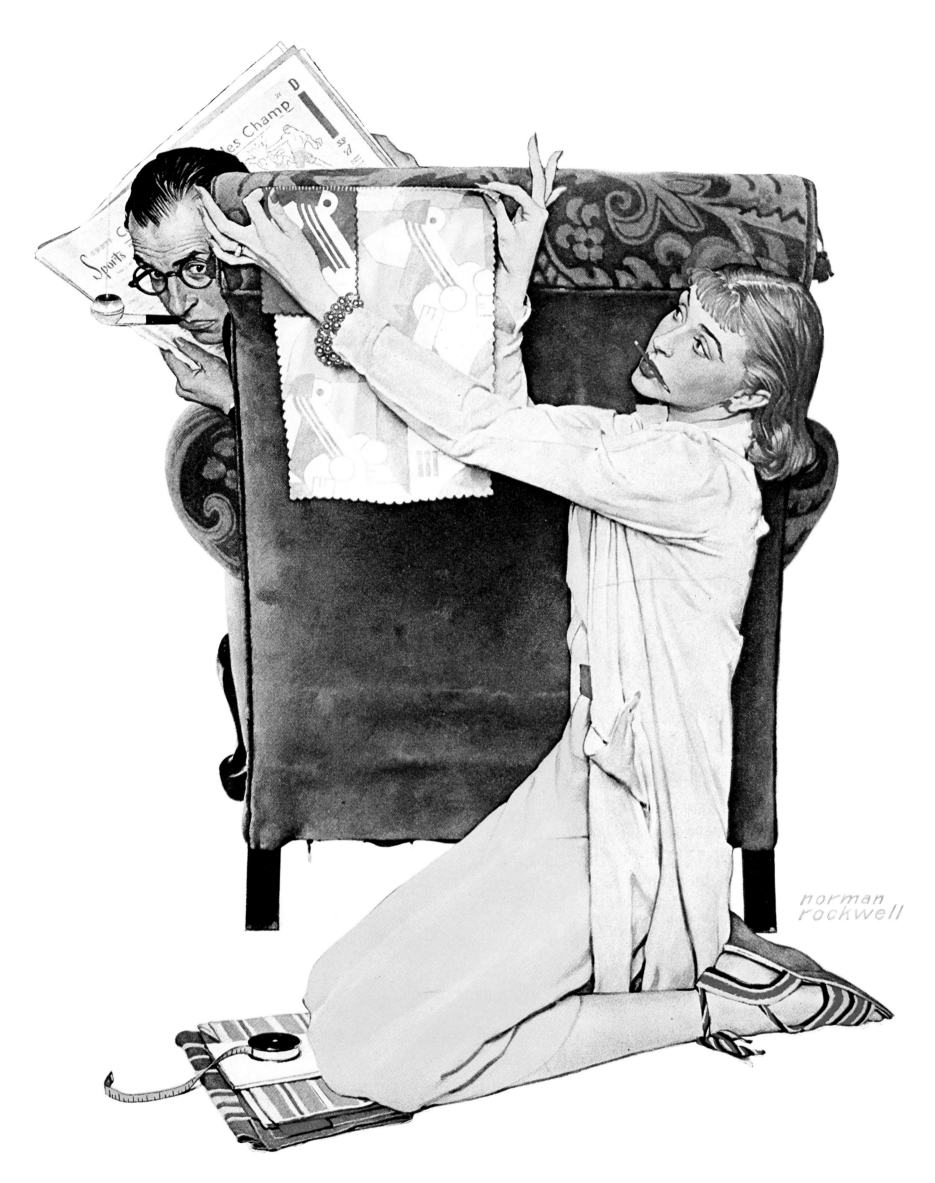

THE DECORATOR
Post Cover • March 30, 1940

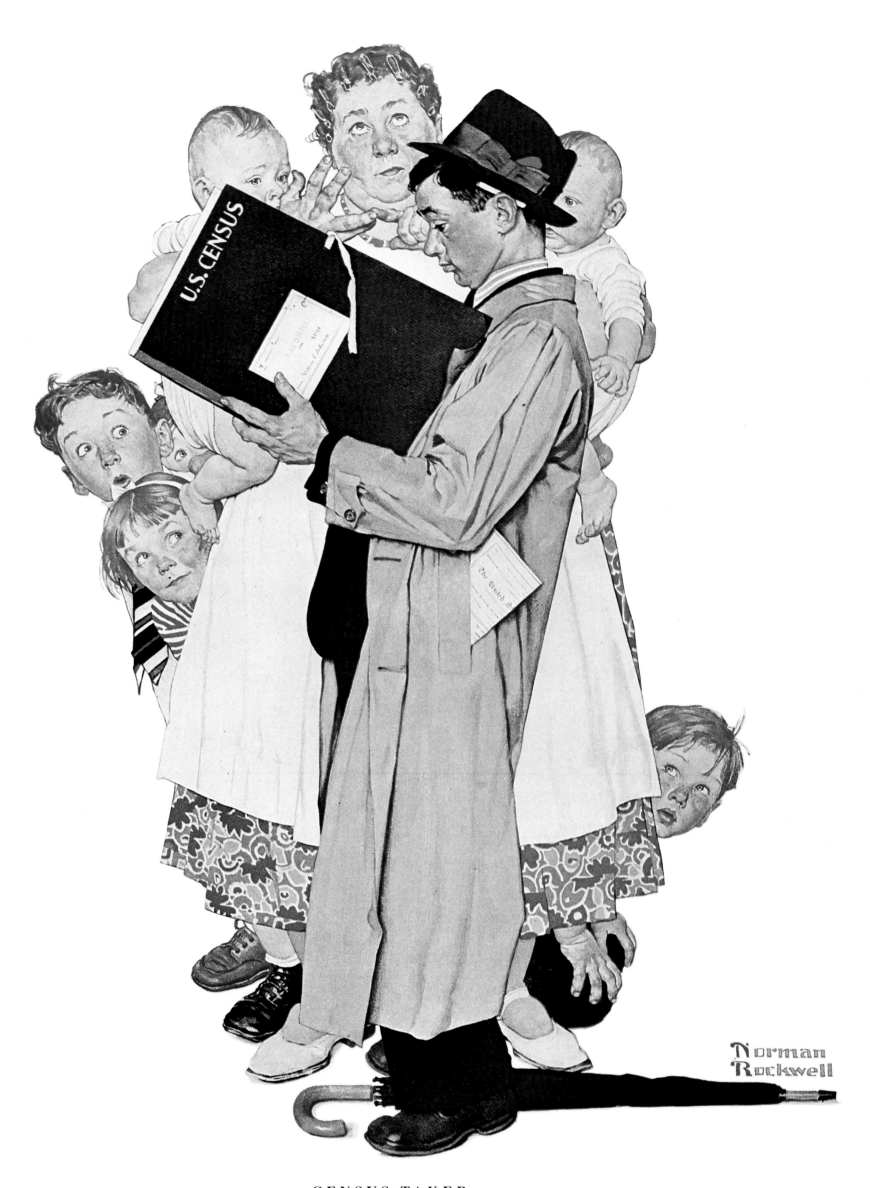

CENSUS TAKER

Post Cover • April 27, 1940

303

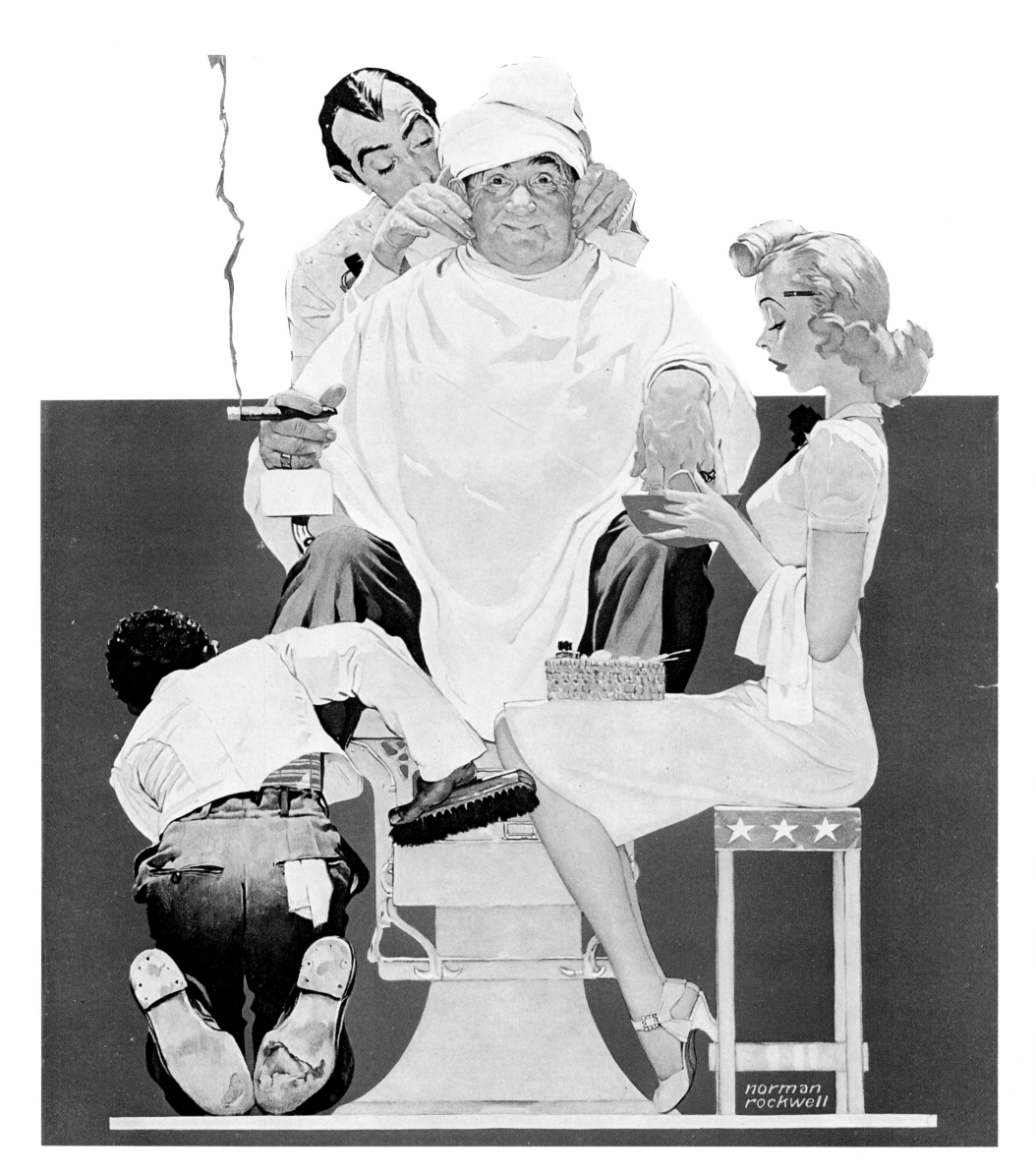

THE FULL TREATMENT

Post Cover • May 18, 1940

304

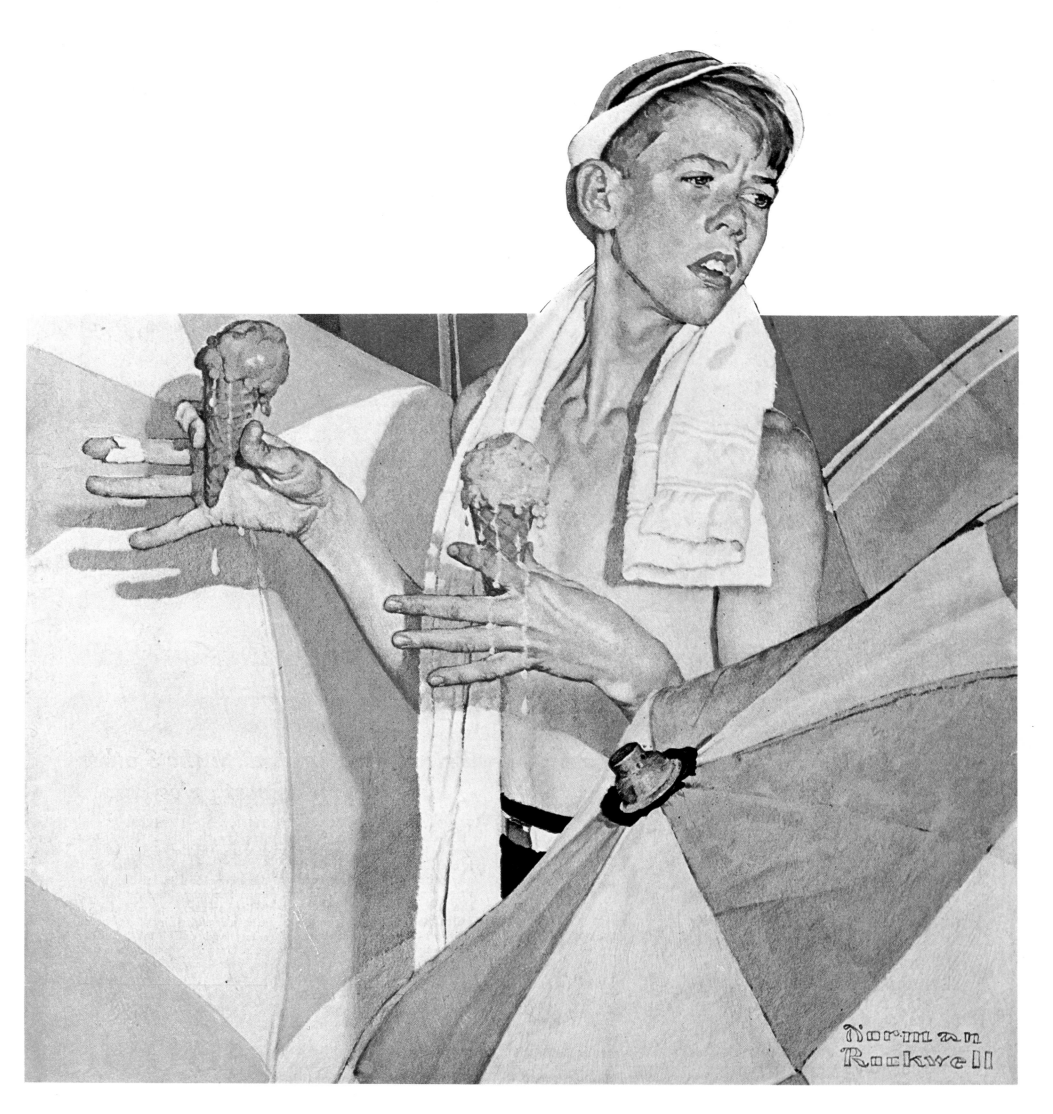

BEACH SCENE

Post Cover • July 13, 1940

305

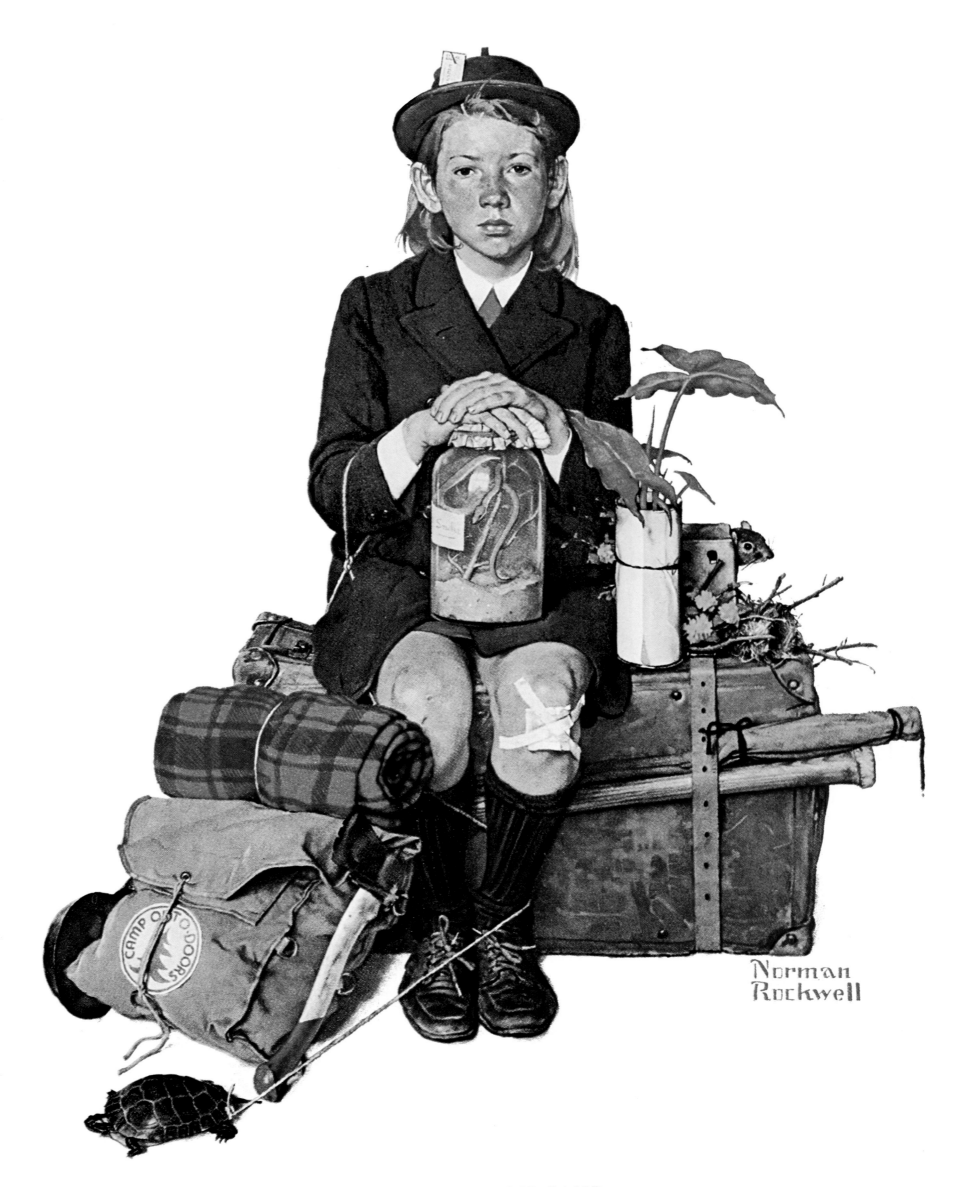

RETURNING FROM CAMP

Post Cover • August 24, 1940

306

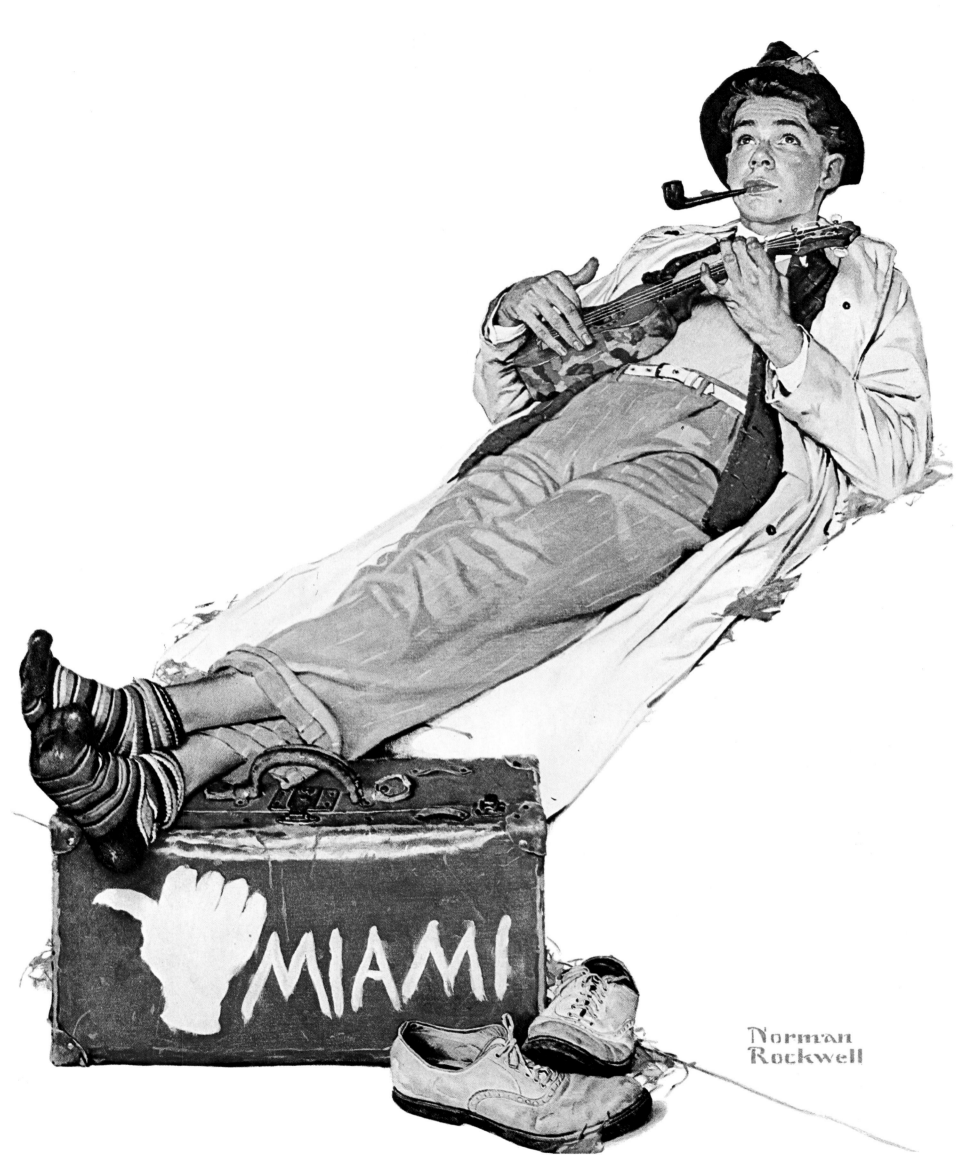

MIAMI BOUND

Post Cover • November 30, 1940

307

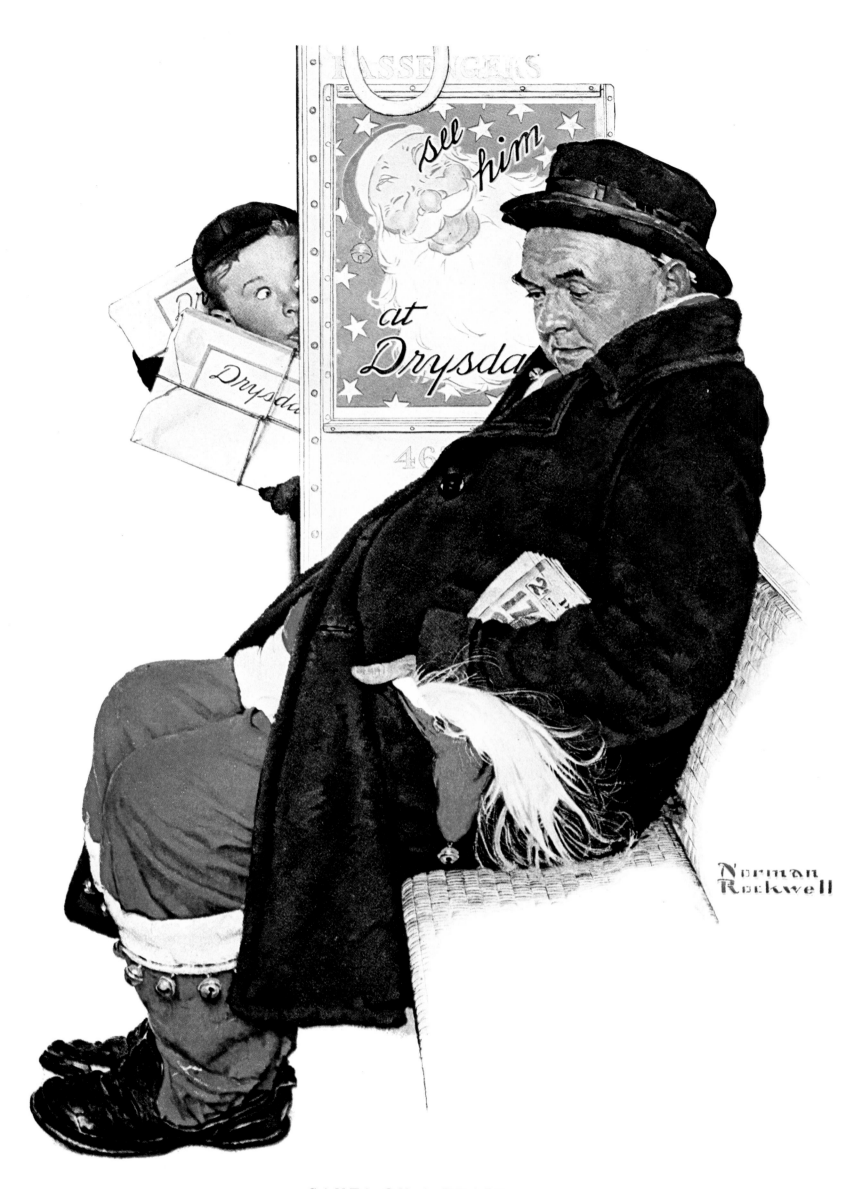

SANTA ON A TRAIN

Post Cover • December 28, 1940

DOUBLE TAKE

Post Cover • *March 1, 1941*

309

HATCHECK GIRL

Post Cover • May 3, 1941

THE FLIRTS
Post Cover • July 26, 1941

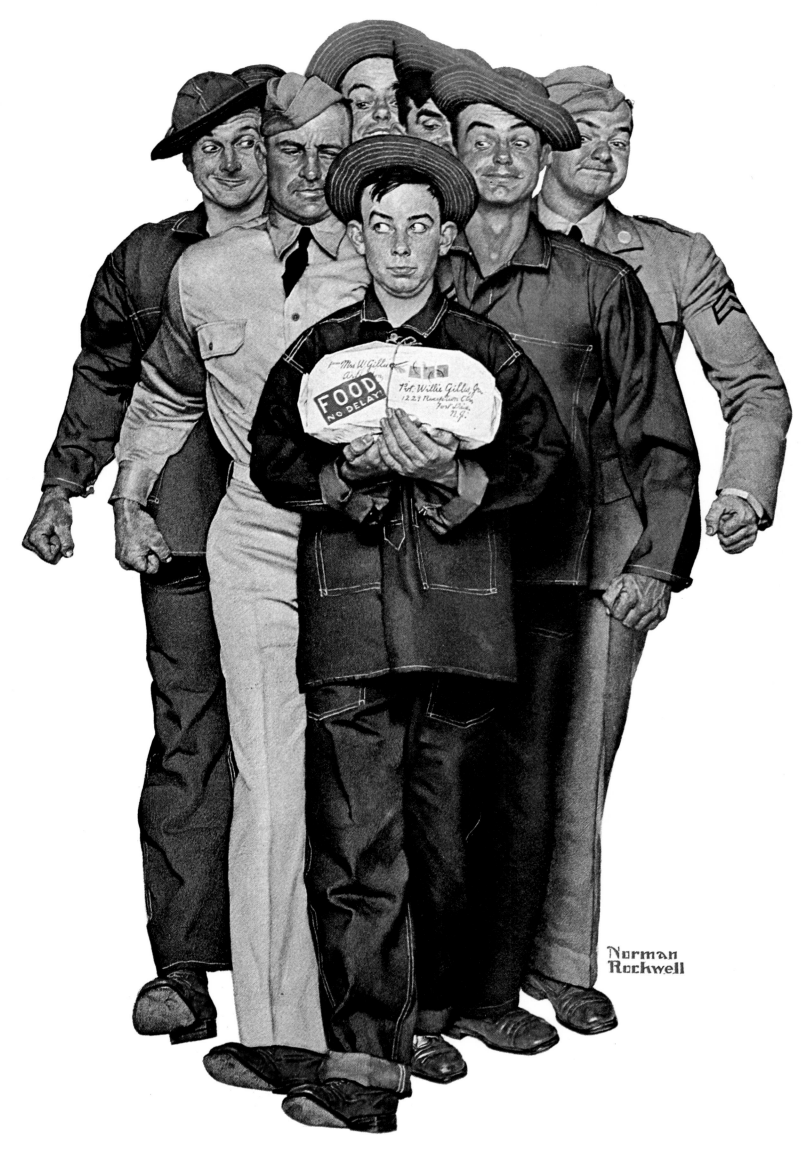

PACKAGE FROM HOME

Post Cover • October 4, 1941

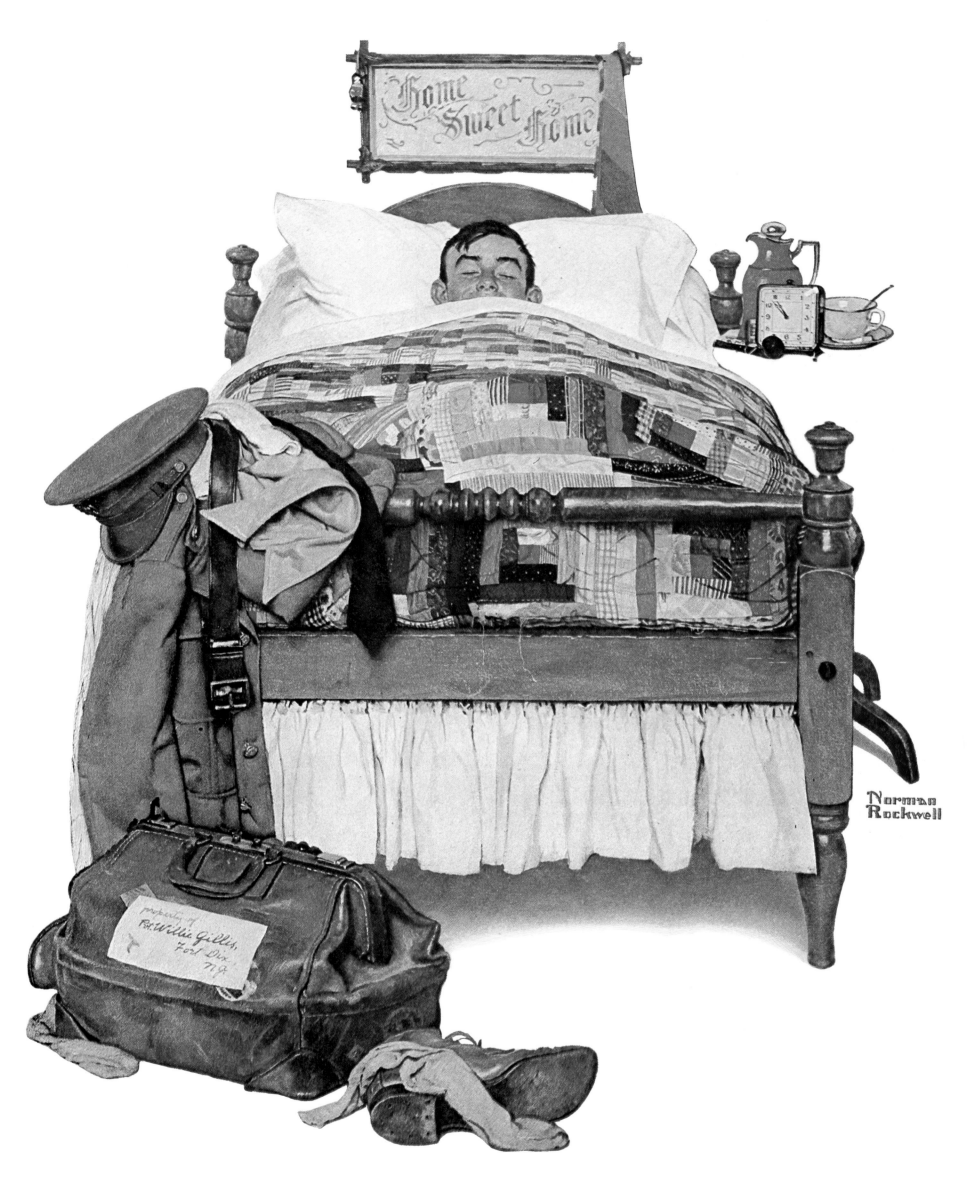

FURLOUGH

Post Cover • November 29, 1941

313

NEWSSTAND IN THE SNOW

Post Cover • December 20, 1941

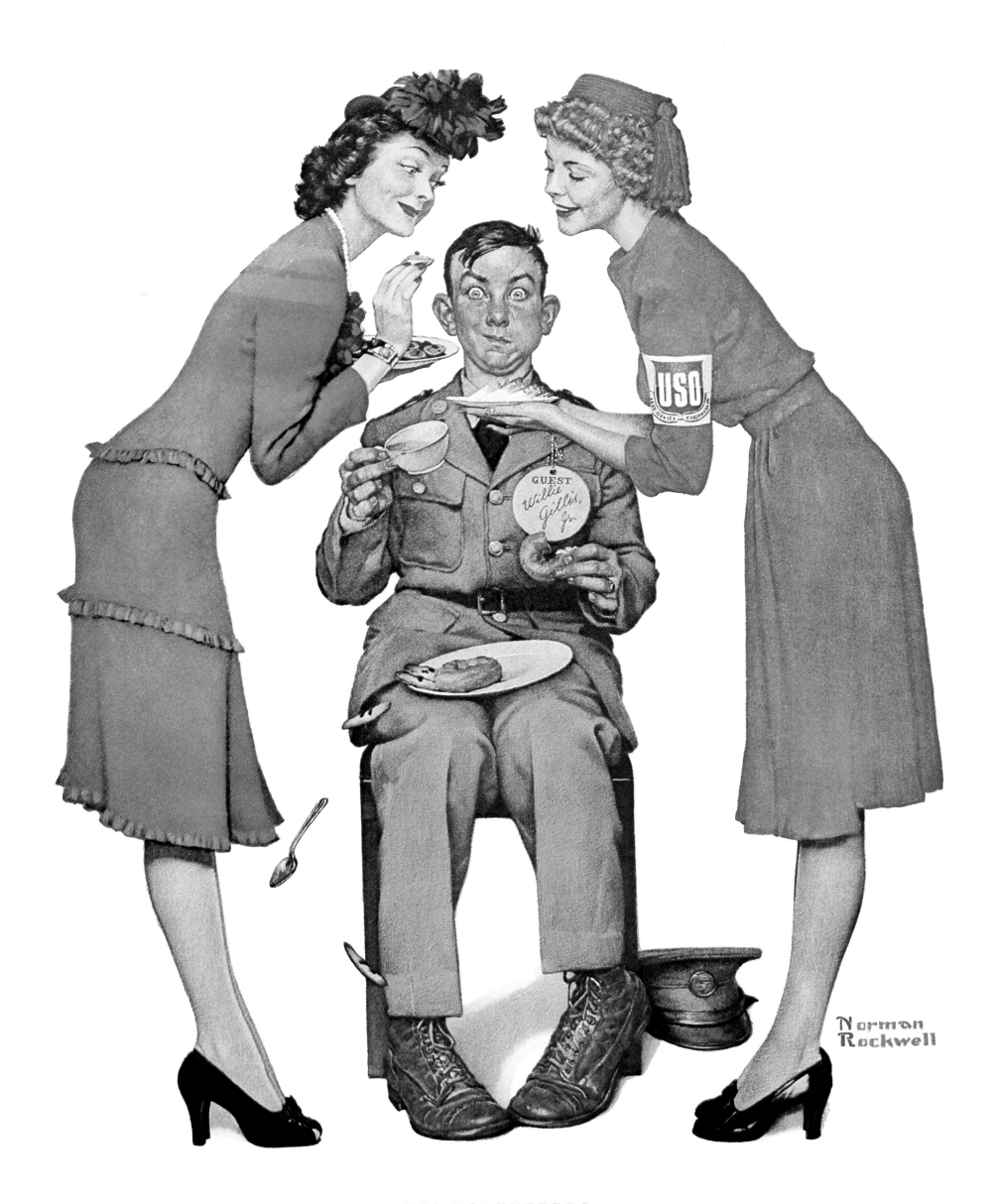

USO VOLUNTEERS
Post Cover • February 7, 1942

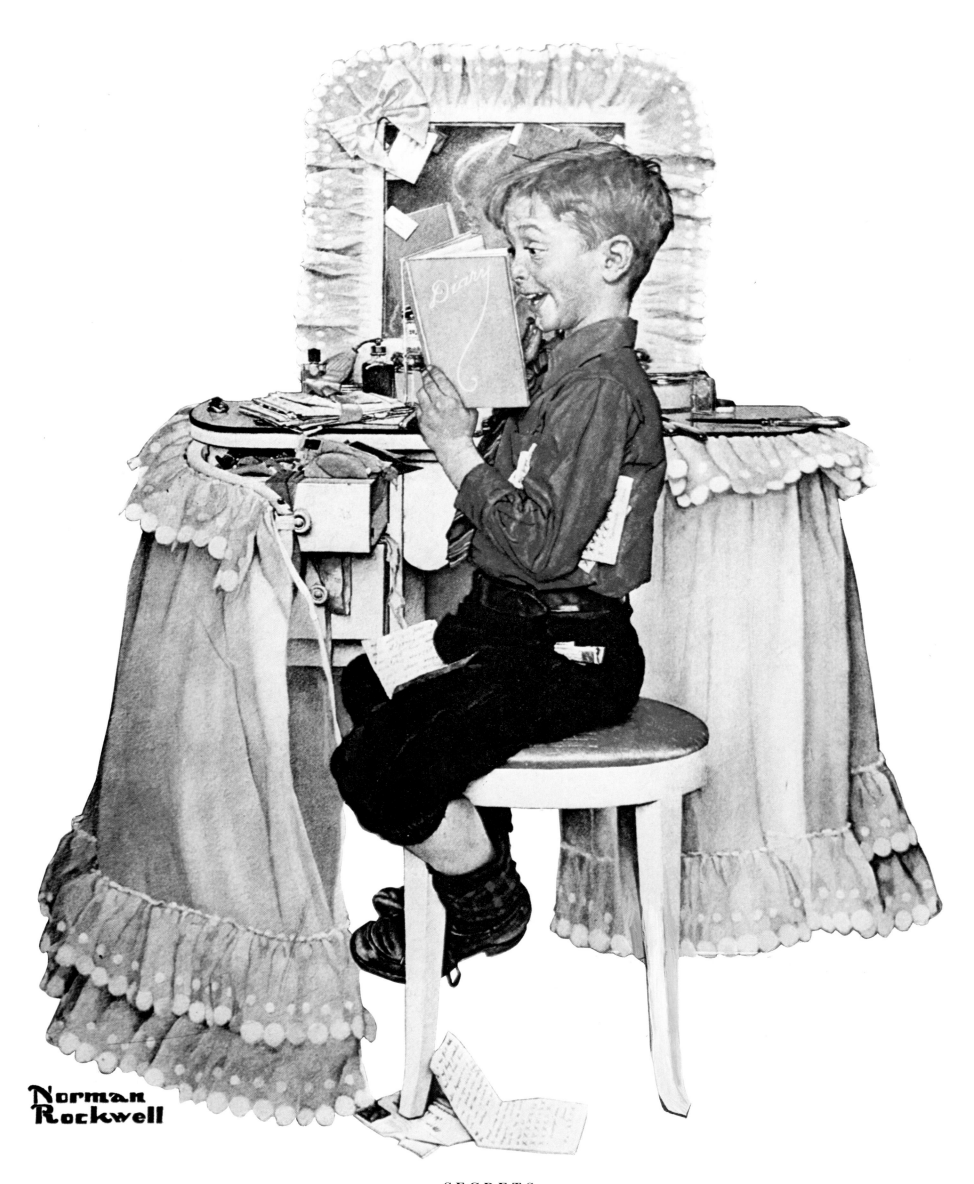

SECRETS

Post Cover • March 21, 1942

316

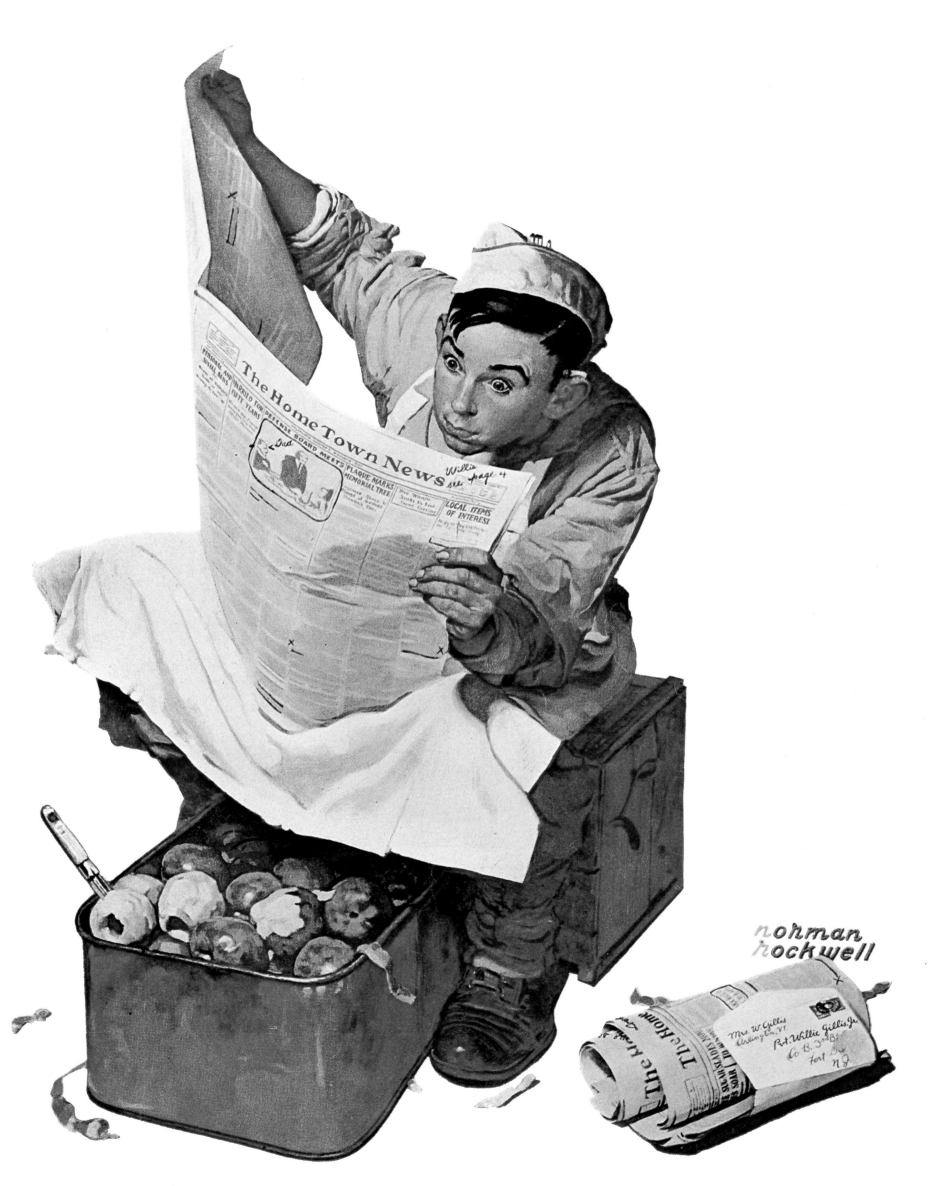

HOMETOWN NEWS
Post Cover • April 11, 1942

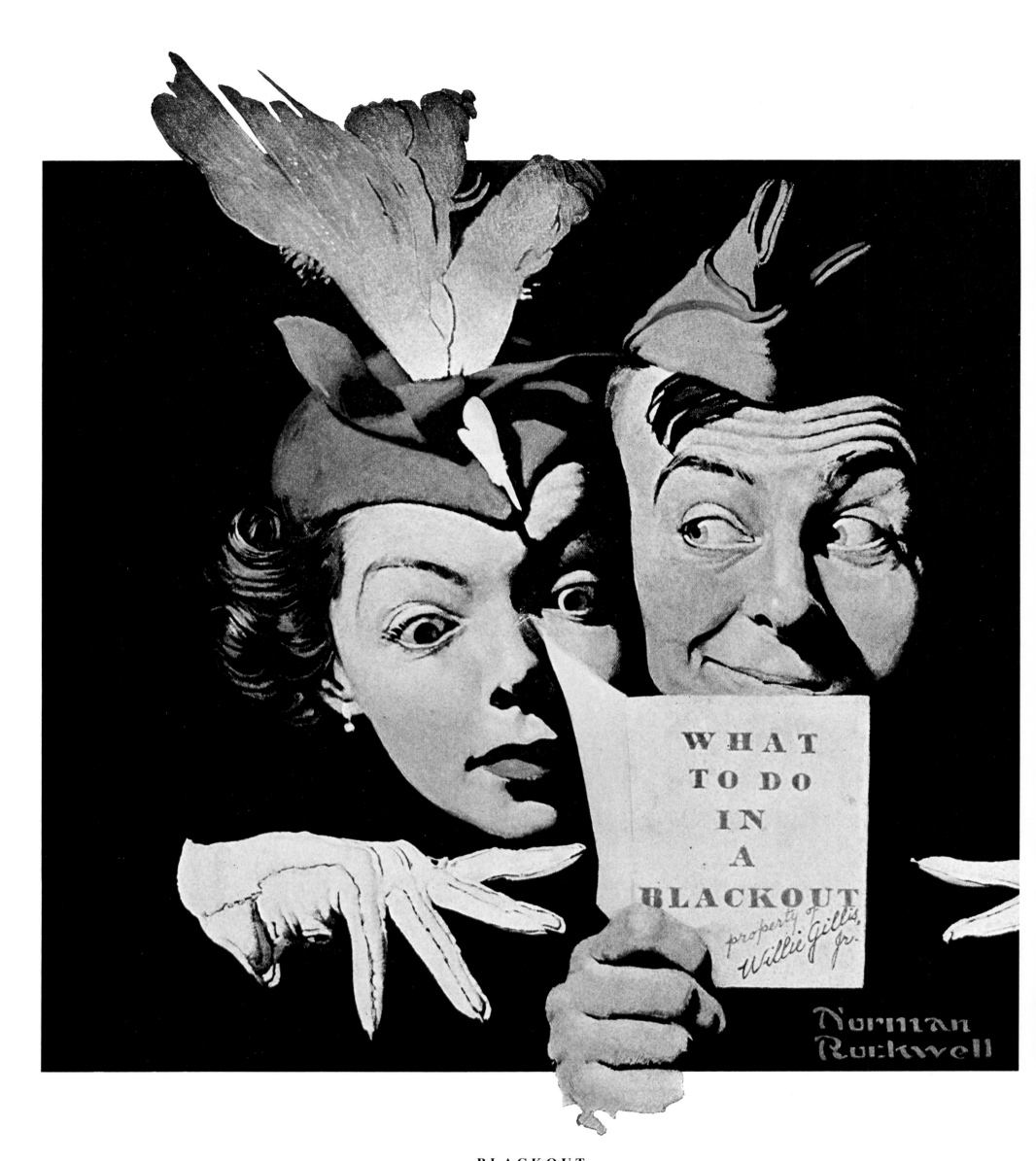

BLACKOUT

Post Cover • June 27, 1942

318

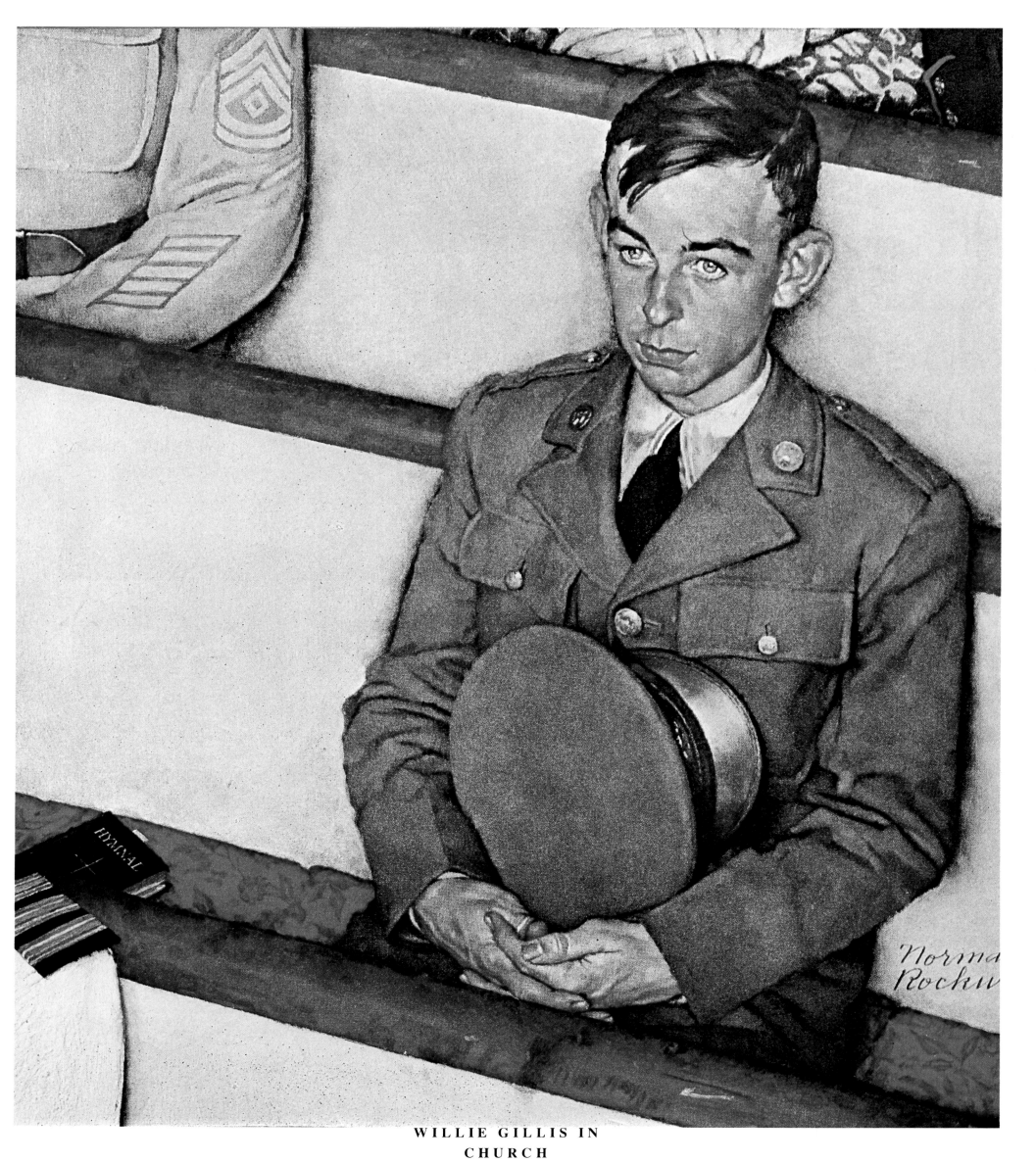

WILLIE GILLIS IN CHURCH

Post Cover • July 25, 1942

Rockwell's Authority Was Based on the Trust of the American Public

HAD NORMAN ROCKWELL CEASED TO WORK at the outset of World War II—he was forty-seven years old—there is every reason to suppose that we should have forgotten him long ago. Students of the period might remember him as one of the dozens of gifted illustrators who thrived between the wars, but that would have been the limit of his fame. The greatest works of his career, the paintings that would give significance to his earlier output, were still ahead. Rockwell's reputation today rests on the covers—there are barely one hundred of them—that he painted for the *Post* between 1943 and 1962. Granted, there are earlier masterpieces, but they are isolated examples and would have been ignored, except by specialists, if it had not been for the sustained quality of his later work and the unique vision that is embodied in his cover paintings after 1943. It was during the war years, then, and the first years of the peace, that Rockwell finally emerged as someone who stood apart from other illustrators—the anointed keeper of a certain well-defined group of American myths.

It is difficult to pick one cover that sums up this change in status; he had been moving toward new goals since the late thirties. But we might select his famous "Rosie the Riveter" (p 333), a magnificent and yet humorous celebration of the Home Front painted at a time when, across the Atlantic, Flying Fortresses by the hundreds were beginning their daring daylight raids over the Ruhr and other strategic targets inside Hitler's Germany. "Rosie the Riveter" has an authority that, I believe, no other illustrator of the day could have commanded, an authority based on the total trust of the American public, a trust that Rockwell had earned over more than a quarter of a century. This trust and this authority would remain with Rockwell for the rest of his life.

It is significant, perhaps, that in 1943 a devastating fire at Rockwell's Arlington studio destroyed most of the props he had collected over the years, as well as many of his early paintings. Tragic as this fire was, it effectively cut him off from many of his past associations and working habits, and it had the effect of sharpening his new focus on contemporary events.

We have only to compare Rockwell's World War II covers—the ones that relate specifically to the war itself—with those that he painted during World War I to see just how far he had come. Those made during the first Great War seem stolid and

conventional. Those painted during the second Great War are alive and inventive. They show us—often with humor—the impact that the conflict has upon real people, people who might live next door. Heroics are avoided at all cost, and we seldom get a glimpse of a war zone ("Thanksgiving," on page 335, is an interesting exception). Instead, Rockwell gives us the small moments that are so important to the individuals caught up in war.

It may be that it was the war itself that permitted Americans to recognize Rockwell for what he was. The scale of world events seemed to dwarf everyday concerns, yet Rockwell had the courage to focus on those mundane affairs. He refused to allow himself or his protagonists to be overwhelmed by history. There was something immensely reassuring about this quiet little man, something inspiring about the way in which he persisted with his chosen task, and with his own simple set of values, as the world tried to tear itself apart.

SATURDAY EVENING POST COVERS
September 5, 1942–November 16, 1946

CONFRONTATION
Post Cover • September 5, 1942

PAGE 329

THIS—the seventh Willie Gillis cover, and the fourth in a row—is an example of the kind of inventiveness that was forced upon Rockwell when his model, Robert Buck, left on active duty. Rockwell's solution was ingenious: he would use photographs of Willie, and other mementos, to keep the series alive.

THANKSGIVING DAY
Post Cover • November 28, 1942

PAGE 330

ONE of the articles in this edition of the *Post* was titled "Woes of an Army Cook." One feels that the author might have objected, justifiably, that Rockwell had told the whole story on the cover. It is difficult to imagine that the most eloquent essay could add very much to this image.

MERRY CHRISTMAS
Post Cover • December 26, 1942

PAGE 331

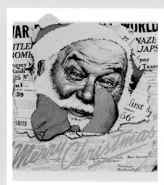

AFTER a long, unbroken string of covers that ranged in quality from good to first-rate, Rockwell finally experienced a temporary lapse and presented the *Post*'s readers with this Christmas cover, which —while one can understand the message it is meant to convey—must rank as the most clumsy piece of work he had turned out in years.

THE GAME
Post Cover • April 3, 1943

PAGE 332

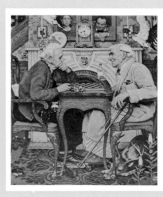

THERE is little to say about this painting except that it was intended as an April Fools' Day cover. It is for the reader to discover the deliberate absurdities that Rockwell has incorporated into this composition. This was the first of a series of such covers painted in the nineteen-forties.

ROSIE THE RIVETER
Post Cover • May 29, 1943

PAGE 333

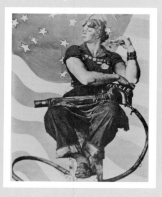

NOTHING is too good for Rockwell's Rosie, and so he borrows for her the pose and muscular physique that Michelangelo devised for the prophet Isaiah on the ceiling of the Sistine Chapel. The notion is inspired, all the more so for being so unexpected. There is no more heroic model in the history of Western painting, but Rockwell did not just borrow, he added many imaginative touches of his own. Balanced on Rosie's ample lap, the heavy riveting machine seems like a toy.

CAT'S CRADLE
Post Cover • June 26, 1943

PAGE 334

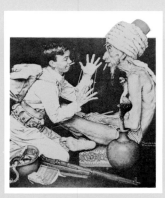

POSTED to the Orient, Willie Gillis confounds a fakir with a demonstration of downhome prestidigitation. The cigarette dangling from the fakir's lips—presumably proffered by Willie—suggests that he is more concerned with snaring tourists than attaining Nirvana. It seems Robert Buck, possibly home on leave, was available to pose for this cover.

THANKSGIVING
Post Cover • November 27, 1943
PAGE 335

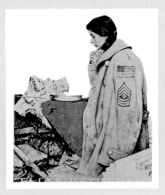

THIS study of a young woman saying grace over her simple meal amid the ruins of war made an effective Thanksgiving cover, one that must have touched a chord in many homes that November. Allied forces were advancing in Italy and the fallen columns suggest that the setting is intended to be on the Italian front.

AULD LANG SYNE
Post Cover • January 1, 1944
PAGE 336

INSTEAD of greeting the New Year at some noisy party, Willie's hometown sweetheart sleeps peacefully, watched over by photos of her hero. Once again, the mood Rockwell strives for—and achieves—is one of reassurance. It is the very ordinariness of the scene that makes it effective.

THE TATTOOIST
Post Cover • March 4, 1944
PAGE 337

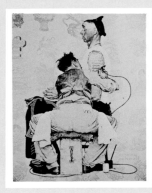

THIS humorous study is one of the best known of all of Rockwell's wartime covers. Rockwell always delighted in portraying the artist at work, no matter what his medium. Here the tattooist's model sheet makes a witty background.

ARMCHAIR GENERAL
Post Cover • April 29, 1944
PAGE 338

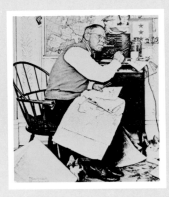

WE can easily imagine that this man is listening to one of Edward R. Murrow's wartime broadcasts from Europe, or perhaps the voice he hears through the static belongs to Lowell Thomas. In any case, he is avid for news of the latest battles, for accounts of hillsides stormed in Italy and bombs rained on Berlin. We might not be far wrong in supposing that his obsession with events abroad is laced with memories of his own role in the first Great War.

FIRE!
Post Cover • May 27, 1944
PAGE 339

HERE Rockwell exploits an idea that he turned to several times during his career, the notion of the painting that comes to life. In this case it is a portrait of a nineteenth-century fireman, and the affront that has shocked him back to the land of the animate is a cigar that has been left burning on the mantle shelf.

WAR BOND
Post Cover • July 1, 1944
PAGE 340

THIS cover was conceived as a frank pitch for the sale of U.S. War Bonds. In this sense it is a companion piece to Rockwell's "Four Freedoms" —the group of paintings that were exhibited all over the country (as well as being issued as posters) and are said to have been responsible for, directly or indirectly, the sale of millions of dollars worth of bonds.

VOYEUR
Post Cover • August 12, 1944

PAGE 341

HERE we see a splendid example of Rockwell's newly evolved style. It is not that he would have avoided dealing with this subject matter at an earlier date—indeed there is a related cover from 1921 (p 110)—but the way that he presents it here is very different from what we find in his work prior to the forties. It is almost as if we were looking at a candid photograph by some master of the genre like Henri Cartier Bresson.

THE GILLIS HERITAGE
Post Cover • September 16, 1944

PAGE 342

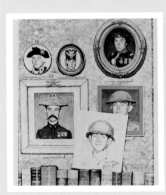

CONTINUING the Gillis series without benefit of direct access to his model, Rockwell gives us Willie's photographic likeness in the company of portraits of his distinguished military ancestors. It is, perhaps, a little surprising to discover that he comes from such warlike stock.

WHICH ONE?
Post Cover • November 4, 1944

PAGE 343

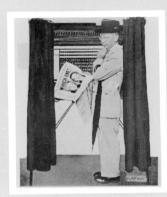

IF Rockwell, during his years with the *Post*, ever had a preference for one presidential candidate over another, he never gave away the secret. Here he presents a voter pondering the choice between FDR—running for a fourth term—and Thomas Dewey.

UNION STATION, CHICAGO
Post Cover • December 23, 1944

PAGE 344

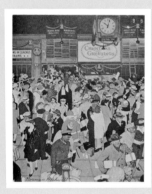

THIS wonderful cover shows the crowds at one of Chicago's busiest railroad terminals. It has been suggested that this painting shows the influence of another *Post* cover artist, John Falter, who specialized in documentary scenes of this sort. Rockwell, of course, brings his own special touch to the composition.

TAXES
Post Cover • March 17, 1945

PAGE 345

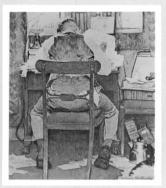

THIS is another well-realized cover in which the setting is as important as the man busy at work on his taxes. The wartime treasury had an urgent need for funds, therefore this painting might qualify as a subtle piece of propaganda.

APRIL FOOL
Post Cover • March 31, 1945

PAGE 346

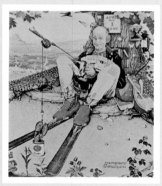

ANOTHER April Fools' Day cover, like the first (p 332), this one requires no commentary.

HOMECOMING GI
Post Cover • May 26, 1945
PAGE 347

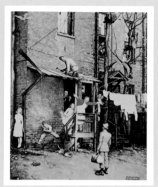

THIS famous cover appeared on newsstands less than three weeks after the war in Europe came to a close. In fact, few GIs were returning home just yet, but this cover wonderfully caught the mood of the day. Once again, as was to be the case with most of Rockwell's later covers, the whole situation gains much from the fully realized setting he has provided for it. The protagonists become more real because of the information we are given about their circumstances.

THE SWIMMING HOLE
Post Cover • August 11, 1945
PAGE 348

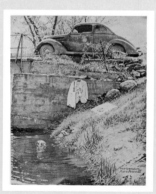

THIS is another splendid example of Rockwell's new naturalistic approach. Had he painted this subject twenty years earlier, he would have cooled the travelling salesman in the idealized swimming hole of everybody's lost childhood. But nothing is idealized here—look at the concrete pier that supports the bridge—except, perhaps, for the salesman's boyish enthusiasm.

ON LEAVE
Post Cover • September 15, 1945
PAGE 349

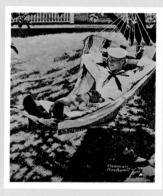

ONCE again "home from the war" is Rockwell's theme, as he evokes the mood of the day by conjuring up a sundappled noon in a familiar garden.

THE WAR HERO
Post Cover • October 13, 1945
PAGE 350

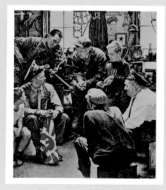

THIS painting recalls some of Rockwell's World War I covers, but here it is greatly enhanced by the true-to-life detail of the protagonists and their setting.

THE CLOCK MENDER
Post Cover • November 3, 1945
PAGE 351

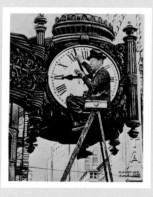

THIS painting is documentary in the most matter-of-fact way. It is almost

as though Rockwell is showing us a scene he has chanced upon in the street.

THANKSGIVING
Post Cover • November 24, 1945
PAGE 352

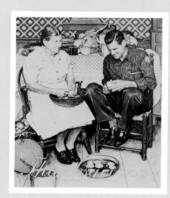

ANOTHER of Rockwell's "home from the war" series, this is a vivid contrast to the 1943 Thanksgiving cover (p 335). Then the holiday was symbolized by the most meager of meals. This happy GI, however, is about to partake of a traditional feast, the likes of which he has probably not seen in years. This is a fine study of a mother and son seen under the happiest of circumstances.

AN IMPERFECT FIT
Post Cover • December 15, 1945
PAGE 353

THIS young flyer, back home once more, has grown during his years in the service, and this fact gives point to the image. The real charm of the painting, however, comes from the fidelity with which Rockwell has placed him in his setting. Comfortable old furniture and boyhood souvenirs are made to stand for the world that this young man has been fighting for.

PORTRAIT
Post Cover • March 2, 1946
PAGE 354

THIS time, instead of having a painting come to life, Rockwell gives us a live person transformed, by chance, into the semblance of a painting. Once more, this looks like a photograph taken by someone armed with a Leica and blessed with a set of quick reflexes. Rockwell has, in effect, reconstructed that fraction of a second in which the camera shutter—an imaginary one in this case—blinks open.

PLAYBILL
Post Cover • April 6, 1946
PAGE 355

THESE two elderly cleaning women are as fascinated by the contents of the playbill as were any of the first-nighters who have just left the theater. By focusing on them, Rockwell makes them the stars of the production, and one almost suspects that the artist has asked himself the question, "Which is the moment that everyone else would ignore?" In his best work, Rockwell generally seeks to avoid the obvious.

STATUE OF LIBERTY
Post Cover • July 6, 1946
PAGE 356

THIS picture of workmen renovating Liberty's torch made a dramatic cover for the Fourth of July holiday issue. Their presence has the effect of humanizing the statue, while at the same time emphasizing its scale. This must have made a fine, bold display on newsstands.

FIXING A FLAT
Post Cover • August 3, 1946
PAGE 357

THIS delightful cover demonstrates that Rockwell's view of rural life was not always idyllic. The contrast between the tidy world of the young women and the squalor of the hillbilly's lifestyle is shown in graphic detail.

WILLIE GILLIS AT COLLEGE
Post Cover • October 5, 1946
PAGE 358

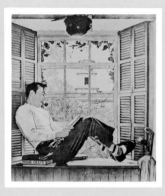

CLOSING out the Gillis series, Rockwell takes a final glance back to the war years. Willie seems content on this peacetime campus, but he has brought along his helmet, his bayonet, and his medal ribbons as reminders of the life he has just left. By showing military souvenirs without overemphasizing them Rockwell suggests the role the war has played in shaping this young hero's life.

COMMUTERS
Post Cover • November 16, 1946
PAGE 359

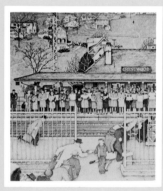

PANORAMIC views are rare in Rockwell's cover art—more often we are given a patch of landscape seen through a window or glimpsed between buildings. But here he presents a whole suburban world, and the results are delightful. Ostensibly the commuters hurrying into the station or waiting patiently on the platform are the main subject, but the background with its frame houses, mock Tudor villas, and prewar cars, is in fact the most fascinating part of the painting.

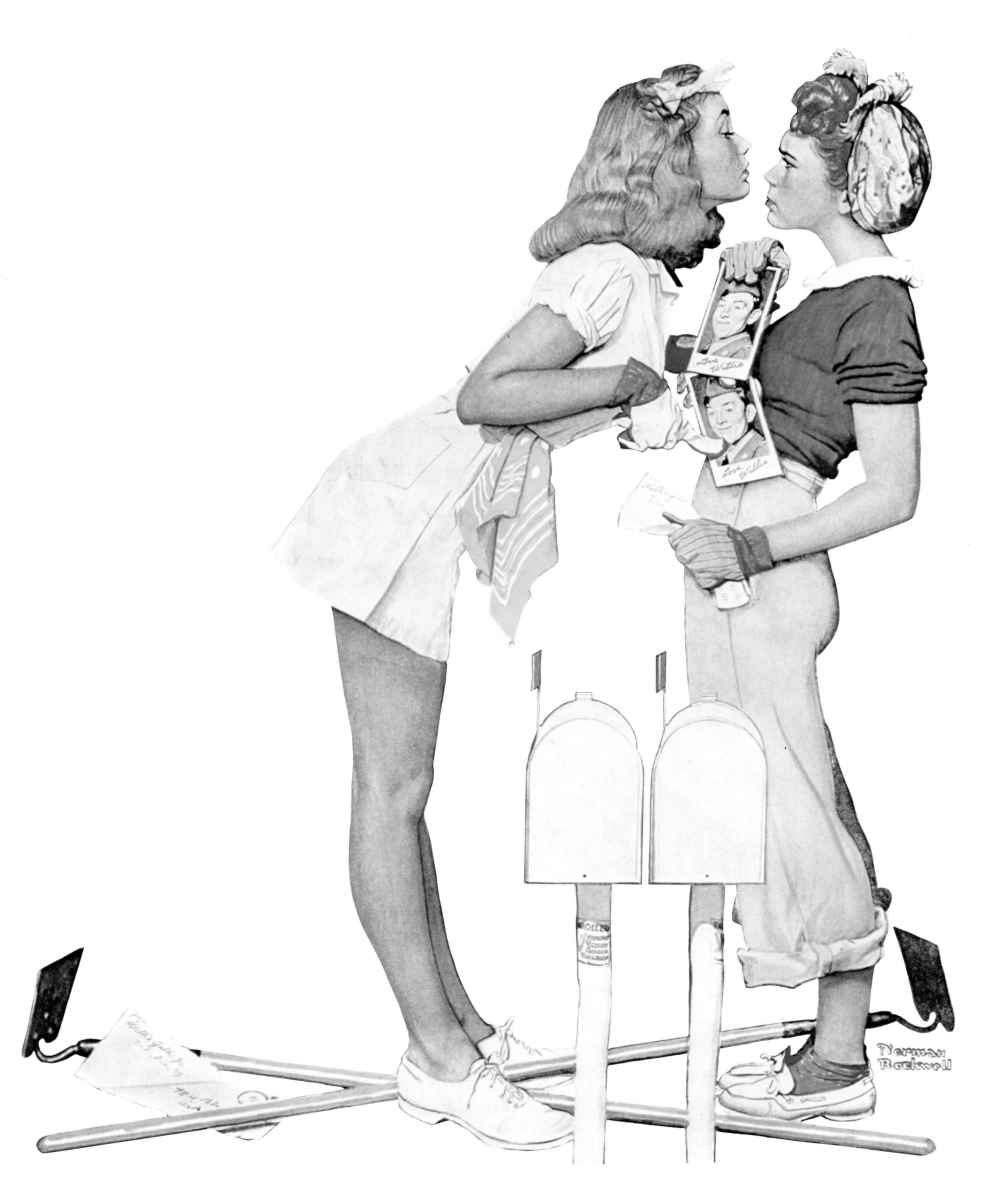

CONFRONTATION

Post Cover • September 5, 1942

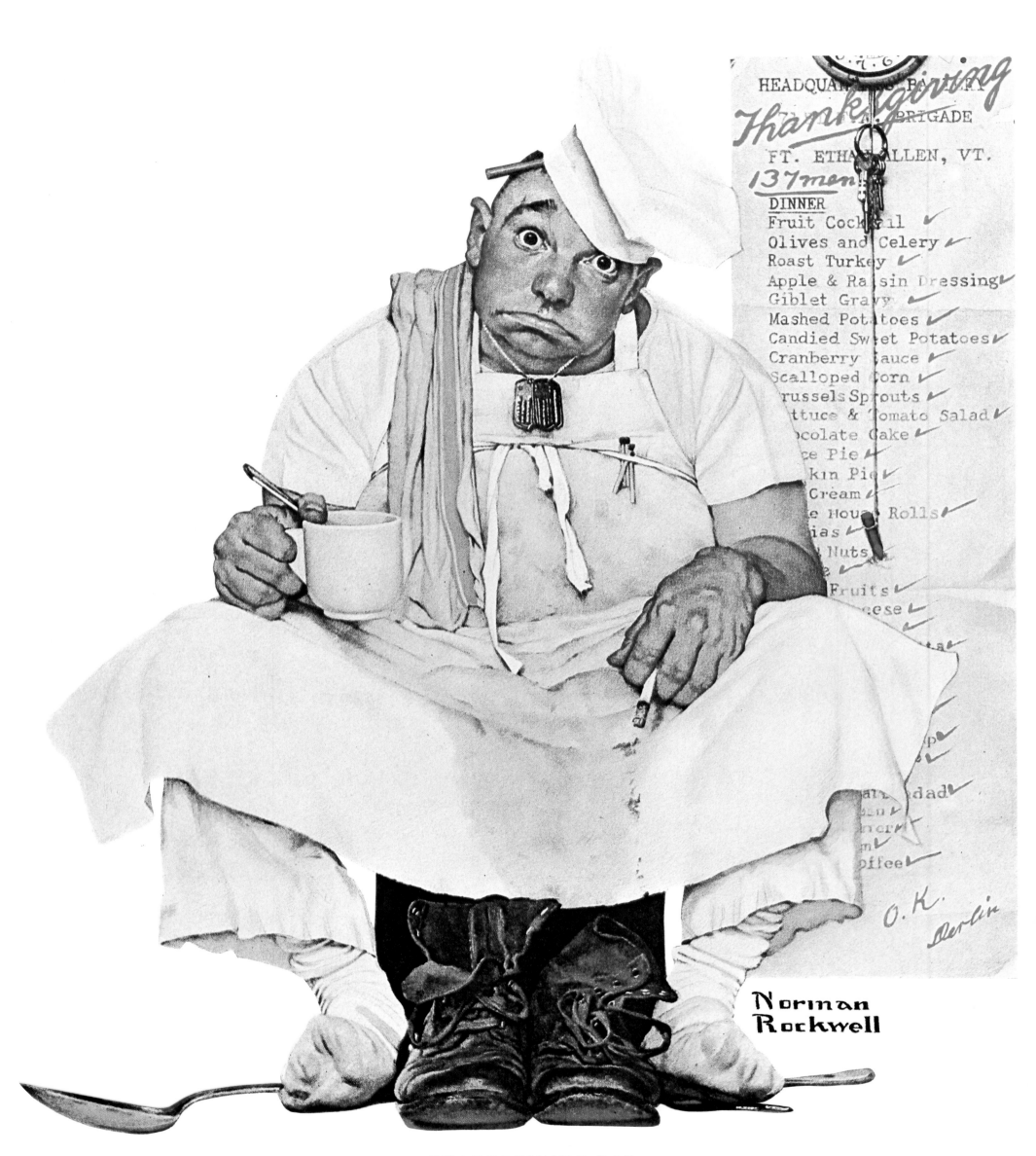

The text visible within the illustration reads:

HEADQUARTERS
Thanksgiving
BRIGADE
FT. ETHAN ALLEN, VT.
137 men

DINNER
Fruit Cocktail
Olives and Celery
Roast Turkey
Apple & Raisin Dressing
Giblet Gravy
Mashed Potatoes
Candied Sweet Potatoes
Cranberry Sauce
Scalloped Corn
Brussels Sprouts
Lettuce & Tomato Salad
Chocolate Cake
Mince Pie
Pumpkin Pie
Ice Cream
White House Rolls
...
Nuts
...
Fruits
Cheese
...
...
...
...Coffee

O.K.
Berlin

Norman
Rockwell

THANKSGIVING DAY
Post Cover • November 28, 1942

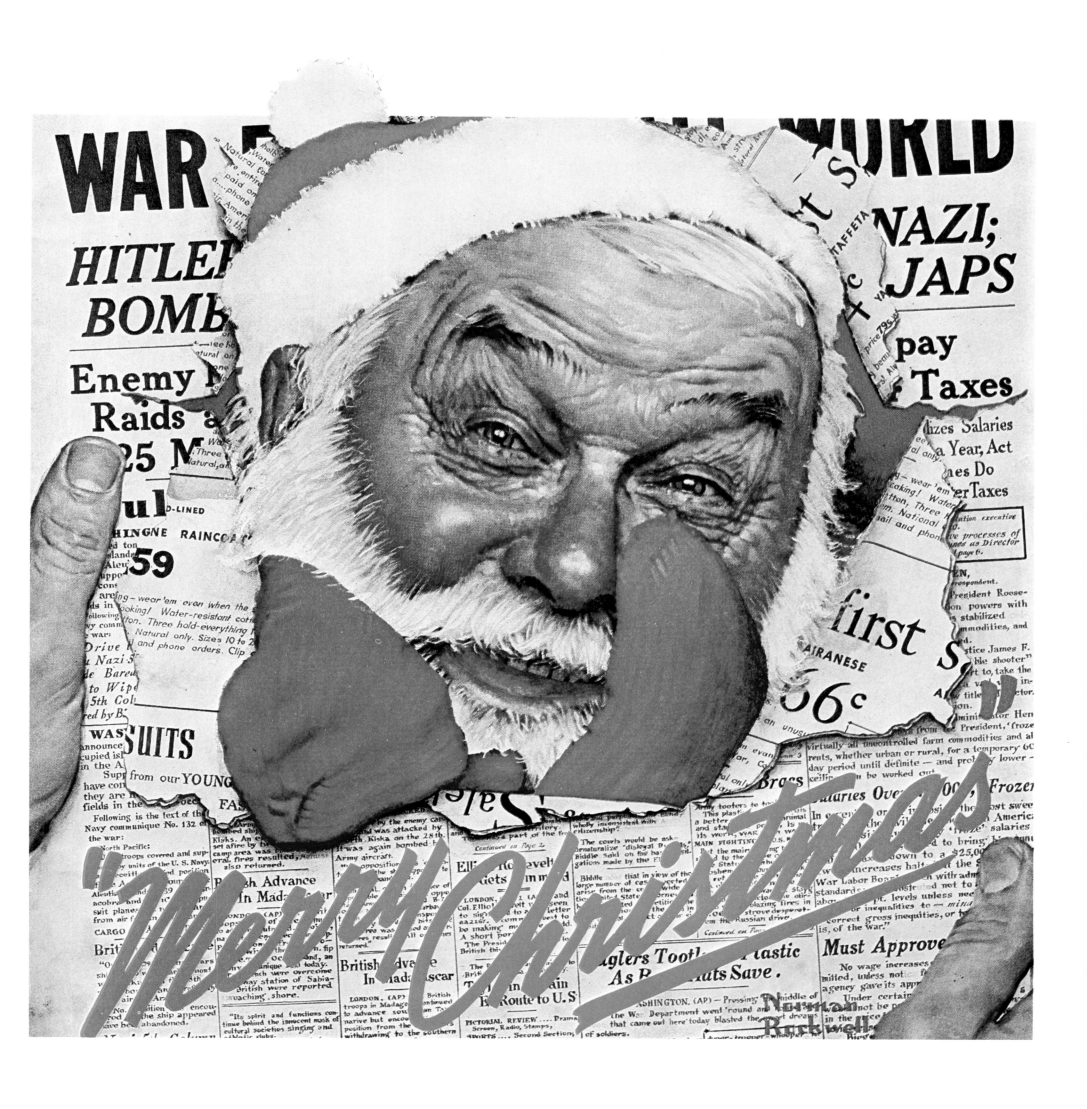

MERRY CHRISTMAS
Post Cover • December 26, 1942

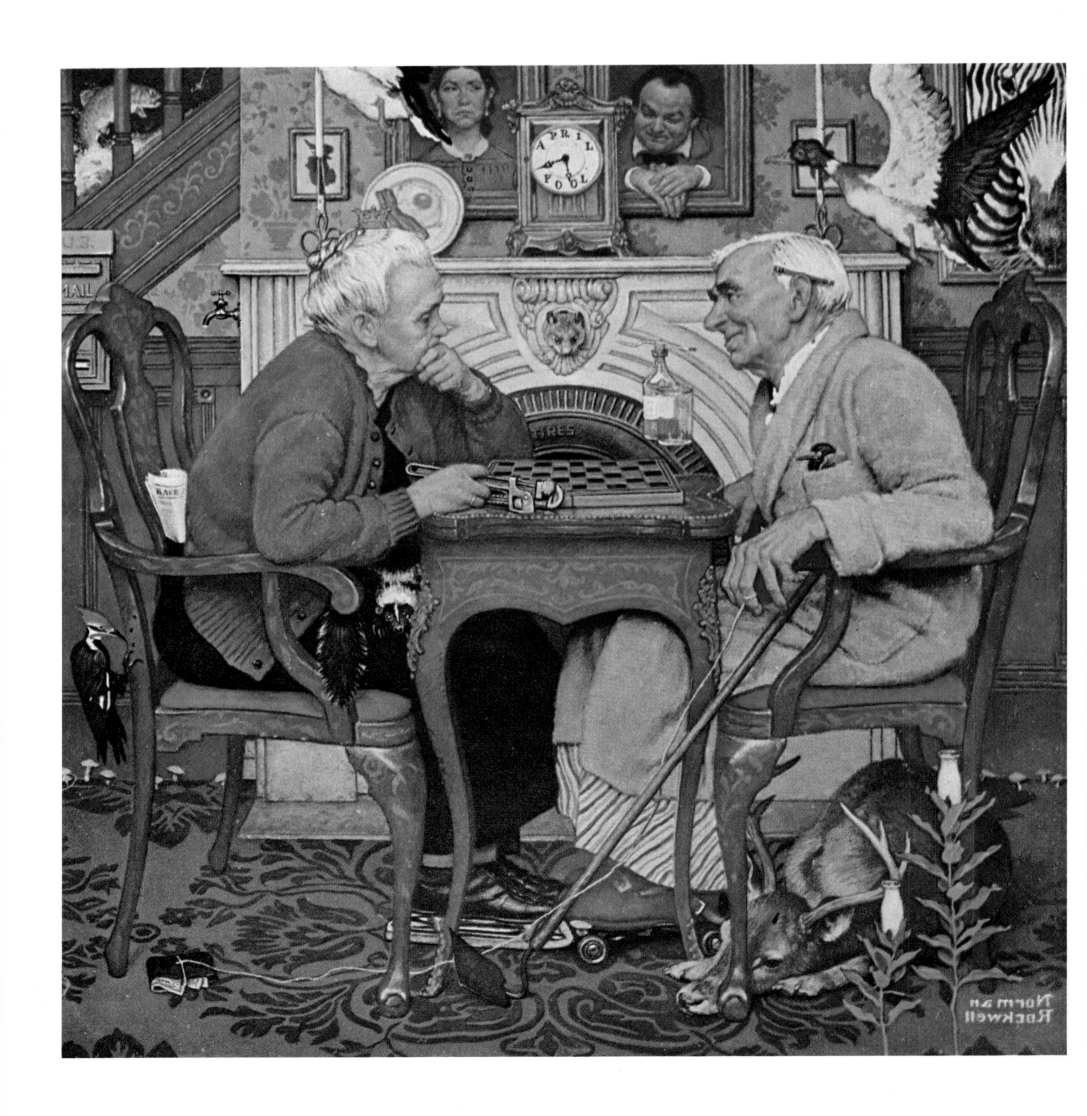

THE GAME

Post Cover • April 3, 1943

332

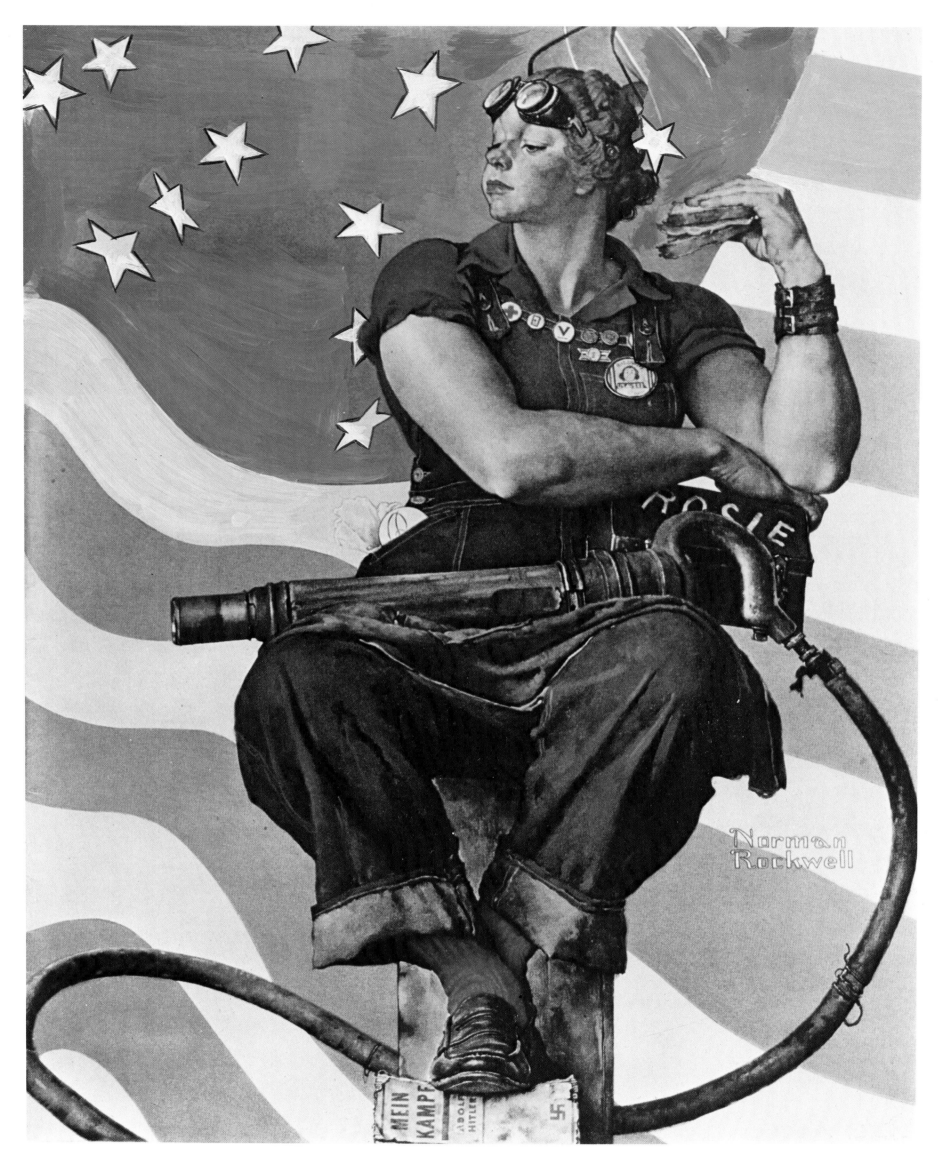

ROSIE THE RIVETER

Post Cover • *May 29, 1943*

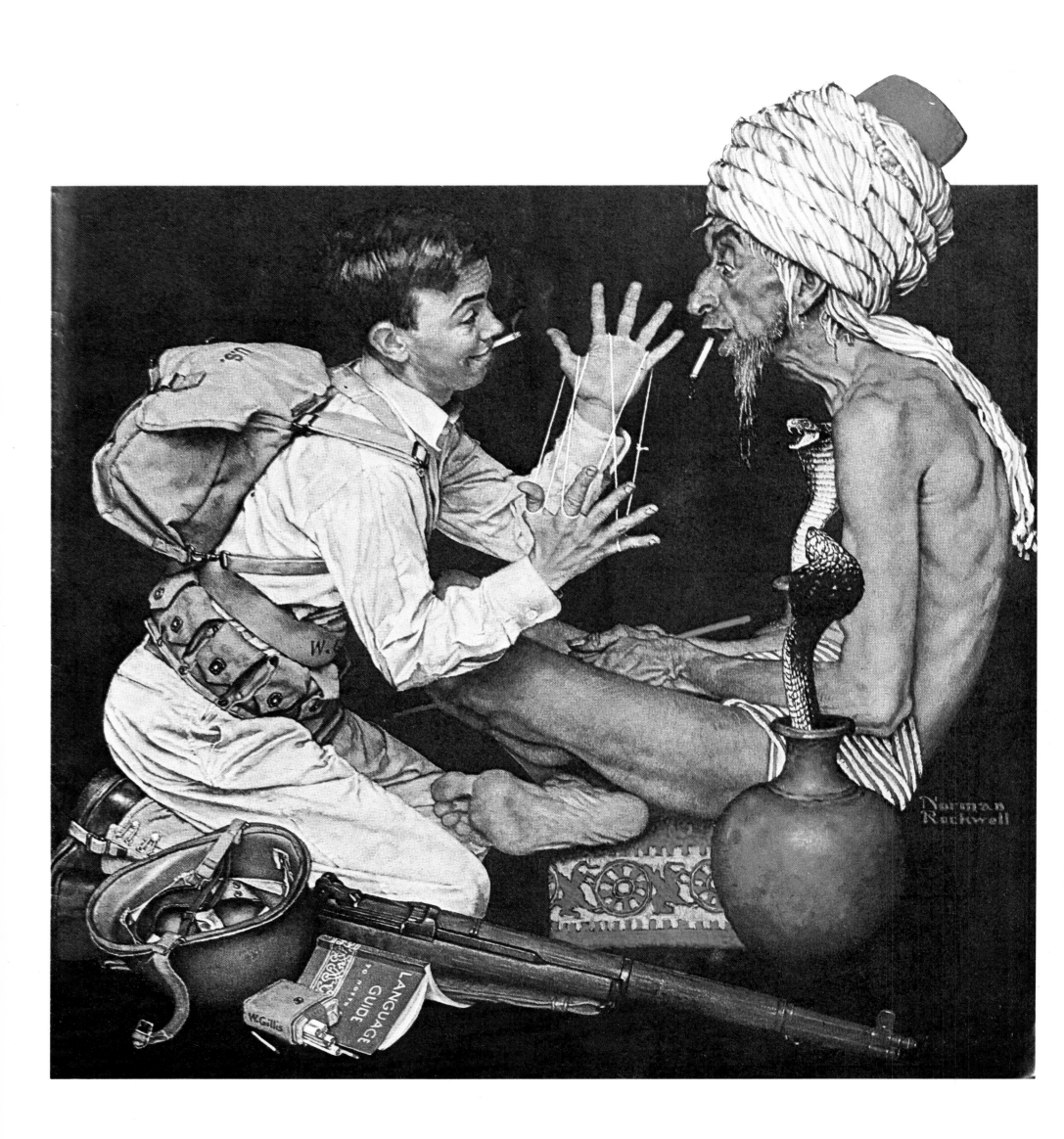

CAT'S CRADLE
Post Cover • June 26, 1943

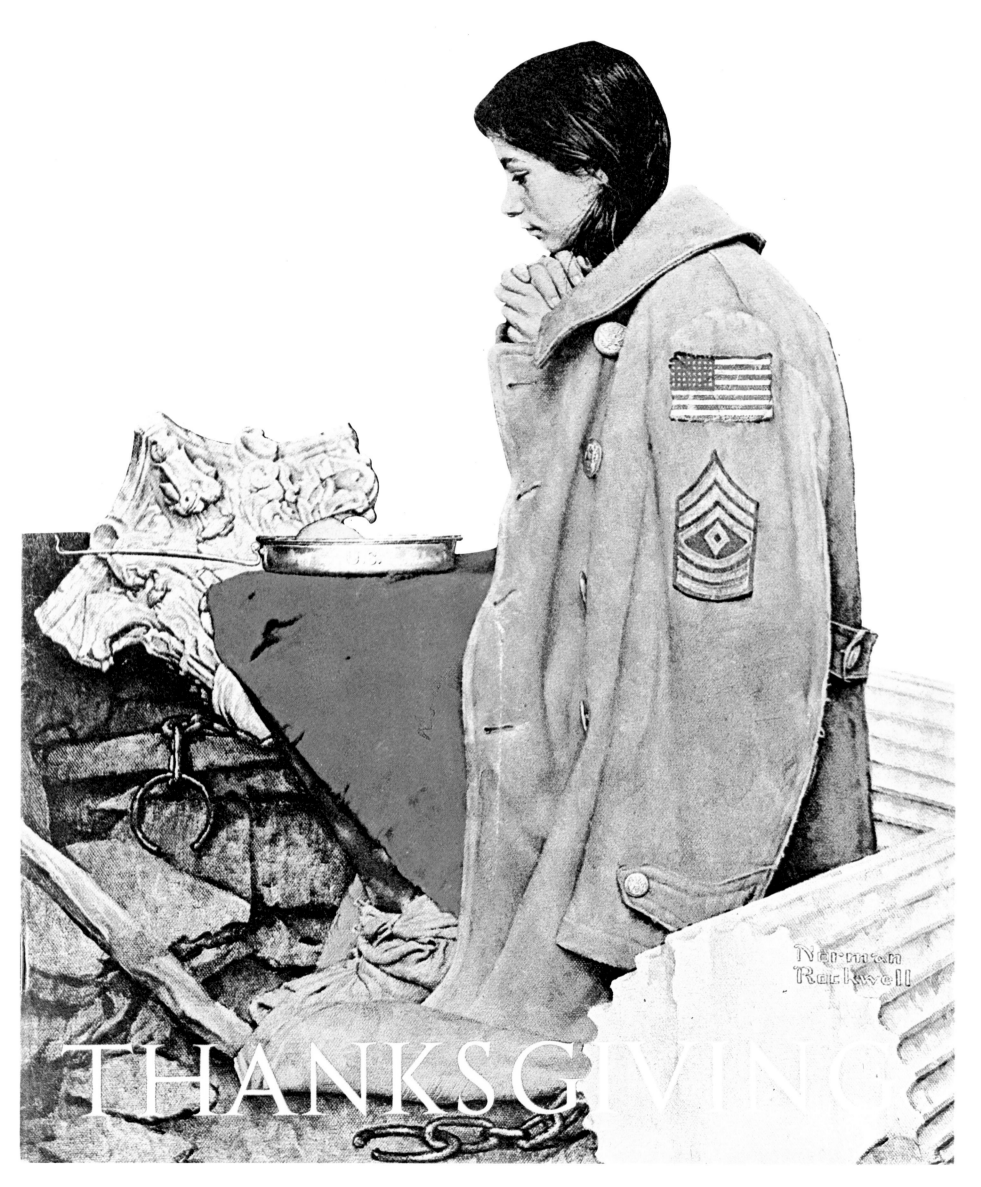

THANKSGIVING

Post Cover • November 27, 1943

335

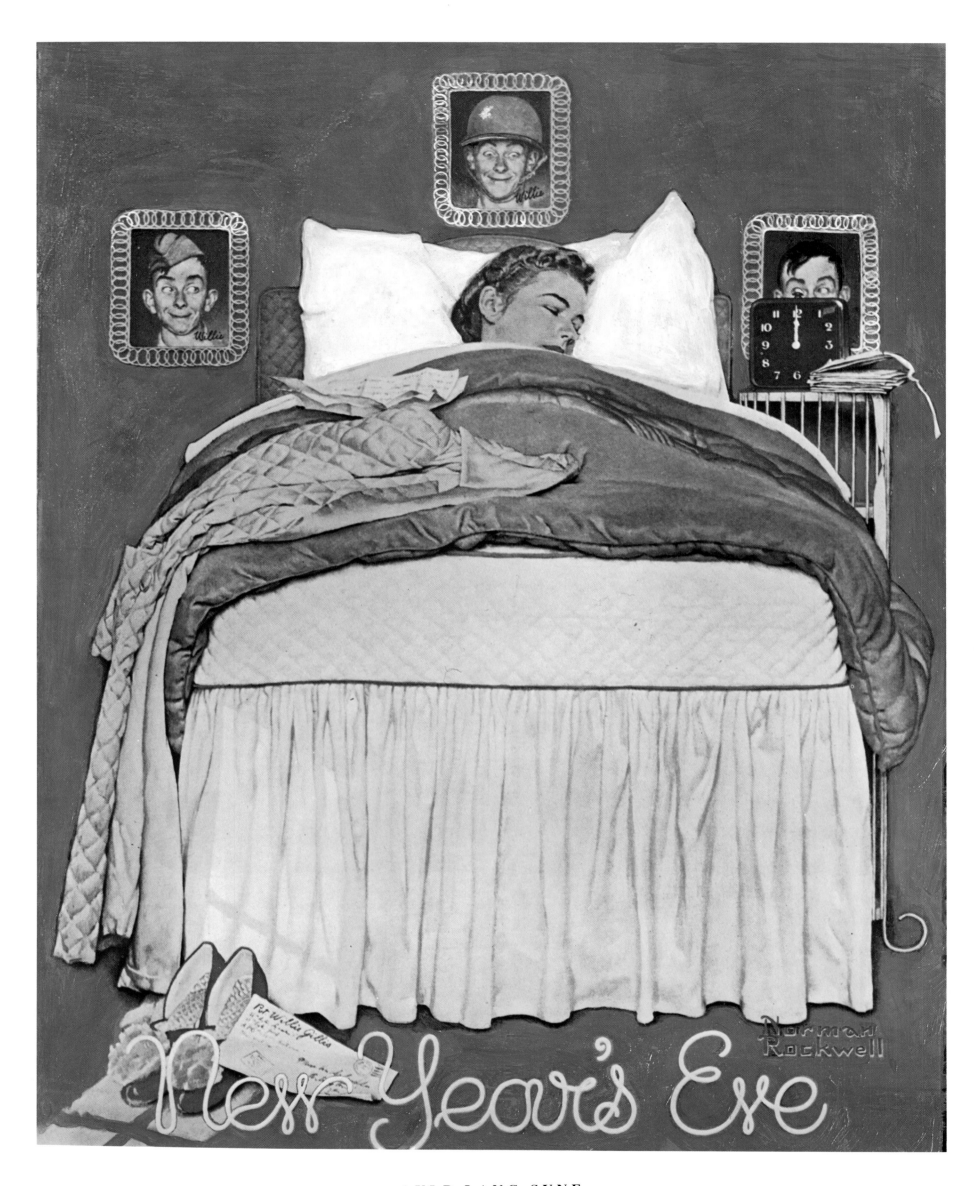

AULD LANG SYNE

Post Cover • January 1, 1944

336

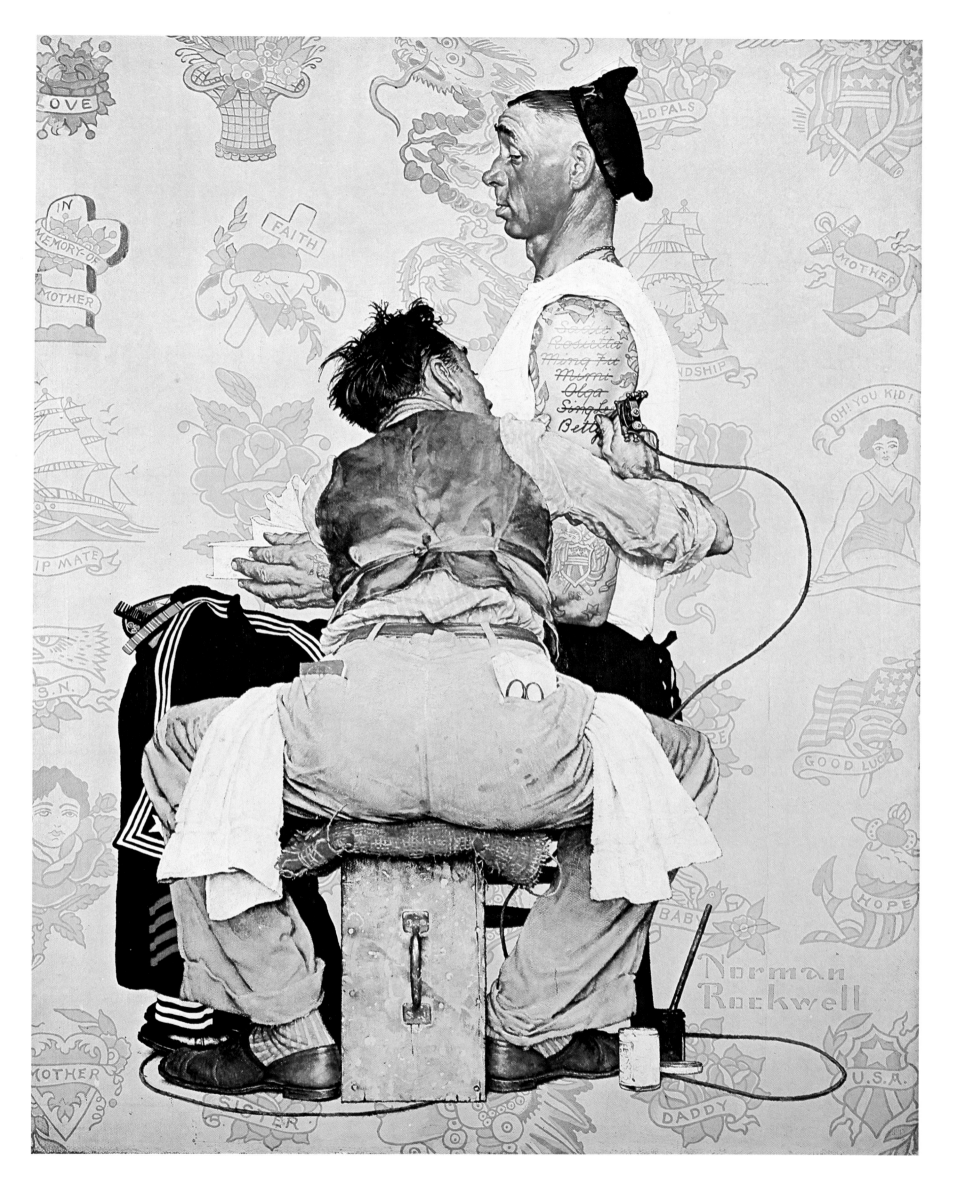

THE TATTOOIST

Post Cover • *March 4, 1944*

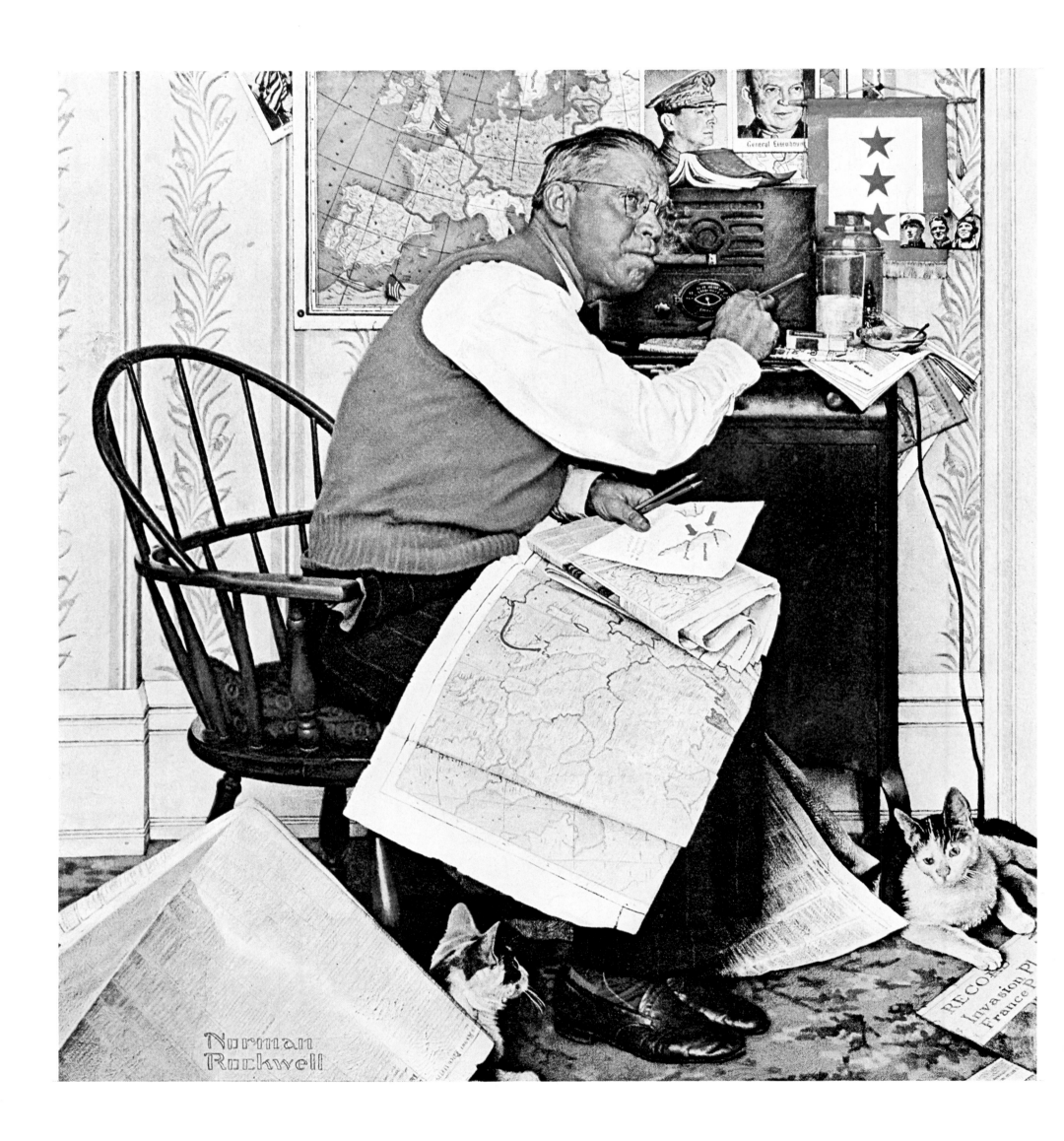

ARMCHAIR GENERAL

Post Cover • April 29, 1944

FIRE!

Post Cover • May 27, 1944

339

WAR BOND

Post Cover • July 1, 1944

VOYEUR

Post Cover • August 12, 1944

341

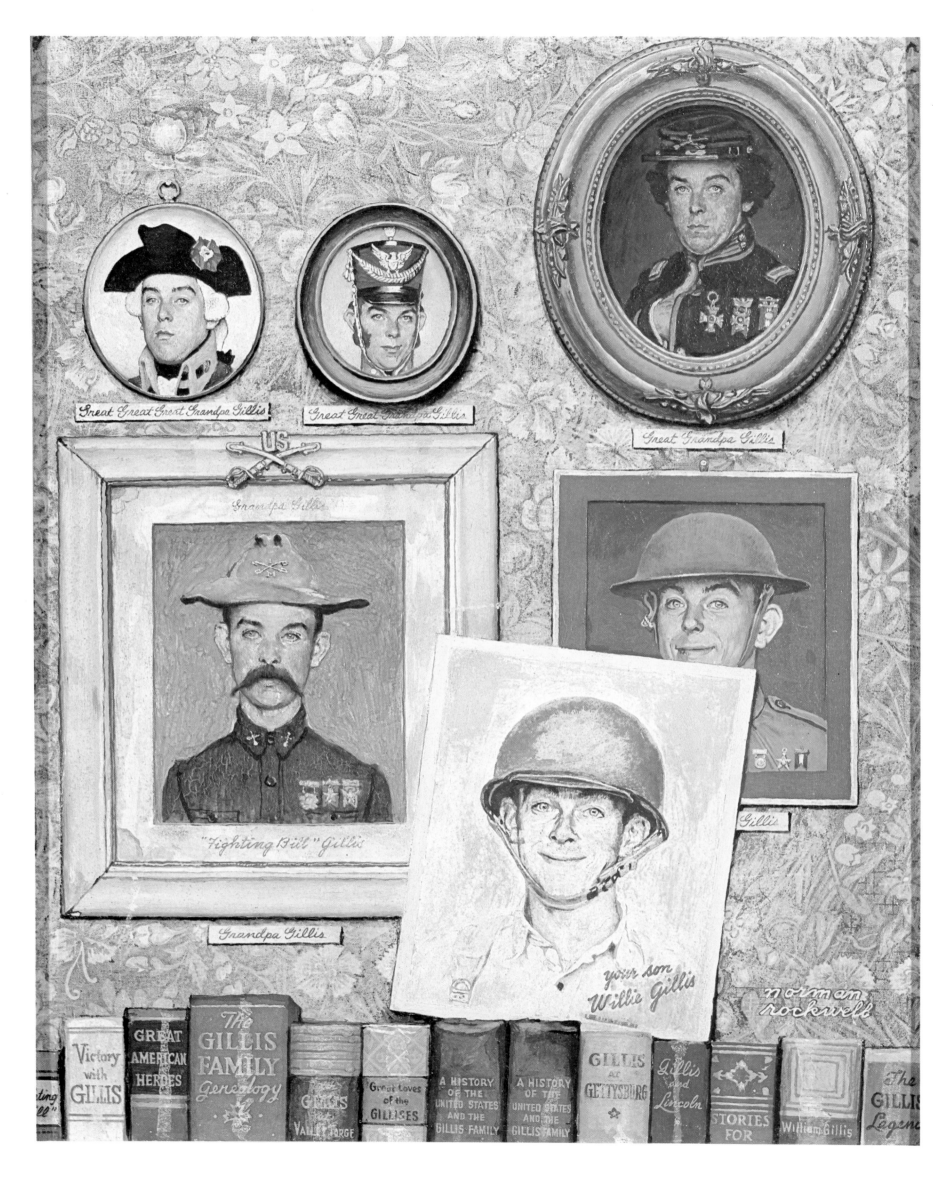

THE GILLIS HERITAGE
Post Cover • September 16, 1944

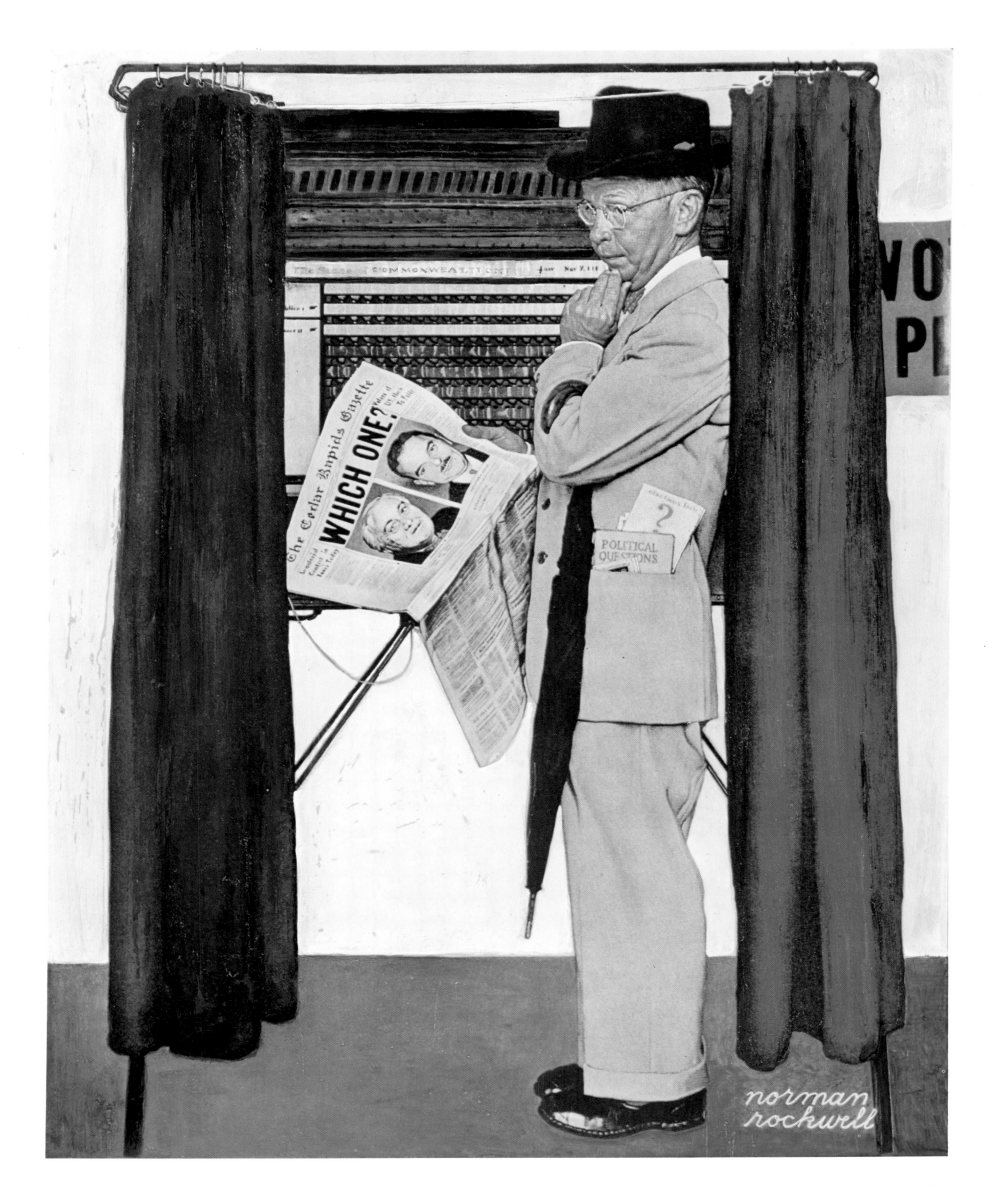

WHICH ONE?

Post Cover • November 4, 1944

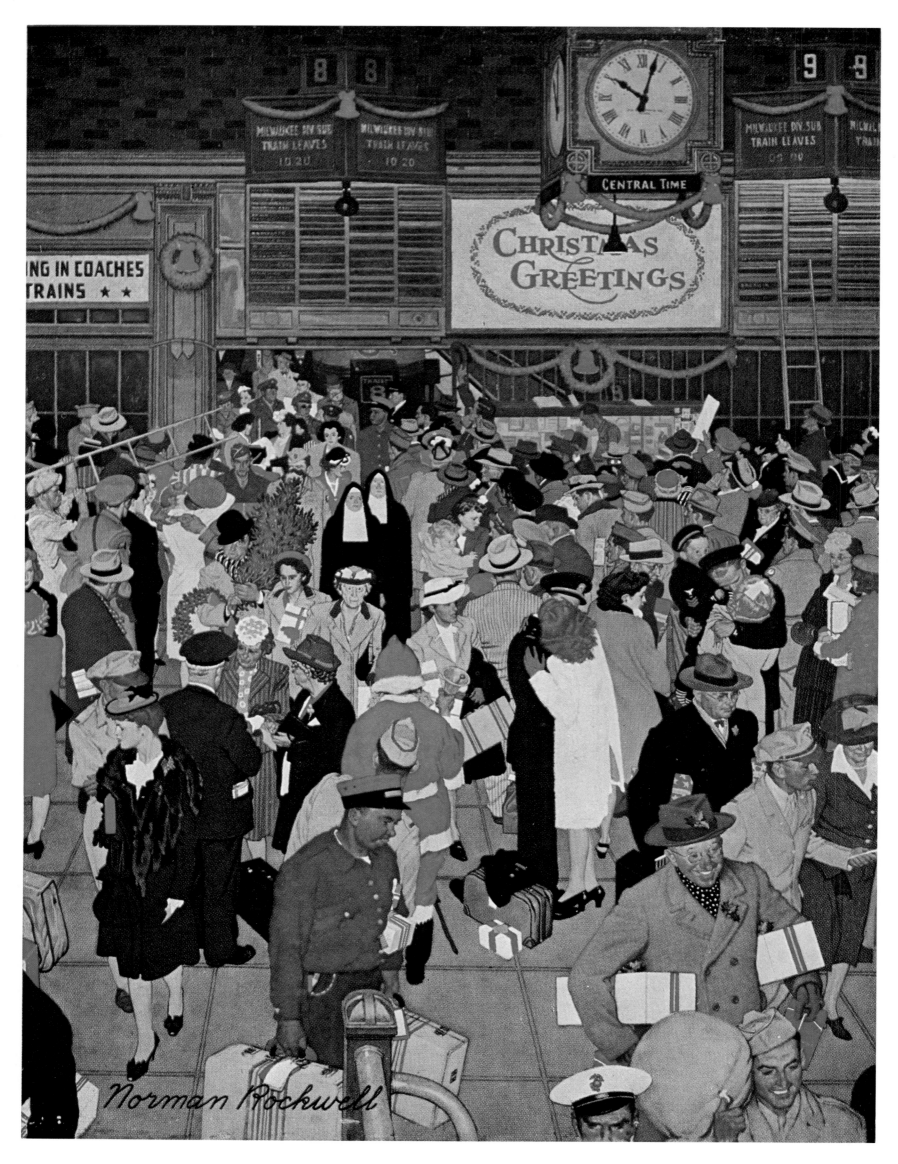

**UNION STATION,
CHICAGO**

Post Cover • December 23, 1944

344

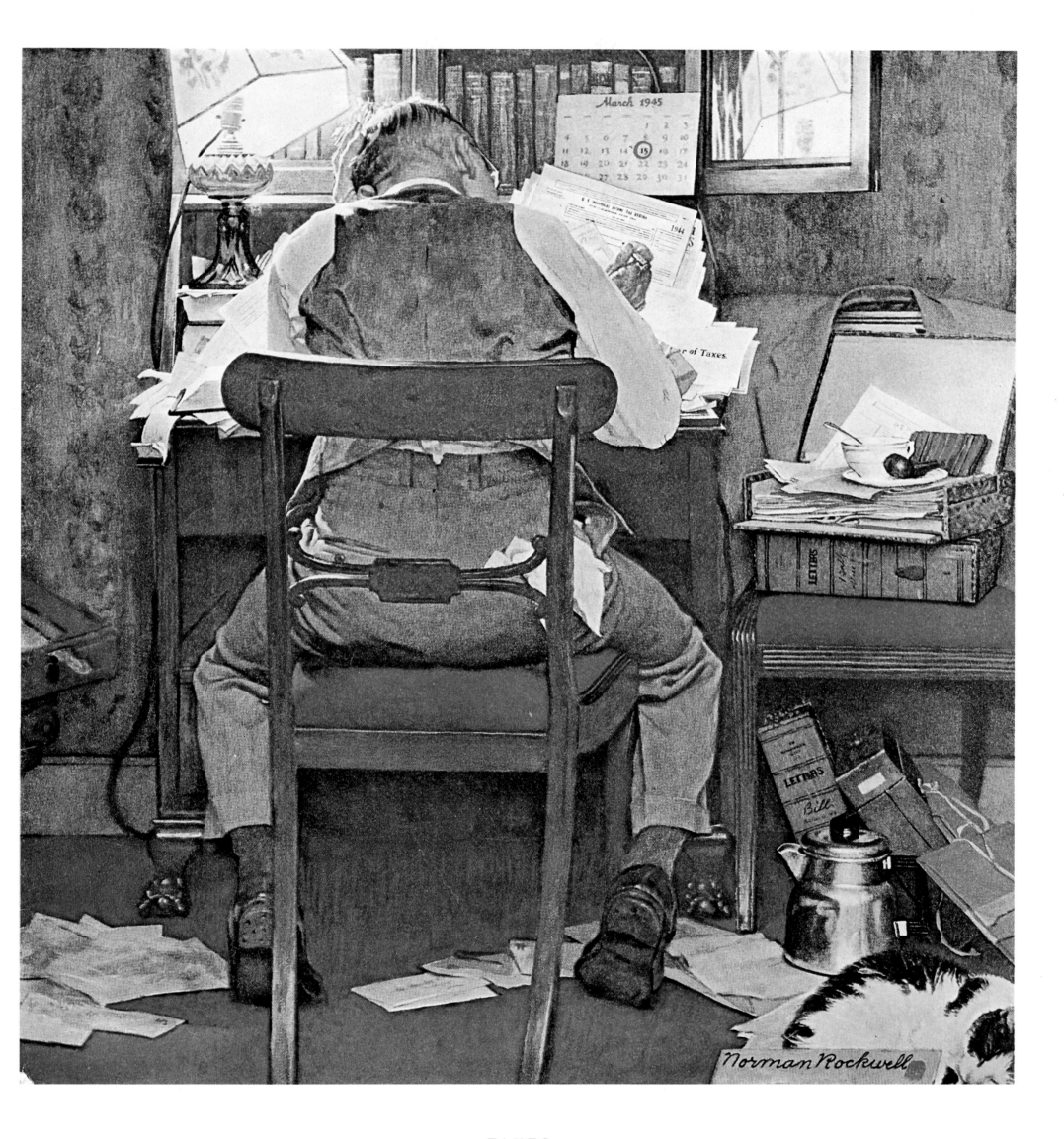

TAXES

Post Cover • March 17, 1945

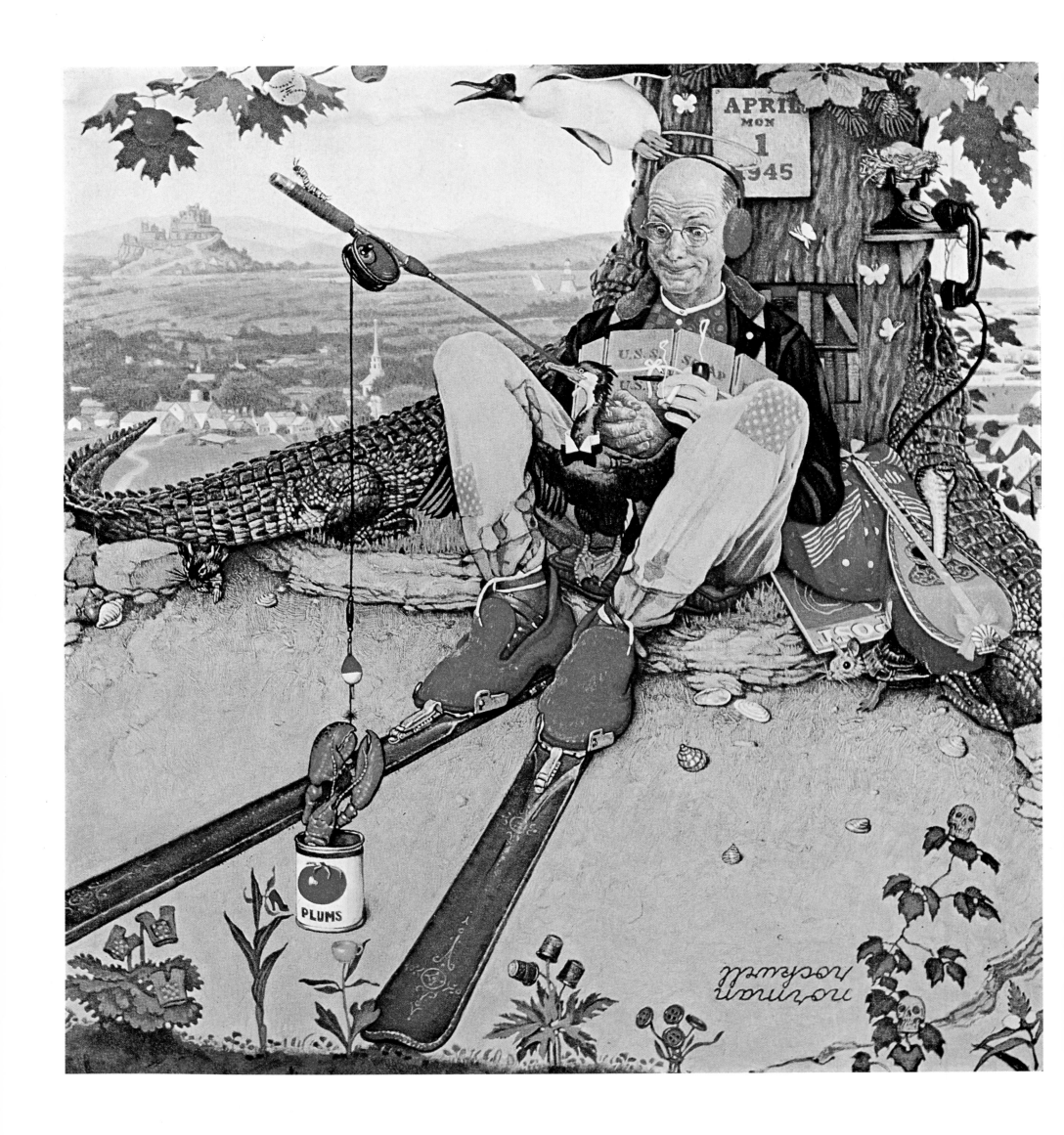

APRIL FOOL

Post Cover • March 31, 1945

346

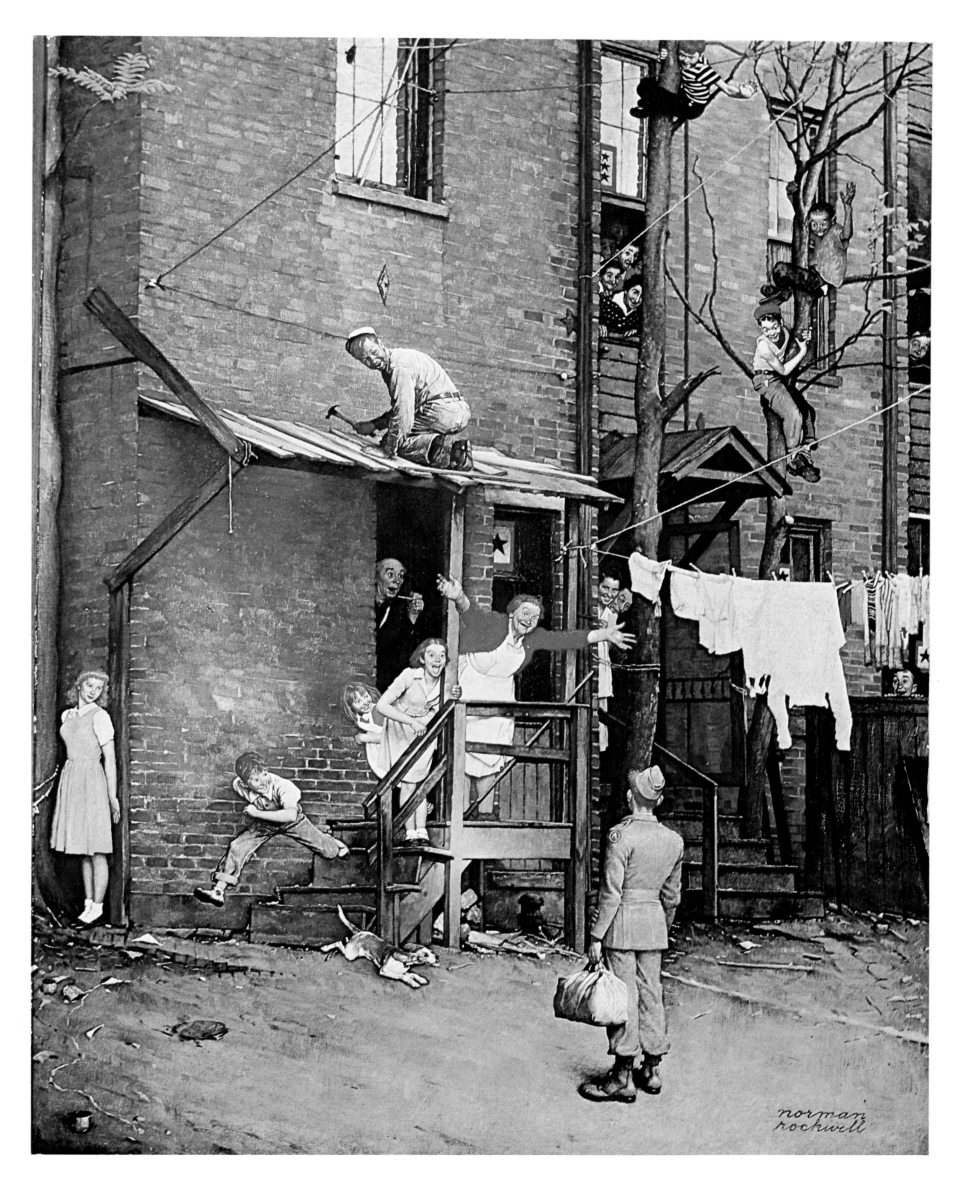

HOMECOMING GI

Post Cover • May 26, 1945

347

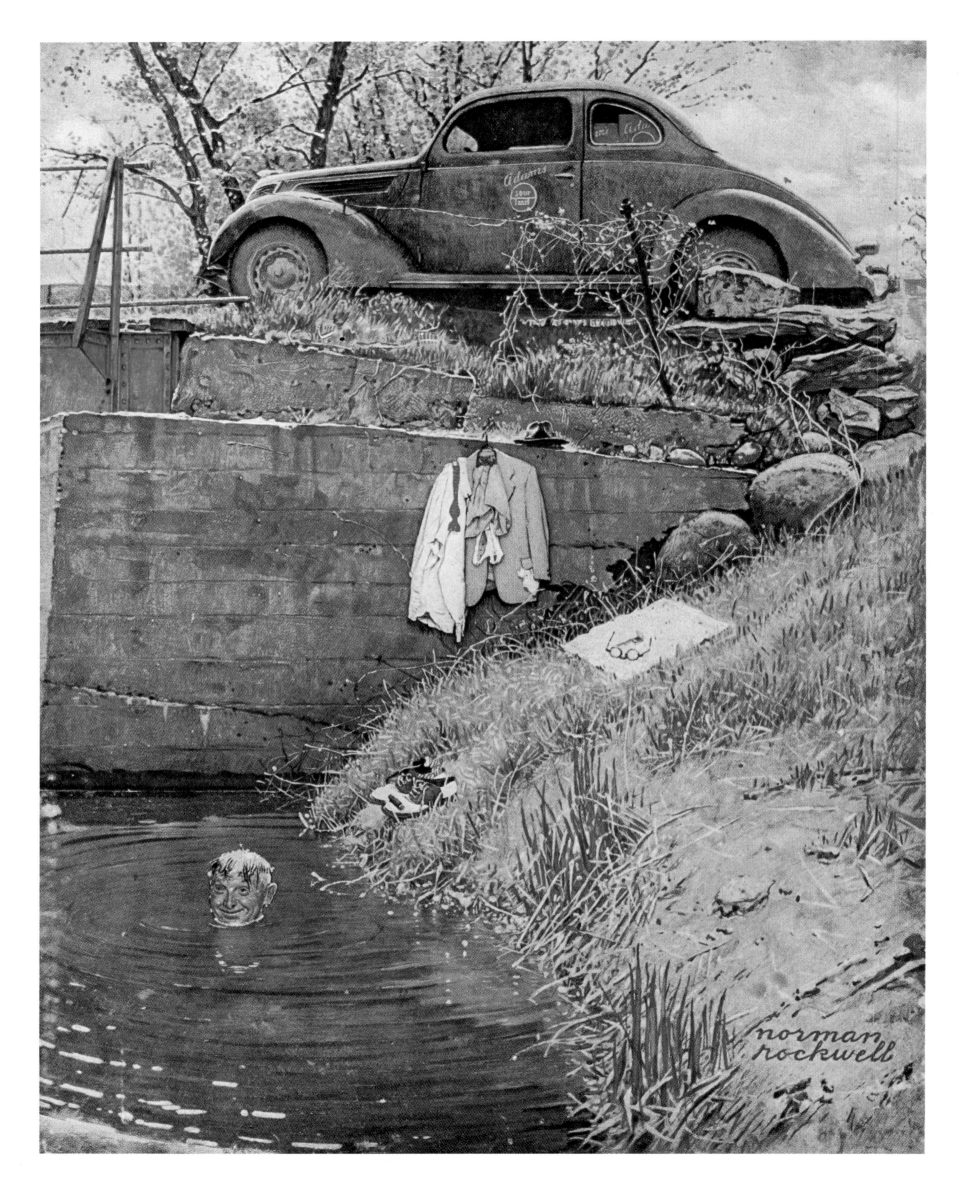

THE SWIMMING HOLE

Post Cover • August 11, 1945

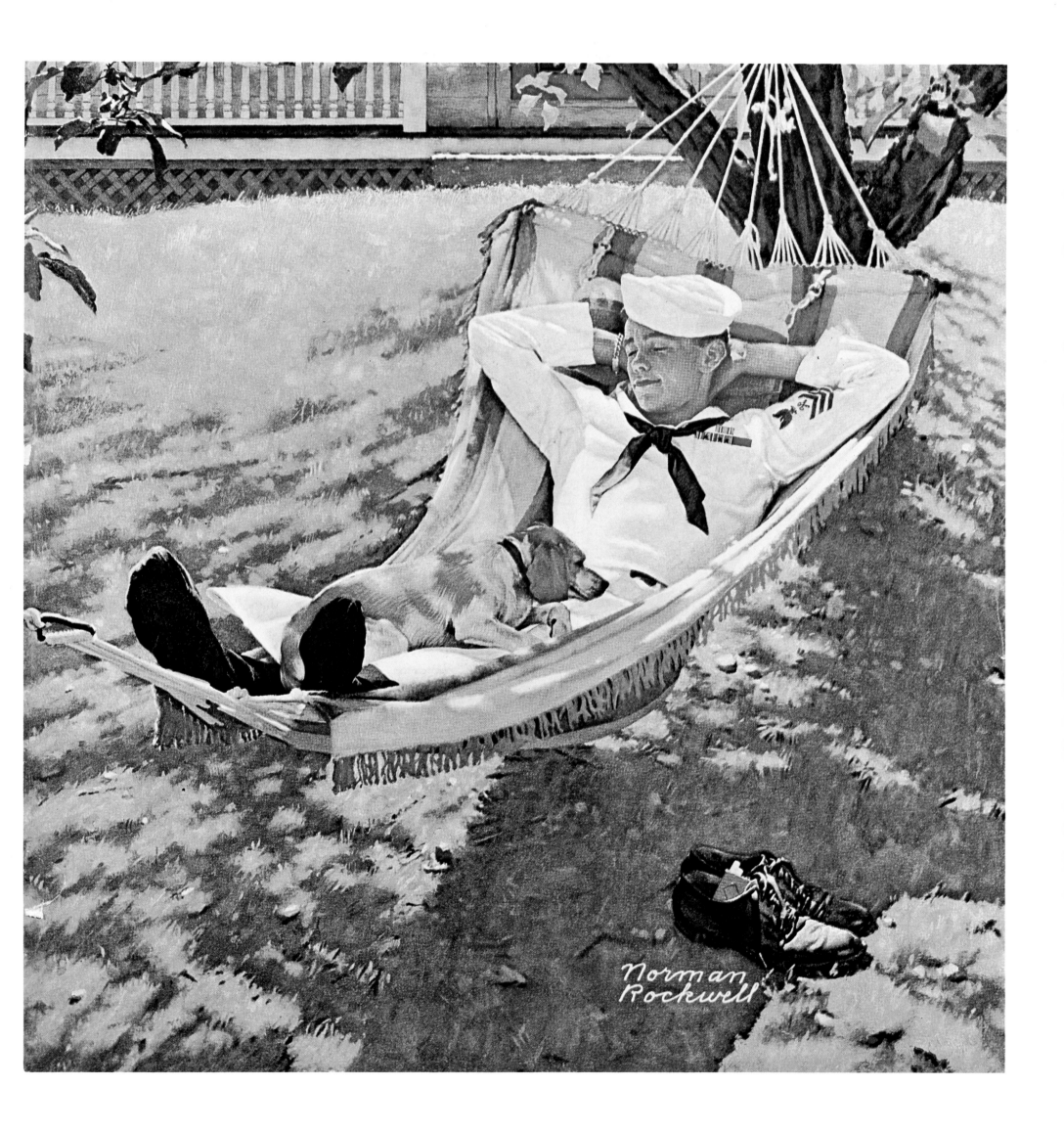

ON LEAVE

Post Cover • September 15, 1945

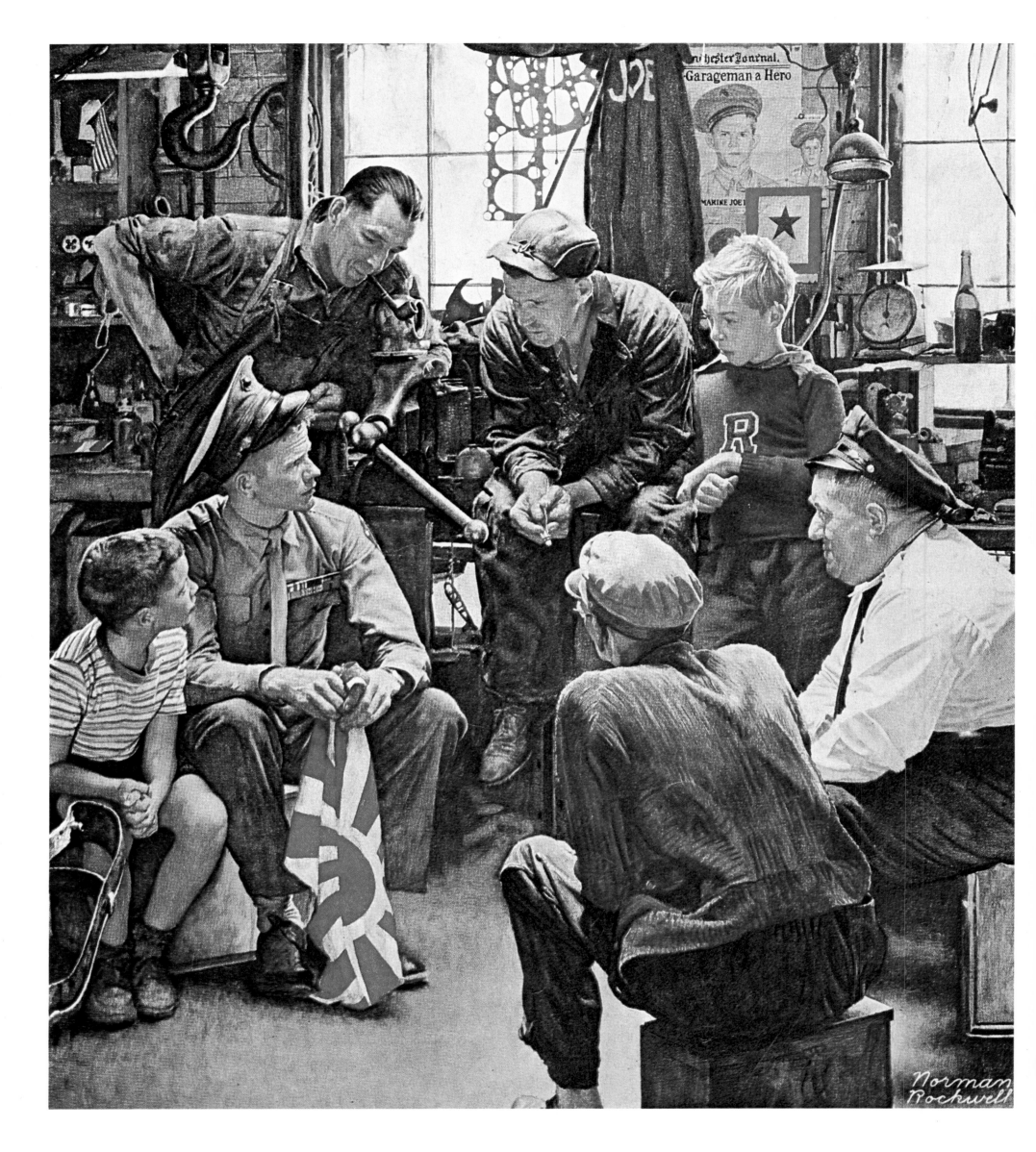

THE WAR HERO
Post Cover • October 13, 1945

350

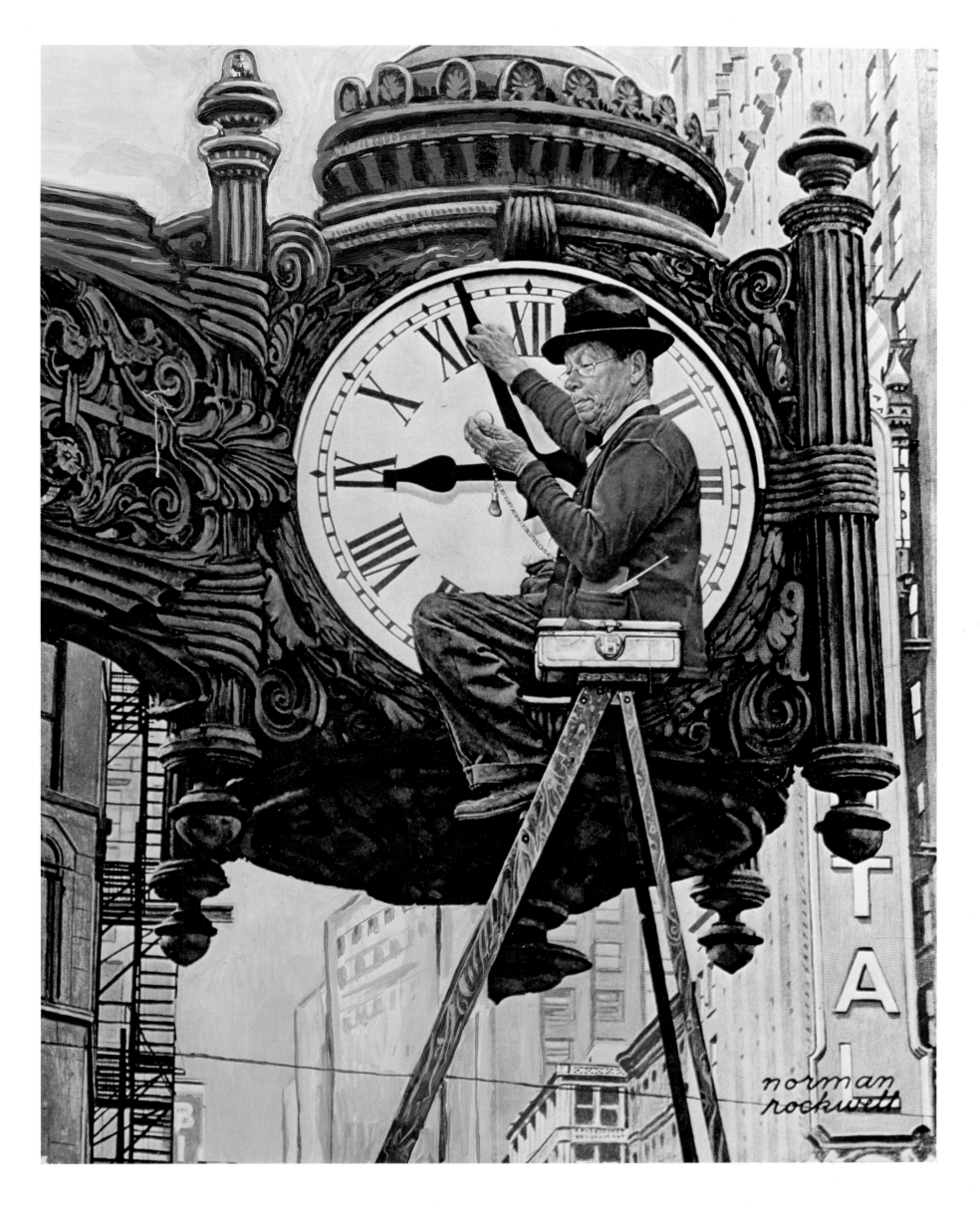

THE CLOCK MENDER
Post Cover • November 3, 1945

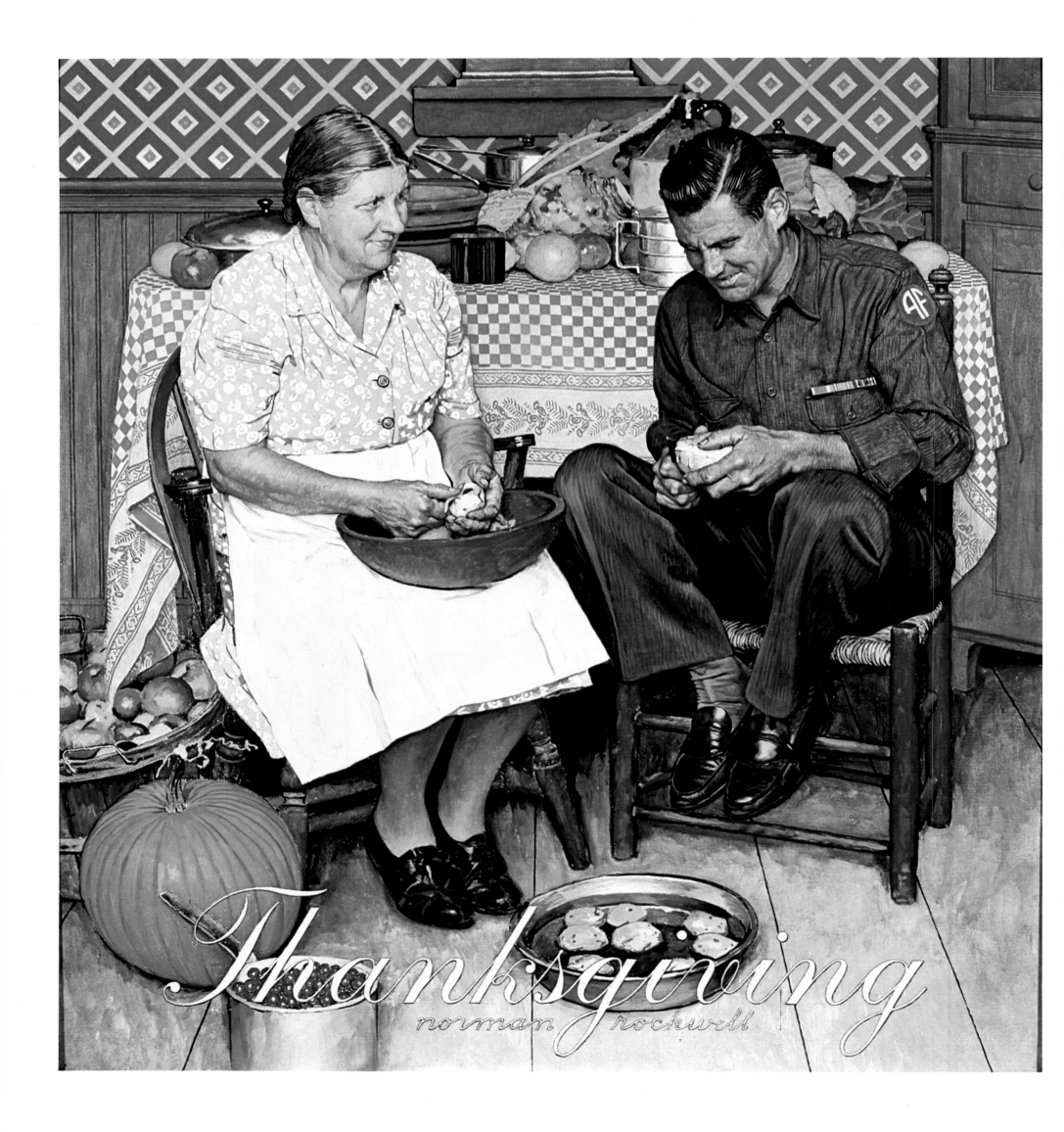

Thanksgiving

norman rockwell

THANKSGIVING

Post Cover • November 24, 1945

352

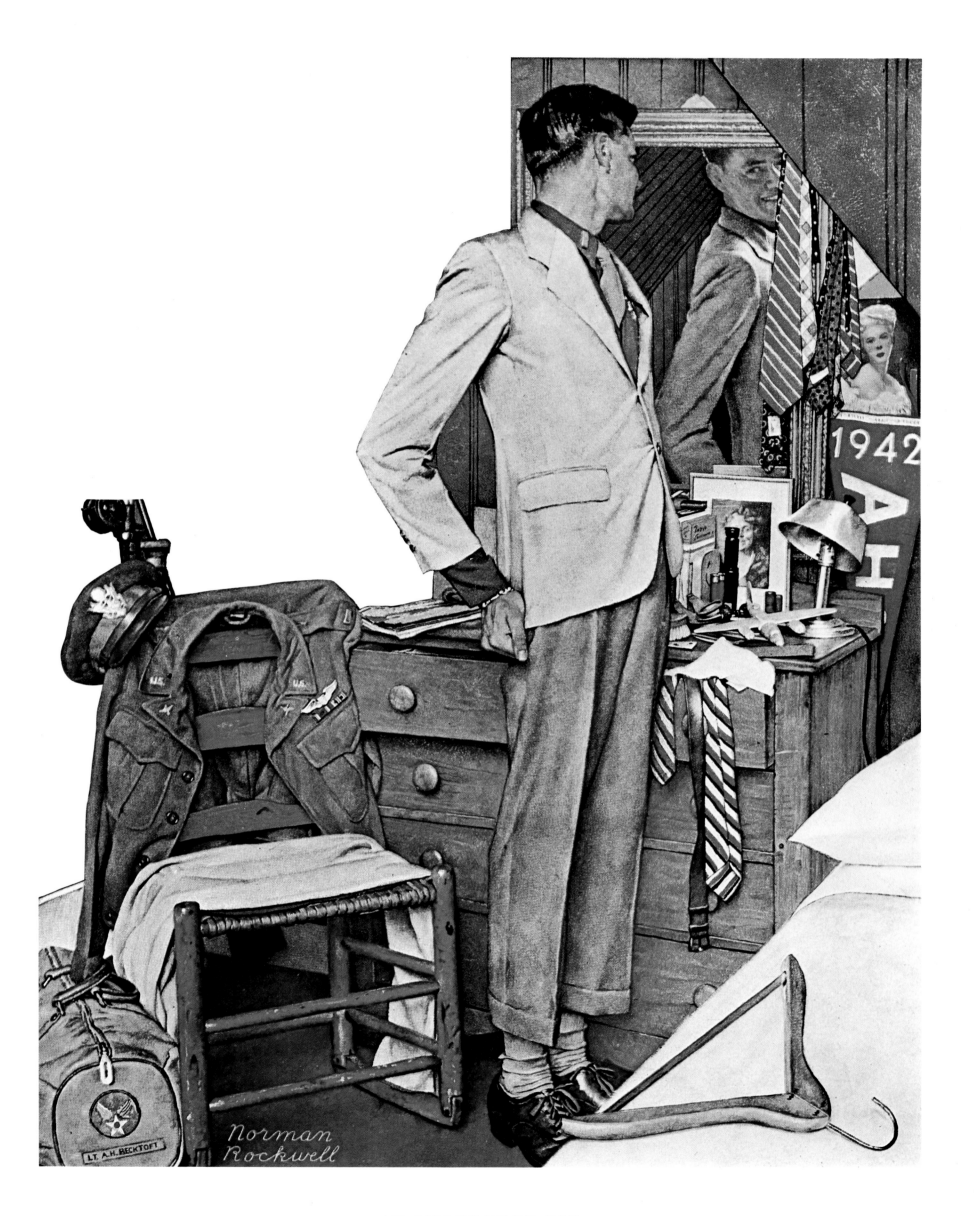

AN IMPERFECT FIT

Post Cover • *December 15, 1945*

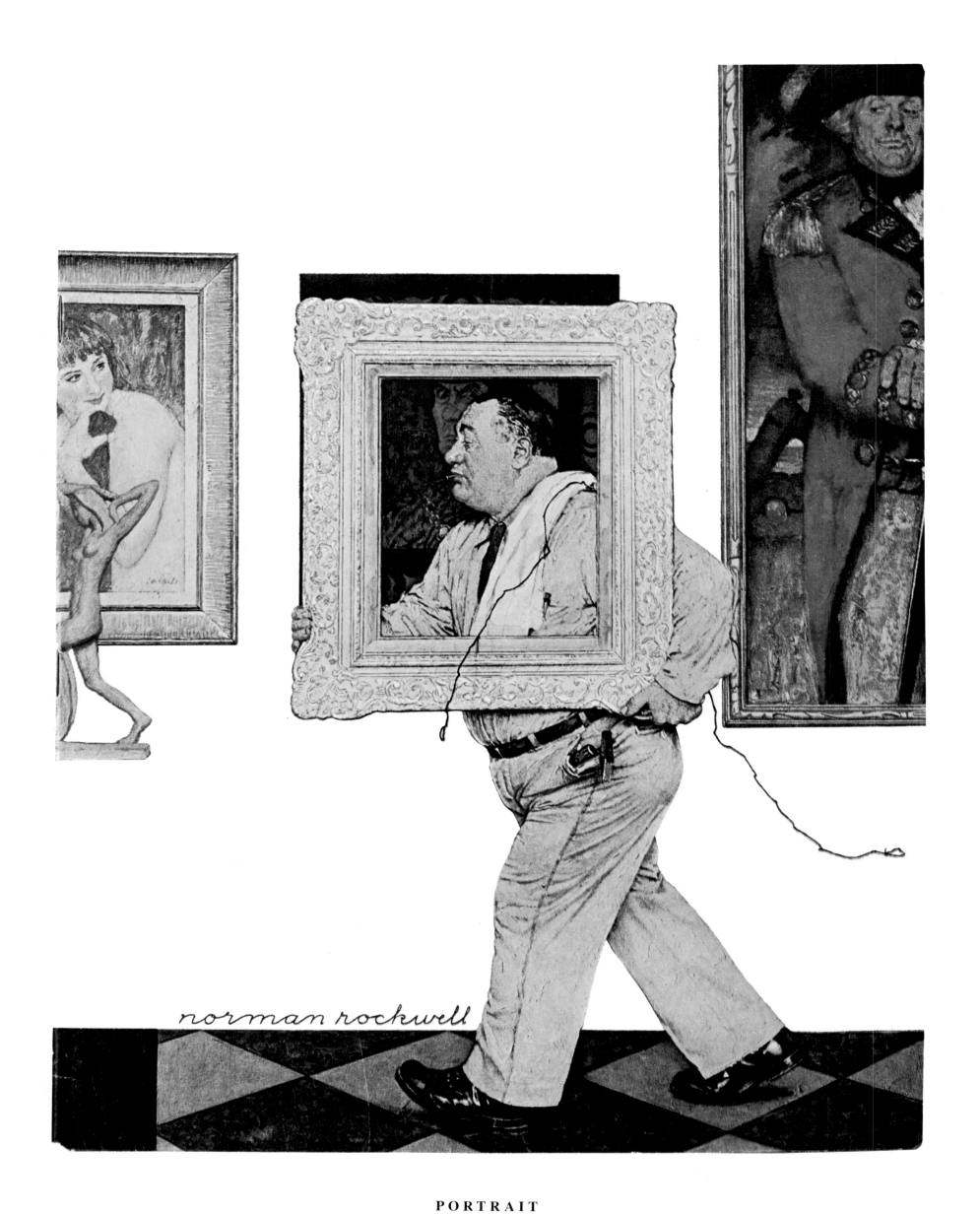

norman rockwell

PORTRAIT

Post Cover • *March 2, 1946*

354

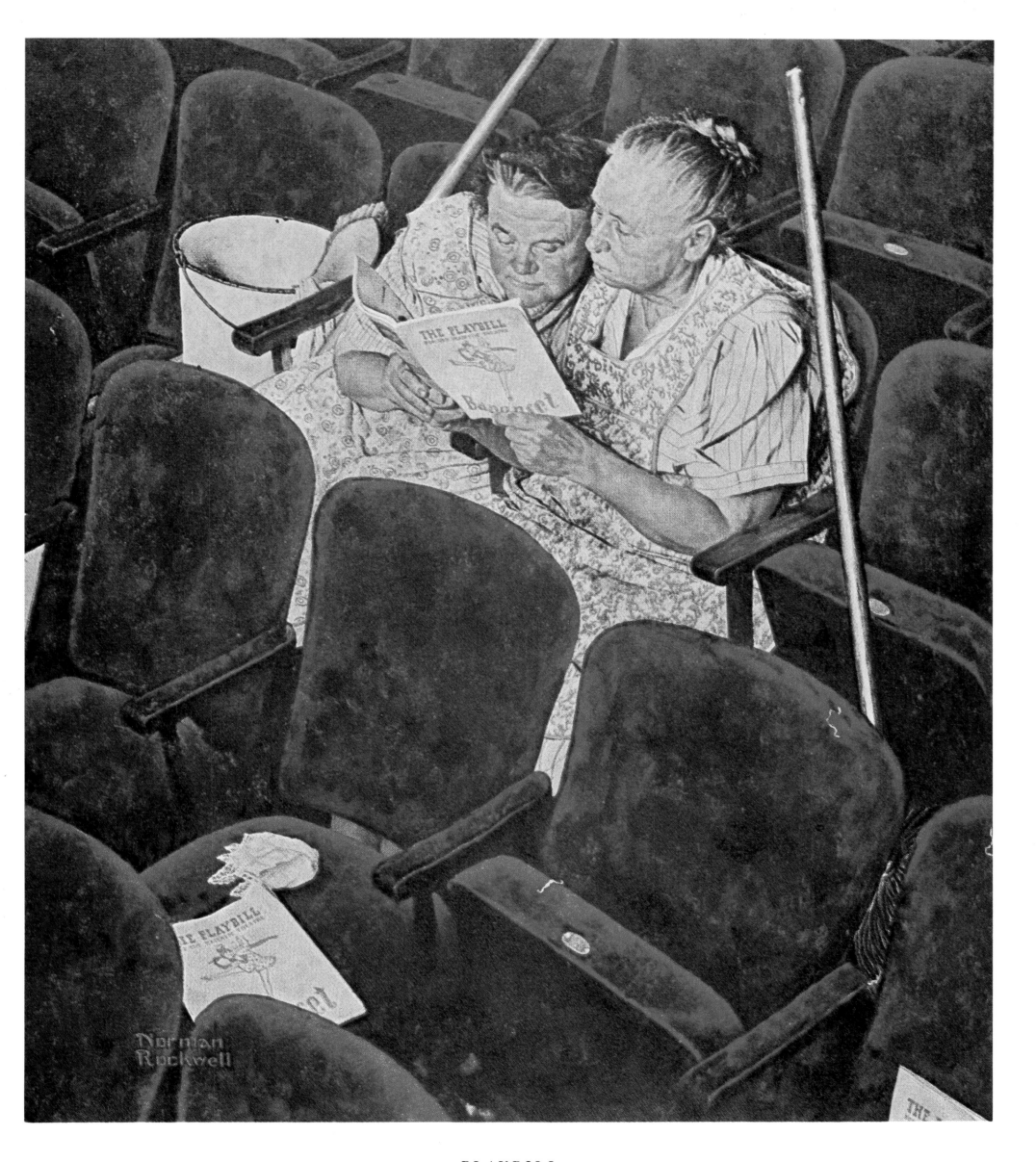

PLAYBILL

Post Cover • April 6, 1946

355

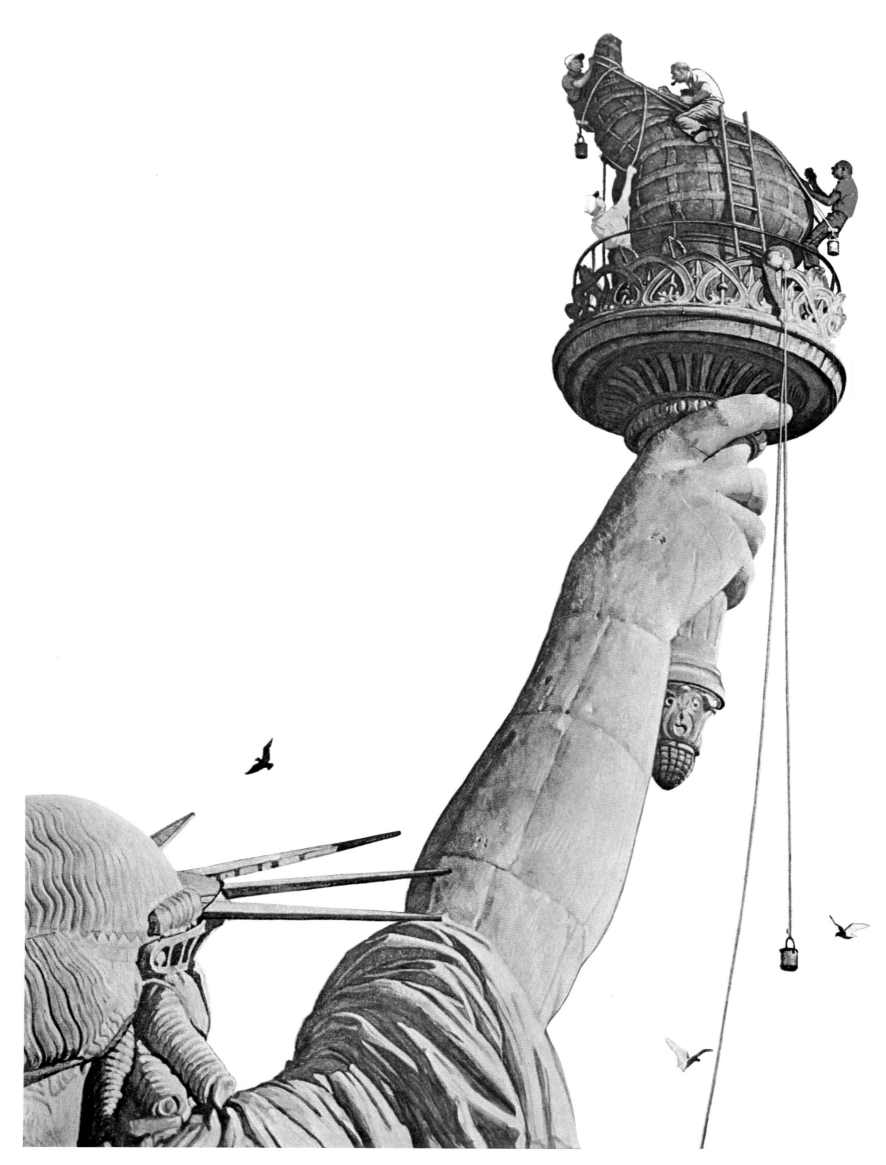

STATUE OF LIBERTY

Post Cover • July 6, 1946

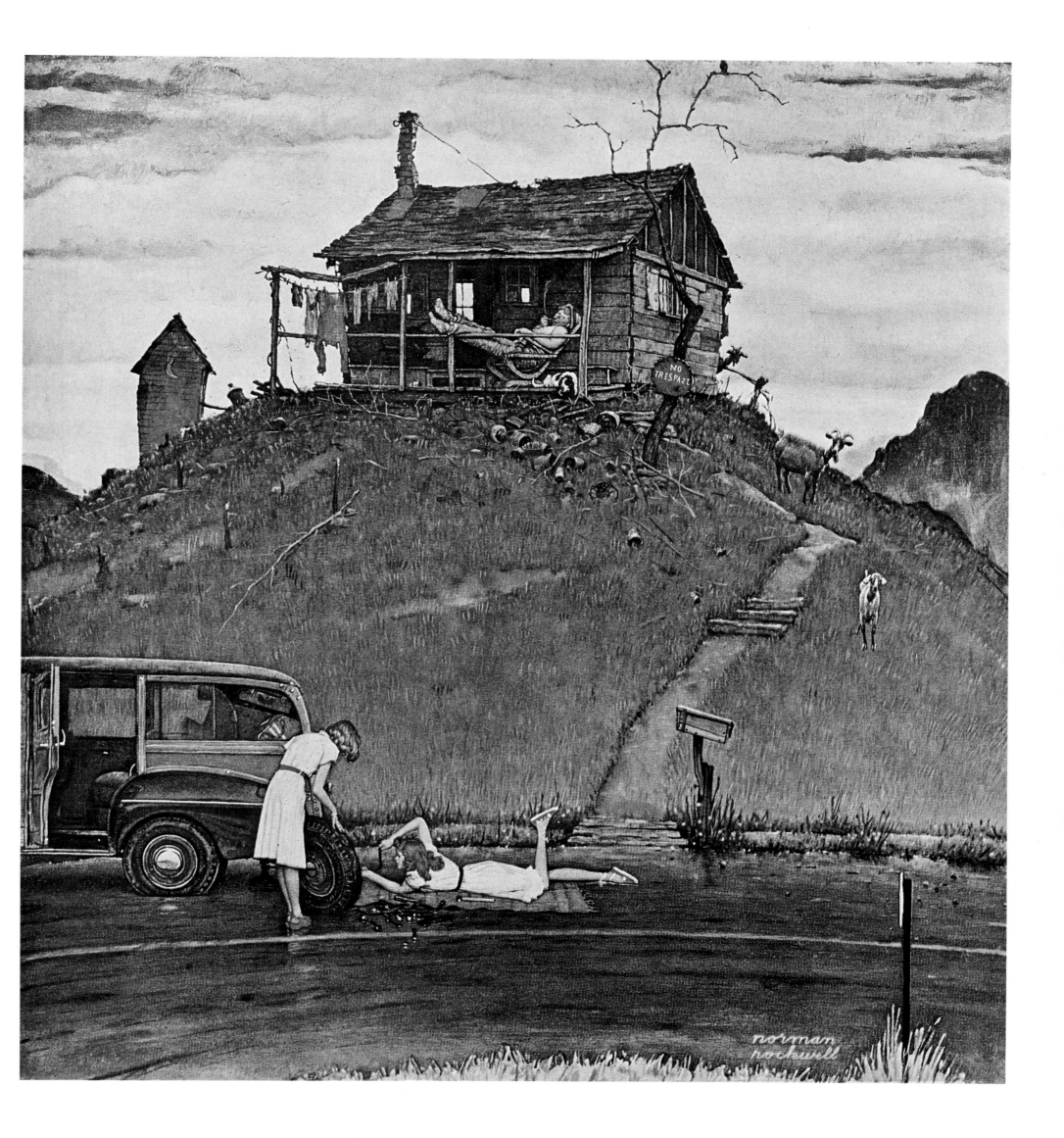

FIXING A FLAT

Post Cover • August 3, 1946

357

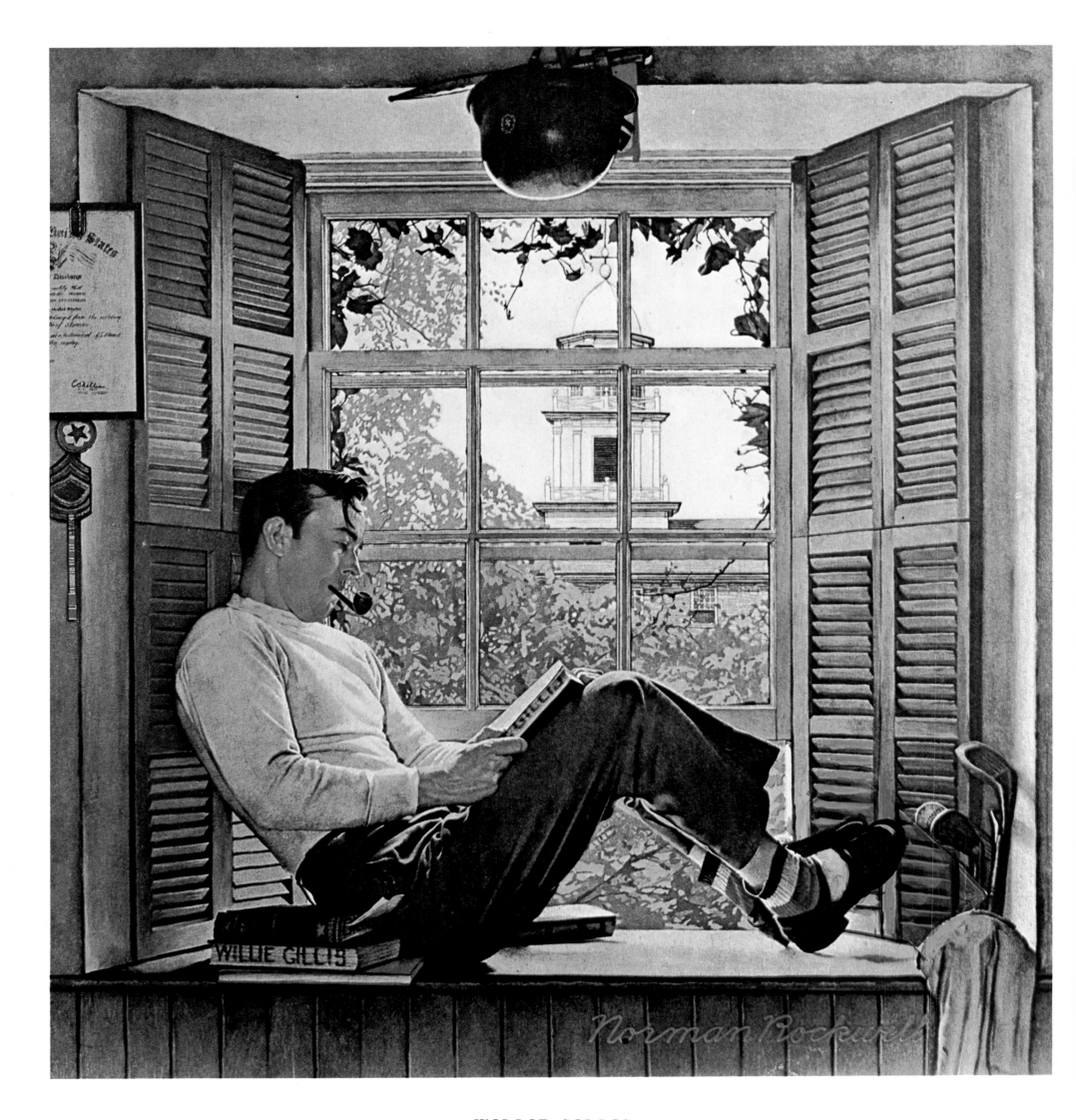

WILLIE GILLIS
AT COLLEGE
Post Cover • October 5, 1946

358

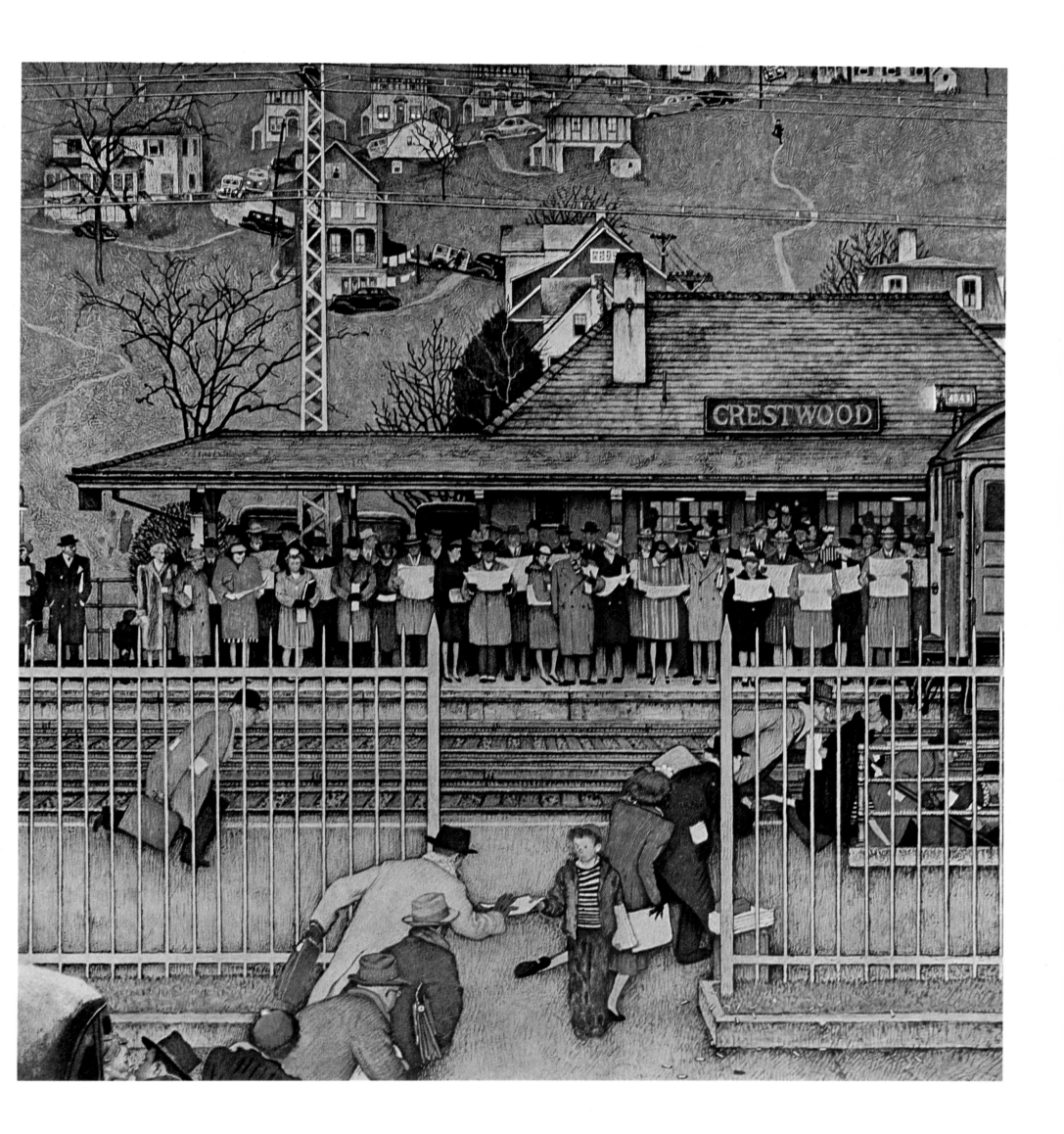

COMMUTERS

Post Cover • November 16, 1946

During the Postwar Years Rockwell Could Hardly Pick Up a Brush Without Producing a Memorable Image

THE ELATION THAT ACCOMPANIED V-E Day and V-J Day was shortlived. The world was no longer at war, but it had entered the nuclear age. Winston Churchill coined the term "Iron Curtain" to describe the barrier between the Western nations and those under the influence of the Soviet Union, and soon politicians were speaking of the Cold War. The Soviet blockade of Berlin in 1948 led to a massive U.S. airlift, and soon Americans were involved in a new shooting war, half a world away in Korea. The newly formed United Nations was beleaguered by problems, but the Assembly did find itself welcoming new nations—India, Pakistan, Israel. In 1949 a Communist People's Republic was declared in China.

Back home, the tensions of the Cold War and fear of nuclear holocaust produced a climate of paranoia in which men like Senator Joseph McCarthy rose to prominence and power, leaving a wake of broken lives and careers in the process. Harry Truman, having succeeded to the presidency at Roosevelt's death, won a surprise victory over Thomas Dewey. Truman led the nation for another four years, a period which saw the development of the hydrogen bomb.

The austerity of the war years was replaced by a growing prosperity. New cars, the first in half a decade, began flowing from Detroit production lines. Television became a major national phenomenon and Milton Berle became "Mr. Television." The first long-playing records went on sale, and Dr. Kinsey's 1948 bestselling *Sexual Behavior in the Human Male* caused a sensation. Kids dressed as Hopalong Cassidy and teenagers wore their bluejeans rolled up almost to the knees. Jackie Robinson became the first black to crack baseball's color barrier in the major leagues. Theatergoers flocked to a string of hit Broadway musicals—*Oklahoma, South Pacific, Kiss Me Kate, Brigadoon, Annie Get Your Gun*—and women hurried to department stores to clothe themselves in Christian Dior's "New Look."

Norman Rockwell's own "New Look"— the exploitation of documentary detail that he had perfected during the war years—was by now well established. If we look back at the covers he painted in the late forties and early fifties, we find an extraordinarily high standard of achievement and a remarkable consistency. During this period

there were very few weak covers. It seems clear that Rockwell had the kind of talent that needed to ripen slowly, and during the four or five years that led up to his sixtieth birthday, he reached his peak as an artist and illustrator.

We are impressed, of course, by the obvious masterpieces, such as "Shuffleton's Barber Shop" (p 387), but even more impressive is the sheer number of paintings that are almost as good as that remarkable cover. Rockwell had been a professional illustrator for more than forty years, but the ideas were flowing more freely than ever. During these years he could hardly pick up a brush without producing a memorable image.

Although his mature images were invariably concerned with the contemporary world, he still tended to avoid the big events (except for such things as presidential elections, and these he domesticated), and he made no attempt to reflect major switches in fashion. It is precisely this, of course, that gives his work its timeless quality. There are few references, in fact, to the world beyond the immediate subject of any given painting, hence there is nothing to tie the image to history. Superficially Rockwell's methods may have been those of the journalist, but his vision always remained that of the utopian.

SATURDAY EVENING POST COVERS
December 7, 1946–January 3, 1953

NEW YORK CENTRAL DINER
Post Cover • December 7, 1946
PAGE 369

BACK in 1946, trains were still glamorous, and the New York Central—operator of famous streamliners like the *Twentieth Century Limited*—was one of the most prestigious of the railroad companies. The small boy poring over his check is a trifle too priggish to be entirely sympathetic, but this is still a crisp piece of work, a glimpse of an era that was almost over by the time this cover appeared on the newsstands.

PIANO TUNER
Post Cover • January 11, 1947
PAGE 370

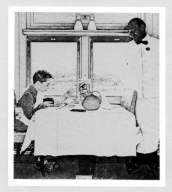

THIS very straightforward cover shows a craftsman at work, watched by a small boy. Rockwell has gone out of his way to avoid cleverness, but there is something disarming about a painting that appears to be guileless yet, on inspection, is clearly painted with consummate skill and a scrupulous attention to detail.

CROCUSES
Post Cover • March 22, 1947
PAGE 371

AT this period Rockwell rarely painted a weak cover, but this is one of those few. The figure of the man is awkwardly posed—in fact, by Rockwell's own standards it seems positively clumsy—and there is something cursory and hurried about the whole composition. It looks like a sketch for a cover, not a finished work.

HIGH BOARD
Post Cover • August 16, 1947
PAGE 372

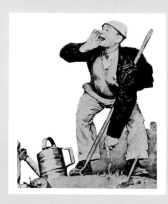

HERE we can see how much things have changed from the early days of Rockwell's career. Small boys no longer head for the old swimming hole; when the temperature soars, they get onto a bus and head for the municipal baths. The artist has chosen just the right angle to make this composition work, and the scaffolding of the diving board lends strength to the design.

THE OUTING
Post Cover • August 30, 1947
PAGE 373

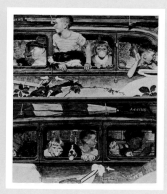

ONE of the best known of all Rockwell's covers, this is a classic example of the before-and-after image, and a splendid example of Rockwell's skill as a story teller. Each detail in the lower picture is carefully matched with something in the upper picture so that the result is a kind of humorous symmetry. The individual character studies are wonderful.

BABY SITTER
Post Cover • November 8, 1947
PAGE 374

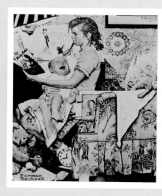

THIS cover picks up on a theme that Rockwell had dealt with before (p 270), but this version benefits greatly from his new attention to documentary detail. From the point of view of design, good use has been made of the patterns on the upholstery fabric and the wallpaper. The frustration of the baby sitter herself is beautifully captured.

CHRISTMAS RUSH
Post Cover • December 27, 1947
PAGE 375

THIS Christmas cover is far removed from the friendly Saint Nicks and Dickensian coachmen that Rockwell had portrayed again and again in the twenties and thirties. Here Rockwell's view of the holiday season is entirely modern. This exhausted saleswoman looks like nothing so much as one of the rag dolls she has been selling until just a few moments ago.

WEEKEND TRAVELLERS
Post Cover • January 24, 1948
PAGE 376

HERE Rockwell imagines the discomfort of a timid commuter who finds himself on a train packed with boisterous weekenders on their way to the ski slopes. As in ''Voyeur'' (p 341), Rockwell selects a rather curious angle from which to portray the scene. It is as if he has observed it from a perch on one of the luggage racks.

CURIOSITY SHOP
Post Cover • April 3, 1948
PAGE 377

THIS April Fools' Day cover is rather more interesting than its predecessors because it has been more carefully thought out and relies, to a certain extent, on more subtle deceptions. Some of the deliberate errors are obvious enough, but others are well disguised and not apparent at first glance.

THE BID
Post Cover • May 15, 1948
PAGE 378

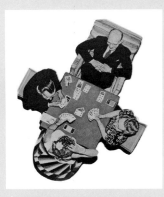

THE notion of showing a card game from directly above the table, so that we can see everyone's hand, is an excellent one, and Rockwell handles it with considerable panache. The angle allows him to treat the painting as an exercise in unusual foreshortening (it seems that Rockwell loved to have his virtuosity challenged in this way). The bird's-eye view also makes for a strong cruciform design, further enlivened by the imaginative use of color, pattern, and texture.

THE DUGOUT
Post Cover • September 4, 1948
PAGE 379

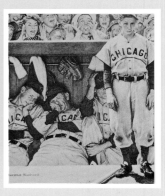

FOR the Chicago baseball teams, 1948 was a disastrous year. Both the Cubs and the White Sox finished in the cellars of their respective leagues, and the White Sox's performance was especially dismal (51 victories against 101 losses). Toward the end of what must have seemed like a very long season—if you were a Chicago fan—Rockwell painted this study of a disconsolate dugout, turning it into a tableau that summed up the frustration of an entire city.

ELECTION DAY
Post Cover • October 30, 1948
PAGE 380

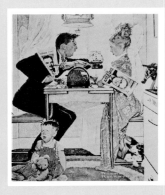

THIS is by far the most animated of Rockwell's election day covers. Over the breakfast table, an angry husband (supporting Thomas Dewey) and a dogged wife (favoring Harry Truman) battle it out, toast cooling and howling infant forgotten in the fury of their quarrel.

HOMECOMING
Post Cover • December 25, 1948
PAGE 381

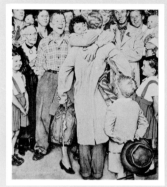

HERE again is a Christmas cover far removed from the kind of seasonal ciphers that Rockwell relied on in the twenties and thirties. A man has returned to the bosom of his family in time for the holiday celebrations: that is all there is to it, and Rockwell simply records the happy event with accuracy and sympathy.

THE PROM DRESS
Post Cover • March 19, 1949
PAGE 382

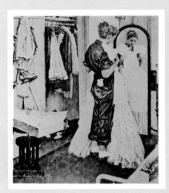

IN this charming painting Rockwell gives us a glimpse of a butterfly emerging from its cocoon. From the angle he has provided, we see an awkward teenager in dungarees and tomboy shirt. In the mirror, however, she sees only the glamorous young woman who will sweep onto the dance floor to admiring glances.

BOTTOM OF THE SIXTH
Post Cover • April 23, 1949
PAGE 383

THE Brooklyn manager is delighted because the rain appears to be ending, and the game will not be called—that would have given Pittsburgh a victory— and the Dodgers' clean-up batter is at the plate. The umpires in the foreground make a fine comic tableau, silhouetted against the sky and a corner of Ebbets Field. (For the record, the 1949 Dodgers went on to win the National League pennant but were defeated by the Yankees in the World Series.)

TRAFFIC CONDITIONS
Post Cover • July 9, 1949
PAGE 384

THIS truculent bulldog blocking traffic provided Rockwell with a fine opportunity to paint a dozen or more comic character studies. The setting—this is actually an alley in Troy, New York—is lovingly evoked, and the entire painting is packed with life and incident. Here Rockwell's Dickensian sensibility is harnessed to a contemporary scene.

BEFORE THE DATE
Post Cover • September 24, 1949
PAGE 385

THIS charming cover makes effective use of a split-page device. Judging by the uniform hanging from her dresser, the young woman must work as a waitress. As for the young man—if we are to infer from his clothing, the two hats that are visible, and the photo of the horse attached to the wall—he is either a cowboy or, at least, someone greatly enamored of the Western lifestyle. Each is firmly placed in a closely observed setting.

THE NEW TELEVISION SET
Post Cover • November 5, 1949
PAGE 386

TELEVISION is generally acknowledged as having gained its widest acceptance in the United States as a major medium of home entertainment in 1949, when 100,000 sets a week were being sold. This man, like people all over the country at that time, is experiencing the thrill of having moving pictures come into his home for the first time. Rockwell uses the occasion as an excuse to paint a picturesque roofscape.

SHUFFLETON'S BARBER SHOP
Post Cover • *April 29, 1950*
PAGE 387

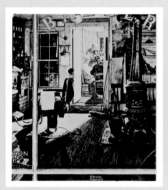

THIS painting must be considered among Rockwell's finest works. Never has he lavished more affection on an interior (dozen of photographs were used to ensure the accuracy of each detail). The light from the back room and the embers glowing in the pot-bellied stove lend warmth to the entire composition. The window sash in the foreground creates the illusion that we have chanced upon the scene while walking by.

SOLITAIRE
Post Cover • *August 19, 1950*
PAGE 388

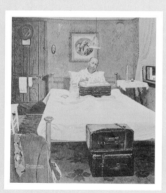

A cut below "Shuffleton's Barber Shop," perhaps, this is, nonetheless, a splendid cover painting, one that is imbued with the faint sadness that occasionally crept into Rockwell's mature work. We cannot but feel sorry for this travelling salesman—who knows how far he may be from home on this sticky summer night?—alone in this dismal hotel room with its peeling wallpaper and sagging ceiling. Every detail seems exactly right. Note, for example, the flyswatter ready at the man's side.

THE TOSS
Post Cover • *October 21, 1950*
PAGE 389

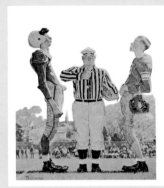

THE engaging charm of this painting is the very scrawniness of these young football players, and we sense the significance that the occasion holds for them.

PRACTICE
Post Cover • *November 18, 1950*
PAGE 390

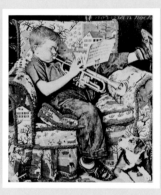

THIS painting is most interesting as an arrangement of patterns and textures. The armchair, with its Grandma Moses upholstery, is a work of art in itself.

THE PLUMBERS
Post Cover • *June 2, 1951*
PAGE 391

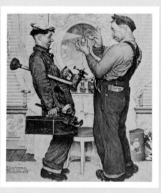

THESE plumbers are reminiscent of Laurel and Hardy. This is another

example of an ideal marriage of characters and situation.

THE FACTS OF LIFE
Post Cover • *July 14, 1951*
PAGE 392

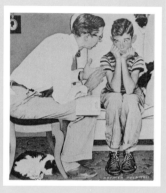

SINCE Rockwell had three sons of his own, this is probably a subject he was all too familiar with. Placing the boy on an easy chair makes his unease all the more apparent. The father leans forward, trying to affect a matter-of-fact demeanor. Neither party is getting too much pleasure out of the encounter.

SAYING GRACE
Post Cover • *November 24, 1951*
PAGE 393

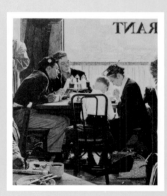

PAINTED as a Thanksgiving cover, this is one of Rockwell's most famous works. He has achieved his aims by placing a somewhat idealized couple—an old woman and her grandson—in a very real setting, a railroad cafeteria with cigarette butts in the saucers and on the floor. Superficially this looks like a Victorian genre painting, but the way it has been cropped—three figures are chopped off by the edge of the canvas—gives it an essentially modern snapshot quality.

CHEERLEADERS
Post Cover • February 16, 1952
PAGE 394

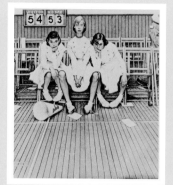

THE scoreboard tells half the story. The expressions on the faces of the three cheerleaders, along with their sagging shoulders, tells the rest. This is a minor painting by Rockwell's mature standards, but it makes its point succinctly, and that is certainly a virtue.

WAITING FOR THE VET
Post Cover • March 29, 1952
PAGE 395

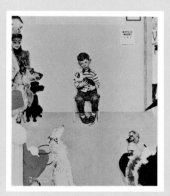

ROCKWELL has isolated this small boy and his pet in the middle of the page, removed from everyone else, thus emphasizing his concern. The three rather chic women in the waiting room seem to have chosen their pets to complement their outfits. There are other amusing touches, but taken as a whole, this is one of the least convincing Rockwell covers of the period.

A DAY IN THE LIFE OF A BOY
Post Cover • May 24, 1952
PAGE 396

HERE Rockwell returns to the "comic strip" technique that he employed for "Gossip" (p 31) and produces another amusing cover. In many ways this is an anthology of the images of boyhood he had produced over the years, carefully selected and arranged to form a narrative.

A DAY IN THE LIFE OF A GIRL
Post Cover • August 30, 1952
PAGE 397

THE companion piece to the previous cover, this one, too, has considerable charm. The sequence has been edited almost as one would edit a film. Since Rockwell was so successful with this narrative device, it is surprising that he did not use it more often.

DWIGHT D. EISENHOWER
Post Cover • October 11, 1952
PAGE 398

THIS portrait of Dwight D. Eisenhower was the first of a number of Rockwell's paintings of prominent political figures to appear on the cover of the *Post*. (Eight such paintings were published there between 1952 and 1963.) Rockwell was not a profound portraitist, but he was an extremely competent one, as is clear from this crisp likeness.

HOW TO DIET
Post Cover • January 3, 1953
PAGE 399

HERE Rockwell takes the classic predicament of the pastry chef who would like to lose weight. The image is a sort of gentle tragicomedy. The cakes lined up on the shelves behind the rotund subject become a kind of ironic frieze.

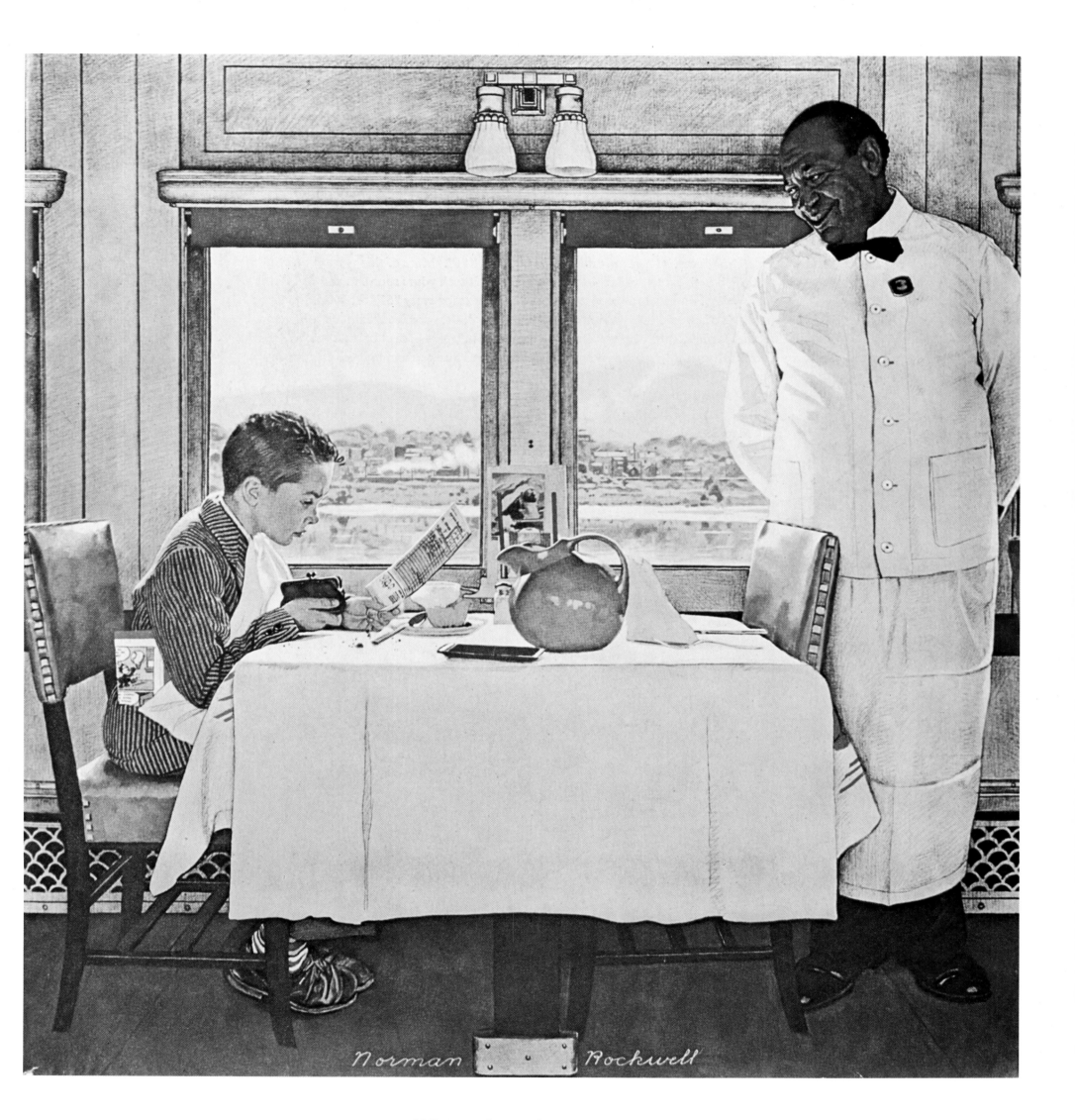

NEW YORK CENTRAL
DINER

Post Cover • December 7, 1946

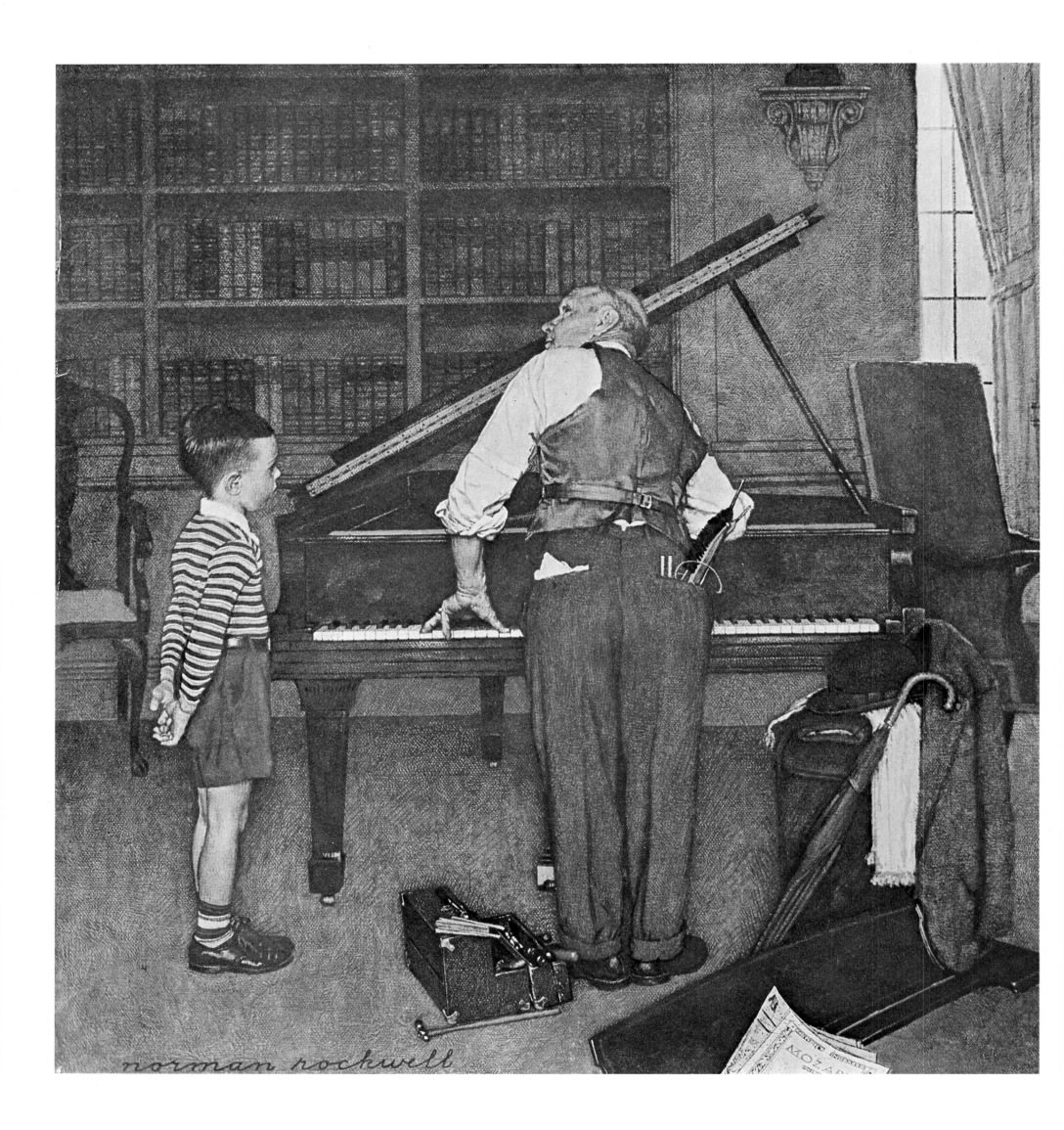

PIANO TUNER

Post Cover • January 11, 1947

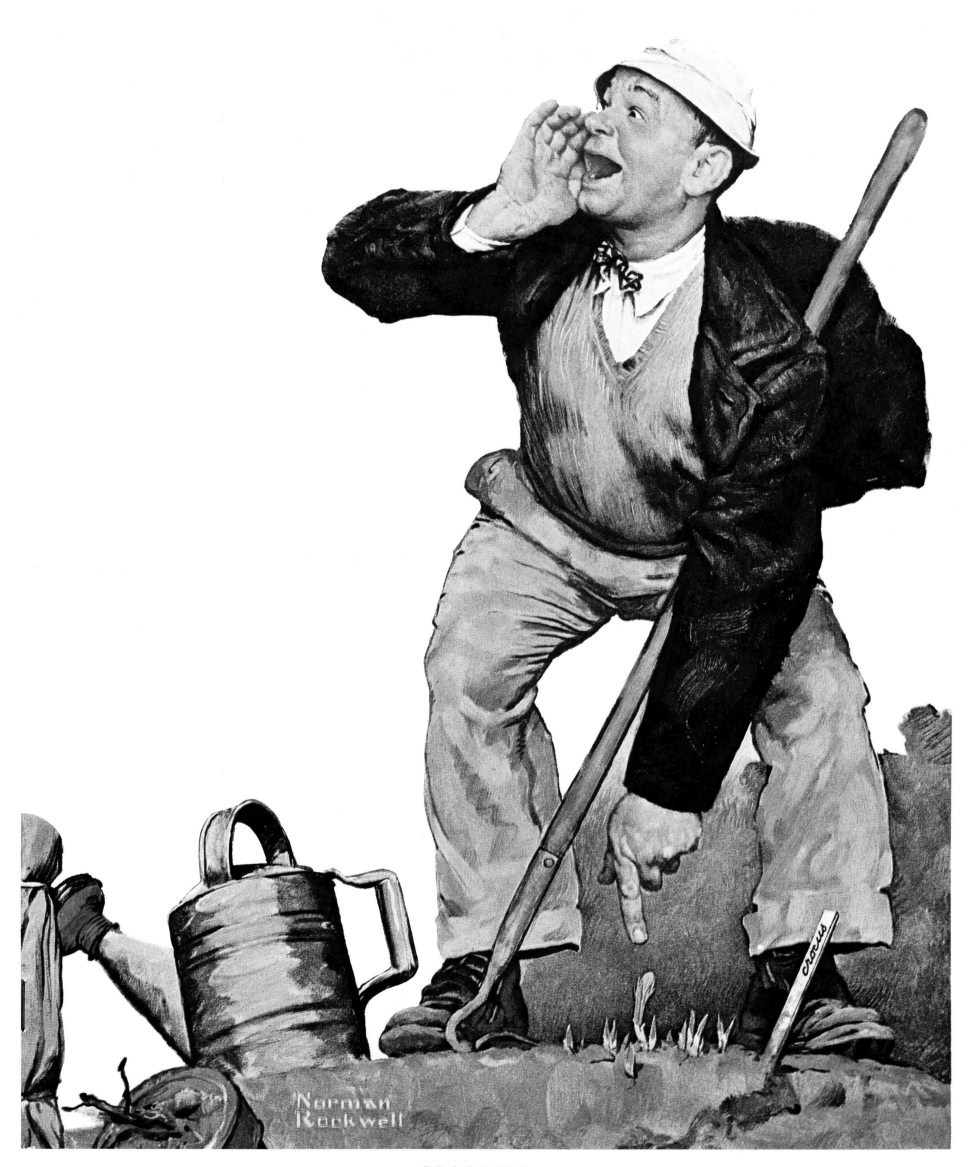

CROCUSES

Post Cover • March 22, 1947

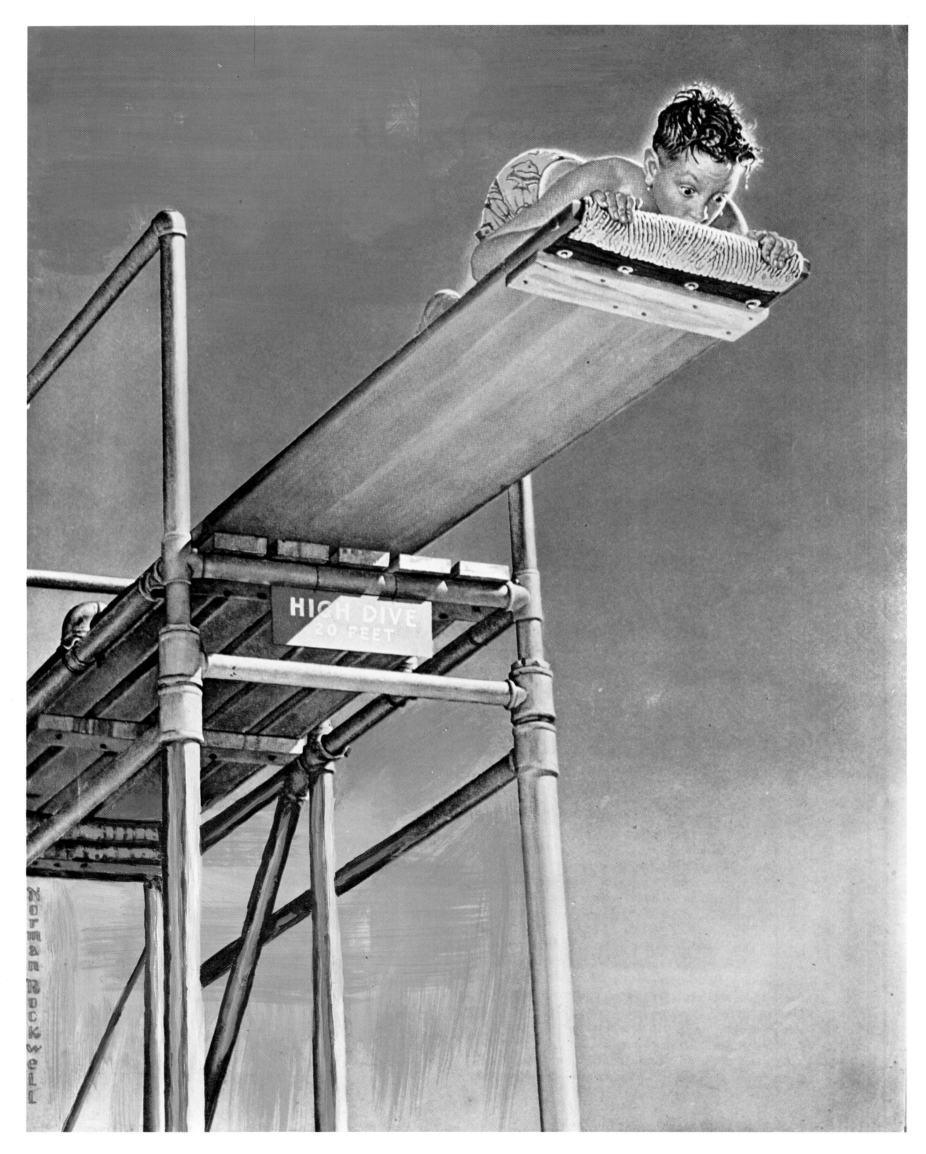

HIGH BOARD

Post Cover • *August 16, 1947*

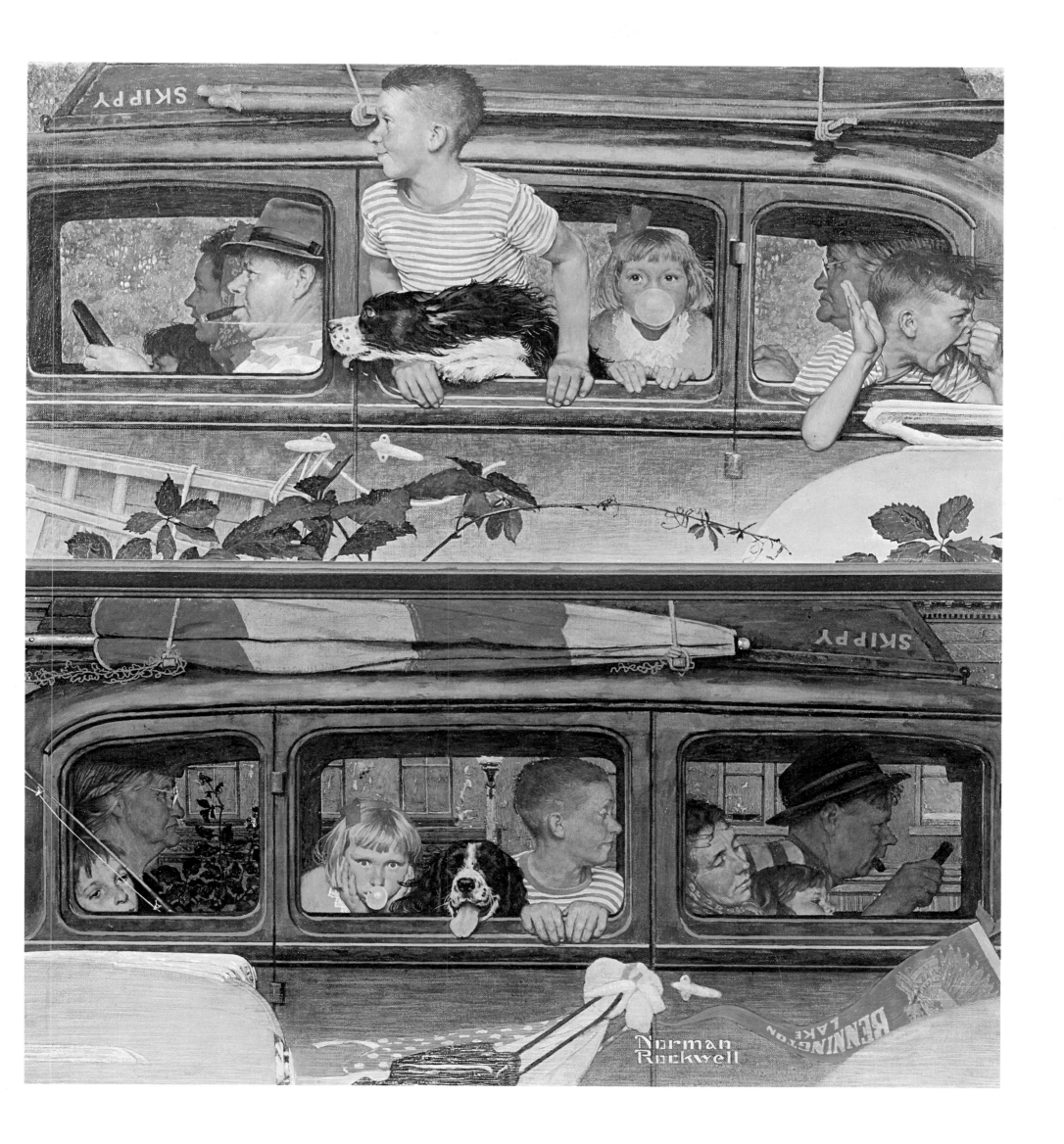

THE OUTING

Post Cover • August 30, 1947

373

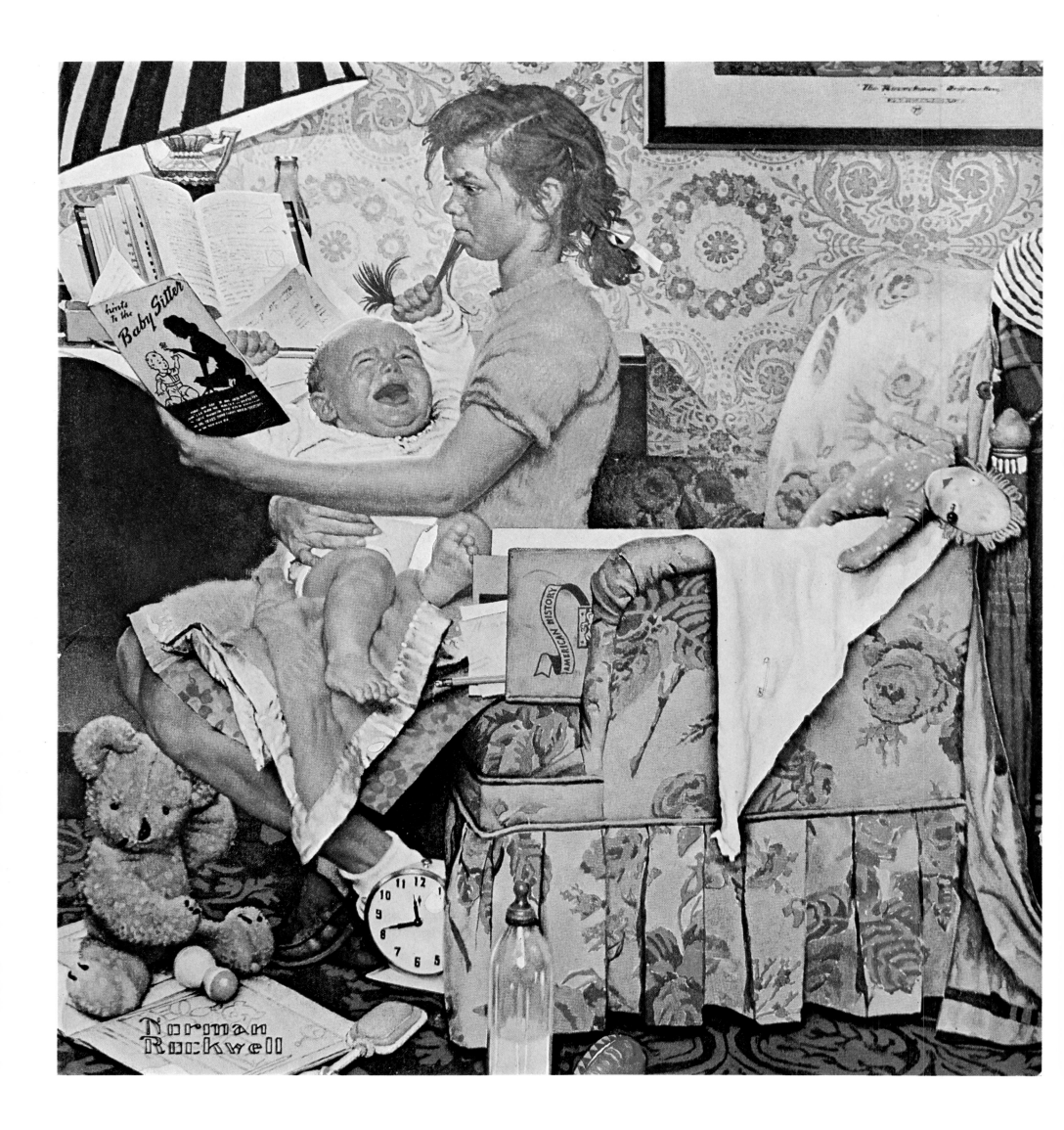

BABY SITTER

Post Cover • *November 8, 1947*

374

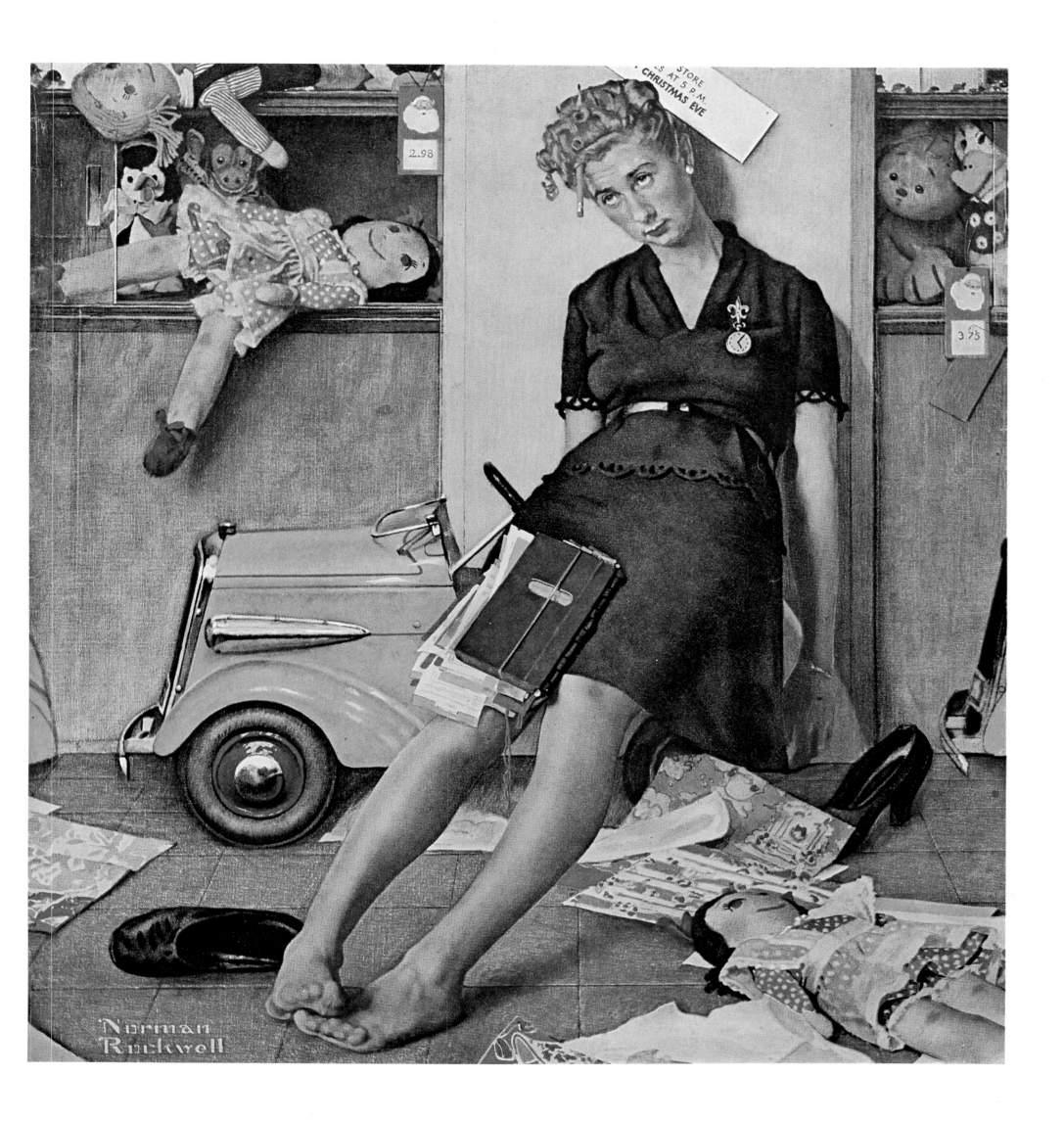

CHRISTMAS RUSH

Post Cover • December 27, 1947

375

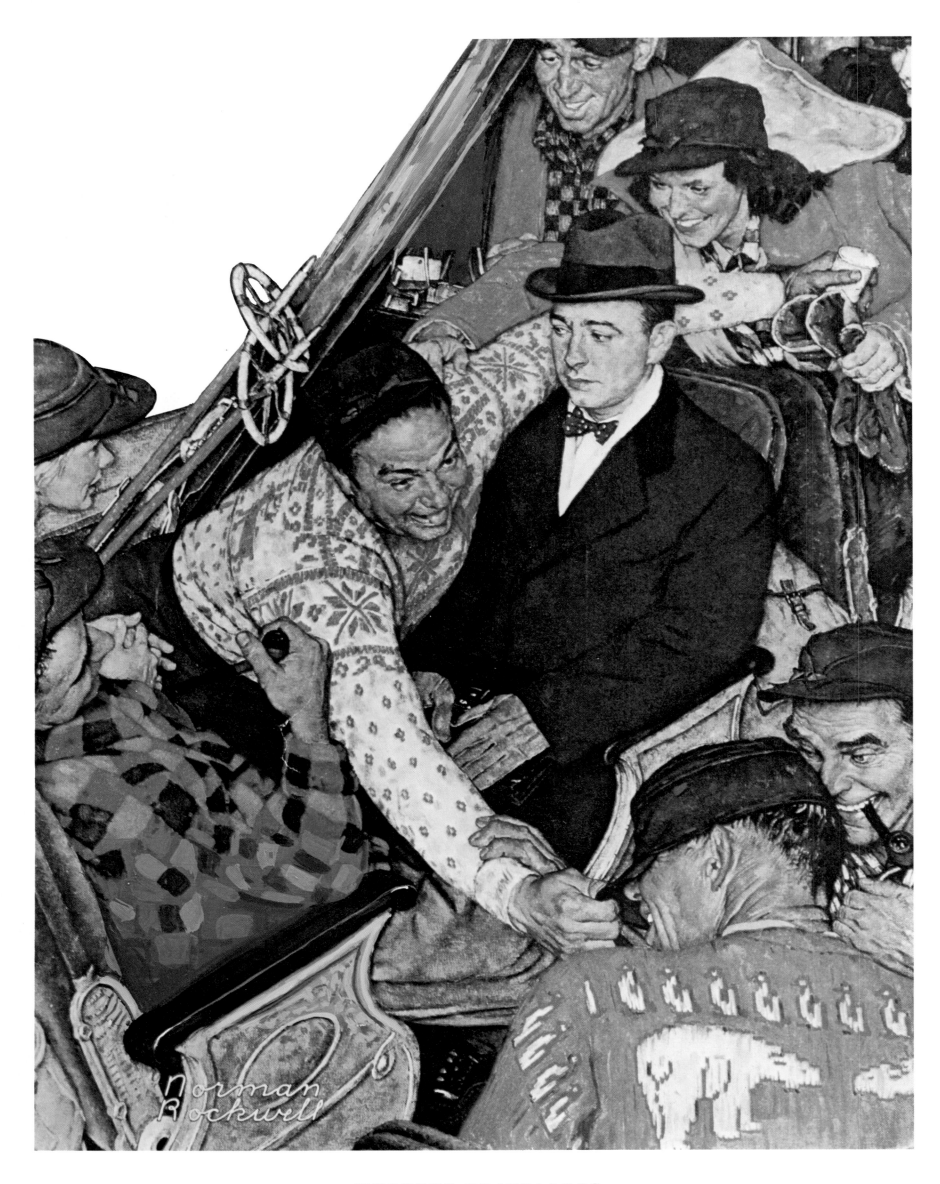

WEEKEND TRAVELLERS

Post Cover • January 24, 1948

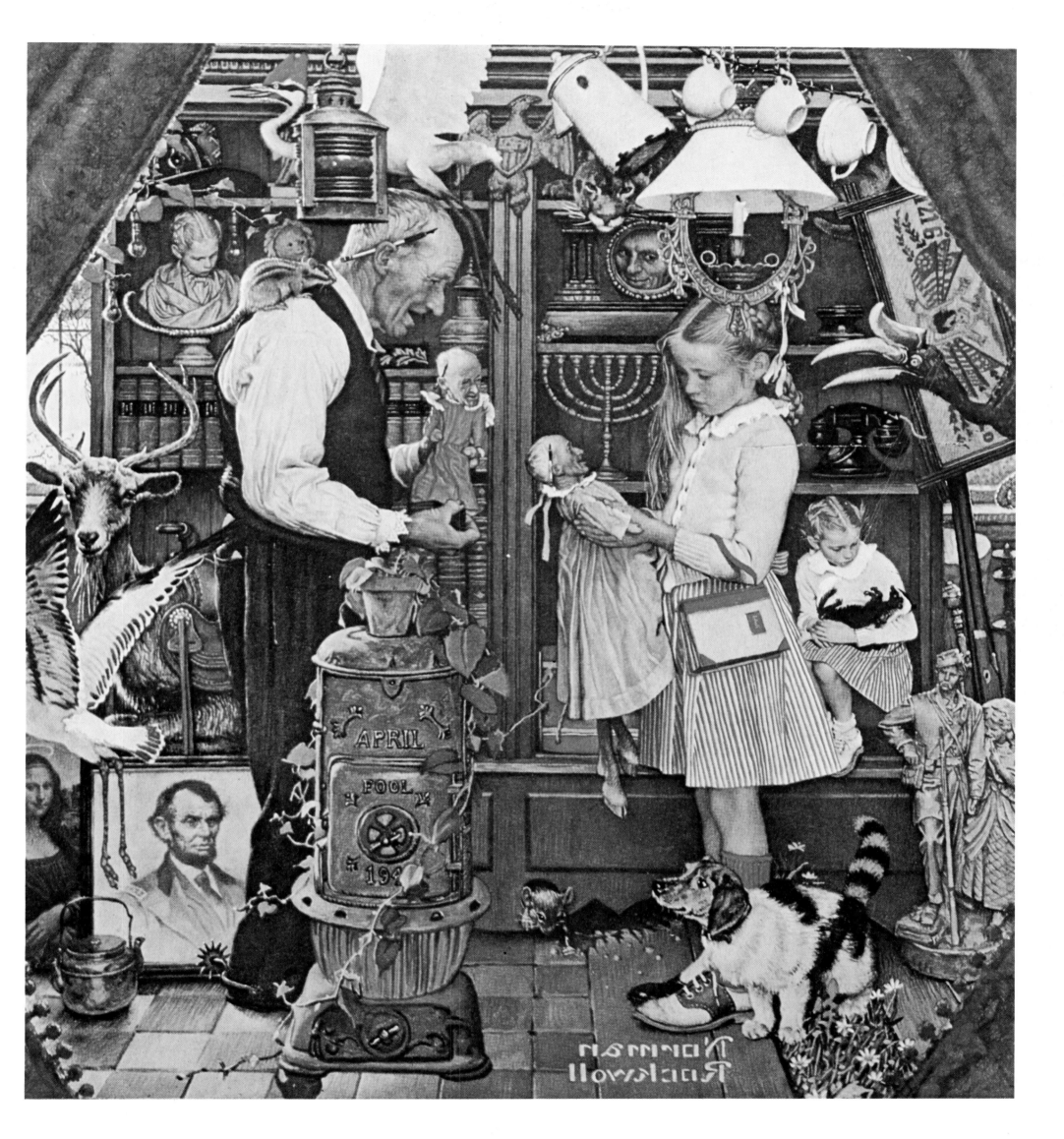

CURIOSITY SHOP

Post Cover • *April 3, 1948*

377

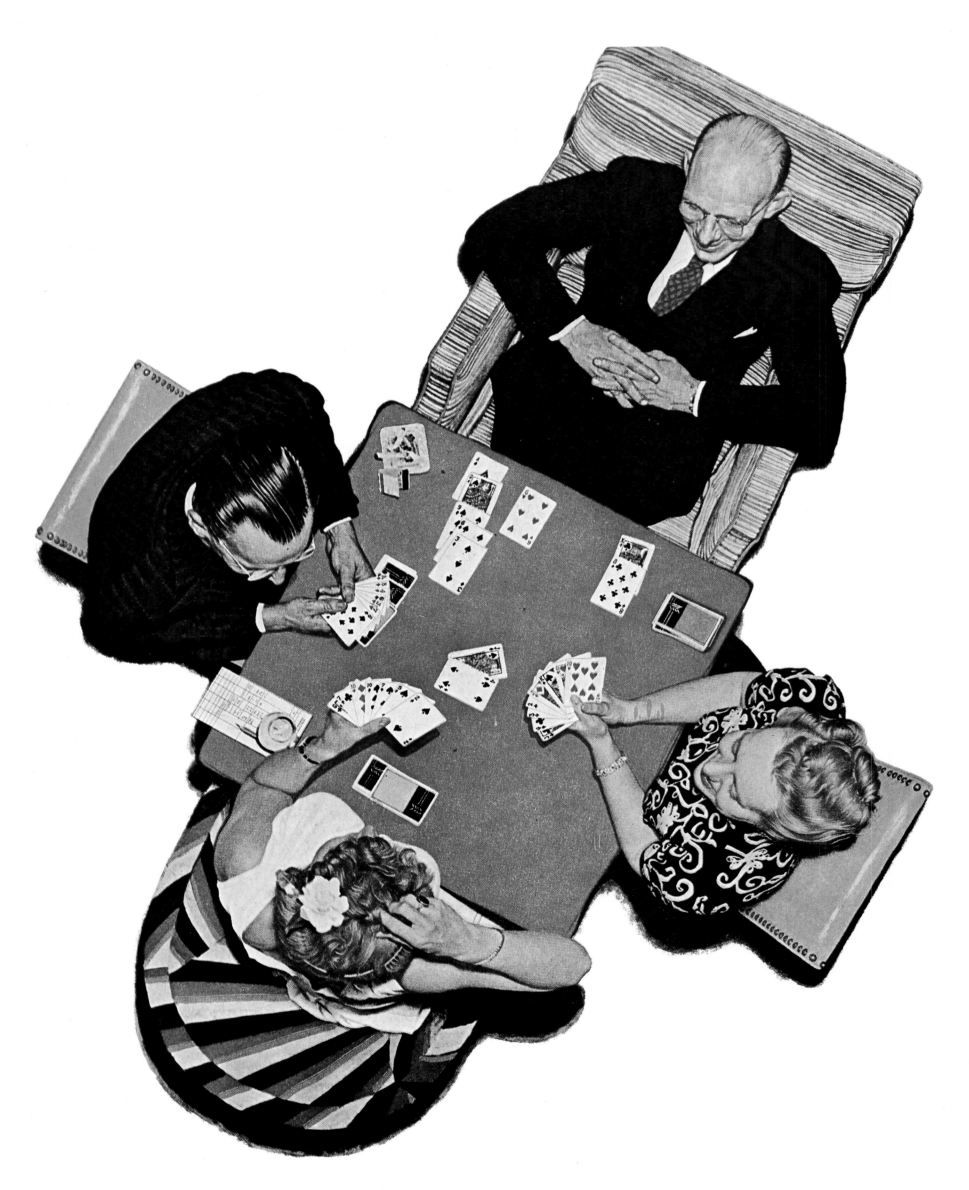

THE BID

Post Cover • May 15, 1948

378

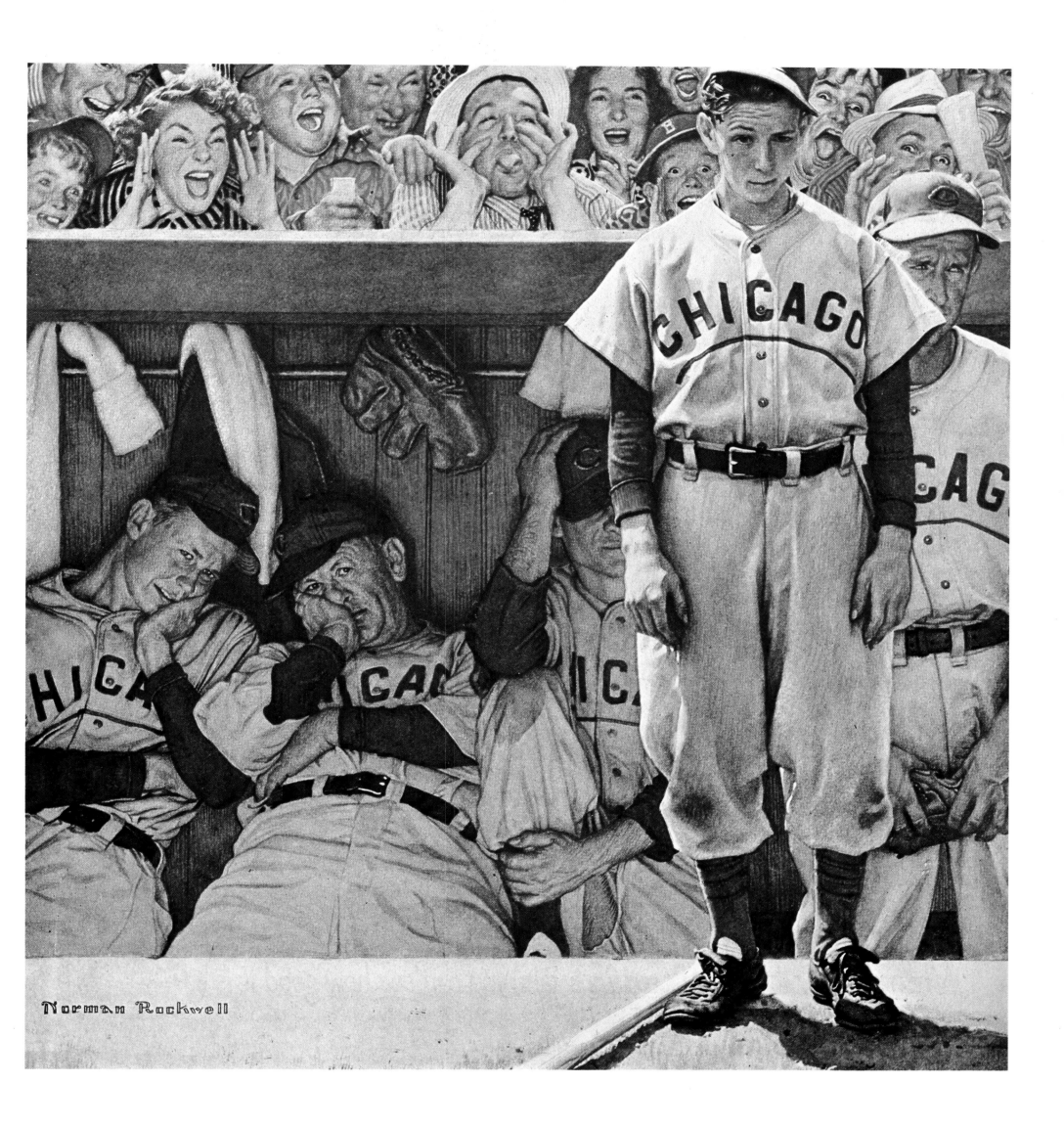

THE DUGOUT

Post Cover • September 4, 1948

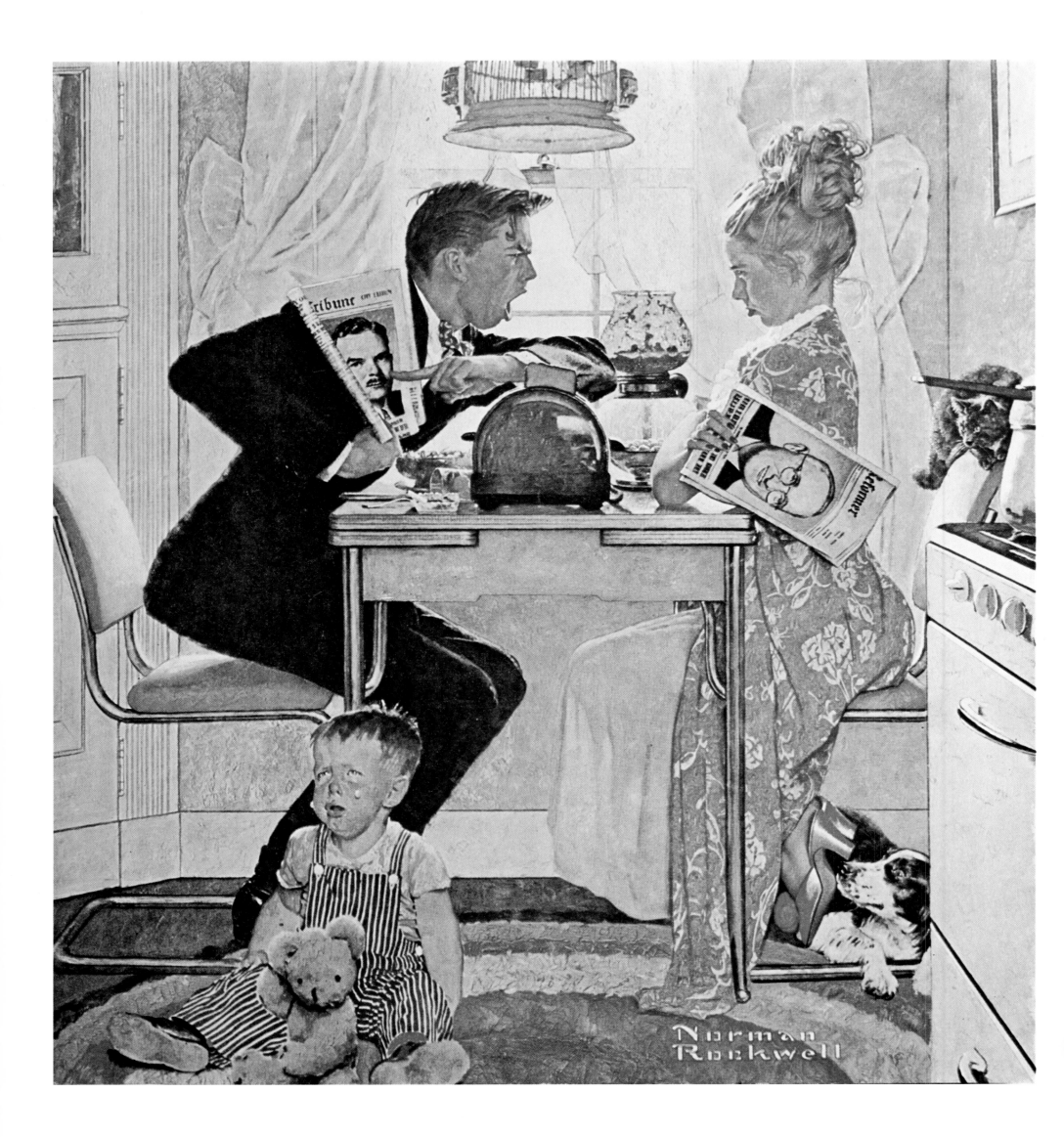

ELECTION DAY

Post Cover • October 30, 1948

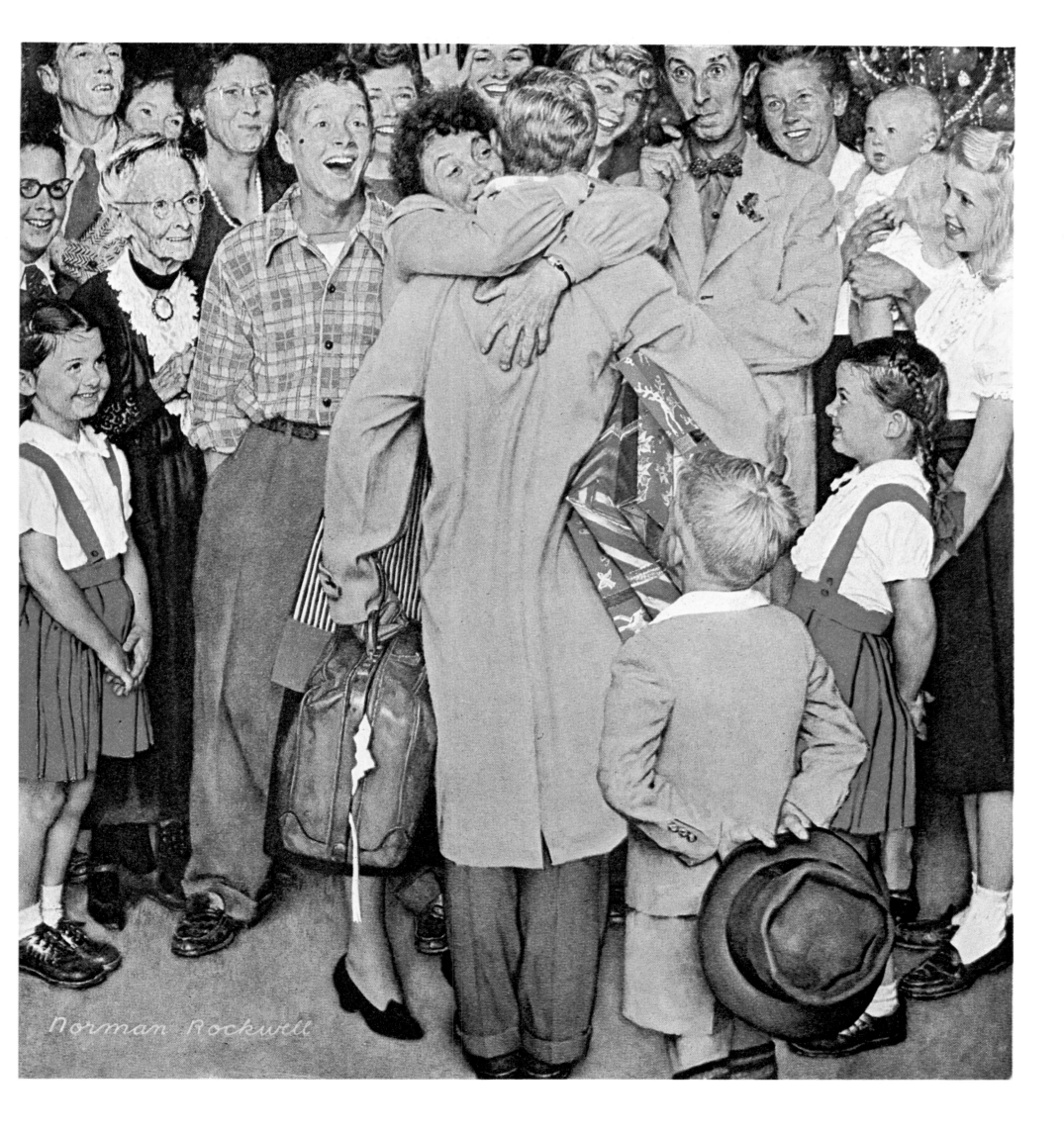

HOMECOMING

Post Cover • December 25, 1948

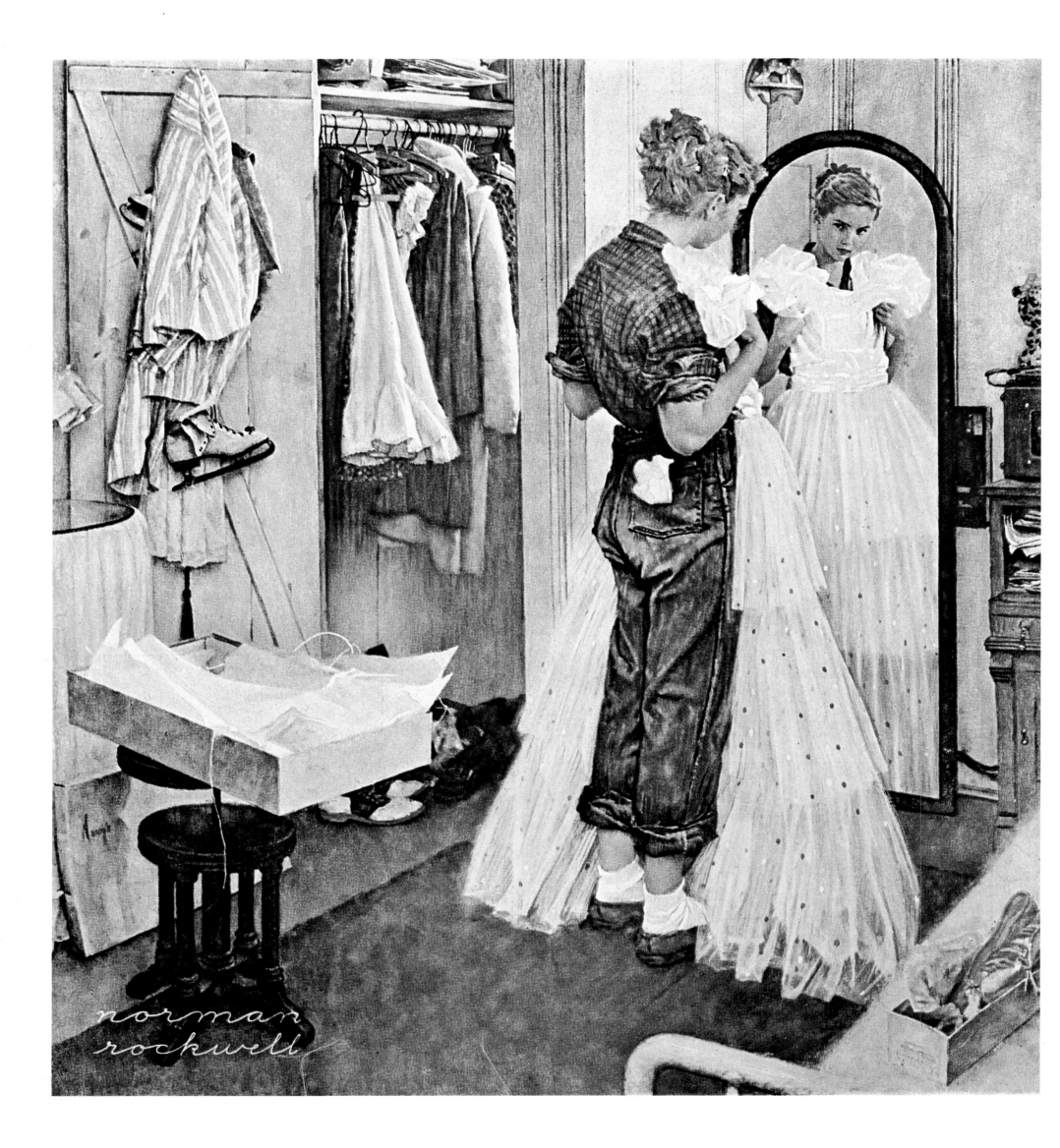

THE PROM DRESS
Post Cover • March 19, 1949

382

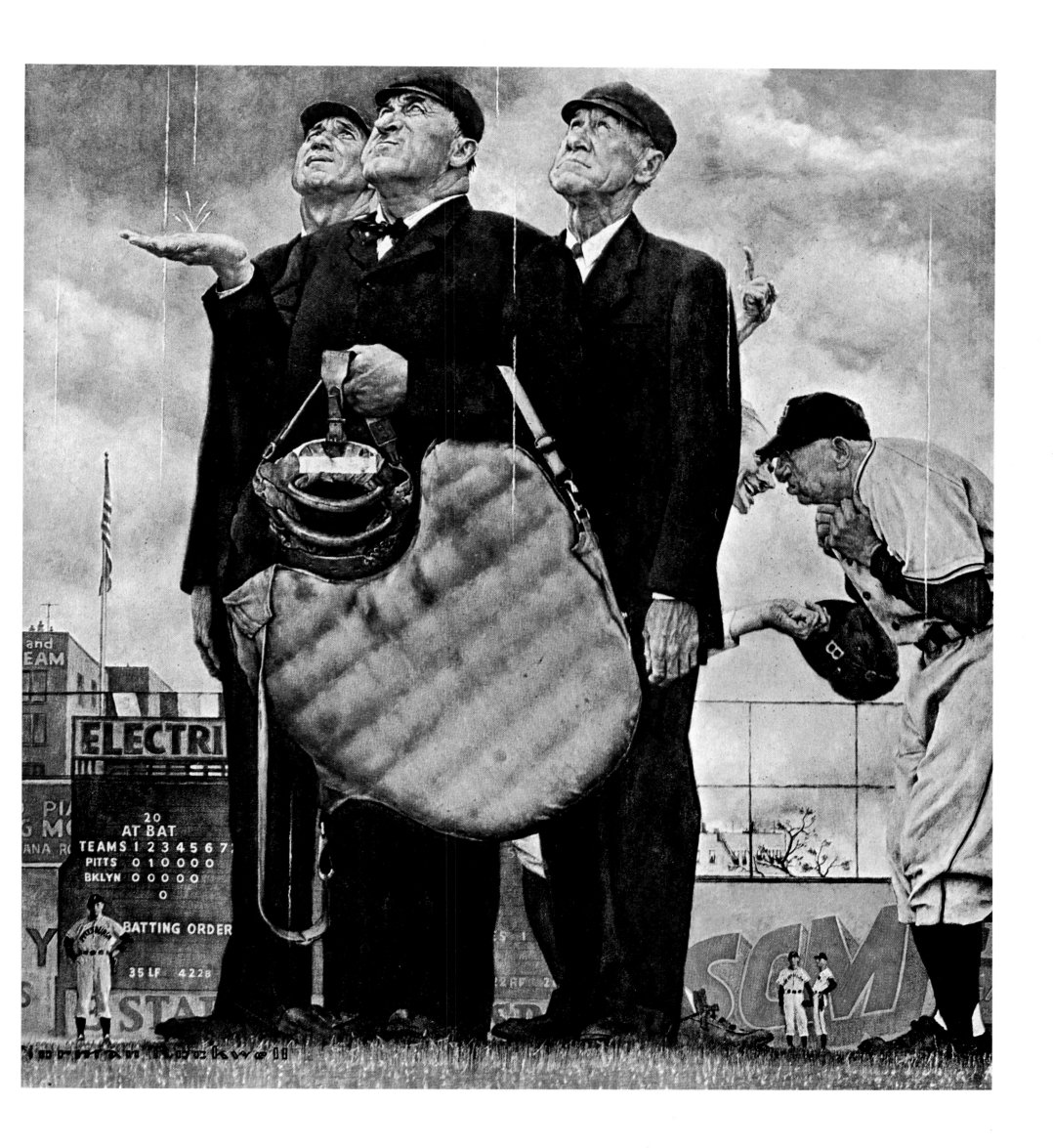

BOTTOM OF THE SIXTH

Post Cover • *April 23, 1949*

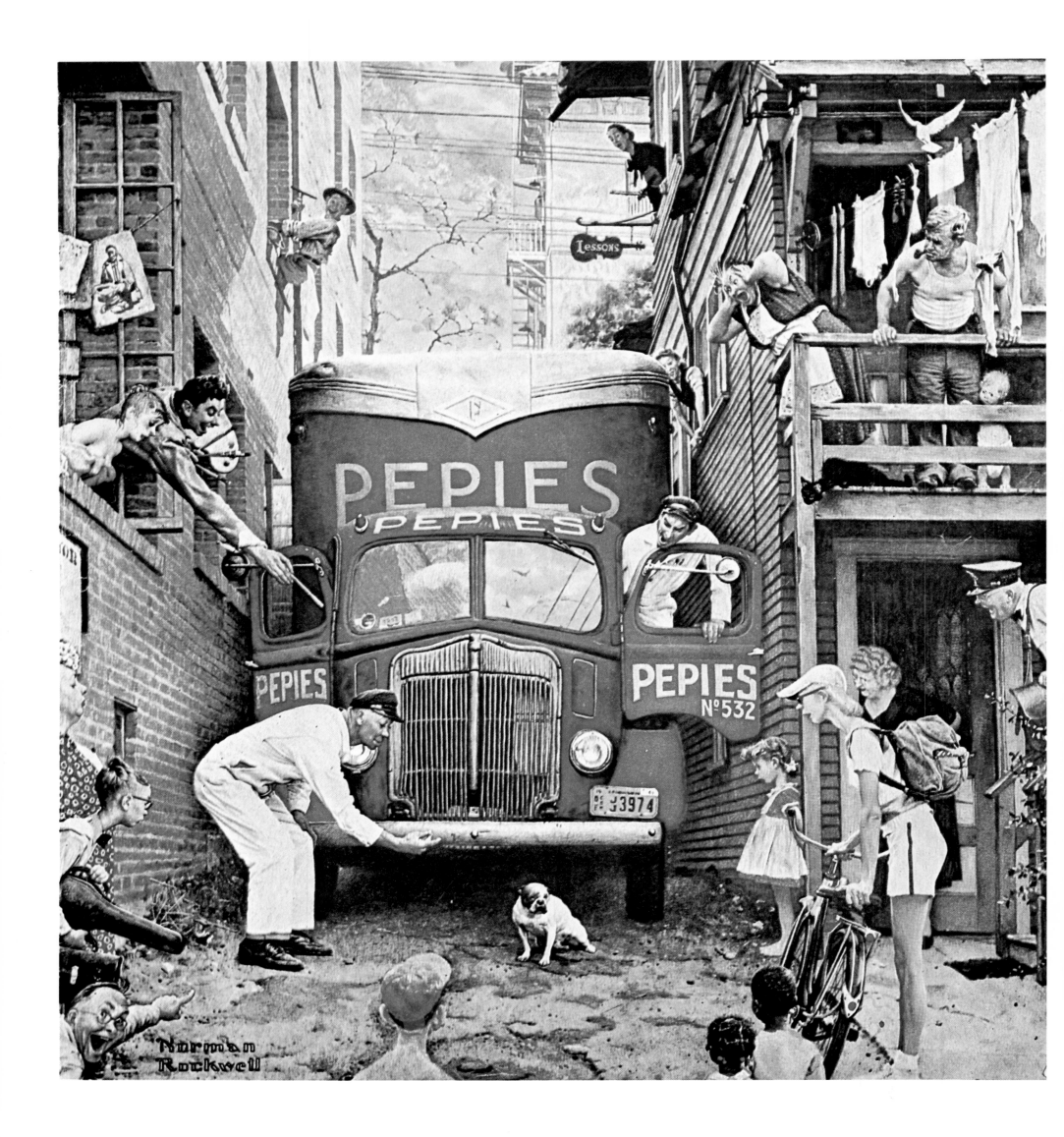

TRAFFIC CONDITIONS

Post Cover • July 9, 1949

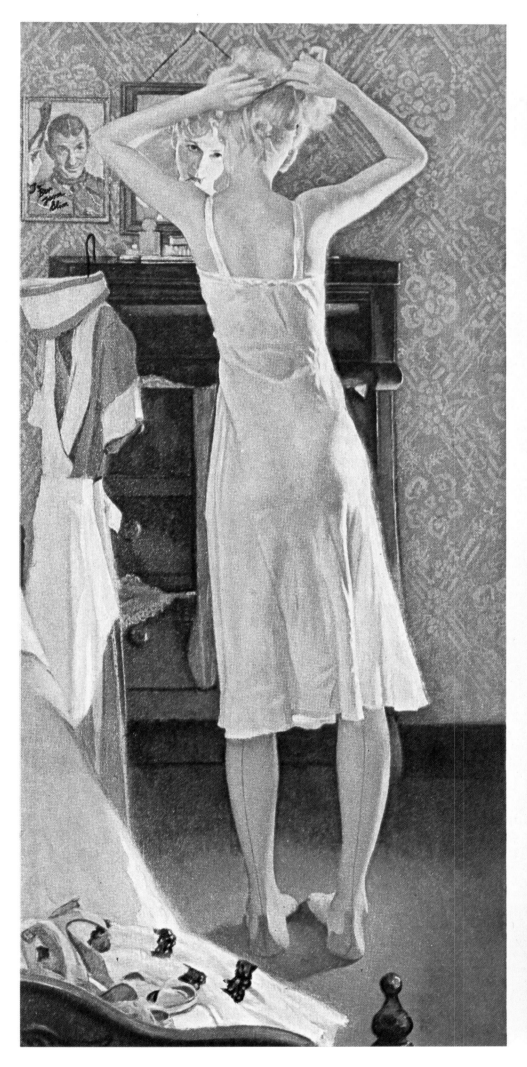
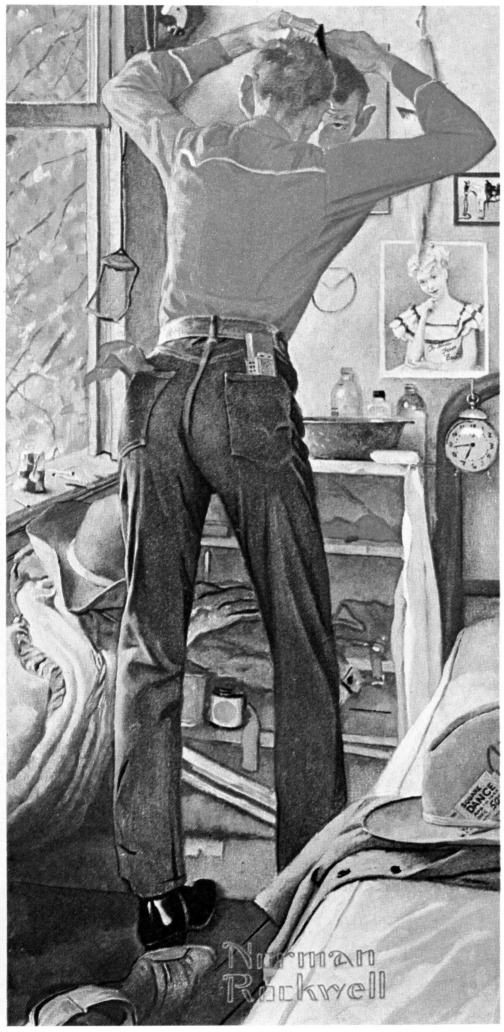

BEFORE THE DATE

Post Cover • September 24, 1949

THE NEW TELEVISION SET

Post Cover • *November 5, 1949*

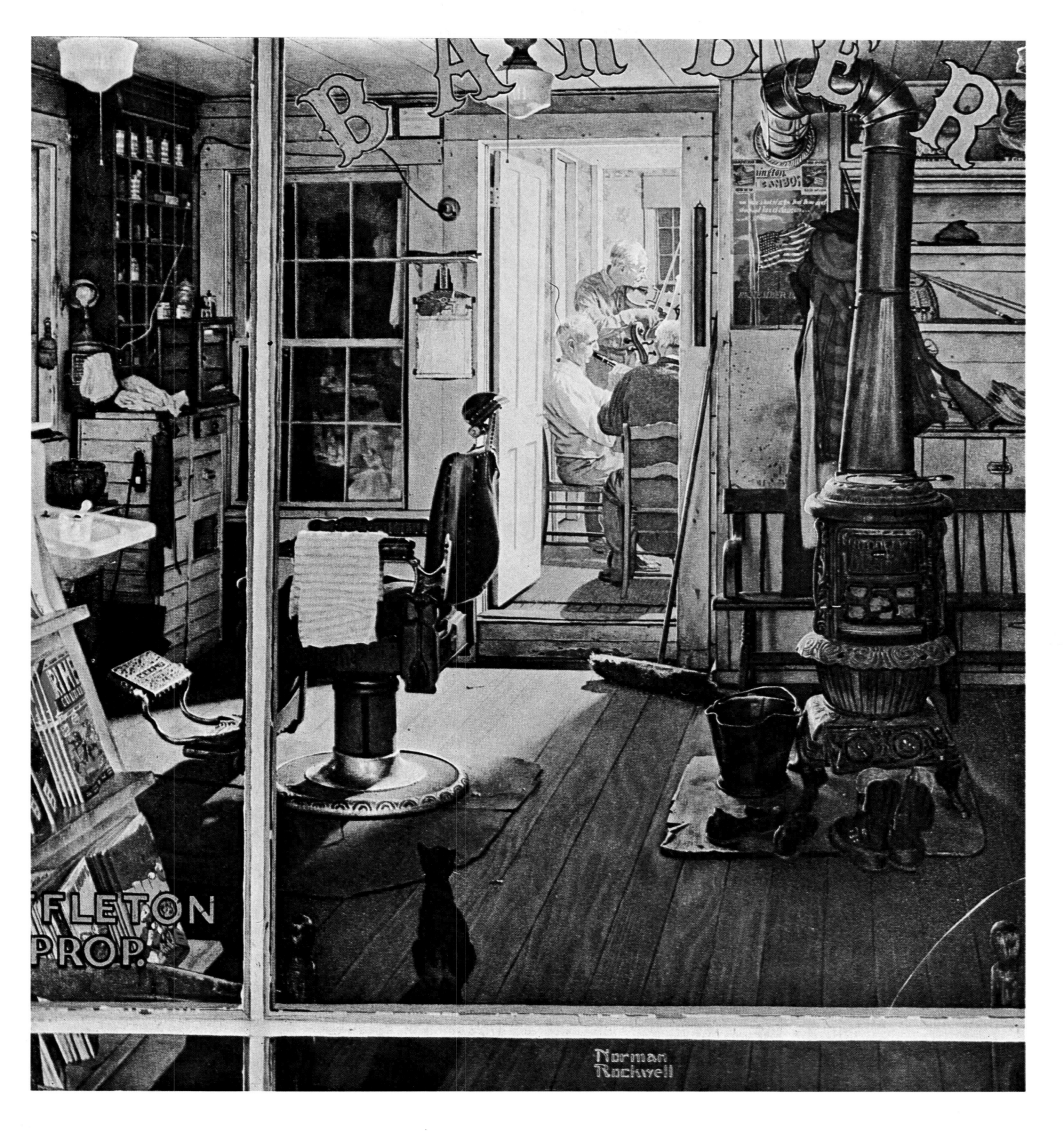

SHUFFLETON'S BARBER
SHOP

Post Cover • *April 29, 1950*

387

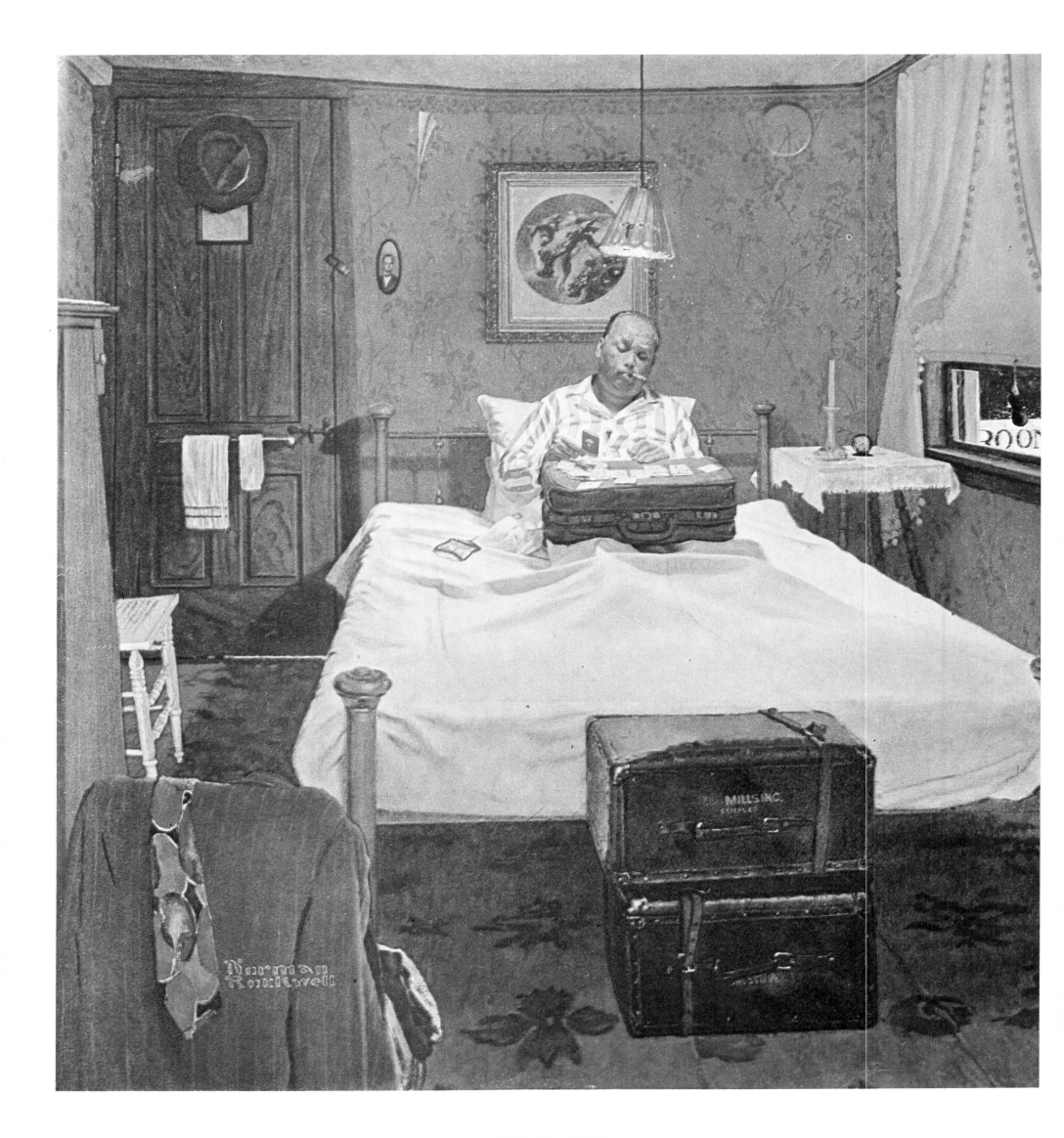

SOLITAIRE

Post Cover • August 19, 1950

388

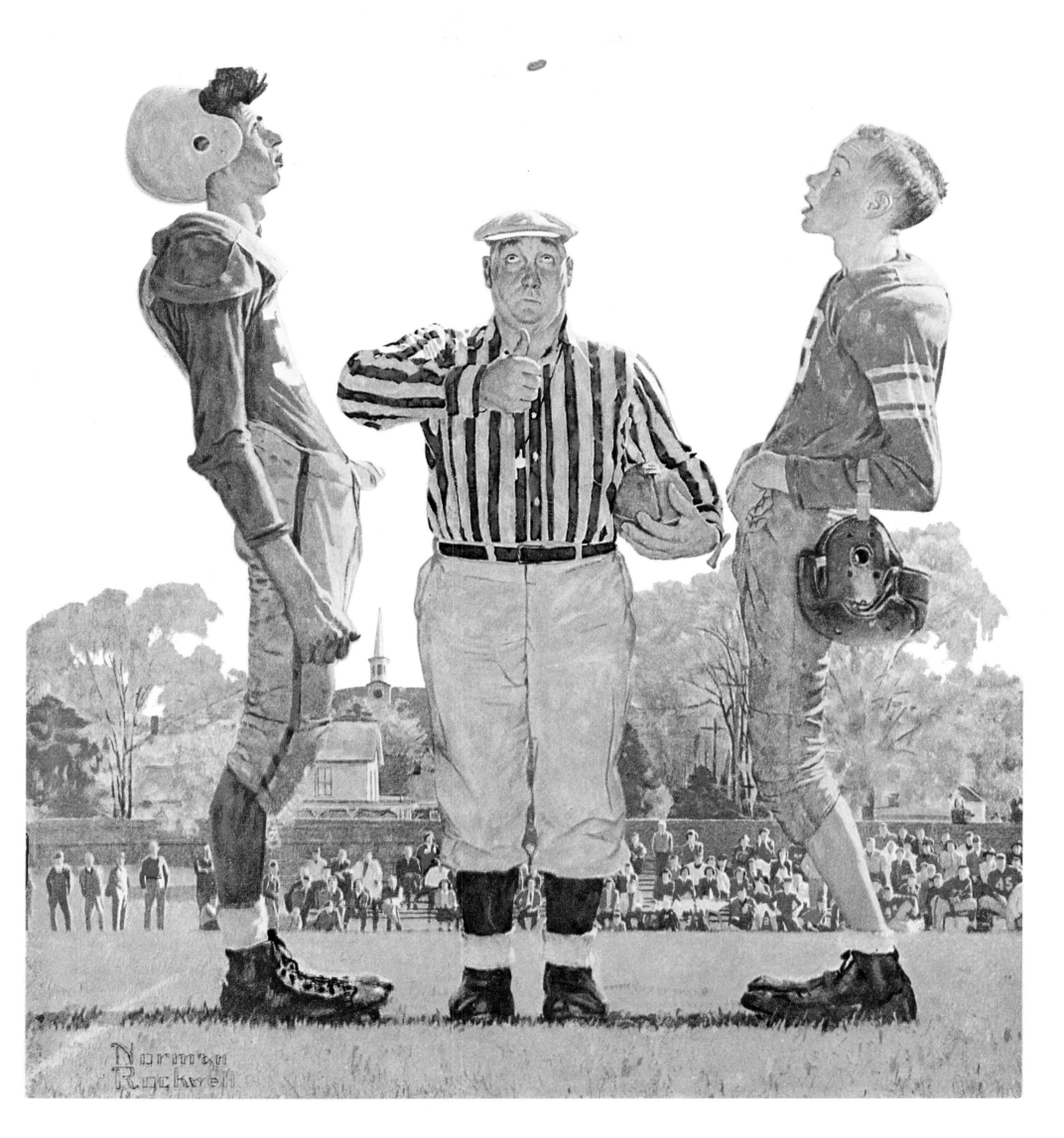

THE TOSS

Post Cover • October 21, 1950

389

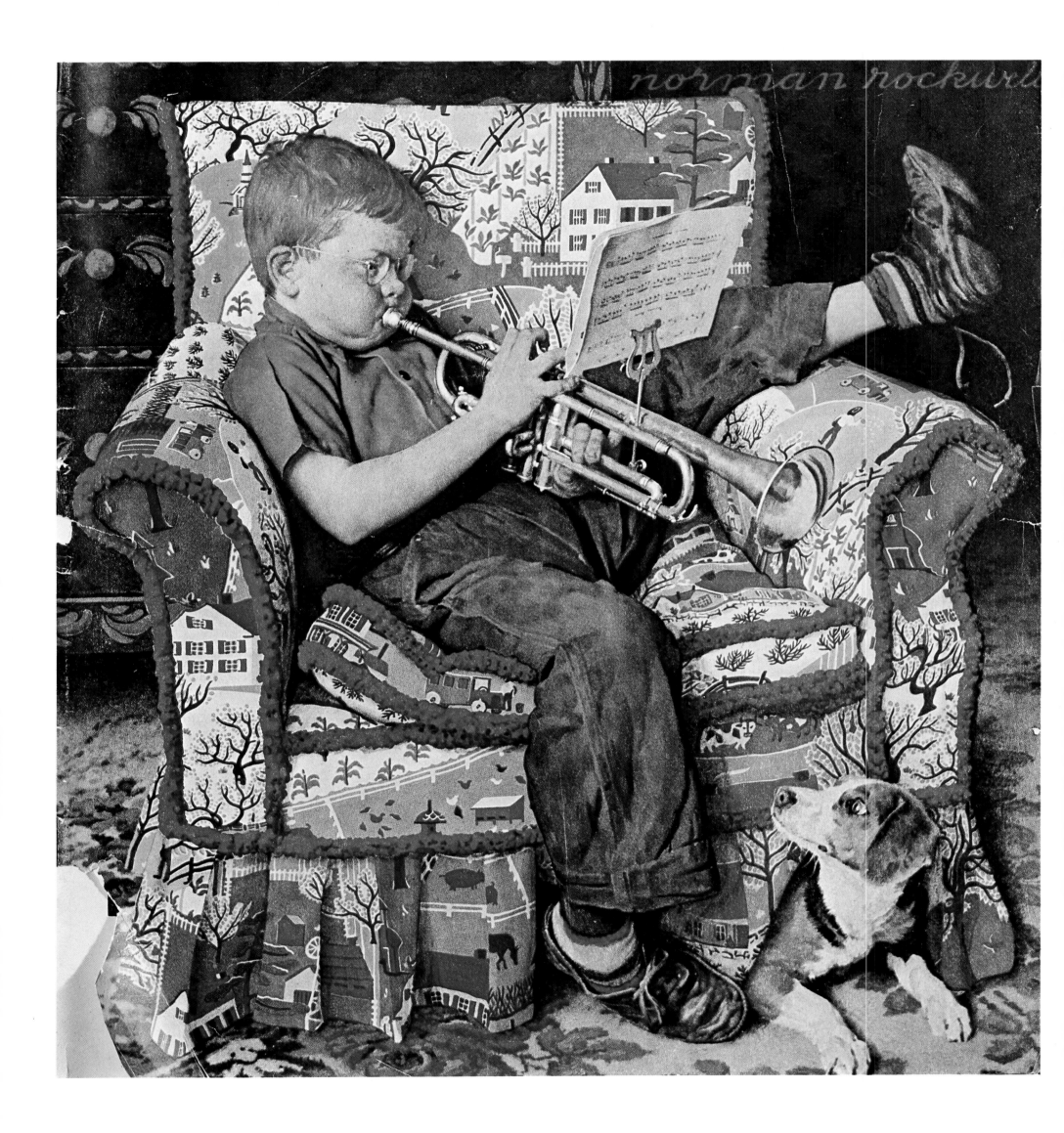

PRACTICE

Post Cover • November 18, 1950

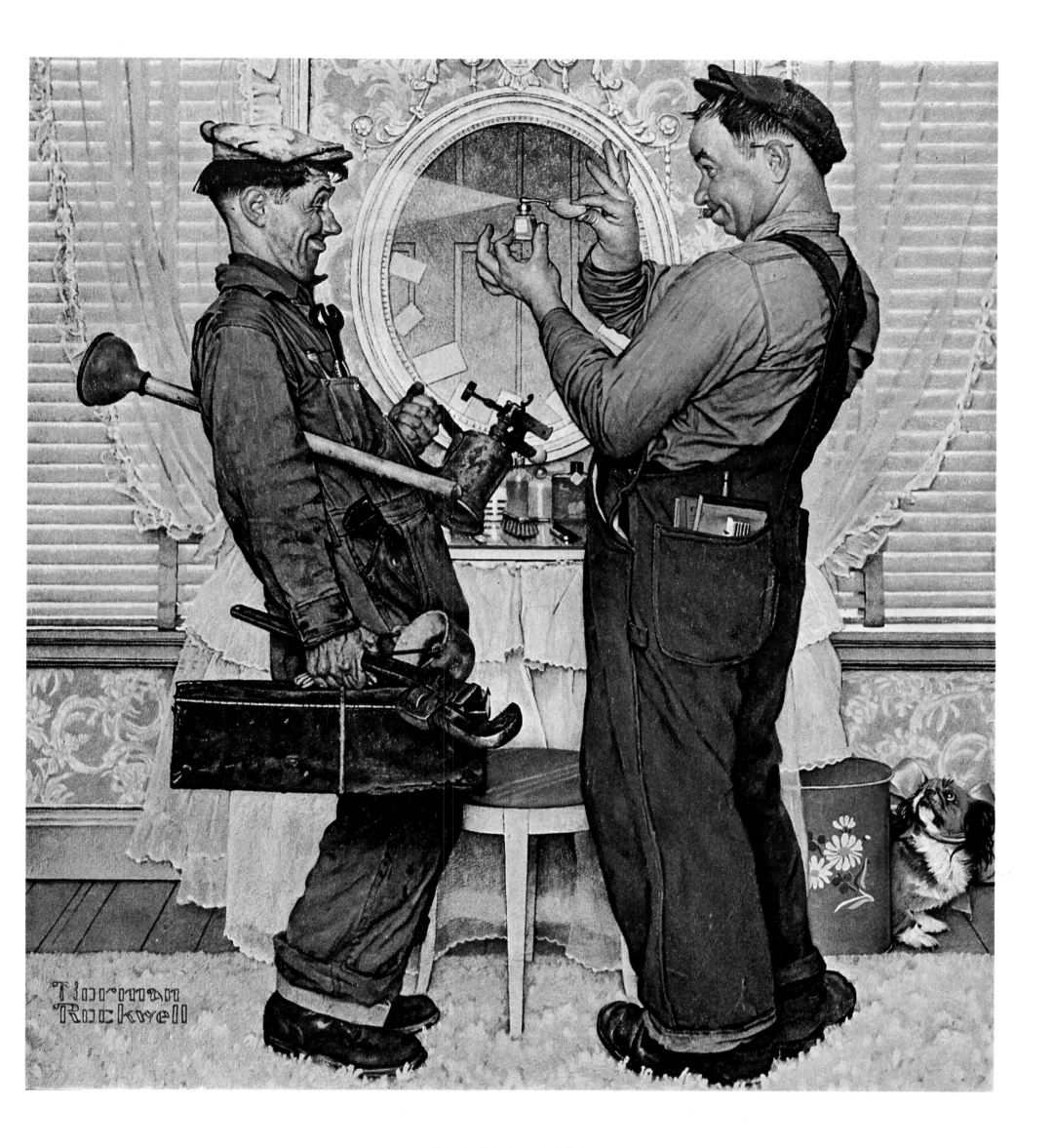

THE PLUMBERS

Post Cover • June 2, 1951

391

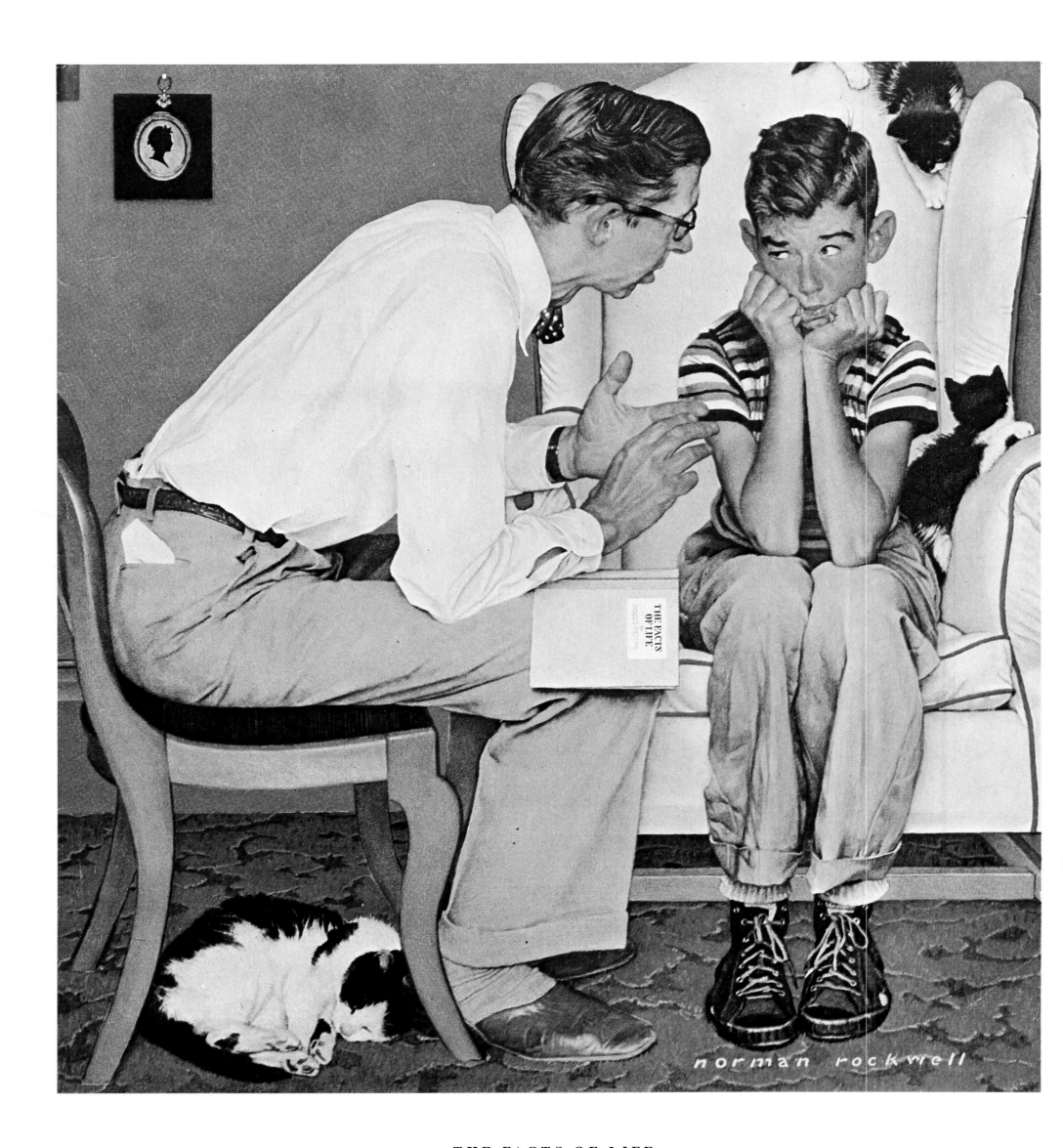

THE FACTS OF LIFE

Post Cover • July 14, 1951

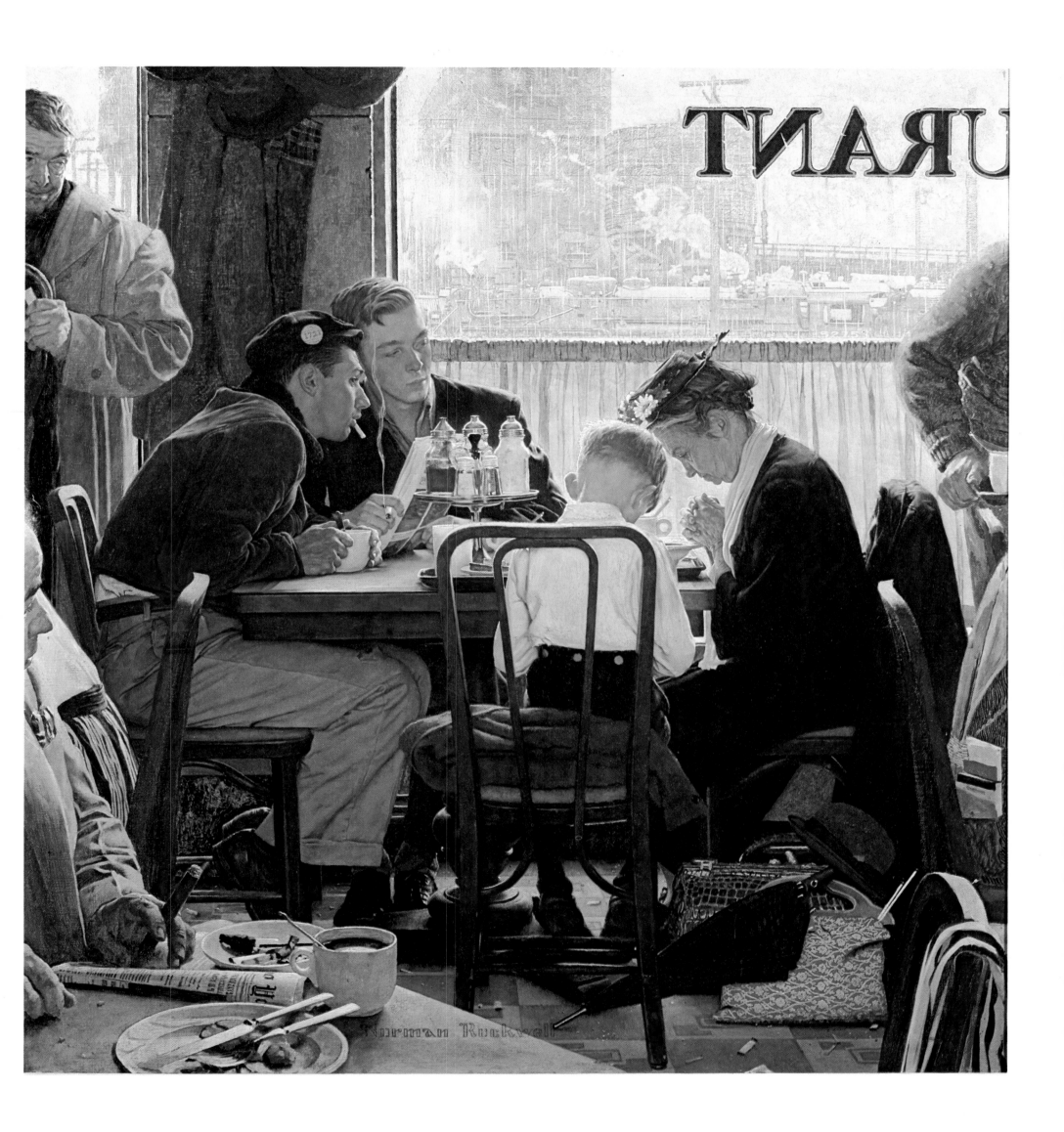

SAYING GRACE

Post Cover • *November 24, 1951*

393

CHEERLEADERS

Post Cover • February 16, 1952

WAITING FOR THE VET

Post Cover • *March 29, 1952*

**A DAY IN THE LIFE
OF A BOY**
Post Cover • *May 24, 1952*

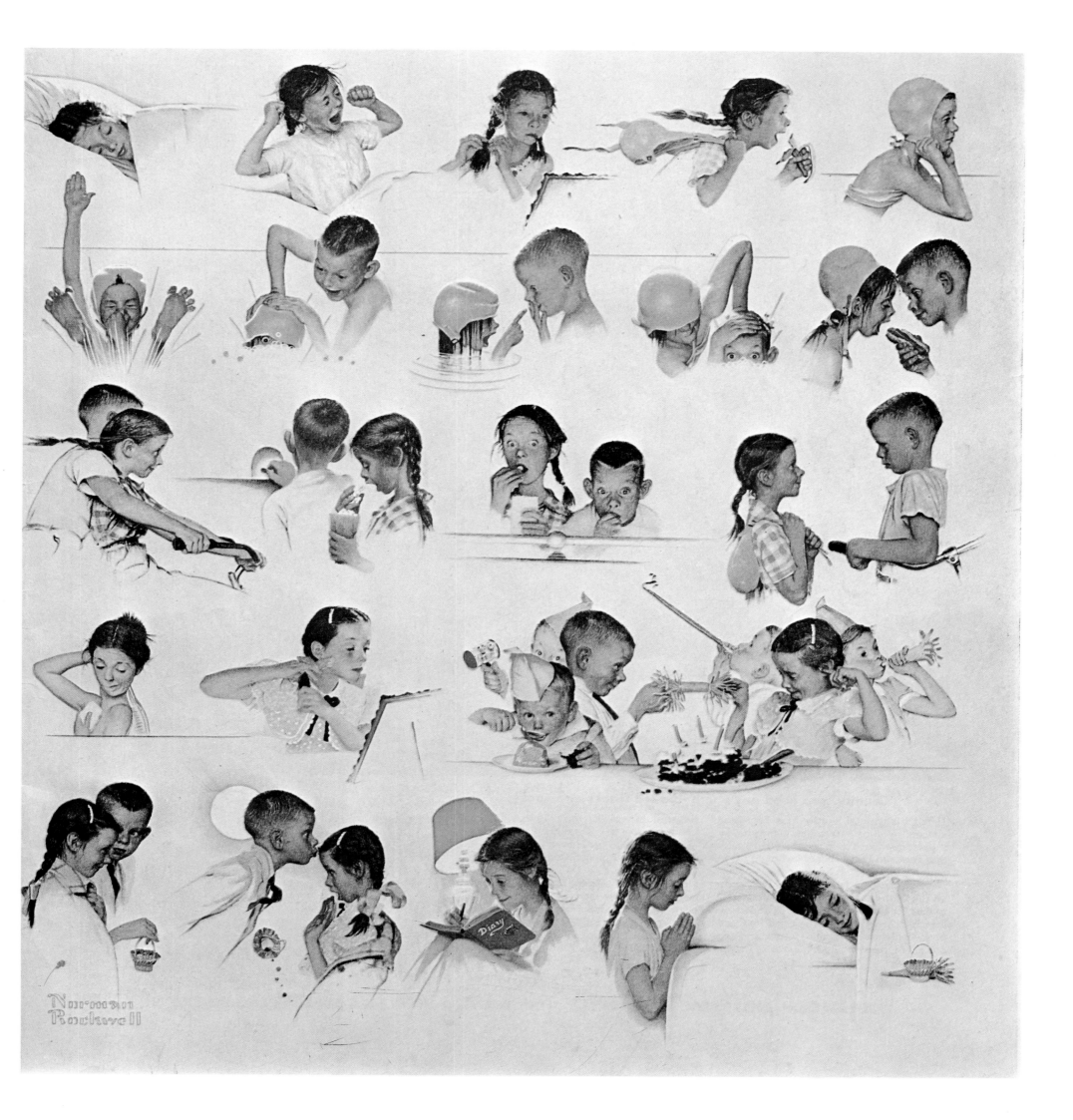

**A DAY IN THE LIFE
OF A GIRL**

Post Cover • *August 30, 1952*

397

DWIGHT D. EISENHOWER
Post Cover • October 11, 1952

398

HOW TO DIET

Post Cover • January 3, 1953

399

Rockwell's Style Puts Its Distinctive Mark on Everything

IN 1953 Norman Rockwell moved to Stockbridge, Massachusetts, which was to be his home for the remainder of his life. In 1959 his second wife, Mary, died. In 1961 he married for a third time; his new bride was Molly Punderson. Nineteen fifty-three also marked the beginning of the final decade of his association with the *Post*. Some artists begin to lose their gifts later in their careers, but happily this was not the case with Rockwell. He retained his powers, in fact, for years after he had painted his last cover for the *Post*; but there were few cover paintings during that final period, and those are beyond the scope of this study. In any case, the majority of his *Post* covers throughout the remainder of the fifties and into the sixties continued to live up to his uniquely high standard. Once again one can point to outright masterpieces (pp 421 & 422), but one is even more impressed by the overall quality of the work.

What is most satisfying about Rockwell's career, taken as a whole, is the way he evolved gradually from an eminently pleasing and salable, though conventional, illustrator into a great original. He always had the basic skills, of course, but it took him decades to hone them. As we look back over the first half of his career, we see him adding to his accomplishments as the years go by. We see him becoming more imaginative in the area of design, and we see him develop fully as a colorist. We see him learn from photography: the photograph suggests new approaches to composing a picture and leads him to master the illusion of spontaneity. We see him build on his natural story-telling ability, and on his ability to evoke character with a few seemingly casual strokes of the paintbrush. We see him learn how to use telling detail. In those early years there were periods of regression and retrenchment, but slowly a distinctive viewpoint and artistic personality began to emerge—and an occasional work stood out from the rest, a canvas with a flash of brilliance that gave fair warning of what he would be capable of.

Then, in the late thirties, came the transitional phase during which Rockwell produced many fine works and evolved into a much more personal artist. It was, however, during World War II that he really hit his stride. Then came the years of his most remarkable artistic output.

We can speak with accuracy of "Norman Rockwell's world" when we turn to the second half of his career because it was so complete a world. The earlier work was like

a series of vignettes, some related thematically to others but each somehow separate from the next. He moved between contemporary subjects, nostalgic subjects, and outright costume pictures without any real sense of continuity. Most early covers, it's true, were rooted in various folklore conventions of the day, but these conventions were undermined by the Depression and swept away by the War. Rockwell's personal values did not change, and so he was forced to construct—perhaps we should say "reconstruct"—a world in which they still made sense. Thus he was obliged to particularize not only the protagonists of his little dramas, but also the setting that framed their existence; and he gave us detailed portraits of city streets, suburban interiors, barbershops, offices, schoolrooms, hotel rooms, soda fountains, gardens, kitchens, gymnasiums, and so forth.

Although he presented these settings realistically, he was highly selective in choosing them, just as he had always been selective in choosing the characters he placed on his canvases. It was this particular combination of settings and characters that came to make up Norman Rockwell's world, and a remarkably homogeneous world it is. The cast of characters is varied, and so are the environments they inhabit. They are bound together, however, by Rockwell's style, which evolved rapidly from the war years on and which puts its distinctive mark upon everything. Each image seems to belong with every other image. Much of Rockwell's work appears so photographic to the casual observer that it might seem a trifle odd to speak of style at all in this context. Close examination of his mature paintings, however, reveals dozens of subtle mannerisms—his curious use of impasto, for example—that continue from one canvas to the next. Beyond that, Rockwell's view of humanity, in his later work, is so consistent that it touches all his characters and makes them players in the same drama.

It is quite evident that for Rockwell nothing was more exciting than this drama of everyday events. As a general rule, one can say of his work that the more exotic the subject matter, the less successful the painting. It is because of this that the early allegories and costume paintings appear relatively uninteresting in retrospect. Rockwell never seemed comfortable when he was having to stretch his imagination to make a point, when he was dealing with subject matter that forced him into conventional cleverness. He was most completely at home, and hence most impressive, when he was dealing with situations that were firmly anchored in the world of quotidian reality. It was in that world that his imagination operated freely and without strain. In that world he was at his most inventive.

We see this again and again in the last decade of his association with the *Post*. "Walking to Church" (p 413) is a wonderful evocation of a quiet spring morning. "Soda Fountain" (p 415) is an archetypal representation of a scene that might have been discovered almost anywhere in the country at the time it was painted. "Girl at the

Mirror'' (p 418) is a touching rendition of a moment of mild trauma in the world of the pre-adolescent. "Breaking Home Ties" (p 421) is a stunning portrayal of a scene charged with both hope and melancholy, a scene that—despite its specifics—anyone could identify with. Much the same could be said of "The Marriage License" (p 422), while "Surprise" (p 424) is a totally straightforward presentation of a touching moment in the schoolroom.

Rockwell was able to sustain this vision until 1963; but one can't help wondering what would have happened had he continued to provide covers for the *Post* for another decade. In 1963 America was about to enter one of those periods of radical change that seem to occur two or three times in a century. (In some ways the sixties would have much in common with the twenties.) How, given the context of the *Post*'s cover, would Rockwell have dealt with the era of protest marches, draft card burnings, Black Panthers, the Beatles, Flower Power, Woodstock and Altamont? Would he have ignored these changes as he had ignored earlier cultural shifts? Or would he have tried to accommodate them into his subject matter?

I think it would have been almost impossible for him to ignore the cultural revolution of the sixties because it had such a far-reaching effect on the youth of the country, even in the small towns that provided Rockwell with so much of his subject matter. Television, radio, and records carried it to the quietest backwaters.

Throughout this period, of course, Rockwell was working for publications other than the *Post* (though he seldom had the opportunity to paint covers after 1963), and so we can find some clues to his developing attitudes. In 1964, for example, he painted "The Problem We All Live With" for *Look* magazine. This dealt with a subject—school integration—that must have surprised many of Rockwell's admirers. It showed a small black girl in a neat white dress being escorted to the classroom by U.S. marshals. In 1967, also for *Look*, he painted "New Kids in the Neighborhood," a plea for open housing; the following year, for *Look* again, he produced "The Right to Know," a plea for equality in education and freedom of knowledge.

These were not among Rockwell's best paintings, but the very fact that they—and others like them—were produced by "America's Best Loved Artist" was enormously significant. Rockwell had spent his entire career studiously avoiding controversial matters, except in times of national crisis. The fact that he was seen dealing with such subjects as racial equality must have had a considerable impact upon many members of the general public.

Whether he would have dealt with such matters on the *Post*'s cover, however, is an entirely different matter. There he had built up certain expectations and had, as we have observed, built up a distinct Rockwell world. Perhaps it is just as well that his association with the *Post* ended when it did since it meant that that world was preserved intact. It is that world for which Rockwell will be remembered.

Rockwell belongs to a period in Western civilization when our culture underwent a startling transformation. His career began when the movies were still a novelty, spurned by the educated; and it ended after we had seen live television images broadcast from the moon. It began when the handmade object was still prized above everything else and it ended in the age of the transistor. Rockwell had one foot in the old world and one foot in the new. His work is prized because it displays all the old-time virtues of craftsmanship that we associate with the tradition of easel painting, yet it was always made with the requirements of modern technology in mind. He was always conscious of the fact that his compositions were intended to be reproduced by the millions and that they would spill off high-speed presses to find their way into homes all over the country, homes lived in by people from many different backgrounds. His patron was more elusive than any that artists had had to deal with prior to the twentieth century. He was not working for an individual or an institution. Nor was he working for a single segment of society, such as had been the case with most painters, novelists, and playwrights. He was working for the mass audience, for the public at large, and so he found himself in the same position as a movie maker like Charles Chaplin, or a song writer like Irving Berlin; and it is in the company of men like these that he belongs.

Chaplin used the technology of the cinema to build on the long-established traditions of music hall and vaudeville. Berlin took advantage of the gramophone record, and its ability to reach millions of people, to enrich a tradition that had its roots in live performances, whether in saloons or on the Broadway stage. Rockwell, as we have remarked, took the traditions of easel painting and carried them into the world of mass production as it existed in the field of magazine publishing. These people, along with their great contemporaries, have a special position in our culture—they made their careers through their understanding of technologies that did not exist when their aesthetics were formed.

Norman Rockwell was a marvelous historical accident, and we shall never see anyone quite like him again.

SATURDAY EVENING POST COVERS
April 4, 1953–May 25, 1963

WALKING TO CHURCH
Post Cover • April 4, 1953
PAGE 413

ROCKWELL once said that it had been a mistake to caricature this family headed for church on a fine Sunday morning in April. Nonetheless this is a delightful cover, a loving portrayal of a slightly seedy neighborhood with garbage on the street and grass growing through the sidewalk cracks. It captures a quiet moment when, to judge by the newspapers and milk bottles waiting in doorways, most people are still asleep.

THE SHINER
Post Cover • May 23, 1953
PAGE 414

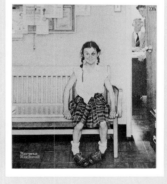

NOTHING that the principal can say to this engaging tomboy is likely to diminish her pride in having acquired this spectacular black eye. Dramatic tension is added by the glimpse into the adjacent office where her crimes are being aired.

SODA FOUNTAIN
Post Cover • August 22, 1953
PAGE 415

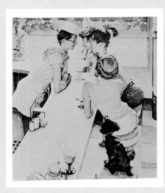

ONE wonders if this soda jerk's popularity derives entirely from his personal magnetism or from his ability to treat his favorites to an extra scoop of butter pecan and an extra dollop of chocolate syrup. Whatever the case, this is a charming piece of early fifties Americana.

FEEDING TIME
Post Cover • January 9, 1954
PAGE 416

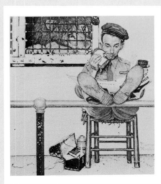

MORE thought has gone into this humorous cover than is, perhaps, apparent at first glance. For example, a less imaginative artist might not have thought of placing the keeper's feet up on the metal guardrail, a device which—because of the foreshortening involved—gives the painting depth and helps draw us into the image.

BOB HOPE
Post Covers • February 13, 1954
PAGE 417

THE occasion for this portrait of Bob Hope was the publication of the comedian's memoirs, serialized in the *Post* beginning with this issue. Less finished than some of Rockwell's portraits, it nonetheless captures the entertainer's public personality and projects it in a way that one seldom finds in photographic likenesses.

GIRL AT THE MIRROR
Post Cover • March 6, 1954
PAGE 418

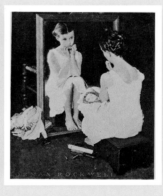

THIS splendid study of a girl approaching adolescence is one of Rockwell's finest cover paintings. The contrived notion of a girl comparing herself to a glamorous woman in a photograph—a movie star or perhaps a fashion model—is transcended by the intensity of Rockwell's vision. Instead of being a skillful presentation of a rather ordinary idea, it becomes, quite simply, a beautiful painting.

CHOIRBOY
Post Cover • April 17, 1954
PAGE 419

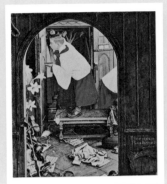

DURING his New York City childhood, Rockwell himself was a choirboy, and while this youngster is very much of the fifties, doubtless this painting was informed by the artist's own memories. The arched doorway, deliberately set off center, has been used as a framing device that accentuates the verticality of the composition.

HOME PLATE
Post Cover • August 21, 1954
PAGE 420

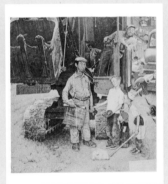

THIS portrayal of a local sandlot about to be transformed into a building site is a frank appeal to sentiment. The workmen seem as upset as the children. Perhaps they played on this same sandlot long ago. In any case, the occasion has evoked memories of summers gone by.

BREAKING HOME TIES
Post Cover • September 25, 1954
PAGE 421

ROCKWELL never painted a better cover than this moving study of a father and son, waiting wordlessly on the running board of an old pickup truck for the train that will carry the boy off to college. It is, quite simply, a brilliant evocation of a moment charged with unforced sentiment. Each detail has been thought out with care, and Rockwell's skill as a painter has never been more apparent. Into this composition is distilled everything that Rockwell had learned over a period of close to half a century.

THE MARRIAGE LICENSE
Post Cover • June 11, 1955
PAGE 422

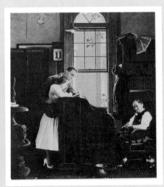

ANOTHER masterpiece, this cover, too, belongs with the very finest examples of Rockwell's art. The contrast between the young couple and the old marriage-license clerk is conventional enough, but the cliché is transcended by the sheer quality of the painting. As a study of an interior, this is as fine as "Shuffleton's Barber Shop" (p 387).

A FAIR CATCH
Post Cover • August 20, 1955
PAGE 423

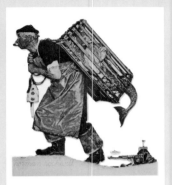

HERE a bizarre subject is made even more bizarre by the expression on the face of the old fisherman. One would think, judging by his demeanor, that finding a mermaid in his lobster pot is an everyday occurrence for him. As for the mermaid herself, she seems to find captivity surprisingly agreeable.

SURPRISE
Post Cover • March 17, 1956
PAGE 424

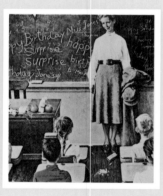

THIS is one of those subjects that Rockwell might have portrayed much earlier in his career. The skill with which he presents it here, though, belongs strictly to his mature period. Nothing is overstated and there are a number of clever touches. Note, for example, the corner of the flag that intrudes into the upper left-hand part of the composition. It serves no obvious purpose, yet somehow makes the scene seem more real.

NEW GLASSES
Post Cover • May 19, 1956
PAGE 425

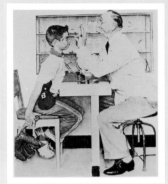

ROCKWELL, as we have noted, needed glasses as a child, and so this is a situation he would have had little difficulty imagining. It is another example of a subject that Rockwell might have tackled at the outset of his career. Only clothes and setting place it in its period.

ADLAI STEVENSON
Post Cover • October 6, 1956
PAGE 426

THIS portrait of Adlai Stevenson was published as the 1956 presidential campaign moved towards its close. Rockwell painted the candidates of both parties for consecutive issues of the *Post*.

DWIGHT D. EISENHOWER
Post Cover • October 13, 1956
PAGE 427

THE companion piece to the preceding cover, this portrait of President Dwight D. Eisenhower is remarkably similar to the one Rockwell had produced at the time of the 1952 election (p 398). The angle has been reversed, and Ike's smile is broader this time (as well it might be), but the overall feeling is very much the same.

BOTTOM DRAWER
Post Cover • December 29, 1956
PAGE 428

AS was the case with "Santa on a Train" (p 308), this is a picture that violates all the traditional rules about Christmas covers. Perhaps this approach was less shocking in 1956 than it had been in 1940; but once again the *Post* took the precaution of publishing this in the issue that appeared just after Christmas, presumably to avoid shattering any small child's dreams before the big day.

THE ROOKIE
Post Cover • March 2, 1957
PAGE 429

TO celebrate the eternal ritual of spring training, Rockwell took *Post* readers inside the Florida camp of the Boston Red Sox, showing the arrival of a raw-boned rookie. This is a group of portraits of actual ballplayers, one of whom—the great Ted Williams—is still immediately recognizable, standing in the background with one hand on his locker.

AFTER THE PROM
Post Cover • May 25, 1957
PAGE 430

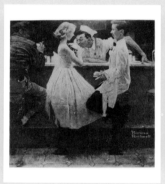

THIS is a fine cover, made all the more effective by Rockwell's judicious choice of models. Throughout his career, one of Rockwell's great strengths was his ability to find the right people to sit for him. One might reasonably say that he "cast" his paintings every bit as carefully as any Hollywood director.

BRIDAL SUITE
Post Cover • *June 29, 1957*
PAGE 431

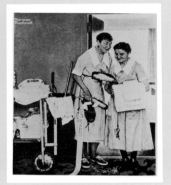

T HIS painting recalls, in some ways, the earlier cover showing two elderly cleaning women reading a discarded Playbill in an empty theater (p 355). There is the same sense of characters being stimulated by an event vicariously experienced. Here, once again, is an example of Rockwell taking a very conventional subject—the wedding day—and approaching it from an unexpected angle.

THE LOST TOOTH
Post Cover • *September 7, 1957*
PAGE 432

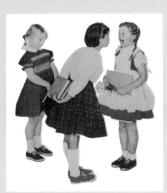

W HAT is unusual about this cover— unusual for the period, at least— is that Rockwell has decided against a detailed setting and has instead silhouetted the three girls against a white background, just as he used to in the old days. Clearly Rockwell did not return to this device for arbitrary reasons. In this instance it made for a very strong composition, one that would not have been improved by a naturalistic setting.

EXPENSES
Post Cover • *November 30, 1957*
PAGE 433

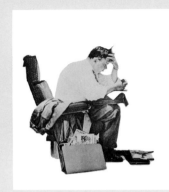

H ERE again Rockwell uses a silhouette, but this time he does not employ a plain white ground. Instead, he places this salesman against a blowup of his own expense sheet. This time, however, the device does not quite work—perhaps the background was added as an afterthought?—and this is a relatively weak cover.

DOCTOR'S OFFICE
Post Cover • *March 15, 1958*
PAGE 434

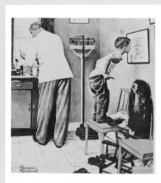

T HE small boy is determined to make quite sure that the doctor is indeed licensed to practice medicine. It is the least he can do before he permits needles to be jabbed into his flesh. This is very much a bread-and-butter cover, lackluster in concept and without any special touch that could lift it out of the ordinary.

JOCKEY WEIGHING IN
Post Cover • *June 28, 1958*
PAGE 435

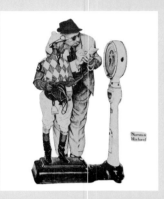

T HIS fine study of Eddie Arcaro, and the racing steward who dwarfs him, was painted for an edition of the *Post* in which Arcaro, then at the peak of his career, was profiled. Again Rockwell opts for a white background, rather than a naturalistic setting, and it works very well. (As a matter of interest, two versions of this composition were painted. In one instance the jockey's britches are spotless. In the other they are spattered with mud.)

THE RUNAWAY
Post Cover • *September 20, 1958*
PAGE 436

I T is the sheer bulk of the policeman, along with the expression on the world-weary face of the counterman, that makes this cover work. The setting is beautifully painted, of course, but this is another of those canvases that succeeds mostly because of Rockwell's skill at "casting" individuals who add authenticity to the situation.

VOTE FOR CASEY
Post Cover • November 8, 1958

PAGE 437

FOR the most part Rockwell painted election covers only in years when the presidency was at stake. In 1958, however, he made an exception and offered *Post* readers this study of an exhausted candidate for local office in his hour of defeat. Most of the humor derives from the contrast between the candidate's present demeanor and his smiling likeness on the poster behind him.

EASTER MORNING
Post Cover • May 16, 1959

PAGE 439

THE view through the window in this painting is the same as the view from Rockwell's studio in Stockbridge. The mother in the painting is Rockwell's daughter-in-law, who—when asked to pose—pointed out that she was too young to be the mother of such a family. Although he was usually a stickler for accuracy about such things, Rockwell went ahead anyway and no one seems to have been bothered.

FAMILY TREE
Post Cover • October 24, 1959

PAGE 441

IT was appropriate for Rockwell to paint an American family tree, and he certainly allowed his imagination to roam quite freely in his search for types that would symbolize his melting-pot theme. It may surprise some people to discover that Rockwell finds America's roots not at Plymouth Rock but, rather, on the shores of the Caribbean, in the swashbuckling world of buccaneers and captured Spanish beauties.

JURY ROOM
Post Cover • February 14, 1959

PAGE 438

THIS lively cover provided Rockwell with the opportunity to paint character studies of eleven good men and true, plus that of one determined woman who is not about to be shaken by arguments that she finds unconvincing. Rockwell has attacked with relish the problem of portraying the debris produced during the course of the marathon session leading up to the moment shown here.

THE GRADUATE
Post Cover • June 6, 1959

PAGE 440

ROCKWELL chose a background of dismal and horrifying news stories for this portrait of a graduate of the class of '59. The question posed by this juxtaposition is obvious—''What kind of a world is this anyway?'' Perhaps, in fact, it is a trifle too obvious, though at the time he had no way of predicting the campus unrest that would spill over into graduation ceremonies just a few years later.

TRIPLE SELF-PORTRAIT
Post Cover • February 13, 1960

PAGE 442

THIS fascinating painting appeared on the cover of the *Post* issue that carried the first installment of Rockwell's memoirs. It was only to be expected that Rockwell would work an American eagle into the picture, but less predictable is the discovery that his favorite artists—represented by reproductions pinned to the canvas—would include Picasso and Van Gogh, along with Rembrandt and Dürer. Curiously, the reflection from Rockwell's glasses make him seem sightless in the image we see in the mirror. The younger man sketched onto the canvas, by contrast, has eyes that are wide open and inquisitive.

STAINED GLASS
Post Cover • April 16, 1960
PAGE 443

As remarked earlier, Rockwell delighted in portraying artists at work, in any medium. In this instance, however, there may have been an added motive behind the choice of subject. Rockwell's second wife, Mary, had died just months earlier, and it seems possible that this painting was intended as a memorial to her.

UNIVERSITY CLUB
Post Cover • August 27, 1960
PAGE 444

Rockwell painted himself (pipe in mouth) into the bottom left-hand corner of this cover, and it is reasonable to assume that this painting was based on something he actually saw—a pert young blonde and a sailor exchanging pleasantries in front of the dignified façade of Manhattan's University Club. The massive scale of the architecture lends a special poignancy to the scene.

JOHN F. KENNEDY
Post Cover • October 29, 1960
PAGE 445

This is a very straightforward portrait of John F. Kennedy, one which conveys the look of boyish determination that captivated the electorate in 1960. This was published toward the end of the presidential campaign.

RICHARD M. NIXON
Post Cover • November 5, 1960
PAGE 446

For the following week's cover, Rockwell painted Kennedy's opponent Richard Nixon, chosing to portray him from exactly the same angle. It was after this election, of course, that many observers blamed Nixon's loss on his failure to project a satisfactory image. Rockwell, we assume, attempted to be fair to both candidates and went out of his way to avoid betraying his own preference. But Nixon's image problem is nonetheless evident in this portrait.

DO UNTO OTHERS
Post Cover • April 1, 1961
PAGE 447

This cover is very much outside the Rockwell mainstream. It represents one of the few occasions during the course of his association with the *Post* when he consciously attempted to make a broad statement about the human condition. Compared with the general run of his cover paintings, always humanitarian in their viewpoint, this seems forced and wooden.

NEW LOGO
Post Cover • September 16, 1961
PAGE 448

During September of 1961 the *Post* changed its logo once more, and Rockwell took note of the occasion by painting a layout artist at his drawing board, comparing the new logo with the many versions that the magazine had used over the years.

CHEERLEADER
Post Cover • November 25, 1961
PAGE 449

ALTHOUGH not as successful as Rockwell's earlier "comic strip" cover paintings, this one is lively enough, nonetheless. Here, atypically, Rockwell does give us the action on the field as well as the cheerleader's reaction. The plays leading to the touchdown are, in fact, spelled out in considerable detail.

THE CONNOISSEUR
Post Cover • January 13, 1962
PAGE 450

THIS was probably the last really memorable cover that Rockwell painted for the *Post*. Its effectiveness lies largely in the contrast between the dapper clothes of the "connoisseur" and the splashed pigment of the "action painting." The painting is in the style of Jackson Pollock but was in fact painted by Rockwell himself. Under an assumed name, he entered it in a local art show; it won first prize.

LUNCH BREAK
Post Cover • November 3, 1962
PAGE 451

THIS was the last "anecdotal" cover that Rockwell ever painted for the *Post*. A museum guard takes his lunch break surrounded by the splendors of another age.

JAWAHARLAL NEHRU
Post Cover • January 19, 1963
PAGE 452

ROCKWELL loved to travel—his trips took him all over the world—and he was in India when he painted this portrait of the country's leader, Jawaharlal Nehru.

JACK BENNY
Post Cover • March 2, 1963
PAGE 453

THIS portrait of Jack Benny makes a companion piece to the earlier

portrait of the comedian's friend Bob Hope (p 417).

JOHN F. KENNEDY
Post Cover • April 6, 1963
PAGE 454

THIS painting is quite different in character from the earlier portrait of President Kennedy (p 445); it presents him in a pensive mood, which was appropriate since this was intended to illustrate the lead story of the week, "A Worried President: The Crisis in his Foreign Policy." It has the look of having been reworked from a newspaper photograph.

GAMAL ABDAL NASSER
Post Cover • May 25, 1963
PAGE 455

FACED with the task of painting Egypt's president, Gamal Abdal Nasser, Rockwell settled on a strong profile treatment, silhouetting the head against an architectural background that suggests the heterogeneous nature of modern Egypt. This was the last cover that Rockwell ever painted for the *Post*, and it is perhaps ironic that it was so far removed in both mood and subject matter from the kind of work that had made him famous.

411

WALKING TO CHURCH

Post cover • April 4, 1953

413

THE SHINER
Post Cover • May 23, 1953

SODA FOUNTAIN

Post Cover • August 22, 1953

FEEDING TIME

Post Cover • *January 9, 1954*

416

BOB HOPE

Post Covers • February 13, 1954

417

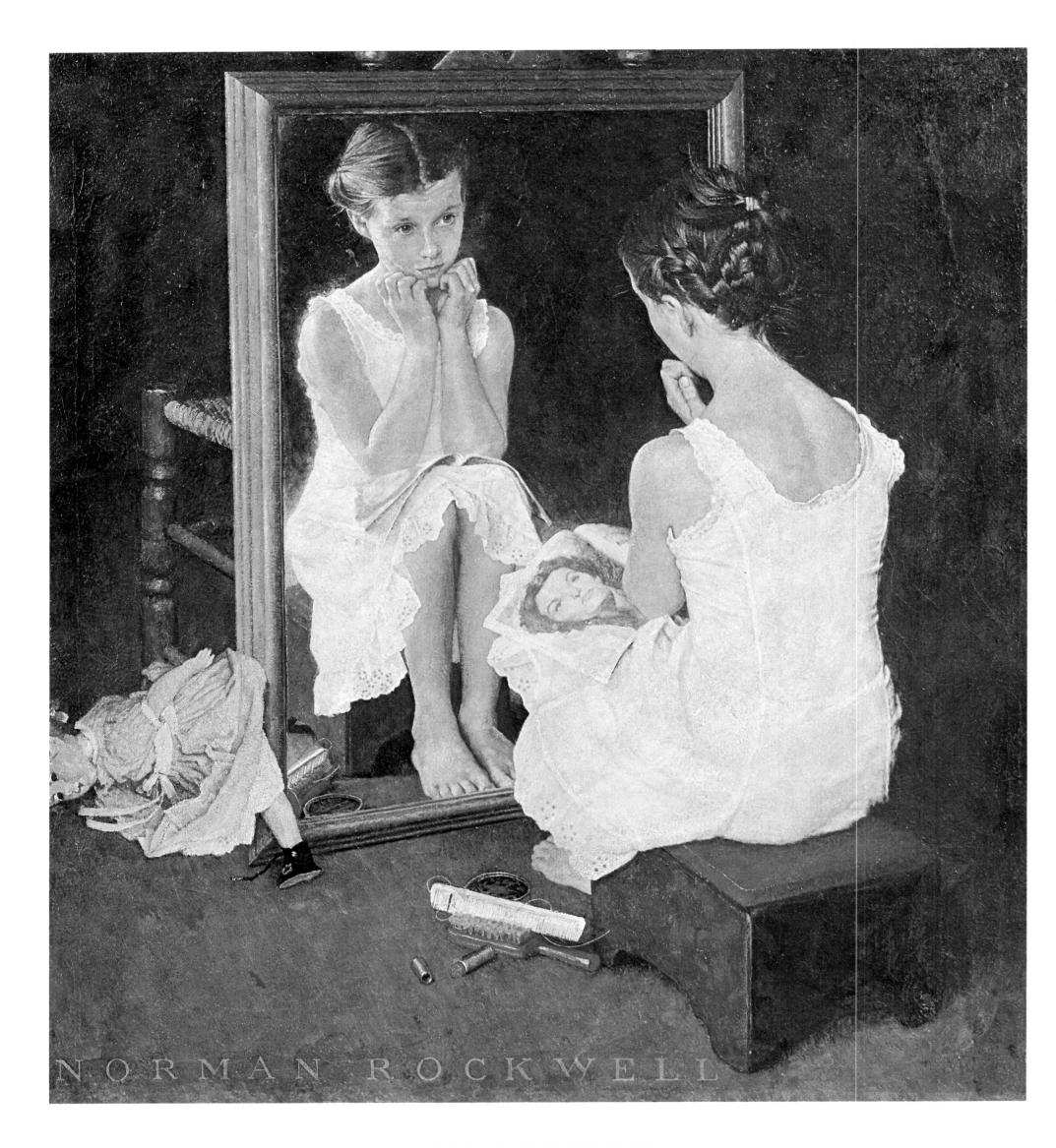

GIRL AT THE MIRROR

Post Cover • March 6, 1954

418

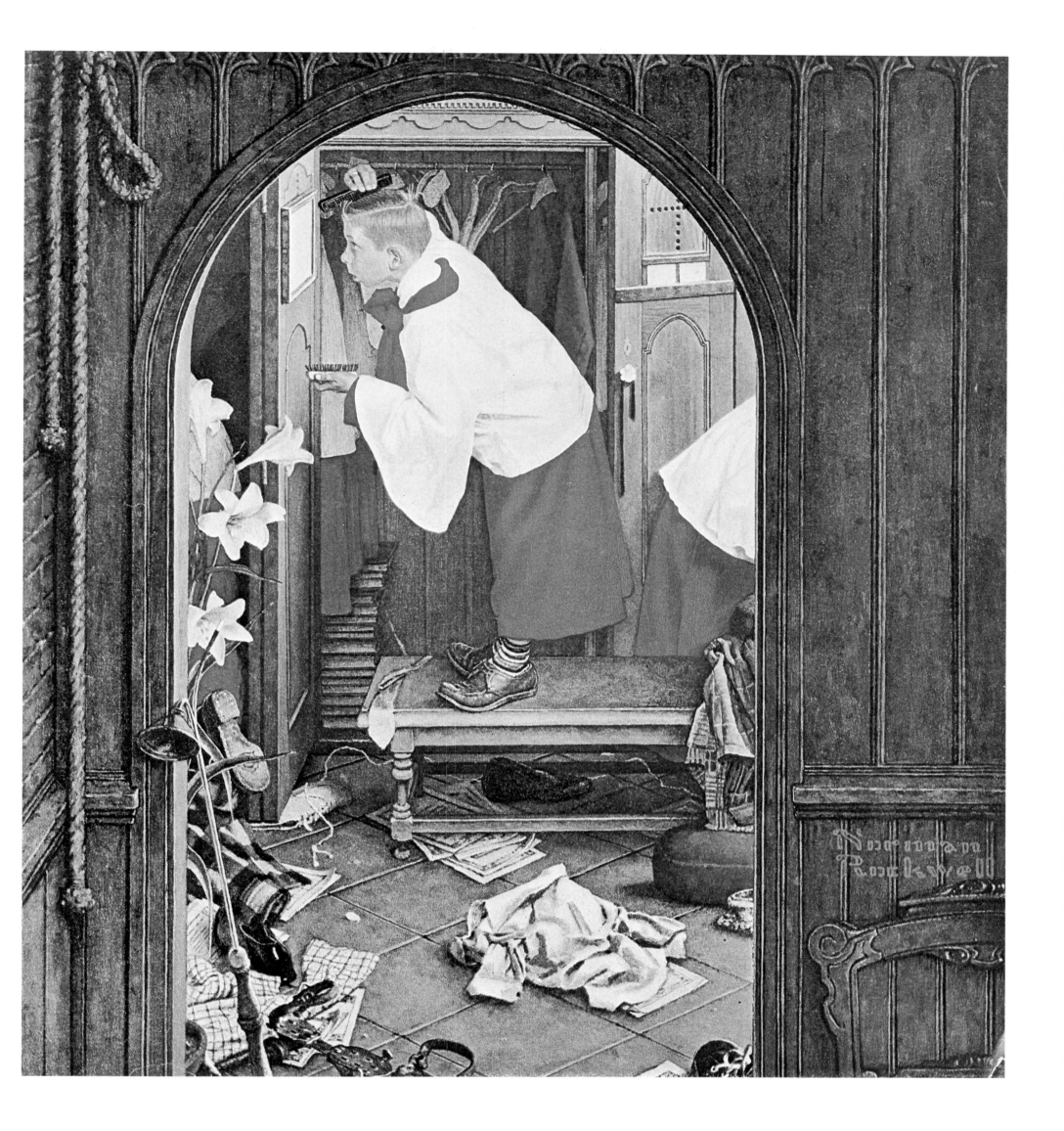

CHOIRBOY

Post Cover • April 17, 1954

419

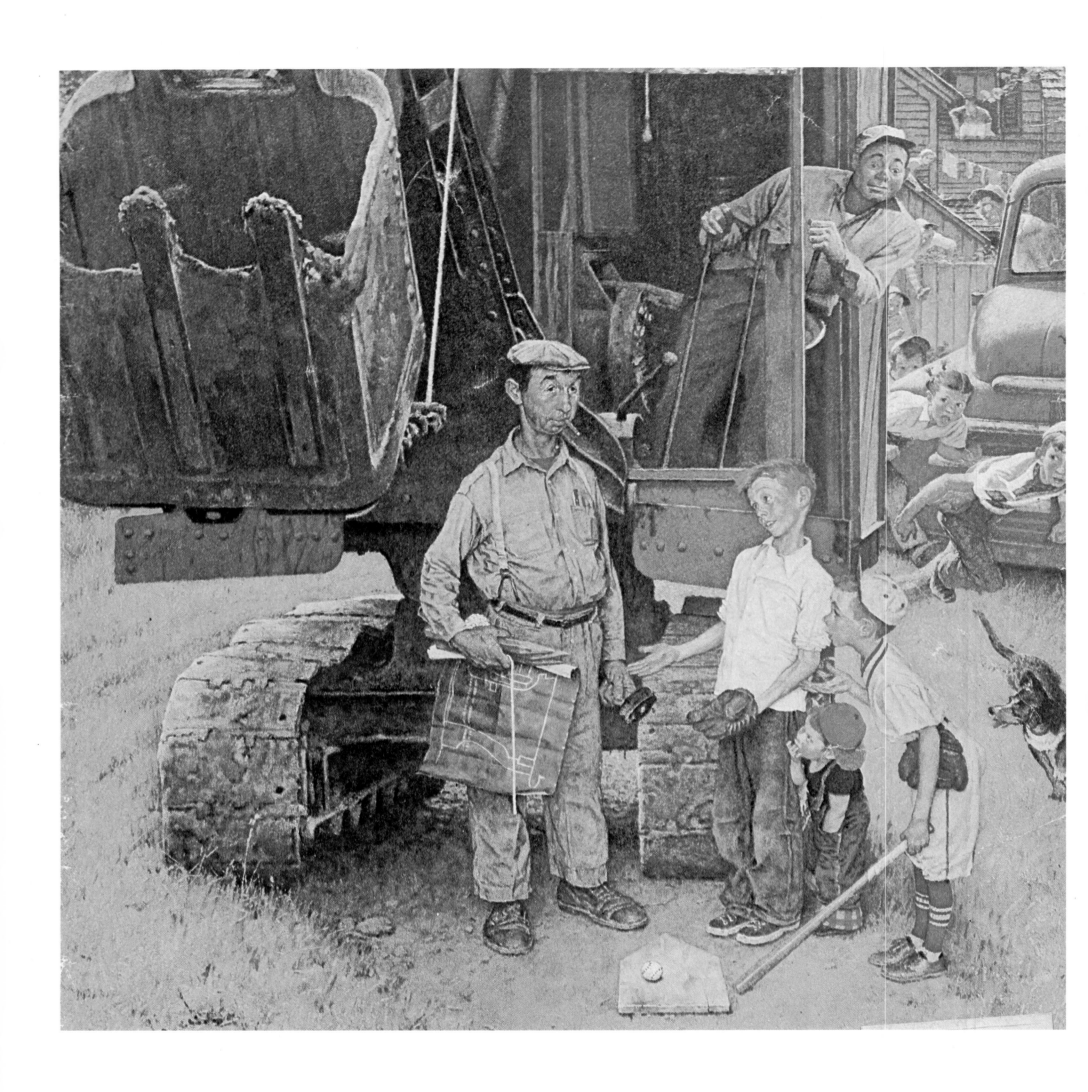

HOME PLATE

Post Cover • August 21, 1954

420

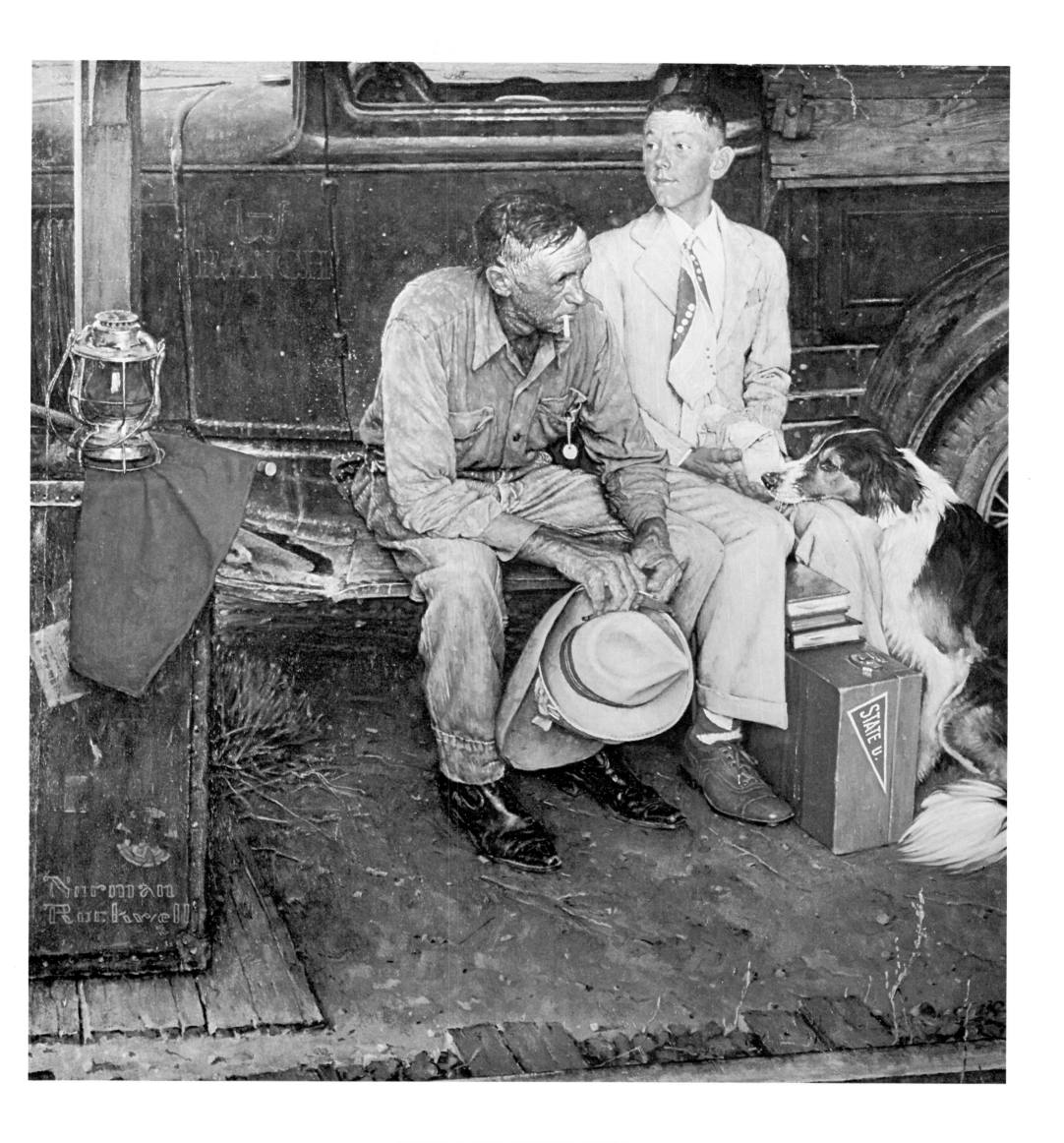

BREAKING HOME TIES
Post Cover • *September 25, 1954*

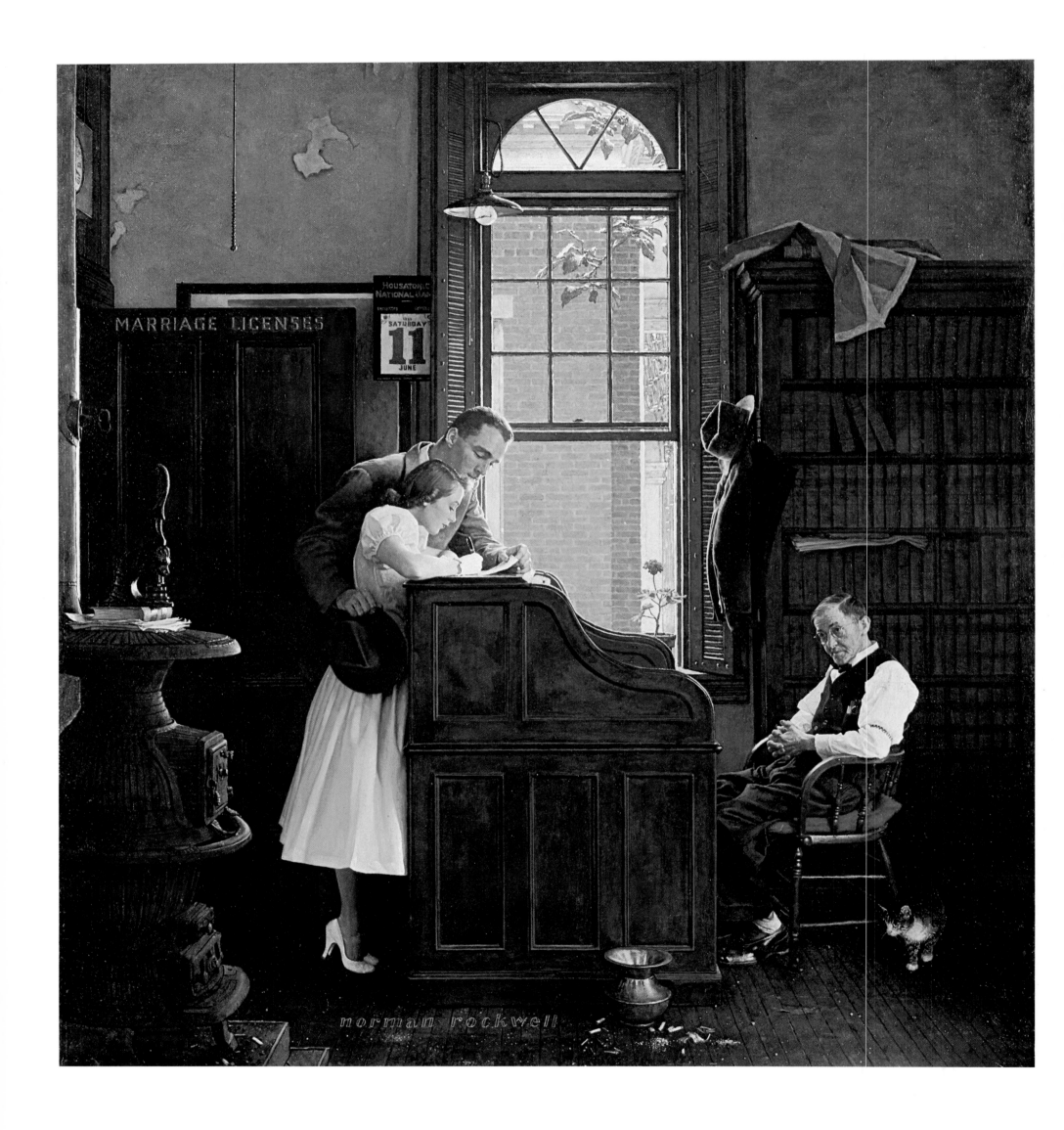

THE MARRIAGE LICENSE

Post Cover • *June 11, 1955*

A FAIR CATCH

Post Cover • August 20, 1955

423

SURPRISE

Post Cover • March 17, 1956

424

NEW GLASSES

Post Cover • May 19, 1956

425

ADLAI STEVENSON
Post Cover • October 6, 1956

426

DWIGHT D. EISENHOWER
Post Cover • *October 13, 1956*

427

BOTTOM DRAWER

Post Cover • December 29, 1956

428

THE ROOKIE

Post Cover • March 2, 1957

429

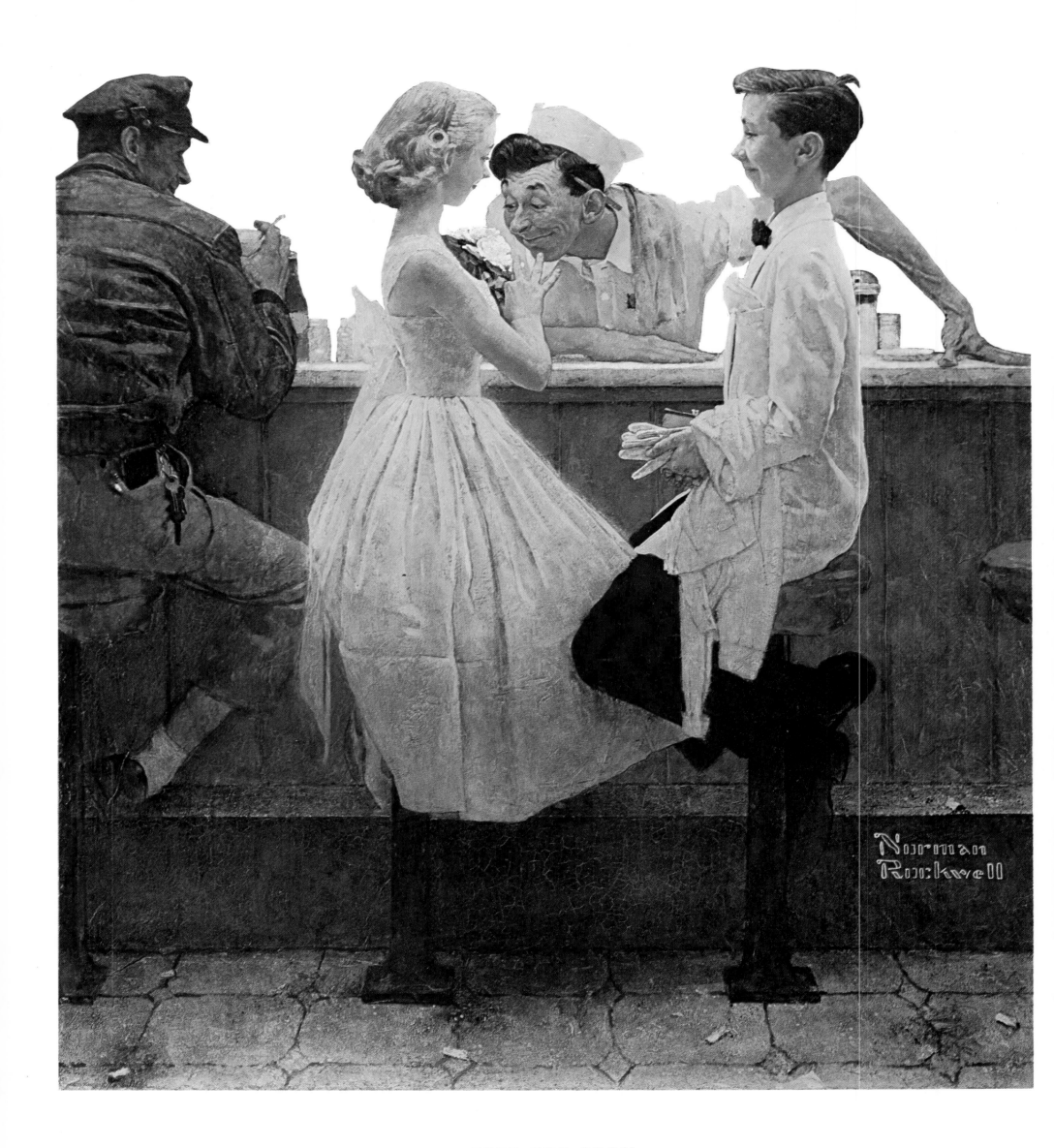

AFTER THE PROM

Post Cover • *May 25, 1957*

BRIDAL SUITE

Post Cover • June 29, 1957

CHECK UP

Post Cover • September 7, 1957

432

EXPENSES

Post Cover • *November 30, 1957*

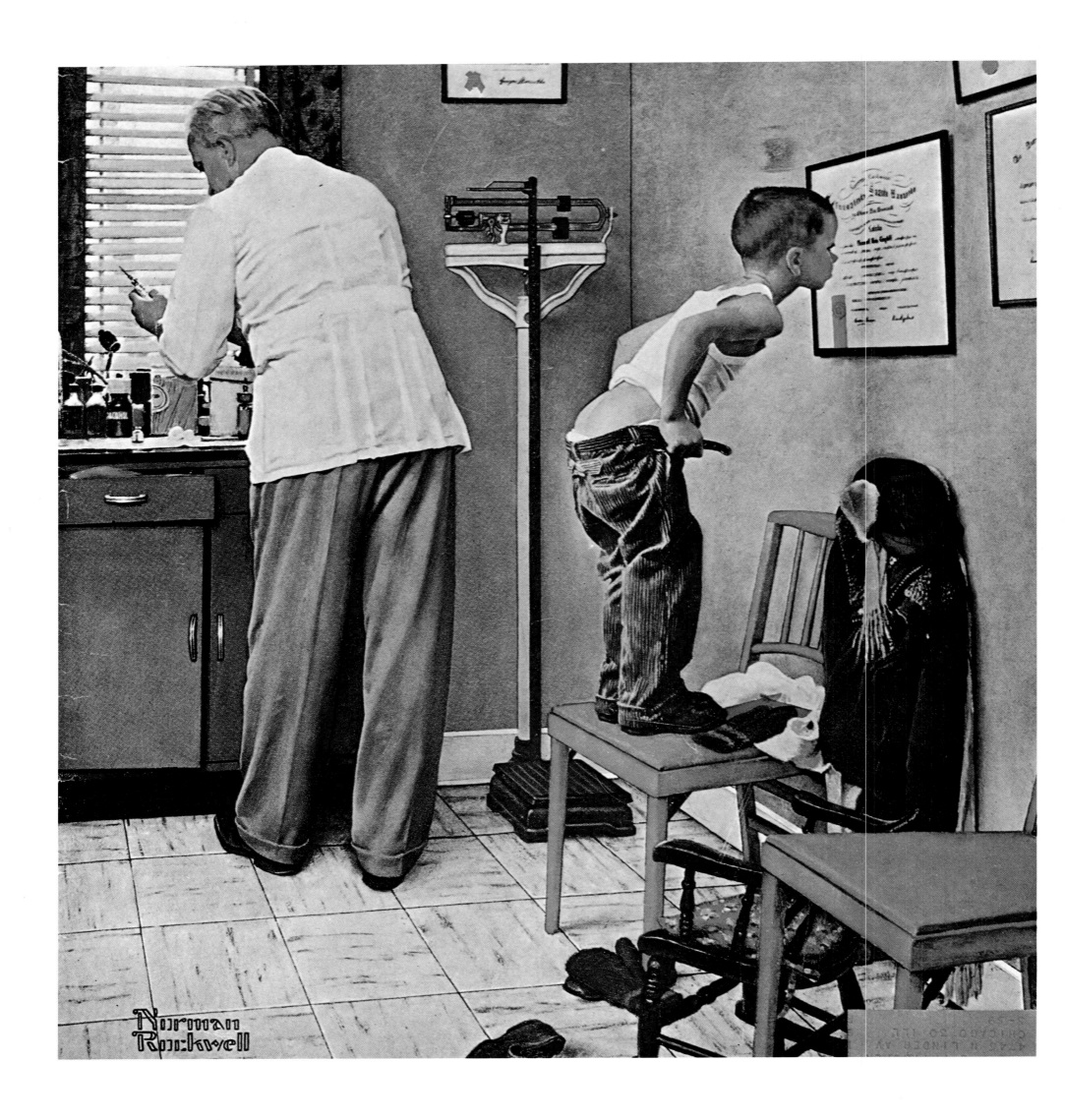

DOCTOR'S OFFICE

Post Cover • March 15, 1958

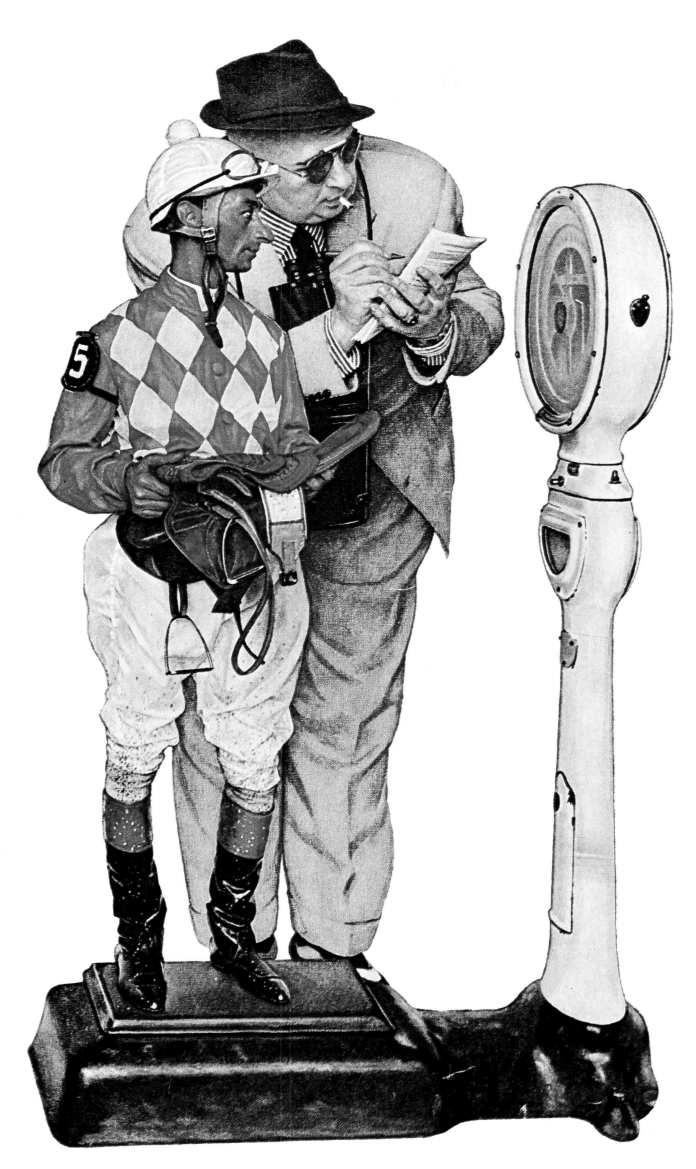

Norman
Rockwell

JOCKEY WEIGHING IN
Post Cover • June 28, 1958

435

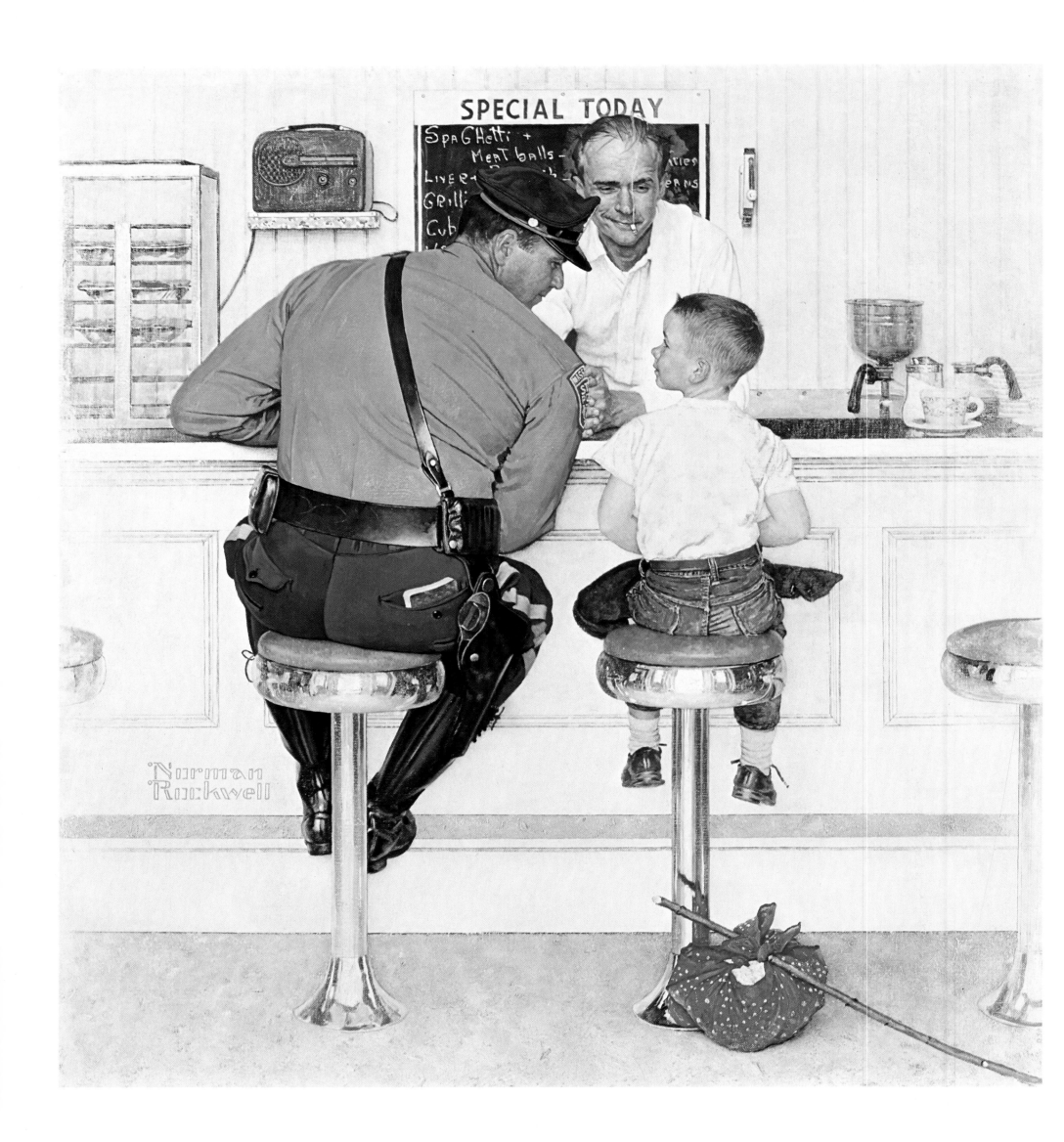

THE RUNAWAY

Post Cover • September 20, 1958

436

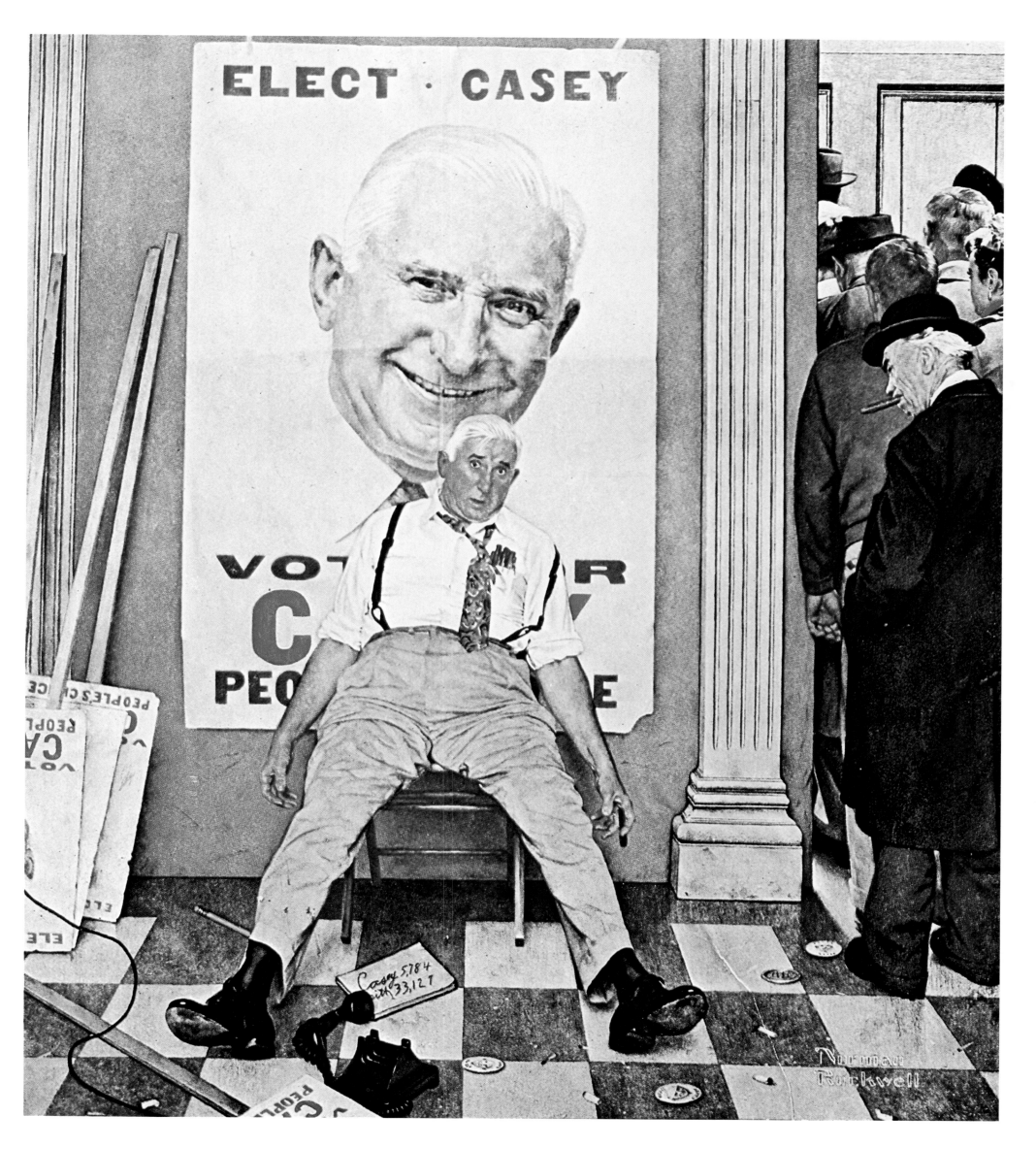

VOTE FOR CASEY

Post Cover • *November 8, 1958*

437

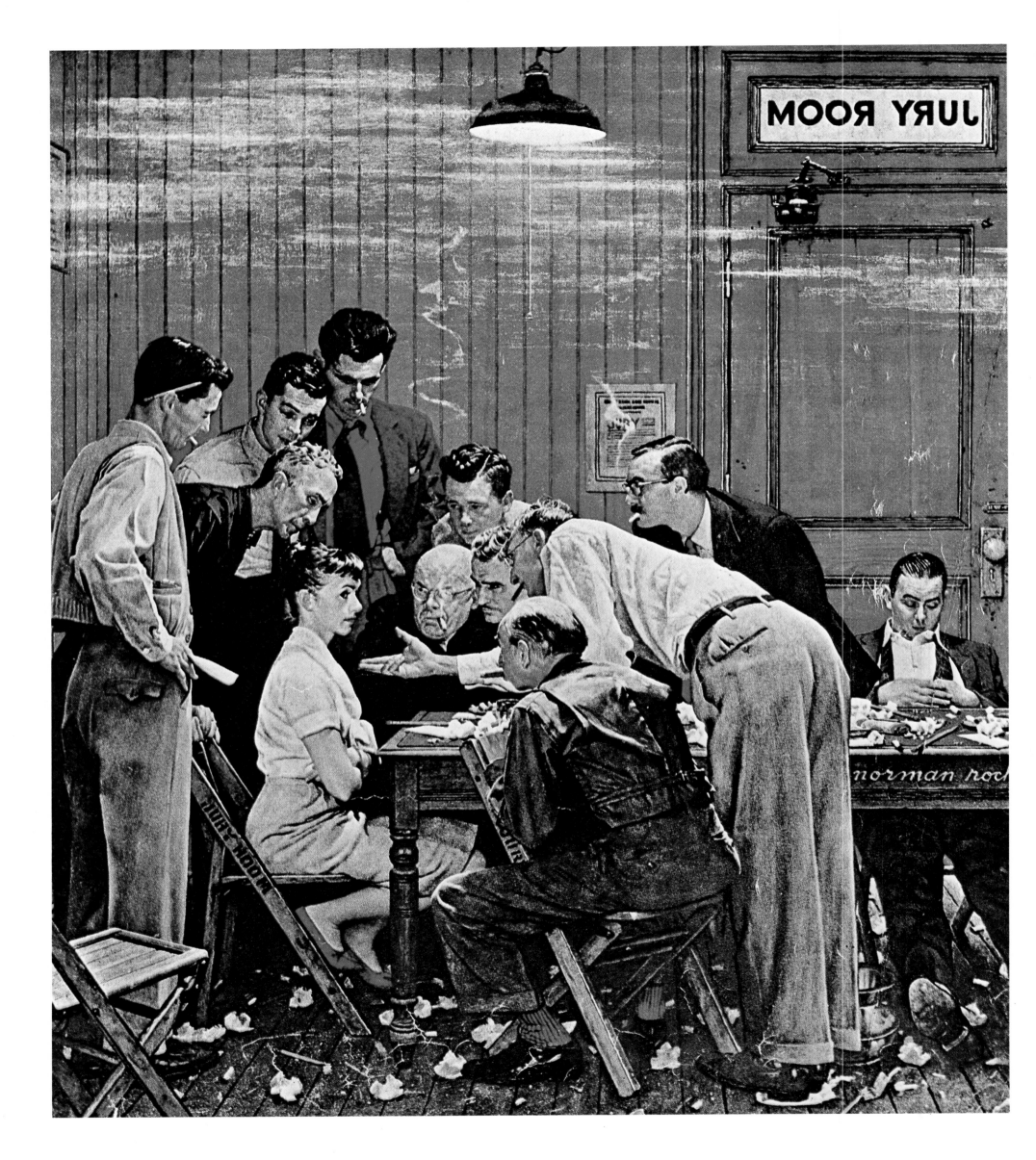

JURY ROOM

Post Cover • February 14, 1959

438

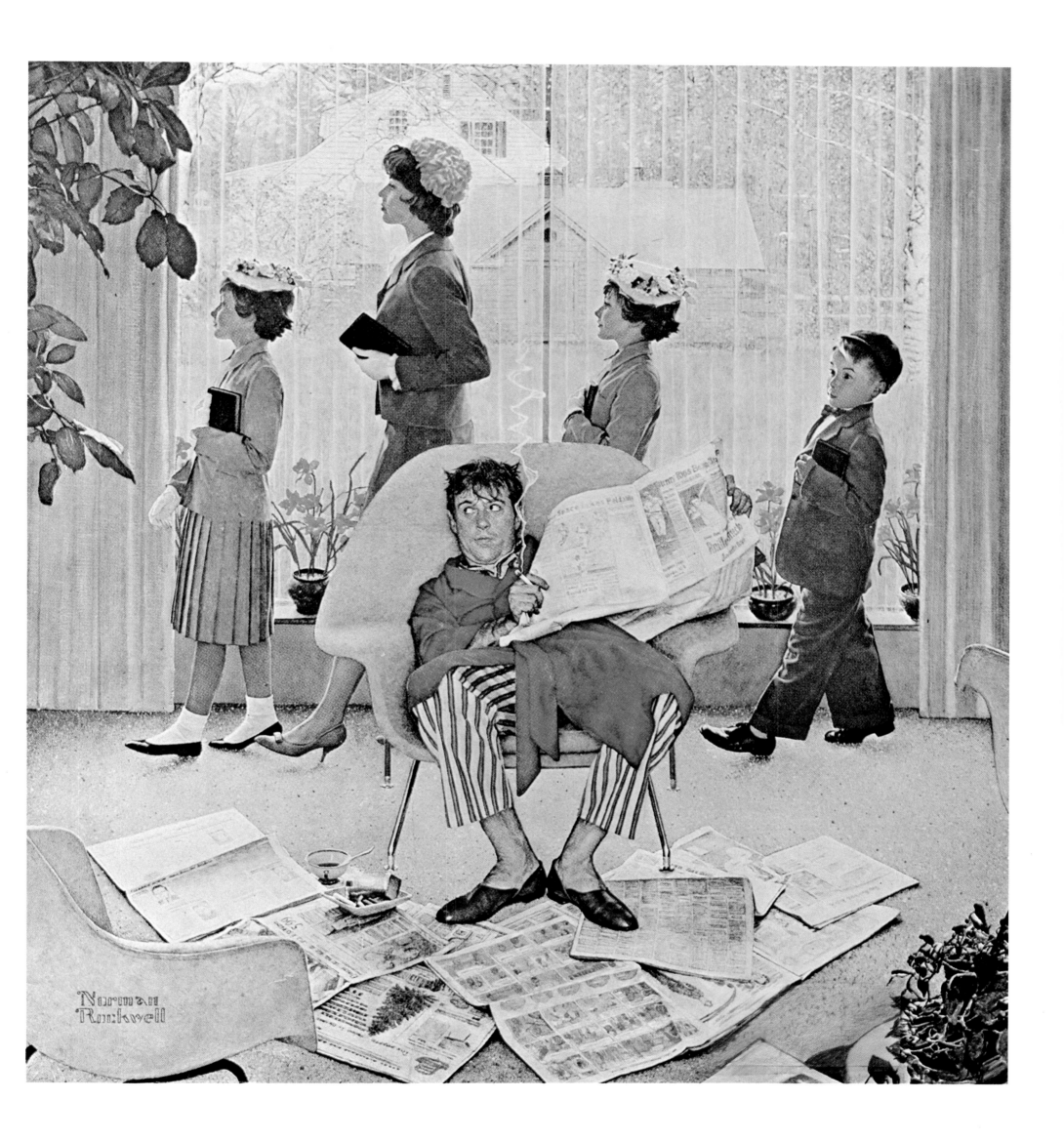

EASTER MORNING

Post Cover • *May 16, 1959*

439

THE GRADUATE
Post Cover • June 6, 1959

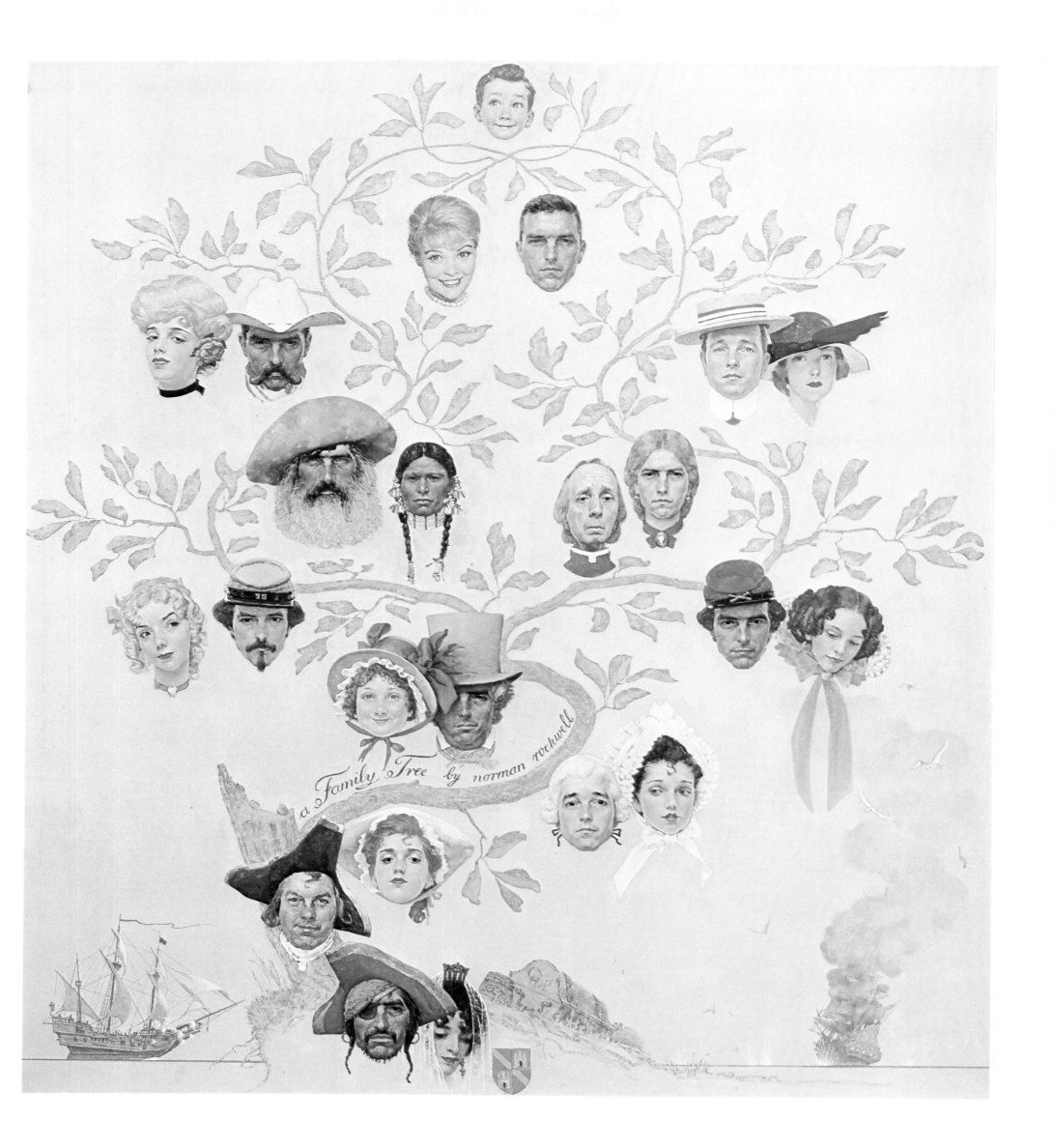

FAMILY TREE

Post Cover • October 24, 1959

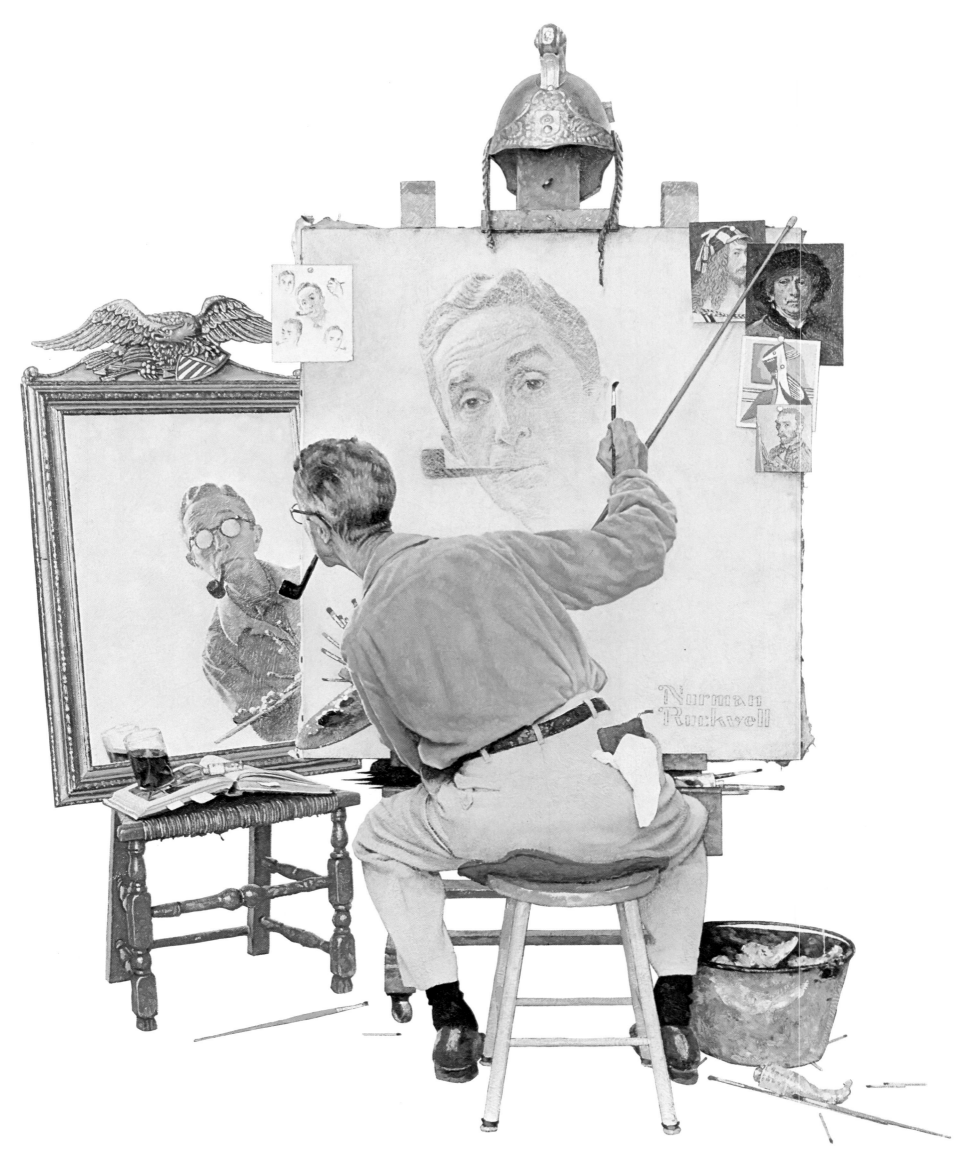

TRIPLE SELF PORTRAIT

Post Cover • February 13, 1960

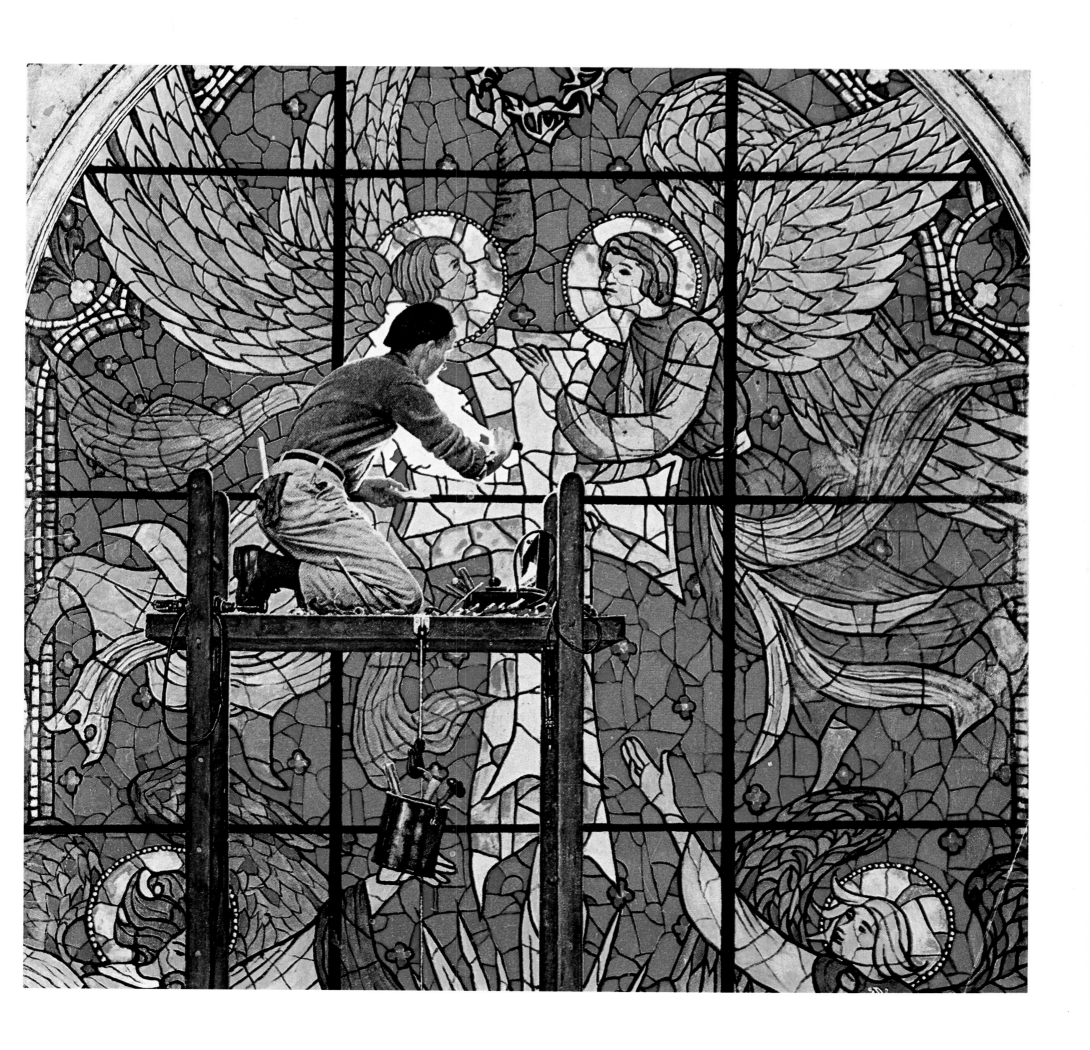

STAINED GLASS

Post Cover • April 16, 1960

443

UNIVERSITY CLUB

Post Cover • August 27, 1960

444

JOHN F. KENNEDY
Post Cover • October 29, 1960

445

NEW LOGO
Post Cover • September 16, 1961

CHEERLEADER

Post Cover • *November 25, 1961*

THE CONNOISSEUR

Post Cover • January 13, 1962

450

LUNCH BREAK
Post Cover • November 3, 1962

JAWAHARLAL NEHRU

Post Cover • January 19, 1963

452

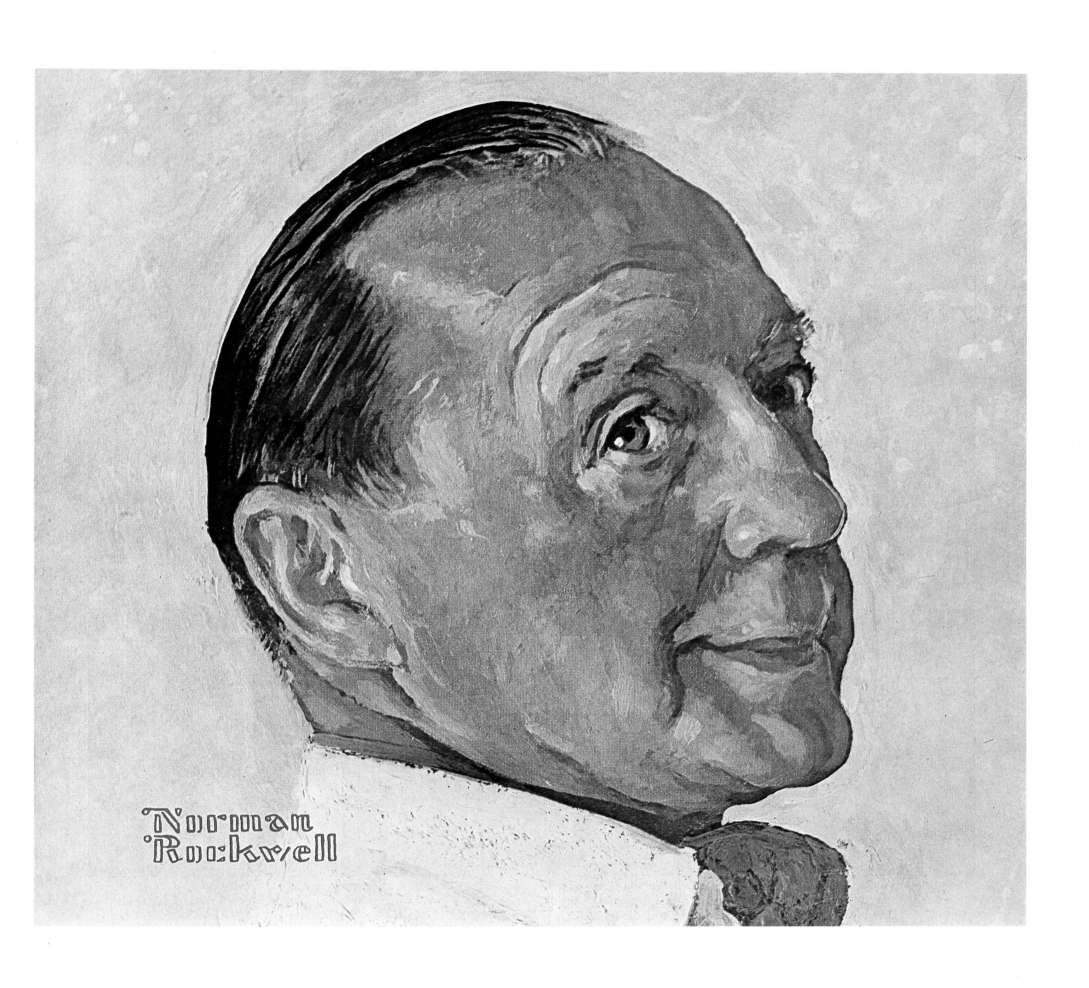

JACK BENNY
Post Cover • March 2, 1963

JOHN F. KENNEDY
Post Cover • *April 6, 1963*

454

Nasser's turbulent world
an exclusive interview
by ROBERT SHERROD

GAMAL ABDAL NASSER
Post Cover • May 25, 1963

455